APR 1 0 2002

AMERICAN ARCHITECTURE

Also by Leland Roth

*Shingle Styles: Innovation and Tradition
in American Architecture*, 1874–1982
(New York: Abrams, 1999).

*Understanding Architecture: Its Elements, History,
and Meaning* (Boulder: Westview Press, 1993).

McKim, Mead & White, Architects (New York:
Harper & Row, 1983).

*America Builds: Source Documents in American
Architecture and Planning* (New York: Harper
& Row, 1983).

A Concise History of American Architecture
(Boulder: Westview Press, 1979).

*The Architecture of McKim, Mead & White,
1879–1920: A Building List* (New York:
Garland Publishing, Inc., 1978).

AMERICAN ARCHITECTURE

A HISTORY

LELAND M. ROTH

Icon Editions
Westview Press
A MEMBER OF THE PERSEUS BOOKS GROUP

Copyright © 2001 by Westview Press, A Member of the Perseus Books Group

Westview Press books are available at special discounts for bulk purchases in the United States by corporations, institutions, and other organizations. For more information, please contact the Special Markets Department at The Perseus Books Group, 11 Cambridge Center, Cambridge MA 02142, or call (617) 252-5298.

Published in 2001 in the United States of America by Westview Press, 5500 Central Avenue, Boulder, Colorado 80301–2877, and in the United Kingdom by Westview Press, 12 Hid's Copse Road, Cumnor Hill, Oxford OX2 9JJ
Design: Abigail Sturges

Find us on the World Wide Web at www.westviewpress.com

A CIP catalog record for this book is available from the Library of Congress.
ISBN 0-8133-3661-9
The paper used in this publication meets the requirements of the American National Standard for Permanence of Paper for Printed Library Materials Z39.48–1984.

10 9 8 7 6 5 4 3 2 1

Dedications, like books, need to be kept up to date;
my first book on American architecture was
dedicated to our bright-eyed newborn daughter

AMANDA

and those who grow with her;
in the hope that their environment will be
cleaner, brighter, and ever more humane

This new book is again dedicated to

AMANDA

who seeks to realize these high aspirations
in her life's work

CONTENTS

PREFACE

Around 1987, Cass Canfield Jr., my editor at Harper & Row, suggested a revised and updated edition of my *Concise History of American Architecture*, first published in 1979. Other projects and duties intervened, however, not least of which was completing *Understanding Architecture*, published by HarperCollins in 1993. What began as an amended and enriched new edition of the *Concise History* became instead a completely new book, almost double the original length and with twice as many illustrations and plans.

Previously I suggested a parallel between building and politics, for both are based on the fine art of compromise. Every building represents a judicious balance between conflicting needs and aspirations on the part of the client, the architect, and builder. In the United States there has been, from the first arrival of European settlers and builders, a divergent tension between satisfying pressing physical needs and expressing transcendent cultural desires, between the impulse to build pragmatically and efficiently, on the one hand, and, on the other, the longing to realize a conceptual ideal. Nearly the same idea was expressed in 1911 by American philosopher George Santayana in an address given at the University of California:

America . . . is a country with two mentalities [he observed], one a survival of the beliefs and standards of the fathers, the other an expression of the instincts, practice, and discoveries of the younger generations. . . . [O]ne-half of the American mind, that not occupied intensely in practical affairs, has remained, I will not say high-and-dry, but slightly becalmed; it has floated gently in the back water, while, alongside, in invention and industry and social organization the other half of the mind was leaping down a sort of Niagara Rapids. This division may be found symbolized in American architecture: a neat reproduction of the colonial mansion—with some modern comforts introduced surreptitiously—stands beside the sky-scraper. The American Will inhabits the sky-scraper; the American Intellect inhabits the colonial mansion. . . . The one is all aggressive enterprise; the other is all genteel tradition.[1]

This account of the history of American architecture is concerned, in large part, with this struggle to find the precarious balance between the real and the ideal. The settlers came to the New World in the beginning driven by idealism, to find a measure of social or economic perfection, and yet they soon discovered they had to shelter themselves in the most rudimentary manner; the conflict between the ideal and the real has continued from that time to the present. Written to introduce the student and the interested observer to the major developments that have shaped the American built environment, from before the arrival of the Europeans through the twentieth century, this new book covers both the high-style architecture of aspiration as well as aspects of everyday vernacular architecture. It sketches the impact of interrelated changes in conceptual imagery, style, building technology, landscape design, and town planning theory.

Teaching courses in native American architecture, and seventeenth- and eighteenth-century colonial American architecture, encouraged me to expand that material into three separate chapters. Endnotes have

been added throughout the text to identify passages quoted and also to make cross references to this book's forthcoming companion volume, the second edition of *America Builds: Source Documents in American Architecture and Planning*. In addition, because of the great surge in publication on American architecture since the mid-1970s, the bibliographical references have been greatly expanded and moved to the end of each chapter.

The text is divided into sections marked by particular coherence in building technique and expression; often these are delineated by economic or political cycles. The last sections are somewhat longer and consciously more subjective in character than the earlier sections, as the proximity of events precludes absolute objectivity. Time will make more correct the relative weight of things. The epilogue at the end of chapter 10 is a brief critical essay sketching some of the problems we face at the end of the twentieth century, posing questions about how all of us—users, designers, and builders alike—can participate in making an architecture that, as the ancient Roman architect Vitruvius wrote, seeks the substance instead of the shadow.

There are many people who must be thanked for their assistance in making this new book possible. First is my family who, perhaps, have sometimes been left without time together at home, but who have also enjoyed, however, the many trips to inspect sites and buildings. To my editor at HarperCollins/Westview Press, Cass Canfield Jr., I owe an enormous debt, as much for his unflagging enthusiasm and support as for his unending patience while this new work slowly emerged. To the many students in my classes exploring American architecture over the past twenty-five years I owe a special debt, for they helped me see through new eyes what perplexes, captivates, and inspires those learning to see and begin to understand the built environment around them. My friends and professional colleagues at the University of Oregon and around the country, as well as fellow members of the Society of Architecture Historians and the Vernacular Architecture Forum, have answered innumerable questions, offered countless suggestions, and taught me much.

In particular I must thank my daughter, Amanda. The *Concise History*, in 1979, was dedicated to her, then an inquisitive infant, the promise of a bright future. This new expanded study is likewise dedicated to Amanda, now a young woman, still inquisitive, now pursing professional studies in architectural and art history; she has been an invaluable sounding board for testing ideas and written expressions.

As ever, to Carol, my wife, belongs special thanks, for she has endured trips to this place and that with enthusiasm and grace. She has put up with my many long evening hours in the study, undertaken tedious editing and preparation of the original manuscript, applied her considerable knowledge of computer text manipulation and of production editing, and she always cordially acquiesced to my entreaties to comment, to edit, or simply to listen. Her unending support has been indispensable, and this book is the better for it.

Leland M. Roth
Eugene, Oregon
June 2001

NOTE

1. George Santayana's address at the University of California, 1911, "The Genteel Tradition," is reprinted in Douglas L. Wilson, ed., *The Genteel Tradition: Nine Essays by George Santayana* (Cambridge, Mass., 1967, 39–40); the essay is discussed in John Tomsich, *A Genteel Endeavor: American Culture and Politics in the Gilded Age* (Stanford, Calif., 1971). This intriguing concept of the dualism in American thought and American arts I used as the point of departure for a chapter outlining the character of American architecture, "A New Architecture, Yet Old," in *Making America: The Society and Culture of the United States*, ed. Luther S. Luedtke, Forum Series (Washington, D.C.: U.S. Information Agency, 1987; reprint Chapel Hill, N.C., 1991).

AMERICAN ARCHITECTURE

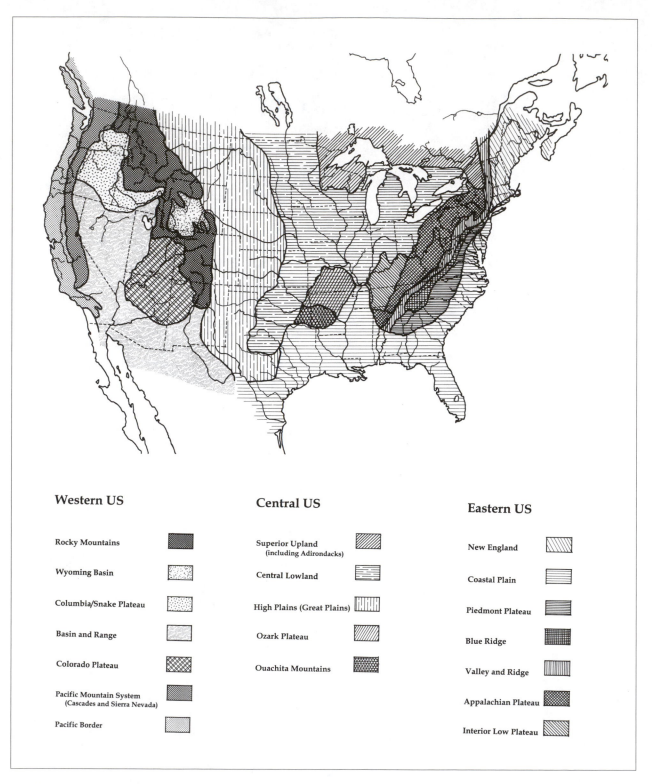

Western US

Rocky Mountains

Wyoming Basin

Columbia/Snake Plateau

Basin and Range

Colorado Plateau

Pacific Mountain System
(Cascades and Sierra Nevada)

Pacific Border

Central US

Superior Upland
(including Adirondacks)

Central Lowland

High Plains (Great Plains)

Ozark Plateau

Ouachita Mountains

Eastern US

New England

Coastal Plain

Piedmont Plateau

Blue Ridge

Valley and Ridge

Appalachian Plateau

Interior Low Plateau

1.1. Physiographic regions and provinces of the United States, map. The large area of the United States is divided into numerous differentiated zones, especially by the three major mountain systems—the Appalachian Mountains, Rocky Mountains, and Pacific Mountain systems. (L. M. Roth, adapted from C. B. Hunt, Natural Regions of the United States and Canada, *2nd ed., San Francisco, 1974.)*

THE FIRST AMERICAN ARCHITECTURE

CEREMONIAL ENCLOSURES AND HOMES

A VAST AND VARIED CONTINENT

Shaping the environment for utilitarian or symbolic ends is architecture in its broadest sense. To build well involves a synthesis of optimum function, sound construction, and sensory stimulation, a formula first elaborated by the Roman architect Vitruvius in about 16 B.C. Yet the way in which these elements are combined and the relative weight given to each are determined by many factors, by the beliefs, values, and objectives of the builders and their culture, by economic resources, by technical capacity, and by climatic forces. Of all of these influences, perhaps natural forces make the most insistent demands on a building, for it must withstand the incessant pull of gravity and the gradual attrition of weather. Yet more important and revealing, architecture, the great and silent cultural artifact, expresses better than any other medium the relationship the builders have with each other and with their universe—in how they place their buildings in the landscape, and in the technologies they use to create a spiritually nourishing community for themselves.

Ethos, culture, technology, and climate together helped to shape the first shelters and ceremonial enclosures made by the first humans to venture into the New World. As the various building types were gradually developed and refined, they paralleled the wide differences in climate and landscape found across the broad North American continent.

The land in which the first Americans made their homes, the area that is now the United States, stretches 3,500 miles from the Atlantic to the Pacific Ocean, and 1,200 miles from Canada to Mexico. It is a vast and fruitful land of striking geographical and climatic contrasts, far more marked in intensity and degree of contrast than the extremes to which the later European settlers were accustomed in their native lands.

The Geological Features

The land that was to become the United States is rich and varied, both physically as a result of geological forces, and in its extremes of climate resulting from a range of meteorological forces.[1] [1.1] In the northeast, starting in the Maritime Provinces of present-day Canada and extending in a southwesterly direction for more than 1,600 miles (2,575 km) down to central Alabama, is a band of parallel folded mountain ridges, the Appalachian Mountains, one of five major geological and geographical zones. To the east of this barrier lies the second zone, the gentle hilly lowlands in the Piedmont Plateau that descend to Atlantic and Gulf Coast beaches. To the north, in what became New England, the lowlands are indented at the mouths of numerous rivers—the Penobscot, the Piscataqua, the Merrimack, the Charles, the Connecticut, and the Hudson, as well as broad Narragansett Bay. Along the mid-Atlantic coast are several broad estuaries such as the mouth of the Delaware River. Almost in the middle opens the huge estuary of Chesapeake Bay, fed by numerous broad rivers reaching back deep into the lowlands of what would become Maryland and Virginia.

South of the Chesapeake Bay begins a gentler broad and rolling landscape, made up of the piedmont that backs up against the Appalachians, and the broad coastal plain that includes most of the southern states,

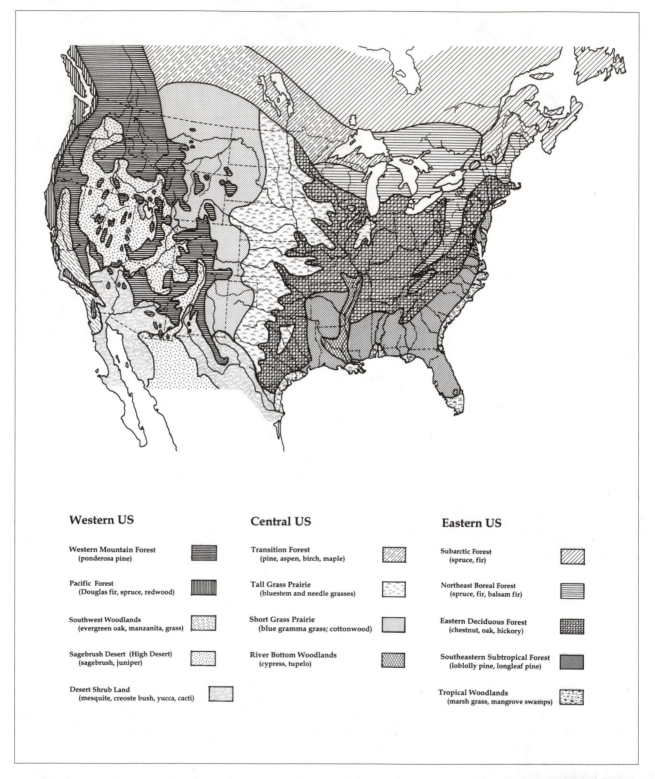

Western US

Western Mountain Forest
(ponderosa pine)

Pacific Forest
(Douglas fir, spruce, redwood)

Southwest Woodlands
(evergreen oak, manzanita, grass)

Sagebrush Desert (High Desert)
(sagebrush, juniper)

Desert Shrub Land
(mesquite, creoste bush, yucca, cacti)

Central US

Transition Forest
(pine, aspen, birch, maple)

Tall Grass Prairie
(bluestem and needle grasses)

Short Grass Prairie
(blue gramma grass; cottonwood)

River Bottom Woodlands
(cypress, tupelo)

Eastern US

Subarctic Forest
(spruce, fir)

Northeast Boreal Forest
(spruce, fir, balsam fir)

Eastern Deciduous Forest
(chestnut, oak, hickory)

Southeastern Subtropical Forest
(loblolly pine, longleaf pine)

Tropical Woodlands
(marsh grass, mangrove swamps)

1.2. *Natural vegetation zones in the United States and North America, map. The patterns of natural vegetation across the United States reveal patterns of climate, so that indigenous plants are determined by latitude, altitude, and moisture as* *influenced by mountain barriers. (L. M. Roth, adapted from C. B. Hunt,* Natural Regions of the United States and Canada, *2nd ed., San Francisco, 1974.)*

including Mississippi, Louisiana, and the eastern half of Texas.

West of the Appalachians and north of the southern coastal plain is a third major geological feature, the great heartland of the North American continent, the rolling plains and high prairies of black earth through which flow the Ohio, Tennessee, and Missouri Rivers, all emptying into the Mississippi (Algonquian for "Big River"), which divides the continent and carries its waters and burden of silt to the Gulf of Mexico. These plains and prairies extend from Minnesota and Wisconsin southward to west Texas, westward from Ohio to central Montana.

Abruptly from the western high plains thrust the sharp peaks of the Rocky Mountains, the eastern edge of the diverse fourth major geological zone. The Rockies form part of a spine of split, folded, and uplifted rock that runs from Alaska in the far north, down across the continent, through Mexico. Just west of the Rockies is a group of high plateaus and basins collectively called the Great Basin, or the Basin and Range. Together with its western boundary formed by the high Cascades and the Sierra Nevada, this region of mountains and high basins comprises a zone technically and collectively identified as the Western Cordillera and its Intermontaine Basins.

Cutting through the western mountains and the Great Basin are three great river systems: the Columbia River in the north, descending through Idaho, Washington, Oregon, and flowing west to the Pacific; the Colorado River, running from Colorado down through Utah and Arizona to the Gulf of California; and the Rio Grande, which extends down from central Colorado through the center of New Mexico and along the Texas-Mexico border.

The peaks of the Sierra Nevada, together with the volcanic Cascade Range in northern California, Oregon, and Washington, mark the dividing line between the high arid intermountain basins and the temperate Pacific Coast, the fifth and last of the major geological zones.

The upper central and northern regions of the continent (New England and the Great Plains) were additionally reshaped by the scouring of miles-thick glaciers that repeatedly advanced and receded, surging into the middle of the continent and then pulling back, with minor advances and retreats during the warmer interglacial ages. Like a slow-moving icy ocean, these waves left behind layer upon layer of sand, gravel, clay, and earth. The great river valleys of the Ohio, Missouri, and Mississippi are the channels cut by the meltwaters from those ancient continental glaciers. Another gift of the glaciers were the narrow Finger Lakes in New York, and especially the bigger chain of the Great Lakes. These scoured-out basins, filled with meltwater, empty one into the other and eventually through the St. Lawrence River out into the north Atlantic. It is sobering to think that the once thick conifer forests of Michigan, Wisconsin, Minnesota, and other northern regions—woodlands that took ten thousand years to develop after the last ice sheet retreated—were virtually eradicated by only a few generations of European settlers, a cycle of pillage now being reenacted in the Pacific Northwest.

The Bioclimatic Zones

In addition to the five geological zones, there are additional distinct bioclimatic zones. In the humid eastern half of the continent, these bioclimatic zones run horizontally and cut across the relatively low mountain barriers. [1.2] Well to the north, running westward from Maine to upper Minnesota, is the Northeast Boreal Forest, marked by thick evergreen conifer growth; here temperature extremes can range from an average of –9° F (–62° C) in the winter to well over 80° F (26° C) in the summer. In the northern forest zone, rainfall and snow tend to be moderately high, roughly 46 inches (1.2m), but often creating snow levels of 180 inches (4.6m) in northern Michigan.

Further to the south is another, broader horizontal band that runs west through lower New England, to southern Wisconsin, extending south to the Virginia piedmont and west through Missouri. In this midlatitude Eastern Deciduous Forest of mixed conifers and deciduous trees, the temperatures are more moderate but still range over extremes much greater than those encountered in Europe, from an average low of 20° F (–6° C) in the winter to over 86° F (30° C) in the summer. Although the temperatures are more moderate around the Chesapeake Bay, they are accompanied by much higher humidity there. In Ohio, in the midst of this zone, rainfall averages about 35 inches (.89m) in a year.

The third horizontal band to the south is the Southeastern Subtropical Forest, extending from the Carolinas west to Arkansas and extending south into the middle of the Florida peninsula; at the lower tip of Florida, below Lake Okeechobee, and in selected places along the Gulf Coast, is a true Tropical Forest of mangrove swamps. In Georgia the average inland lowest winter temperature is just above freezing, at 33° F (about 0° C), with an average summer high of

about 92° F (33° C). In the tropical zone around Miami, at Florida's tip, the winter average low is seldom less than 58° F (14° C), while the average summer highs are approximately 90° F (32° C), accompanied by high humidity. Rainfall in this broad zone is plentiful, averaging about 57 inches (1.4m) in central Alabama, while in southern tropical Florida it can exceed 64 inches (1.6m) in a year.

West of the humid eastern half of the country, the bioclimatic bands begin to run vertically and are determined more by comparable rainfall than by comparable temperatures. The first of these vertical bands to the west occurs where the land begins its ascent to the high western plains, and this transitional humid-to-arid area, dominated by long grasses, runs from the Dakotas south through central Texas. Here temperatures can vary in the far north from the great extremes of –4° F (–20° C) in the winter and well over 90° F (32° C) in the summer, to the hotter climate in Texas that seldom drops below an average of 40° F (4.5° C) in the winter and easily reaches 100° F (38° C) in the summer. In this transitional band from humid to arid, rainfall varies little, from 17 inches (431mm) a year in North Dakota to a dryer 10 inches (254mm) in central Texas.

The next vertical band farther to the west corresponds to the high plains at the eastern base of the Rockies; this is the semiarid zone that runs from central Montana south to the tip of Texas, a landscape dominated by short grasses. In this zone temperature extremes are equally great, ranging in northwestern Montana from average winter lows of –1° F (18° C) to highs of 85° F (29.5° C) in the summer, whereas in western Texas, winter lows average 32° F (0° C), while summer highs easily top 100° F (38° C). Precipitation across the entirety of this semiarid zone, however, is extremely low, seldom exceeding 7 inches (17.8cm) a year.

In the large western mountain and Great Basin area, climate varies considerably according to altitude, so that the cold higher peaks receive considerable snowfall, while the basins below receive only sporadic thunderstorms and light dustings of snow, remaining semiarid. While more than 50 to 100 inches (1.3 to 2.5m) of snow may collect at the mountain tops, supporting scattered portions of the western mountain forest of various pines, only 7 inches (17.8cm) of rain may reach the basin floor, where stunted juniper trees are sparse and where sagebrush dominates in this high desert.

Even more distinct is the southerly portion of the Great Basin; here is a true desert, forming a crescent that runs from Nevada and western Utah, down through lower California and southern Arizona, eastward through lower New Mexico and western Texas. In this desiccated area rainfall varies from a low of 3 inches in Nevada to 6 inches in the four corners area, where the borders of Utah, Arizona, New Mexico, and Colorado form a right angle. The major water resources in these arid desert highlands are the Rio Grande and the Colorado, together with their tributary rivers.

Further west, across the Sierra Nevada and Cascade Range, however, far different climates prevail. Along the northern Pacific coast, from British Columbia down to San Francisco, the prevailing westerly winds incessantly drive clouds up against the mountain barrier, forcing them to drop their moisture; only in the late summer does this cease. Here are found dense forests of towering Douglas fir, spruce, redwood, and sequoia. In Washington and Oregon, along the coast, temperatures range from winter lows of 40° F (2° C) to summer highs of 75° F (24° C)—although summer temperatures in the interior valleys range about ten Fahrenheit degrees higher. Rainfall can reach 150 inches (3.8m) in the mountains of Washington's Olympic Peninsula, but the average is closer to 100 inches (2.5m) elsewhere in the peaks of the Cascades and Sierra Nevada, creating snow packs in excess of up to 22 feet (6.7m) in depth.

THE FIRST AMERICANS

The physical forms of the landscape into which the first Americans ventured were geologically much as they are today. The climate, however, was drastically different. Because of the presence of the glaciers from 50,000 to 10,000 years ago, the zones of vegetation described above were compressed into narrower bands far to the south of their present locations. [1.3] Glaciers covered all of central and eastern Canada, extending down over the Dakotas, Minnesota, Iowa, Wisconsin, Illinois, Ohio, New York, and New England. Glaciers also covered the western mountains down to Colorado, past present-day Lake Tahoe, with cold alpine climates in the mountains even farther to the south, all the way through Mexico. Between the mountain glaciers and those on the eastern plains, however, there is believed to have been an intermittent ice-free corridor of steppe tundra all the way from central Alaska down to Colorado and curving around to the east, across lower Kansas, Missouri, and Kentucky. Below this band, across the panhandle of Texas,

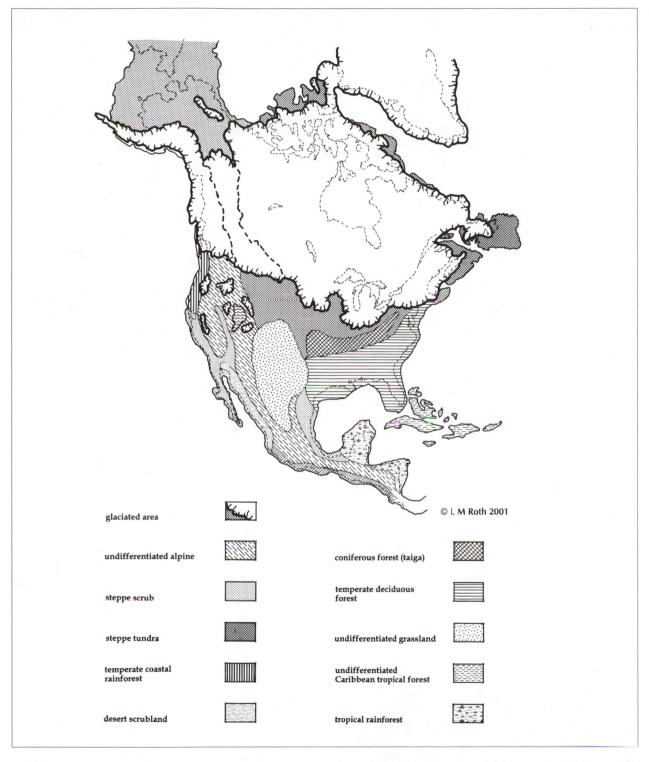

© L M Roth 2001

glaciated area			
undifferentiated alpine		coniferous forest (taiga)	
steppe scrub		temperate deciduous forest	
steppe tundra		undifferentiated grassland	
temperate coastal rainforest		undifferentiated Caribbean tropical forest	
desert scrubland		tropical rainforest	

1.3. *Vegetation zones in North America, 20,000 to 11,000 years ago. Toward the end of the last period of glaciation, vegetative zones were found several hundred miles to the south of where they are found today; also, due to so much water being captured in the glacial sheets, sea level was* 200 to 300 feet below present levels, exposing large areas of the continental shelf, especially along the eastern and Gulf coasts. (L. M. Roth, adapted from National Geographic Magazine, *December 2000, and Jesse D. Jennings,* Ancient North Americans, *New York, 1983.)*

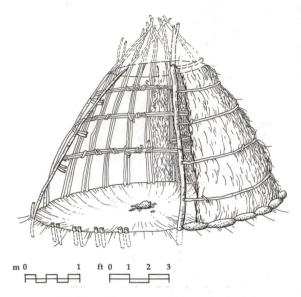

m 0 1 ft 0 1 2 3

1.4. Dirty Shame Wickiup, Dirty Shame Rock Shelter, Oregon, c. 1450 B.P. Drawing (restored) of rock-shelter dwelling. Although the surviving portions of this particular shelter date from about 1,450 years ago, remains of others suggest nearly identical dwelling or lodges were built as far back as 9,500 years ago. The arid conditions east of the Cascades since 10,000 years ago have preserved much organic material, including the lower portions of these hunting lodges. (L. M. Roth, after C. M. Aikens, Archaeology of Oregon, *Washington, D.C., 1986.)*

Oklahoma, Arkansas, Tennessee, and up into Virginia, was a conifer forest similar to what is now in northern Minnesota through northern Michigan. In the southernmost tier, from Texas east to the Carolinas, was mixed broadleaf forest. In the four corners region was mixed grassland, scrub steppe, and small deserts.

How and when native American peoples first appeared in this outstretched land is debated. Euro-American anthropologists generally support the theory that the ancestors of the first Americans walked across a dry land bridge then connecting Siberia and Alaska. In search of migrating game, perhaps, these Asiatic ancestors, called Paleo-Indians by anthropologists, crossed into the Western Hemisphere as early as 50,000 years ago, in the first of several waves of emigration from Siberia. The theoretical land bridge, called Beringia, was exposed when the glaciers locked such a great volume of oceanic water in the polar ice cap that sea level dropped as much as 300 feet (91m) below the present level.[2] Moving down through the ice-free corridor, or by boat around the west coast of Alaska as it then existed, the Paleo-Indians quickly spread across

the compressed vegetated landscapes to the south. Periodically the glaciers advanced and retreated, while ocean levels dropped and then rose, sometimes covering the Beringia isthmus. A second major influx of immigrants seems to have occurred between 15,000 and 12,000 years ago, when especially frigid weather again built up the glaciers and lowered sea levels. Clear evidence exists of an early settlement along Dry Creek, Alaska, between 11,200 and 10,700 years ago. After that the weather warmed, the glaciers began their gradual retreat, and sea levels rose, covering the Beringia land bridge from that time to the present.

Native Americans for the most part do not support this migration theory, since they see it as another way in which Euro-Americans minimize the natives' claims to their ancestral homelands. There are no accounts in any of the many origin stories that speak of migrations as described by the anthropologists and archaeologists, although the Navajo, Hopi, and Pueblo creation stories describe the ascent of the first people from lower, darker worlds up to the present world, and perhaps these accounts recall aspects of those distant ancient migrations. The Euro-American mentality insists that there can only be one true story (and it is theirs), but in truth there are many valid if partial versions of reality whose multiple levels add a density of texture and richness to the whole.

What architectural structures these first Americans may have built may never be clearly known, since they apparently used organic materials—wood, skins, grasses—as recent archaeological discoveries have shown. In 1990 the charcoal remains of hearths and the bottoms of wooden house poles for what appeared to be at least one oval dwelling measuring roughly 13.1 by 16.5 feet (4 by 5m), were uncovered near the Newberry Crater in eastern Oregon. The lodge pole pine supports, almost 8 inches in diameter, had been felled 9,450 and 9,490 years ago, making this the oldest dwelling yet found in North America.[3] The remains of the house and many artifacts were preserved under a thick layer of ash deposited when Mount Mazama exploded around 7,600 years ago. Also around 9,500 years ago, a cache of carefully woven sandals of sagebrush fiber was stored in a rock shelter near Fort Rock, Oregon; the sandals were discovered in the 1930s, but their ancient date of making was not confirmed until the development of radiocarbon dating in the 1950s. Also preserved were the lighter remains of much later dwellings uncovered under the protective overhang of the Dirty Shame rockshelter of southeastern Oregon. The extremely arid conditions that pre-

vailed following the retreat of the glaciers preserved large portions of several light sapling wikiups, about 14 feet (4.5m) in diameter, covered with rye grass thatch. [1.4] They had been built about 1,450 years ago, but lower layers in this same rock shelter contained evidence of similar shelters having been made perhaps as far back as 8,000 years ago.

About 11,500 years ago in the midcontinental valley there arose an Archaic big game hunting tradition, identifiable, as is each of the successive cultural traditions, by the way in which stone tools were fashioned, particularly the distinctive Clovis flint spear points, first uncovered at Clovis, New Mexico. Such readily identifiable points have been found broadly dispersed across the continent. Evidence indicates that Clovis spear points were used from about 11,500 to 11,000 years ago, succeeded by the slightly different Folsom points used from about 11,000 to 10,000 years ago. Mammoths, the huge *bison antiquus*, and other large game species, including horses, were widely hunted. As human hunters diffused to the east and west, they adapted to the slowly moderating bioclimatic regions into which they moved. To the east a distinct eastern woodlands Archaic tradition emerged about 9,500 years ago, while later a plains Archaic tradition emerged, about 7,500 years ago. Meanwhile a unique desert tradition emerged in the Great Basin about 8,000 years ago, shaped by the far drier climatic conditions there. As the climate gradually warmed and the bioclimatological zones expanded, shifting north-

ward to their present locations, native peoples spread further. The favored big game, however, no doubt under considerable stress due to these climatic changes and now heavily hunted, soon disappeared. The horse would not reappear until reintroduced by Spanish explorers in the fifteenth century.

In the east, the Archaic woodland tradition passed through successive early, middle, and late phases, dated approximately 9,500 to 8,000 years ago (early), 8,000 to 6,000 (middle), and 6,000 to 3,000 years ago (late). One of the richest sources of information about eastern Archaic woodland village life is revealed by the fourteen distinct habitation layers uncovered at Koster, in central Illinois, occupied almost continually from 9,500 years ago to nearly 800 years ago. The major change that occurred both in the east and west was the introduction of staple crops, maize corn and beans in particular, brought up from Mexico. Agriculture gradually brought the nomadic Archaic hunting traditions to an end with a shift to a more sedentary way of living.

Archaic and Prehistoric Eastern Woodland Cultures

In the southern woodlands, in Louisiana, at the end of the Archaic period, around 6,500 years ago, there emerged a distinct culture that began building earth mounds as ceremonial structures, grouping them to form enclosures. These mounds began to be clustered in arcs or circles and built on slightly elevated earth

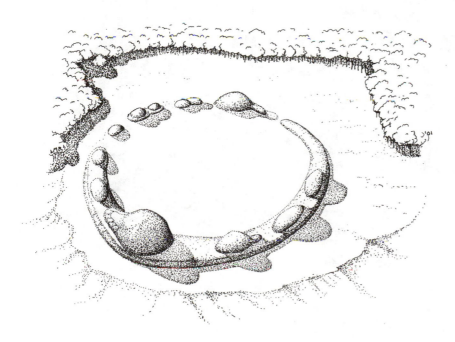

1.5. Watson Break mound group, near Monroe, Ouachita Parish, Louisiana, c. 5000 B.P. In this, the oldest remaining human construction in North America, (predating the Egyptian pyramids by 1,300 years), a series of rounded circular mounds were built on a low oval platform nearly 853 feet across its longest dimension. (L. M. Roth, after R. Kennedy, Hidden Cities, New York, 1994.)

platforms. One of the best defined of these mound groups is that recently identified at Watson Break, on the Yazoo and Ouachita Rivers, near Monroe, Louisiana. [1.5] Here eleven mounds were built up on a roughly oval platform measuring nearly 853 feet by 650 feet; the largest individual mound was over 25 feet high. Radiocarbon dating suggests this complex may have been constructed starting about 5,400 years ago. Similar mound groups have been found in the surrounding area, and evidence suggests that this phase of mound building lasted from about 6,500 to 4,500 years ago (Watson Break being started 1,100 years after this mound-building tradition began). So recent is the discovery of this mound-building culture that it has, as yet, no widely accepted name.

After a pause of 750 years, ceremonial mound building on a monumental scale began again in the area of northern Louisiana. This second mound-building culture flourished about 3,700 to 2,700 years ago and has been given the name Poverty Point after what appears to have been its central ceremonial center and largest complex, at Poverty Point on Maçon Bayou, near Epps, West Carroll Parish, in northern Louisiana. [1.6] At this site, where there appears to have been a settlement of about 2,000 people, a series of six concentric ring mounds were created, beginning about 3,700 years ago, enclosing a plaza and focusing on a much larger mound to the west. Additions and modifications to this elaborate mound complex continued for about 1,000 years.

Better known are the successive Adena and Hopewell cultures, which can be dated respectively to about 3,000 years ago to 1,900 years ago, and from about 2,200 years ago to about 1,600 years ago. The

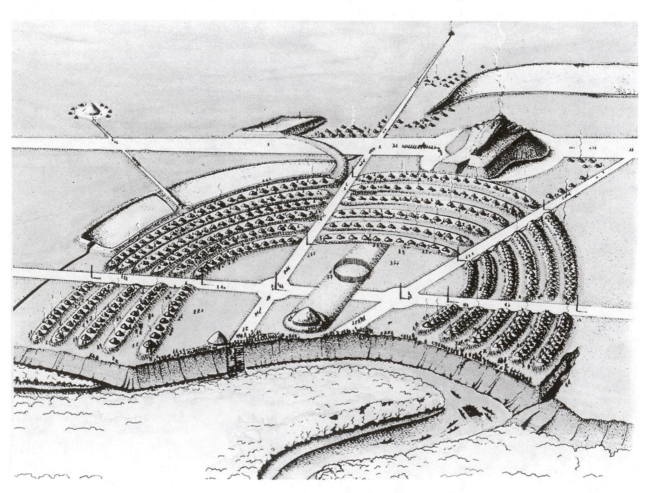

1.6. Poverty Point mound group, near Epps, West Carroll Parish, Louisiana, c. 3500 B.P. This complex, perhaps a ceremonial site with few permanent dwellings, had six concentric rings of low mounds focusing on a central plaza. (From Gene S. Stuart, America's Ancient Cities, Washington, D.C., 1988.)

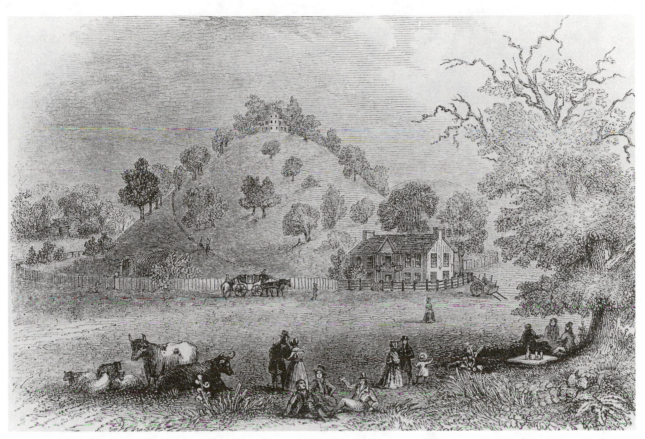

1.7. *Grave Creek Mound, near Wheeling, West Virginia, c. 2000 B.P. This domed burial mound, about 70 feet high and roughly 1,000 feet around its base, was made up of many layers of earth, placed basketful by basketful,* one atop the other, over many years. (From E. G. Squier and E. H. Davis, Ancient Monuments of the Mississippi Valley, Washington, D.C., 1848.)

Adena culture was centered along the Ohio River, ranging from western Pennsylvania to Indiana, whereas the following Hopewell culture thrived both along the Ohio and along the Mississippi drainages as far as Illinois and Missouri.

The Adena and Hopewell cultures were technologically similar, using tools of chipped flint, polished stone, and beaten copper, both had a complex ceremonial life centered around a cult of the dead, and a highly developed artistic tradition in the making of ritual objects placed in burials. This is apparent in the care taken in funerary earthworks built by both the Adena and Hopewell peoples. Like the earthworks built by the Watson Break and Poverty Point cultures, the Adena earthworks were built up of thousands of basketsful of earth, carried by hand, for there was no domesticated animal other than the dog. [1.7] Adena mounds were used for burials, beginning with the placement of evidently respected individuals in round ceremonial charnel houses, framed of paired posts with woven wattle walls and a conical roof. The houses were ceremonially burned and the remains then covered with a mounded layer of earth. Over the years additional layers would be added to such mounds, with either burials of bodies in a flexed fetal position or burials of cremated remains collected in baskets. Year by year, decade by decade, the round conical or rounded mounds would increase in size. Of course, all this is known only because these burial mounds were opened by later settlers in Ohio and elsewhere, the human interments disturbed, and many mounds eventually destroyed.

The successive Hopewell people developed more elaborate burial practices, and they also developed a wider variety of mound forms, including what seem to be defensive fortifications, effigy mounds, and, especially, extensive ceremonial enclosures. These mounds were enlarged not so much by extending their vertical

Sections.

Area 50 Acres

Area 20 Acres

Road

Parallels 2½ miles long

POND

Sandy Loam

Area 20 Acres

Lock

Area 30 Acres

Lock

NEWARK WORKS

LICKING COUNTY,

OHIO.

C. Whittlesey, E. G. Squier & E. H. Davis 1837-47.

SCALE.
1300 ft. to the Inch.

1.8. Hopewell Culture, Newark Earthworks, Newark, Ohio, 2,200 to 1,300 B.P. Hopewell earthworks were primarily low, linear ridges enclosing ceremonial spaces; many were circles or octagons, as seen repeated in one of the largest complexes at Newark, Ohio. (From E. G. Squier and E. H. Davis, Ancient Monuments of the Mississippi Valley, Washington, D.C., 1848.)

height but instead by expanding their area and complexity. Hopewell social organization and dedication of purpose can be gauged by looking at the complex they built at what later became Newark, Ohio, constructed sometime between 2,200 and 1,300 years ago. [1.8] The entire complex, shown in a plan surveyed by E. G. Squire and E. H. Davis in the 1840s before much had been obliterated, covered an area measuring nearly 2 by 2.5 miles. The best-preserved portion of this complex now is the large circular ring about 1,200 feet in diameter with a low-profile bird effigy mound at its center, its head pointing toward the opening of the enclosure.

The Newark bird is one of the thousands of effigy mounds once found throughout the Ohio-Mississippi Valley, such as the well-known Serpent Mound near Locust Grove, in southern Ohio. [1.9] Built about 1,100 to 800 years ago, this is a serpentine-shaped earth sculpture, about 1,254 feet long, constructed atop a natural rocky bluff. The significance of such geometrical formations and enclosures is unknown, although the orientation of many forms and lines toward the summer solstice and the rising points of significant stars suggests the linking of life with cycles of the sun and the heavens. Other constructions were on naturally defensible bluffs, and their elaborate gates indicate that they may have been forts. Among such strongholds are "Fort Hill," in Highland County, Ohio, and "Fort Ancient," in Warren County, Ohio. All of these large constructions, whether ceremonial, effigy, or perhaps defensive, were far outnumbered by thousands of freestanding

domical or conical burial mounds, ranging from modest swells to large imposing artificial hills, such as the mound at Cave Creek, West Virginia, which originally rose over 70 feet and measured 1,000 feet in circumference at its base.

Many implements of the Adena and Hopewell cultures were looted from these mounds early in the nineteenth century; other mounds were studied later by means of more careful excavations, revealing beautifully made tools, small ceremonial objects, and items of jewelry included with the remains. Among the more intriguing grave objects are delicately carved stone pipes in the form of animals or silhouettes cut from Appalachian sheet mica. Such grave items reveal a widespread trade network maintained by the Adena and Hopewell eastern woodland peoples, with copper brought down from the upper Great Lakes, grizzly bear teeth and obsidian carried from the Rocky Mountains, conch shells and carved shell plaques brought up from the Gulf Coast, sheets of mica from North Carolina, and other materials carried from other remote points. A particularly fine grade of flint, removed from quarries in central Ohio, was traded for these goods.

Detailed excavations of the grounds around Adena and Hopewell mounds reveal no traces of extensive villages or towns; the population seems to have been dispersed in small family clusters near their fields and hunting areas. Customarily, no structures were

built atop the Adena or Hopewell mounds, though buildings clearly were built atop the flatter platform mounds distinct to the Temple Mound culture, which followed in the first phase of what is called the Mississippian tradition. This platform mound building began about 1,800 years ago and continued on the part of some southeastern historic tribes up until contact with the European explorers. The period of greatest social, architectural, and artistic achievement, however, occurred about 1,000 to 700 years ago. The mounds of this Mississippian tradition were highly geometric, often rectangular in plan, with flat terraces at the top. On these terraces residence of nobles, temples, and other sacred enclosures were built. There were regional cultural centers, such as Spiro on the Arkansas River in Oklahoma, the apparent center of the Caddoan Mississippian culture; Etowah, Georgia, the apparent center of the south Appalachian Mississippian culture; and, biggest of all, Cahokia, on the Mississippi River in Illinois, across the Mississippi River from modern-day St. Louis.

Cahokia, which thrived from about 950 years ago to nearly 750 years ago, had the largest population of any site north of Tenochtitlán (Mexico City); it was the focal point of a network of nearly twenty towns. [1.10] On roughly 2,000 acres lived 30,000 people in hundreds of houses spaced around a central group of mounds defining a ceremonial plaza. The largest of

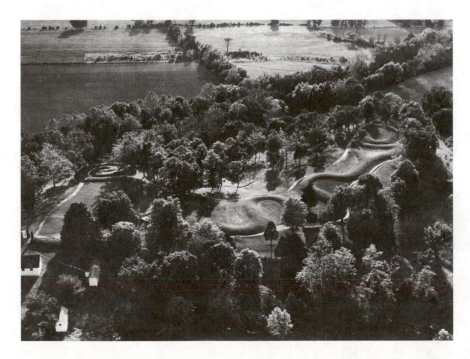

1.9. Adena Culture, Serpent Mound, near Locust Grove, Ohio, 1100–800 B.P. *The form of the Serpent Mound, atop a narrow ridge, has several alignments to solar and stellar features. (Courtesy of National Geographic Society, Washington, D.C., copyright 1948.)*

the mounds (and the largest human-made structure north of the pyramids of the Aztecs) came to be called Monk's Mounds, because of the mission later built by French priests on one of its middle terraces. Originally measuring more than 790 by 1,050 feet at the base and rising nearly 100 feet high (241 by 320 by 31m), it was built in several stages and eventually came to have four terraces. Placed around this huge earthwork were as many as two hundred other smaller mounds and earth forms, including an astronomical observatory circle of wood. By the time the French arrived, however, the site was virtually abandoned and the purposes of its mounds were unknown by local native people.

As Cahokia faded in importance, other large settlements with equally impressive mound complexes surpassed it. Among them were Aztalan, Wisconsin (the northernmost such site); Moundville, Alabama, second only to Cahokia in size; and Etowah, near Cartersville, Georgia. In general, mound building began to decline about 1,000 to 750 years ago, and successive cultural changes and population movements gradually erased the knowledge of the mounds' specific purpose, except in the deep south, where the Natchez people continued to use their mounds in the ancestral way, as recorded by Frenchman Antoine de la Page du Pratz, who lived with them from 1718 to 1725.

Archaic and Prehistoric Plains Culture

As early as 10,000 years ago the largest mammals had been hunted to extinction on the plains, but hunting the smaller modern bison remained the basis of life on the plains from that time until the mid-nineteenth century. Beginning about 7,500 years ago Archaic traditions developed on the plains, passing through early, middle, and late stages up to about 2,000 years ago. A precontact cultural phase developed then, marked by the appearance of the bow and arrow (which supplanted the spear), and the making of pottery. The most dramatic change in plains life occurred a little more than 400 years ago, when horses were reintroduced by the Spanish, bringing a mobility to plains life that radically changed and enriched the quality of life. Now plains peoples could follow the cycle of movement of the numberless bison.

Archaic and Prehistoric Western Desert Cultures

In the southwest, Archaic hunting and gathering cultural traditions developed perhaps as early as 8,000 years ago, passing through early, middle, and late stages up to about 2,000 years ago. By that time, inhabitants of the region had already been engaged in agriculture based on raising corn (maize), squash, and beans for perhaps a thousand years or more. About 2,000 years ago three distinct adjacent cultures devel-

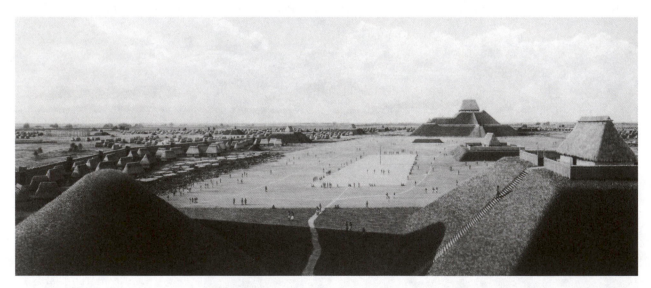

1.10. *Cahokia Mound Complex, near East St. Louis, Illinois, depicted as it appeared in 1100–1150 C.E. Lying at what may have been the center of the Mississippian Culture area, Cahokia was the largest settlement in North America, with a population of 30,000 people. This reconstruction painted by Lloyd K. Townsend shows the central ceremonial area.*

The view is between the large Twin Mounds over the Grand Plaza of 40 acres in size, toward the huge Monk's Mound, 100 feet high and covering an area of 14 acres. (Courtesy of Cahokia Mounds State Historic Site; restoration painting by Lloyd K. Townsend.)

oped in the region now made up of Utah, Colorado, Arizona, and New Mexico—the Hohokam, the Mogollon, and the Anasazi. The Hohokam (Pima for "vanished one") appeared about 1,600 years ago, occupying the region of southern central Arizona extending down into northern Mexico, and lasting until about 500 years ago. Their largest settlement was Skoaquik (Snaketown), near the Gila River in Arizona, flourishing about 1,000 years ago. As in their other settlements, there are remains of houses, ball-playing courts, and small pyramid mounds. They built extensive irrigation canals, some of which have been erased by modern aqueduct channels in the same locations. The Mogollon (named later after the mountain area in which they lived) flourished from about 1,700 years ago to roughly 550 years ago; they occupied the area of lower New Mexico, extending into central Arizona and northern Mexico. Their villages tended to be smaller than those of the Hohokam, with perhaps 30 semisubterranean shelters housing a community of up to two hundred people. Their descendants became the modern Zuni. The Anasazi (Navajo for "the old ones" or "ancient enemies") appeared about 2,000 years ago and continued to flourish up to the arrival of the Spanish. They occupied the four corners region of Utah, Colorado, New Mexico, and Arizona, building the many excellent villages that survive in ruins at places like Kayenta, Canyon de Chelly, Chaco Canyon, Aztec, and Mesa Verde. Their descendants are the Hopi of the western pueblos in Arizona and the people of such eastern pueblos as Acoma, Taos, and Santa Clara and its many neighboring pueblo villages in New Mexico along the Rio Grande.

Excellent basket makers and potters, these three neighboring groups were a people rooted to the soil, deriving their sustenance from farming. Of all the native Americans, they were the most attached to a specific place. Their architecture, like that of all of the native Americans, had its origin in the primeval semisubterranean Asiatic pit house, variations on which are found across the North American continent. The archetypal house was rounded or circular in plan and so the Anasazi houses started, but as they were pushed together to form tight clusters, the plans became rectilinear.

In the dry broad valley of the ephemeral Chaco River in northern New Mexico, spread out in a line nearly 4.4 miles long, stand the ruins of eleven monumental pueblos that have captivated the imagination of visitors since the mid-nineteenth century. Built in phases of construction, from about 900 to 1160, these great houses, as they are called, seem to have been the ceremonial center of an area that stretched hundreds of miles in all directions. The structures look like villages built of stacked rooms, not unlike modern-day apartment complexes (see, for example, the Habitat apartment complex in Montreal, 1967, fig. 9.66), but there are no burial grounds in the area that are nearly the size that would have been required if each room had contained a family. The rooms may have served as storage chambers for corn, kept in this central dry location, for shipment to any of the settlements in the surrounding region suffering from local drought. And perhaps the great houses were used at particular times of the year for ceremonies, with no large population living in the canyon year round. The stone walls were constructed of exquisitely crafted dry masonry, the work done from 1050 to 1115 marked in particular by distinctive layering, with courses of carefully squared large stones separated by three or four courses of wafer-thin stone, with any irregularities of between-stone surfaces fitted with minute slivers of rock. The stones were so carefully prepared and fitted that sharp corners could be formed as the stones were laid up, looking as crisp as if cut by a knife. The great house plans vary, ranging from rectangles to forms that resemble a large **D** or **E**, but nearly all have internal plazas. Roughly in the middle of the Chaco Canyon are two large great houses, one bearing a Navajo name and the other one a Spanish.[4] Pueblo Chetro Ketl, built from about 1010 to 1109, was one of the largest, in the form of an **E** and measuring 490 feet along the northern edge, where rooms were stacked five stories high; it had 337 rooms and 21 circular ceremonial kivas (Hopi for "ceremonial rooms"), subterranean ceremonial chambers where male societies carried out essential religious rituals. Even larger was Pueblo Bonito, begun about 920, and built in at least three distinct phases, the last of which ended about 1109. Its plan forms a huge **D**, with the single-story straight wall, 490 feet long, to the south; the northern curved wall, where rooms were stacked up to five stories high, measured nearly 830 feet around. [1.11] There may have been 482 rooms in all. The large central plaza is divided down the center, with 40 circular kivas dispersed on either side.

There appears to have been some sort of social disruption in the region around 1130 that resulted in the abandonment of many well-established settlements, especially Chaco Canyon, with the populations moving outward, building new village complexes within the alcove recesses formed by erosive undercutting of the

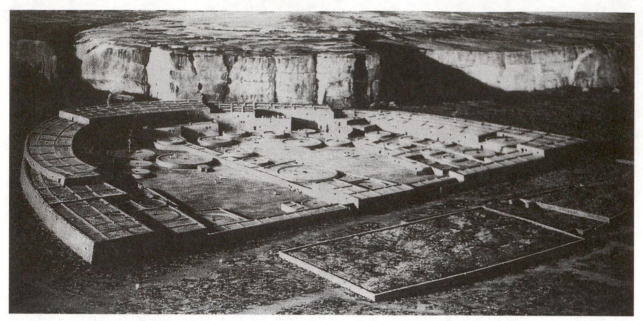

1.11. *Pueblo Bonito, Chaco Canyon, New Mexico,*
c. 920–1300. Pueblo Bonito, shown here in a reconstruction
by Lloyd K. Townsend, was the largest of the great house
structures in Chaco Canyon. This **D**-*shaped complex had*
about five hundred rooms and rose at the north side to five stories. (Reproduced with permission from Mysteries of the Ancient Americas, *published by The Reader's Digest* Association, Inc., Pleasantville, N.Y., *www.readersdigest.com,* copyright © 1986. Illustration by Lloyd K. Townsend.)

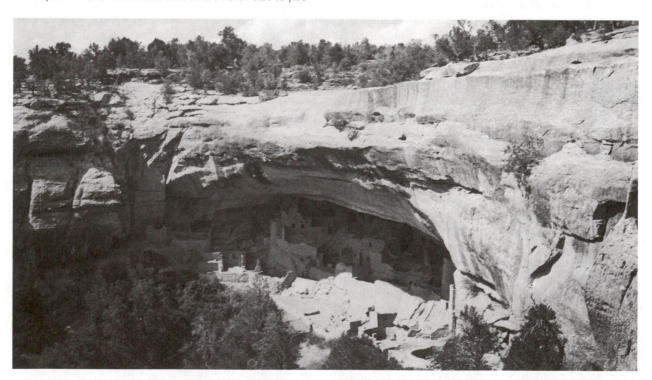

1.12. *Cliff Palace, Mesa Verde, southeastern Colorado,*
c. 1100–1275. Many housing clusters were built into the
extended alcoves of Mesa Verde, generally facing south; this
complex had 220 rooms in an arc nearly 425 feet long. Note that this photograph was taken before the extensive stabilization and reconstruction undertaken by the National Park Service. (Photo: Lindsay Hall, n.d., Special Collections, University of Oregon Library.)

sides of mesas. Perhaps best known are the several villages built in the alcoves along the sides of Mesa Verde, well to the north of Chaco Canyon, particularly Spruce Tree House and Cliff Palace, built about 1050 to 1279. [1.12] Such villages were linear and fitted to the irregularities of their particular alcove. Most of the Mesa Verde cliff dwellings are in alcoves that face south or southwest, to take advantage of the afternoon sun in the winter months, but nearly all are set back far enough that the cliff overhang provides protection from the hot summer sun. Some cliffside villages were quite small, housing only one or two families, but Cliff Palace at one time had perhaps 220 rooms and 26 kivas. Access was difficult, involving treacherous footpaths down from the mesa top or up from the canyon floor, and a final access by ladder. Yet there was constant foot traffic to reach farming plots on the mesa top. Standing within one of these cliff dwellings, looking out at the surrounding landscape from under the protective eyebrow of the sheltering alcove, one feels distinctly rooted in the earth, part of it.

THE HISTORICAL OR POSTCONTACT CULTURES

By the time of European arrival in the mid-sixteenth century, the native American population was perhaps eighteen million or more in the area north of Mexico, divided into eight major cultural and language groups corresponding closely to the major geographic-bioclimatic regions: the northwest coast, the California coast, the Columbia River plateau, the Great Basin of Nevada and Utah, the Southwest, the high plains and central prairie, the northeastern woodlands, and the southeastern woodlands. These geographical divisions also closely correspond to distinct language groups. When the Spanish moved into New Mexico in 1539, they encountered the descendants of the Hohokam, Mogollon, and Anasazi—the modern Zuni, Tiwa, and Tewa tribes—in the four corners region of Utah, Colorado, Arizona, and New Mexico.[5]

The eastern woodland area was divided into three basic language and culture groups: Algonquin along the northern coast, and westward around the northern Great Lakes as far as the Mississippi and down the Ohio Valley; Iroquois along the St. Lawrence, around Lakes Ontario and Erie, and through New York; and Otomian in the region south of the Ohio River. The natives of the eastern woodlands developed house types adapted to the forest. Algonquin villages of the

Northeast contained freestanding houses for fifty or more families (some large towns had as many as five hundred families); these were invariably on high ground near fresh water. The basic house type common to all Algonquin-speaking tribes was the wigwam, which the Ojibwa (Chippewa) around Lake Superior continued to construct through the nineteenth century. [1.13] The wigwam consisted of a domical frame of saplings lashed together and covered with sheets of bark, hides, or sewn mats of rushes, depending on the material most readily available. There was a single door, protected by a skin, and usually a hole at the top through which the smoke of the central fire might escape. The wigwam varied from 10 to 16 feet in diameter and was up to 10 feet high; it could house two or three families.

The principal variation was the elongation of the wigwam into a long round-ended or rectangular house whose wooden frame was closely covered with available materials such as birch bark, elm bark, skins, or rush mats. Such longhouses were found by the first European explorers all along the Atlantic coast, but the largest of all were built by the Iroquois in central New York, who took one of their names for themselves, *haudenosaunee*, from the name of their long-

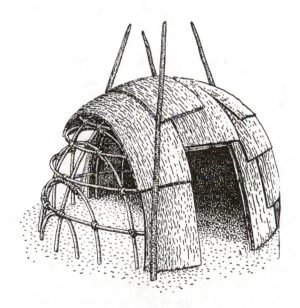

1.13. Ojibwa (Chippewa) wigwam. The wigwam, used by scores of Algonquian-speaking nations in the Northeast and around the Great Lakes, was a conical or domical frame covered with bark slabs, hides, or sewn reed mats. (From J. M. Fitch and D. P. Branch, "Primitive Architecture," Scientific American, December 1960.)

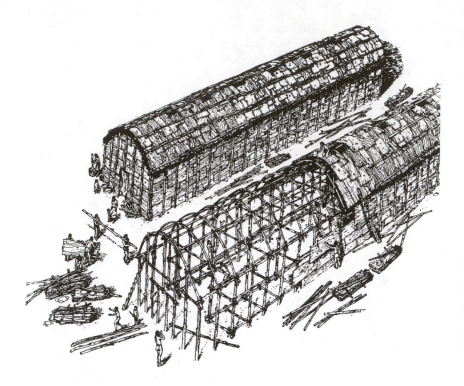

1.14. Iroquois longhouse, or hodenosote; drawing by Vic Kalin. The Iroquois longhouse, sometimes hundreds of feet long, was both physical multifamily residence and a model of social order. (From America's Fascinating Indian Heritage, Pleasantville, N.Y., 1978.)

houses; the word means "people of the longhouse." [1.14] Iroquois longhouses were up to 100 feet long by 18 feet wide, with a gable or bowed roof; in such houses lived as many as fourteen families with space for their stores of maize, squash, dried meats, and other foodstuffs in the end chambers. One such Onondaga house was described by Pennsylvania naturalist John Bartram in 1743, and detailed excavation has been done of an Iroquois village south of Syracuse, New York.[6]

Bartram was fortunate in being one of the last Euro-Americans to see a thriving aboriginal village whose houses were still being built in the traditional manner. There are even earlier descriptions of Algonquin villages, including the accounts of John White and Captain John Smith. White was one of the leaders of the expedition sent out by Sir Walter Raleigh in 1584 in an attempt to establish a colony on Roanoke Island off northeast North Carolina. He was skilled as an artist, and on visits to the Indian towns of Pamlico, Secotan, and Pomeiock he made detailed sketches of village layout and house types. [1.15] His drawing of Pomeiock shows it to have been a cluster of eighteen longhouses arranged around a central open space and surrounded by a circular wooden palisade, the ends of which were overlapped slightly, forming a defensible gate. This kind of arrangement was typical of the pal-

isaded Indian towns among Algonquin and Iroquoian tribes, but Secotan, the chief town of the Powhatan Indians, was more open and lacked a defensive wall. Its buildings were scattered in clusters among fields of maize and tobacco. In the labels and inscriptions on his drawings, White said that the Powhatan houses were "constructed of poles fixed in the ground, bound together and covered with mats, which are thrown off at pleasure, to admit as much light and air as they may require." About thirty years later, Captain John Smith wrote in his *Generalle Historie of Virginia* (London, 1624) that the houses were "so close covered with mats, or the bark of trees, very handsomely, that notwithstanding either wind, rain, or weather, they are as warm as stoves."[7] In the late fall entire villages usually moved to winter quarters deep in the forests, where in the midst of the thicket they would be protected from cold winds and have ready access to game.

In the southeast, the area originally inhabited by the Cherokee, Creek, Chicasaw, Natchez, and other groups, a somewhat different house type evolved. William Bartram's son John traveled in the south and described in some detail the houses in a Yuchi village on the Chattahoochee River in Georgia. He wrote that the houses had a wooden frame, with lath between the posts covered with red-tinted plaster inside and out, and a roof of cypress bark shingles cut from cypress trees.[8]

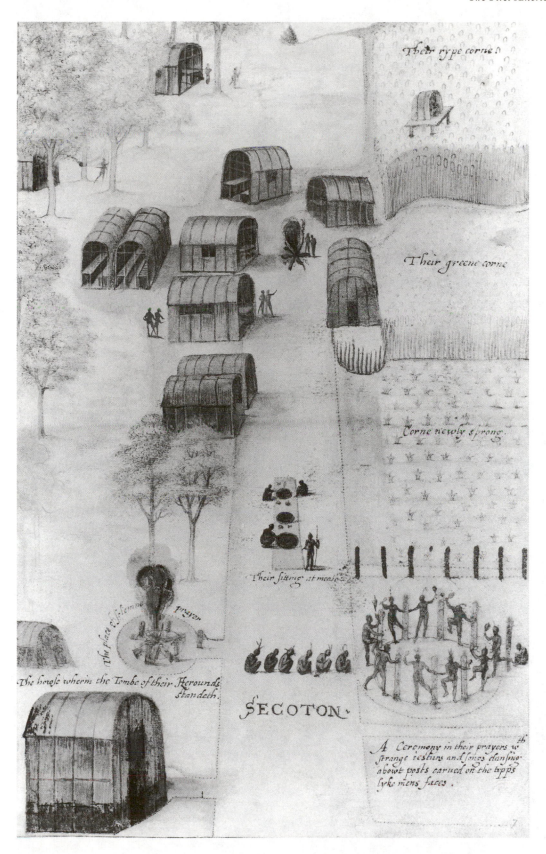

Their rype corne

Their greene corne

Corne newly sprong.

Their sitting at meate.

the place of solemne prayer.

The house wherin the Tombe of their Herounds standeth.

SECOTON.

A Ceremony in their prayers wth strange iestures and songes dansing abowt posts carued on the tipps lyke mens faces.

1.15. John White, Indian Village of Secotan, c. 1577–90. White's watercolor aerial drawing, made on the spot, shows the open arrangement of the major town of the Powhatan Indians, with buildings placed among maize fields. (Courtesy of the Trustees of the British Museum.)

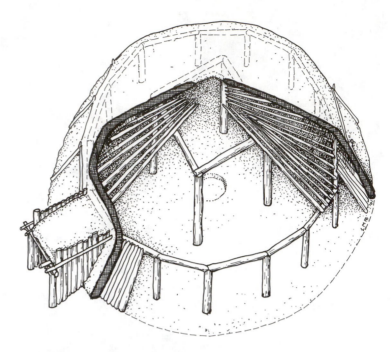

1.16. Mandan lodge, as of c. 1830. The Mandan earth lodge was able to house two or three families, their supplies and equipment, as well as their horses, around a central fire. (L. M. Roth, after Nabokov and Easton, Native American Architecture, New York, 1989.)

1.17. Blackfeet tipi. Among the indigenous plains peoples, the Blackfoot (in Alberta, Canada) and the Blackfeet (in Montana) painted their tipis more extensively than did other tribes. The designs connect earthly and heavenly realms with images of spirit visions. (Photo: Walter McClintock, c. 1896, courtesy of the Beinecke Library, Yale University.)

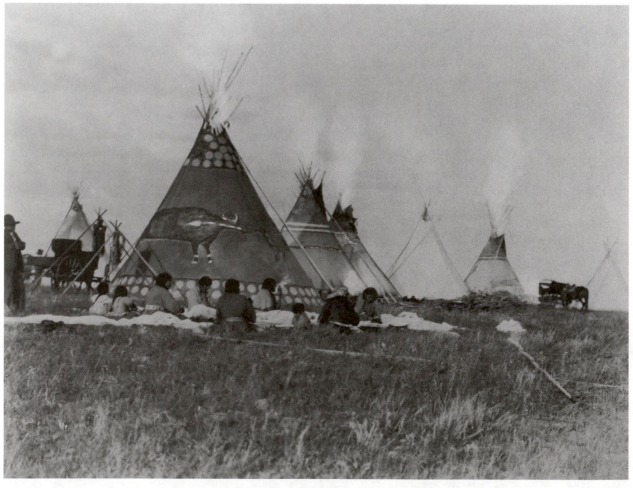

In the region to the west, on the prairie and high plains, lived three major language groups. In parts of Nebraska and Colorado lived the Algonquin-speaking Cheyenne and Arapaho, but the two major language groups were the Sioux-speaking tribes or nations and the Caddoan-speaking nations. The Wichita and Caddo tribes built large domical dwellings, with a wigwamlike frame but covered by thick mats of grass. Coronado saw and described such houses in 1540, and Edward S. Curtis photographed examples as late as 1927. Two quite different types were more prevalent, however. The more sedentary nations living along the Platte and Missouri Rivers, such as the Pawnee, and the Hidatsa and Mandan to the north, built large permanent earth lodges. The Mandan built large villages of thirty to fifty houses, sometimes surrounded by palisades, along the banks of the Missouri River. Mandan and Hidatsa houses were large low conical structures about 40 feet in diameter, depressed about a foot below grade. [1.16] Inside was a heavy wooden frame of radiating rafter poles that rested on an outer circumferential frame, about 6 feet high; the rafters rose to center supports about 12 to 15 feet high. Against this frame woven mats were placed and then earth was packed to a thickness of a foot and a half at the top and several feet at the base. In time this covering became hard and often became one with the turf of surrounding prairie grass. The entrance was a small tunnel through the thick earth cover. In such houses five or six families lived, secure against the howling winds of plains winters; in the summer the thick blanket of earth kept the midday heat from penetrating, maintaining a relatively constant temperature inside.

The more nomadic tribes to the north and west, such as the Blackfoot, Crow, Cheyenne, Assiniboin, and Arapaho, among many others, built conical tent houses that were fully portable. In this way they could follow the migrating bison and also change location between summer camps and more sheltered locations for winter camps. The tipi (a Sioux word for "dwelling place") had a basic tripod or four-pole frame against which about fifteen long poles of cedar or lodgepole pine were placed. [1.17] Around this was stretched a conical skin fashioned of buffalo hides. Originally smaller tipis had been moved from place to place by dog travois (as the French called them), but when the horse was acquired by the plains Indians, after it had been introduced by the Spanish to the south, the tipi became larger, heavier, and more elaborate. In plan the tipi was not circular but oval, with the entrance on one of the narrow sides, usually facing east toward the rising sun and also downwind. Above the entrance, where the skin was fastened together, were two long smoke flaps held out by movable poles and guy ropes. The tipi had an aerodynamic shape positioned to give least resistance to prevailing winds, with flaps that could be easily repositioned to correspond to shifts in wind direction to maintain an upward draft through the tent to carry off smoke. Clusters of tipis were usually set up (by the women of the tribe) on the lee side of low hills or copses of trees to gain additional shelter during the winter. Such placement, combined with an inner lining fastened to the inside of the poles and kept tight against the ground (with the space between outer shell and inner lining packed loosely with insulating dry grass), made this seemingly fragile dwelling comfortable in summer and winter alike. Of all Indian building types, only the tipi was dependent on constant sources of heat energy during cold weather. Plains tribes also built smaller wigwamlike frames, tightly covered with various materials, for ceremonial sweat lodges.

In the northern area of the Basin and Range the Umatilla, Flathead, Coeur d'Alene, and other nations built variations of both the earth lodge pit house and the tipi. Some of their tipis were covered with rush mats and were built in extended form, not unlike the Iroquois longhouse. Lewis and Clark said of the Nez Percé village of Tumachemootool that it was one long house of about 150 feet, housing forty-eight families.[9] Even after canvas was introduced by white traders,

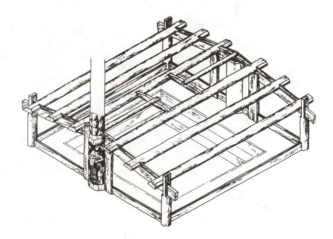

1.18. *Haida lodge. The Haida house, accommodating a large extended family, was made of carefully fitted cedar planks. This drawing shows only the base of an identifying family crest pole. (From Nabokov and Easton,* Native American Architecture, *New York, 1989.)*

such long tipis were built, as depicted in Curtis photographs of about 1910. Smaller pit houses were also built, covered with earth.

Along the Pacific coast two distinct building methods were used. In the colder, wet north, large extended-family houses were built by the seacoast fishing tribes of the Tillamook, Quinault, Makah, and Salish in what is now the United States, and by the Kwakiutl, Haida, and Tlingit tribes through what became British Columbia all the way up to Alaska. Placed along the beach, with their long axes running from the forest to the sea, these communal houses had massive timber frames carrying broad boards split from driftwood logs or sometimes split off, or "begged from," living trees. [1.18] Long-grain, knot-free red cedar was most prized for its durability and strength. Frequently the gable ends of these houses, especially the village community longhouses, were painted with the mythic images of animals; also rising against the center of the front would be a carved and painted crest or totem pole, likewise bearing images that celebrated the mythic animal ancestors of that particular family and the time when humans and ani-

mals were one living community, shifting easily from one form to the other.

In the gentler climates of California the Yurok, Pomo, Miwok, Chumash, and other peoples built various kinds of lodges and ceremonial houses. In the north, gable-roof houses were built of redwood or cedar planks. Pit houses and earth lodges were also built. The Yokuts of the San Joaquin valley built distinctive steep conical-frame houses covered with grass or tule thatch; sometimes a group of aligned houses would be sheltered by a large ramada or sun break. [1.19] Particularly distinctive were the large round houses built by the Miwok in the nineteenth century. Built with wood frames, with low-pitched conical roofs, they were covered with split planks or large shingles.

For the most part, the native dwellings and ceremonial structures described above largely disappeared or underwent significant changes when the various tribes and nations were forced onto proscribed reservations. When the buffalo were virtually exterminated, there were no more skins for tipi coverings and canvas was not a suitable substitute. Federal government programs, in fact, forced native groups to live in Western-

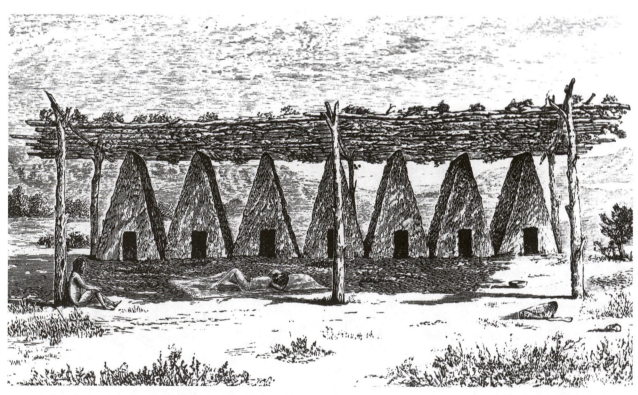

1.19. Yokuts house, southern end of Imperial Valley, California, as of c. 1830. In the hot central valley of California, the Yokuts often built sun screens (ramadas) over a group of houses. (From H. M. Lewis, Houses and House Life of the American Aborigines, Washington D.C., 1881.)

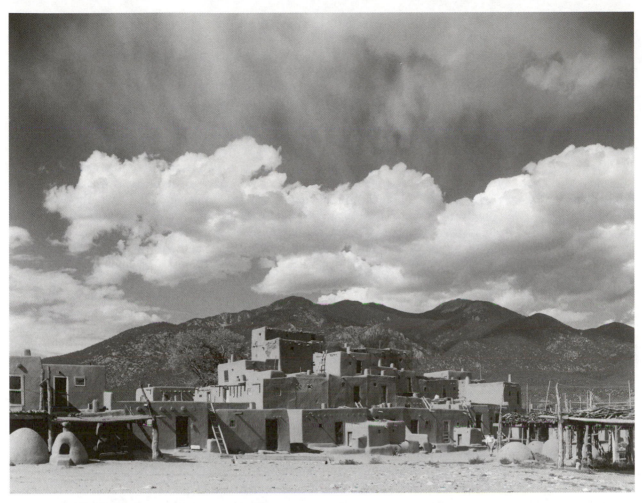

1.20. *Taos Pueblo (North House), Taos, New Mexico, begun c. 1400. North House is one of two clusters of dwellings that define a central ceremonial dance ground; the groups of* houses *have been slightly modified and rebuilt over time. (Photo: © Wayne Andrews/Esto.)*

style dwellings, forbidding families to live communally in the large houses that strengthened ties of kinship. In nearly every tribe or nation, moreover, the traditional house shape was intimately connected with ceremonial life; and the shape of the dwelling, its orientation, and the placement of objects within conformed to an order that mirrored the perceived order of the universe and reasserted the position the people saw themselves occupying in that universe. The Western, Anglo houses had none of those rich associational affirmations. Significantly, however, in the last quarter of the twentieth century, many of these traditional dwelling and ceremonial building forms have been actively revived as a way of reestablishing traditional cultural values.

In only one area were native Americans significantly successful in retaining their traditional architecture, and that was in the desert Southwest. Both the solitary Navajo and the village-oriented pueblo peoples have preserved their traditional modes of dwelling construction and their ways of living. One of the best-known examples is the Taos Pueblo, north of Santa Fe, New Mexico. [1.20] Settlement in the Taos valley goes back at least 1,100 years. Over the centuries villages were constructed in successive locations leading up to what is called Cornfield Pueblo, built about 650 years ago. That was abandoned about 500 years ago, when construction of the present Taos Pueblo complex was begun. Still inhabited today, the complex of houses has been modified gradually over the centuries; yet even today everything is built in the traditional way, of adobe mud brick. The Taos Pueblo consists of two clusters of houses, the north and south buildings, enclosing

a ceremonial plaza for dances, the "center-heart-place." This open space is bisected by the sacred Taos River. Both house clusters are built of sun-dried mud brick, with walls ranging from 2 feet thick at the bottom to about a foot thick at the top. Each year, just before the Fiesta of San Geronimo on September 30, the walls are refinished with a new coat of hand-smoothed adobe plaster as part of a village ritual ceremony. The rooms are stepped back at the upper levels so that the roofs of the lower units form terraces for those above. The units at ground level and some of those above are entered by doors that originally were quite small and low; traditionally access to all rooms was by ladders through holes in the roof. The living quarters are on the top and outside, while the dark cool rooms deep within the structure are used for storage. The roofs are made of cedar logs, *vigas*, their ends protruding through the walls. On the *vigas* are mats of saplings, *latillas*, on which are laid grass mats covered with a thick layer of mud and a finishing coat of adobe plaster. Traditionally, translucent blocks of the mineral selenite were used to admit light into the outer rooms; today stock window frames and glass serve this purpose.

Pueblo construction is a massive system of building but one well suited to the rigors of the climate, for the thick structure, whether of stone or adobe, absorbs the midday heat and then during the night slowly suffuses heat to the rooms within, so that the internal temperature remains relatively constant over a range of about ten degrees Fahrenheit, hovering around the upper 70s, while the outside temperature varies over more than forty degrees. Drafts were originally kept to a minimum by the low narrow doors and fixed selenite windows.

Among the Navajo, historically recent arrivals in the Southwest, the single-family house or hogan assumes a central place. The creation of the first hogan is described in the Blessingway sing, a religious ceremony that is the foundation of all other Navajo ceremonial sings or chantways. In the Navajo creation story, the gods first build a hogan in which they could then plan out the rest of creation. Thus the ancestral hogan is a model of the perfectly organized, harmonious universe. The purpose of the Blessingway curing ceremony is to return the person for whom the ceremony is being performed to a state of harmony, or *hozho*, with his or her family, the community, and the spirit world. To have the desired effect, therefore, a sing or chantway must be performed in a properly built and consecrated traditional hogan, so that the hogan is not only house but workshop, meeting place, medical clinic—a model of

the balanced Navajo universe. [1.21] The doorway of the round or polygonal hogan, moreover, faces east, toward the rising sun, so that the Navajo can rise and greet the sun, to start each day in *hozho*, in harmonious beauty with the world.

The forms of Indian village plans and dwellings were the result of centuries of trial and error, in adjusting to the nature of each individual regional climate, and in developing ways of living in accord with myth and ritual. The houses of all North American natives seem to have derived from a basic archaic type—the circular semisubterranean earth lodge. This was modified by each group according to need and climatic conditions. Where great extremes of temperature prevailed, as on the plains, the walls became thick to retard heat loss and gain; where humidity was high, in the east and south, the walls were demountable to facilitate ventilation.

It may appear that there was great homogeneity among the disparate native American nations, when in fact there were great differences in culture, language, and custom, just as there was great diversity in their house types. Nonetheless, there were important common precepts that ran through all native American cultures, whatever the tribe or language, and that shaped the conduct of daily life and, consequently, the form of villages and houses. Most important were the code of hospitality, the practice of communal living, and the communal ownership of land. The code of hospitality required that food be prepared and ready at all times so that any visitor might be greeted amicably and be offered nourishment while an appropriate feast was prepared for a subsequent ceremony; it also meant that there could be no starvation in one section of a village while there was food in any other section, for food was shared in times of stress. No native American before the sixteenth century "owned" his or her own home, as Europeans defined ownership. Though it was the men who usually obtained the building materials, it was the women who normally fabricated the buildings. The pueblo building complexes were largely built by the men, but the annual ceremonial fall replastering was and is still done by the women. "Ownership" of dwellings most often resided in the women. The extended families who occupied the houses were most often related along matrilineal lines, and utensils and furnishings of the house were shared. Land was also held in common by the tribe as a whole, but cleared portions were allotted to the women for cultivation of crops; like bearing children, farming involved the magical gift of procreation unique to women. A chief or his

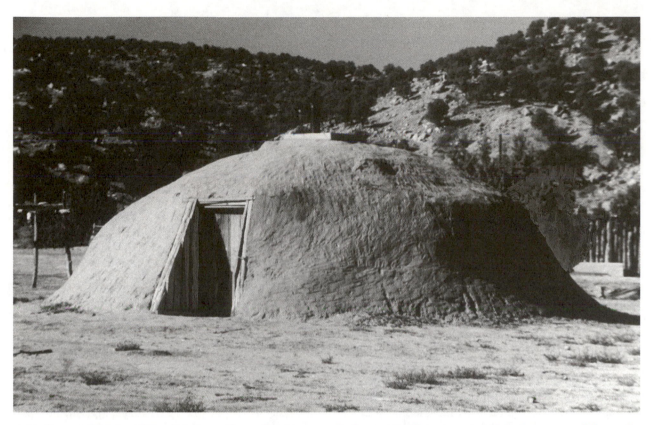

1.21. *Hogan of Ethel and Vern Salt (part of overall Salt out-fit), near town of Tsegi, northeast Arizona, 1995. Although the hogan has evolved significantly over the past several hun-dred years, it still retains a rounded plan, a central fire, and an east-facing door to greet the rising sun. (Photo: L. M. Roth, 1995.)*

wife might be vested with the authority to trade land use or goods with outsiders. The land itself, however, was never considered a commodity by the native Americans; one might have the privilege of the use of the land, one might even be able to trade such privilege of use, so that individuals might exchange the use of plots with the consent of the tribal leaders (the so-called right of disposal), but seldom if ever did an individual have the right of total possessive ownership, much less the right or prerogative to destroy that land or the things on it, such as through mining or clear-cutting of timber. Nor were there conceptions of fixed and absolute linear boundary lines or of speculation in land or of exclusive rights to timber, game, or water. The land and the flora and fauna found on the land were the free gifts of the Great Spirit to the native peoples that the code of hospitality dictated be accessible to all.

The dwelling or ceremonial building was not simply an abstract object set upon the landscape; it was part of the land. The stepped-back risings of the adobe houses of Taos echo the rising of the sacred mountains behind them. There, and in the other pueblo communities, the kiva is built below the floor of the dancing place, with a single hole in the roof for the entrance, through which poke the greatly extended poles of a ladder. The kiva gives physical shape to how the people see themselves in relationship to the earth. To enter the kiva is to return to the womb of the mother earth. To leave the kiva by going up the ladder is to reenact the story of creation, which tells how the first people climbed up from a dark world below using a stalk of corn. The Pacific northwest lodges were aligned to be parallel to the sacred axis that ran from the forest to the sea; the traditional Southwest Navajo hogan, like the plains tipi, faced east toward the rising sun. From its orientation in the landscape down to the smallest detail of placement of utensils, the sum of all the parts of the dwelling iterated over and over the essential link between an invisible spirit realm, the visible earth, and human life. This integral connection between building, land, and culture was described this way by Vincent Scully in his study of the Southwest pueblos:

the environment inhabited by human beings is created partly by nature and partly by themselves. All human construction involves a relationship between the natural and the man-made. That relationship physically shapes the human cultural environment. In historical terms, the character of that relationship is a major indication of the character of the culture as a whole. It tells us how the human beings who made it thought of themselves in relation to the rest of creation.[10]

The native American built environment suggests that the builders saw themselves as part of the landscape, "walking in beauty," as expressed in Navajo ceremonial sings, with the animals and plants in that landscape, and living at peace with the spirit people. The transplanted European buildings, and the American innovations that followed, however, reveal in contrast a people often at odds among themselves and antipathetic toward their physical environment.

From the perspective of the Europeans, the Indians—even when naively viewed at first as "noble savages"—possessed no virtues or significant culture compared to European culture. Faced with the hardships of establishing footholds in the New World, the European settlers had little time or inclination to ponder the merits of Indian culture. It ran counter to all of their own traditions, and native building traditions along the Atlantic seaboard in no way provided the immigrants with the emotional and symbolic links they needed in what was to the Europeans an alien land. Native building symbolized instead a heathen culture that the Europeans felt themselves charged to eradicate or at the very least reshape into a Christian culture. Native notions of communal living and sharing countered the settlers' Calvinist dogma of individual responsibility and thrift. Where native patterns of living were not actively and ruthlessly suppressed, they were simply ignored. Moreover, the suppression of native beliefs and practices was made easier by the rapid decimation of the native peoples, who had no immunity to common European diseases. Approximately 18,000,000 natives lived in all of North America in 1492; only about 250,000 lived in the United States by 1890.[11] The benefits of native architectural practices—the creation of multifamily housing, its concomitant savings in energy, but more important its fostering of familial and communal values, and the adjustment of building types to regional climate—were all largely rejected. Ironically and sadly, most of this ancient wisdom would have to be painfully rediscovered over the next five centuries.

BIBLIOGRAPHY

Bushnell, David I. *Native Villages and Village Sites East of the Mississippi.* Bureau of American Ethnology, Bulletin 69, 1919.

———. *Villages of the Algonquian, Siouan, and Caddoan Tribes West of the Mississippi.* Bureau of American Ethnology, Bulletin 77, 1922.

Coe, Michael, Dean Snow, and Elizabeth Benson. *Atlas of Ancient America.* New York, 1986.

Driver, Harold E. *Indians of North America,* 2nd ed. Chicago, 1969.

Driver, Harold E., and William C. Massey. *Comparative Studies of the North American Indians.* Transactions of the American Philosophical Society 47 (1957): 165–456.

Fagan, Brian M. *Ancient North America: The Archaeology of a Continent.* London, 1991.

Hewett, Edgar L. *The Canyon and Its Monuments.* Albuquerque, New Mexico, 1936.

Jennings, Jesse D. *Prehistory of North America.* New York, 1968.

Laubin, Reginald, and Gladys Laubin. *The Indian Tipi: Its History, Construction, and Use.* Norman, Oklahoma, 1957.

Markovich, Nicholas C., Wolfgang F. E. Preiser, and Fred G. Sturn, eds. *Pueblo Style and Regional Architecture.* New York, 1990. See especially Rina Swentzell, "Pueblo Space, Form, and Mythology," 23–30.

Maxwell, James A., ed. *America's Fascinating Indian Heritage.* Pleasantville, N.Y., 1978.

Morgan, Lewis H. *Houses and House-Life of the American Aborigines,* reprint Chicago, 1956. (Originally published in Washington, D.C., 1881.)

Morgan, William N. *Prehistoric Architecture in the Eastern United States.* Cambridge, Mass., 1980.

Nabokov, Peter, and Robert Easton. *Native American Architecture.* New York, 1989.

Norbeck, Edward. *Prehistoric Man in the New World.* Chicago, 1964.

Scully, Vincent. *Pueblo: Mountain, Village, Dance.* New York, 1975.

Stannard, David. E. *American Holocaust: Columbus and the Conquest of the New World.* New York, 1992.

Viola, Herman J. *After Columbus: The Smithsonian Chronicle of the North American Indian.* Washington, D.C., 1990.

Waldman, Carl. *Atlas of the North American Indian.* New York, 1985.

———. *Encyclopedia of Native American Tribes.* New York, 1988.

Waterman, T. T. "North American Indian Dwellings," *Geographical Review* 14 (1924): 1–25.

Willey, Gordon R. *An Introduction to American Archaeology, vol. 1, North and Middle America.* Englewood Cliffs, N.J., 1966.

Willey, Gordon R., and Jeremy A. Sabloff. *A History of American Archaeology,* 2nd ed. London, 1980.

NOTES

1. This section, describing the physical and climatic variations across the American continent, draws from Pierce Lewis, "America's Natural Landscapes," in *Making America: The Society and Culture of the United States*, ed. Luther S. Luedtke (Washington, D.C.: U.S. Information Agency, 1987; rev. ed., Chapel Hill, N.C., 1991). See also the similar discussion in Michael P. Conzen, ed., *The Making of the American Landscape* (Boston, 1990).

2. The evidence for migration over Beringia into Alaska is not conclusive for the early date of 50,000 years ago. Data given here regarding the Paleo-Indians and the various Archaic cultures is drawn on Brian M. Fagan's comprehensive *Ancient North America*, 3rd ed. (London, 2000), which synthesizes current research in detail concerning habitation and cultural development before European contact.

3. Thomas J. Connolly, *Newberry Crater: A Ten-Thousand-Year Record of Human Occupation and Environmental Change in the Basin-Plateau Boderlands* (Salt Lake City, 1999, 86–121.) Additional evidence was found at this site to indicate habitation in the area as far back as 11,500 year ago.

4. Stephen Lekson relates that the names were given by a Navajo guide to the first U.S. Army surveyor who entered the valley, calling out some names in his own language, and others in Spanish.

5. The Navajo (a Tewa name given to the newcomers) and the Apache, both Athapaskan-speaking peoples, migrated to the southwest from as far as northwestern Canada about seven hundred years ago. Though of very different cultures and religions, the Navajo and Apache peoples both tended to live in widely scattered individual houses (hogans) rather than in dense pueblos.

6. John Bartram, *Observations, etc., Travels to Onondaga* (London, 1751), 40–41.

7. An excerpt of John Smith's account from the *Generalle Historie*, with an illustration from Captain John Smith's map of Virginia, engraved by William Hole and published in 1624, is given in L. M. Roth, *America Builds: Source Documents in American Architecture and Planning* (New York, 1983), 2–4.

8. William Bartram, *Observations on the Creek and Cherokee Indians*, Transactions of the American Ethnological Society, vol. 3 (1853), quoted at length in John R. Swanton, "Housing," in *The Indians of the Southeastern United States* (Smithsonian Institution, Bureau of American Ethnology, Bulletin 137, 1946).

9. Quoted in P. Nabakov and R. Easton, *Native American Architecture* (New York, 1989), 180.

10. Vincent Scully, *Pueblo: Mountain, Village, Dance* (New York, 1975), 4.

11. Population figures from Harold E. Driver, *Indians of North America*, 2nd ed. (Chicago, 1969), 63. For a searing indictment of Europe-American policies designed to exterminate native American peoples, see Ward Churchill, *A Little Matter of Genocide: Holocaust and Denial in the Americas, 1492 to the Present* (San Francisco, 1997). Churchill recounts the incredible story of British military commander Lord Jeffrey Amherst, who ordered his subordinate to distribute smallpox-infected blankets to Ottawa and to the Lenni Lenapes leaders gathered to discuss a peace treaty in 1763. Amherst urged his lieutenant to use the blankets "as well as try every other method that can serve to extirpate this execrable race" (154). This attitude changed very little over the next century and a half.

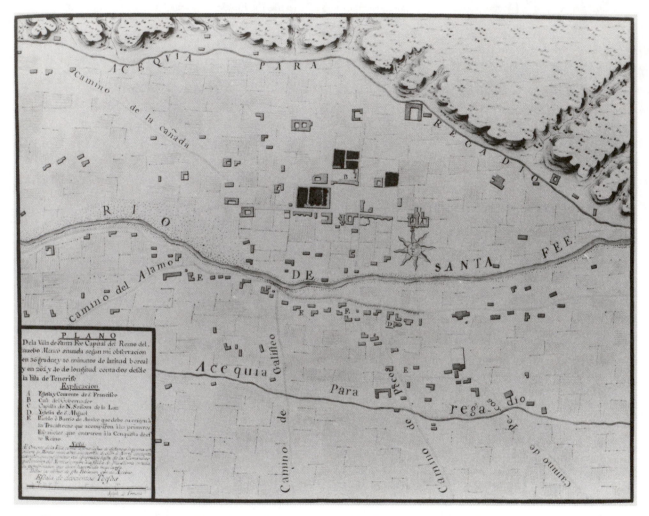

2.1. Plan of the City of Santa Fe, c. 1766. Originally laid out in a strict grid in 1609, a century and a half later the rigid orthogonal grid mandated by the Laws of the Indies had been greatly relaxed, but the evidence of the grid is still visible. *(Lt. Josef de Urrutia,* Plano dela Villa de Santa Fee Capital del Reino del Nuebo Mexico . . ., *by c. 1766; Library of Congress, Map Division.)*

EUROPEANS IN THE NEW WORLD, 1600–1700

TRANSPLANTED VERNACULARS

In the desert Southwest, in the grasslands of Texas, in the tropical beach lands of Florida, and in scattered settlements on the rivers and in the dense forests along the Atlantic seacoast, European newcomers struggled to recapture a bit of home. Alone in a strange land, the colonists did a most natural thing—they began to build as they had in the lands from which they came, trying to re-create the best of their homelands. They shaped their vision of a new society in the accustomed fabric of their European traditions, and their transplanted architecture in turn shaped them. These first settlements were scattered across the continent, the Spanish touching Florida and moving northward from their bases in Mexico; the French moving down the St. Lawrence and then the Mississippi, laying claim to the middle part of the continent; the Swedish and Dutch sailing up the Delaware and then Hudson Rivers; and the English touching various points along the Atlantic coast.

SPANISH SETTLEMENTS

Both the Spanish and Portuguese had made numerous voyages to the New World in the two decades after Columbus stumbled onto the Bahamas Islands in 1492 hoping to find a easy sea route to the spice islands and China. The first Spaniard to touch what is now the United States was Ponce de Leon, who landed near St. Augustine, Florida, in 1513. Following that, in 1528–36 Cabeza de Vaca led a group of explorers along the lower Rio Grande in Texas, and in 1539–43 Hernando de Soto led a long trek from Florida to the Mississippi. Meanwhile, in 1540–42, Francisco Vazques Coronado led a party from Mexico into

Arizona and eastward into New Mexico, seeking the fabled Seven Cities of Gold, venturing as far as central Kansas before he turned back in disappointment.

The high basins of Arizona and New Mexico seemed to offer no prospect of the gold so eagerly sought by the Spanish, but nonetheless colonization started with the creation of Santa Fe as the administrative center of New Mexico in 1609. Rules for laying out settlements in the New World had been carefully drawn up in Spain, to establish uniformity throughout the entire colonial empire. Towns were to have wide streets, laid out in an orderly grid, "with ruler and compass," with a clear public and administrative center focusing on the garrison, the house of the governor, and the church. During the reign of Philip II these regulations were clarified and codified, eventually being printed as "The Laws of the Indies" in 1681.[1] In actual practice, in distant colonies far from Madrid the rigid laws were applied in a more relaxed way, but the plan of Santa Fe, printed in 1766 [2.1], shows the regular order of the underlying grid, with the open space of the plaza roughly at the center, with the Palace of the Governors on the north side of the plaza. In putting up the first buildings, a blend of Indian and Spanish building techniques was used for the Palace of the Governors, built in 1610–14. [2.2] The Spanish readily employed local construction adobe because it was so similar to familiar vernacular traditions at home. As in other later presidios, the palace was a long range of rooms connected by a front loggia or porch colonnade with wooden columns. The use of wooden posts for sheltering porches and the wood framing of door and window openings was a Spanish addition to local techniques. To the rear of the

2.2. Palace of the Governors, Santa Fe, New Mexico, 1610–14. Extensively restored c. 1913, the present-day Palace of the Governors shows what New Mexicans thought early adobe construction looked like. (Courtesy of the New Mexico Commerce and Industry Department.)

2.3. Severino Martinez Hacienda, near Taos, New Mexico, begun before 1804. Plan. Hatched sections show walls now destroyed but with bases clearly evident. (L. M. Roth, after Boyd C. Pratt and Chris Wilson, The Architecture and Cultural Landscape of North Central New Mexico, Field Guide for 12th Annual Vernacular Architecture Forum, 1991, Albuquerque, N.M., 1991.)

palace was a patio. Though the construction was carried out by local Indians in their own fashion, they used wood molds provided by the Spanish to produce standardized bricks.

Although generally well known, the Governor's Palace in Santa Fe is in truth an early-twentieth-century romantic reconstruction, for although the core of the building survives from the early seventeenth century, the front portal and its wood posts were rebuilt to suggest what may have been there originally. A better and less-modified representative example of early Spanish residential building in New Mexico can be seen in the Severino Martinez hacienda near Taos. [2.3 (plan)] Precisely when the house was started is not known, since Don Severino Martinez purchased the oldest portion of the adobe brick structure (the three northwest rooms) from its Indian owners in 1804; over the next two and half decades the Martinez family added room after room around internal courts, or *placitas*, with covered portals along the northern edges of the placitas. Because of often unsettled conditions, and the exposed position of the hacienda, the exterior walls were generally devoid of windows, giving the house a fortified character and creating a decidedly inward focus.

Franciscan priests too adapted native American building techniques in the construction of Latin cross–shaped mission churches, in or just outside existing native pueblo villages. They made the churches taller than surrounding houses and included twin towers at the west fronts, but the severe cubic masses punctuated by the protruding log ends bespeak a long Indian building tradition. Often the roof over the crossing would be raised several feet to provide a horizontal clerestory window, providing a flood of seemingly miraculous light over the altar area in the otherwise dark church interior. Good examples of early Spanish churches are San Estéban del Rey at the Acoma Pueblo, New Mexico, built about 1630–64, and San Francisco at Taos, New Mexico, built about 1772. [2.4]

During the eighteenth century, expanding Spanish colonization resulted in the building of presidios, rancheros, and churches in new territories. Particularly important in the Spanish settlement of southern California was the string of twenty-one missions, nearly all established by Father Junípero Serra and Father Fermin de Lassuén. Local Indians were required to live at the mission, to learn agriculture, and to build and repair the mission buildings. While the simplest mission churches were designed by Father Serra himself, or by the Franciscan priests he installed, the construction was often supervised by masons brought up from Mexico, since the California natives had no traditions of building in permanent materials comparable to that of the Pueblo converts of Arizona and New Mexico. Consequently the designs tended to be extremely simple, with a rather plain church block with a domestic and educational quadrangle to the side. More ambitious was the second mission church at San Juan Capistrano, built in 1797–1806, of solid cut stone, built by master mason Isidorio Aguilar; unfortunately its domical masonry vaults collapsed in the earthquake of 1812. Perhaps the mission that today best conveys the spirit of Father Serra is San Carlos de Borromeo at Carmel, 1793–97, which has been restored. [2.5] The facade is a rather primitive and naive evocation of high Baroque churches of Mexico and Spain. Construction, especially of the interior, was supervised by Manuel Ruiz, a mason from Catalonia, and the parabolic transverse arches of the sanctuary, the only ones of their kind in North America at this time, reflect a Catalan influence.

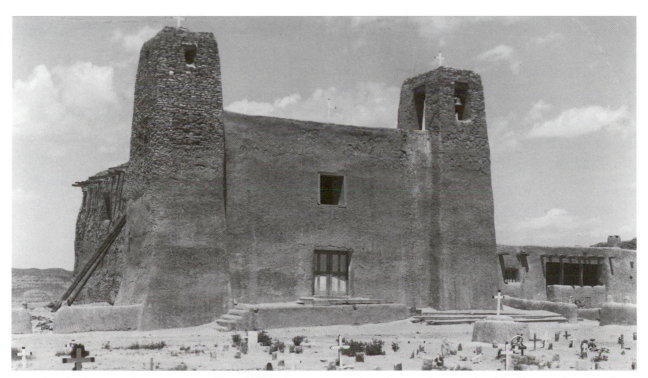

2.4. *Church of San Esteban, Acoma Pueblo, New Mexico, 1630–64. Built atop the mesa, occupied by the Acoma people since c. 950, the Spanish church shows the adaptation of* European Baroque forms to local building traditions and methods. (Sandak, courtesy of the University of Georgia.)

2.5. Mission San Carlos de Borromeo, Carmel, California, 1793–97. Although smaller than some missions, this one is remarkable for its interior elliptical arch supports and for its bold and simplified Spanish Mudejar embellishment. (Sandak, courtesy of the University of Georgia.)

2.6. Mission San José y San Miguel de Aguayo, San Antonio, Texas, 1768–77. This Texas mission church was embellished in the traditional Mexican and Spanish way with dense and beautifully sculptural frames around the main door and windows. (Library of Congress, HABS photo TX 333 A-2 15-Sant.V.S-2.)

The region between Monterey (south of San Francisco) and Santa Barbara retains a number of residential survivals from the period of Spanish colonization. These houses include the de la Guerra house, in Santa Barbara, from 1819–26; and the Thomas Larkin house, in Monterey, built in 1834, the residence of the first American consul to the Mexican government in Alta California.

The eighteenth-century missions of Texas, New Mexico, and Arizona show more familiarity with late Spanish Baroque models, and a desire to emulate the mother houses of Mexico and Spain. These later and more architecturally ambitious mission churches demonstrate more developed construction skills as well as more ample building funds. Representative of such missions is San José y San Miguel de Aguayo, near San Antonio, Texas, built in 1768–77. [2.6] In many of its details it is the most authentic Spanish Baroque structure in the United States, although the carving of its tufa masonry is necessarily rough. The walls originally were stuccoed and painted with brilliant quatrefoil patterns. Its dome vaults also merit special attention, as most of the missions had flat framed ceilings. Most striking are the intricate elaborate portal sculpture and baptistery window, carved by Pedro Huizar, a trained stonecutter. Although the bold frontispiece of San Xavier del Bac near Tuscon, Arizona (1784–97), is more untutored in design and execution than that of San José y San Miguel, the matching towers, with their oversized diagonal flying buttresses, exemplify the vigor and plastic inventiveness of the provincial builders, especially when the brilliant whitewashed forms are seen against the deep blue high desert sky. Yet as beautiful as such ecclesiastical stone carving at San José y San Miguel was, it meant little to the many transplanted English-speaking settlers who began to arrive in Spanish territories in increasing numbers during the nineteenth century; such elaborate stone carving gradually came to an end. The new Yankee arrivals, however, did retain the Spanish/Mexican square courtyard form for housing, applying Federalist stylistic details around windows and doors so that some connection was made with current developments where the settlers had come form.

FRENCH SETTLEMENTS

French attempts to establish settlements and colonial trading enterprises occurred as early as the Spanish. Initial French settlements were attempted

2.7. Poteaux-en-terre *and* poteaux-en-sole *construction. These traditional French ways of building employed closely spaced logs carrying an upper plate, but* poteaux-en-terre *timbers placed directly in the earth tended to rot away in less than a generation; placing the wall timbers on a horizontal base sill plate (en-sole) resulted in a much longer life.* (L. M. Roth.)

at Charlebourg in Quebec, Sainte Croix in Maine, and Port Royal in Nova Scotia from 1534 to 1605; an attempt at settlement in northern Florida in 1562 spurred Spanish investment in St. Augustine. Shortly thereafter, French explorers Marquette and Jolliet and then La Salle moved through the Great Lakes and down the Mississippi, laying the foundation for French claims for the northern and central portions of the continent. By the end of the first decade of the seventeenth century permanent settlements were established along the St. Lawrence River at Quebec City and Montreal; by the end of the century additional settlements were secure at Louisbourg, Nova Scotia, and Biloxi and New Orleans, Louisiana.

Early houses along the St. Lawrence, such as the Lachance house, in Saint-Joachim, Quebec, built sometime in the eighteenth century, had flared eaves that came to be typical in this area. In southern New France, along the Mississippi River in the region around what became St. Louis, and farther south in

2.8. Cahokia Courthouse, Cahokia, Illinois, c.1737. Although much moved, shortened, and then reconstructed over the centuries, this remains a good example of early French Colonial construction techniques. (Photo: Lester Jones; Library of Congress, HABS ILL 82-CAHA 4-1.)

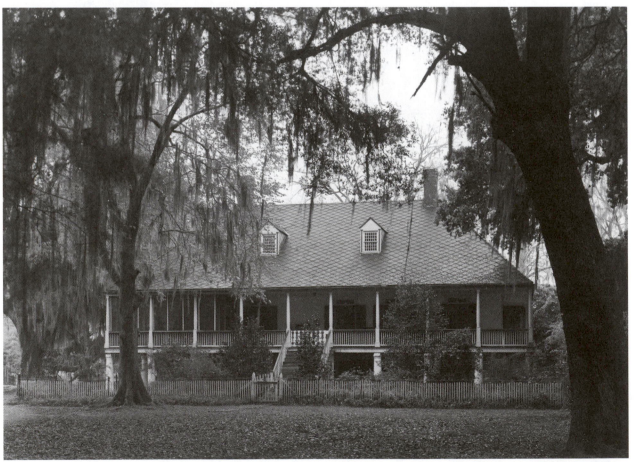

2.9. Parlange Plantation, Point Coupée Parish, Louisiana, 1750. In Louisiana, particularly, the old French house form, with its protective surrounding galleries, was enlarged to form the basis of many early plantation mansions. (Sandak, courtesy of the University of Georgia.)

Louisiana, wooden houses were built with even larger flared eaves. These were built of closely spaced vertical wooden timbers, either placed in holes in the earth (*poteaux-en-terre*, posts in the ground) or timbers placed on a wooden sole plate (*poteaux-sur-sole*, posts on sole). [2.7] No houses of this type remain from the seventeenth century in the deep South, but in the French settlement of Ste. Genevieve, Missouri, established in 1750, a number of eighteenth-century houses remain little changed. The Louis Bolduc house, built about 1785, with its flared eaves and surrounding gallery porch, is a good example. The Bequet-Ribault house, built with *poteaux-en-terre* construction in about 1808, also survives, largely because the wood used was cedar and has withstood termites, which destroyed so many other examples. Not far away on the east side of the Mississippi River, at Cahokia, Illinois, is the much restored Cahokia Courthouse, originally built in about 1737, in *poteaux-sur-sole*, as the residence and shop of a French trader. [2.8] These two illustrate a house type once familiar along the length of the Mississippi. The surrounding *galarie*, or gallery, of the courthouse, supported by wooden posts, has a distinctive double-pitched saddleback shape. The roof is extended in this way to provide protection for the exposed frame and infill construction. In the southernmost regions in what is now the state of Louisiana such houses were raised up on an airy basement, so that the upper gallery formed a breezy veranda. A later adaptation of this form is found in the galleried Parlange Plantation, in Point Coupée Parish, Louisiana, from 1750. [2.9]

French activity in lower North America was focused on New Orleans, founded in 1718 and surveyed as an orderly grid by LeBlond de la Tour and Adrien de Pauger in 1722; to this, additional gridded sections were added between 1803 and 1817, aligned to the changing curve of the river. Frames of closely spaced wood *porteaux-en-sole* posts were used here as well, as seen in Lafitte's Blacksmith Shop, 1772–91, with bricks tightly fitted in the spaces between the framing timbers. Perhaps most impressive as a transplantation of high-style architecture is the Cabildo, on the Place d'Armes, New Orleans, built in 1795. As the name might suggest, it was built at a time when Louisiana was briefly under Spanish control. The two-story masonry building, with its open arcaded ground, was inspired perhaps by the Casa Reales in Antequerre, Mexico, built fourteen years earlier.

SWEDISH SETTLEMENT

Today a politically neutral nation, Sweden was an active participant in European imperial politics in the seventeenth and eighteenth centuries. Like the other nation states, it sought to establish oversees colonies, but these never prospered as did those of England, France, and Spain. The New Sweden company, chartered in 1638, founded about six trading posts along the estuary of the Delaware River in what is today Delaware and Pennsylvania. The most important was Fort Christiana (now Wilmington, Delaware). It is generally believed that it was the Swedes who introduced the first log construction to North America, laying the dressed logs horizontally, with notched corner joints. This was certainly a form of vernacular construction well known throughout Sweden. Almost none of these first structures survives, although the oldest section of the John Morton residence, in Prospect Park, Chester County, Pennsylvania, was built in 1654, with later additions of 1698 and 1806. When English Quaker settlers began to arrive in the mid- to late seventeenth century, they were aided by Swedish settlers already there, who assisted them in building these unfamiliar log structures. In 1679 visiting Dutchman Jasper Daenkaerts described these early log houses as

> being made according to the Swedish mode . . . which are blockhouses, or houses of hewn logs, being nothing else than entire trees, split through the middle or somewhat squared out of the rough[;] these trees are laid in the form of a square upon each other as high as they wish to have the house[;] the ends of these timbers are let into each other, about a foot from the ends of them. So stands the whole building, without a nail or spike.[2]

The Swedes also introduced a particular form of gambrel roof in which the outer surfaces have very steep slopes; the profile differs from the Dutch and English gambrel roofs. Although the building is of stone, not squared logs, the Andrew Hendrickson house of 1690, now in Wilmington, Delaware (originally located near Chester, Pennsylvania), shows this particular Swedish gambrel roof profile. [2.10] The corner placement of the fireplace was also unique to early Swedish houses, as well as what came to be called the "Quaker" plan, comprised of a single *stuga*, or main room, flanked by two smaller rooms to one side. [2.11] A promotional tract prepared in London in 1682, aimed at Penn's Pennsylvania settlers, describes the plan of a typical house being built in and around

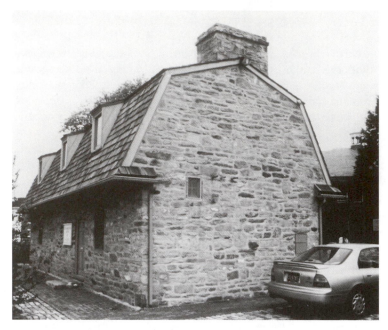

2.10. Andrew Hendrickson house, Wilmington, Delaware, 1690. Although moved from its original site near Chester, Pennsylvania, the Hendrickson house was meticulously rebuilt next to Old Swedes Church, Wilmington, and shows the Swedish gambrel roof form. (Photo: L. M. Roth, 1997.)

2.11. Diagram of Swedish house, plan. The Swedish stuga house plan had one principal room, flanked on one side by two smaller rooms. (L. M. Roth, after H. Morrison.)

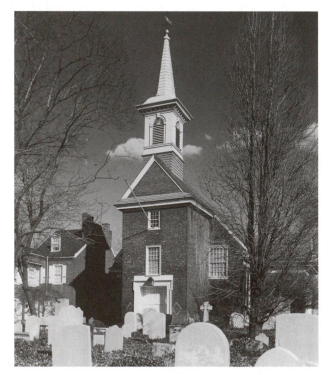

2.12. Gloria Dei Church, Philadelphia, Pennsylvania, 1698–1700. This church (originally Lutheran) survives from the early Swedish settlement at what became Philadelphia. (Library of Congress, HABS PA 51-PHILA 174-8.)

Philadelphia; such a house would measure 30 feet in length and 18 feet in depth, "with a partition neer the middle, and another to divide one end of the House into two small Rooms."[3] Today, the major remnants of this Swedish period are two brick Lutheran churches built during the Swedish period: Holy Trinity ("Old Swedes") Church, Christiana (Wilmington), Delaware, 1698–99; and Gloria Dei Church, Philadelphia, Pennsylvania, 1698–1700. By the time these churches were built, however, stylistic trends were governed by English standards rather than Swedish influence. [2.12]

DUTCH SETTLEMENTS

The Dutch also set out to establish an oversees empire, with great success in Indonesia and parts of South America. Their colony of New Netherlands, centered along the Hudson River, however, remained under Dutch control for only about seventy years before it was taken over peaceably by the British and joined to the developing British colonies to the north and south.

Henry Hudson, sailing for the Dutch in 1609, came upon the river to which he gave his name, thinking it was the mouth of the fabled Northwest Passage provid-

ing easy water access around North America to the spice islands and China. It did not take him long to discover his error, but the Dutch recognized the region as one highly suitable for colonial development. Settlement began in 1610, and in 1621 the Dutch West India Company was formed to operate the colony, beginning with the creation of a port city, New Amsterdam, in 1625. The tale of the purchase of the island of "Manhattes" (Manhattan) from the native Algonquin tribe by Peter Minuit is well known in American lore. Soon other towns were established up the length of the river, as were villages around the edge of what the Dutch called the "Lange Eylandt" (Long Island).

As they did in the Netherlands, the Dutch in the New World built with brick, constructing small houses turned with their pointed gables facing the street. [2.13] The edges of the gables were finished with small steps, or, as a variation, the step sections were filled with bricks laid perpendicular to the slope of the gable and trimmed with stone (the "mouse tooth" gable). The brick end gables of the residence called Fort Crailo, built about 1642 in Rensselaer, New York, and the Hendrick Bries (or Breese) house in East Greenbush, New York, built about 1723, have such "mouse tooth" construction. [2.14, 2.15]

In addition to these Flemish-gabled buildings, a distinctive rural type developed among the farms in Long Island and northeastern New Jersey. This was based on the traditional domestic architecture of the Walloon settlers, who came from Belgium and northern France. An example is the Pieter Wyckoff house [2.16] in Flatlands, Bruecklen (Brooklyn), built in 1639 in what was then a rich farming belt around New Amsterdam. The low roof, sweeping out along the side to form a canopy over windows and entrance, is characteristic, as is the double-pitched gambrel roof that gave the

2.13. Stadt Huys (City Hall), New Amsterdam (New York), 1641–42. The city hall, the larger four-story building, is in the center. This lithograph, printed in 1869, shows typical narrow Dutch brick houses, with tall stepped gables facing the street. (Lithograph by George Hayward, J. Clarence Davies Collection, Museum of the City of New York, 29.100.3533.)

2.14. *Hendrick Bries house, East Greenbush, New York, c. 1723. Although built early in the eighteenth century, this house retains the raised mousetooth gable at the ends. (Library of Congress, HABS NY 42-GREBUE 1–5.)*

2.15. *Detail of mousetooth gable end of the Bries house. The mousetooth gable (muisetanden gable), sometimes called the straight line gable, is essentially a stepped gable with brick fitted into the steps but laid perpendicular to the angle of the gable, with the edge covered with long capping stones; this drawing is based on the mousetooth gable of the Bries house in East Greenbush, New York. (L. M. Roth, after HABS.)*

2.16. *Pieter Wyckoff house, Flatlands, Brooklyn, New York, 1639. The Wyckoff house shows the distinctive Dutch gambrel, and the projecting eave over the entry. (Courtesy of Essex Institute, Salem, Massachusetts.)*

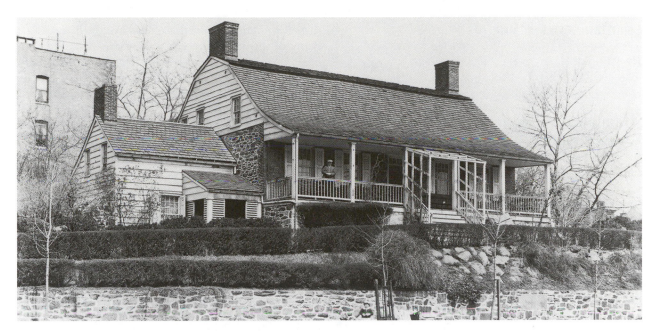

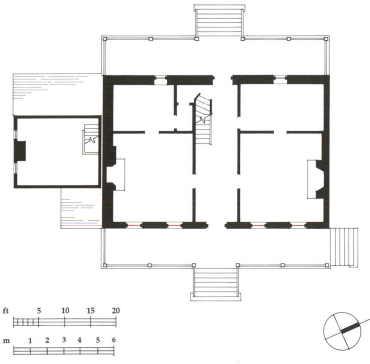

2.17. Dyckman house, New York, New York, 1783. This house, rebuilt by William Dyckman after the earlier house was destroyed by the British during the Revolutionary War, still retains the side-additions and curved gambrel roof of Flemish Walloon houses built a century and a half earlier. (Library of Congress, HABS NY 31-NEYO 11-1.)

2.18. Plan of Dyckman house. This plan shows how the upper floor of the side addition is reached by its own stair; the existing fieldstone wall and fireplace prevented the opening of a door. (L. M. Roth, after HABS.)

ft 5 10 15 20

m 1 2 3 4 5 6

name to a domestic type revived at the end of the nineteenth century—"Dutch Colonial." Significant too are the separate fireplaces at each end of the house, the use of shingles to cover both roof and wall surfaces, and the way in which successive additions were placed at the sides of the original unit rather than to the rear as was done to form the New England "saltbox." As in other regions, this early vernacular type persisted outside the stylish centers of commerce and politics. An illustration of how long-lived these vernacular traditions were is found in the gambrel-roof Dyckman house, rebuilt in the countryside of northern Manhattan Island about 1783 after being heavily damaged in the Revolutionary War. [2.17, 2.18]

ENGLISH SETTLEMENTS

New England

The English Crown also sought a foothold in the Americas and dispatched several early explorers who probed the northern coasts, beginning with Sir Martin Frobisher, who touched Labrador in 1576, followed by Sir Humphrey Gilbert, who reached Newfoundland in 1583. Along the shore in what is now Maine, New Hampshire, and Massachusetts several settlements were built between 1620 and 1640, resulting in seven separate colonies; the Plymouth colony, centered on Plymouth, Massachusetts (1620, merged with Massachusetts Bay in 1691), and the Massachusetts Bay colony, with its center at Boston (1628), were the most important. There were also Rhode Island on Narragansett Bay, with its center at Providence (1636); Connecticut, an inland colony with its focus at Hartford (1636); New Haven on the coast (1638, merged with Connecticut in 1662); Maine, settled as a proprietorship of Sir Ferdinando Gorges (1639, merged with Massachusetts Bay in 1677–1820); and New Hampshire, a proprietorship of Captain John Mason (1639, merged with Massachusetts Bay 1641–79).

In truth, the English who settled in Massachusetts Bay did learn many things from the native Americans, whose land initially the English took care to buy (though the natives at first had little concept of what that entailed in the European sense). Maize, pumpkin, and wild turkeys, among many other foodstuffs, were added to the settlers' diet, and in time the colonists adopted the Indian practice of placing a herring with maize seed during planting, a form of fertilization that prolonged soil productivity. Desperate for immediate shelter, the colonists shoveled dugouts in hillsides and threw up wigwams very much resembling the houses of the natives, but actually based on English shepherds' and charcoal burners' huts. These first homes disappeared long ago, but modern reconstructions based on early descriptions show that, except for framed doors, windows, and the chimneys at the end, built of twigs and lined with clay (wattle and daub), these wigwams did indeed look like Algonquin houses.

As quickly as conditions allowed, however, the wigwams were replaced with cottages built according to prevailing English vernacular traditions. As Edward Johnson related in his history of New England (1654), the Lord was "pleased to turn all the wigwams, huts, and hovels the English dwelt in at their first coming in to orderly, fair, and well-built houses, well furnished many of them."[4] Such "fair" or framed houses had a heavy hewn wood frame, with the spaces filled with interwoven twigs (wattle) and covered with mud plaster (daub), with a roof of thatch. These usually consisted of a single room, with few windows (glass had to be imported), and a large masonry fireplace mass at one end, with the door next to it. Such half-timbered cottages proved much too sensitive to the extremes of New England weather, for temperatures ranged a good thirty degrees more in Massachusetts than in the West Country or East Anglia, where most of the New England settlers came from. The exposed frame moved too much through thermal expansion and contraction; cracks opened up between the frame and the wattle-and-daub panels. The solution was to cover the frame with a wind-tight skin of narrow clapboards or split shingles. Since thatch, too, reacted poorly to the New England climate, tending to rot, the roof likewise became a skin of shingles.

By the latter half of the seventeenth century the Massachusetts Bay colonists had developed a unique house type, based on the traditional heavy hewn or sawn frame construction of English houses, but adapted to the New England climate. The oldest surviving example in New England is the core of the Jonathan Fairbanks (Fayerbankes) house, in Dedham, Massachusetts, erected in about 1637–38, but added to several times later so that the original unit is obscured.[5] The basic unit type is well illustrated by the later Parson Joseph Capen house, in Topsfield, Massachusetts. [2.19, 2.20] It sits atop a gentle knoll next to the Topsfield Common, close to the town meetinghouse, convenient for the Reverend Joseph Capen. Born in 1658 in Dorchester, Massachusetts, and educated at Harvard College, Capen was called to God's ministry and to the pastorate at Topsfield in 1681. Following marriage to the daughter of a prosperous Ipswich family, Capen built their house in 1683 on land in Topsfield given to him by the community. According to the date carved on one of the roof rafters, the frame was raised on June 8, 1683. As was customary with such houses, the upper floors project beyond the lower floors, and the windows are pushed outward, tight against the clapboard skin. Carved brackets beside the door help to transmit the weight of the upper frame to the posts below, but at the corners the upper posts hang below the projecting second story in the form of carved pendills. The plan consists of two rooms on either side of a central masonry mass containing fireplaces back to back. In

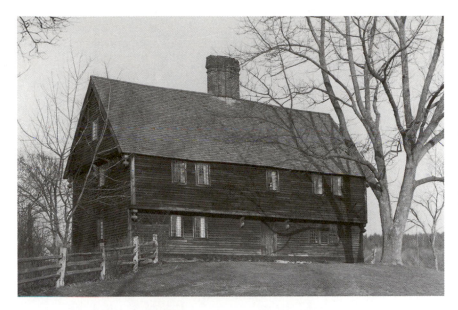

2.19. Parson Joseph Capen house, Topsfield, Massachusetts, 1683. This house survives in remarkable condition and shows the retention of English medieval details such as the overhanging upper story. (Sandak, courtesy of the University of Georgia.)

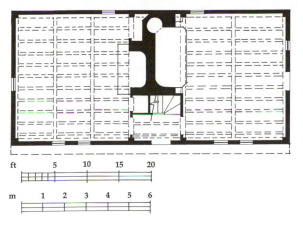

2.20. Parson Capen house, plan. The plan of the Capen house shows the basic type of early Massachusetts Bay houses. (L. M. Roth, after HABS.)

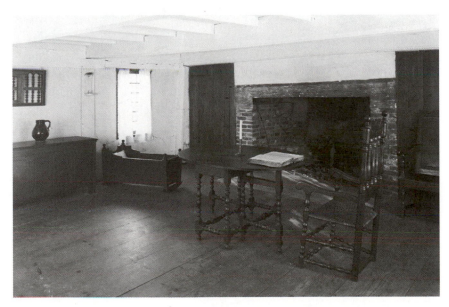

2.21. Parson Capen house. The interior of the parlor shows the heavy girts and joists usually left exposed, the broad mouth of the fireplace, and the simple detailing. (Sandak, courtesy of the University of Georgia.)

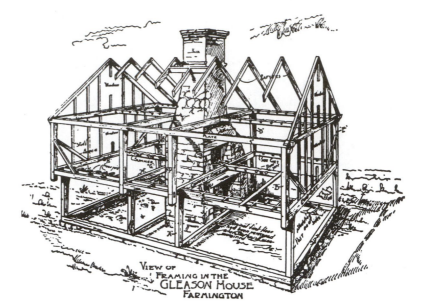

2.22. Frame of the Gleason house, Farmington, Connecticut, c. 1660. The heavy principal timbers were connected with mortice and tenon joints that could become quite complex where post, upper plate, and roof rafter all came together. (From N. M. Isham and Albert F. Brown, Early Connecticut Houses, 1900.)

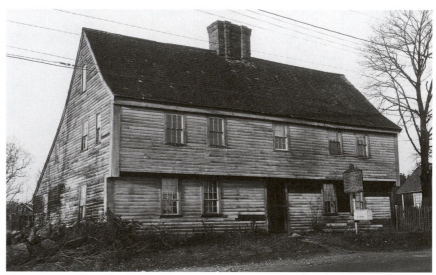

2.23. Boardman house, Saugus, Massachusetts, principal section c. 1687; lean-to addition c. 1695. The Boardman house is a good example of the saltbox house, with a lean-to addition put up less than a decade after the original section had been built. (Library of Congress, HABS MASS-492 5-SAUG 1-1.)

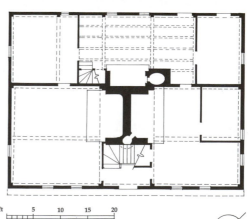

2.24. Boardman house, plan as of 1696. The lean-to addition allowed the kitchen to move to the rear (with a larger oven), so that the old kitchen became the hall; flanking the new kitchen were a small bedchamber and a milk house. (L. M. Roth, after HABS.)

front of the masonry core is a narrow hall, opposite the entrance door, with a cramped winding stair leading to the rooms above. Such an arrangement was economical of fuel, for during the winter the huge bulk of stone and mortar at the center of the house absorbed and stored the heat of the wood fires during the day, gently radiating it back during the long night.

From the outside, houses such as the Capen house often appear stark and imposing; although the exterior might seem chaste, the interior rooms were delicately embellished with such details as distinctive molded, chamfered edges on the main beams. The interiors were subdivided into close, snug, intimately scaled rooms. This came about partly because of the short hardwood timbers of the stout frames and partly because of the need to minimize the air space to be heated in winter. The intimate scale is reinforced by the framing members left exposed in the low ceiling and walls, as in the parlor of the Capen house [2.21], or the parlor of the Thomas Hart house of Ipswich, Massachusetts, built in about 1640. Both rooms show well the huge focal fireplaces and the simplicity of the handcrafted furniture, based on Elizabethan and Jacobean models, ornamented chiefly with lathe-turned supports.

The frames of such houses were prepared by skilled joiner carpenters who cut the detailed interlocking joints where posts and beams (and roof rafters) came together. [2.22] Once the members were slid into place, one or more dowels would be driven in to secure the connection. Such work required special training and much experience, and in the early years the demand for frames far exceeded the capacity of the few available joiners. The result was a rapid increase in rates charged, prompting officials to impose wage controls: "Carpenters, joyners, bricklayers, sawers, and thatchers shall not take above 2s a day, nor any man shall giue more vnder paine of xs to taker and giver and that sawers shall not take aboue 4s 6d the hundred for boards, att 6 scoote to the hundred, if they have their wood felled and squared for them, and not aboue 5s 6d if they fell and square their wood themselues."[6] With excellent wood so abundant in the colonies, and skilled craftsmen so scarce (the exact opposite of conditions in England), colonial builders simplified construction details compared to standards that prevaied in their homeland.

By the middle of the seventeenth century, the typical enlarged version of this house type was the "saltbox," exemplified by the Boardman house, Saugus, Massachusetts, which began as a two-story, two-room house with central chimney and stair in about 1687. [2.23, 2.24] The basic front portion of the house is nearly identical to the Parson Capen house, without

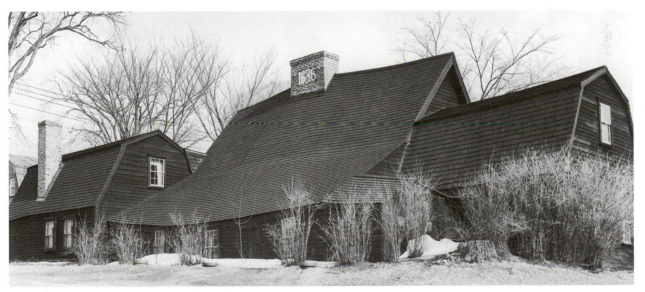

2.25. Fairbanks house, Dedham, Massachusetts, begun c. 1637; lean-to added c. 1665–68; gambrel-roof wings added in the eighteenth century. Seen from what was the rear, the long sloping roof dominates, and its undulating line, the result of shifting and sagging over the centuries, clearly suggests its age. (Library of Congress, HABS MASS-223-4 11-DED 1-9.)

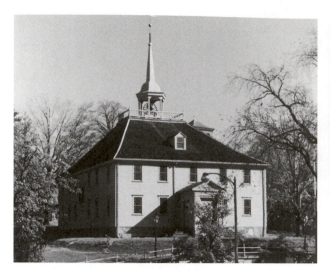

2.26. Old Ship Meetinghouse, Hingham, Massachusetts, 1681. The last surviving of the old Puritanically austere seventeenth-century meetinghouses, this was enlarged and later trimmed with a few classical details. (Library of Congress, HABS MASS 12-HING 5-17.)

2.27. Old Ship Meetinghouse. The enormous timbers making up the exposed roof trusses were, according to tradition, crafted by ship's carpenters, hence the popular name of Old Ship Church. (Sandak, courtesy of the University of Georgia.)

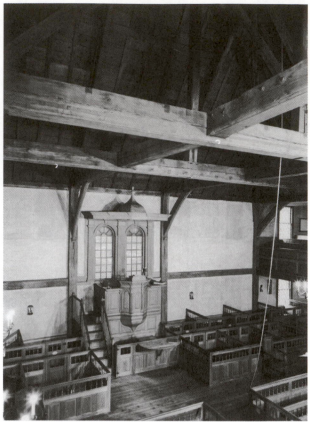

the overhang and pendants. More space was needed by the Boardmans so quickly that before 1695 the lean-to addition was added to the rear, with the roof extended on the back, creating the distinctive saltbox profile. Typically, these lean-to additions housed a new, larger kitchen, flanked by a small bedchamber and a storage room, with more sleeping or storage space in the half story under the lean-to roof. In order to add the kitchen, of course, it was necessary to enlarge the chimney mass at the back to provide a new cooking hearth and oven.

This and more was added to the Fairbanks house. Around 1665–68 a saltbox lean-to addition was built, and the kitchen relocated. [2.25] In the later seventeenth and eighteenth centuries more small additions were built, covered with gambrel roofs. Another variation was the addition of steep-peaked gables on the long fronts of these houses, as in the John Ward house, in Salem, Massachusetts, built in 1684. The John Turner house in Salem, built before 1680, with extra gables on the main block and as well as on an extension, became known as "The House of Seven Gables."

Particularly in Massachusetts the town functioned as a religious commune (at least in the early seventeenth century), and was a theocracy of God's elect. In fact, rules of the Massachusetts Bay Colony stipulated that not until the necessary number of prospective settlers had pledged to build and support operation of a meetinghouse could a new town be started. The eight signers of the Articles of Agreement for Springfield, Massachusetts, dated May 14, 1636, began their first article by pledging, "We intend by God's grace, as soon as we can, with all convenient speed, to procure some Godly and faithful minister with whom we purpose to join in church covenant to walk in all the ways of Christ."[7]

The center of each town, both figuratively and literally, was the meetinghouse in the town common. The meetinghouse was an innovative building created by the New Englanders; the Separatists and Puritans who turned their backs on the liturgy of the established Church of England wanted a building whose directness and appropriateness would strengthen the impact of the spoken word. Moreover, the meetinghouse was

more than a church, for it housed political gatherings such as the annual town meeting and served as a haven in times of adversity. At a time when religion and daily life were nearly one, the meetinghouse was the communal assembly hall. Few of these seventeenth-century structures survive, since most were replaced by larger buildings during the next century, but still extant is the heavily and perhaps romantically restored meetinghouse in Hingham, Massachusetts [2.26, 2.27], built in 1681 with additions of 1731 and 1755. Representative of most of the early meetinghouses, it is a relatively large hip-roof barnlike structure, covered with clapboards. As were most of the early meetinghouses, it was originally nearly square in plan, enclosing one large room with the roof supported by three enormous king-post trusses that, because of their resemblance to naval construction, gave rise to the popular name "Old Ship Church."

There was to the seventeenth-century New England town, such as Hartford, Connecticut [2.28], a comparative overall unity of expression just as there was a great unity of purpose among the early builders and settlers. The houses in these communities were solidly built and plain, but demonstrations nonetheless of God's manifest approval of their owners as evident in their material increase. Of a type and sharing a common vernacular architectural tradition, the houses were broadly dispersed along the roads and grew according to the needs and circumstances of the owners, sprouting gables, dormers, ells, wings, and sheds in a kind of ordered confusion. Houses along the coast took on a silver sheen as sun and sea worked on the wood. Later, in the eighteenth century, as tastes and styles changed, houses might be replaced by new ones painted in tints and colors, with crisp white classical trim, but the placement of the houses on the land had,

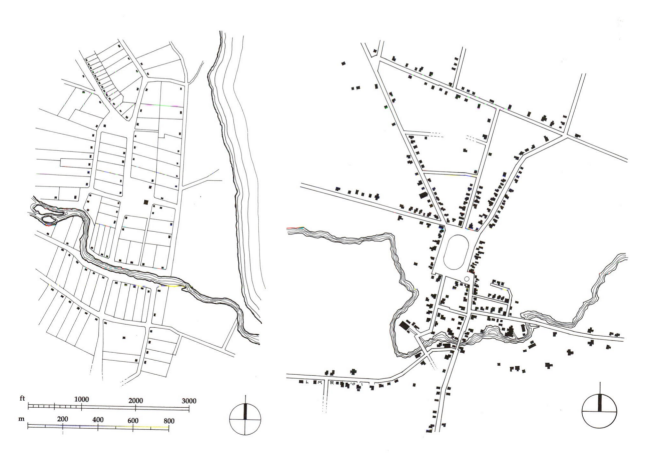

2.28. Map of Hartford, Connecticut, 1640. The plan shows a desire for regularity, focused around the center square and the church. (L. M. Roth, after J. W. Reps.)

2.29. Fair Haven, Vermont. Founded in the eighteenth century, even a century later the town retained the footprint of its original plan, with its original focus on the central square and church. (L. M. Roth, after J. W. Reps, map of 1868.)

2.30. *Pierce-Little house, Newbury, Massachusetts, c. 1667. Built in part of stone, in part of brick, this house has a projecting entry bay embellished by details recalling fashions in* England. *(Society for the Preservation of New England Antiquities.)*

in large part, been fixed. The houses spaced themselves along curved and bending roads that followed the contours of the land and ran wherever convenience dictated. But always near the center of the cluster, at the nexus of the paths, was the village common and the meetinghouse. In rural areas of New Hampshire, Vermont, Massachusetts, and Connecticut such villages survive, their patterns virtually intact though the individual buildings periodically have been replaced. Woodstock, Fair Haven, and Stratford, all in Vermont, or Lebanon, New Hampshire, are good examples. [2.29]

Although most New England buildings in the seventeenth century were of wood, a plentiful material easily worked, masonry was used on occasion as well. One example is the massive stone Reverend Henry Whitfield house, in Guilford, Connecticut, built by congregants of the community for their minister in 1639–40 but intended as meetinghouse and refuge as well as residence. Another intriguing example is the part-stone, part-brick Pierce-Little house, in Newbury,

Massachusetts, built in about 1667. The decorative brickwork in the center pavilion, apparently an attempt to emulate current fashion in England, suggests that the stern, self-denying rejection of worldly things of the founding Puritans was by this time disappearing. [2.30]

The Mid-Atlantic English Colonies

Until the end of the seventeenth century, English settlement in the area between the Hudson River and the Chesapeake Bay was sparse, for the Dutch controlled the area next to the New Haven/Connecticut colony westward, including what is now northern New Jersey. In 1632 Charles I granted to George Calvert, the first Lord Baltimore, a charter for a new colony between the Potomac River in Chesapeake Bay and the 40th parallel. Lord Calvert was a Roman Catholic, and as Catholics were welcome neither in the northern colonies, nor to a great extent in the southern Virginia colony, it was Calvert's intent to create a haven for Catholics in the colony. Wishing to attract Protestant

settlers, he established religious tolerance. The first ships of settlers arrived in 1633, landed in what they called St. Mary's River, and set up a town there by that name. Although wood was used for most initial building, brick quickly became the preferred material. A uniquely Maryland house type consisted of a compromise between timber and brick construction, with frame front and rear walls, the brick end walls incorporating externalized chimneys. The Marylanders also took special delight in using glazed brick in decorative diagonal patterns, as later illustrated in Make Peace, Somerset County, built perhaps early in the eighteenth century. [2.31]

The region along the Delaware River was contested by the Swedes, the Dutch, and the English, and although all three nations established temporary posts along the river, the Swedes created the largest and most important settlements. In 1655, however, the Dutch captured Fort Christiana and took over political control (the Swedish community and their building traditions remained strong). When New Amsterdam fell to the English in 1664, the Swedish-then-Dutch colony along the Delaware became English. As early as 1666 William Penn, a prominent Quaker leader in England, sought a colony in America as a refuge for adherents of his faith, and in 1680 petitioned the crown for a colony charter. Because of the English definition of their colonies, the area west of the Delaware River was technically part of the colony of New York, but because of its distance from New Amsterdam, now renamed New York, Penn was given the western "Three Lower Counties" of the duke of York's in 1681. Penn immediately sent emissaries to draw up a treaty with the natives and to lay out a city. Penn vigorously sponsored the colony's settlement, calling it Penn's Woods (Pennsylvania) in his father's honor, and naming the planned settlement the City of Brotherly Love (Philadelphia). The city's orderly grid plan is discussed in connection with other cities laid out in the seventeenth century in a section that follows. Its early buildings were, from the start, patterned "after the mode in London," and accordingly are more properly discussed in the next chapter.[8]

The Southern English Colonies

Because of the influence of economics and geography, the story of architecture in the southern colonies in the seventeenth and eighteenth centuries is largely that of isolated country houses, their location identified by county rather than by city. Just as the New England homes were based on English vernacular village houses, the earliest Virginian houses were based on vernacular traditions from home. Every one of these initial houses has disappeared, for they were built much like French *poteaux-en-terre* houses, with the structural vertical timbers placed directly in the soil—what the first Virginia settlers called "palisade" or "earth-fast," or sometimes "puncheon" construction. The durability of these houses depended directly on the kind of wood used for the earth-fast posts; red cedar, cypress, and black locust were the most long-lasting. As in New England, there was a great abundance of wood and a scarcity of skilled labor, leading to a simplification here too of English framing traditions. One aspect of this in the South was the introduction of a false plate to bear the weight of upper floor joists, or even tilting of the plate to bear the roof rafters, adjusting its angle to lie parallel to the rafters. Within a few years, in Virginia as in the North, the earth-fast house frames were covered with "weatherboards" or clap-

2.31. *Roach-Gunby house, Make Peace, Somerset County, Maryland, c. 1730. This plantation house shows the interest in the middle colonies in decorative patterns laid into the brick walls. (Sandak, courtesy of the University of Georgia.)*

ft
20 40 60

m
5 10 15

2.32. Clifts Plantation, Westmoreland County, Virginia, c. 1670–75. Although the building has long since rotted away, this puncheon house reveals its plan in the post-molds of its principal posts set directly in the earth. (L. M. Roth, after Fraser D. Neiman.)

boards, but in the South they were soon given a beaded or rounded lower edge.

Another factor that tended to foster construction of such relatively inexpensive wood frame houses was the economic basis of the Virginia colony. This was a money-making venture, and those who came to settle tended to plow most of their profits back into the enterprise rather than diverting them into the building of elaborate houses. What profit they could clear was used to purchase more land and to build up their labor force through acquisition of slaves. There was also the possibility, once a fortune was acquired through growing tobacco, of returning to England to a life of triumphant ease, so large permanent houses were not desired. In another fifty or seventy-five years, however, with fortunes and plantation lands established, Virginians and other southern planters used their considerable income to build very handsome houses indeed.

In the warmer southern climate, these early earth-fast wood frame houses soon rotted away or were destroyed by fire. Our knowledge of them comes from seventeenth-century written records, and also from painstaking archaeological analysis of the postmolds left by the rotted posts, the voids created by their gradual disappearance filled with soil of a different color and texture. A good example re-created on

paper from postmold evidence is the Thomas Pope homestead, Clifts Plantation, in Westmoreland County, Virginia, originally built in about 1670–75 and enlarged in 1720. Its three-cell house with projecting entry is traced out by the postmolds.[9] [2.32] The small village of Wolstenholme Towne, in York County, Virginia (now within the grounds of the later Carter's Grove plantation), has been re-created on paper in a similar way. Established in 1619, it provided homes for about two hundred people within its surrounding military palisade.[10]

What survive today are the far more limited brick houses that were able to resist the ravages of weather, fire, and termites. These too were adapted from English manor houses, modified for a different climate. The sons of the educated landed gentry who came to Virginia had more experience with high-style domestic architecture in England and aspired to bring some of its developed character to their new homes, as can be seen in one of the earliest surviving examples, the Adam Thoroughgood house, in Princess Anne County, near Norfolk, Virginia, once thought to have been built between 1636 and 1640 but now thought to date closer to the eighteenth century. [2.33, 2.34] Thoroughgood arrived in the New World in 1621 an indentured servant, but by the time he had worked out his contract in 1629 he sat in the House of Burgesses

(elected advisors to the Royal Governor), and by 1636, when his house may well have been under way, he had amassed an estate of 5,250 acres. The working of such huge plantations was made possible in part by letters of indenture, in which the poor could sell their labor over a future time period in exchange for transport to the New World and sustenance provided by their master, but increasingly the heavy labor was done by Negro slaves, first brought to Virginia in 1619. By 1680 the use of slaves had become firmly rooted.

The Thoroughgood house celebrated the position of the family by referring to contemporary English traditions in brick masonry, making use of the local sources of good clay and oyster shells for lime. The house is one and a half stories, and while from certain angles it has a vertical emphasis, from other vantage points it has a horizontal emphasis that suggests a desire for classical repose, a debt perhaps to the influence of Renaissance architecture just beginning to be seen in England in the work of Inigo Jones. The near bilateral symmetry of the front, masking the asymmetry of two rooms of unequal size inside, and the subtle brick stringcourse at the eave line recall vaguely the classical elements in Elizabethan and Jacobean architecture. The massive stepped-back chimney at the end, however, is more medieval. There are separate fireplaces at each end of the house, one for each of the rooms, for in Virginia it was unnecessary and undesirable to cluster the chimneys in the center of the house. Indeed, it was necessary to throw off as much heat as possible during the spring and fall months.

An attempt at something like "high style" is evident in the design of "Bacon's Castle," the home of Arthur Allen, in Surrey County, Virginia, built in about 1655. [2.35, 2.36] It is a full two stories high, with two large

2.33. *Adam Thoroughgood house, Norfolk, Princess Anne County, Virginia, c. 1690. This house survived because of its durable brick material, but it must be remembered that it represented only a tiny fraction of the number of houses built in the Virginia colony, most of which used posts set directly in the earth. (Library of Congress, HABS VA-77 LYNHA.V 1-3.)*

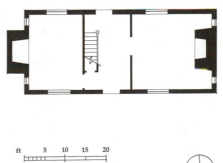

2.34. *Plan of the Thoroughgood house. The two-room plan is based on typical rural houses of the period in England; the use of externalized chimneys marks the beginning of a distinctive Tidewater architectural tradition. (L. M. Roth, after HABS.)*

rooms on the ground floor, projected towers front and rear housing entrance porch and stairs, and huge chimney stacks at the ends. Although the house is not notably different from minor manor houses in England, its ambitious scale sets it well apart from other Virginia houses of the period. The curved Flemish gables recall Montachute house in Somerset, England, built in about 1599, while the clustered chimney stacks are much like those rising above Condover Hall, in Shropshire, finished in 1598. Colonials too, the Allen house suggests, knew something about the early forms of Renaissance classicism then appearing in England. The entrance tower originally had a simple pediment over the door, which helped to emphasize the classical aspects of the facade suggested by the correspondence of parts and the stringcourse between floors. Internally, the main rooms are unequal in size, belying the external symmetry. The curved Flemish gables and massive chim-

neys dominate the ends of the house. In fact, the composition of the ends is so strong that they overpower the rest of the house, indicative of the work of a sincere but unpracticed designer. Still, there is a masterful play of light and shadow and of solid and void in the chimneys. The massive base rises two and a half stories with a small setback at the top; from this rise three slender, freestanding chimney stacks, which are joined at the top by a continuous corbeled cap. In all, the house is a mixture of European traditions: "a transplanted cultural symbol," as William Pierson put it, "which took nothing architectural from its environment except its materials."[11]

Most of the earliest churches in Virginia, like the first houses, were also of wood construction and have disappeared. Generally they were quite different in character from northern meetinghouses, however, since they housed Anglican Church of England congregations; indeed it was mandatory in the charter of

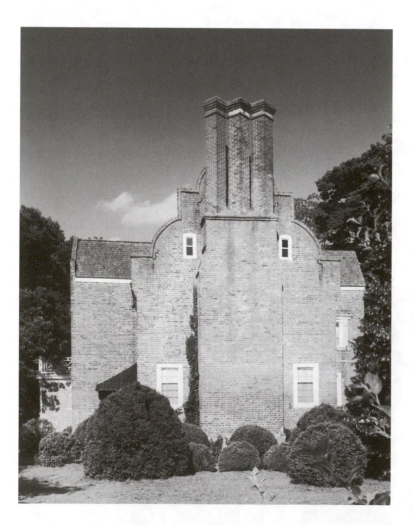

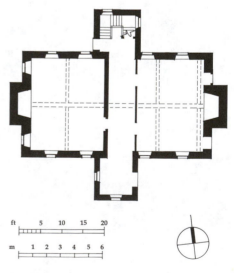

2.35. Arthur Allen house, Bacon's Castle, Surrey County, Virginia, c. 1655. More elaborate in plan, the Allen house has projecting bays housing an entry room and a stair. (Sandak, courtesy of the University of Georgia.)

2.36. Arthur Allen house, plan. The plan clearly indicates the special importance given to the stair, in its separate projecting bay. (L. M. Roth, after HABS.)

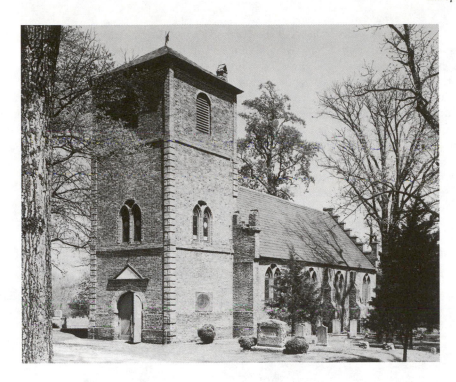

2.37. *St. Luke's, the Newport Parish Church, Smithfield, Isle of Wight County, Virginia, 1632–c. 1675. Positioned alone in the countryside, the Virginia Anglican Church differs remarkably from the New England meetinghouse that was the focus of its respective town or village; of particular note here is the use of Gothic arches, not a revival but a survival of a long vernacular rural tradition in England. (Library of Congress, HABS VA 47-SM.F.V 1-6.)*

the Virginia Company that the Church of England be established in that colony. It was most natural, then, that the southern colonists built in a way that recalled the parish churches of rural England, such as those of Shropshire, Derbyshire, Suffolk, and Essex, which were of a generalized vernacular Gothic. The best surviving seventeenth-century Virginia church is the Newport parish church (St. Luke's), in Isle of Wight County, begun in about 1685. [2.37] Like the houses just mentioned, it is of brick, with traces of medieval tradition in its lancet Gothic windows in the sanctuary and tower, and in its crow-stepped Flemish gables. What makes it decidedly different from other earlier and later Virginia churches, however, is that it had a tower; most churches in the region were simply gable- or hip-roof rectangular boxes. Also Gothic are the open heavy wood roof trusses of St. Luke's (now restored to their original appearance). By the time St. Luke's was near completion the fashionable mode had changed in England and so, accordingly, various Jacobean classical touches were added to the tower, such as the stylized pediment over the round-arched entrance, and the quoins at the corners. As at Bacon's Castle, there is a mixture of medieval vernacular traditions of the sixteenth century and bits and pieces of the new classicism of the seventeenth century in buildings that were, truly, homes away from home.

TOWN PLANNING IN THE SEVENTEENTH CENTURY

The strong village pattern of development in New England demonstrates how much life in the northern colonies was town-oriented, even in the rural areas. The urban focus was stronger still in the large cities, such as Boston and Philadelphia. In 1630, when lack of adequate fresh water necessitated building a new seat for the Massachusetts Bay colony, the neck of land protruding into the middle of the bay was selected. The main thoroughfares of this new Boston, named for the city in Lincolnshire, followed the ridges and hollows across the then rugged peninsula, along paths trod by the natives and by the first English settlers. A map of Boston in 1722 shows the seemingly random network of streets and the patchwork of fields behind the scattered houses. [2.38] On the east shore, around the harbor cove, was the town's center, with two open squares dominated by business houses, an open market, the meetinghouse, and a town hall. Here, over the next two generations, wharves began to push out into the harbor as trade grew. The town common was a large undivided area on the west side of the peninsula, stretching below Beacon Hill, so called because on its heights navigation emergency lights could be set up. Boston was, from the beginning, conceived as a center of cultural and economic activity—the fire on the hill

was the signal to shipping that soon made Boston the chief city of New England, surpassing Salem and Newport. Though it had always been viewed as a major city, Boston was given the tight weblike street pattern of a village, and there was little thought given to the effect this might have on future growth.

Much the same turned out to be true of New Amsterdam (New York), though originally it had been planned on paper in 1625 by Cryn Fredericksen, engineer for the Dutch West India Company, as an orderly series of rectangular subdivisions behind the defenses of a strong fort. When it was actually settled by Flemish Walloons, however, the layout of the settlement was considerably changed. A much smaller fort was built at the southern tip of Manhattan Island, and behind it streets were extended as need and convenience dictated, following the contours of the land. Moreover, creeks running into the Hudson and East Rivers were enlarged to make "canals," so that the New Amsterdam resembled the old.

There were, however, several cities laid out in the seventeenth century with formal geometric plans, the first of which was New Haven, Connecticut. The plan was based on a large square, subdivided into nine equal squares; the center of one of the squares was the town common. [2.39] It was platted by surveyor John Brockett in 1638, but may have been conceptually planned by the Reverend John Davenport, the minister and leader of the town's founders. While the plan seems to follow the classical planning precepts laid down by the Roman architect Vitruvius—even having the grid turned at an angle to the points of the compass—it seems more likely that the geometric grid was based on the plan of the New Jerusalem described in the Revelation of Saint John.[12]

A larger and much more ambitious later venture was the city of Philadelphia. Begun as Penn's Woods

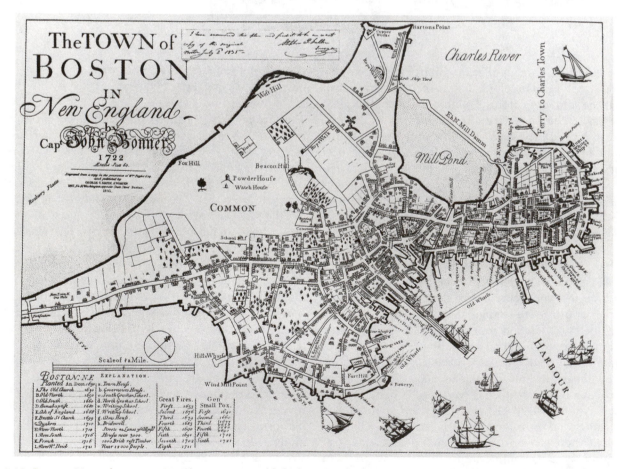

2.38. Boston, Massachusetts, 1630. This city map published in 1722 shows the winding, twisting streets laid out following the path of least resistance in this hilly terrain. (From Boston Society of Architects, Boston Architecture, Boston, 1970.)

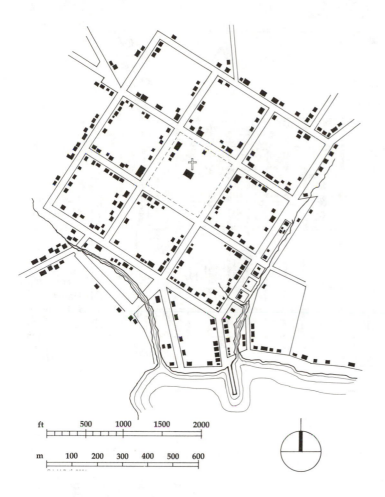

2.39. *John Brockett, surveyor, perhaps with John Davenport, plan of New Haven, Connecticut, 1638. This strict orthogonal plan, so classical at first glance, is more likely a literal interpretation of the orderly New Jerusalem described in the Book of Revelations. (L. M. Roth, after William Lyon drawing of 1748,* A Plan of the Town of New Haven . . . , *1806; in J. W. Reps,* Making of Urban America, *Princeton, N.J., 1965.)*

(Pennsylvania) in 1681, Philadelphia was a proprietary colony given by the crown, from the duke of York's lands, to William Penn in settlement of great debts, both political and monetary, due the Penn family. Because Penn himself had often suffered because of his Quaker religious convictions, he proposed to establish a colony in which freedom of religion was to be practiced, a "holy experiment," as he called it; it would have dispersed model farm settlements and a small commercial port on the Delaware River estuary.[13] He envisioned large land parcels, but his original specifications would have resulted in a settlement a mile in depth stretching in a line fifteen miles along the riverbank. When Penn sent out agents to begin settlement, they discovered there were already a number of small settlements existing at the chosen location, some Swedish, some English, and some of English Quakers. With the land Penn had planned to start on already occupied, the agents found some open land available farther up river, where the settlers

proved amenable to exchanging their land for larger allotments elsewhere.

When Penn himself arrived in 1682, the Quaker immigrants who had come on ahead implored him to redesign the settlement as a denser community where closeness to neighbors would be a comfort. Penn and Captain Thomas Holme, his surveyor general, set aside the original scheme and devised a new plan that incorporated the orderliness Penn favored. Both men were well acquainted with the spacious grid plan devised by Richard Newcourt for rebuilding London after plague and fire had swept through the city in 1665–66; their revised plan drew heavily from Newcourt's scheme. The revised plan, now more clearly urban, incorporated a small cove on the Delaware suitable for ships, with lots on the east edge that had river frontage. To the west would be lots facing the Schuykill River, the water route to the interior. The new plan, sketched out by surveyor Holme and then engraved for publication in London, had a regu-

2.40. *Philadelphia, Pennsylvania, 1682. Plan as laid out by Thomas Holme according to instructions from William Penn, 1682.* (A Portraiture of the City of Philadelphia, *London, 1683.)*

lar grid of streets aligned to the two rivers that ran parallel to each other at this point, with two major perpendicular principal streets running through the center, intersecting at a central square; each of the quadrants in the grid were also given a central square. Following Penn's earlier written instructions, Holme indicated on the published plan that the individual houses would be set well back from the streets, each "in the middle of its platt . . . so that there may be ground on each side for Gardens or Orchards, or feilds, yt [that] it may be a greene Country Towne which never be burnt and always be wholesome."[14] Holme's general layout also embodied the principles of universal order and symmetry expressed by Robert Hooke in his London plan, so that "all the chief streets [would] lie in an exact strait line; and all the other cross streets turning out of them at right angles."[15] [2.40] Participants in Penn's experiment already in Pennsylvania were apportioned lots along the eastern Delaware River side, where their new dwellings would be highly visible, while absentee participants were apportioned lots on the western Schuykill River side. In this way, Penn hoped that the emerging town would make a more favorable impression on shippers and visitors. By the time Penn

returned to England in August 1684, he noted, 357 houses had already been built.

South of Maryland there was no intense urban focus as in the northern colonies, and during the eighteenth century relatively few new commercial centers developed, with the important exception of Charleston (originally Charles Town), South Carolina, founded in 1670. Intended to be a strong settlement countering Spanish advances from Florida to the south, the settlement was first placed on the coast, but in 1672 it was moved to the peninsula between the Ashley and Cooper Rivers. Here too the order and regularity proposed by Sir Christopher Wren, Hooke, and Newcourt for rebuilding London exerted a profound influence. Chief proprietor Lord Anthony Ashley-Cooper, instructed the governor, Sir John Yeamans, to lay out the town into regular streets, and in this task Yeamans was guided by a "Grand Modell" that had been prepared in London. Resident Maurice Mathews, writing in 1680, spoke approvingly of the care taken in the plan, since this meant "wee shall avoid the undecent and incommodious irregularities which Inglish Collonies are fallen unto for want of ane early care in laying out the Townes."[16]

The relative absence of an urban focus in the South was partly because of geography and partly because of economic determinants. After the unsuccessful attempts of Sir Walter Raleigh to establish a colony on the Carolina coast during 1584–90, a permanent settlement was made in Virginia in 1607. It set the pattern for settlement in the South: it was populated not by religious dissidents who sought isolation from interference of crown or church, but rather by agents of the mercantile Virginia Company. Many of those who came to Virginia were sons of peers and landed gentry who, denied fortunes at home because of the laws regarding primogeniture, sailed to the New World to build their own estates. In comparison with Massachusetts' Plymouth Company, the group that settled Virginia was decidedly commercial and, from the start, maintained strong religious, economic, and cultural ties with the mother country.

Economic ties were made all the easier by the fortuitous geography of the Chesapeake Bay in Virginia and the Albemarle and Pamlico sounds in North Carolina, for the many deep inlets, sheltered from the ocean and its uncertain weather, made it possible for ships to load at a thousand private tidewater wharves. Hence the southern economy quickly came to be based on large plantations specializing in single commercial bulk crops—tobacco, cotton, indigo, rice, and other raw materials—to be shipped out for processing elsewhere. This meant that every plantation on tidewater could ship from its own wharf and receive manufactures from England without going through a regional seaport. Each landowner was his own exporter, importer, and wholesaler. This was also true to a lesser extent in the Carolinas, but even Charleston was never quite the focal point of commercial activity as were the cities of the North, perhaps because its most influential citizens were summer residents only, living at their inland plantations during the winter months. The fifth largest city in the nation at the time of the first national census in 1790, Charlestown rapidly fell to a very minor position thereafter.

All things considered, the colonists bothered to learn relatively little from the natives as they swept into the American continent. The Europeans viewed the open lands of the New World as theirs for the taking, just as they accepted as their unquestioned duty the forced inculcation of Christianity and "civilization" among the natives. Unparalleled in their avaricious and unquenchable thirst for gold, the Spanish claimed vast domains but created few large settlements north of the Rio Grande. Their impact on the land, therefore, and on the ancestral patterns of natives' living, especially in the Southwest, was comparatively limited. The French, although claiming equally large territories, likewise made little impact on the land, for their trappers were interested largely in the "soft gold" of pelts. By 1800 perhaps only 6,200 Frenchmen lived in Canada, and even fewer along the Mississippi. By 1700 the English population in North America, by comparison, numbered somewhat more than 294,000, with about 130,000 in New England, about 152,300 in the middle colonies and around the Chesapeake estuary, and another 12,000 in the Carolinas. How many of these were African slaves is difficult to tell, but of the 123,000 people in the English Caribbean colonies, perhaps only 18,000 were white.[17]

Only the English settled in large numbers on the landscape, cutting away the thick forests of what they considered "a hideous and desolate wilderness, full of wild beasts and wild men."[18] They housed themselves in crude wigwams and dugouts only long enough to build more traditional structures, in a transplanted vernacular idiom in the North that recalled the familiar architecture of their homeland, and in the South in buildings that suggested recent high-style developments in Europe. In time the unsuitable aspects of the transplanted English forms were modified to better weather regional variations in climate. The colonists perpetuated the English system of land tenure and use, laying the foundation of the American myth of the private house standing on its own grounds. The New Testament socialism first embraced with religious zeal by the northern Puritans, with their communal ownership, gradually disappeared in the face of assertive individual enterprise in the eighteenth century. As the seventeenth century drew to a close, increasingly the Atlantic English colonies became more genteel and urbane, their eyes fixed on the model of London society.

The native Americans' concepts of the people, their buildings, and their culture being maintained in harmony with the spirit of the land, of living with minimal demands on the land, and of using the resources of sun, water, and forest without diminishing them, were suppressed and denigrated. Ironically, many of these attitudes toward the land and to fostering a larger sense of community would need to be painfully relearned four centuries later. That transformation is still incomplete, for the reconciliation between the original Americans and those who came centuries ago and who still come in search of their dreams—and a reconciliation between Americans with their imperiled landscape—remains to be attained.

BIBLIOGRAPHY

Bailey, Rosalie F. *Pre-Revolutionary Dutch Houses and Families in Northern New Jersey and Southern New York.* New York, 1934, reprint 1966.

Benson, Adolph B., and Naboth Hedin, eds. *Swedes in America, 1638–1938.* New York, 1938, reprint 1969.

Bishir, Catherine W., Charlotte V. Brown, Carl Lounsburg, and Ernest Wood. *Architects and Builders in North Carolina: A History of the Practice of Building.* Chapel Hill, N.C., 1990.

Blackburn, Roderic Hall, "Architecture: The Dutch Colony," in *Encyclopedia of the North American Colonies,* ed. Jacob E. Cooke. New York, 1993.

Bridenbaugh, Carl. *Cities in the Wilderness: The First Century of Urban Life in America, 1625–1742.* New York, 1955.

Briggs, Martin S. *The Homes of the Pilgrim Fathers in England and America, 1620–1685.* London, 1932.

Candee, Richard M. *Wooden Buildings in Early Maine and New Hampshire: A Technological and Cultural History, 1600–1720.* Ann Arbor, Mich., 1976.

Carlsson, Sten C. O. *Swedes in North America, 1638–1988.* Stockholm, Sweden, 1988.

Carson, Cary, Norman F. Barka, William M. Kelso, and Garry Wheeler Stone. "Impermanent Architecture in the Southern American Colonies," *Winterthur Portfolio* 16 (1981): 135–78.

Carson, Cary, Ronald Hoffman, and Peter J. Albert, eds. *Of Consuming Interests: The Style of Life in the Eighteenth Century.* Charlottesville, Va., 1994.

Chappell, Edward A. "New History at the Old Museum," *CRM* 15 (1992): 6–9. An account of the development of interpreting the African-American social history at Carter's Grove plantation.

Chappell, Edward A., and Marley R. Brown. "Archaeology and Garden Restoration at Colonial Williamsburg," *Journal of Garden History* 17 (January–March 1997): 70–77.

Coolidge, John. "Hingham Builds a Meetinghouse," *New England Quarterly* 34 (December 1961): 435–61.

Cummings, Abbott Lowell. *The Framed Houses of Massachusetts Bay, 1625–1725.* Cambridge, Mass., 1974.

Dinkin, Robert. "Seating in the Meeting House in Early Massachusetts," *New England Quarterly* 43 (1970): 450–64.

Donnelly, Marian Card. *The New England Meetinghouses of the Seventeenth Century.* Middletown, Conn., 1968.

Downing, Antoinette F., and Vincent Scully. *The Architectural Heritage of Newport, Rhode Island, 1640–1915,* 2nd ed. New York, 1970.

Echeverria, Durand. *Mirage in the West: A History of the French Image of American Society to 1815.* Princeton, 1957, esp. 3–38.

Embury, Aymar. *Early American Churches.* New York, 1914.

Fairbanks, Jonathan L., and Robert F. Trent, eds. *New England Begins: The Seventeenth Century.* 3 vols. Boston, 1982.

Forman, Henry C. *The Architecture of the Old South: The Medieval Style, 1658–1750.* Cambridge, Mass., 1948.

Garvan, Anthony. *Architecture and Town Planning in Colonial Connecticut.* New Haven, Conn., 1951.

Howells, John M. *Lost Examples of Colonial Architecture.* New York, 1931.

Isham, Norman M., and Albert F. Brown. *Early Rhode Island Houses: An Historical and Architectural Study.* Providence, R.I., 1895. The first scholarly investigation of British colonial architecture.

Jackson, Joseph. *American Colonial Architecture.* Philadelphia, 1924.

Johnson, Amandus. *The Swedish Settlements on the Delaware: Their History and Relations to the Indians, Dutch, and English, 1638–1644.* Philadelphia, 1911.

Kimball, Fiske. *Domestic Architecture of the American Colonies and of the Early Republic.* New York, 1922.

Kubler, George. *The Religious Architecture of New Mexico.* Colorado Springs, Colo., 1940.

Mercer, Eric. *English Vernacular Houses: A Study of Traditional Farmhouses and Cottages.* London, 1975.

Moogk, Peter N. "Architecture: The French Colonies," in *Encyclopedia of the North American Colonies,* ed. Jacob E. Cooke. New York, 1993.

Morrison, Hugh. *Early American Architecture, from the First Colonial Settlements to the National Period.* New York, 1952.

Morrison, Samuel Eliot. *The Oxford History of the American People.* New York, 1965.

Neiman, Fraser D. "Domestic Architecture at the Clifts Plantation: The Social Context of Early Virginia Building," *Northern Neck of Virginia Historical Magazine* 28 (December 1978): 3096–128.

Newcomb, Rexford. *Spanish Colonial Architecture in the United States.* New York, 1937.

Patton, Glenn. "The College of William and Mary, Williamsburg, and the Enlightenment," *Journal of the Society of Architectural Historians* 29 (March 1970): 24–32.

Pierson, William H., Jr. *American Buildings and Their Architects,* vol. 1, *The Colonial and Neo-Classical Styles.* Garden City, N.Y., 1970.

Pratt, Boyd C., and Chris Wilson. *The Architecture and Cultural Landscape of North Central New Mexico: Field Guide for the Twelfth Annual Vernacular Forum.* Albuquerque, N.M., 1991.

Reynolds, Helen W. *Dutch Houses in the Hudson Valley before 1776.* New York, 1929.

Schuetz-Miller, Mardith K. "Architecture: The Spanish Border Lands," in *Encyclopedia of the North American Colonies,* ed. Jacob E. Cooke. New York, 1993.

St. George, Robert Blair, ed. *Material Life in America, 1600–1860.* Boston, 1988.

Summerson, John. *Architecture in Britain, 1530–1830,* 5th ed. Baltimore, 1969, (The Pelican History of Art.)

Upton, Dell. "Architecture: The British Colonies," in *Encyclopedia of the North American Colonies,* ed. Jacob E. Cooke. New York, 1993.

———. *Sacred Things and Profane: Anglican Parish Churches in Colonial Virginia*. Cambridge, Mass., 1986.

———. "Vernacular Domestic Architecture in Eighteenth-Century Virginia," *Winterthur Portfolio* 17 (Summer–Fall 1982): 95–119.

———. "Traditional Timber Framing," in *Material Culture of the Wooden Age*, ed. Brooke Hindle. Tarrytown, N.Y., 1981.

———. "Architectural Change in Colonial Rhode Island: The Mott House as a Case Study," *Old-time New England* 69 (Winter–Spring 1979): 18–33.

———. ed. *America's Architectural Roots: Ethnic Groups That Built America*. Washington, D.C., 1986. Although quite concise, this is a good survey of the many distinct building traditions brought to the United States by numerous immigrant groups.

Van der Pool, James Grote. "The Restoration of St. Luke's, Smithfield, Virginia," *Journal of the Society of Architectural Historians* 17 (March 1958): 12–18.

Waterman, Thomas T. *Domestic Colonial Architecture of Tidewater Virginia*. New York, 1932.

———. *The Dwellings of Colonial America*. Chapel Hill, N.C., 1950.

Wood, Joseph. *The New England Village*. Baltimore, 1997.

Wright, Charles A. *Some Oldtime Meeting Houses of the Connecticut Valley*. Chicoppee Falls, Mass., 1911.

NOTES

1. See John W. Reps, *The Making of Urban America: A History of City Planning in the United States* (Princeton, 1965), 26–44.

2. Jasper Daenkaerts quoted in Hannah Benner Roach, "The Planting of Philadelphia: A Seventeenth-Century Real Estate Development," *Pennsylvania Magazine of History and Biography* 92 (1968): 159.

3. "Information and Direction to Such Persons as Are Inclined to America . . . ," *Pennsylvania Magazine of History and Biography* 4 (1880): 334–35, quoted in Roach, "The Planting of Philadelphia," 160.

4. Edward Johnson, *A History of New England* (originally *Johnson's Wonder-Working Providence*, 1654), ed. J. Franklin Jameson (New York, 1910), 113–14.

5. Although the date 1636 is prominently displayed on the chimney, Abbott Lowell Cummings believes that the date of construction of the Fairbanks house is around 1637 to 1638. In any event, it is still the oldest surviving frame house in Massachusetts, the next-oldest being the Blake house, in Dorchester, of about 1650. See Abbot Lowell Cummings, *The Frame Houses of Massachusetts Bay, 1625–1725* (Cambridge, Mass., 1979).

6. From *Records of the Governor and Company of the Massachusetts Bay*, ed. N. B. Shurtleff (Boston, 1853–54), 1:74.

7. Articles of Agreement for Springfield, Massachusetts, reprinted in L. M. Roth, *America Builds*, 4–7, from *New England Historical and Genealogical Register* 13 (1859): 295–97.

8. The period descriptive phrase "after the mode in London" is quoted in H. Morrison, *Early American Architecture*, 513.

9. See Fraser Neiman, "Domestic Architecture at the Clifts Plantation," in *Common Places*, ed. Upton and Vlach (Athens, Ga., 1986), 292–314.

10. See Ivor N. Hume, "First Look at a Lost Virginia Settlement," *National Geographic* 155 (June 1979): 734–67.

11. William H. Pierson Jr., *American Buildings and Their Architects, vol. 1, The Colonial and Neo-Classical Styles* (Garden City, N.Y., 1970), 32.

12. For the similarities between the New Haven grid plan and the principles of town plan layout as discussed by Vitruvius, see Anthony Garvan, *Architecture and Town Planning in Colonial Connecticut* (New Haven, Conn., 1951), 44–49.

13. See Edward Teitelman and Richard W. Longstreth, *Architecture in Philadelphia: A Guide* (Cambridge, Mass., 1974), 1–2; Roach, "Planting of Philadelphia," 3–47, 143–94.

14. Penn's instructions quoted in Roach, "Planting of Philadelphia," 19.

15. Hooke's London plan description quoted in Carl Bridenbaugh, *Cities in the Wilderness: The First Century of Urban Life in America, 1625–1742*, 2nd ed. (London, 1955), 12.

16. Lord Ashley-Cooper quoted in Braidenbaugh, *Cities in the Wilderness*, 12; Mathews quoted in Reps, *The Making of Urban America*, 177.

17. Data given in Samuel Eliot Morrison, *Oxford History of the American People* (New York, 1965), 131–32.

18. From William Bradford's *History of Plymouth Plantation*, ch. 9, first written 1630–46; the most authoritative version is that edited by Samuel Eliot Morrison, *Of Plymouth Plantation, 1620–1647* (New York, 1952).

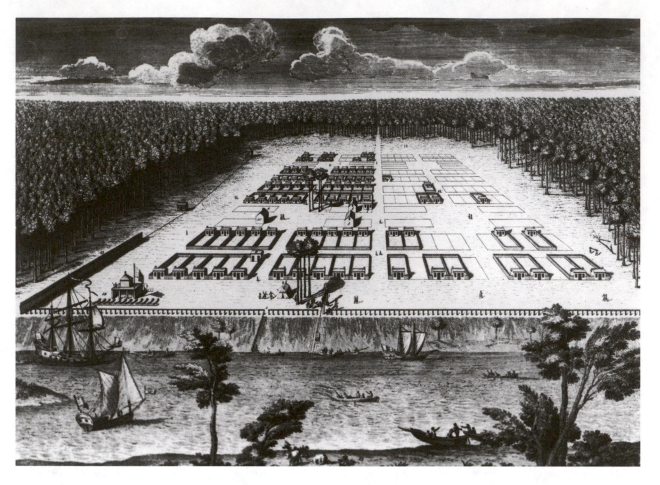

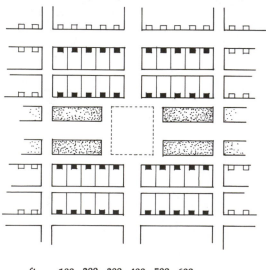

ft 100 200 300 400 500 600

m 50 100 150

3.1a. James Oglethorpe, Savannah, Georgia, 1733, A View of Savannah As It Stood the 29th of March 1734 (London, 1734). The plan of Savannah, as devised by Oglethorpe, consisted of a basic cellular planning module (shown in the adjoining detail) that could be repeated as needed with the growth of the population; each modular unit focused on its own internal neighborhood park. (Library of Congress, Prints and Photographs.)

3.1b. Diagram of Oglethorpe's basic planning module for Savannah. The basic unit consisted of four blocks of ten lots each (five on each side of an alleyway) plus four larger blocks, all arranged around a central open square. (L. M. Roth.)

IN THE LATEST FASHION, 1690–1785

GEORGIAN ARCHITECTURE AND VERNACULAR THEMES

The European immigrants of the seventeenth century generally had built on the basis of their individual vernacular traditions, using materials at hand in response to local environmental conditions. In the eighteenth century, however, this practice changed markedly in favor of building more in accordance with stylistic developments in England. Very quickly the disparate pluralism of building forms and methods that had characterized the seventeenth century was replaced by a conscious emulation of current fashion in England, no matter what the original ethnic basis of the colony. By 1710 both the Dutch holdings on the Hudson and the Swedish settlements on the Delaware had been added to the British empire, and by about 1725 a fairly uniform English culture was well established, extending from Maine south to Georgia. Thus, in place of many distinct ethnic cultures, there developed one; although there were clear regional differences and local stylistic preferences, gradually the more ambitious architecture of the Atlantic seaboard began to assume a more unified character. Thus appeared a recurrent theme in American life and architecture— the impulse to superimpose a uniform culture and a uniform building mode on a people and landscape characterized by great multiplicity of ethnic backgrounds, tradition, and character. This said, however, it must be remembered that this self-consciously stylish architecture was the work of a few wealthy individuals; the great bulk of building was still governed by persistent vernacular tradition. It should be remembered too that communication by land along the seaboard was still extraordinarily difficult. People and goods moved by sea, and often connections with distant locations were better than with locations just a

hundred miles away by land; Charleston, for example, had far stronger links with the Caribbean than with the Northern seaboard colonies.

Consciously trying to emulate England, planters and merchants shed the provincialism of their forebears and aspired to enter more into the mainstream of English life, looking to London as the arbiter of fashion. The medieval aspects of vernacular architecture of the seventeenth century gave way to a variant of late English Baroque architecture. English culture and the architecture of the English court and the wealthy upper class became the model not simply because of the preponderance of English settlers in the colonies, but also because of the restrictions of the Navigation Acts, which sought to enforce the mercantile system in the American colonies; England was the only country with which the colonies could legally trade.

American colonial building of the eighteenth century shares with English architecture of the period the name Georgian, after the monarchs who sat on the British throne during that century, but American buildings are identified as Georgian Colonial to make a clear distinction. By the middle of the eighteenth century, the most progressive architects in England were increasingly making more accurate references to ancient architecture in the movement called Neoclassicism, but American colonial builders, for the most part, retained and elaborated the Georgian Baroque style.

Generally, American Colonial Georgian architecture during the eighteenth century falls into two broad chronological periods. The first, early Georgian, from about 1700 to around 1750, shows the general influence of Inigo Jones and more especially of Sir

Christopher Wren; buildings and details tended to be comparatively restrained. The subsequent period, late Georgian, from roughly 1750 to about 1785, is characterized by the influence of James Gibbs (especially in church design) and the Neo-Palladian movement centered around the Earl of Burlington and William Kent; buildings and details now tended to be more complex in form and massing, with more three-dimensional, sculptural details.

These stylistic influences were effected in several ways. For one thing, increasing wealth resulted in more frequent travel to England and an increased awareness among the wealthy colonials of what their English counterparts were doing. Also, wealthy builders imported skilled craftsmen from England, workmen well versed in the latest developments and familiar with the most recent publications. Another influence resulted from the commercial publication of scores of architectural treatises in English, beginning in earnest at the start of the eighteenth century. The first of the fourteen editions of Palladio's *Four Books of Architecture* appeared in England in 1663, but most popular was the edition of 1715, edited by Giacomo Leoni and sponsored by Lord Burlington. This was followed in 1727 by William Kent's *Designs of Inigo Jones*, which illustrated the work of the first English Renaissance architect. Extremely important were the five volumes of Colen Campbell's *Vitruvius Britannicus*, 1715–25, and William Adam's *Vitruvius Scotius*, of 1750. In addition to these were the two folios by Isaac Ware. Far and away the most important architectural book in the colonies during the last half of the century, however, was James Gibbs's *A Book of Architecture*, published in 1728.

Such books, aimed at the gentleman scholar, were large in format, expensive, and largely theoretical. Even more popular in the colonies, however, because there was a chronic shortage of trained workmen, were numerous carpenter's handbooks, such as William Salmon's *Palladio Londinensis*, of 1734, or the books by William Halfpenny, Abraham Swan, and Robert Morris. Especially useful was Batty Langley's *The City and Country Builder's and Workman's Treasury of Designs*, which appeared in 1740, went through more than eleven editions up to 1808, and traveled to the farthest reaches of the English-speaking world. Langley's *The Builder's Jewel*, of 1741, was nearly as popular. Altogether, by 1750 eighteen different folios and handbooks were being used in the colonies; in ten years this number had almost tripled, to fifty-one different books.

GEORGIAN COLONIAL TOWN PLANNING

The eighteenth century was a period of urbanization in the colonies, largely through concentration and development of the centers already established. By 1700 several thousand French, Dutch, and Spanish settlers were living among the millions of native American inhabitants, scattered through the Southwest as well as along the coasts and inland-reaching river systems of the North American continent. They had been joined during the seventeenth century by a few hundred intrepid English settlers clustered around the Chesapeake and Massachusetts Bays. Almost immediately, however, that small English population began to grow rapidly, with the influx of thousands of additional English, and then Scots, Irish, and Germans, among other groups. At the start of the eighteenth century the population of the coastal English colonies (of all ethnic groups combined) was perhaps 350,000; within fifty years it had grown to 1.5 million, and on the eve of the Revolutionary War in 1776 it was about 2.8 million. Of the population in the Southern colonies at least 40 percent consisted of Negro slaves brought from Africa.

Although towns and city residents made up a very small part of the total population, it was in the Atlantic coastal cities that political and mercantile activity centered, and it was there that architectural trends were first emulated following English sources of fashion. At the start of the eighteenth century Boston was the most cosmopolitan town, with 6,700 inhabitants, followed closely by New York and Philadelphia, which already had about 5,000 people. Newport was a busy seaport with 2,600 residents; Charleston, its counterpart to the south, had about 2,000. Even at midcentury Boston retained its preeminence, with nearly 16,500 residents, followed by Philadelphia and New York, with 13,000 and 11,000, respectively. The rate of growth in smaller Newport and Charleston was about the same; Charleston had grown to about 7,000 people, and Newport trailed slightly, with about 6,500 residents by 1750.

By the eve of the Revolutionary War, in 1775, however, Philadelphia had burgeoned to more than 40,000 residents; not only was it the largest city along the coast, but it was very likely the second-largest city in the western British empire, exceeded only by London itself (and the huge cities of British India). New York City had 25,000 people, but Boston's population had dropped to about 16,000 by 1775. Charleston had grown to nearly 12,000 people, and Newport stood at

3.2. Bernard Ratzer, New York, New York, 1767. Ratzer's plan shows the irregular streets of the original Dutch settlement (southern tip), later irregular growth, and the more orthogonal additions of the eighteenth century (west and north edges). (Bernard Ratzer, Plan of the City of New York, in North America, *London, 1776; Library of Congress, Map Division.*)

about 11,000. Numerous settlements that had previously been villages had become significant small cities—among them New Haven, Connecticut; Baltimore, Maryland; New London, Connecticut; Lancaster, Pennsylvania; Salem, Massachusetts; Portsmouth, New Hampshire; and Providence, Rhode Island—all with populations between 4,000 to 8,000. In the next year, 1776, as the break with England commenced, there was a great flight from most cities except Boston, where Tory conservatives flocked for safety.[1] During the eighteenth century several new cities were established as well, among them Savannah, Georgia, in 1733; Pittsburgh, Pennsylvania, in 1784; and Louisville, Kentucky, in 1778.

Nearly all of the cities, established and new, expanded following the lines of least resistance, but a few city plans continued in the pattern of deliberate conscious design already seen in the geometric order of New Haven, Charleston, and Philadelphia. One was Savannah, created in 1733 as the chief city of the newest and most southerly colony, Georgia. This new colony, chartered in 1730, was the special concern of General James E. Oglethorpe. Politically it provided a strategic base between Spanish Florida and South Carolina, but Oglethorpe had a far more important driving social concern—to create a refuge for the poor who were systematically thrown into English debtor's prisons. Now they could be relocated to Georgia and given a chance to start over; Moravian, Swiss, and Scots settlers flooded in as well. Savannah, the port and base of the colony, was laid out under Oglethorpe's direct supervision in 1733 [3.1a, b], with a unique grid plan that provided for small neighborhoods grouped around open parks or market squares. Oglethorpe's plan was based on a simple square cellular module made up of four subsquares, each divided into five building lots, and four additional narrow blocks, all enclosing a central open space. The modular idea with central squares seems to have been inspired by Robert Hooke's plan for London follow-

3.3. "Frenchman's Map," Williamsburg, Virginia, 1699. The plan of the center of the town as devised by Governor Francis Nicholson. Called the Frenchman's Map, this was drawn up in 1788 by an unnamed visiting Frenchman. (Courtesy of the Swem Library, College of William and Mary, Williamsburg.)

ing the disastrous fire of 1666, and the landscaped squares themselves may refer to the residential squares then being created in west London. Oglethorpe's streets were wide: main thoroughfares were 75 feet, minor streets 38 feet, and alleyways 22.5 feet.

For the coastal merchant cities, the eighteenth century was to be a period of great growth, as centers of commerce and as centers of culture. For some cities, such as Charleston, Salem, and Newport, this was their finest period; they never again enjoyed such influence or creative power. In a sense it is fortunate that progress passed these cities by, for their finely wrought architecture was never extensively replaced in later centuries and hence these smaller cities present us still with a vivid picture of material life in this period. In other cities, however—such as New York and Williamsburg—developments occurred that were to have repercussions for centuries.

In 1664 New Amsterdam had been seized by the English as a result of political squabbles between King Charles II and the Dutch; it surrendered without a fight. The Dutch colony was renamed New York, as was the port town of New Amsterdam. Part of this new acquisition was separated out as the colony of New Jersey; other parts became Pennsylvania. The city of New York continued to grow fairly slowly, with each addition extrapolating existing tracts [3.2], the roads following worn paths across the hilly terrain ("Manhattan," the native name for the island, is said to have meant "island of hills"). The Ratzer plan of 1767 shows the irregular pattern of the Dutch settlement at the tip of Manhattan island as well as the early irregular English additions to the north. Later additions, such as the subdivision of Trinity Church lands along the Hudson, or the easterly tracts on either side of Bowery Lane, were divided into regular grids, and the divisions east of the Bowery even had a large public square ("Great Square") set aside in the manner of London squares. The principal public park in the city was a small triangle east of Broadway below City Hall. To the north, however, beyond these additions, stretched the rolling and varied agricultural landscape of Manhattan Island.

What is significant about New York, as restructured by the English, is the corporate legislation creating it, similar to that enacted for other cities. All land between low and high water belonged to the city, giving rise to the exploitation of the shoreline for municipal wharves. All land not already in private hands when the corporation was modified in 1696 became municipal property; because of this the park land in the division east of the Bowery, originally privately held, eventually became city property after the Revolutionary War and was subdivided and sold. Other open land was also subdivided and sold. All land used for streets, alleys, and lanes became municipal property. Such legislation was to form the background for the later speculative subdivision of the entire island.

While New York grew in stages northward from the Dutch nucleus, Annapolis, Maryland, and Williamsburg, Virginia, were laid out as new towns. The original colonial capital at Jamestown had never been a good location, and when the Virginia capitol burned in 1698, newly appointed governor Nicholson lost no time in having the General Assembly move the seat of government to Middle Plantation, a nearby village on higher ground. Just a few years before, in 1694, as the governor of Maryland, Nicholson had sketched out the plan for its new capital city, Annapolis, along French Baroque lines—and perhaps drawing from Wren's proposal for rebuilding London—with radiating diagonals issuing from low rises in the landscape. Nicholson was also instrumental in laying out the plan for the new Virginia capital, to be renamed Williamsburg. Surveying began in May 1699 for a town of two thousand people. [3.3]

One reason for relocating in Middle Plantation was that four years earlier the College of William and Mary had been established there, and influential landowners agreed that the school would make a good adjunct to the capital. The new college building, then under construction, was selected as one terminus of a broad boulevard, running east and west, that formed the major axis of the town. Named Duke of Gloucester Street, it was a mall 99 feet wide and nearly 4,000 feet long. So that it could be laid out, several houses had been removed and the materials returned to their owners in one of the earliest instances of the exercise of eminent domain in the English colonies.[2] The legislation establishing Williamsburg was exacting, stipulating that the houses along Duke of Gloucester Street be of a certain size and all set back 6 feet. At the east end of the new street the new capitol was built in an open square. Midway along the boulevard were the market square, the Bruton Parish Church, and the powder magazine. Just to the west of the market square was a perpendicular axis extending to the north, the palace green, 200 feet by 1,000 feet, which terminated in the Governor's Palace, which was begun in 1706. The palace, the most elaborate and finely finished house in the colonies at that time, was built directly on the axis of the green, with rooms balanced around a central hall. The axis then continued beyond the house as the basis of the formal gardens to the north. In addition to the marked sumptuousness of detail of the palace, the organization of the house plan about a predetermined axis initiated a significant change in domestic design in the colonies; during the remainder of the century grand private houses were almost invariably axially planned.

EARLY GEORGIAN ARCHITECTURE, 1690–1750

The Georgian house—of which the Governor's Palace, Williamsburg, 1706–20, was one of the first and most elaborate examples—is based on a body of normative abstract principles, although there were many regional variations.[3] The fully developed Georgian house is bilaterally symmetrical about a center axis, both in plan and facade. This axis is marked by a central hall, often running the full depth of the house. The double-pile plan (as it has come to be called) normally consisted of two important front rooms flanking the hall, and two lesser rooms behind. The hall, in fact, and the division into more specialized rooms, reflects the increasingly greater formality in social structure, and the degree of separation and insulation that was desired between the owners and their managers and servants.[4]

The Georgian house is cubical and restrained, divided into horizontal ranges by the use of low hip roofs, balustrades, prominent cornices, stringcourses between each floor, and a water table where the building rests on the foundation. It is disposed so as to have careful proportional relationships among elements; it is ornamented with selected devices derived from classical antiquity and from classical English Baroque sources; and it is clearly articulated in its parts so that edges, windows, and the center entrances are all elaborated. A small but important detail was the use of double-hung sash windows with rectangular panes of glass, replacing the smaller, hinged casement windows with small diamond-shaped panes.

Southern Tidewater Colonies

The early Georgian country residence appeared almost simultaneously in the various tidewater colonies in the South and in Massachusetts in the North. Where the

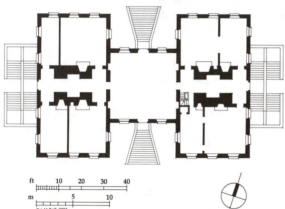

ft 10 20 30 40
m 5 10

3.4. Thomas Lee house, Stratford, Westmoreland County, Virginia, 1730–38. This house was distinguished by its high lower floor, made even more emphatic by the use of over-sized brick in contrast to the normal brick of the upper living level; the brick is laid in Flemish bond. (Library of Congress, HABS VA 97 4-4; photo by Jack Boucher, 1969.)

3.5. Stratford, plan. The upper main living level has a unique plan with clusters of private rooms arranged on either side of a large public room; the broad stairs are completely externalized. (L. M. Roth, after HABS.)

New England Georgian houses tended to be clustered in the busy seacoast cities, those in the South were scattered in separated plantations. The connection to water was vital, however; since improved roads were almost nonexistent, the tidewater rivers served as the "highways." The tidewater plantation houses of the Chesapeake Bay, isolated from one another, were placed on low rises above the Chesapeake estuary's rivers, near private wharves for the shipping of tobacco or rice and the importing of English luxury goods. Like Georgian houses to the north, southern mansions were elaborately embellished with classical details without and within. In fact the Virginia House of Burgesses passed legislation requiring that prospective jurors were required to possess property that visibly demonstrated their wealth. The increasingly resplendent interiors of these southern houses were designed to be signals as to the relative importance of the room or space, and also to the social position of those who used these rooms.

In addition there was in the South a desire for increasing separation and insulation of private family areas from those spaces used for public reception and entertainment—hence the great importance of the central hall as a separator and insulator. One of the first Virginia plantation houses to have a central hall was Arlington, built in 1660, by which time field labor was done almost entirely by slaves. Seldom if ever were field slaves admitted to the main house, for only a specialized group of house slaves now worked there. Mundane activities related to the operation of the plantation were removed to a separate office; increasingly, this was in a building separate from the main house.

One of the most dramatic early southern examples is Stratford, in Westmoreland County, Virginia, built by Thomas Lee in about 1730–38 as the seat of the Lee family estate of sixteen thousand acres. [3.4, 3.5] Unique among the early brick Georgian house, it is **H**-shaped in plan, apparently based on a design pub-

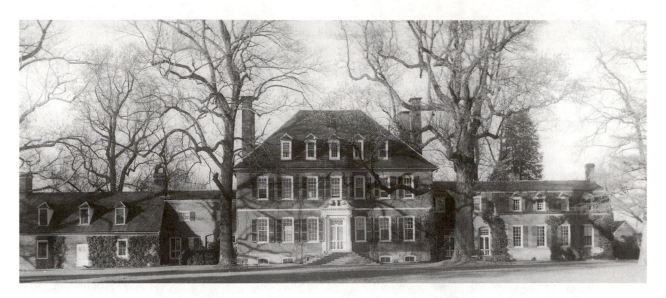

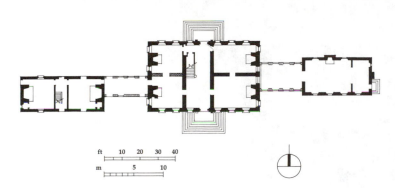

3.6. William Byrd house, Westover, Charles City County, Virginia, c. 1750. A prototype of the grand Virginia plantation house, based on large, nearly contemporary country houses in England; the embellished doors on both front and back show the effort to keep up with fashionable trends in England. (Library of Congress, HABS VA 14-WEST 1-1; photo by Thomas T. Waterman, 1939.)

3.7. William Byrd house, plan. The in-line or lateral plan seen here is the result of the hyphens added later to connect the main house to the flanking office and kitchen buildings. Walls added later are indicated by cross-hatching. (L. M. Roth, after HABS.)

lished in Stephen Primatt's *City and Country Purchaser and Builder*, published in London in 1667. Because of the austerity of the design, the scale of the house is somewhat deceiving. Somewhat atypical for this region, the main floor was elevated above the ground, with an imposing brick stair rising to the central saloon; flanking it are two four-room apartments in the extremities of the H. The 10-foot brick base below the main floor is built of special oversized brick, laid in a bold Flemish bond with glazed headers, thus creating a distinctive pattern. The decidedly sculptural mass of the house, and the great clusters of four chimneys connected by arcades at their tops, suggest that the unknown designer of the house may have had in mind John Vanbrugh's Blenheim Palace, in Oxfordshire, which was begun in 1705.

Another Virginia plantation house that established a pattern repeated in the region for almost half a century was the home of William Byrd II, Westover, in Charles City County, Virginia. [3.6] In 1729 Byrd wrote to a friend in England that "in year or 2 I intend to set about building a very good house," which would suggest that the house went up around 1730–34; however, it is now thought to have been built closer to 1750.[5] It may well have been partially designed by Byrd, a highly successful planter who gathered one of the best libraries of his day—four thousand volumes, many of them on architecture. Active in colonial affairs, Byrd spent much of his time in England and knew well the trends in domestic architecture there. It is also possible that Richard Taliaferro contributed to the design of Westover, and his name is connected with many other tidewater houses, including several in Williamsburg. Westover has a very steep roof, in the manner of the Governor's Palace in Williamsburg. Below its pedimented dormers, however, the house is fully Georgian, with broad window bays, stringcourses between floors, and an

embellished central entrance. Auxiliary outbuildings, constructed on either side of the house, were later connected to the main house by "hyphen" extensions. [3.7] Westover is built of red brick, with dramatic frames of white stone emphasizing the centrally placed entrance doors. Based on plates from Salmon's *Palladio Londinensis*, the framing entrance aedicules were imported from England, as was the door facing the river. Curiously, the somewhat irregular internal room arrangement contradicts the clear external symmetry. The through hall of the double-pile plan, which was an enlargement of the central passageways of seventh-century Virginia houses, was especially welcome in the South, where it facilitated ventilation during the summer months. It was set off-center so that a window to one side illuminated the central hall.

The interiors of Westover are perhaps not so sophisticated as the exterior, but a fine example of interior detail is found in the central hall of the nearby house of Carter Burwell, Carter's Grove, in James City County, Virginia, of 1750–53. [3.8] The house itself was designed by Carter Burwell, who also supervised construction. Burwell selected details for the interior from Salmon's *Palladio Londinensis*, a copy of which he had purchased in Williamsburg; the work was done by carpenter and woodcarver Richard Bayliss, whom Burwell had brought, with his family, from England for this project. The house itself is much like Westover in form [3.9], although the roof was modified with dormer windows inserted in 1927–29. Bayliss's paneling of the stair hall, the Ionic pilasters that divide it into sections, and the full entablature they carry, are all carved from pine, while the stairs and balustrade are of walnut.

The contemporary references to Richard Taliaferro (1705–1779) (pronounced to rhyme with oliver) make it clear that this gentleman landowner had given con-

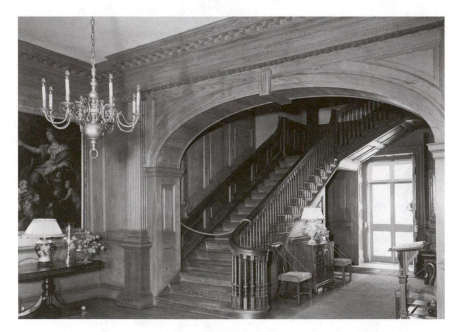

3.8. Richard Bayliss, wood carver, central hall of Carter's Grove, James City County, Virginia, 1750–53. Designed in part by owner Carter Burwell, the wood carving was executed by Bayliss brought from England by Burwell to do this work. (Courtesy of Virginia State Library.)

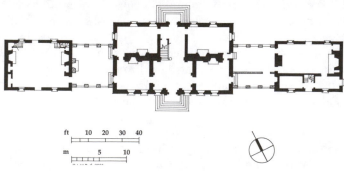

ft 10 20 30 40

m 5 10

3.9. Carter's Grove, plan. Although slightly expanded later, the plan of Carter's Grove shows the unbroken lateral axis governing the placement of office and kitchen that was later much favored in Tidewater plantation houses; this plan also shows the growing importance of the central entry and stair hall. (L. M. Roth, after HABS.)

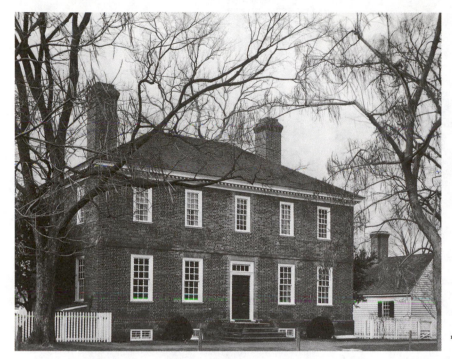

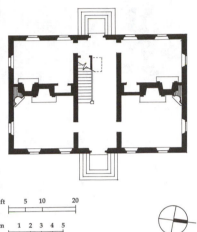

3.10. Richard Taliaferro, George Wythe house, Williamsburg, Virginia, 1755. The restrained exterior of the Wythe house incorporates simple geometrical proportions. (Courtesy of Colonial Williamsburg, 1956-GB-905.)

3.11. Wythe house, plan. The ground floor of the Wythe house illustrates well the basic southern double-pile Georgian plan. (L. M. Roth, after HABS.)

siderable attention to architectural studies; in 1749 Governor Thomas Lee referred to Taliaferro as "our most skilful architect."[6] It is also known that he was in charge of building the ballroom addition to the Governor's Palace in Williamsburg, that he made alterations to the residence of the president of William and Mary, and that in 1755 he designed and built the George Wythe house in Williamsburg, a smaller version of Westover and Carter's Grove. [3.10, 3.11]

The Brice house, in Annapolis, Maryland (1740), illustrates the early Georgian phase in that colony, and in South Carolina, Drayton Hall, built in about 1738–42 for John Drayton, shows the clear impact of a plate in Palladio's *Four Books of Architecture*. [3.12] Built of brick on the Ashley River about ten miles from Charleston, Drayton Hall is almost exactly a cube and has superimposed Palladian porches; the elaborate interiors, however, were derived largely from plates in Kent's *Designs of Inigo Jones*.

Middle Colonies

In Pennsylvania, the formal balance of Georgian design was introduced very early in the stone H-shaped house built in about 1690 by mason James

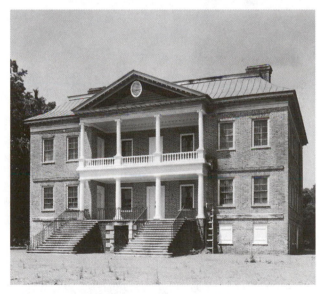

3.12. John Drayton house, "Drayton Hall," near Charleston, South Carolina, c.1738–42. The elevated cube of Drayton Hall (with kitchen in the basement), with its superimposed porches, is based on Palladio's villas. (Photo: © Wayne Andrews/Esto.)

3.13. James Porteus, Samuel Carpenter house, "Slate Roof House," Philadelphia, Pennsylvania, c. 1690. Long since demolished, the formality of this house hints at the Georgian architecture that would become the fashion in less than a decade; this house was also remarkable at the time for having a roof covered entirely in slate. (From J. Harter, Images of World Architecture, New York, 1990.)

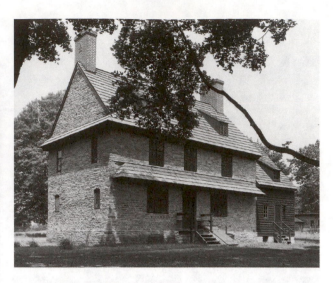

3.15. Brinton house, Dilworthtown, Pennsylvania, 1704. Built by a prosperous Quaker, the Brinton house may be deliberately plain as a result; it incorporates a good example of the pent roof over the ground-floor windows and door, and it is also a good example of regional building in random ashlar field stone. (Library of Congress, HABS PA 23-DIL.V 1-3.)

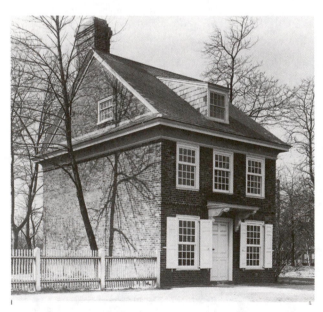

3.14. James Smart, house carpenter (attrib.), Letitia Street house, Philadelphia, Pennsylvania, c. 1703–15. This compact urban residence has been moved to the more open landscape of Fairmont Park, but it still shows how similar houses could be built contiguously as row houses, which became typical of cities like Philadelphia. (Courtesy of the Philadelphia Museum of Art.)

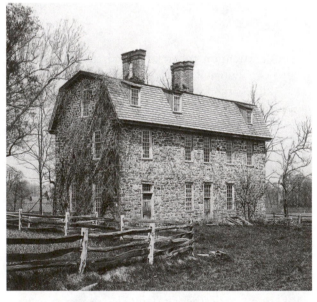

3.16. Sir William Keith house, Graeme Park, near Horsham, Pennsylvania, 1721–22. Somewhat atypical in plan, this country house blends English and Swedish forms in local fieldstone construction. (Courtesy of the Essex Institute, Salem, Massachusetts, neg. 1942.)

Porteus for wealthy merchant Samuel Carpenter. Because its roofing material was then unique in the city, it was popularly called the Slate Roof House. It had a hip roof with a classical modillion cornice, a emphatic stringcourse between floors, and a projected pediment over the entry door. [3.13] Brick became a dominant building material within Philadelphia, as in the compact Letitia Street house, built in about 1703–15 (moved in 1883 to Fairmont Park). Its cantilevered pent roof over the front door and windows was to become a distinctive regional feature. [3.14]

Fieldstone construction, developed by Germans and Welsh who settled in the region north and west of Philadelphia, also because a distinctive regional practice. Of all the local building traditions, fieldstone construction around Philadelphia proved to be particularly strong and influenced local design through the eighteenth century and even into the twentieth century. The original Swedish ethnic character was rapidly supplanted by the English who took over the colony, and by the end of the seventeenth century the earlier building traditions there had virtually disappeared.

The local tradition of building with random ashlar fieldstone is well illustrated in the Brinton house in Dilworthtown, Pennsylvania, from 1704 [3.15], and was used in many area Georgian country houses, such as Moore Hall, in Chester County, built in 1722. A bit more unusual in form is Graeme Park, built at Horsham, in Montgomery County, Pennsylvania, in 1721–22. [3.16] Built by the governor of the colony, Sir William Keith, the exterior is intentionally severe, with walls built of rubble fieldstone, door and window openings unframed and seemingly randomly placed. The random ashlar masonry and gambrel roof suggest local Swedish, German, and Welsh Quaker traditions. The plan, however, is unusual in that it is not a symmetrical double-pile plan but a row of three rooms: a square parlor, a center hall, and an end kitchen. Although it would seem to derive from the Swedish *parstuga* plan, it is in fact a survivor of an older plan that was once commonly used from the Plymouth colony south to early Virginia. The elaborate pine paneling inside, with richly pedimented doorways and chimneypieces, was installed during renovations undertaken about 1750 by the second owner, Thomas Graeme, for whom the property is now named.

Northern Colonies

In Massachusetts and adjacent colonies the saltbox form of the seventeenth century persisted right through the eighteenth century. The Whitman house,

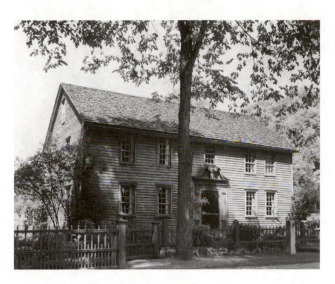

3.17. *Parson John Sergeant house, Stockbridge, Massachusetts, 1739. The Sergeant house is a good example of the traditional New England saltbox house updated and made fashionable with a classical Georgian door. (Photo: © Wayne Andrews/Esto.)*

of Farmington, Connecticut, built around 1715, is a good example of how truly conservative building traditions were in the hinterlands. Gradually the medieval overhangs of upper gable and front second floor were eliminated, but the long shed roof to the rear remained. The front facade became decidedly symmetrical, and the center door was embellished with classical frames, complete with curved or broken scroll pediment on pilasters. A good example is the John Sergeant house, of Stockbridge, Massachusetts, built in 1739, austere and stripped except for the centered entry door, which is capped by an elegant broken scroll pediment. [3.17]

Along the New England seaboard, in or near the major ports there remains today a large number of exemplary early Georgian houses. A principal variation on the basic double-pile plan in the North was the addition of a kitchen ell to the rear of the house, sometimes with additional sections providing pantries, sheds, or even a stable. If what is shown in a drawing of 1836 is correct, the Foster-Hutchinson house, in Boston, built in about 1688, is the earliest classically inspired residence in the colony. [3.18] The corner pilasters, however, would suggest alterations of a later date. By 1718 the Georgian style was well established in the region, as the MacPheadris-Warner house, built in 1716–18 in Portsmouth, New Hampshire, demonstrates. [3.19] Built for Captain Archibald MacPheadris, it incorporates an elegant segmental

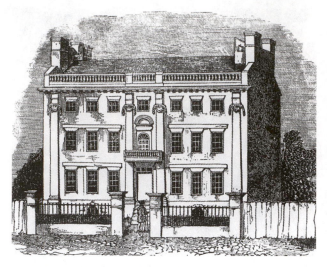

3.18. Foster-Hutchinson house, Boston, Massachusetts, c. 1688. Long ago demolished, this was perhaps the earliest formally designed Georgian house in New England. (From J. Stark, Stark's Antique Views of Boston, Boston, 1907.)

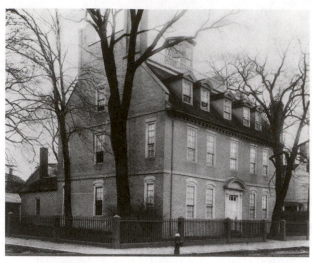

3.19. John Drew, designer and builder, MacPheadris-Warner house, Portsmouth, New Hampshire, 1716–18. One of the earlier New England Georgian houses, this was built entirely of brick, but is especially notable for its staircase murals. (Carnegie photo.)

pediment on Corinthian pilasters at the door, and alternated segmental and triangular pediments over the dormer windows.

Equally elegant is the Isaac Royall house in Medford, Massachusetts. Begun in the seventeenth century by John Usher, it was purchased by sugar grower and rum and slave trader Isaac Royall in 1732 and extensively rebuilt in 1733–50. The original brick shell was encased in wood with decorative wood corner quoins, and a new east facade was built. [3.20] Behind it slave quarters and other outbuildings were constructed. In 1739 Isaac Royall Jr. inherited the house and in 1747–50 he carried out further enlargements and alterations, including a new west facade, whose center door was embellished with a segmental pediment on Ionic pilasters. The finely detailed interiors were done by joiner and carpenter William More. Work such as this in and around Boston prompted an English gentleman visitor of 1740 to admit that Boston contained "a great many houses, and several fine streets, little inferior to some of our best in London."[7] Like a large number of the wealthy home builders, Royall was a Tory and fled to Halifax, Nova Scotia, during the Revolutionary War; his attempts to regain his forfeited property after the war were unsuccessful.

Newport was perhaps the second most prosperous New England port after Boston, and its streets facing Narragansett Bay were lined with the sumptuous homes of merchants and captains, among them the Captain John Warren house of about 1736 and the John Dennis house of about 1740. Especially well finished is the William Hunter house of 1748, which was furnished with pieces by local cabinetmakers John and Edmund Townsend and John Goddard.

Perhaps the last of the early Georgian residences in the North was the Wentworth-Gardner house of Portsmouth, New Hampshire, built as a wedding gift for Thomas Wentworth around 1760 by his mother. [3.21] Although there is no central projecting pavilion, there are other characteristics that show the impact of new decorative ideas, including a particularly sculptural door frame with a sinuous broken scroll pediment on Corinthian pilasters, flanked by pedimented first-floor windows. Although clapboards were used on side and rear walls, the facade is enhanced by the use of flat plank sheathing, with chamfered grooves cut in imitation of rusticated ashlar masonry, and wooden quoins at the corners.[8] The projecting cornice of the roof is narrow and sits too tightly on the tops of the second-floor windows. Even in black-and-white reproductions, the difference in color of the wall surfaces and the trim elements is noticeable. Generally these frame houses were painted in colors intended to suggest masonry, with dull yellow for the walls (as here) or tan or light brown, with white used for the details and trim. Often sand was mixed with the paint to give the surface the texture of stone.

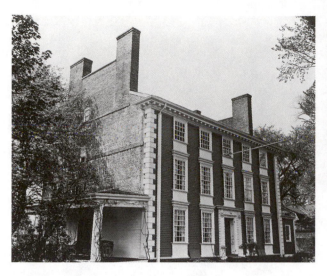

3.20. *Isaac Royall house, Medford, Massachusetts, 1733–50. Set between brick end walls, the east facade incorporates wood decorative quoins and an elaborate central entrance. (Library of Congress, HABS MASS 9-MED 1-17.)*

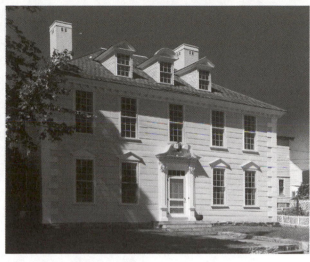

3.21. *Wentworth-Gardner house, Portsmouth, New Hampshire, c. 1760. Built for Thomas Wentworth, this house retains many features of the early Georgian houses despite its late date. (Photo: Samuel Chamberlain.)*

Early Georgian Churches and Public Buildings

As with the houses, the public buildings of the first half of the eighteenth century were based on the work of Wren; churches in particular drew their motifs from Wren's London city churches built to replace those destroyed in the great fire of 1666. The first colonial church to have a steeple and columnar portico was St. Philip's in Charleston, South Carolina, built in 1711–23, based on Wren's St. Magnus the Martyr, in London, but destroyed by fire in 1835. Two Boston churches survive and show well their debt to Wren. The first of the two was Old South Meeting House, built in 1713, which was designed by Joshua Twelves and built by master mason Joshua Blanchard. [3.22] A Congregationalist meetinghouse, it retains the traditional side entry, but it also incorporates a tower and steeple at the end, with a secondary entrance; it is a good illustration of how in the eighteenth century Puritan asceticism began to give way to more worldly and artistic forms, even borrowing from Anglican churches. The steeple is a simplified version of the one Wren devised for Saint Mary-le-Bow, in London. The second of the Boston churches was Christ Church (popularly called "Old North"), begun in 1723, an Anglican church built from designs provided by William Price, cabinetmaker and dealer of books and engravings, who had studied Wren's church designs. Its more rectilinear steeple with spire, built in 1741 and rebuilt in 1807, is based on Wren's St. James, in

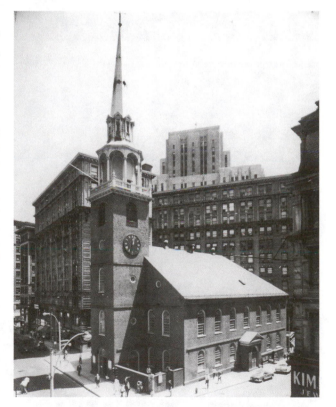

3.22. *Joshua Twelves, designer; Joshua Blanchard, builder; Old South Meeting House, Boston, Massachusetts, 1713. Among the earliest New England meetinghouses influenced by the work of Sir Christopher Wren. (Library of Congress, HABS MASS 13-BOST 54-2.)*

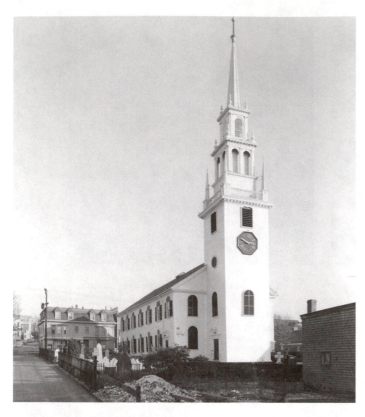

3.23. Richard Munday, Trinity Church, Newport, Rhode Island, 1725–26. This Anglican church incorporates a spire patterned after that of St. James, Piccadilly, London, 1676–84, by Sir Christopher Wren. (Sandak, courtesy of the University of Georgia.)

3.24. College of William and Mary, (Wren Building,) Williamsburg, Virginia, 1695–1702. Built from plans said to have been approved by Sir Christopher Wren. (Courtesy of Colonial Williamsburg, 76-FO-690.)

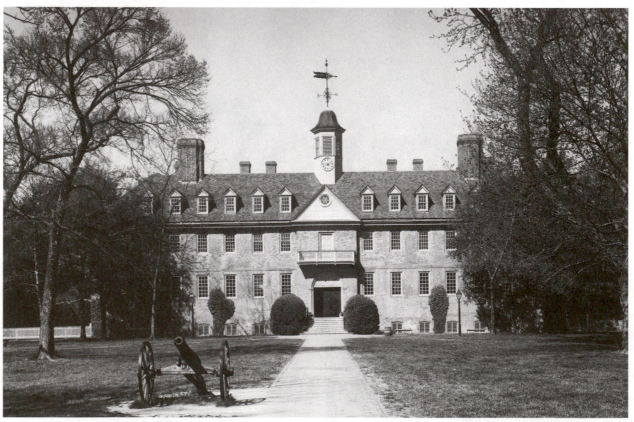

Piccadilly, London. Similar to both of these, although of frame construction with white-painted clapboard siding, was Trinity Church in Newport, built by local carpenter-builder Richard Munday in 1725–26. [3.23] The influence of Wren's churches may well have come via the Society for the Propagation of the Gospel, based in London, which helped raise funds for colonial Anglican churches.

One relatively new Colonial building type of the eighteenth century was the college hall. The first frame building for Harvard is a good example; it was a multipurpose structure containing sleeping rooms for professors and students, classrooms, dining hall, library, and chapel. Whether at Harvard, Brown, Yale, or Dartmouth, the Georgian buildings that replaced the first frame structures followed the basic pattern of the Wren Building, constructed in 1695–1702 at the newly established College of William and Mary in Williamsburg, Virginia. [3.24] That building, said at the time to have been designed by Sir Christopher Wren himself, consists of a tall four-story **U**-shaped block. One of the first Georgian Colonial buildings, it is formally planned around an axis that runs through

the central arched door and rear court. This focus is emphasized by the central pavilion, which breaks slightly forward, crowned by a steep gable, and the tall cupola atop the hip roof.

Through the rest of the century other college buildings at Harvard, Yale, and King's College (later Columbia University) followed this pattern, though roofs became lower, pediments broader, and horizontal emphasis stronger. Essentially variants on large brick country houses, they had more window bays and far more restrained ornament. Good surviving examples are Massachusetts Hall at Harvard, built in 1718–20 [3.25], whose design is attributed to Colonel Thomas Dawes; and Connecticut Hall at Yale University, built in 1750–52, whose builders, Francis Letort and Thomas Bills, based their design on Massachusetts Hall.

Richard Munday did much the same in designing the Colony House, in Newport, in 1739–41, to house the Rhode Island Assembly. [3.26] Although built before midcentury, it incorporates elements that later came to characterize late Georgian, such as the pedimentlike gable on the long entrance side, a particular

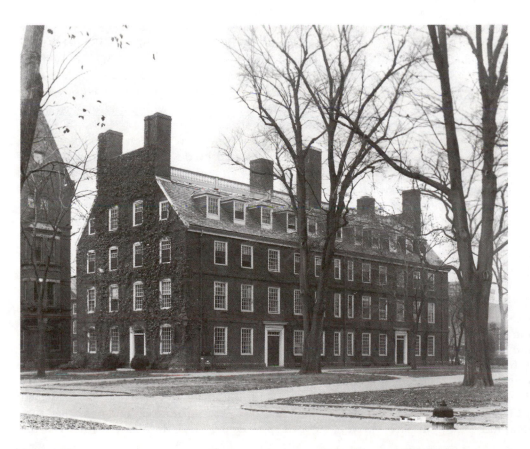

3.25. Col. Thomas Dawes, Massachusetts Hall, Harvard University, Cambridge, Massachusetts, 1718–20. Early collegiate buildings resembled English country houses in many respects; the difference was in the repeated internal winding staircases that led to stacked clusters of bedchambers. (Sandak, courtesy of the University of Georgia.)

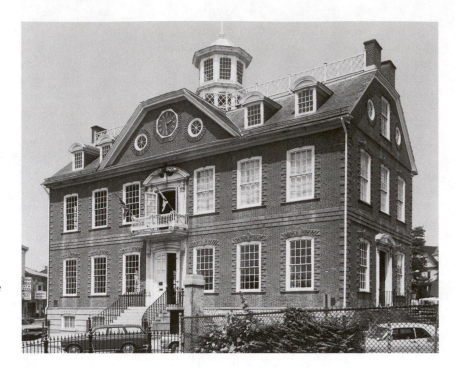

3.26. Richard Munday, Old Colony House, Newport, Rhode Island, 1739–41. Although designed to house the colonial assembly, the building is essentially a large residence in form. (Library of Congress, HABS RI 3-NEWP 9-28.)

emphasis on the central door surmounted by a cantilevered balcony and door topped by a broken scroll pediment, the delicate roof balustrade, and the prominent cupola. It also possesses a certain naive vigor in its awkwardly cut-off gable and curiously proportioned ornamental details.

LATE GEORGIAN ARCHITECTURE, 1750–1785

Northern Colonies

About midcentury, a subtle change swept over high-style design, with growing reliance on the models published in James Gibbs's *Book of Architecture* of 1728 and an increased quantity and density of decorative detail. Roofs tended to be lower in slope, with the upper edge capped by a decorative balustrade, adding a further horizontal emphasis. The most obvious visual change was the emphasis on the center of the facade, most often through the use of a central projecting pavilion, also derived from Gibbs, usually capped by a large pediment. Normally the edges of the projecting pavilion and the corners of the house were further emphasized by large quoins or colossal pilasters running up to the roof cornice. A splendid northern example is found in the John Vassal house of 1759, in Cambridge, Massachusetts, then a relatively quiet suburb of Boston. [3.27, 3.28] This incorporates

a roof balustrade, central pavilion, crowning pediment, and tall Ionic corner pilasters.

Another northern example is the Lady Pepperrell house at Kittery Point, Maine, built in about 1760 by the widow of the first colonial baronet, Sir William Pepperrell, who had been honored for military service to the king. [3.29] As with other northern houses, it is built completely of wood, with wood quoins at the corners. Smooth plank construction, based on Gibbs, was used in the center pavilion, and the center bay is further emphasized by the colossal Ionic pilasters on pedestals and by the richly embellished door with its cornice carried on consoles. Nevertheless, the main cornice here, too, is weakly proportioned for the house as a whole, and it sits directly on top of the windows of the second floor.

The Middle Colonies

In the middle colonies late Georgian architecture was more elaborate still, following the examples published by Gibbs. Particularly grand is the home of the privateer and sea captain John MacPherson, Mount Pleasant, now in Fairmount Park, Philadelphia, then a suburb of the city. [3.30] Built in 1761–62, this country retreat is a good example of the strong influence of James Gibbs. Although not connected by arcaded quadrants, there are separate outbuildings that suggest an entry court. [3.31] In plan the rooms of the

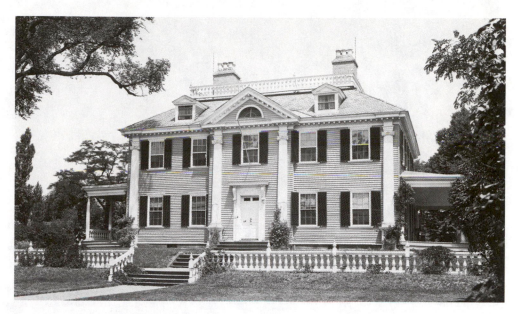

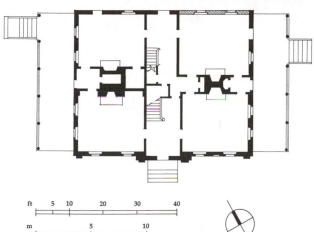

3.27. John Vassal house, Cambridge, Massachusetts, 1759. The projecting central pavilion and the framing corner pilasters mark this as a late Georgian design. (Library of Congress, HABS MASS 9-CAMB 1-5.)

3.28. Vassal house, plan. The Vassal house is a good example of a northern double-pile Georgian plan. Later enlarged, the house plan is shown here in its original configuration. (L. M. Roth, after HABS.)

| ft | 5 | 10 | 20 | 30 | 40 |
| m | | 5 | | 10 | |

3.29. Lady Pepperrell house, Kittery Point, Maine, c. 1760. The Pepperrell house is also marked by a projecting central pavilion, emphasized by being sheathed in close-fitting boards presenting a smooth flat surface in contrast to the clapboards of the rest of the house. (Courtesy of the Society for the Preservation of New England Antiquities.)

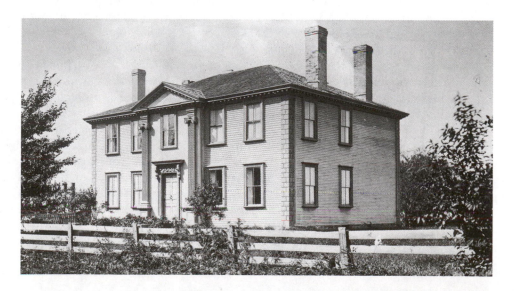

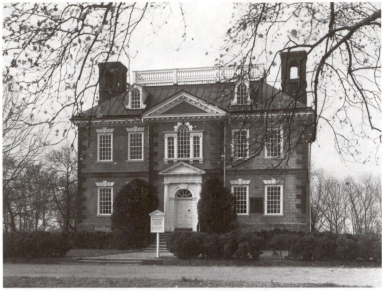

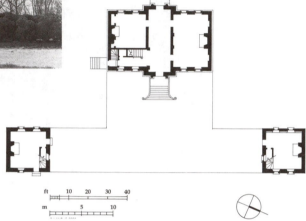

3.30. John MacPherson house, Mount Pleasant, Philadelphia, Pennsylvania, 1761–62. The MacPherson house is particularly compact compared to other grand country estates, with its stair placed in the left corner chamber. (Library of Congress, HABS PA 51-PHILA 15-13.)

3.31. Mount Pleasant, Philadelphia, plan with dependencies. At Mount Pleasant the dependencies are freestanding buildings. (L. M. Roth, after HABS.)

house lie on either side of a central hall running through the house, expressed externally by the projecting center pavilion. Atypical is the placement of the stairs in the corner, where they ascend and cut in front of one of the windows, indicating one of the problems of fitting functions into a priori formal conceptions. The flat-topped hip roof is crowned by a balustrade that continues the horizontal stretch of the house; this is reiterated by the strong cornice line, the brick stringcourse between floors, and by the swelling water table at the base. The widely spaced windows are capped by heavy flat arches, but most elaborate is the Palladian window in the upper level of the center pavilion and the richly embellished entrance consisting of an arcaded door surrounded by a Roman Doric frame and pediment. Contributing to the solid appearance of the house are the two massive chimney clusters; in each are four freestanding flues rising from a square base and tied at the top by arches, somewhat like those in Vanbrugh's Blenheim Palace. The construction is of masonry, indicated by the brick quoin-

ing, stringcourses, and other details, but the rubble masonry walls (in the tradition of buildings like Graeme Park) are covered by a smooth coat of stucco.

While Mount Pleasant and other resplendent country villas were being built in the woodlands outside of Philadelphia, within the city development veered sharply away from Penn's original intentions. Whereas he had hoped to have "a greene Country Towne" of houses spaced well apart, each surrounded by gardens and orchards, so the city would "never be burnt and always be wholesome," development of the city crowded against the Delaware shore, and the original large blocks were subdivided over and over. What became truly distinctive in Philadelphia were not the hoped-for freestanding houses, but townhouses lining the streets. Fortunately, too, a large number of these townhouses survived as the city expanded to the west toward the Schuykill River. Of the many good examples, the Charles Stedman house on South Third Street, built in 1765, is particularly fine. Of brick, three bays wide and three stories in height, it has a

well-proportioned modillion cornice at the roof line. The entry door, on the right side of the ground-floor facade, is graced by a round-arched light above the door, and an exceptional door surround of Tuscan Doric columns carrying a full entablature and cornice. Also of particular interest is narrow Elfreth's Alley, one of the slender streets cut through the original blocks. It remains completely lined with two- and three-story townhouses, some only two bays wide, dating from 1724 to 1836, and provides perhaps the best example of the eighteenth-century city and its decidedly pedestrian scale.

Furniture and Interior Design

During the third quarter of the eighteenth century Philadelphia became one of the most urbane cities in the colonies, and its craftsmen turned out most accomplished pieces of furniture, as can be seen in the interiors of Mount Pleasant or the parlor from the Blackwell house of Philadelphia, built in about 1764. [3.32] The change in scale from the low, intimate confines of the seventeenth-century saltbox is immediately evident. Ceilings in Georgian houses up and down the coast were uniformly high. The pervasive formality of planning is revealed in such details as the way the fireplace is centered between the doors. Each part is richly embellished, the doors heavily framed and topped with broken pediments, the fireplace capped by a mantel carried on carved consoles. Above this, the overmantel contains a painting within a broad carved frame, which in turn is surrounded by carved plaster foliate reliefs. A full and heavy cornice marks the meeting of wall and ceiling. Because of the increased height, suspended crystal chandeliers became common in the more prestigious homes.

Fine furniture was made in several centers. Salem and Newport became well known for finely wrought furnishings, Newport through the work of John Goddard and John and Edmund Townsend. Philadelphia especially had large numbers of artisans who produced furniture based on designs by Thomas Chippendale. Like the houses in which they stood, these pieces are marked by rich three-dimensional carved embellishment. There is throughout both the houses and furniture an interest in antiquity that was becoming more exacting, blended with the play of curve and countercurve of the Rococo. High chests indicate the level of craftsmanship colonial artisans had attained by the middle of the century; indeed, Philadelphia pieces compare very favorably with their English counterparts.

High chests generally stood seven and a half feet tall. When one compares them to the five-foot-high seventeenth-century court cupboards, one can readily see that drastic changes occurred in the scale of domestic design in the eighteenth century; ceilings, for example, were about three feet taller. While severe climatic conditions forced the early houses to be compact, under the same conditions Georgian houses could be larger in size, partly due to improved fireplace design with air ducts allowing more heat to be obtained from burning fuel, but mainly because of the simple use of grates to raise the fire, and the use of coal as fuel in the seaboard towns. There was also more money for fuel, candles, and whale oil; rooms therefore could be bigger with ceilings higher, and still be well heated and illuminated. All of this was brought about by the growing economic base, fed, ironically, by goods produced largely in defiance of English mercantile law. The cast-iron stove perfected by Benjamin Franklin in 1742 is one example of this; manufactured illegally, it was designed to produce significantly more heat from a given amount of fuel, and thus helped to increase the volume of usable space.

3.32. Blackwell house, Philadelphia, Pennsylvania, c. 1760. Parlor, as reinstalled in the Henry Francis du Pont Winterthur Museum. (Courtesy of the Henry Francis du Pont Winterthur Museum.)

Southern Colonies

Late Georgian southern plantation houses, set in expansive landscaped grounds, were more extensive than their northern counterparts, and required large separate kitchens and service facilities. Not too far distant were quarters for house slaves, and farther out would be ruder buildings for field slaves. In perusing Palladio and Gibbs, the plantation-owning gentlemen scholars found suggestions for planning their large formal houses, and in fact the villas designed by Palladio for the reclaimed farmland of the Veneto around Venice were indeed comparable to the Virginia plantations in function and social life. One example of Palladio's influence is Shirley, in Charles City County, Virginia, built for Charles Carter in about 1769, based directly on plate 61 in the second of Palladio's books, but with an even bigger and more prominently projecting pedimented two-level porch.

One of the clearest examples of Gibbs's pervasive influence is found in the Virginia plantation house called Mt. Airy, attributed to an English architect newly arrived in the colony. John Ariss (1725–1799), advertised his services in the *Maryland Gazette* of May 22, 1751, directing special attention to his familiarity with Gibbs's modern style:

John Oriss,—By the Subscriber (lately from Great Britain) Buildings of all Sorts and Dimensions are undertaken and performed in the neatest Manner, (and at cheaper rates) either of the Ancient or Modern Order of Gibbs' Architect and if any Gentleman should want plans, Bills of Scantling or bill of Charges, for any Fabric, or Public Edefice, may have them by applying to the Subscriber at Major John Bushrods at Westmoreland County, Va.,

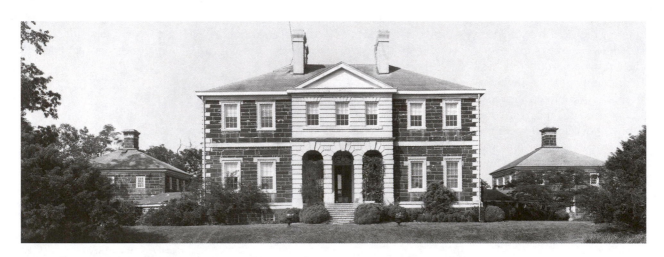

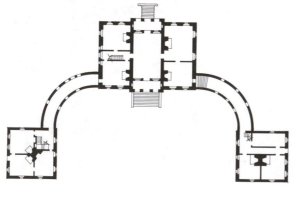

3.33. *John Ariss (attrib.), Col. John Tayloe house, Mount Airy, Richmond County, Virginia, 1758–62. This house shows a clear knowledge of the published work of the English architect James Gibbs. (Library of Congress, HABS VA 80-WAR.V 4-21.)*

3.34. *Mount Airy, plan with dependencies. Plan of Mount Airy, showing the curved quadrants connecting the main house to outlying office and kitchen. (L. M. Roth, after HABS.)*

ft 10 20 30 40 50

n 5 10 15

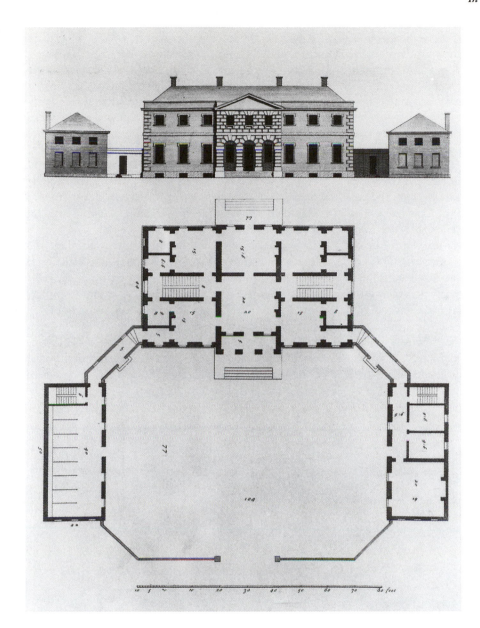

3.35. James Gibbs, plate 58 from A Book of Architecture, *London, 1728. Using such plates as this, designers such as Arris could design nearly identical houses in the colonies, exactly what Gibbs had intended. (Courtesy of the Avery Library, Columbia University.)*

where may be seen a great variety and sundry Draughts of Buildings in Miniature, and some buildings near finished after the Modern Taste.[9]

Although it could not have been one of the "buildings near finished," the direct references to Gibbs in Mt. Airy have led to its attribution to Ariss. Mt. Airy, in Richmond County, Virginia, built in 1758–62 for John Tayloe, was the operating center of a large plantation. [3.33, 3.34] The Tayloe family was one of the most powerful in Virginia, owning thousands of acres, hundreds of black slaves, a house in Williamsburg, and an iron furnace in Neabsco. This grand house was

to be the showpiece of the plantation, with a plan and south elevation based closely on plates 55 and 58 from Gibbs's *Book of Architecture*.[10] [3.35] The main block of the house consists of a two-story rectangle with a pedimented central pavilion; an entrance forecourt is formed by dependencies at the end of curved quadrants connected to the main block by curved covered passageways. The dependencies or outbuildings provided two necessary facilities: an office for conducting plantation business (thus keeping field slaves and foremen away from the main house) and an isolated kitchen (thus keeping odors out of the main house and reducing the risk of fire spreading from the

kitchen to the rest of the house). Less typical for the colonies is the construction of brown sandstone with light limestone used for the central pavilion, but even this is based on suggestions from Gibbs's plates (the poor-quality brownstone may have originally been covered with plaster).

Another imposing plantation house associated with Ariss is Mount Vernon, the original section of which was built in 1726–35. In 1754 it was inherited by George Washington, who began a series of expansions and additions, designed in large part by himself, perhaps with suggestions from Ariss. Constructed in phases, 1757–58, 1773–79, and 1784–87, the additions elevated and broadened the house, with numerous details adapted from Battey Langley's *Treasury and Swan's British Architect.* The last addition of 1784–87 was the broad two-story portico facing the Potomac River, its square piers adapted from a design in Langley's *Treasury.*

One of the most ambitious southern houses was the palace complex designed by British architect John Hawks for Governor William Tryon of North

Carolina. Built at New Bern in 1767–70, it had an exceptionally large central house block, seven bays wide and measuring 52 by 82 feet, in a variant of the double-pile plan; curved quadrants connected to outer dependencies (residences for guests) that were themselves modest double-pile houses. Curved outer walls and a large iron gate with brick piers completed the entry court. The original drawings for the complex, preserved in the Public Record Office in London, indicate that the facade was based on one in Robert Morris's *Select Architecture.* Destroyed by fire in 1798, the house was carefully rebuilt from the original drawings in 1952–59.

In South Carolina the broad double-pile plan was used for several residences in Charleston, as illustrated in the well-proportioned Miles Brewton house, built c.1769–73 for the very wealthy slave trader and merchant. [3.36, 3.37] Today the Brewton house complex is notable not only for the excellence of its interior details by carvers Ezra Waite, John Lord, and Thomas Woodin, but also because it retains a good number of its outbuildings and slave quarters. Such houses were

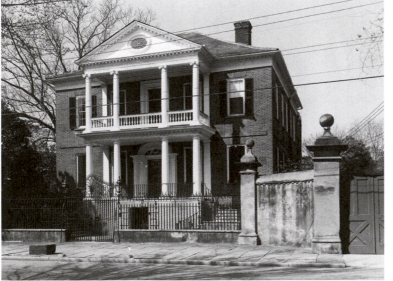

3.36. Richard Moncrieff, builder, Miles Brewton house, Charleston, South Carolina, c. 1769–73. The Miles Brewton house exemplifies the southern city residence of wealthy plantation owners; the detailing of the two-story porticoes is especially fine. (Library of Congress, HABS SC 10-CHAR 5-4.)

3.37. Miles Brewton house, plan. Because of the width of the land owned by Brewton, this house could have a wide double-pile plan, called a "Double House" in Charleston. (L. M. Roth, after HABS.)

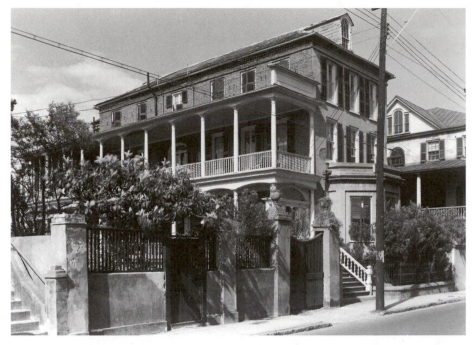

3.38. *Judge Robert Pringle house, Charleston, South Carolina, c. 1774. "Single houses" were narrow and built with the short end facing the street and the long entry facade facing a narrow garden or court (the bay window is a later nineteenth-century addition). (Library of Congress, HABS SC 10-CHAR 148-1.)*

3.39. *Pringle house, Charleston, South Carolina, plan. The plan shows that "single houses" were typically only one room deep, but still had a central stair hall. This restored plot plan shows the position of former related auxiliary buildings such as slave quarters and stables. (L. M. Roth, after A. R. Huger Smith and D. E. Huger Smith,* The Dwelling Houses of Charleston, South Carolina, *Philadelphia, 1917; and a property plat of 1789, McCrady Plat Collection, in J. H. Poston et al., eds.,* The Vernacular Architecture of Charleston and the Low Country, 1670–1990, *Charleston, 1994.)*

called double-wide residences to distinguish them from the more plentiful narrow "single houses" in Charleston. Partly developed from ideas brought from the West Indies, the "single houses" consisted of a single row of rooms extending back from the street, from the formal parlor in the front to office, kitchen, and slave quarters to the rear. These rooms, and the bedrooms above, opened out onto long superimposed galleries that looked over a narrow court separating one single house from the next. A good example is the Judge Robert Pringle house, in Charleston, built c.1774. [3.38, 3.39]

The major innovation introduced in the southern tidewater plantation house was the lateral hyphenated block form, in which the main house is connected by in-line low hyphens to two-story flanking dependencies. Tulip Hill, in Anne Arundel County, Maryland, built by Samuel Galloway in 1756, has a five-bay double-pile main house, with hyphens connecting to an outer office and kitchen. Brandon, in Prince George

County, Virginia, built by Nathaniel Harrison in about 1765, did away with the double-pile plan by placing the subsidiary rooms in the hyphenated wings. This laterally extended arrangement was based on Morris's *Select Architecture*, which in turn came from Palladio's design for a "Roman Country House."

Late Georgian Churches and Public Buildings

Late Georgian flourishes appeared somewhat earlier in churches than they did in residential work, largely because Gibbs had provided such persuasive designs in his *Book of Architecture* of 1728. Most engaging were the plates illustrating his design for St.-Martin's-in-the-Fields, London (1721–26), as well as alternative unused designs for the church. It had been Gibbs's intent from the start that his designs be made available to the general public, "as this would be of use to such Gentlemen as might be concerned in building, especially in the remote parts of the Country, where little or no assistance for Designs can be procured. Such

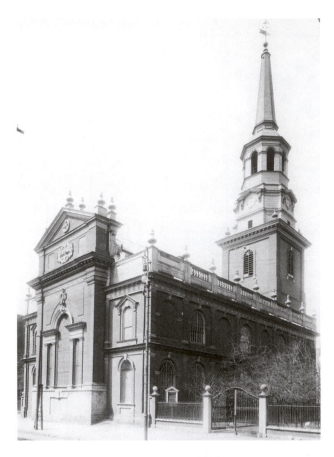

may be here furnished with Draughts of useful and convenient Buildings and proper Ornaments."[11]

One of the first colonial churches touched by Gibbs's influence was Christ Church, Philadelphia. [3.40] The body of the church, begun in 1727, was based on designs by the physician John Kearsley, who superintended construction. The tower was built later, in 1750–54, probably designed by the prominent Philadelphia builder Robert Smith; it is clearly inspired by Gibbs's plates. The body of the red brick church is divided by a stringcourse into two stories with windows heavily framed and pedimented. The ornamental trim elements, such as the balustrade atop the wall and its bulbous finials, are slightly overscaled for the bulk of the building but are balanced by the chancel wall, with its large Palladian window framed between colossal pilasters. The interior is patterned after Gibbs's St.-Martin's-in-the-Fields, and consists of three wide bays carried by freestanding Roman Doric columns with full entablature blocks. [3.41] As in St.-Martin's-in-the-Fields, galleries are carried midway up the columns. Kearsley simplified the interior by having a flat ceiling and avoiding the intricacies of the suspended elliptical plaster vaulting of Gibbs. It is an interior suffused with light through the many windows (originally the Palladian chancel was glazed with

3.40. Dr. John Kearsley, designer, Christ Church, Philadelphia, Pennsylvania, 1727–54. This church, especially in its tower added in 1750–54 by builder Thomas Smith, shows the strong influence of James Gibbs. (Courtesy of the Essex Institute, Salem, Massachusetts, neg. 2385.)

3.41. Christ Church, interior. Although heavily influenced by James Gibbs in its details, this church has a flat rather than vaulted ceiling. (Library of Congress, HABS PA 51-PHILA 7-30.)

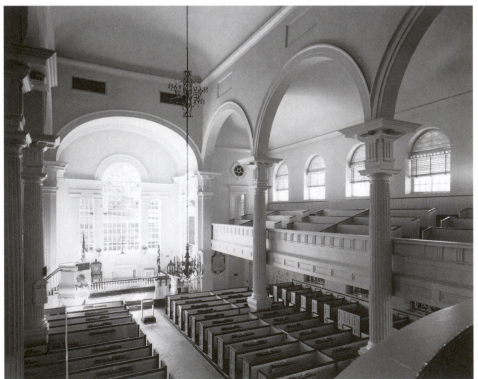

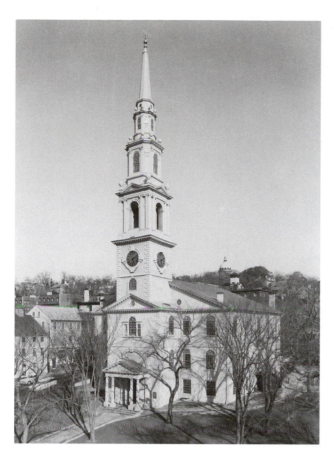

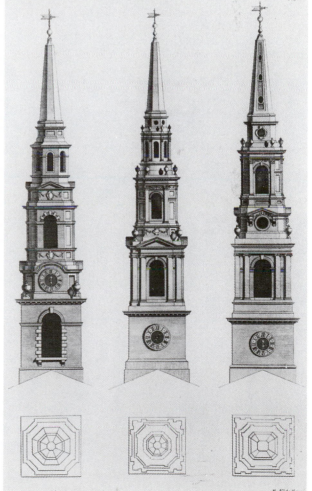

3.42. Joseph Brown, designer, First Baptist Meetinghouse, Providence, Rhode Island, 1774–75. Of all the Gibbs-inspired spire designs in the colonies, this most closely resembled one of Gibbs's proposals. (Sandak, courtesy of the University of Georgia.)

3.43. James Gibbs, plate 30. Three of the alternative designs for the spire of St.-Martin's-in-the-Fields, London. (From Gibbs, A Book of Architecture, *London, 1728, courtesy of the Avery Library, Columbia University.)*

clear glass), helping to alleviate the heavy scale of the embellishment.

The First Baptist Meetinghouse of Providence, Rhode Island, built in 1774–75 [3.42], was also designed by an amateur, Joseph Brown, who had acquired wealth as a merchant. He thereafter devoted himself to the study of mechanics and astronomy, and became a professor at Rhode Island College (Brown University). As would Peter Harrison, Brown found his solution for this nonconformist congregation among his architectural folios. For the meetinghouse Brown designed a large three-story frame cube, originally 80 feet to a side, with entrances on each side, the main entrance surmounted by a tower of 185 feet copied directly from plate 30 in Gibbs's book. [3.43] To carry it out Brown had master carpenter James Sumner brought down from Boston; Sumner deleted only minor details intended to have been done in cut stone in the original. In contrast, the freestanding entrance portico, derived from another Gibbs design, is much too small for the tower, demonstrating Brown's desire for correct details but also his lack of

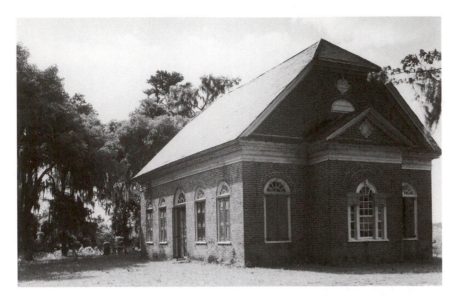

3.44. Pompion (Pumpkin) Hill Chapel, outside Charleston, South Carolina, 1763. One example of the small Anglican "chapel of convenience," often located on riverbanks within rowing distance of the nearby plantations. (Library of Congress, HABS SC 8-HUG. V 2-3.)

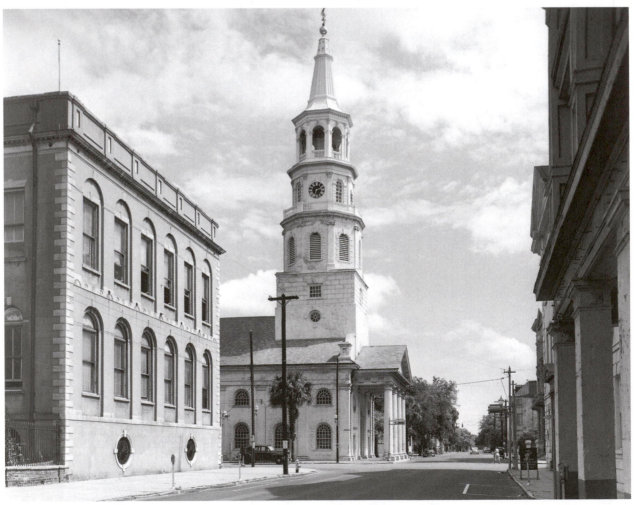

3.45. Samuel Cardy, builder, St. Michael's, Charleston, South Carolina, 1752–53. Built of stone, the tower is a massive adaptation of Gibbs's prototype. (Photo: © Wayne Andrews/Esto.)

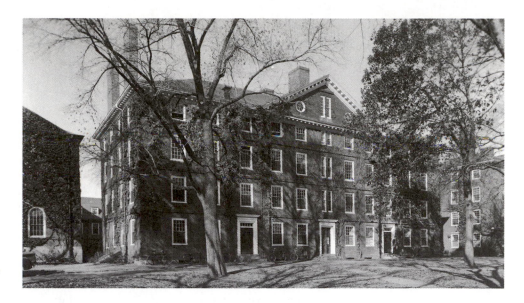

3.46. Hollis Hall, Harvard University, Cambridge, Massachusetts, 1762–63. The major changes in late Georgian collegiate halls were a lower hip roof and a projecting center pavilion. (Sandak, courtesy of the University of Georgia.)

formal training. Where Christ Church, Philadelphia, is of brick with wood trim, the First Baptist Meeting-house, like other New England structures, is entirely frame, with clapboard siding and quoined corners.

Other late Georgian churches were variations on this Gibbsian theme, including the carefully detailed St. Paul's Anglican Church, in New York City, built in 1764–66, designed by Thomas McBean with the columnar portico at one end and the tower at the other. Soon spired meetinghouses and churches began to appear in villages throughout Massachusetts and Connecticut; the Congregation Meeting-House in Farmington, Connecticut, built in 1771, is just one of many examples and shows how the Congregationists preferred the plainer earlier Wren models over the more sculptural Gibbs models used so frequently for Anglican churches.

While northern and central churches, both Anglican and nonconformist, followed London models—first Wren and then Gibbs—the smaller scattered parish churches in the tidewater and southern colonies remained small and comparatively unembellished with colonnaded porticoes or soaring steeples and spires. Numerous examples survive of these "chapels of convenience," including Christ Church, in Lancaster County, Virginia, built in 1732; Pohick Church, in Fairfax County, Virginia, built in 1771–72; and Pompion (Pumpkin) Hill Chapel, in South Carolina, built in 1763. [3.44] In South Carolina, especially, these chapels or churches were fairly easily reached by water from the surrounding plantation houses. The dramatic southern exception to this rule

is the massively proportioned and steepled St. Michael's Anglican Church, in Charleston, South Carolina, [3.45] erected by master builder Samuel Cardy in 1752–53 from plans that may have been reviewed by Peter Harrison, who often traveled to Charleston in connection with his business and who knew members of the building committee well. St. Michael's has survived assaults from many hurricanes, perhaps because the tower base and the steeple itself, up through the upper octagonal stage, is solidly built of brick masonry.

By 1760 colonial churches had achieved such a high level of tasteful design that the English architect James Bridges could propose to rebuild St. Nicholas's, in Bristol, England, using "a plan I saw erected, when on my travels through the Province of Pensilvania, in America."[12] Such an idea would have been out of the question only twenty or thirty years earlier.

The individual colonies were also busy establishing or expanding their colleges. Their reasons were twofold, first to train ministers and second to send missions among the native tribes. The early brick buildings at Harvard and Yale (noted earlier) were built in accordance with early Georgian formulas, but later buildings, such as Nassau Hall, at Princeton University, built by Robert Smith of Philadelphia in 1754–56, and Hollis Hall, at Harvard, built in 1762–63 [3.46], had lower hip roofs, with projecting and pedimented center sections. This late Georgian form was also used in University Hall, at Brown University, built in 1770–71, and in Dartmouth Hall, built in 1784–91, at Dartmouth College, located in northern New

Hampshire, in what was then largely native territory. The added embellishment in this example was a tall cupola at the center of the roof. More elaborate still was the building erected for King's College (later Columbia University), in New York City, in 1760; this had four projecting pedimented pavilions each marking one of the four entrances.

Yet another adaptation of the large country house type is the Old State House, in Philadelphia, now known as Independence Hall. [3.47] Built from 1731 to 1748 to house the Pennsylvania Provincial Assembly, it was designed by the prominent Philadelphia lawyer Andrew Hamilton, working with carpenter Edward Wooley. It is a two-story rectangular brick block, with a simple single-pile plan but greatly expanded about a huge square central hall. One side was a large room for the assembly, and on the other an equally large chamber for the Supreme Court. The end walls rise to chimney banks. At the roof, between the chimneys, run balustrades whose horizontal line is reinforced by stringcourses and

water table. The corners are quoined. Small in-line offices were originally attached to the main block by open colonnades. Later, even larger outer dependencies were added to either side. The south facade was soon dominated by the addition in 1750–56 of a massive square stair hall, capped by a great bell tower and steeple. The designer and builder was again Edward Wooley. The tower was ordered by the assembly to bring special attention to what was the grandest state house in the colonies; Wooley invented the design using as his basis the soaring Gibbsian church tower type, the only appropriate symbol colonial American then knew. The original wooden armature of the tower and steeple soon began to suffer from the weather, necessitating demolition of the tower in 1804; it was restored by William Strickland in 1828, then rebuilt again in the 1890s. Together with Christ Church, the imposing new State House vividly exemplifies the mature and cosmopolitan character of Philadelphia; it quickly became the biggest and most sophisticated city in the colonies.

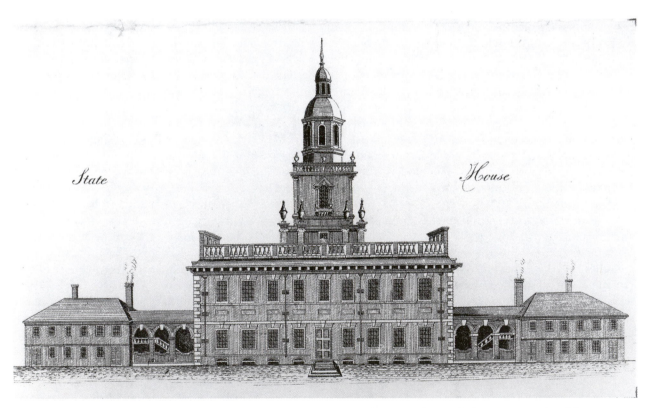

3.47. Andrew Hamilton, designer, Old State House (Independence Hall), Philadelphia, Pennsylvania, 1731–48. This contemporary view, from a map published in 1774, shows the original tower before its removal and later reconstruction. (Library of Congress, Map Division.)

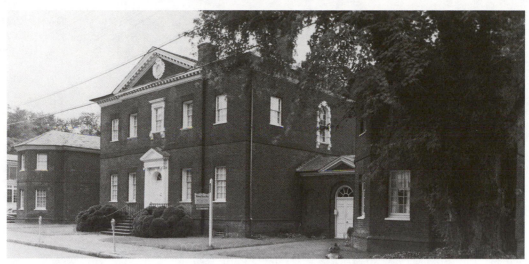

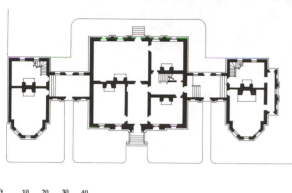

ft 10 20 30 40

m 5 10

3.48. William Buckland, Hammond-Harwood house, Annapolis, Maryland, 1773–74. Restrained on the exterior, this house incorporates some of the most elegant original ornamentation in its interiors. (Sandak, courtesy of the University of Georgia.)

3.49. Hammond-Harwood house, plan. Even for town houses, if enough land could be acquired, the preferred extended transverse plan could be used. (L. M. Roth, after Great Georgian Houses of America, *vol. 1, New York, 1933.)*

Gentlemen-Amateurs and Builder-Designers

A number of Virginia tidewater houses and a few northern buildings can be attributed to designers or architects. More often, however, the designer is unknown even when the reference to a Gibbs or Salmon source design is clear. The professional architect, as we use that term today, had not yet come into existence in the colonies. The major houses and public buildings of the eighteenth century were designed by well-to-do gentlemen with the leisure to read and pursue private study in architectural theory and design. That their designs blend together well is due to their common reliance on a coherent body of knowledge based on Renaissance principles, for the most part deriving from Palladio. There were a few individuals who received some training in England before moving to the colonies, such as James Porteus (in Philadelphia), John Hawks (North Carolina), James McBean (New York City), who was a pupil of Gibbs,

and John Ariss (Virginia). Most designers, however, were amateurs, having been trained in medicine or law, or as carpenters and cabinetmakers. Richard Munday, for example, designer of Trinity Church, in Newport (1725–26), and the Old Colony House, in Newport (1739–41), was a carpenter. William Buckland, born in Oxford, England, started as a woodcarver but trained himself in other trades, came to the colonies as an indentured servant, established himself as a builder-designer, and built one of the finest houses in Annapolis, the Hammond-Harwood house (1773–74), a kind of elegant urban villa built at the edge of the city for wealthy lawyer and tobacco grower Matthias Hammond. [3.48, 3.49] Although an urban residence, it employs a lateral five-part hyphenated plan more commonly used for country houses.

Among the gentlemen-architects were Joseph Brown of Providence, a merchant, mathematician, and a professor at Rhode Island College (later Brown

University); Dr. John Kearsley, a physician active in Philadelphia; and Andrew Hamilton, a lawyer active in politics in Pennsylvania. Richard Taliaferro of Williamsburg was a well-to-do planter. Moreover, painters, such as John Smibert and John Trumbull, often drew up designs for buildings—for example, Smibert's Faneuil Hall, in Boston, built in 1740–42 [see 5.8], or Trumbull's modifications to Connecticut Hall, at Yale University, built in 1797. Such amateurs were responsible for much creditable work, because building practice at the time left much of the detail and ornamentation to the builder and his craftsmen, who in turn referred to the standard details in builders' guild handbooks. The lean quality of architectural drawings of the period is well illustrated by Richard Munday's floor plan for the Daniel Ayrault house, in Newport, built in 1739, and the plan of the demolished Ninyon Challoner house of Newport, drawn up by Benjamin Wyatt (perhaps with Munday's assistance). [3.50] Munday and Wyatt Challoner, Newport carpenters, worked together at times; the contract for the Ayrault house was made jointly by Munday and Wyatt with Daniel Ayrault, although the inscriptions on the drawing appear to be in Munday's hand. The plan of the Challoner house is inscribed with the briefest but essential contract language:

This is a Draft of a Dwelling Houfe that Benjn Wyatt is to Build for Ninyon Challinor [sic] . . . March the 13 1735.

Benjⁿ Wyatt

Witnefes
Josia Lyndon
William Rogers.[13]

Peter Harrison

Perhaps the most erudite and accomplished of the gentlemen-architects of the century was Peter Harrison (1716–1775) of Newport, a native of Yorkshire who became a merchant and quickly accumulated a fortune working with his brother Joseph in the highly profitable luxury goods trade between New England, South Carolina, the West Indies, and England. He married a Newport woman of position and wealth. Thus situated, he had the time and means to pursue his hobby—architecture. He pored through the books in his growing library for models suited to particular building tasks. At the time of his death his architectural library consisted of twenty-seven titles, reputed to be the largest such collection in the colonies. His first major building, the Redwood Library, in Newport, built in 1748–50 [3.51], is based on an illustration by Edward Hoppus for the fourth book of

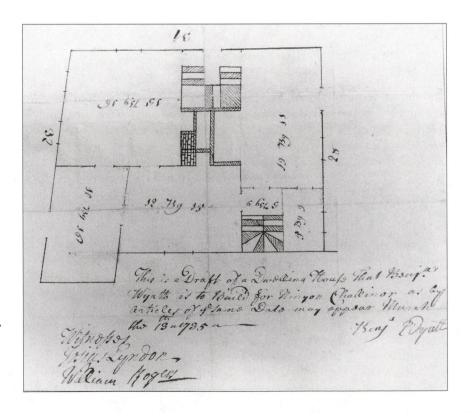

3.50. Richard Munday, Daniel Ayrault house, 1739. Typical of many working drawings of the time, this shows only basic dimensions, with locations of stairs, windows, and doors. The details were filled in by the builder. (Courtesy of the Newport Historical Society.)

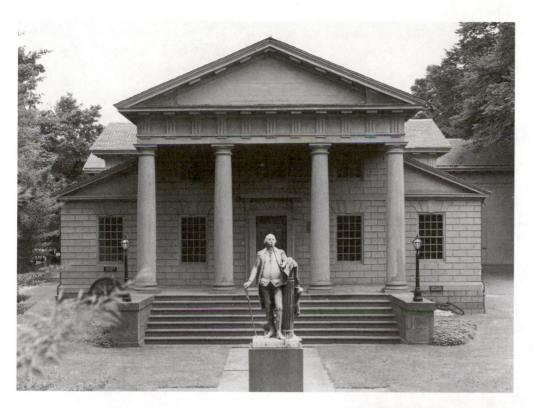

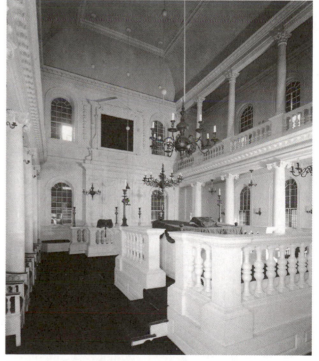

3.51. Peter Harrison, Redwood Library, Newport, Rhode Island, 1748–50. For this design Harrison drew from the plates in Edward Hoppus's Andrea Palladio's Architecture, *London, 1736. (Library of Congress, HABS RI 3-NEWP 15-3.)*

Andrea Palladio's Architecture . . . Carefully Revis'd and Redelineated, (London, 1736). Harrison's Redwood library consists of a Tuscan Doric temple front superimposed on a broader lower gable-ended block. Although the side wings appear to have rusticated masonry, the entire building is of wood, painted a chocolate brown with sand mixed into the paint to make the surface look like stone. For the details throughout, Harrison was totally dependent on his books. The library is also significant for the unusual nature of its public function at that time in the colonies.

One can see this scholarly quality more clearly in the interior of the Touro Synagogue, in Newport, built in 1759–63. [3.52] It too is drawn entirely from books, particularly Kent's *Designs of Inigo Jones*, but it is exquisitely done. Harrison's problem here was compounded since he had no well-established sectarian architectural heritage upon which to draw. He was designing a house for Sephardic Jews who had been attracted to Newport because of religious tolerance in Rhode Island. Indeed the colony itself had been established by dissenting Baptists who, led by Roger Williams, had fled from Massachusetts. Having no building type to emulate, Harrison used the simplest, most direct Georgian forms. Externally the building is

3.52. Peter Harrison, Touro Synagogue, Newport, Rhode Island, 1759–63. Plain outside, this has an interior drawn from plates published in several books. (Library of Congress, HABS RI 3-NEWP 29-10; photo by Arthur W. LeBoeuf, 1937.)

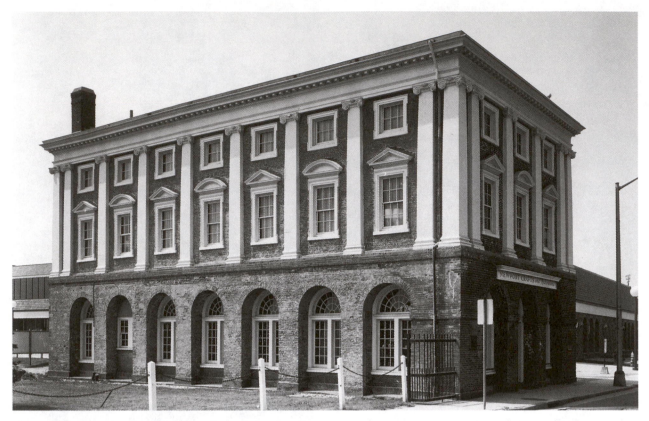

3.53. *Peter Harrison, Brick Market, Newport, Rhode Island, 1761–62. For this design, Harrison took his inspiration from Jones and Webb's Great Gallery of Somerset House,* published in Vitruvius Britannicus. *(Library of Congress, HABS RI 3-NEWP 26-3.)*

a plain cube with the main embellishment a small Ionic entry porch. Inside is a large room, its form suggested by Dutch synagogues and the Bevis Marks Synagogue in London of 1701. The room is framed on three sides by balconies for women, carried on twelve columns representing the twelve tribes of Israel. Altogether it is an exercise in lightness and refinement seldom equaled in the eighteenth century. The accomplishment of Harrison's synagogue is, as Harrison's biographer Carl Bridenbaugh put it, the perfect example of the "sweet reasonableness" of eighteenth-century Newport: Harrison, a devout Anglican Christian, was asked by Jews, professing a Near-Eastern faith, to devise a house of worship, which he pieced together with design elements based on models developed by pagan Romans.[14]

Harrison also was asked to design two churches in the Boston area: King's Chapel in Boston, built in 1749–58, and Christ Church in Cambridge, built in 1760–61, both greatly influenced by Gibb's St.-Martin's-in-the-Fields, though neither of them ever

received the steeples and spires designed for them by Harrison. The measure of his increasing professional competence is suggested by the number of drawings he supplied for these churches, including plans, elevations, sections, and drawings for interior details. But he asked for and received no payment for his considerable services.

Harrison was a staunch conservative, and throughout his life remained loyal to the British crown; he eventually ended his career as collector of customs for His Majesty's Government in New Haven, Connecticut, where his extensive library and collection of drawings most unfortunately were destroyed by an irate revolutionary mob. His innate conservatism, in life and in design, can be seen in the Brick Market, in Newport, built in 1761–62 [3.53], one of his last designs. This was to house market stalls on the open ground floor, with meeting rooms above. For his solution Harrison turned to a plate in the first volume of Campbell's *Vitruvius Britannicus* (1715) showing the Great Gallery at Somerset House, in London, by Inigo Jones and John

Webb. Subtle modifications were required, since the Newport building was to be brick with wood trim, but the proportions were retained, such as in the emphasis on the corners through widened arcade piers and double pilasters. The massiveness of the corner piers were visually necessary, since the ground floor was originally an open arcade (the openings have since been glazed and the area enclosed). Like the synagogue interior, the Brick Market is a very sophisticated and correct design, with perhaps a trace of the dryness to which academicism is prone.

Vernacular Traditions

The fashionable architecture discussed so far in this chapter—an architecture based on a self-conscious emulation of the latest published designs—perhaps constituted two percent of the total building activity of the period. These fashionable buildings have survived largely because they were built by individuals with the means to preserve them, or because the importance of these buildings was firmly established in their respective communities. As is always the case, however, a great many more buildings were erected that did not show any attempts to match the latest high fashion. They were built by settlers, untrained in the latest high-style design, who preferred to follow established practice, oral tradition, and local example in accordance with essential functional needs—to build, in other words, following vernacular traditions, yet often incorporating some references to fashionable building forms or details to the extent that they were able.

The Massachusetts saltbox houses, built on what was then the western frontier in Deerfield and Stockbridge, Massachusetts—the houses noted earlier in this chapter—are good examples of the gradual amendment of longstanding tradition, with the elimination of useless overhangs (which had required complicated joinery) and the introduction of double-hung windows and classical door frame surrounds in an otherwise late medieval house form. In this form, the updated saltbox spread westward into Vermont and upstate New York.

Another evolving tradition emerged in Pennsylvania, in the York and Lancaster counties west of Philadelphia, among German emigrants from the Palatinate region along the Rhine. Encouraged by William Penn, these Pennsylvania Dutch (so called because they identified themselves as *Deutsche*, "German") began arriving in large numbers after 1710; they introduced new skills, and because of their industriousness their farms were very prosperous. Some of the new arrivals stayed close to the western edge of Philadelphia, in an area soon called Germantown. One example of their stone construction there is the Green Tree Inn, built by Daniel and Sarah Pretorius in 1748, incorporating more local

3.54. Georg Müller house, Milbach, Pennsylvania, 1752. The Müller house is a good example of transplanted German house forms and building methods. (Courtesy of the Philadelphia Museum of Art.)

3.55. Müller house, plan. This plan type, with one large room flanked by two smaller ones, spread west through Ohio. (L. M. Roth, after Morrison.)

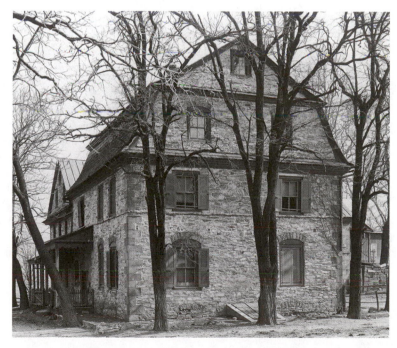

3.56. *Pennsylvania "Dutch" bank barn. The German (Deutsch) and Swiss barns found in southeastern Pennsylvania, are distinguished by the projecting, cantilevered forebay; often the end walls were of stone or brick. (From Fred B. Kniffen, "Folk Housing: Key to Diffusion,"* Annals of the Association of American Geographers, *December 1965.)*

3.57. *English barn. Rectangular in plan, under a gable roof, the English barn has a wagon door in the center of the long side. (From Kniffen.)*

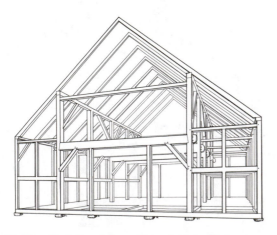

3.58. *New York Dutch barn. Found originally in upper New York State, the Dutch barn had heavy transverse frame bents over a longitudinal wagon passage. (L. M. Roth, after J. Fitchen,* The New World Dutch Barn . . ., *Syracuse, N.Y., 1968.)*

English traditions—especially in the long pent roof that stretches across the front. The distinctive Pennsylvania Dutch form of heavy timber framing, a variation on German *fachwerk* construction, can be seen in the Moravian Meeting-House, in Berks County, built in 1743–45. Stone construction was traditional among the Germans, as illustrated in the massive Georg Müller house, in Milbach, Pennsylvania, built in 1752, based on a Rhine valley plan type. [3.54] This has a large *küche* (kitchen, plus dining room) with a broad hearth, and two rooms to one side: a *stube* (living room) and a smaller *kammer* (bedchamber). [3.55] The Müller house also has the distinctive German gambrel roof, with flaring eaves on both the upper slope and the lower slope. Another dramatic expression of transplanted late medieval German architecture to Pennsylvania is found in the cluster of buildings called the Cloister, in Ephrata, near Lancaster, built in 1740–46 to house an ascetic community led by Johann Konrad Beissel. Abandoned by 1925, the communal buildings have been restored by the State of Pennsylvania.

It could be said that the single most important contribution of the Germans to American vernacular architecture and culture was the unique barn type they perfected—though perhaps equally important was their rapid adoption of "Swedish" log construction, which they introduced throughout the opening western territories. [3.56] The distinctive Pennsylvania Dutch bank barns were built on gentle hillsides, with a stone ground-floor basement set back into the hill or bank, with a two-level timber frame built atop it and overhanging on the downhill side, creating the distinctive "forebay" profile. Livestock were kept in stalls in the lower stone level and could exit through doors to the downhill barnyards; they were easily fed with grain and hay dropped from the upper storage area. On the uphill side ground-level doors permitted entry of hay wagons.

The Pennsylvania German barn is distinctive externally because of its projecting forebay (and also its painted folk designs). Two other regional barn types are somewhat less easily spotted, since their distinguishing features are primarily their internal frame construction and the point of wagon entry. The English barn, introduced into New England and the Chesapeake Bay areas, was basically a three-bay barn (three structural bays), with substantial corner and wall posts, and central posts marking the three bays. [3.57] Wagons entered through the middle bay on the long side, under the eave of the gable roof. Grain and

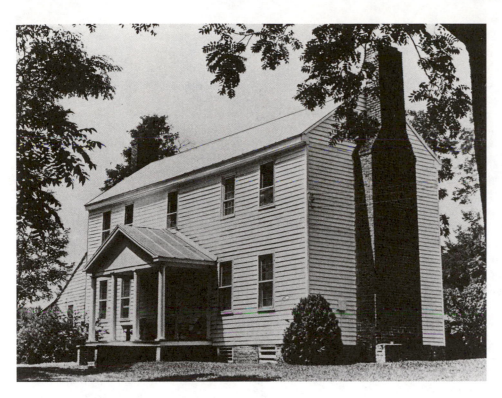

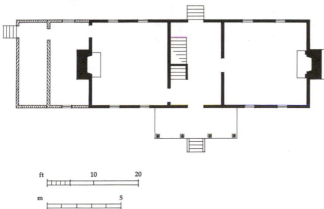

3.59. Shelton-Rigsby house, Louisa County, Virginia, c. 1770. Early prototype of the I-house type carried westward to the territories in Indiana, Illinois, and Iowa. (From Henry Glassie, Folk Housing in Middle Virginia, Knoxville, Tenn., 1975.)

3.60. Shelton-Rigsby house, first-floor plan. The absence of internal hallways is illustrative of the I-house plan type that developed from such houses in the nineteenth century. (L. M. Roth, after Glassie.)

hay were stored in the side bays, with the central bay kept clear to provide a threshing floor. If sloping ground was available, and animals could be housed in a masonry base level, the framed English barn could be built above; on flatter ground a ramp provided access to the threshing floor.

The Virginians modified the traditional English barn, introducing numerous top-pivoted vertical boards, or tall narrow doors, that could be opened for plentiful ventilation. These ventilated tobacco barns facilitated the slow curing of tobacco leaf and were vital to the enormously profitable tobacco agriculture that provided the economic base for this region.

Along the Hudson River, and elsewhere in the original Dutch settlement, the distinctive Dutch barn was prominent. Its plan was more square than that of the English barn, with heavy transverse frames or bents of stout timbers spanning a central longitudinal wagon passage that ran under the ridge of a more steeply pitched gable roof. [3.58] Whereas the English barn was used primarily for storage, Dutch barns were intended to house animals as well.[15]

In Virginia, two vernacular house types evolved during the eighteenth century that were then carried westward over the Appalachians and used, with numerous variations, in farmsteads throughout

Kentucky and beyond. The so-called I-house type developed in central Virginia; a good example is the wood frame Shelton house outside the town of Orchid in Louisa County, built in about 1770.[16] [3.59, 3.60] It consists of two nearly square rooms, roughly 19 feet deep in this case, on either side of a narrow entry/stair hall. Above are two additional rooms flanking the center hall. Large brick or stone chimneys are placed outside the walls at either end of the house. The tall rectangular block is capped by a steeply pitched gable roof. Square porches, or broader porches extending the width of the house, were the principle external embellishment. The other Virginia house developed closer to the bay and has been termed the tidewater house. Typically one room deep and two rooms wide in its larger form, it had an upper loft or an additional half story in the larger versions. In this house, too, large chimney masses are placed outside on either end of the house. Dormers punctuate the steep gable roof, lighting the upper rooms. A gallery porch might run across the front, and additions to the rear would be made with shed roofs.

In America the eighteenth century came to an abrupt and early close, at least culturally and politically, with the declaration of political independence from Great Britain in 1776. The resulting hostilities of the Revolutionary War ended with Lord Cornwallis's surrender to General Washington at Yorktown in October 1781. The conflict was not officially and formally resolved until two years later with the signing of the Treaty of Paris (where the negotiations took place), which granted the colonies their independence and fixed international boundaries. Then ensued the even more difficult task of determining how to make a democratic union of thirteen squabbling sovereign states; this would take another five years. Trying to define and build a more identifiable *American* architecture would be the next task of builders and architects in the new United States.

BIBLIOGRAPHY

Adams, William Howard. *Jefferson's Monticello*. New York, 1983.

Bridenbaugh, Carl. *Cities in Revolt: Urban Life in America, 1743–1776*. New York, 1955.

———. *Cities in the Wilderness: The First Century of Urban Life in America, 1625–1742*. New York, 1955.

———. *Peter Harrison, First American Architect*. Chapel Hill, N.C., 1949.

Downing, Antoinette F., and Vincent Scully. *The Architectural Heritage of Newport, Rhode Island, 1640–1915*, 2nd ed. New York, 1970.

Eberlein, Harold, and Cortland Hubbard. *American Georgian Architecture*. Bloomington, Ind., 1952.

Garvan, Anthony. *Architecture and Town Planning in Colonial Connecticut*. New Haven, Conn., 1951.

Howells, John M. *Lost Examples of Colonial Architecture*. New York, 1931.

Jackson, Joseph. *American Colonial Architecture*. Philadelphia, 1924.

Kimball, S. Fiske. *Domestic Architecture of the American Colonies and of the Early Republic*. New York, 1922.

McLaughlin, Jack. *Jefferson and Monticello: The Biography of a Builder*. New York, 1988.

Morrison, Hugh. *Early American Architecture, from the First Colonial Settlements to the National Period*. New York, 1952.

Morrison, Samuel Eliot. *The Oxford History of the American People*. New York, 1965.

Noble, Allen G. *Wood, Brick, and Stone: The North American Settlement Landscape, vol. 2, Barns and Farm Structures*. Amherst, Mass., 1984.

Patton, Glenn. "The College of William and Mary, Williamsburg, and the Enlightenment," *Journal of the Society of Architectural Historians* 29 (March 1970): 24–32.

Peterson, Charles E., ed. *Building Early America*. Radnor, Penn., 1976. Contains excellent essays on the Carpenter's Company of Philadelphia, early frame houses in tidewater Virginia, and the reconstructions of Independence Hall tower.

Pierson, William H., Jr. *American Buildings and Their Architects, vol. 1, The Colonial and Neo-Classical Styles*. Garden City, N.Y., 1970.

Reinberger, Mark. "Graeme Park and the Three-Cell Plan," in *Perspectives in Vernacular Architecture*, vol. 4. Columbia, Missouri, 1991.

Summerson, John. *Architecture in Britain, 1530–1830*, 5th ed. Baltimore, 1969. (The Pelican History of Art.)

Tatum, George B. *Philadelphia Georgian: The City House of Samuel Powel and Some of Its Eighteenth-Century Neighbors*. Middleton, Conn., 1976.

Upton, Dell. "Architecture: The British Colonies," in *Encyclopedia of the North American Colonies*, ed. Jacob E. Cooke. New York, 1993.

———. "Vernacular Domestic Architecture in Eighteenth-Century Virginia," *Winterthur Portfolio* 17 (Summer–Fall 1982): 95–119.

Waterman, Thomas T. *Domestic Colonial Architecture of Tidewater Virginia*. New York, 1932.

———. *The Dwellings of Colonial America*. Chapel Hill, N.C., 1950.

———. *Mansions of Virginia, 1706–1776*. Chapel Hill, N.C., 1951.

Wells, Camille. "The Planter's Prospect: Houses, Outbuildings, and Rural Landscapes in Eighteenth-Century Virginia," *Winterthur Portfolio 28* (Spring 1993): 1–31.

Wenger, Mark R. "The Central Passage in Virginia: Evolution of an Eighteenth-Century Living Space," in *Perspectives in Vernacular Architecture*, vol. 2. Columbia, Missouri, 1986.

Whiffen, Marcus. *The Eighteenth-Century Houses of Williamsburg: A Study of Architecture and Building in the Colonial Capital of Virginia*. Rev. ed. Williamsburg, Va., 1984.

———. *The Public Buildings of Williamsburg, Colonial Capital of Virginia: An Architectural History*. (Williamsburg, Vir., 1958.

Whiffen, Marcus, and Frederick Koeper. *American Architecture, 1607–1976*. Cambridge, Mass., 1981.

The White Pine Series of Architectural Monographs. 1915–28 and 1932–41.

NOTES

1. Colonial population figures adapted from Bridenbaugh, *Cities in the Wilderness*; Bridenbaugh, *Cities in Revolt*; and Joseph R. Conlin, *The American Past* (New York, 1987), 89.

2. Noted in J. W. Reps, *The Making of Urban America* (Princeton, N.J., 1965), 111.

3. The Governor's Palace in Williamsburg, built by Henry Cary, was the most elegant residence in any of the colonies, but it burned to the ground in 1781; what stands in Williamsburg today is a twentieth-century reconstruction, complete with a modern internal steel frame! By the time of its completion the house was already being called "a palace" by Virginian colonials who resented the high tax levies caused by its exorbitant cost.

4. See Dell Upton, "Vernacular Domestic Architecture in Eighteenth-Century Virginia," *Winterthur Portfolio* 17 (Summer–Fall 1982): 95–119.

5. Byrd, letter to Mr. Spencer, London, quoted in Thomas T. Waterman, *The Mansions of Virginia, 1706–1776* (Chapel Hill, N.C., 1944), 149. More recently scholars have suggested that the present house dates from the years immediately following a fire, 1748–49.

6. Cited in H. Morrison, *Early American Architecture*, 348.

7. Quoted in Bridenbaugh, *Cities in the Wilderness*, 308.

8. The Wentworth-Gardner house was restored by Wallace Nutting in around 1915. The front door itself is original, but the door surround, destroyed by a nineteenth-century portico addition, was rebuilt, and the broken scroll pediment was copied from one from Salem, Massachusetts, held by the Essex Institute in Salem. See Richard M. Candee, *Building Portsmouth: The Neighborhoods and Architecture of New Hampshire's Oldest City* (Portsmouth, N.H., 1992), 64–65.

9. Quoted in Waterman, *The Mansions of Virginia*, 244.

10. Selections from Gibbs's *Book of Architecture* (London, 1728) are reproduced in *America Builds*, including his preface, introduction, and plates 3, 30, and 58, mentioned later in this chapter.

11. Gibbs, *A Book of Architecture*; see also *America Builds*, 16–22.

12. Quoted by Marcus Whiffen, *American Architecture, 1607–1976*, 76.

13. The Ayrault and Challoner drawings by Munday Wyatt are in the collection of the Newport Historical Society, Newport, Rhode Island, P2773, P2774. The plans are also reproduced and discussed in Fiske Kimball, *Domestic Architecture of the American Colonies and of the Early Republic* (New York, 1920). The contract between Munday and Wyatt, jointly, with Ayrault, dated 1739, was published along with other papers relating to the Ayrault house in George C. Mason, "Colonial Architecture II," *American Architect and Building News* 10 (August 20, 1881): 83–84, and is reprinted in *America Builds*.

14. See Carl Bridenbaugh, *Peter Harrison, First American Architect* (Chapel Hill, N.C., 1949), 104.

15. The were many variations regionally, as well as numerous smaller specialized farm structures facilitating particular activities. For an introduction see Allen G. Noble, *Wood, Brick, and Stone: The North American Settlement Landscape*, vol. 2, *Barns and Farm Structures* (Amherst, Mass., 1984).

16. The term I-*house* was popularized by cultural geographer Fred B. Kniffen; see his article "Folk Housing: Key to Diffusion," in *Common Places*, ed. Upton and Vlach, 3–26 (first published in 1965). For the upland vernacular houses of Virginia, see Henry Glassie, *Folk Housing in Middle Virginia* (Knoxville, Tenn., 1975).

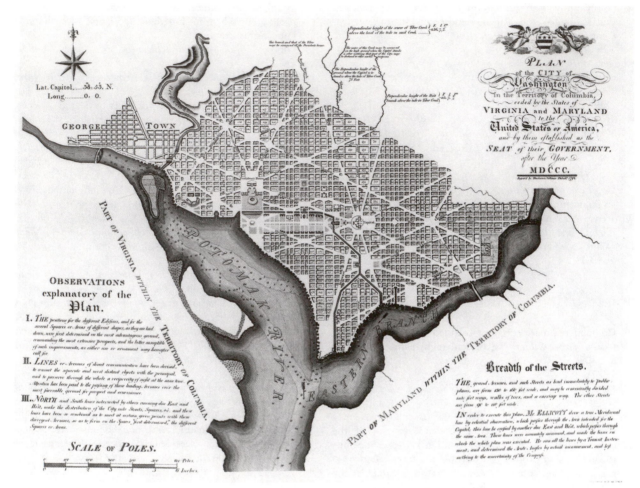

4.1. Charles Pierre L'Enfant, Washington, D.C., 1791, "Plan of the City of Washington in the Territory of Columbia," as prepared by Andrew Ellicott, Philadelphia, 1792. L'Enfant's plan for the seat of the new democracy was, most ironically, inspired by the radial roads of the gardens of Versailles, the retreat of the king of France, but L'Enfant's radial arteries were named for the thirteen original colonies. (Library of Congress, Map Division.)

A NEW ARCHITECTURE
FOR A NEW NATION, 1785—1820

SEARCHING FOR SYMBOLS OF DEMOCRACY

During the Revolutionary War building activity virtually came to a halt. When building resumed with improved economic conditions after the Peace of Paris in 1783, architecture in the new United States of America began to change as architects came to feel that it should be symbolic of the new nation. In some areas, particularly in Virginia, and among those people influenced by Thomas Jefferson, this quest for a new architecture became a passion.

The constitutional government created in 1787 was an experiment in applied Enlightenment philosophy that rejected monarchical absolutism and attempted to re-create the natural society in which it was believed human beings were meant to live. Thus architects correspondingly rejected Baroque-Rococo complication of form (as in English-influenced Georgian architecture) in search of a simpler architecture suggestive of the first civilized state of primal humans. The most radical architects, such as Ledoux in France, and Jefferson and Latrobe in the United States, even suggested that architecture should be an instrument of social reform, a tool to instruct and reshape men's minds, and to enhance civil intercourse.

This new architecture, drawn from a supposedly purer past, developed as part of an increasingly critical, scientific, and analytical view of human history that arose during the eighteenth century. According to this new perception of history, the past consisted of consecutive evolutionary periods. Once the period in which the democratic and republican state arose had been identified, it became theoretically possible to re-create its architecture. Moreover, since the new nation borrowed so heavily from the form and terminology of the Roman republican government, it was natural that architectural forms of the Roman Republic should have been among the first taken up by American architects.

ECLECTICISM

In addition, American architecture in the period from 1785 to 1820 lost its distinctly provincial status and began to enter the mainstream of Western romantic eclecticism. This eclectic approach to architectural design stressed the visual associations that a building's design made to a period in history whose image was instructive or enlightening. The sensations evoked by these associations might include pleasure and idyllic nostalgia, or even awe and terror. Forms could be drawn from all phases of human history, from any time or place, past or present, near or distant. This architectural associationalism first appeared about 1730 in eighteenth-century Europe, in landscaped gardens where freestanding isolated pavilions recalled Roman gates, Chinese pagodas, Greek temples, or ruined Gothic abbeys as objects of contemplation.

Around 1785 this generalized associationalist phase led to more complex references to specific styles whose images were historically and symbolically associated with the function of a proposed new building—Gothic for churches, Roman for governmental structures, Egyptian for mortuary structures, for example. A few architects, like Benjamin Henry Latrobe, extrapolated essential principles of structure and elemental form from this study of past architecture and fashioned wholly new buildings, employing a truly synthetic eclecticism. In addition, there were always some

designers who, knowing the styles, attempted to demonstrate as many as possible in a single building, combining elements in a show of erudition, exemplifying a different form of synthetic eclecticism.

After 1820, however, increasingly knowledgeable clients required, and better trained architects were able to provide, a high degree of archaeological accuracy in their historicist designs, even to the point of replicating well-known ancient buildings. Lasting up to about 1850, this was the age of architectural revivalism.

Following the Civil War the limits of revivalism were broken by an extremely inventive phase of creative eclecticism in which classical and Gothic models were more freely interpreted to permit great flexibility in planning and personalized detail. By 1885, however, an increasing number of architects were being academically trained, and they brought a firmer sense of discipline to design, resulting in wholly contemporary plan arrangements in buildings carefully detailed with great archaeological accuracy. The trained sensibilities of these architects allowed them to design such things as large post offices, museums, even huge train stations, as though they were Roman, Renaissance, or Gothic designers. This creative but academic eclecticism lasted in the United States from about 1885 up through 1940. In 1946, after the Second World War, eclectic associations in design were drastically restricted so that the only references that could be made were to mechanical and industrial imagery. American architects embraced Modernism as it had been defined in Europe. For several decades the conventional wisdom was that eclecticism was forever dead, and that the new industrial imagery was the true architecture and not an applied style. By 1965, the limitations of this strictly utilitarian and mechanical imagery were becoming evident, and gradually a new acceptance of older traditional eclectic associations emerged in what came to be called Postmodernism.

To mention all these phases of eclecticism at this point puts us ahead of the story, but it is important to recognize that virtually all of Western architecture since at least 1750 has been based in some measure on adaptations of historical styles to create associations in the mind of the user or observer in order to strengthen and enhance the functional purpose of the building, even when those associations were to industrial processes.

In their search for associational references, architects of the early American republic were greatly aided by the flood of publications that began to appear in

the eighteenth century authoritatively illustrating classical antiquity. The excavations of Herculaneum, started in 1738, and of Pompeii, begun ten years later, mark the beginning of modern archaeology, and were followed by publications of the architecture and artifacts uncovered there. Numerous expeditions set out to measure and record ancient building sites, such as those of Robert Wood to Palmyra, Robert Adam to Spalato, and James Stuart and Nicholas Revett to Athens. All of these resulted in illustrated folios that for the first time put into the hands of architects relatively accurate records of antiquity. Furthermore, there was a new focus on the structural logic of ancient architecture, initiated by the French Jesuit priest Marc-Antoine Laugier in his *Essai sur l'architecture* (1753), in which Laugier argued for a truthful expression of shelter based on a hypothetical "primitive hut." Structure, he said, consisted basically of column, entablature, and roof; buildings should be formed of simple geometric units such as spheres, cubes, and pyramids. Treatises such as Laugier's led to the development of an architecture that was rational, clearly articulated, and that attempted to show in its parts how it was put together and how it worked.

American architecture began to express all of these emerging ideas. Latrobe best exemplifies the rationalist attitude, while Jefferson is a good example of the idealist who sought to translate classical architecture to the New World because of its associational lessons. In New England especially, after the Revolutionary War, architects were more tradition-oriented, and they evolved a new national style based on Roman sources as interpreted by the contemporary English architects Sir William Chambers and Robert Adam. Thus American architecture from 1780 to 1820 was a combination of many expressions; it was a period of searching: combining ideas both conservative and radical, old and new, in search of an American identity.

PLANNING THE NATIONAL CAPITOL

The establishment of the capital city for the new nation is a good demonstration of the way in which many artistic sources were combined. The site along the Potomac River between Maryland and Virginia, selected by George Washington to appease factions in the North and South, was convenient to sea vessels and yet had water connections to the interior uplands. The planning of the city, based on suggestions by Washington and Jefferson, was entrusted to one of

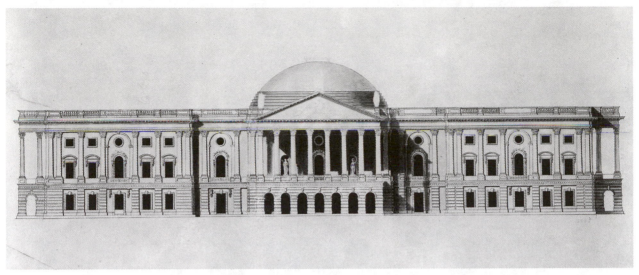

4.2. Dr. William Thornton, United States Capitol, Washington, D.C., 1792. Dr. Thornton's design for the legislative house, called Capitol after the Capitoline Hill in Rome, was a combination of broadly scaled Georgian classicism in the wings, with a low Roman saucer dome over the central circulation space. Ink and watercolor on paper. (Library of Congress.)

Washington's aides during the war, French architect and military engineer Major Pierre Charles L'Enfant (1754–1825). As L'Enfant surveyed the site in spring 1791 he selected the two highest points in the tidal plain as the locations of the two centers of the government, the house of the Executive and the house of Congress. Around these two nodes the entire plan for the District of Columbia was established. [4.1] From the Federal or Congress House (or Capitol, as it was later called) a wide esplanade was projected westward to the river, to be framed on either side by residences of ambassadors and new public buildings. Intersecting it at right angles was another lawn stretching southward from the President's House, resulting in an arrangement much like that of Williamsburg. Directly connecting the two centers, L'Enfant projected a bold diagonal street, Pennsylvania Avenue, providing ease of access and "reciprocity of sight," which he believed very important.[1] In this way he sought to symbolize the balance of powers in the new constitutional government. Using this diagonal as a starting point, L'Enfant then sketched out complementary diagonals radiating from the two centers, and over this web of diagonals he threw a rectilinear grid of streets aligned to the points of the compass. Where the diagonals met in great *rond points* L'Enfant provided places for public buildings and monuments. Essentially the conception of Washington, D.C., is based on axial and radial Baroque planning that L'Enfant had seen as a boy in the Garden of the Tuileries and at Versailles, but he added a standard, orthogonal rectilinear grid. Far in advance of its time was the vast scale on which L'Enfant planned, for only in the twentieth century was the district fully built over.

At the two foci of his plan, L'Enfant positioned grand monumental buildings, but when the competition for the House of Congress was held in 1792, the submissions proved that native designers were simply not yet sufficiently trained to handle such large compositions. The design eventually awarded first prize was submitted after the deadline by Dr. William Thornton (1759–1828), a physician, born in the West Indies and trained in Edinburgh and Paris. [4.2] His scheme was basically late Georgian in conception, consisting of wings for the House of Representatives and the Senate flanking a center block with the temple front capped by a low saucer dome. The smooth low Roman dome and the temple front show Thornton's study of antiquity, but the pilasters and other details show his traditional roots in Georgian architecture. Construction proceeded slowly, and when the government officially occupied the new city in 1800, the two wings stood on either side of a void where the domed rotunda was intended to be. Under Latrobe's supervision from 1803 to 1817, and then Bulfinch's from 1817 to 1830, the exterior of the building was slowly carried to completion, essentially according to Thornton's plan.

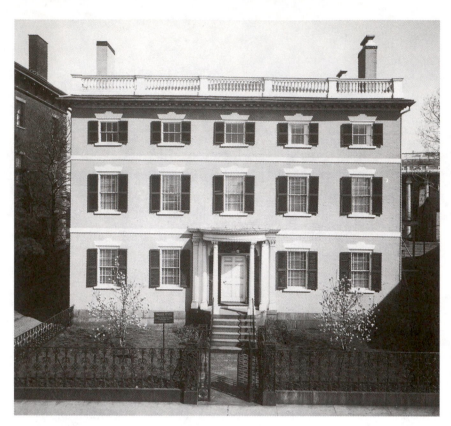

4.3. *Samuel McIntire, John Gardner (Pingree) house, Salem, Massachusetts, 1805. McIntire's Gardner house shows the strong influence of his contemporary Charles Bulfinch in Boston in its emphasis on restricted ornament and carefully calculated proportions. (Courtesy of Essex Institute, Salem, Massachusetts.)*

The premium for the design for the President's House went to an architect who had European training, the Irishman James Hoban (c. 1762–1831), whose design was inspired by plate 51 in Gibbs's *Book of Architecture* and also greatly resembled Leinster House, in Dublin, Ireland. It was a dignified, sedate block, punctuated on its south front by a projecting bay containing an oval office, the most distinguished feature of the design. Construction was supervised by Hoban (who unlike Thornton was specifically trained as an architect) and started in 1793, continuing through 1801, when President Adams moved into the still unfinished house. For a time Hoban supervised construction of the Capitol as well. Though Hoban's work was more restrained and sophisticated than Thornton's, no one seemed to note the irony that the two most important and symbolic buildings created for a radically new government were highly conservative in design and adhered closely to the traditions of English Georgian architecture. Nor, for that matter, did anyone protest that the city's plan was derived from the park surrounding the palace of Europe's most self-important absolute monarch.

SAMUEL McINTIRE

In New England, too, architecture remained particularly conservative during this period, but increasingly, along the eastern seaboard, major private and public buildings were being designed by known designers and trained architects rather than by builders and housewrights. Because of the resulting association with the ruling mercantile aristocracy in and around Boston, the term *Federal* (or sometimes Federalist) has been given to the architecture there during the years 1785 to 1820. Although this term is problematic when applied to the more innovative neoclassical work farther south, it is very apt in describing the work of McIntire in Salem and Bulfinch in Boston. Both of these men were conservative in nature and, in working for the well-to-do merchants of their respective areas, made modifications on contemporary English models, gradually moving away from colonial and English prototypes.

Samuel McIntire (1757–1811) was from Salem Massachusetts; he was the son of a housewright and woodcarver and became a carpenter and woodcarver

4.4. Gardner (Pingree) house. Parlor interior. What especially distinguishes McIntire's houses is the great attention he and his assistants gave to the interiors, with delicate, attenuated classical forms used throughout. (Sandak, courtesy of the University of Georgia.)

himself. Because of this, his buildings have an assured tightness of carved wooden ornament that is distinctive. An early example is the house he designed for merchant Jerathmeel Pierce in Salem in 1782 (now called the Pierce-Nichols house), which was based on Georgian types such as the Major John Vassal house in Cambridge, Massachusetts (1759) and the Isaac Royal house in Medford (1747–50). Like them McIntire's Pierce house has a compact rectangular plan with central hall, central entrance, and clapboarded walls with colossal pilasters at the corners in place of quoins. Unlike McIntire's models, however, the Pierce house has a balustrade directly atop the main cornice, so that the low hip roof is entirely obscured and the house has a sharper, more cubic appearance.

This cubic severity is even more pronounced in McIntire's masterpiece, the John Gardner (Pingree) house, in Salem, built in 1804–6 for a grandson of Richard Derby, one of McIntire's earliest patrons. [4.3] Actually the house extends well to the rear, and its plan is more irregular than the facade suggests [see 4.9], but the front is austere to the point of starkness

and gains its particular distinction entirely through the careful arrangement of proportioned parts and the position of windows and horizontal stringcourses. The central entrance is the clear focal point, and the extremely thin white Corinthian columns stand in sharp contrast against the brick walls. This portico is characteristic of much New England Federalist work, with its attenuated, wiry, taut, linear details—forms originally meant for stone but translated here into delicately carved wood.

The same crisp linearity appears in the ornamental devices of the interior, all designed and in part carved by McIntire himself. [4.4] In a sense, this is a furniture-maker's aesthetic, for the same refinement of component parts appears in the chests designed and carved by McIntire, most particularly the chest-on-chest constructed for its designer, McIntire, by William Lemon in 1796 (now in the Boston Museum of Fine Arts). This too has elegantly severe and elongated forms, such as reedlike Ionic colonnettes at the corners, so much like the colonnettes supporting entablature-mantelpieces in the rooms of the Gardner house.

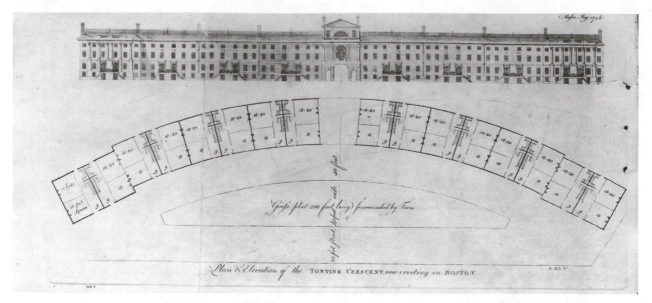

4.5. Tontine Crescent complex, Boston Athenaeum, 1794. Bulfinch's venture into urban design was inspired by the elegant town house rows he had seen in England; this crisp engraving showing half of the proposed oval was perhaps the first significant architectural illustration produced in the new United States. (From Massachusetts Magazine, February 1794, courtesy of the Boston Athenaeum.)

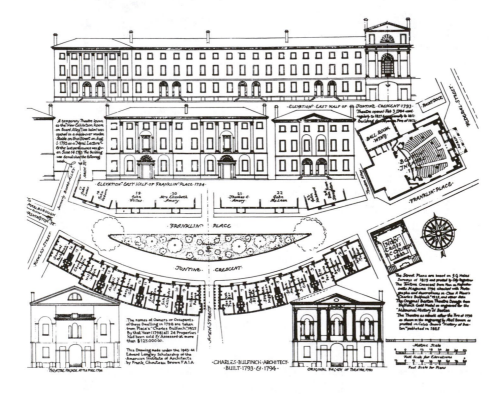

4.6. Charles Bulfinch, Tontine Crescent (Franklin Place), Boston, Massachusetts, planned 1793. This redrawing of the Tontine Crescent complex, done by Frank Chouteau Brown in 1933–44, combines the finished half crescent, the other town houses across the park strip also designed by Bulfinch, together with his Holy Cross Roman Catholic Church, 1803, and his Boston Theater of 1793. Together these made up the first planned housing complex in the United States. (From C. Greiff, Lost America: From the Atlantic to the Mississippi, Princeton, N.J., 1971.)

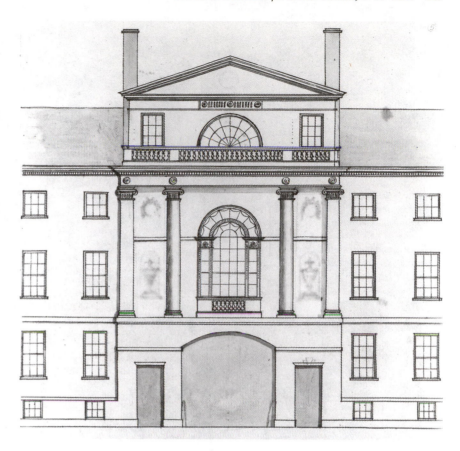

4.7. Charles Bulfinch, elevation of the central pavilion open to Arch Street. Bulfinch's early draftsmanship was simple, leaving much to the builder's discretion in the details; note the bleached erasures where Bulfinch changed his mind about the recessed niches with decorative urns. (Library of Congress, USZ62-32386.)

CHARLES BULFINCH

McIntire was not possessed of a particularly inquiring or probing mind and was content to repeat himself in his work, making only gradual changes. His fees, like those of other carpenters and craftsmen, were paid when specific phases of work were done, bit by bit. Charles Bulfinch (1763–1844) was altogether different. The well-educated son of a wealthy Boston merchant family, Bulfinch took up architecture as a gentlemen's avocation but eventually made it his true vocation, being paid fees for design and construction. Although Bulfinch's early designs were based closely on contemporary English examples, he developed a more unique and recognizable personal style, and his work underwent a greater degree of stylistic evolution than did McIntire's.

Bulfinch was educated in the classics at Harvard College, and, thanks to a bequest to his family, was able to make the Grand Tour of Europe, spending most of his time in England. While still a youth he had begun the gentlemanly study of architectural design,

but later when reverses in family fortunes forced him to develop a source of income, he made his living by designing buildings, which were executed by housewrights and carpenters. His primary fixed income was the small salary he drew as superintendent of police of Boston, and the fact that he held this post is a measure of his concern for the welfare of his city. Bulfinch was elected to the Board of Selectmen when he was twenty-one and he served almost continuously (except for four years) until he went to Washington, D.C., in 1817; perhaps no American architect since Bulfinch has been so politically active.

Bulfinch's exposure to the great cities of Europe, especially London, had made it clear to him that Boston in the 1780s was still basically medieval; and so Bulfinch devoted himself to reshaping his home city. One of his first designs shows the scope of Bulfinch's thinking; this was the Tontine Crescent, planned in 1793, a speculative venture into which Bulfinch poured his personal fortune. It was to consist of two curving arcs of town houses, facing each other and enclosing an elliptical park. [4.5, 4.6] Only the

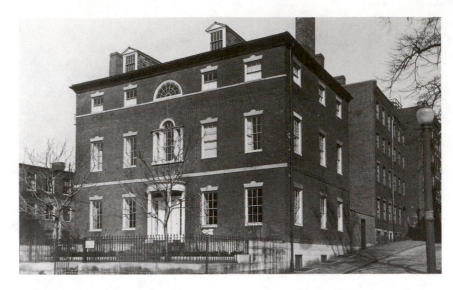

4.8. Charles Bulfinch, First Harrison Gray Otis house, Boston, Massachusetts, 1795–96. Bulfinch designed three houses for Otis, as he and fashionable Boston society gradually moved westward from Beacon Hill and the heart of the old city. In this first Otis house, Bulfinch eliminated nearly all exterior ornament, relying on the delicate tracery of the center door and windows, as well as the studied proportions of window shapes and wall surfaces for visual delight. (Library of Congress, HABS 13-BOST 113-1.)

O-1

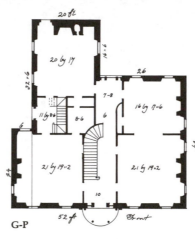

G-P

ft	10	20	30	40

m		5		10

4.9. O-1: Charles Bulfinch, First Harrison Gray Otis house, Boston, Massachusetts, 1795–96, plan. This relatively compact double-pile plan has the kitchen in an ell extension to the rear. The debt of Salem builder-architect Samuel McIntire to Bulfinch is evident in the comparison of the Bulfinch's first Otis house plan, 1795, to McIntire's plan for the Gardner-Pingree house in Salem, G-P, designed in 1804. (O-1 plan: L. M. Roth, after Hugh Simpson; G-P plan: L. M. Roth facsimile of McIntire plan, T. Hamlin, Greek Revival Architecture in America, *London, 1944.)*

southern crescent was completed as planned. Construction was of brick (painted gray to suggest stone), but ornament was so restrained that there were not even frames around the windows. In the center of the arc was a projecting pedimented pavilion, opened at ground level by a passage leading to a street behind. [4.7] The ends of the arc were emphasized by bringing the houses slightly forward and embellishing them with engaged colossal columns. While the basic sources of this residential group were Robert Adam's Adelphi Terrace in London, and the Circus and Crescent in Bath by the two John Woodses (father and

son), in comparison to these Bulfinch's work was very spartan and severe, relying for visual enrichment on the proportions of solid and void.

Bulfinch completed an impressive number of fine houses on or near Beacon Hill, including the three large houses built in succession for Harrison Gray Otis (1795–97 [4.8, 4.9], 1800, and 1806), as well as several house rows or terraces, continuing the theme introduced in the Tontine Crescent, first with a group of eight town houses (1804) on Park Street across from the new State House, and then the larger Colonnade Row of nineteen units (1811) on the south

side of the Common. These, and other houses by Bulfinch on Chestnut and Mt. Vernon Streets on Beacon Hill, set the pattern for later development, leading to Louisburg Square, built from 1826 to 1840, one of the best adaptations of the London residential square in the United States. [4.10] More fortunate than the demolished Tontine Crescent and Colonnade Row, Louisburg Square survives nearly intact, a rectangular court developed by S. P. Fuller with about thirty adjoining houses enclosing a private fenced park. The houses, particularly those lining the south side, have the bowed fronts that soon became characteristic of this area of Boston, and though they have accurately detailed Greek Doric porticoes, characteristic of the 1840s, the severity of solids and voids and the plain brick construction show the pervasive influence of Bulfinch, which eventually shaped the architectural character of nineteenth-century Boston.

The residential development of the Beacon Hill area had, in fact, been accelerated by construction of another Bulfinch building, the new Massachusetts State House, built in 1795–97. [4.11] As early as 1787 the youthful Bulfinch, just returned from England, had made a proposal for a new state house, but it was eight years before construction was begun. Again the architect referred to contemporary English buildings in his design. One was the central pavilion of Sir William Chambers's Somerset House, of 1776–86, but Bulfinch avoided Chambers's heavy carved ornament and stressed instead lightness and attenuation, using brick with stone and wood trim. Set near the top of Beacon Hill at a time when only fields lay to the south, the new state house commanded the open expanse of the Boston Common, and to accomplish this Bulfinch employed a broad portico on a high arcaded brick base in front of the rectangular building (similar to the broad colonnade on arcade built at Heveningham Hall, in Suffolk, by James Wyatt in 1778–84). Furthermore he called for a particularly tall, smooth hemispherical dome, framed in wood (later covered with gold leaf). The large central Hall of Representatives inside, with its low, hemispherical vault (of plaster on lath), was similar to the plaster dome of Wyatt's popular Pantheon in London, built in

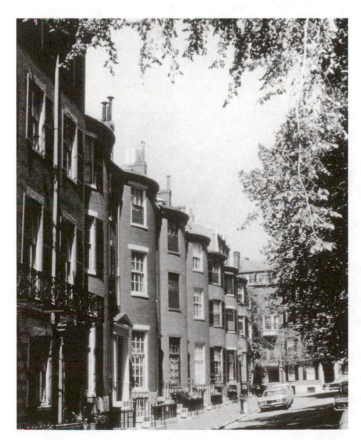

4.10. S. P. Fuller, builder, Louisburg Square, Boston, Massachusetts, 1826–40. Inspired by the example of Bulfinch's individual houses and his row houses, developers like Fuller expanded on these ideas; in the British tradition, the central fenced-off park preserve is held in common by those owning the houses around the park. (Photo: L. M. Roth.)

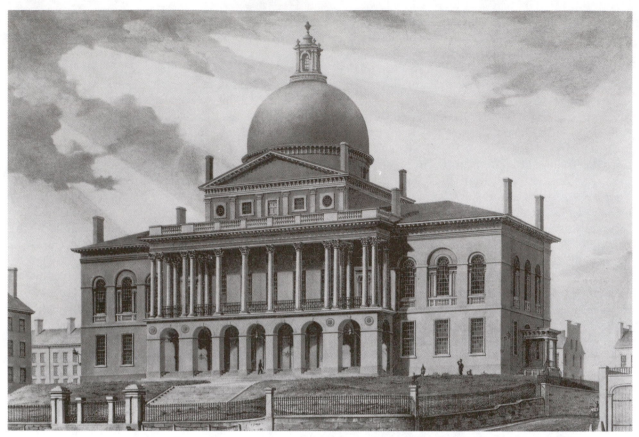

4.11. Charles Bulfinch, Massachusetts State House, Boston, Massachusetts, 1795–97, lithograph. Designed by Bulfinch as early as 1787, the design was slightly modified and built in 1795–97; it helped establish the image of the dome as appropriate for major government buildings. This lithograph, after a drawing by A. J. Davis, shows the building before later additions. (Courtesy of the Boston Athenaeum.)

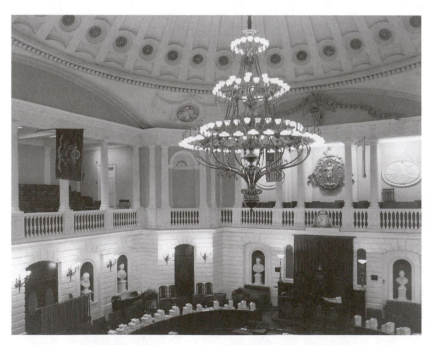

4.12. Massachusetts State House. The original Hall of Representatives is covered with a plaster on-lath dome. (Sandak, courtesy of the University of Georgia.)

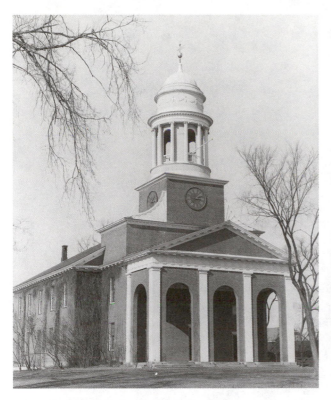

4.13. *Charles Bulfinch, Lancaster Meetinghouse, Lancaster, Massachusetts, 1815–17. In the Lancaster Meetinghouse, Bulfinch draws upon the well-established eighteenth-century meetinghouse form but expresses it in terms of Grecian details. (Library of Congress, HABS MASS 14-LANC 1-1; photo by Frank O. Branzetti, 1941.)*

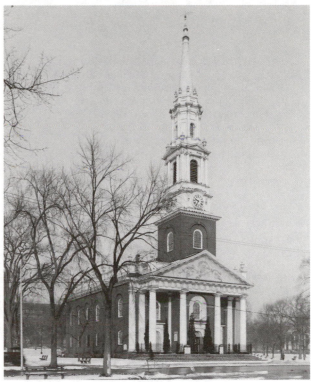

4.14. *Asher Benjamin (with Ithiel Town), First Congregational Church (Center Church), New Haven, Connecticut, 1812–14. This type of church design, conservatively based on the Gibbs model, was repeated throughout New England up to 1860. (Sandak, courtesy of the University of Georgia.)*

1769–71. [4.12] Even if inspired by various recent English models, Bulfinch's capitol was a bold and heraldic solution to the new American architectural problem of what a democratic state government building should be. It also defined the character of the common, and when, soon after, Bulfinch designed the town houses that lined the common to the northeast and southeast, the urban character of Boston was clearly determined. His effect on the city's waterfront was similar, for his India Wharf complex served as a model there, too.

In the state house and the Tontine Crescent, both early designs by Bulfinch, the debt to English sources is clear, but in his Lancaster Meetinghouse, built in 1815–17, greater stylistic maturity is evident. [4.13] The direct quotations are gone, and in their place is a marked concern for visual clarity and bold geometric forms. Each element of the meetinghouse—auditorium, tower base, belfry, portico—has its own distinct form but is related in turn to adjacent elements. The

portico is a simple arcaded block in brick, embellished with Doric pilasters supporting a full entablature, the cornice of which continues around the entire building, tying all parts together. The belfry in particular shows study of ancient Greek architecture. While the general configuration of the meetinghouse refers back to the Wren-Gibbs tradition of the generic New England meetinghouses, the overall sharpness of form and the reduction in ornament reveal the increasing innovative simplicity and unity of Bulfinch's work.

ASHER BENJAMIN

When the Lancaster Meetinghouse is compared to the First Congregational Church in New Haven, Connecticut, by Asher Benjamin, built in 1812–14, it is clear how much Bulfinch had moved away from his sources and how relatively conservative Benjamin was at this time. [4.14] Asher Benjamin (1771–1845) had

4.15. *Asher Benjamin, design for a church, fold-out plate 27 from* The Country Builder's Assistant *(Greenfield, Mass., 1797). This plan is similar to that of the Center Church in New Haven, but with a stouter spire. (Courtesy of the Art Institute of Chicago.)*

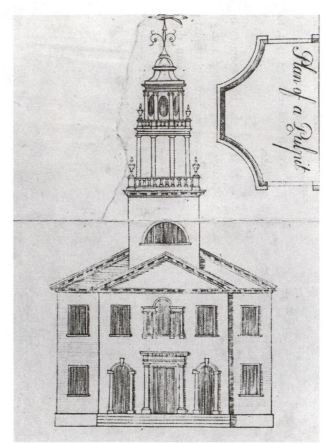

4.16. *Asher Benjamin, Ionic and Corinthian orders. In his first publication, the classical orders were not detailed, but in the second edition Benjamin included detailed plates such as this for the Roman versions of the orders; by the 1820s these plates were replaced with Greek versions borrowed directly from the publications of James Stuart and Nicholas Revett. (From Benjamin,* Country Builder's Assistant, *2nd ed., 1798.)*

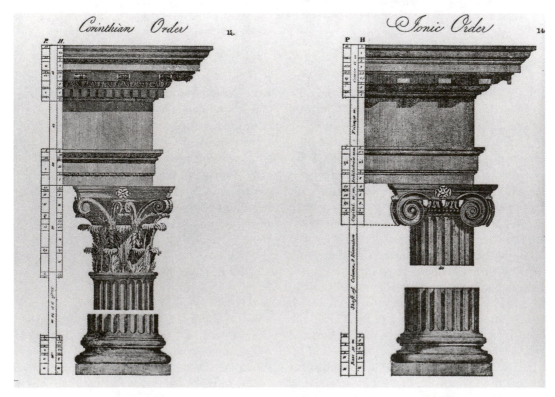

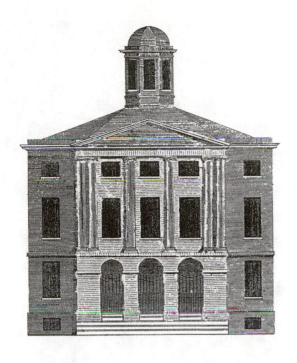

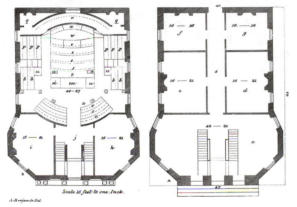

4.17. *Asher Benjamin, design for a county courthouse, facade, from* The American Builder's Companion, *Boston, 1806. Although looking a bit like a church, this design provides for ample circulation space and offices needed for a county courthouse. (From A. Benjamin,* The American Builder's Companion, *6th ed., Boston, 1827, plate 58.)*

4.18. *Design for a county courthouse, plans, from* The American Builder's Companion. *The upper-floor plan includes a courtroom and two jury rooms, while the ground floor provides space for country clerk, registry of deeds, grand jury, and probate court. (From Benjamin,* American Builder's Companion, *6th ed., Boston, 1827, plate 58.)*

been an assistant to Bulfinch and had helped in supervising construction of Bulfinch's new Connecticut State Capitol at Hartford, 1796, building the circular staircase following designs in Peter Nicholson's *The Carpenter's New Guide* (London, 1792). Even as the New Haven church was under construction, Benjamin himself was beginning to exert an enormous influence on rural architecture in New England through the publication of his own books patterned after those of Nicholson.

The Center Church, as it is called (for it stands in the center of the New Haven Green), is heavily indebted to the eighteenth-century Georgian Wren-Gibbs type. Such quality of design—well studied, well proportioned, well detailed, but rather conservative—

characterized the seven books by Benjamin, beginning in 1797 with *The Country Builder's Assistant* (Greenfield, Mass., 1797)—usually considered the first American pattern book—and followed by the enormously popular *The American Builder's Companion* (Boston, 1806), which ran through six editions up to 1827. [4.15, 4.16] Benjamin made special emphasis of the word *American* in the title, indicating that building needs and solutions on this side of the Atlantic had begun to differ significantly from practice in England. One example is his model design for a county courthouse, so much in demand in the rapidly developing hinterlands of all the new states.[2] [4.17, 4.18] His subsequent building manuals—*The Rudiments of Architecture* (Boston, 1814), *The*

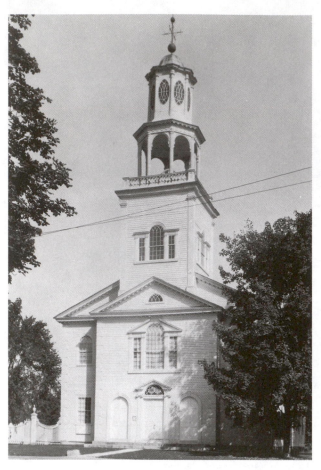

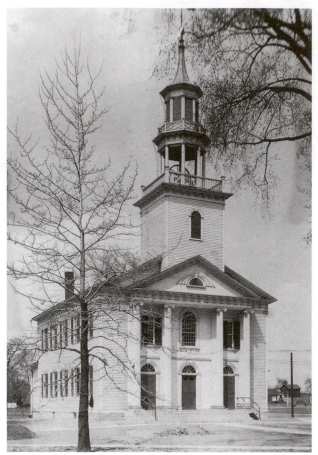

4.19. Lavius Fillmore, Congregational Church, Bennington, Vermont, 1806. Filmore's numerous churches, expanding on the Benjamin pattern, helped to establish this type of church all across the Northeast and westward through New York into northern Ohio. (Library of Congress, HABS VT 2-BEN 1-1.)

4.20. Lemuel Porter, builder, Congregational Church, Tallmadge, Ohio, 1822–25. Settled by emigrants from Connecticut, the Northern Reserve of Ohio had towns laid out like New England villages, with churches in their center squares just like those left behind. (Library of Congress, HABS OHIO 77-TALM 1-1.)

Practical House Carpenter (Boston, 1830), *Practice of Architecture* (Boston, 1830), *The Builder's Guide* (Boston, 1839), and *Elements of Architecture* (Boston, 1843)—appeared in numerous new editions through 1857, and, together with copies of his first books, were carried by settlers throughout the Northwest Territory, and even to Utah, Oregon, and California.

Variations on Benjamin's traditional meetinghouse design presented in *The Country Builder's Assistant* appeared throughout New England. An early example by Lavius Filmore once credited to Benjamin himself, is the Congregational Church of Bennington, Vermont, built in 1806. [4.19] More refined examples, closer in feeling to the Center Church and worthy derivatives of Gibbs's St.-Martin's-in-the-Fields, include Samuel Belcher's Congregational Church at

Old Lyme, Connecticut, built in 1816–17; David Hoadley's Congregational Church at Milford, Connecticut, built in 1823; and L. Newall's Congregational Church at Litchfield, Connecticut, built in 1828–29. The westward dissemination of Benjamin's influence is well illustrated in the Congregational Church at Tallmadge, Ohio, built in 1822–25 by Lemuel Porter, a master builder who came to the Connecticut Western Reserve (later northeastern Ohio) from Waterbury, Connecticut. [4.20] Even the Mormon Temple at Kirtland, Ohio, designed by Joseph Smith in 1833, shows the adaptation of Benjamin's designs to serve the needs of the fledgling Mormon church, and Benjamin's manuals were taken by the Mormons to Illinois and from there to Utah. Extremely practical books, aimed at the carpenter and

mechanic rather than the gentleman-amateur, filled with plates showing moldings, profiles, windows, staircases, and other details, Benjamin's first volumes established a refined New England Federalist style as the style of the newly opened West, especially in Connecticut's Western Reserve (later northeast Ohio). Later volumes, and later editions of the early books with updated plates, presented the Greek and Roman orders and helped spread the influence of the classic revival after 1820. Evidence suggests that Benjamin's books (or at least the memory of his designs) were carried as far west as Oregon.

BENJAMIN HENRY LATROBE

If the work of McIntire and Bulfinch represents conservative northern Federalist architecture, the architecture of Benjamin Henry Latrobe presents a far different and deliberately avant-garde model. Latrobe (1764–1820) rejected conventional Georgian sources and attempted to fashion an architecture of nearly pure geometry. He was an ardent student of classic architecture and often used classic elements; in this he was a neoclassicist. But Latrobe combined modern inspiration with numerous precedents from the past, making a truly synthetic architecture.

Born in England and educated in Germany, Latrobe trained in England with engineer John Smeaton and with the architect S. P. Cockerell. He knew well the advanced work of George Dance and Sir John Soane in England, and of Claude-Nicolas Ledoux in France. Although he began his practice in England, Latrobe's progressive political inclinations, financial reverses, and then the death of his first wife persuaded him to start anew in the United States. Of all the individuals discussed so far, he was the first to attempt to derive his sustenance solely from designing buildings; his entire energy was focused on the study of architectural and engineering problems, and his solutions accordingly departed radically from traditional forms. He supervised construction and insisted that his working drawings be followed explicitly, causing innumerable difficulties with the well-established and traditionally conservative carpenters' companies. Yet through his work, his example, and the influence of his students, he established the American architect as a professional.

Latrobe's radically progressive leanings and concern for social improvement are seen in one of the first buildings he completed in his adopted land, the State Penitentiary in Richmond, Virginia, built in 1797–98. [4.21, 4.22] The penal reform promoted by Latrobe and Jefferson incorporated a number of new ideas,

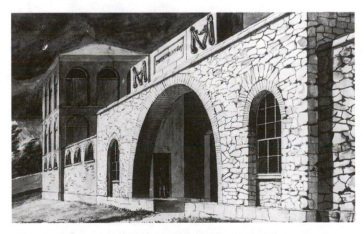

4.21. *Benjamin Henry Latrobe, Virginia State Penitentiary, Richmond, Virginia, 1797–98. Latrobe's watercolor perspective of entry uses the new word* penitentiary *over the door, to signify a place of reform, flanked by symbolic images of chains. (Courtesy of the Virginia State Library.)*

4.22. *Virginia State Penitentiary. Plan of ground floor showing the second phase of construction never carried out; the cells of the completed first section are arranged in a radial pattern then being studied by penal authorities in England. (L. M. Roth, after Latrobe.)*

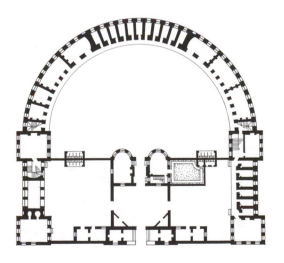

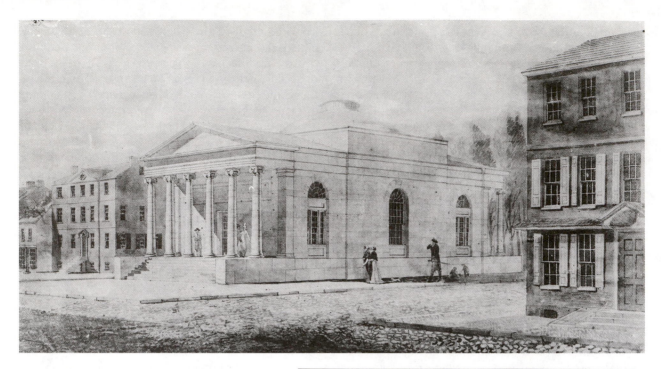

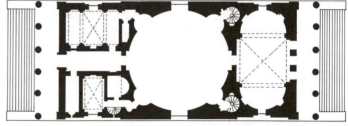

4.23. Bank of Pennsylvania. Latrobe's watercolor perspective shows his skills as an artist; the Ionic columns he used on the end porches were among the earliest true Greek orders used in the United States. (Papers of Benjamin Henry Latrobe, Maryland Historical Society.)

4.24. Benjamin Henry Latrobe, Bank of Pennsylvania, Philadelphia, Pennsylvania, 1798–1800. Latrobe's plan has the essential spaces arranged around a masonry-vaulted central banking room. (L. M. Roth, after Latrobe.)

such as cells arranged in a semicircle for easy surveillance from the center, improved ventilation and sanitary facilities, and cells for groups of reformed convicts. Externally the building was striking; the walls of brick formed unadorned massive superimposed blind arcades with windows sharply cut inside them. The entrance was formed by a huge semicircular arch springing directly from the foundation. Through the expressive power of the masonry itself, the building indicated its purpose; it was an American example of *l'architecture parlant* (the contemporary French phrase meaning, literally, "speaking architecture"), functionally expressive architecture in the manner of Ledoux or Boullee.

Latrobe's Bank of Pennsylvania in Philadelphia,

which soon followed, carried these expressive ideas further but with even more refinement of form. [4.23, 4.24] Built in 1798–1800, the building appears at first glance to be a Roman temple on a podium, but the building combines many elements, each of which is used to create and express a space designed for a specific use. The bank consists essentially of a large circular banking room flanked by offices and chambers. Externally this can be seen in the cubical block that forms the center unit, with extensions front and rear that end in Ionic colonnades and pediments. Each of the rooms is vaulted in masonry; the banking room is covered by a saucer dome in brick, visible from the exterior, and lighted by a lantern over a central oculus. Each of the elements is thoroughly studied and com-

bined in such a way that the parts reinforce one another and form one harmonious whole. In addition to this architectonic unity, the suggested image of Roman republican probity and civic virtue is clear.

Latrobe's largest commission, the Baltimore Cathedral, is also Roman, but in preparing the designs in 1804 Latrobe also drew up a Gothic design because of the long association of Catholicism with Gothic architecture. He felt the diocese should have a choice. Happily the decision was in favor of the classic mode, which Latrobe preferred and in which he was much more proficient. This incident reveals Latrobe's professional ability, for no earlier American architects had the historical knowledge to draw up two radically different proposals based on consciously selected histor-

ical models. In his classical design Latrobe broke away from the Wren-Gibbs tradition, using Soufflot's modern Pantheon in Paris and the ancient Pantheon of Hadrian in Rome as his points of departure. [4.25, 4.26, 4.27] The focus of the church is a large masonry dome on a drum penetrated by four large segmental arches; these lead to the apse, arms, and nave, with four smaller arches on the diagonals. All portions of the church are vaulted in masonry; the section drawing by Latrobe [4.28] shows the saucer dome on pendentives over the nave. Entry to the church was to be through an accurately detailed Corinthian portico, whose Ionic order was studied from the columns of the North Porch of the Erechtheion in Athens.[3] Each of the internal spaces was indicated externally as a

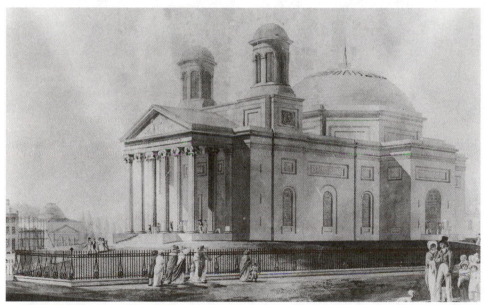

4.25. Benjamin Henry Latrobe, Baltimore Cathedral (Cathedral of the Assumption of the Blessed Virgin Mary), Baltimore, Maryland, 1804–21. This delicate perspective, prepared in Latrobe's office in 1818, shows the plain character of the walls and low Roman character of the domes; in the distance Godefroy's Unitarian church is visible to the left. (Papers of Benjamin Henry Latrobe, Maryland Historical Society.)

4.26. Baltimore Cathedral, plan. Although Latrobe prepared a relatively traditional Latin cross Gothic Revival design, the scheme selected was a modern design using a compact Greek cross, its crossing capped by a low Roman masonry dome. This reconstructed plan shows the east end before the expansion. (L. M. Roth, after Latrobe and Hamlin.)

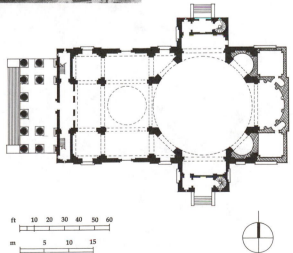

ft 10 20 30 40 50 60

m 5 10 15

4.27. Baltimore Cathedral, chancel and altar. The expanded final plan included a vaulted bay east of the great central dome. (Library of Congress, HABS MD 4-BALT 41-2; photo by Larry Miyamoto, 1958.)

4.28. Baltimore Cathedral, longitudinal section by Latrobe, 1805. This carefully rendered and colored section/elevation (prepared before the plan was enlarged) shows the high level of Latrobe's professional skills. (Courtesy of the Diocese of Baltimore and the Maryland Historical Society.)

separately articulated mass; crisp moldings, and a single entablature encircling the building, form the sole enrichment of the stone walls. Beyond this the only embellishments are the two severe tower belfries flanking the portico.

Latrobe's painstaking and beautiful drawings indicate his professional stature. He steadfastly refused to have workmen question his artistic authority; and when, during his absence, the builder of the cathedral changed some of the features to follow standard eighteenth-century practice, Latrobe threatened to resign if his drawings were not adhered to absolutely, and he won his point when the diocese supported him.[4]

Latrobe's views concerning the professional prerogatives of the architect were well developed. In 1806 he admonished his pupil Robert Mills, then starting his own practice, for not insisting on his professional rights.[5] Mills, like most of the early professional architects, struggled against the prevailing public attitude among clients that "if you are paid for your designs and directions, he that expends his money on the building has an undoubted right to build what he pleases," as Latrobe put it in his letter. Against this Latrobe countered that the architect must adhere to the Latin proverb *in sua arte credendum* (one must

believe in one's own work), and that Mills should take specific precautions: do nothing gratuitously, make certain that the drawings are clearly understood by the client and that all changes are agreed to mutually, supervise all construction, authorize all payments to the builders, and retain the drawings.

Yet Latrobe was more than an artist-idealist, he was an engineer as well and understood the physical nature of materials and mechanics. He designed several canal improvements in England and the United States, as well as a steam engine for the Navy Yard in Washington. His water system for Philadelphia, planned in 1798 and built in 1799–1801, securely established his reputation. His scheme called for a dammed settling basin on the Schuylkill northwest of the city at what is now Fairmount Park. Here water was to be pumped by steam to an elevated reservoir and fed by gravity to hydrants throughout the city.[6] One of his most abstractly geometric buildings was the pump house at Center Square, built in 1799–1801 [4.29], which consisted of a cubical block at the base (housing offices) through which rose a cylinder (which housed the steam engine and pump), at the top of which was a doughnut-shaped water tank. Through the opening in the center of the water tank was a flue

4.29. *Benjamin Henry Latrobe, Center Square Pumphouse, Philadelphia Waterworks, Philadelphia, Pennsylvania, 1799–1801. The lower square accommodated offices around the perimeter; through the center rose a tall cylindrical space to house the steam engine and pump that lifted water to an annular-shaped tank at the top that provided a head of water for pressure throughout the system. (Courtesy of Prints Division, New York Public Library; Astor, Lenox, and Tilden Foundations.)*

4.30. William Hamilton house, Woodlands, Philadelphia, Pennsylvania, 1786–89. The exterior of the Woodlands presents one of the early examples of a freestanding multistory columnar portico; but it also shows the random ashlar stone construction so favored in southeastern Pennsylvania. (Sandak, courtesy of the University of Georgia.)

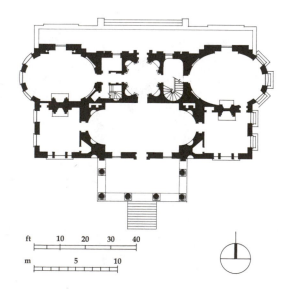

4.31. Hamilton house, Woodlands, plan. The many geometrically shaped rooms show Hamilton's interest in the contemporary work of English architects Robert Adam and John Soane. (L. M. Roth, after HABS.)

for engine smoke. All trim was eliminated, with the primary ornament consisting of Greek Doric columns at the entrance carrying a geometricized entablature that circled the lower block. It is highly significant that Latrobe's pump house, so like Ledoux's Barrière de la Villette in Paris, uses Greek Doric, the heaviest and most severe of all the orders. Appearing here for the first time in the United States, it became the hallmark of the Greek Revival, elaborated and spread later by Latrobe's pupils William Strickland and Robert Mills.

In addition to his private commissions following the cathedral, Latrobe also served as architect for federal buildings during Jefferson's administration, from 1803–11. It was he who brought the interiors of the Capitol to completion, and his spartan and massive geometric clarity appears in the vaulted Old Supreme Court chamber with stout Doric columns, in the highly original maize and tobacco capitals he designed for the columns in the Senate anterooms, and in the domes of the old Senate and House chambers.

OTHER INFLUENCES AND EMIGRÉ ARCHITECTS

Latrobe's activity in Philadelphia at the very beginning of the nineteenth century is illustrative of the advanced cultural and architectural position of that city. With a

population of over 41,000, it was second only to growing New York City in size, but was perhaps unequalled in its cultural attainments. Another building in Philadelphia, Woodlands, the suburban country home of William Hamilton, is characterized by a special interest in the shaping of interior spaces that is close to that of Latrobe, but the house (begun in 1770) was completely remodeled in 1786–89 according to plans that Hamilton had perfected in England. [4.30. 4.31] The intricacies of the plan, in which each room is given a distinct geometric shape, suggests the work of Sir John Soane. The exterior, which incorporated an engaged as well as a projecting portico, predated those used by Hoban in the President's House. Woodlands also has walls built of unplastered rough fieldstone, carrying on a Philadelphia-area tradition nearly a century and a half old.

Philadelphia also boasted an early example of a house type that became exceedingly popular after the Civil War. Pierre L'Enfant designed there a large suburban house for Robert Morris, using the double-pitched mansard roof, with projecting end pavilions whose walls were partially curved. Under construction from 1793 to 1801, it was not finished, and this particular mode with mansard roofs was not to be picked up for half a century.

If French traditions had not yet been adopted for residential design, they were used by a few architects for public buildings, particularly for municipal government buildings. In part this was the result of an admiration of aspects of the culture and art of a political ally. Many of these buildings were the work of emigré French architects. Such was the case in the design of the New York City Hall, won in competition in 1802 by Joseph François Mangin (died after 1818), who had been trained in France, working with John McComb Jr. (1763–1853). Reduced in size by both designers in 1802–4 and built under McComb's supervision in 1804–11, the building owed much of its clear articulation of parts, and its lightness of feeling, to the influence of the work of French architect Jules Hardouin Mansart. [4.32] Something of the same

4.32. Joseph F. Mangin, with John McComb Jr., New York City Hall, New York, New York, 1802–11. Still used for the city hall, McComb and Mangin's design combines neoclassic details in the cupola with the lightness of French academic classicism in the building itself. (Carnegie Photo.)

4.33. Maximilian Godefroy, Unitarian Church, Baltimore, Maryland, 1817–18. Godefroy's design incorporates the strong geometries favored by French neoclassicists. (Sandak, courtesy of the University of Georgia.)

clear, light-handed articulation can be seen in the work of Philip Hooker (1766–1836) of Albany, New York, perhaps best in his Albany Academy, built in 1815–18, which seems to owe much to Mangin and McComb's City Hall.

Another prominent French emigrée was Maximilian Godefroy (1765–c. 1840), who came to the United States from France in 1805 and settled in Baltimore, where he taught drawing at the College of Baltimore (later St. Mary's Seminary). His first completed American building was the seminary chapel of 1807, which used Gothic motifs in the first conscious revival of medieval architecture in the United States. The building that best shows his French training, however, is the Unitarian Church in Baltimore, built in 1817–18, which is contained in a cube with a domed sanctuary [4.33, also visible in the distance in 4.25]; there is little of the standard neoclassical detail but rather a compactness and clarity that are classical in the best generic sense. Godefroy's career in the United States faltered, and after completion of the Baltimore Unitarian Church he returned to Europe.

4.34. William Thornton, Col. John Tayloe III house, the Octagon, Washington, D.C., 1797–1800. The Tayloe house shows Thornton's ingenuity in responding to an awkward narrow triangular lot. (Library of Congress, HABS DC WASH 8-35.)

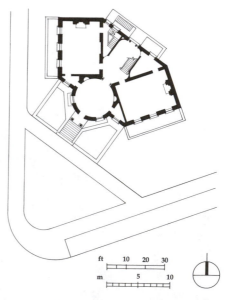

4.35. Tayloe house, the Octagon. The plan shows Thornton's ingenious response to the pointed corner lot at the intersection of northwest Eighteenth Street and New York Avenue, based on two rectangular rooms rotated around a central circular hall. (L. M. Roth, after W. L. Bottomley, ed., Great Georgian Houses of America, vol. 2, New York, 1937.)

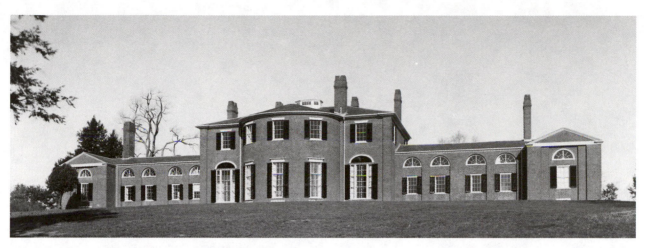

4.36. *Christopher Gore house, Gore Mansion, Waltham, Massachusetts, 1801–4. The Gore house outside Boston* *parallels Thornton's interest of bold massing and simple details. (Sandak, courtesy of the University of Georgia.)*

Also recently arrived from France was Joseph-Jacques Ramée (1764–1842), trained in Paris and greatly influenced by the work of Ledoux and J.-N.-L. Durand. Fleeing France during the revolutionary bloodshed, he settled first in Hamburg, Germany, and then was persuaded to travel to northern New York State to carry out some buildings for a German landowner there. (Ramée's very important design for Union College, in Schenectady, New York, is discussed below in conjunction with Jefferson's University of Virginia.) Ramée's work fell off after building Calverton Mansion for Dennis Smith in Baltimore in 1815–16, and he too returned to Europe.

The most eminent English architect to relocate to the United States was Benjamin Henry Latrobe, but William Thornton (1759–1828) was also influential. Born to a wealthy West Indian planter on Tortola Island, he was sent to England at age five to be educated. In 1784 he received his degree in medicine at Edinburgh. Although he first returned to Tortola, by the end of the year he had relocated to Philadelphia, and he became an American citizen in 1788. He won a competition for a new building for the Library Company in Philadelphia. A gentleman-amateur, he based his facade on plate 9 of the second book of Abraham Swan's *Collection of Designs in Architecture* (London, 1575). In 1790 he returned to Tortola with his bride. Late in July 1792 he learned of the announcement of the U.S. Capitol competition and hastened back to Philadelphia. Because of the length of time it had taken the announcement to reach him, he was allowed to submit a design for the Capitol after the July 15 deadline. His design, far superior to

the other submissions, was praised by President Washington and Jefferson, and Thornton was awarded the prize. His status as gentleman-amateur, and his lack of knowledge in building, however, led to difficulties with the succession of superintendents appointed to oversee construction. Although not a trained architect, he produced sophisticated building designs for friends in the vicinity of Washington, D.C. His most accomplished was an elegant city residence in Washington, D.C., for wealthy Virginia planter Colonel John Tayloe III, built in 1797–1800. [4.34, 4.35] Consisting of a central brick cylinder, it had two wings folded back at an angle of 70 degrees, to fit into a sharply pointed corner lot in L'Enfant's unusual city plan. Spare in its details and graceful in its proportions, the Tayloe house—called the Octagon because of its uncommon geometries—was later acquired through the efforts of Charles Follen McKim to house the offices of the American Institute of Architects. Thornton also designed the equally spare elongated country residence Tudor Place, in Georgetown west of Washington, D.C., built in 1816. The hyphenated five-part linear plan recalled late Georgian plantation houses of the area, but Thornton's center block was graced by a projecting half-domed classical semicircular tempietto with slim Tuscan Doric columns.

Several years earlier, in 1801–4, a similar linear country house, Gore Mansion, was built for Christopher Gore, a prosperous lawyer in Waltham, Massachusetts, a distant suburb of Boston. [4.36] It is believed that the plans were drawn by French architect Jacques Guillaume Legrand while Gore and his wife Rebecca were visiting Paris in 1801, but the linear

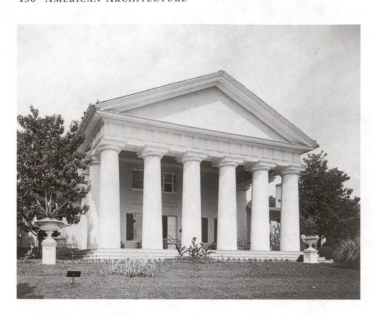

4.37. George Hadfield, Custis-Lee house, Alexandria, Virginia, 1817–20. The imposing colonnade added by Hadfield to the Custis-Lee plantation house is perhaps the oldest surviving American example of the influence of true Greek classicism. (Library of Congress, USZ62-9788.)

hyphenated plan, the unembellished windows set in blind arches, the doors flanked by broad side lights and surmounted by delicate fanlights, and also the gentle curve of the central bay seem to suggest another as yet unknown American designing hand.

One further emigré who established a limited but influential practice was George Hadfield (c. 1763–1826), born in Livorno, Italy, of British parents. A pupil of the eminent James Wyatt in England, and recipient of the first traveling scholarship sponsored by the Royal Academy, Hadfield became frustrated by limited professional opportunities in England and moved to the United States in 1795. For a brief time he served as superintendent of construction of Thornton's U.S. Capitol, and then established a practice in Washington, D.C. Even before Latrobe used accurate Grecian orders, Hadfield used Erechtheion Ionic columns, in the first U.S. Treasury in Washington, built in 1796 (no longer standing). One of his most impressive works is still visible from the Potomac shore of Washington, the dramatic hexastyle pedimented portico with six immense unfluted Doric columns that Hadfield added in 1817–20 to the front of the existing Custis-Lee mansion standing on the bluff at Arlington, Virginia (today overlooking the National Cemetery at Arlington). [4.37] Hadfield's portico anticipated by a year the beginning of the true Greek Revival that swept over the United States after 1818, and Hadfield's later work—most notably his abstractly severe cluster of buildings for the Washington City Hall, 1820–26—is decidedly Greek Revival in style.

THOMAS JEFFERSON

In many ways the single most influential designer of the period was native-born Thomas Jefferson (1743–1826). Whereas Latrobe was a rationalist, clarifying structure to serve an expressive and didactic purpose, his friend and admirer Thomas Jefferson was an idealist to whom architecture was a means of effecting social reform, education, and enlightenment. He was well educated and a voracious reader of architectural books; over the years he amassed a library of over 130 books on the fine arts—compare this to the 15 books on architecture in Bulfinch's library, or the 7 that McIntire owned.[7] Jefferson was nonetheless self-trained, and pursued architectural design as an avocation. He was the last and best of the gentlemen-amateur designers. Over the course of his life Jefferson moved in the direction of more abstract design, and introduced the use of graph paper to study proportion in his preliminary designs. Because of his uncompromising political convictions Jefferson rejected English architectural influences outright, turning instead first to the Roman-inspired work of Palladio and then to ancient Rome itself.

When as a young man Jefferson began his own home, in 1769, he placed it atop the hill he called Monticello [4.38], not at the river's edge in the colonial manner, for he wanted to see the full sweep of the Blue Ridge Mountains to the west. In contrast to the emphasis on auxiliary buildings in most colonial and English country houses, Jefferson pushed the dependencies at Monticello into the earth so as to preserve

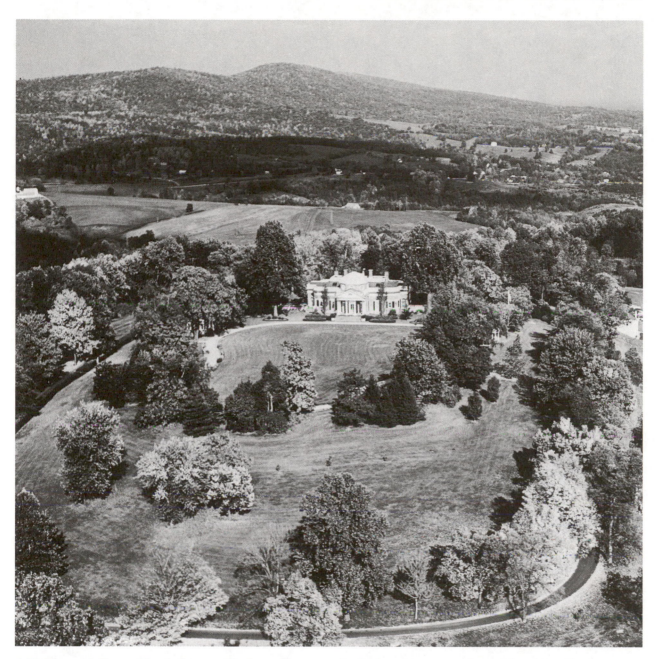

4.38. *Thomas Jefferson, Monticello, near Charlottesville, Virginia, 1769–82, 1796–1809. Jefferson's home was placed atop the "little mountain," Monticello, rather than at the river's edge, so as to provide sweeping views. (Courtesy of Thomas Jefferson Memorial Foundation, Inc.)*

the view; only at the ends of the arms did he place small cubical pavilions for a library and a guest room. The plan of the complex in the shape of a broad U, with the house standing free at the center and arms stretching and hugging the hill, was based on plans published by Palladio in the sixteenth century and by English architect Robert Morris in 1757. The facade

of the house also derives from these dual sources. Built section by section from 1769 to 1782, it stood with a Palladian two-story central pavilion until 1796, when Jefferson returned from France and began a second building campaign that continued until 1809, changing the proportions of the house so that it gave the impression of being a single-story house under a heavy

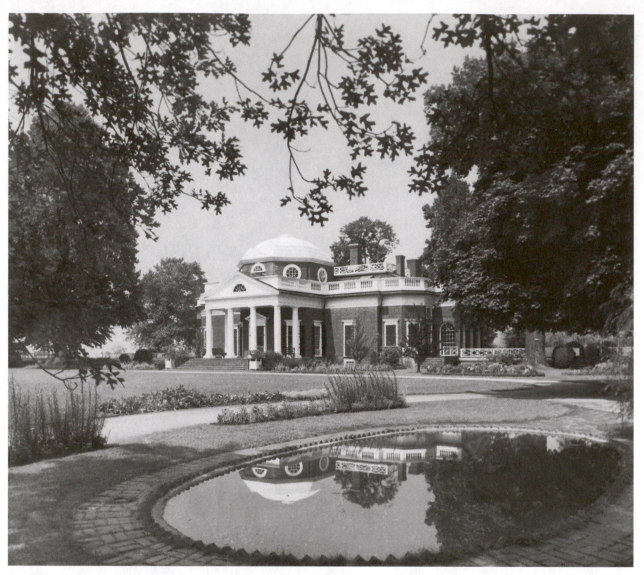

4.39. Monticello. The garden facade, rebuilt 1793–1809, incorporates the one-story appearance and the form of the dome Jefferson had admired in Parisian hotels. (Sandak, courtesy of the University of Georgia.)

Doric entablature that ran around it. Inspired by the Hotel de Salm in Paris, Jefferson added a low dome to the garden front of the house. [4.39] All these modifications seemed to press the house further into the hill and to stretch and emphasize its horizontal dimension. It became a personal expression incorporating contemporary French and neoclassical elements; it is abstract, complex, and yet highly adapted to comfortable living.

Jefferson fervently believed in architecture as a symbol and wrote candidly of the buildings of Williamsburg, which he despised because of their association with colonial exploitation. In 1776 he was one of the first to suggest that the Virginia state capitol be moved to Richmond, nearer the center of the state. New buildings should be erected, he advised, one for each branch of the state government. Action was slow; the state legislature moved in 1780, but it was not until 1784 that Jefferson was asked to procure a design for a single building that the legislature insisted should contain all government offices. By this time Jefferson was in Paris serving as minister to the

4.40. Thomas Jefferson, with C.-L. Clérisseau, Virginia State Capitol, Richmond, Virginia, 1785. Plaster model, prepared in Paris and shipped to Virginia. (Condit Archive, Northwestern University.)

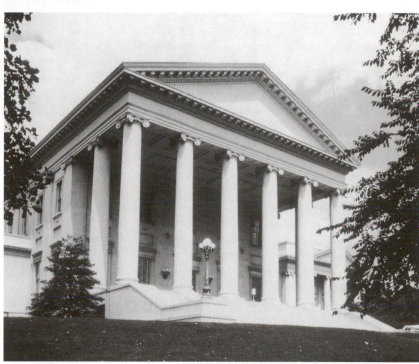

4.41. Virginia State Capitol. Jefferson's capitol design was strongly influenced by the Roman temple, the "Maison Carrée" in Nîmes, France. (Photo: L. M. Roth.)

French court and had established a close working relationship with Charles-Louis Clérisseau, a French architect prominent in the French neoclassic movement and author of *Monuments de Nismes* (Paris, 1778), which included the first measured drawings of the well-preserved Roman temple in Nîmes. Jefferson selected the Maison Carrée in Nîmes as his model, since it had all the abstract visual symbolic properties he felt were urgently needed in Virginia. Mistakenly, he interpreted it to be a product of the Roman republic, erected by self-governing free men; it was built

during the reign of the emperor Augustus, although it was based on models of the republican period. Jefferson's modified version was simple and pure in form. He had been obliged to cut windows in the outer walls since this building had two floors of interior rooms, and he shortened the porch by one bay. Nonetheless the building would have strong associations with Rome, not with colonial rule under England. At this point Jefferson heard that legislators back in Virginia, frustrated by Jefferson's delays in providing drawings, had begun construction of a

building designed locally. Jefferson fired off a letter, imploring them to stop and wait for his design. He informed them that he had settled on the Maison Carrée because it was widely acclaimed to be "one of the most beautiful, if not the most beautiful and precious morsel of architecture left us by antiquity."[8] "It is noble beyond expression," he continued, "and would have done honor to our country, as presenting to travellers a specimen of taste in our infancy, promising much for our maturer age." Most important, Jefferson argued, "how is a taste in this beautiful art to be formed in our countrymen unless we avail ourselves of every occasion when public buildings are to be erected of presenting to them models for their study and imitation." Jefferson and Clérisseau finished drawings, crowding the required functional spaces into the rectangular shell, and had a plaster model sent back to Virginia with the drawings. [4.40, 4.41] The building was constructed in 1785–89 under the supervision of Samuel Dobie with subtle modifications to the original model.

The Virginia State Capitol is significant for being the first building of the international neoclassical movement, in either the United States or Europe, to be a literal reinterpretation of the classical temple. Although there had been decorative temple pavilions on English estates, none had been full-scale, inhabitable buildings. The Virginia capitol filled exceedingly well the didactic role Jefferson had envisioned. The lofty cultural associations were obvious. It would be easy for architects subsequently to copy a building from the measured drawings increasingly available in architecture books, while the subtle and more architectonic lessons in Latrobe's work were much harder to grasp. Hence, through Jefferson's example, official sanction was given to revivalism; the Greek Revival was now perhaps inevitable.

The associations Jefferson incorporated into his buildings were always elevated ones, exercises in scholarship meant to sensitize the eye to proportion, scale, and rhythm, with political associations meant to symbolize republican self-governance. Architecture to him was a form of visual education in support of the democratic ideal. Furthermore, practical academic education itself was crucial to Jefferson, for he believed that only an enlightened, educated people could intelligently govern their own affairs. To this end he pressed for creation of a publicly funded state university in Virginia, with instruction grounded in natural sciences and modern subjects rather than exclusively in the classics. Beginning with the curricu-

lum, he designed a program of study based on ten major divisions of learning. Around this curriculum he designed the physical form of the school, conceiving it as an "academical village," a community of students and scholars. Remembering perhaps the arrangement of the Chateau de Marly near Versailles by J.-H. Mansart (begun in 1679), with its ranks of small buildings framing a court leading from the main house, Jefferson arranged two rows of five pavilions facing each other across a grassy lawn. Following a suggestion from Latrobe, at their head he placed the library.

Other contemporary college designs may have influenced Jefferson. He certainly knew of the parallel ranges of buildings in Robert Mill's competition-winning plan of 1802 for South Carolina College. Jefferson may also have had in mind the novel plan arrangement of Union College, in Schenectady, New York, laid out in 1813 by Joseph-Jacques Ramée, who was then in northern New York to develop lands for the Ogden family.[9] Ramée planned Union College for Eliphalet Nott following planning principles he learned at the École des Beaux-Arts, in Paris. [4.42. 4.43] The classroom and residential buildings were grouped in expanding ranks around a central axial court, focusing on a central building—here, as at Charlottesville, a library. Jefferson's University of Virginia combines classic form with romantic associational ideals, and so does Ramée's Union College, but the grounds at Schenectady combined an unusual amount of romantic picturesque freedom in their curving irregular paths and clumps of trees; the ordered buildings and geometric courts were to be contrasted with the planned "natural" irregularity of the landscape.

Unfortunately the library at Union College was not built at first and its place was later taken by a colorful High Victorian Gothic structure, but at Charlottesville Jefferson carefully supervised construction, which began in 1817. [4.44, 4.45] Each of the ten large pavilions on the Lawn (as the quadrangle is called) was to house a different department of learning providing both lecture rooms and living quarters for the professors. No two were alike; rather, each one exemplified a specific classical architectural order or some variation. Some of the pedimented facades were pure inventions, and one was based on Ledoux's Paris gates and his Hotel Guimard, of 1770, thus giving students an example of the kind of modern French architecture that Jefferson thought worthy of study. Appropriately, the library, the largest of all the buildings, was based

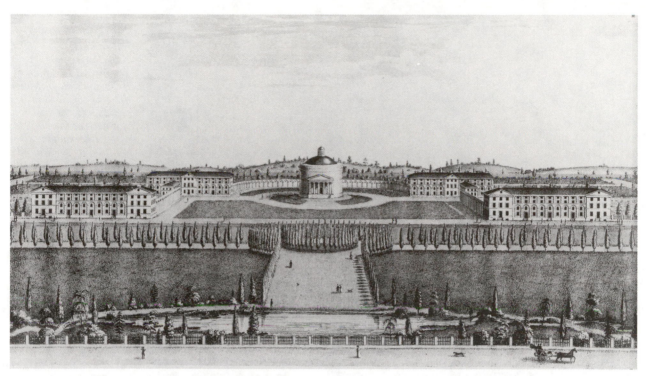

4.42. *Joseph Jacques Ramée, Union College, Schenectady, New York, 1813, aerial perspective. Although only partially built, this aerial view suggests how Ramée intended to finish* the central library. *(From P. Turner,* Campus, *New York, 1984.)*

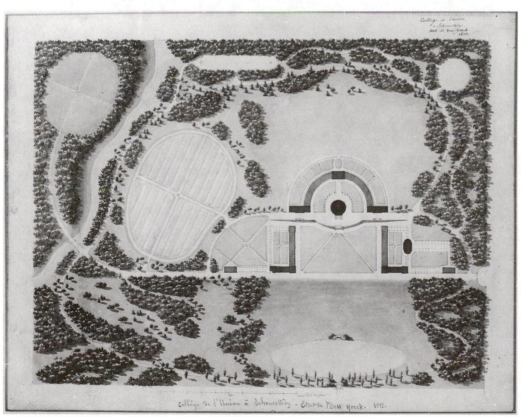

4.43. *Union College, plan. "Collège de l'Union a Schenectady, Etat de New York, 1813"; Ramée's plan for Union College combined both academic formality in the arrangement of the buildings and romantic landscaping. (Courtesy of the Schaffer Library, Union College.)*

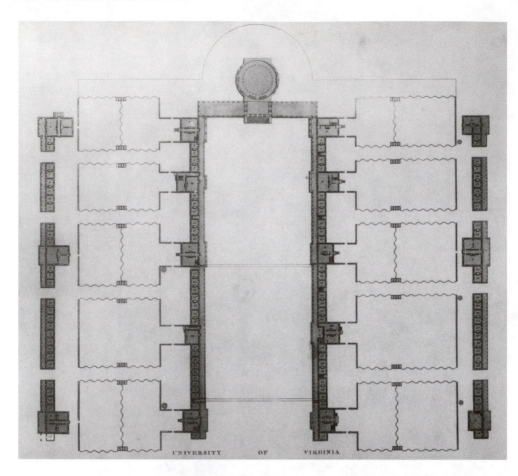

UNIVERSITY OF VIRGINIA

4.44. Thomas Jefferson, University of Virginia, Charlottesville, Virginia, 1817, plan. Jefferson's plan, shown here as engraved in 1825, had one pavilion for each of the ten disciplines taught, all focused on the rotunda library, the "common laboratory," as Jefferson called it. (Thomas Jefferson Papers, University of Virginia Library.)

4.45. University of Virginia, aerial view of campus as built, 1817–26 and later. New construction at the rear of the Rotunda and buildings at the south end of the lawn by McKim, Mead & White, 1896–98. (Courtesy of the Department of Graphic Communications, University of Virginia.)

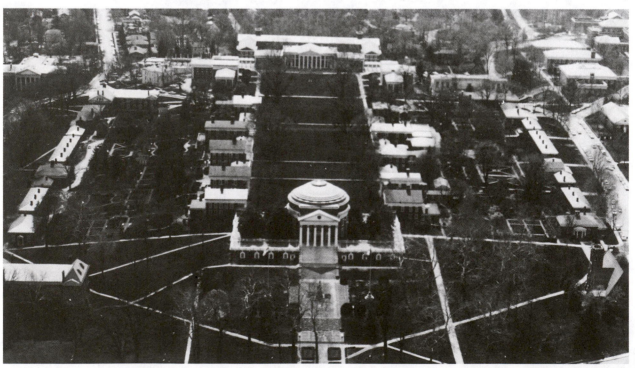

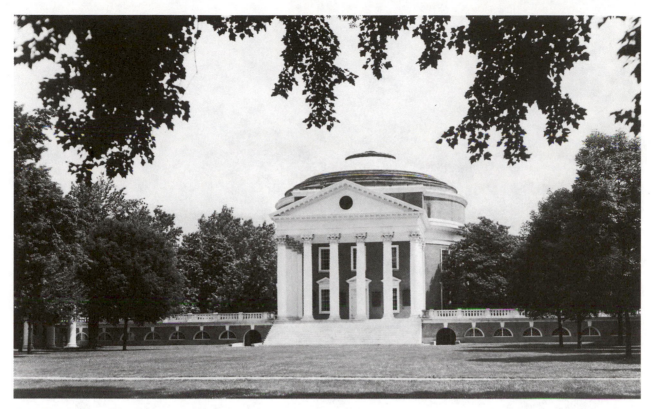

4.46. *University of Virginia, Rotunda, 1823–27. Rotunda exterior (as restored by McKim, Mead & White, 1896–98,* *following a fire). (Courtesy of the Department of Graphic Communications, University of Virginia.)*

on the perfect spherical harmonies of the Roman Pantheon. [4.46] The pavilions, "specimens for the architectural lecturer," as Jefferson described them, were connected by low colonnaded rows of student rooms, thus bringing dormitories and classrooms together. Behind each row of pavilions, separated by gardens enclosed with low serpentine brick walls, were parallel ranges of student rooms and dining pavilions.

Jefferson used local brick with white wood trim, thus necessitating some modifications from the classical models for his buildings. This is especially true of the library rotunda, with its porch of six instead of eight columns, its rows of windows cut into the wall of the drum, and most notably the large entablature that encircles the building like a hoop, suggesting both visual compression and horizontal continuity. The interior is not the single great room as in Rome, since Jefferson was obliged to introduce several levels, with classrooms and the library directly below the wood dome. What might have become a sterile grid is subtly relieved, for as the ground drops away in terraces from the rotunda, the connected pavilions descend in

three terraces; and as they move away from the rotunda, the lengths of the terraces and the spacing between the pavilions become greater, enhancing the perspective and teasing the eye. Combining nature and geometry, clarity and reasoned tension, classic temples and Virginia brick, the University of Virginia is Jefferson's didactic educational philosophy tangibly realized.

URBAN GROWTH

While the American architects in these early years sought to formulate a truly American architecture, the major business of the country was to establish its own industries and develop its economy, to gain economic independence in some measure comparable to its new political independence. Chief promoter of this industrialization was Secretary of the Treasury Alexander Hamilton, and in his Report on Manufactures submitted to Congress in December 1791, he concluded that "everything tending to establish substantial and permanent order in the affairs of a country, to increase

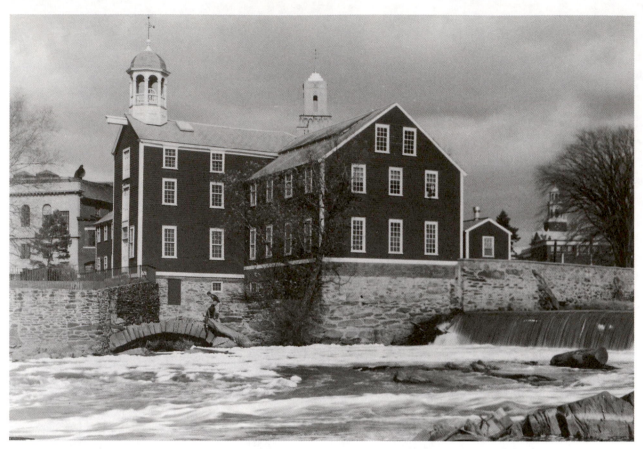

4.47. *Slater Textile Mill, Pawtucket, Rhode Island. Slater emigrated from England, bringing with him the knowledge of mechanized spinning and weaving; the mill he built was* *a long narrow building adapted to water-powered equipment. (Sandak, courtesy of the University of Georgia.)*

the total mass of industry and opulence, is ultimately beneficial to every part of it."[10] Hamilton, among others, was directly involved in developing an early industrial town that, if it had succeeded, might have had a significant influence on the development of American industry and industrial towns. Unfortunately, it was not to be. This experiment in industrial town planning was Paterson, New Jersey, begun in 1791. Eager to see American manufacturers develop on a large scale and centralize operations, Hamilton personally supported the venture, which was underwritten by a group of New Jersey businessmen and investors. Land was acquired at the falls of the Passaic River in New Jersey, and a large mill town was proposed in which a variety of goods were to be produced, including paper, cotton fabric, and brass wire. The planning of the town was put in the hands of Pierre L'Enfant, who was assisted by Nehemiah Hubbard. Unfortunately, all drawings of the plan were destroyed, but the brief written description that does survive indicates that here too L'Enfant proposed to use diagonal thoroughfares but with the important difference that at Paterson the radial streets were to follow the general contours of the land.[11] What was so important in this venture, even though nothing came of it at all because of lack of managerial skills among the organizers, was that for the first time a new industrial city was planned according to a grand comprehensive scheme.

While Hamilton was preparing these recommendations for Paterson, a small cotton mill was opened in 1791–93 by Samuel Slater (in association with Moses Brown and William Macy) on the Blackstone River in Pawtucket, Rhode Island. [4.47] The mill building itself was very simple and plain: an extended barn, but with an added clerestory to provide more light for the machine operators inside. There was no need at the time to build extensive workers' housing in Pawtucket, much less to plan or build an entire town,

for the workers lived nearby, but soon these provisions would become necessary. The early mills were built wherever there was water power, often inland, far from large settlements. In fact, these first isolated mills, and the workers' housing that owners were obliged to build next to them, were in rural, wooded locations, making them seem almost idyllic.

Slater's mill operation was small, perhaps due to the limited capital backing, but later industrial developments were larger in scale. The model for the textile industry was provided by Francis Cabot Lowell and his business associates. Lowell built a textile mill at Waltham, west of Boston, but when the War of 1812 seriously reduced the number of young men available to operate the power looms, Lowell developed a system that took advantage of an previously untapped source of labor. He set up a series of boardinghouses run by matrons and instituted a social program so rigorous and all-encompassing that families in the area were quite willing to send their young women to operate the machinery. Indeed the situation was made to order for young women eager to enlarge their dowry by working for a few years before marriage.

Lowell then began to think about an even larger textile plant, and in the years before his death in 1817 he worked out a physical arrangement that incorporated the lessons learned at Waltham. In 1821 Lowell's Boston Manufacturing Company acquired tracts of land at the falls of the Merrimack River north of Boston and proceeded to lay out the industrial town that the founder had visualized; the actual planning of the new town was done by Kirk Boott. [4.48] The factories were placed along the power canal looking out over the river; behind them ran streets at right angles, along which were the boardinghouses for single employees and row houses and tenements for married workers. Simple in the extreme, this was a scheme that allowed for gradual expansion and efficient operation, and virtually assured profits for company owners. In 1826 there were thirty dwellings built for the employees in a village of 2,500; by 1836 the total population was 17,633; and in 1865 the population had risen to 30,990. So effective and attractive was the early physical and social organization of Lowell, Massachusetts (as the new town was called in honor of the founder), that nearly a score of other major manufacturing towns were patterned after it, including Chicopee, Lawrence, and Holyoke, Massachusetts, and Manchester, New Hampshire. Perhaps the most important lessons of Lowell and its imitators were that an industrial town could be built according to a

rational plan and that it was good business for the employer to build attractive and substantial housing so as to discourage transience among skilled workers.

Such a view was not widely held in 1814, when Francis Cabot Lowell and the Boston Manufacturing Company began operations at Waltham. In fact a strong current of anti-urban feeling touched many influential people—particularly Jefferson, whose views characterized those of many. In his *Notes on the State of Virginia*, published in 1785, he wrote that "the mobs of great cities add just so much to the support of pure government as sores do to the strength of the human body," while in contrast he asserted that "those who labour in the earth are the chosen people of God."[12] Though his opinion softened slightly in the

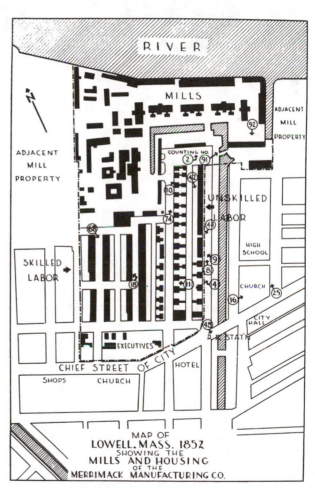

4.48. Kirk Boott, Merrimack Manufacturing Company, Lowell, Massachusetts, 1821 and later. Water was brought by canal from the south, powering the mills arranged along the river's bank. The boardinghouses for female employees extend in a line south from the mills. (From J. Coolidge, Mill and Mansion, Cambridge, Mass., 1942.)

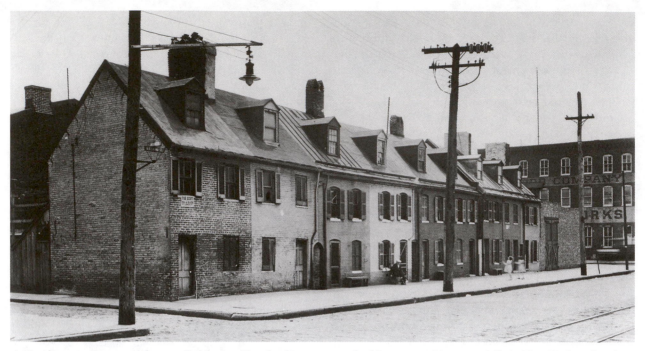

4.49. *Aliceanna Street row houses, Baltimore, Maryland, early nineteenth century. By the end of the eighteenth century, urban land was so costly that row housing became* *standard in eastern cities, especially in New York and mid-Atlantic states. (Library of Congress, HABS MD 4-BALT 86-1.)*

following years, he remained intellectually opposed to the idea of great cities. To James Madison he wrote in 1787 that "when they [the populace] get piled upon one another in large cities, as in Europe, they will become corrupt as in Europe." With such views prevalent it is understandable why Paterson failed so precipitously. By 1816, however, events in Europe brought Jefferson to admit to Benjamin Austin in a letter that "we must now place the manufacturer by the side of the agriculturalist," for the development of industry was essential if the United States were to remain politically and economically disentangled. Yet even as late as 1823 Jefferson wrote to William Short deploring the fact that great metropolises like New York City, and imperial Rome before it, were "sewers of all the depravities of human nature."[13]

Jefferson's remarks were an early expression of the anti-urban attitude that conditioned American life from the beginning of the nineteenth century and still exists in some measure today. Cities had hardly achieved any great size when the desire grew to escape them. Even before the end of the eighteenth century those who could afford it commuted to work by carriage from suburbs of Philadelphia and Boston, or took ferries from Manhattan across the East River to the more idyllic bedroom community of Brooklyn,

New York. In the first three decades of the nation's existence, from 1790 to 1820, Boston grew from over 18,000 to over 43,000; Philadelphia expanded from nearly 29,000 to almost 64,000; Charleston, South Carolina, grew from around 16,000 to over 30,000; New Orleans grew from about 5,000 to over 27,000; and small, relatively new cities like Baltimore grew from 13,500 to nearly 63,000, rivaling much older, established cities. The capital, Washington, D.C., grew from a marshy tidal basin to a city of well over 23,000 by 1820. The largest city of all, destined to become the major port of entry for the entire North American continent, was New York, with 33,000 people on the island of Manhattan. (Including Brooklyn and the surrounding economically dependent area, the total metropolitan population exceeded 196,000 by 1820.)

In the growing eastern seaboard cities the ideal of a freestanding house for every family quickly disappeared in the face of urban crowding. In about 1801–3 Thomas Carstairs of Philadelphia prepared plans for a row of twenty contiguous five-story town houses, and a number of the smaller house designs published in Asher Benjamin's pattern books have no side windows, suggesting that they too could be built side by side in continuous rows. One early row of eight compact town houses, built early in the nine-

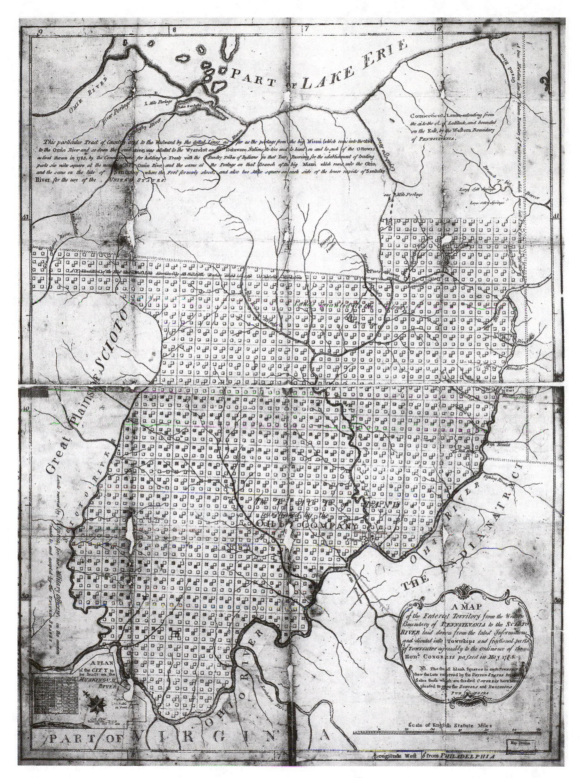

4.50. Manasah Cutler, "Map of the Federal Territory from the Western Boundary of Pennsylvania to the Scioto River . . .," c. 1787. This early expression of the impact of the Northwest Ordinance of 1785 shows a uniform grid laid over what was in reality a rugged mountainous landscape. The unplatted land in the upper right section is the Western Reserve of Connecticut. (Library of Congress, Map Division.)

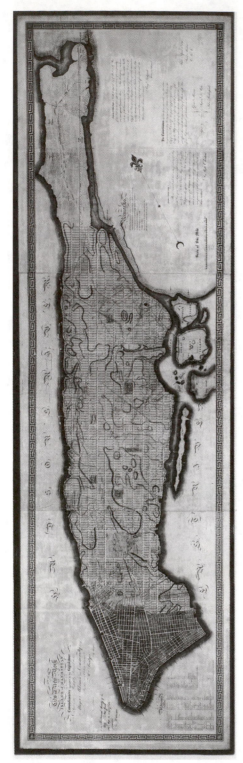

4.51 . Commissioners' Plan of New York, New York, 1807–11. The Commissioners' plan laid an unmodulated street grid over the entire island of Manhattan, further helping to fix the idea of a city plan being a endless grid. (Courtesy of the New-York Historical Society.)

teenth century, survives on Aliceanna Street, in Baltimore. [4.49]

The overall population of the nation grew explosively, with a jump of almost a million new residents in the decade after 1780. In 1790, when the first official federal census was taken, a total of about 4,000,000 citizens were counted. By the 1820 census the total population had grown by a factor of two and a half, reaching 9,638,000 (almost half the population of Great Britain at the time). With new arrivals and eastern settlers pouring over the Appalachians, ten new states had been added to the union by 1820, including Vermont, Kentucky, Tennessee, Ohio, Louisiana, Indiana, Mississippi, Illinois, Alabama, and Maine (formed from former counties of Massachusetts).

The pattern of settlement in the new western states was established by the Northwest Ordinance on 1785 (drafted by Jefferson), which called for an orderly grid of township squares, six miles to a side and divided into 36 sections of 640 acres each. Within each township, four sections were reserved for the federal government and one for establishment of public schools. Town settlements within this huge grid were nearly always laid out following the same orthogonal scheme. The grid was proposed for the entire western region, irrespective of topography. A plat of southwestern Ohio, said to have been drawn up by Manasseh Cutler about 1787, followed the ordinance pattern to the letter [4.50]; all the land between the Ohio and the Scioto Rivers is divided into six-mile squares, but it proved impossible to lay out the grid on so mountainous a region. Farther west, however, in the flatlands of western Ohio, Indiana, Illinois, Michigan, and Wisconsin, the township grid could be employed easily.

Of course this appropriation of vast territories paid no heed to the native Americans who viewed the land as their ancestral homeland; they were crushed in military defeat, deprived of treaty promises, and pushed, dispossessed, ever westward.

In the sprouting western towns officials vigorously encouraged growth, emulating the attitude favoring speculation in land that had shaped New York City early in the century. What would be called today urban planners and like-minded architects could not thrive in an atmosphere conditioned by Jeffersonian anti-urbanism coupled with speculative greed; into the void stepped the businessman and commercial booster, and the city where this was most manifest was New York. By the end of the eighteenth century New York had grown northward only about thirteen blocks beyond the boundary existing at the time of the

revolution. The outcome of the war, however, dramatically changed the shape of the city, for, according to state law, all lands abandoned by Tory loyalists on Manhattan Island were considered forfeited to the state and became city and state property. In an effort to promote the growth of the city, the state established a commission in 1807 to devise a plan for subdividing the newly appropriated lands; the commissioners appointed were Simeon DeWitt, Gouverneur Morris, and John Rutherford, financiers and businessmen. In their report, which appeared four years later, the commissioners indicated that one of their chief concerns "was the form and manner in which the business should be conducted." Briefly, they had considered radial avenues, ovals, stars, and other planning embellishments, but eventually decided that "since right-angled houses are the most cheap to build, and the most convenient to live in," the plan of the city should be strictly rectilinear.[14] Thus arose the famous Commissioners' Plan for New York of 1811 [4.51], consisting of thirteen broad north–south avenues running parallel to the axis of the island and intended as the major traffic arteries. These were to be crossed by 155 narrower east–west streets beginning at the northern edge of Washington Square. As far as the potential growth of the city was concerned, it was an efficient plan, but as for the realities of traffic circulation, it was tragically myopic; no consideration was given to the existing thoroughfares, and only one of them, Broadway, was sufficiently popular to assert itself into the grid. Absolutely no recognition was given to topography, and, insofar as possible, the "Island of Hills" was flattened out; only in portions of Central Park, set aside much later, does any suggestion of the original rugged landscape remain. It was a plan that, visually, had very little to offer the residents of the city, but to the commissioners it assured financial success.

Nonetheless, in the planning of a few selected cities there was some interest in using radiating diagonals such as those L'Enfant had laid out for Washington, D.C., and had suggested for Paterson. An early example was the new plan for Detroit, Michigan, prepared by Augustus B. Woodward in 1805 and based on the hexagon; in time only one of the foci of Woodward's plan survived the pressure to use the more conventional grid. Indianapolis, laid out in 1821 by Alexander Ralston, who had worked under L'Enfant in Washington, had two major diagonal streets cutting through the grid, as did Madison, Wisconsin, laid out in 1836, but the grid was far more widely employed in building the new cities of the Northwest Territory.

TRANS-APPALACHIAN DEVELOPMENT AND VERNACULAR ARCHITECTURE

Among the new western cities that rose to importance after 1790 were Lexington and Louisville, Kentucky, where the initial log forts had been replaced with settlements even before the revolution began. The earliest houses constructed were usually log cabins, a single-pen (room) plan, a double-pen plan, or even two rooms connected by a roofed open space in between—the "dog trot" cabin. [4.52, 4.53] In *Huckleberry Finn* Mark Twain later described a "double house" built in the mid-1830s, writing that between the two rooms "a big open place betwixt them was roofed and floored, and sometimes the table was set there in the middle of the day, and it was a cool, comfortable place."[15]

In part, the inspiration for the log house, normally but incorrectly considered the ancestral American house, came from the mountainous area of the Carolinas, where log houses were built by Moravian settlers as early as the 1720s. The ultimate source of the log dwelling, however, lies in New Sweden, where several early log structures still survive, one dated to 1697.[16] The Swedes, and ethnic Finns and Norwegians, who came to the Delaware valley brought with them the familiar technique of log con-

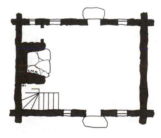

4.52. *Single-pen cabin. The single-pen cabin was determined in its size by available straight logs. (L. M. Roth.)*

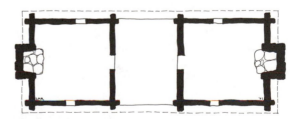

4.53. *Dog-trot cabin. Two single-pen cabins, facing each other with a roof over the open space between, formed the dog-trot cabin. (L. M. Roth.)*

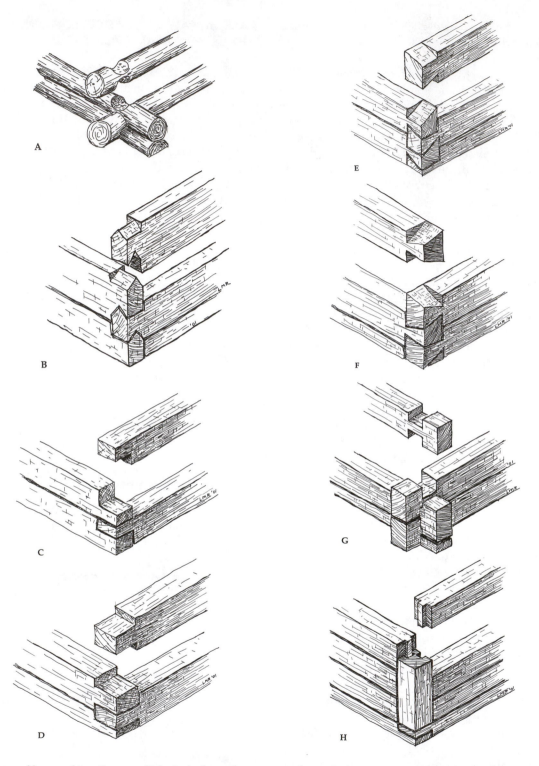

4.54. Types of log notching. Logs could be locked together with a variety of notching techniques, some easily shaped with an ax and others requiring more specialized tools and a trained builder. A: saddle notch; B: V notch; C: half notch; D: square notch; E: half-dovetail notch; F: full-dovetail notch; G: double notch; H: French pièce-sur-pièce log construction. (L. M. Roth, after F. B. Kniffen and H. Glassie, "Building in Wood in the Eastern United States: A Time-Place Perspective," Geographical Review 56 [January 1966].)

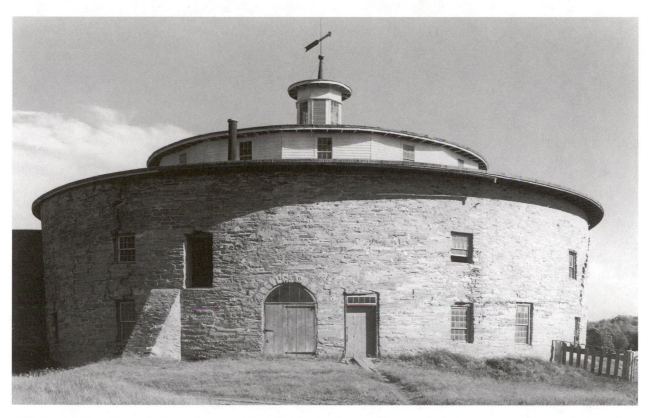

4.55. *Round Barn, Hancock, Massachusetts, 1826. Efficiency was an important element in Shaker life and design;* the round barn made feeding many cattle easier for a single person. *(Library of Congress, HABS MASS 2-HANC 9-1.)*

struction, a well-developed tradition at home. From Pennsylvania the technique spread quickly to the southwest along the valleys of the Appalachian range into Virginia and the Carolinas; from there it was carried westward into Kentucky and Tennessee. Different patterns of notching, using round logs or squared logs, were used in distinct regions of ethnic influence, whether German, Swiss, or Finnish—single notch, double notch, half notch, half-dovetail notch, V notch, and diamond notch, to name just a few. [4.54]

As economic production in western regions increased—in the Bluegrass area of Kentucky around Lexington, and then in Tennessee, as well as in lower Ohio, Indiana, and Illinois, along the Ohio River—and as cultural aspirations rose, early log structures were sheathed in clapboards and better windows inserted so that the age and true structural nature of many of these houses can be revealed only with careful investigation. As local brick production began, more fashionable Federalist houses were built, such as the John Brown house, Liberty Hall, in Frankfort, Kentucky, built in 1796, with its pilaster-framed entrance and Palladian second-floor window, or the

John Wesley Hunt house, Hopemount, in Lexington, built in 1812–14, with its broad fanlight entry. The wealthiest and most aspiring clients even procured designs from fashionable eastern architects; examples designed by Latrobe include the country residence Adena, outside Chillicothe, Ohio, built in 1798–1806 for the territory's first governor, Thomas W. Worthington, and the country residence built in 1811 for Senator John Pope outside Lexington, Kentucky, with its central domed rotunda.

Purely functional farm buildings also were carried westward. Some of the first storage structures were simply one-cell log cribs, but traditional, framed ethnic barn forms also made the westward trek. The gable-roof English barn was used in northwest Pennsylvania and in large areas of northern Ohio, throughout Indiana, and extensively in central Kentucky. Bank barns with overhanging forebays, introduced by German and Swiss settlers in southeastern Pennsylvania, continued to dominate there and in areas of central and western Ohio settled by Amish and other German groups (by midcentury these barns also began to appear in large numbers in Wisconsin).

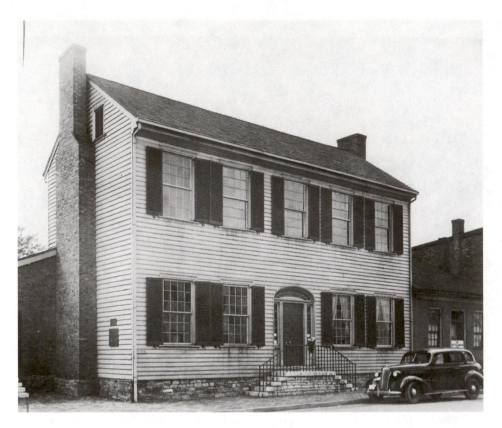

4.56. Dr. Ephraim McDowell house, Danville, Kentucky, 1803–4. This combination residence and apothecary shop is essentially an I-house in front, graced with a delicate elliptical fanlight Federal-style entry. (Library of Congress, HABS KY 11-DANV 1-1.)

A variation on this was the Frisian or north coast German barn, without an overhanging forebay but with two rows of center posts defining a through aisle under the ridge and long roofs sloping almost to the ground.

Something of a hybrid of the English and German barn was the so-called Appalachian barn, with a passageway for wagons running perpendicular to the ridge along one end (that is, an English barn with the aisle at the end). This barn type was widely used first in the southern mountains of Pennsylvania and then in what became West Virginia, portions of Kentucky, and southern Indiana and Illinois. As the ethnic barn types were carried westward and populations crossed paths, the distinctive forms were modified. All of these barns—English, Frisian, Dutch, German, Swiss, Appalachian, and the evolving American hybrid— were typically built with ponderous, heavy hewn timber frames, fastened with mortice and tenon joints pinned with hardwood dowels (the exception was the German barn, which often had end walls of brick or stone, often through three stories to the ridge).

However, one highly specialized barn type arose not from transplanted ethnic traditions but from the spir-

itual convictions of the American utopian sect called the Shakers. Originating in 1747, this branch of the Quakers in England called itself the United Society of Believers in Christ's Second Coming, but its members were commonly known as Shakers. The group moved to the United States in 1774 and established their utopian community at Watervliet, New York. By 1826, at their peak, the Shakers consisted of six thousand members and had established eighteen communities in eight states. Shaker artisans developed a particularly ascetic quality of design in their houses and furniture, aiming for utmost simplicity achieved through the highest craftsmanship, believing that the making of a thing well was itself an act of prayer. Having a strong interest in the circle as a perfect and simple form, they created round barns; a particularly fine example is the round barn of the Shaker community at Hancock, Massachusetts, built in 1826, measuring nearly 90 feet in diameter. [4.55] Within the lower part of the outer stone wall are stalls for fifty-two cattle (with a threshing floor above), and at the center, lit by the windows in the timber-framed circular clerestory, was a large storage loft for hay. This arrangement was highly efficient, making feeding of

the cattle much easier for a single person.[17]

Rural houses, of necessity as simple and as functional as barns and other outbuildings, also developed into distinctive forms that were carried westward from Pennsylvania and Virginia and persisted well into the early twentieth century. The simplest was the single-pen log or hewn frame house that could be expanded by addition of another pen on top, creating the tall and narrow stack house. More flexible was the I house, one room deep, two rooms wide and two stories high, sometimes with a central transverse hall.[18] The origins can be traced to examples such as the Shelton-Rigsby house, in Louisa County, Virginia, built in about 1770. [see 3.59, 3.60] This pattern was repeated with subtle variations across the western and Northwest territories settled after the Revolutionary War, sometimes in brick (as in the Orange Johnson house, in Worthington, Ohio, just outside Columbus, built in about 1816). Slightly earlier is a frame version of this transplanted Virginia upland I house, the Dr. Ephraim McDowell house in Danville, Kentucky, built in 1803–4. [4.56] The front portion of the house illustrates this house type well, with a touch of fashionable Federalist embellishment in the fanlight and slender side lights around the entry door. To the rear is a large ell, modifying the basic I house footprint; such extensions were common on this kind of house.[19]

Unique to the United States is the vernacular "shotgun house" developed by free negroes living in New Orleans in the early decades of the nineteenth century. Unable to purchase large parcels of land, and apparently drawing from models they remembered from Haiti and Africa, these free blacks developed their own form of compact urban house, about 12 to 13 feet wide, and perhaps 65 feet long, a series of nearly square rooms arranged in a straight line, all under one long continuous gable roof. [4.57] Often these shotgun houses had a front porch about 8 feet deep. With variations in decorative trim, the shotgun house continued to be built into the twentieth century.[20]

During the crucial years at the turn of the eighteenth century, attempts to create a uniquely American architecture ranged from ambitious symbolism in urban planning, to the elegant refinements of high-style Federalist classicism, to the simple shotgun houses of Louisiana negroes. All of it, however, was an expression of the American devotion to personal freedom. American artists, architects, and planners were also eager to establish their own place in the fashionable and symbolic rediscovery of the art of antiquity. Just

as classic architecture came to be associated with classic virtues, so too, as L'Enfant indicated, the larger form of a city such as Washington, D.C., could be symbolic of its special governmental function. Regrettably, L'Enfant's example of the conscious planning of cities, like that of William Penn a century before, had almost no influence as commercial expediency was made the basis of territorial and town planning. The individual buildings of the period were not marked by the same degree of homogeneity as had prevailed before the revolution. Immediately following the revolution architects and designers still looked to England as the model, but France became a source of ideas as well. Most important in shaping an American architectural character were the increasing educational and professional aspirations of the architects themselves. Despite varying backgrounds and predispositions, a common cultural vision inspired these architects so that each—Bulfinch through his refinement of form, Latrobe through structural expression, and Jefferson through historical association—helped in defining a new era. Through their early professional dedication the search for a national architecture was set in motion.

4.57. *"Shotgun" house. The shotgun house, inspired by long linear African tribal houses, was easily built at little cost and was used extensively by free urban African Americans. (L. M. Roth, after Preservation Alliance of Louisville and Jefferson Co.,* The Shotgun House, *Louisville, 1980.)*

BIBLIOGRAPHY

Alexander, Robert L. *The Architecture of Maximilian Godefroy.* Baltimore, 1974.

Brown, Glenn. *History of the United States Capitol.* Washington, D.C., 1900.

Caemmerer, H. Paul. *The Life of Pierre Charles L'Enfant.* Washington, D.C., 1950; reprinted 1970.

Candee, Richard M. "New Towns of the Early New England Textile Industry," *Perspectives in Vernacular Architecture* 1 (1982): 31–50.

Coolidge, John. *Mill and Mansion: A Study of Architecture and Society in Lowell, Massachusetts, 1820–1865.* New York, 1942.

Frary, Ihna Thayer. *Thomas Jefferson, Architect and Builder.* Richmond, Va., 1931.

Gilchrist, Agnes A. "John McComb, Sr. and Jr., in New York, 1784–1799," *Journal of the Society of Architectural Historians* 31 (March 1972): 10–21.

Glassie, Henry. *Folk Housing in Middle Virginia.* Knoxville, Tenn., 1975.

Guinness, Desmond, and Julius T. Sadler Jr. *Mr. Jefferson, Architect.* New York, 1973.

Hamlin, Talbot. *Benjamin Henry Latrobe.* New York, 1955.

Herman, Bernard L. *Architecture and Rural Life in Central Delaware, 1700–1900.* Knoxville, Tenn., 1987.

Jordan, Terry G. *American Log Buildings: An Old World Heritage.* Chapel Hill, N.C., 1985.

Jordan, Terry G., and Matti Kaups. *The American Backwoods Frontier.* Baltimore, 1989.

Kauffman, Henry J. *The American Farmhouse.* New York, 1975.

Kilham, Walter H. *Boston after Bulfinch: An Account of Its Architecture, 1800–1900.* Cambridge, Mass., 1946.

Kimball, S. Fiske. *Domestic Architecture of the American Colonies and of the Early Republic.* New York, 1922; reprinted 1966.

———. "Latrobe's Designs for the Baltimore Cathedral," *Architectural Record* 42 (December 1917): 540–56.

———. *Mr. Samuel McIntire, Carver, the Architect of Salem.* Salem, Mass., 1940.

———. "Thomas Jefferson and the First Monument of the Classical Revival in America," *American Institute of Architects Journal* 3 (September–November 1915): 370–33, 473–91.

———. *Thomas Jefferson, Architect.* Boston, 1916; reprinted 1968.

Kirker, Harold. *The Architecture of Charles Bulfinch.* Cambridge, Mass., 1969.

Kirker, Harold, and James Kirker. *Bulfinch's Boston, 1787–1817.* New York, 1964.

Lehmann, Karl. *Thomas Jefferson, American Humanist.* Chicago, 1947.

McLaughlin, Jack. *Jefferson and Monticello: The Biography of a Builder.* New York, 1988.

Newcomb, Rexford. *Architecture in Old Kentucky.* Urbana, Ill., 1953.

———. *Architecture of the Old Northwest Territory.* Chicago, 1950.

Noble, Allen G. *Wood, Brick, and Stone: The North American Settlement Landscape.* Amherst, Mass., 1984.

O'Neal, William B. *Jefferson's Buildings at the University of Virginia: The Rotunda.* Charlottesville, Va., 1960.

———. *Jefferson's Fine Arts Library.* Charlottesville, Va., 1976.

Patrick, James. *Architecture in Tennessee, 1768–1897.* Knoxville, Tenn., 1981.

Pickens, Buford. "Mr. Jefferson as a Revolutionary Architect," *Journal of the Society of Architectural Historians* 34 (December 1975): 257–79.

Quinan, Jack. "Asher Benjamin and American Architecture," *Journal of the Society of Architectural Historians* 38 (October 1979): 244–61.

Reps, John W. *Monumental Washington: The Planning and Development of the Capitol Center.* Princeton, N.J., 1967.

———. *Washington on View: The Nation's Capitol since 1890.* Chapel Hill, N.C., 1991.

Ridout, Orlando. *Building the Octagon.* Washington, D.C., 1989.

White Pine Series of Architectural Monographs. 1915–28 and 1932—41.

NOTES

1. See L'Enfant's essay describing his plan for the capital, reprinted in *America Builds*, 32–36.

2. See plates and preface in Asher Benjamin, *The American Builder's Companion* (Boston, 1806), reprinted in *America Builds*, 39–43.

3. Although the pedimented Ionic portico is clearly shown in Latrobe's drawings, it was built only much later, in 1865, by Latrobe's son, John H. B. Latrobe. The domed choir was completed according to Latrobe's design in 1890.

4. See Talbot Hamlin, *Benjamin Henry Latrobe* (New York, 1955), 238–41. Many of the letters relating this conflict are reprinted in John C. Van Horne, ed., *The Correspondence and Miscellaneous Papers of Benjamin Henry Latrobe*, vol. 2 (New Haven, Conn., 1986).

5. Latrobe's letter to Robert Mills, July 12, 1806, is reprinted in *America Builds*, 43–47. It should be noted that Latrobe himself did not always follow the stern advice he gave Mills.

6. For a selection of Latrobe's engineering drawings, including plans for both the buildings and steam engines of the Philadelphia water system, see Darwin H. Stapleton, ed., *The Engineering Drawings of Benjamin Henry Latrobe* (New Haven, Conn., 1980).

7. See William Bainter O'Neal, *Jefferson's Fine Arts Library* (Charlottesville, Va., 1976), 1–12.

8. See Jefferson's letter to James Madison, September 20, 1785, reproduced in *America Builds*.

9. There is no definite evidence that Jefferson knew of Ramée's plan, as noted in Paul Venable Turner, *Campus: An American Planning Tradition* (Cambridge, Mass., 1984). For Mills's South Carolina College see Turner, 56–59.

10. Hamilton's report is reprinted in *The Annals of America*, vol. 3 (Chicago, 1968), 92–72.

11. A portion of L'Enfant's commentary on his Paterson plan is reprinted in *America Builds*, 36–37.

12. Jefferson's anti-urban comments in his Notes on the State of Virginia are reprinted in *America Builds*, 24–25.

13. Jefferson's anti-urban views are discussed in Morton and Lucia White, *The Intellectual versus the City* (Cambridge, Mass., 1962).

14. The New York commissioner's report is reprinted in part in *America Builds*, 38–39.

15. Cited in Howard W. Marshall, *Folk Architecture in Little Dixie* (Columbia, Missouri, 1981), 55–56.

16. The Lower Swedish Cabin, Creek Road, Clifton Heights, Pennsylvania, illustrated in Terry G. Jordan and Matti Kaups, *The American Backwoods Frontier* (Baltimore, 1989), 153.

17. See Edward R. Horgan, *The Shaker Holy Land: A Community Portrait* (Cambridge, Mass., 1982); June Sprigg and David Larkin, *Shaker: Life, Work, and Art* (New York, 1987); Julia Neal and Elmer R. Pearson, *The Shaker Image* (Boston, 1974); and John Poppeliers, ed., *Shaker Built: A Catalog of Shaker Architectural Records from the Historic American Buildings Survey* (Washington, D.C, 1974). For the round barns, see Eric Sloane, *An Age of Barns* (New York, 1967).

18. First identified as a particular type by cultural geographers in the 1930s, the I house was so called because of its prevalence in states such as Indiana, Illinois, and Iowa. See Frederick B. Kniffen, "Folk Housing: Key to Diffusion," in *Common Places: Readings in American Vernacular Architecture*, ed. D. Upton and J. M. Vlach (Athens, Ga., 1986).

19. The McDowell house, restored in the mid-1930s, is significant as the residence and office of the first American surgeon to perform, in 1809, successful abdominal surgery (without anesthesia or antisepsis). Dr. Ephraim McDowell's grandfather, John, had lived in Rockbridge County, Virginia, where Ephraim's father, Samuel, was born. Samuel McDowell was appointed governor of the Kentucky territory by General George Washington after the Revolutionary War, moving first to Harrodsburg and then to Danville.

20. See John Michael Vlach, "The Shotgun House: An African Architectural Legacy," in *Common Places*, ed. Upton and Vlach.

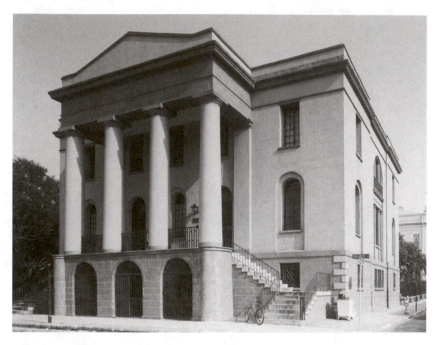

5.1. Robert Mills, County Records Office Building, "Fireproof Building," Charleston, South Carolina, 1821–27. Because of the importance of preserving records, Mills used solid masonry construction, with all halls and chambers vaulted. (Library of Congress, HABS SC 10-CHAR 64-7.)

5.2. Robert Mills, U.S. Treasury Building, Washington, D.C., 1836–42. Built in sections as operations of the Treasury expanded, this building was begun with the long colonnade on Fifteenth Street. (Lithograph, E. Sachse & Co., Baltimore, Maryland, printed by C. Bohn, Washington, D.C., c. 1861–67. Library of Congress, Prints and Photographs.)

APPROPRIATION AND INNOVATION, 1820–1865

IMAGES OF THE PAST, VISIONS OF THE FUTURE

The years between 1820 and 1865 saw the emergence of a broad popular culture. As the authority of the patrician standards of the Federalist and Virginian aristocracies began to wane, they were replaced by the more homespun values associated with the popular western folk hero Andrew Jackson, elected president in 1828. In several ways, however, the cultural changes, and their architectural manifestations, first began to appear a decade before Jackson's election. There were many causes, inextricably linked, one of which was the rise of a strong capitalist economy fueled by the rapid expansion of the nation, the concurrent acquisition of bountiful raw materials, and dramatic improvements in the transportation of goods and people after 1825 by means of canals, steamboats, and then railroads. Similar improvements in agriculture, such as McCormick's reaper, greatly increased production of grain, which was then more easily shipped on the canals and railroads. Altogether, this period witnessed the beginning of an industrialized system of mass production and mass distribution, geared to an expanding popular market. Whereas the economies had been distinctly regional at the start of the period, with poor roads between major cities, by 1860 the commerce between cities and between far-flung reaches of the union was extensive.

This industrialization, bred of an unshakable faith in material and physical progress, also created a broad middle class, the new patrons of the arts, who took material progress as their creed. Many of these parvenu patrons were relatively well educated or well read, with informed convictions about what they felt appropriate to have built, painted, or carved. For a brief time in the 1840s and 1850s, the promise of an egalitarian American art was offered in the establishment of the American Art Union and its wide distribution of lithographs. More architectural handbooks and builder's manuals began to appear, some in smaller, almost pocket-size form. These manuals and handbooks became increasingly popular, making household words of the names of such authors as Asher Benjamin, Minard Lafever, and Andrew Jackson Downing. And the first histories of American architecture began to be written.[1]

This was also a period in which humanitarian social ideals were wedded to fervent romantic feelings of individualism and a nostalgia for cultures far removed in time or place. The eclectic associationalism developed in the previous half century, augmented by the growing numbers of book and prints on ancient and medieval architecture, caused selected historical styles to become linked in the popular imagination with particular building types and functional uses. At the same time, industrialization produced new materials and techniques—iron, plate glass, wire nails, and mass-produced machine-sawn lumber—which enterprising architects endeavored to incorporate in their romantic creations. Consequently, the struggle between abstract universalities and the vagaries of regional adaptation, between the ideal and real, continued unabated, with only periodic shifts in the accuracy of detail or historical association of specific styles.

THE GREEK REVIVAL

The tendency during this period was for architects to use correct historical details in their buildings. In some instances—especially with Greek-inspired buildings—

the result was to virtually duplicate specific source buildings, resulting in, quite literally, a Greek Revival. In other instances, however, the plan and massing might be more individual, with the decorative details drawn from specific historical models. Given the strong classical emphasis of late Georgian and then Federalist architecture, it was natural perhaps that the Greek Revival should develop first among the many revivals of the nineteenth century. In fact, in the United States, to a greater degree than in European countries, ancient Greek models (rather than Roman) were reproduced with exactitude. Two contributing factors in this particularly American fondness for Greek architecture were the obvious association with the American reinvention of democratic government and the impact of the contemporaneous Greek War of Independence, in 1821–30, in which the Greeks threw off their Turkish overlords of several centuries.

The dramatic use of Greek architecture can be seen in the work of Robert Mills (1781–1855), one of the first American-born architects to have professional training. Mills was born in Charleston, South Carolina, where he obtained a classical education at Charleston College and where he met James Hoban, who gave him lessons in drawing. When Hoban transferred to Washington, D.C., to build the president's house, Mills followed him and came to Thomas Jefferson's attention. Soon he was given free use of Jefferson's considerable architectural library. In 1803, with letters of introduction from Jefferson, Mills was admitted to Latrobe's office, where he spent five years as Latrobe's assistant and was much influenced by Latrobe's insistence on masonry vaulting in public buildings. Mills began to establish himself in Philadelphia, designing several churches with specialized round or octagonal plans well suited to the spoken word. His octagonal Monumental Church, in Richmond Virginia, built in 1812–17, incorporated severe, even archaic Greek Doric columns, while his County Record Office (the "Fireproof Building") of Charleston, South Carolina, built in 1821–27, had an especially rational character, using more abstracted orders combined with masonry vaulting throughout for fire safety. [5.1] Mills used solid masonry vaulting for similar reasons in his U.S. Treasury Building, in Washington, D.C., built in 1836–42, with an exterior graced by a beautifully proportioned and detailed Greek Ionic order based on that of the North Porch of the Erechtheion. [5.2] Clearly Mills knew historical types well, and he knew how to reproduce them when he felt it most appropriate.

Greek architecture was sometimes specified by clients, even specific ancient buildings. The role played by clients is illustrated by this notice for the competition for the design of the Second Bank of the United States, printed in the *Philadelphia Gazette and Daily Advertiser* on May 13, 1818:

Architects of science and experience, are invited to exhibit to the Board of Directors, on or before the 1st day of August next, Appropriate designs and elevations for a Bank House. . . . The building will be faced with marble, and have a portico on each front, resting upon a basement or platform of such altitude as will combine convenience of ascent with due proportion and effect.

In this edifice, the Directors are desirous of exhibiting a chaste imitation of Grecian Architecture in its simplest and least expensive form.[2]

William Strickland (1788–1854), also a former student in Latrobe's office, read this notice and decided to give the directors of the bank what they asked for, quite literally. His winning entry for the Second National Bank of the United States, in Philadelphia, built in 1818–24, was based on the Parthenon in Athens, taken directly from the engraved plates published by Stuart and Revett. [5.3, 5.4] In his unsuccessful entry Latrobe proposed a Greco-Roman domed design similar to but better articulated than his earlier Bank of Pennsylvania. His design was rooted in functional arrangements. Strickland's, however, was decidedly Greek, one of the earliest "copies" of the Parthenon in America. Latrobe's buildings had seldom been drawn directly from books, and his bank designs always expressed clearly the internal volumes through external massing. Strickland, in contrast, based his porticoes for the Second National Bank directly on the measured drawings of the Parthenon. He eliminated the Parthenon's side colonnades but kept the unbroken gable roof line of the temple intact. Only the slightest projection along the sides gives any indication of the transverse barrel-vaulted banking room housed within. [5.5] In its strict adherence to a specific ancient model, Strickland's bank marks the beginning of the true Greek Revival in America.

In the same year as the bank competition, John Haviland (1792–1852) published *The Builder's Assistant* in three volumes, presenting for the first time in an American publication all five Greek and Roman orders (Asher Benjamin soon added Greek orders to

5.3. William Strickland, Second National Bank of the United States, Philadelphia, Pennsylvania, 1818–24, lithograph. This view published by W. H. Bartlett carefully avoids showing the noncolonnaded side of the bank. (Courtesy of the Historical Society of Pennsylvania.)

5.4. Parthenon, Athens, Greece, elevation. This plate of the end elevation from Stuart and Revett's Antiquities of Athens *served as Strickland's model. (From J. Stuart and N. Revett,* Antiquities of Athens, vol. 2, London, 1787.)

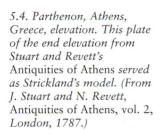

ft 10 20 30 40 50

m 5 10

5.5. Second National Bank of the United States. The plan shows how Strickland arranged the necessary offices and banking room within the envelope of a Greek temple. Unlike Latrobe's earlier bank, with its domed central banking room, the only indication of the banking room in Strickland's building is a slight outward projection of the center side walls. (L. M. Roth, after HABS.)

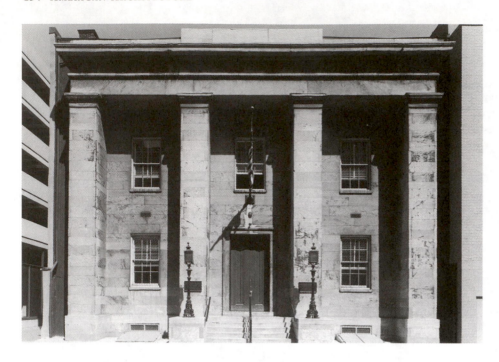

5.6. John Haviland,
Franklin Institute (now
Atwater Kent Museum),
Philadelphia, Pennsylvania,
1825. Here Haviland
devised a bold facade
for this small building,
employing projecting
massive Doric piers instead
of rounded columns.
(Library of Congress, HABS
PA 51-PHILA 153-1.)

his sixth edition of his *American Builder's Companion* in 1827). Haviland had been born and trained in England, had tried to develop a career in Russia in 1815–16, and then came to Philadelphia in 1816 at the suggestion of John Quincy Adams. Hoping to support himself through publication and teaching, he produced his elaborate and expensive folios (they did not sell nearly as well, however, as Benjamin's compact, more practical, and less costly volumes). Haviland also taught drawing at the newly founded Franklin Institute, Philadelphia, designing its new building in 1825 with a bold facade of four massive square Doric piers and entablature. [5.6] Haviland designed several of the earliest Greek Revival churches, including the First Presbyterian Church, in Boston, in 1820–22; and St. Andrew's Episcopal Church, Philadelphia, in 1822–24. Another of his innovations was the use of precast panels of cast iron (made to resemble ashlar masonry) for the facade of his Miner's Bank, in Pottsville, Pennsylvania, built in 1830–31 but demolished in 1926.[3] Despite his notably early uses of Greek sources for public buildings, Haviland's major impact, both in the United States and throughout Europe, came not through his careful Grecian designs but rather through his medieval and Egyptian prison designs, which are discussed later in this chapter.

Of the various styles revived early in the century, classic Greek at first seemed to be adaptable to a variety of new uses. Massive columnar facades were employed for churches, public and institutional buildings, and government structures. In some instances true columns might not be used at all (as in Haviland's Franklin Institute). General severity of form was one of the appealing attributes of the Greek Revival; indeed, the unadorned bare wall was one of the lasting contributions to American architecture made by the Greek Revival (the other important contribution of historicism was the open plan inspired by the Gothic Revival). Another example of this Grecian astylar severity (that is, with no columns) is the Sears House, in Boston, built in 1816, by Alexander Parris. [5.7] Parris (1780–1852) was trained as a carpenter-builder, later establishing a strong reputation in massive stone construction; he was, for example, construction supervisor of Charles Bulfinch's massive granite Massachusetts General Hospital, in Boston, built in 1818–23. In Parris's Sears house restrained Grecian details appear in the columnar portico and the carved panels above the windows, but otherwise there is utmost severity in the smooth curve of the bowed wall and the crisp incisions of the windows. Parris's use of Chelmsford granite in this house, and in many of his other works, also reveals the impact of developing transportation systems, for this granite was made commercially available only with the opening of the Middlesex Canal in 1803. Parris's austerity is Grecian in sentiment, showing a desire for basic geometrical shapes, but at the same time the bowed

front honors the tradition of Boston's earlier bowed facades. Also Grecian is the color, with granite approximating classic marble. It is possible too that the intractability of this granite helps to account for the severe lines and lack of ornament. Parris was the first in New England to use the Grecian temple form for a church, in his St. Paul's Church on the Boston Common, built in 1819 (soon followed by the temple-form churches by John Haviland).

Parris also used granite for the long warehouse and wholesale blocks he was commissioned to build by Boston mayor Josiah Quincy; the group of three parallel buildings was constructed on landfill on the Boston waterfront in 1825–26. [5.8] The central building of the Quincy Market group is punctuated by a center block capped with a low Roman saucer dome; each end is treated as a Grecian temple block with five pilasters along the sides and a prostyle porch of four unfluted archaic Doric columns. Behind the temple fronts, under the continuous gable roof, the walls are formed of large granite piers and lintels, making a simple but massive lithic frame. In comparing the white Quincy Market with Smibert's delicate red brick Georgian Faneuil Hall directly behind it (as

5.7. *Alexander Parris, David Sears house, Boston, Massachusetts, 1816. Simply detailed, the Sears house (with the original section to the right) was built in granite. (Sandak, courtesy of the University of Georgia.)*

5.8. *Alexander Parris, Quincy Market, Boston, Massachusetts, 1825–26; engraving, 1852. Behind the Quincy Market is Faneuil Hall, designed by John Smibert,* 1740–42, *and enlarged by Bulfinch, 1805–6. (Courtesy of the Bostonian Society.)*

later enlarged by Bulfinch), one can see the bold, massive assertiveness of the Greek Revival, a quality that made this style all the more appealing to an increasingly self-conscious nation.

The very fact that so many buildings in New England were built of hard Chelmsford and Quincy granites is also illustrative of the industrialization of the American building industry. Quincy granite, in particular, was made available throughout the East by the ingenuity of Solomon Willard (1788–1862), carpenter, sculptor, architect, and inventor. Willard opened the granite quarry at Quincy and developed an ingenious integrated system of stonecutting and handling machinery, rail transport, and deep water berth, which permitted him to cut and ship blocks of granite on a scale unknown during the previous fifteen hundred years. He used this granite for his own buildings: for example, the Bunker Hill Monument, in Charlestown, Massachusetts, built in 1825, and the Suffolk County Courthouse, in Boston, built in 1845. Soon buildings all along the New England coast were being built not of local materials but of Quincy granite, partly because it was durable and partly because it was readily available from a commercial source. Later, with the gradual extension of the railroad system in the East, the replacement of local materials by cheaper commercial substitutes was greatly expanded.

Greek Revival Temple Houses

The Greek Revival was championed by such well-to-do educated Hellenophiles as Nicholas Biddle, who, as president of the Second National Bank of Philadelphia, occupied Strickland's Doric bank building. A student of classical literature at Princeton, Biddle traveled to Greece in 1806 to see the buildings for himself. It became increasingly urgent for Biddle that his family home, called Andalusia, north of Philadelphia, be made Grecian, so in 1836 he engaged Thomas Ustick Walter (1804–1887) of Philadelphia to remodel the house. In addition to major internal changes, Walter wrapped around the house a Doric colonnade patterned directly after that of the Hephaisteion in Athens, built in 449–44 B.C. on a knoll just above the agora marketplace. [5.9] As a result there is no correspondence between the columns of Andalusia and the windows and doors, and the heavy entablature throws the upper windows into deep shadow. But the Doric colonnade is archaeologically correct; Biddle knew exactly what he wanted and he knew that Walter could provide it, for Walter had been in Strickland's office and thus was heir to the rich professional tradition of Latrobe.

This belief in symbolic associations was advanced by professional architects, whose numbers were steadily growing; they often had some college educa-

5.9. Thomas Ustick Walter, Nicolas Biddle house, Andalusia, near Philadelphia, Pennsylvania, remodeling of 1836. For his client, Nicholas Biddle, Walter wrapped a colonnade based on the Hephaisteion in Athens around an existing Georgian house. (Library of Congress, HABS PA 9-ANDA 1-11.)

5.10. *Ithiel Town and Alexander Jackson Davis, S. Russell house, Middletown, Connecticut, 1828–30. Town and Davis's elegant adaptation of the Greek temple form for a residence incorporates intelligently modified Ionic Greek details inside and out. (Sandak, courtesy of the University of Georgia.)*

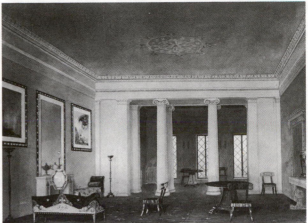

5.11. *Alexander Jackson Davis. Davis's detailed study for a Greek Revival double parlor, perhaps for the John Cox Stevens house, New York, c. 1845, shows a complete Grecian interior with furniture inspired by images from Greek vases. (Courtesy of the New-York Historical Society.)*

tion or basic engineering experience, sometimes both, and they collected extensive libraries. The firm of Town and Davis exemplifies this new generation of highly educated architects without whom the romantic archaeological revivals would have been impossible. Ithiel Town (1784–1844), born in Connecticut, received his architectural training in the Boston office of Asher Benjamin. He opened his own practice in New Haven in 1810, and while designing buildings he investigated the use of iron, wrote on mathematics and navigation, read in the arts, and traveled. In 1825 Town moved his office to New York City, but he was often called away to supervise installations of the wooden truss bridge he patented in 1820 and that was being widely used throughout the eastern states. The royalties on the bridge truss soon made Town wealthy and enabled him to amass one of the largest and finest architectural libraries of his day (it was sold and disbursed in 1843). Town tended toward clear, rational compositions and, perhaps predictably, because of his interest in mathematics, favored classical Greek. An example is his Connecticut State Capitol, on the New Haven Green, which he designed in 1827 (with the assistance of A. J. Davis); it is a severe Greek Doric temple with a hexastyle porch and side walls so deeply pilastered as to suggest a peripteral colonnade. A student of the history of architecture, Town knew other styles; in 1814, immediately next to Benjamin's Center Church on the New Haven Green, he built a dark brownstone Gothic church for an Episcopalian con-

gregation—the style chosen in recognition of traditional churches in England.

Because Town was often called away from his New York office, he took on a young partner in 1829, Alexander Jackson Davis (1803–1892). The opposite of yet a complement to Town, Davis had spent a large part of his youth reading and devising theater sets for his own amusement. He attended the American Academy of Fine Arts in New York and aspired to become an artist. To support his painting studies, Davis began making drawings of public buildings for reproduction in popular engraved views (one of these is shown in 4.11); eventually Davis became one of the foremost draftsmen and watercolorists of his day, but he always remained an "architectural composer," in his words. He thought of architecture as scenographic design that provided exotic backdrops for stylized activity rather than the shaping of space or structure. Nevertheless, he appreciated simple rational design, as his later work shows. His strong commitment to professional ideals led him, in 1837, to join with Town, Strickland, Haviland, Walter, and others (including Minard Lafever, Isaiah Rogers, Benjamin, Parris, and Ammi B. Young), in an attempt to found a professional society, but this venture came to naught.

The early works of Town and Davis were largely Greek Revival; they were solid, carefully planned, with consummate detailing by Davis. A good example is the S. Russell house, in Middletown, Connecticut, built in 1828–30. [5.10] A pure cube with a

5.12. *Town and Davis, Joseph Bowers house, Northampton, Massachusetts, c. 1830. Because the temple model precluded modifying the basic house design, expansion could be achieved by adding separate lower wings on either side of* the main temple block. *(From E. V. Gillon,* Pictorial Archive of Early Illustrations and Views of American Architecture, *New York, 1971.)*

Corinthian hexastyle porch, it is characterized by formally arranged rooms, elegantly refined proportions, and careful alignment of the wall openings with the colonnade (compare this precision with the irregularities of Andalusia). The entrance door, with its framing Doric pilasters, entablature, and glazed side lights, is an outstanding example of the kind of entrances that soon became popular, usually in simpler form, throughout the country. The interiors of such houses were equally well ornamented, and a good example is one rendered by Davis that was possibly intended for the John Cox Stevens residence, in New York, 1845. [5.11] The walls are left plain, with ornamentation reserved for the ceiling entablature molding, the Ionic columns of the passway, and the door with its Greek frame. The furniture by Davis, moreover, is based on pieces shown on Greek vases and resembles the late work of Duncan Phyfe.

Because of the fixed form of the temple block, enlarging such houses could prove difficult without destroying the temple in the process. One way of providing for larger houses was developed by Town and Davis and used by many other architects and designers. No longer standing, the Joseph Bowers house in Northampton, Massachusetts, built in about 1830, was a massive two-story hexastyle Greek Ionic house block flanked on either side by lower one-story templelike blocks. [5.12] The height of the side projections was carefully proportioned so that their pedimented gable roof ridges intersected the main house just below the architrave wrapping around the main block. Unlike in temples, however, the side blocks had open porches on their long sides, behind square Doric piers, facing the same direction as the main portico.

Because of its use of repeated modular forms, the classic revival lent itself well to urban town houses

(contiguous houses with party walls). Excellent, highly conservative examples can be found on Beacon Hill, in Boston, or on the north edge of Washington Square, in New York; in both cases the houses are of brick with restrained Greek entrances. More elaborate, and more characteristic of the fully developed Greek Revival of the 1830s, is La Grange Terrace, in New York [5.13], a group of nine houses built in 1830–33 by developer Seth Geer on Lafayette Place, and named after Lafayette's country home. It is possible that the block-long group was designed by Davis, though fragmentary evidence suggests that the designer may have been Robert Hingham of Albany. The colossal Corinthian colonnade shelters two full stories, while the rusticated base contains the entrances. Recessing the column-framed entrances so that no projecting elements could break up the stretch

of the terrace allowed the march of the colonnade and the flow of the street to continue smoothly. Where a suburban freestanding house, such as the Russell house of Middletown, could be expressed as an isolated unit in the landscape, La Grange Terrace, like the town houses of Bath or London from which it derives, recognizes the continuity of the street and reinforces its urban character.

Such buildings as the Russell house and La Grange Terrace represent urban high-style design and were the work of trained professional architects. As yet, however, the United States was not an urban nation. The great majority of people lived in rural areas, where building was largely in the hands of carpenters and mechanics who relied on books. Thus it was through pattern books that the Greek Revival spread across the nation and persisted for nearly forty years as the

5.13. *Alexander Jackson Davis or Robert Hingham, designer, Seth Greer, developer, La Grange Terrace ("Colonnade Row"), Lafayette Street, New York, New York, 1830–33. An* *extended Greek colonnade could also gather together a row of urban town houses; only a small portion of this row survives. (Courtesy of the Museum of the City of New York.)*

national style. The later, modified editions of Asher Benjamin's books, in which the Georgian-Federalist plates were replaced with new illustrations of Greek Revival forms, were important sources for this Greek Revival. Haviland's large, expensive book was less so. While Benjamin's many books were most popular in New England and Connecticut's Western Reserve (which by now was part of Ohio), a new author appeared who made the Greek Revival his particular cause and whose books enjoyed special influence in the territory not already won by Benjamin.

Minard Lafever (1798–1854) was a self-trained designer and builder from the Finger Lakes region of upstate New York. His first book appeared in 1829, but it was his second and third titles that exerted the most profound influence. *The Modern Builder's Guide* appeared in 1833 and ran through five editions

until 1855; *The Beauties of Modern Architecture* came out in 1835 and went through four editions until 1855. These books presented detailed engravings of the classical Greek orders, their sources in ancient examples clearly identified. [5.14] Though no later editions appeared, it should be remembered that in outlying regions Lefever's books continued to be used for another decade or more. Some of the more elaborate examples of the spreading Greek Revival are the Boody house, called Rose Hill, in Geneva, New York, built in about 1835; the De Zeng house, in Skaneateles, New York, built in 1839; and the Sidney T. Smith house, in Grass Lake, Michigan, built in 1840. In his *Modern Builder's Guide*, Lafever included an elaborate house design similar to Town and Davis's Bowers house, with projecting side wings. It, too, has highly detailed fluted Ionic columns on the

5.14. Minard Lafever's Greek Doric and Ionic orders, plates 45 and 48. Lafever's orders are taken directly from the plates published by Stuart and Revett and were instrumental in instilling a love of the Greek form of these orders instead of

the Roman. The Doric is from the Temple of Athena (the Parthenon) and the elaborate Ionic is from the North Porch of the Erectheion, both on the Acropolis in Athens. (From M. Lafever, The Modern Builder's Guide, *New York, 1833.*)

5.15. Minard Lafever, "Design for a Country Villa." *The frontispiece from* The Modern Builder's Guide *showed how to build a fashionable Grecian house when only flat board lumber was available. (From Lafever,* Modern Builder's Guide.*)*

5.16. Greek Revival house, Eastham, Massachusetts, c. 1850. When skilled wood-carvers were unavailable, Greek forms and details could be suggested in flat boards. (Sandak, courtesy of the University of Georgia.)

main porch, with fluted Greek Doric porticoes on the ends of each flanking wing. It is significant, however, that for the frontispiece of *The Modern Builder's Guide*, Lafever provided a simpler version of this same design, with details suitable for construction with board lumber and hence more easily realizable by untrained mechanics. [5.15] The columns of porch and wings are converted to square piers with simple geometric capital blocks. All of this could be built of

mill-sawn lumber. Houses of this type soon began to appear all across the Old Northwest Territory, each varied according to the ability of local craftsmen and the aspirations of the client, although several of them demonstrated particular suavity of detail.

A possible example of Lafever's influence can be seen in a small house at Eastham, Massachusetts, on Cape Cod, built in about 1850 [5.16], for it has the kind of abstracted mill-board Grecian detail suggested

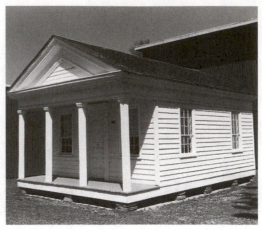

5.17. *Lane County Clerk's Office, Eugene, Oregon, c. 1853. In Oregon, the Greek Revival was used through the 1850s, with abstracted details, and often square posts instead of round columns. (L. M. Roth.)*

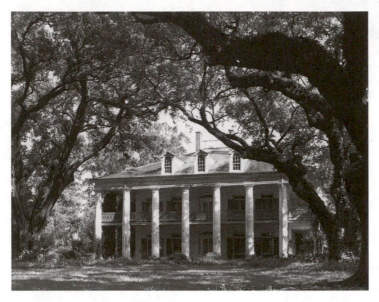

5.18. *George Swainey, Alexander Roman house, Oak Alley, St. James Parish, near Vacherie, Louisiana, 1836. Originally called "Beau Sejour," the Roman house, with its majestic approach through an allée of live oaks, has come to epitomize the southern plantation house. (Photo: © Wayne Andrews/Esto.)*

in *The Modern Builder's Guide*. A discrete white cube with a low-pitched gable roof, it has a stylized entablature that runs completely around the house, creating a pediment at the gable end. There is no colonnade, but the corners are treated with pilasters with elaborate capitals, and the door has a classical frame of pilasters and entablature with glazed side lights (compare the Russell house entrance by Town and Davis). Everything is stripped, devoid of carved ornament, with geometrical equivalents substituted for archaeological detail. It has the pristine probity of the most elaborate revival temple, but is rendered in vernacular materials, with clapboarded facade and shingled side walls. Another example at the opposite end of the continent is a comparable building, the little Lane County Clerk's office, in Eugene, Oregon, built c.1853, a small tetrastyle temple, complete with heavy entablature and pediment, but with plain square posts substituted for columns (yet the posts are given capitals). [5.17]

The Greek Revival spread also through the South, resulting in the large white antebellum mansions of Alabama, Mississippi, and Louisiana. The seventeenth-century economic system of the South had changed only slightly, with tobacco, cotton, and sugar replacing indigo and rice as the principal crops. The plantation system, and the accumulation of private wealth, through the exploitation of subjugated slave labor made possible the creation of even more expansive and elaborate homes. The columnar Grecian mode was eagerly adopted, especially in Mississippi and Louisiana, where circumferential porches and galleries had been customary since the eighteenth century (as at Parlange Plantation). Along the humid shores of the Mississippi the sheltering colonnades had a particular climatic function they did not have in the North, shading the walls and preventing heat build-up. Dunleith at Natchez, Mississippi, built in 1847; Greenwood, near St. Francisville, Louisiana, built in about 1830; and Houmas, near Burnside, Louisiana, built in about 1840, are all good examples of the southern plantation house with peripteral colonnade. Perhaps the most lyrical of them all is Oak Alley, near

Vacherie, Louisiana, built in 1836, the home of planter Alexander Roman. [5.18] The massive encircling columns support a continuous veranda at the second floor, and the twenty-eight columns are matched by an equal number of live oaks that line the formal approach to the house from the Mississippi River, the highway that connected this plantation to nearby New Orleans. In few other locations was such a dream-image of formal rectitude and romantic splendor so perfectly realized.

If such temple-form mansions represented one end of the Greek Revival spectrum, the other was represented by highly simplified but no less symbolic allusions to Grecian details in the frontier settlements. Once the Santa Fe Trail was opened in 1821, and wagon trails began to open up commerce between the United States and the Spanish territorial capitol of New Mexico, simplified Greek details began to appear there mixed with local Spanish and Mexican traditions. By the 1840s what is called the Territorial Style had developed, with slender classicizing wood post columns, with greatly stylized Doric capitals, replacing the heavy masonry piers of the portals (porch colonnades). Equally indebted to Greek sources were the very slightly pitched crowns over New Mexican windows, hinting at their source in classical triangular pediments.

State Capitols

Of the many new building types that appeared in this romantic period, one of the first was the state capitol. In the first years of the century many of the state legislatures continued to meet in eighteenth-century chambers after independence. As the states grew in population, and the number of representatives increased, they needed new quarters; and in any case new state images needed to be created. Moreover, new states were rapidly being admitted to the union as swarms of settlers surged westward, shoving native tribes before them, clearing forests, and plowing the land. Twelve new states were created between 1820 and the start of the Civil War, joining the original thirteen and the nine that had been added to the Union in the intervening years: Maine (1820), Missouri (1821), Arkansas (1836), Michigan (1837), Florida (1845), Texas (1845), Iowa (1846), Wisconsin (1848), California (1850), Minnesota (1858), Oregon (1859), and Kansas (1861).

What these state houses should be and what they should look like were knotty questions. Jefferson's Virginia capitol furnished one model validated by ancient references, and Bulfinch's capitol for Massachusetts provided a modern example; one was a classical temple, and the other was more generically

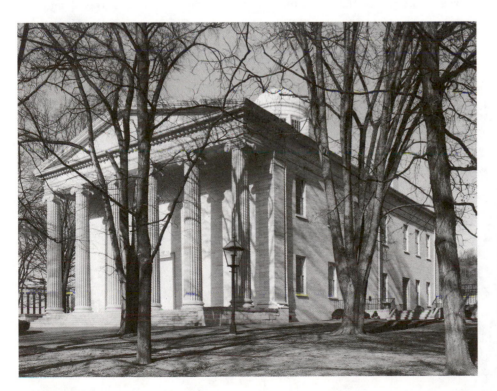

5.19. Gideon Shyrock, Kentucky State Capitol, Frankfort, Kentucky, 1828–30. Shyrock opted for the more delicate Ionic order for the end colonnades of his Kentucky capitol, with a domed lantern over the central stair. (Library of Congress, HABS KY 37-FRANO 1-17.)

classical, capped by a Renaissance dome. New York architects Town and Davis drew upon Jefferson's example in their severe Doric Connecticut capitol, a temple on the New Haven Green, built in 1827–33 (for a time Connecticut had two capitals where the legislature met in alternate years). More delicate in its detailing was Gideon Shyrock's Ionic temple for the Kentucky capitol at Frankfort, 1828–30 [5.19]; it had an internal central circulation rotunda with a double curved stair lit by a tall cupola on the roof (a variation on the dome idea). This idea was expanded by Town and Davis in their Indiana state capitol, in Indianapolis, built in 1831–35, which had a ribbed dome rising through the Doric temple roof. Several of the capitols built in this period—such as the North Carolina capitol, built in 1833–40, by Town and Davis, or the Vermont capitol, in Montpelier, built in 1832–36, by Ammi B. Young—consisted of massive rectangular blocks, sometimes embellished with thick pilasters, punctuated by heavy Doric entry porticoes on one or both of the long sides, opening to central rotundas capped by low-set Roman domes.

Arguably the best of these Grecian temple-form capitols was William Strickland's Tennessee state capitol in Nashville, built in 1845–59. [5.20] Strickland devised a large Ionic temple, placed dramatically on a hilltop, but he made significant departures from previous models. To ensure proper proportions in the Ionic columns, the temple fronts at each end were made octastyle (eight columns across). Unpedimented hexastyle (six columns) colonnaded entrances were added to the otherwise unmodulated long side walls. Strickland's Ionic order was carefully scaled and proportioned after Greek sources. Additionally, the whole block was raised on a tall rusticated base. Instead of mixing his sources and devising a Renaissance dome, Strickland drew from another well-known Greek model, the Choragic Monument of Lysicrates, in Athens, creating a surmounting towerlike form. The ungainly combination, with the tower base thrusting through the temple roof, is most un-Greek, despite the individually accurate motifs. What Strickland wanted, however, was a building that would recall the national Capitol in Washington, with its wings flanking a domed central hall, but would also employ Greek elements with their contemporaneous connotation of democracy. Despite the mixed success of this experiment, the details reveal Strickland's love of elegant form and graceful embellishment.

Of the many Grecian state capitols erected during the romantic period perhaps none was bolder or more assertive than the Ohio state capitol, in Columbus, built in 1838–61. [5.21] In the competition for the design, the first prize was won by Cincinnati architect Henry Walters, second place was awarded to Martin E. Thompson working with Town and Davis, and the

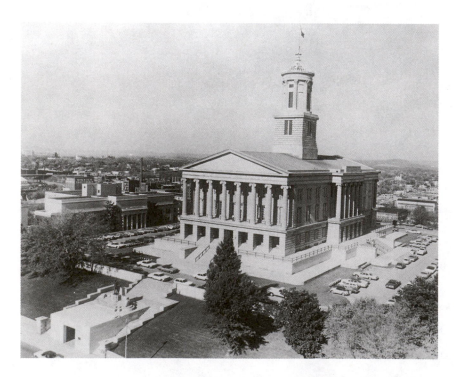

5.20. William Strickland, Tennessee state capitol, Nashville, Tennessee, 1845–59. Strickland substituted a huge version of the ancient Greek Choragic Monument of Lysiscrates in Athens for the more typical Roman-Renaissance central dome. (Courtesy of the Tennessee Department of Conservation.)

5.21. Henry Walters and others, Ohio state capitol, Columbus, Ohio, 1838–61, period photograph, c. 1860. The Ohio capitol, devised by Walter from several competition entries, is austere in the extreme. (Author's collection.)

5.22. Thomas Cole, The Architect's Dream, 1840. Oil on canvas, 54 by 84 inches. The long section behind the Ionic temple, with its square piers and domed round temple cupola, closely resembles Cole's nonwinning entry in the Ohio capitol competition. As noted in the inscription seemingly carved into the enormous block from which the sleeping architect rises, "Painted by T. Cole for I. Town. 1840." (Courtesy of the Toledo Museum of Art.)

third prize was awarded to landscape painter Thomas Cole. To combine the best features of all these designs the New York architect Alexander Jackson Davis was brought in as consultant. Out of this "collaboration" came the final design, heavily indebted to Thomas Cole's design—bold, massive, austere, masculine (as this term was used in the nineteenth century)—in contrast to Strickland's more delicate "feminine" solution. This austerity resulted from keeping unbroken the rectangular pilastered block of the building, and forming entrance porches in recesses cut into the block behind screens of stout, unfluted Greek Doric columns. Hence, the heavy overscaled Doric entablature runs unbroken around the building; even the low pediments on the long sides are floating and isolated, slightly set back. Internally the plan resembles that of the national Capitol, with the legislative chambers on either side of a central rotunda. In an effort to retain the austere character of the exterior, the rotunda dome is contained in a tall pilastered drum, which was to be capped by a very low Roman saucer dome. This capping dome was never built, unintentionally reinforcing the austerity of the silhouette, but the intended appearance of the finished capitol is suggested by the dome-topped drum in the middle ground of Cole's *The Architect's Dream*, painted in 1840 for Davis's partner, Ithiel Town. [5.22] This canvas was painted after the competition but it shows the essence of Cole's proposal for the capitol. In part the austerity of the heavily scaled unfluted columns may have been due to the large-grained local limestone used for the building, as well as to the employment of convicts from the state prison as laborers. As a result the exterior is one of the most massive and austere among the Greek state capitols.

5.23. Charles Bullfinch, U.S. Capitol, Washington, D.C. This very early photograph, taken by John Plumb in 1846 or 1847, shows the eastern central portico and the wood dome as completed by Bulfinch during 1818–27. (Library of Congress, USZ62-46801.)

5.24. Thomas Ustick Walter, United States Capitol, Washington, D.C., Senate and House wings, 1851–55, dome, 1855. In the distance is the Washington Monument by Robert Mills, 1836–88. Walter's cast-iron dome was designed in proportion to the newly added wings at each end of the original building. (Library of Congress, PC-4205A.)

The United States Capitol

The major work of Thomas Ustick Walter's later years was the enlargement of the United States Capitol, in Washington, D.C., begun in 1851. By that date the Union, and the population of the country had grown to nearly nine times what it had been when Thornton had designed the Capitol. Government services were hampered by lack of space, and the chambers were hopelessly crowded. Moreover, the central dome, completed in 1818–27 by supervising architect

Charles Bulfinch, had been made of wood and was a constant fire hazard, a concern brought very much to the fore by a fire in the building in 1851. [5.23]

To solve the problem of space a competition was held for extensions of the building and of the entries President Millard Fillmore selected four, giving Walter instructions to design new wings by combining the best from these plans. Walter's final design provided for identical wings to the north and south of Thornton's building, employing the same rusticated base and

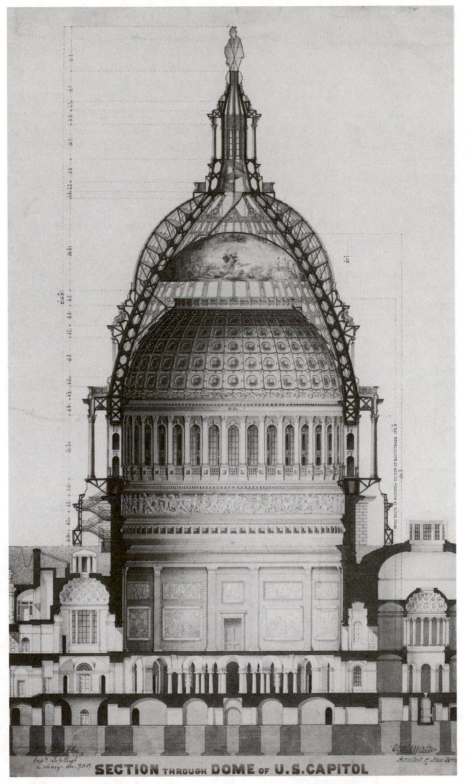

SECTION THROUGH DOME OF U.S. CAPITOL

5.25. U.S. Capitol. Section drawing by Walter and his staff showing construction of the cast-iron dome, and its placement on Bulfinch's stone drum. The perforated cast-iron building components reduced the weight so the larger dome could be built on Bulfinch's existing rotunda drum. (Courtesy of the Architect of the U. S. Capitol.)

colossal Corinthian order of the original section, but with the classical details at the same time more Grecian and more elaborate. [5.24] Each new wing, with its projecting pedimented portico echoing the center section, was built of white Massachusetts marble, subtly different in hue from the Virginia sandstone of the original section. Most significant, however, all the internal elements were made of iron, the result of Walter's decision to prevent fires like the one that damaged part of the Capitol late in 1851. Wrought iron was used for the roof trusses, while cast iron was used for all other sections, including ceiling and wall panels, window moldings, and trim—it was the largest use of iron in any public building in the United States up to that time, and roughly contemporary to the new Houses of Parliament in London, which were also being rebuilt internally of iron for fire safety.

The addition of the wings, however, destroyed the relationship of Bulfinch's timber-framed dome to the whole, so in 1854–55, as the wings neared completion, Walter drew up plans for a huge new iron dome over the central rotunda, big enough to be in balance with the new length of the building. This new construction would also remove the last major wood portion of the Capitol's fabric, reducing the likelihood of a catastrophic fire. For such a huge dome there were no precedents in Greek or even Roman architecture, and since Walter needed a steep profile (he had to stay within the diameter of Thornton's dome and build on the existing walls), he turned to the Renaissance domes of Michelangelo and Wren, one indication that by 1855 the exacting force of the Greek Revival was in decline. To set such a towering new work on existing walls and foundations, Walter had to lighten the load as much as possible, and his solution was to perforate all the structural iron members, making in effect a trussed iron frame that carried internal and externals shells of cast-iron panels; the result was lighter than traditional solid masonry construction. [5.25] Work on the dome started in 1855 but was not completed until early 1864, largely because the Civil War interrupted supplies of iron and legislative approval of appropriations. Yet the fact that the dome was pushed to completion during the war illustrates the compelling force formal aesthetics and symbolism exerted on Walter, President Lincoln, and the Congress. Lincoln, replying to a pointed question as to why construction continued while the nation was split in war and material was so dear, said "if people see the Capitol going on, it is a sign we intend the Union shall go on."[4] Here restated was Jefferson's belief in the symbolic power of architecture to mold the people's minds and to direct their action.

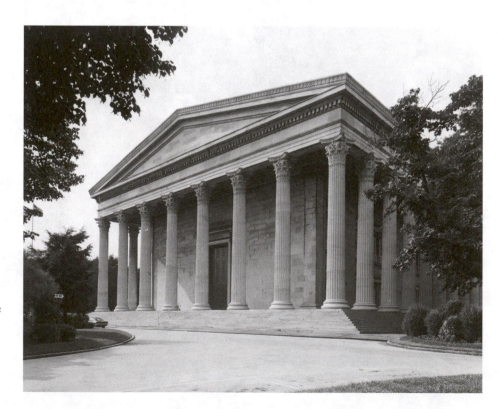

5.26. Thomas Ustick Walter, Girard College, Founder's Hall, Philadelphia, Pennsylvania, 1833–47. For this college for working-class young men, Ustick devised a Corinthian temple block of great archaeological precision. (Library of Congress, HABS PA 51-PHILA 459A-1.)

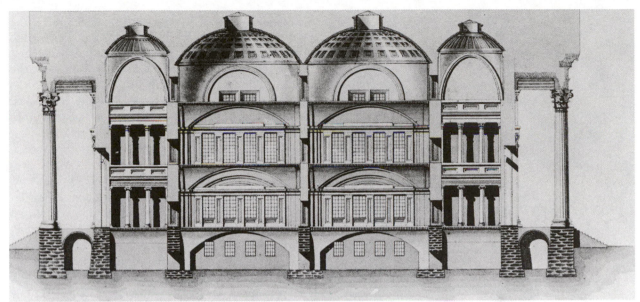

5.27. *Girard College. Longitudinal section showing the vaulting of the classrooms, with skylights used in the* uppermost rooms. *(Condit Archive, Northwestern University.)*

Grecian Public Buildings

Greek temples were used to house nearly every conceivable functional building, from banks and residences to schools, churches, and public buildings. One of the purest adaptations for the use of a school was Girard College in Philadelphia, another design of Thomas Ustick Walter. [5.26] In 1833 Nicholas Biddle, one of the officers of the newly established school, was instrumental in selecting Walter from among other competitors as the architect for Girard College. The school was being built through the bequest of the wealthy Philadelphia banker Stephen Girard, whose will stipulated the dimensions of the buildings for the proposed college for orphaned boys; it was Biddle who urged Walter to develop the design as an elaborate Corinthian temple. Founder's Hall, the main building, is a peripteral temple (columns all around) with four classrooms on each of three floors. This arrangement, necessitated by Girard's will, resulted in skylighted rooms on the third floor. Throughout, the rooms are vaulted in masonry, in the tradition of Latrobe and Mills. [5.27] Although the building is not a copy of a Greek temple in the literal sense (because it is too short for its width), its detailing has a delicate authenticity that suggests the best Athenian work. Flanking the main building, two to a side, are four dormitories, each a separate pedimented astylar block (with no columns or pilasters). Walter kept each of the buildings isolated, in a row, so that instead of enclosing a Roman forum, as at Charlottesville, the buildings stand free, more like ancient Greek temples did.

Few people seem to have been troubled by the idea of adapting the pagan Greek temple for use in churches as well. The early examples by Parris and Haviland, in Boston and Philadelphia, have already been mentioned. Nearly every Christian denomination built Grecian churches, and Charleston, South Carolina, still retains a large number of excellent examples, including Robert Mills's Tuscan (unfluted) Doric First Baptist Church (1822), a pure Parthenon Doric Second Baptist Church, by Edward B. White (1841–42), the Doric Bethel Methodist Church (1852–53), a grandly proportioned Corinthian temple for the Third Presbyterian Church by Edward C. Jones (1848–50), as well as Cyrus Warner's Doric Jewish synagogue, Kahal Kadosh Beth Elohim (1839–41). [5.28]

Social clubs, and educational associations like the Athenaeums, also built Greek temples, perhaps none finer in detail than the magisterial Corinthian temple for the Hibernian Club in Charleston, South Carolina, by T. U. Walter, built in 1835–41.

Between 1820 and 1860 public institutions began to require larger and more distinctive buildings. While prisons and other penal institutions were generally linked to medieval or Egyptian stylistic forms because of reformatory associations, hospitals, almshouses, and insane asylums were frequently built in classical forms, Grecian Doric being the most preferred. John

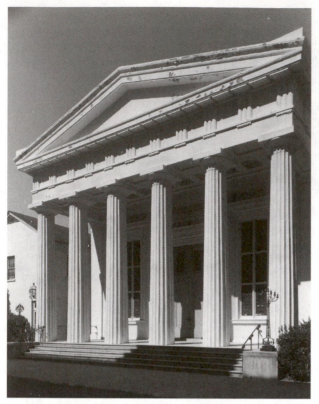

5.28. Cyrus Warner, Kahal Kadosh Beth Elohim Synagogue, Charleston, South Carolina, 1839–41. The Greek temple form was used for all manner of houses of worship, including this synagogue. (Library of Congress, HABS SC 10-CHAR 41-8.)

Haviland provided a very early model, using the Greek orders for his Pennsylvania Institution for the Education of the Deaf and Dumb, in Philadelphia, built in 1824–26. The later Indiana Hospital for the Insane, at Indianapolis, built in 1854, with its Ionic central pavilion and set-back flanking pavilions, shows both the increase in the size of such facilities over a quarter century, and also the preferred plan arrangement based on French hospital prototypes. Especially impressive in its sheer size and massive proportions is the carefully detailed four-story hexastyle Doric portico of the New York State Lunatic Asylum at Utica, built in 1836–43, whose portico is reported to have been designed by the hospital's director, William Clarke. [5.29] Such massive and imposing classicism may have been preferred for institutions for the mentally ill, since it suggested balance and order, and perhaps it was believed it would instill in the patients a sense of calm.

THE GOTHIC REVIVAL

Although there was a bias toward classical forms and details arising from the nation's early associations with Roman government and the contemporary struggle by the Greeks for their political freedom, there had been, from the beginning of European settlement, a

5.29. William Clarke, designer (attrib.), New York State Lunatic Asylum, Utica, New York, 1836–43. The Utica asylum used Greek Doric, perhaps to suggest an aura of stability and calm. (Photo: © Wayne Andrews/Esto.)

parallel interest in medieval forms and building traditions. The Newport parish church in Virginia, discussed in chapter 2, was begun in a late variant of vernacular Gothic that was still very much alive in rural England in the early seventeenth century. As the interest in Gothic novels (for example, Horace Walpole's *The Castle of Otranto* of 1756) burgeoned in the eighteenth century, there also arose an interest in Gothic ornament, particularly in rather fanciful garden "follies." A major impetus was the appearance of Batty Langley's Gothic *Architecture Improved by Rules and Proportions in Many Grand Designs* in 1742, which offered designs for garden pavilions in supposedly Gothic styles. This earliest phase of "Gothick" (to use the eighteenth-century spelling) was not concerned with archaeological accuracy and served largely for garden embellishments and interior details, such as Josiah Brady's pointed windows and finials on what was a basically Georgian-Federalist building for Trinity Church, in New York, built in 1788–94. Even dedicated classicist Jefferson proposed using Gothic in one of the pavilions he planned for the landscaped grounds around Monticello, and in 1771 he wrote in his journal that in the center of the burial plot he wanted to "erect a small Gothic temple of antique appearance."[5] The project was not carried out, but this does illustrate the flexibility of Jefferson's associationalism, for while Roman classic was appropriate for seats of government, Gothic was seen as more properly evocative for places with strong religious associations, or even interment.

As noted, Latrobe had proposed a detailed Gothic solution for the Baltimore Cathedral in 1804, and even before this, in 1799, he had built for William Crammond a "Gothick" country house, Sedgeley, outside Philadelphia. Other Latrobe "Gothick" buildings soon followed, including Latrobe's Bank of Philadelphia, built in 1807, and two churches: Christ Church, in Washington, D.C., built in 1808 (which had iron gallery columns), and St. Paul's, in Alexandria, Virginia, built in 1816. Still standing is another important early example, the small chapel for the Sulpician Academy of St. Mary's Seminary, in Baltimore, built in 1806–8, designed by the architect then teaching drawing at the seminary, Maximilian Godefroy. [5.30] Thereafter Gothic was increasingly used for churches and also for new collegiate buildings, such as Old Kenyon, for Kenyon College, in Gambier, Ohio, built in 1827–29, designed by the Reverend Norman Nash and slightly modified by Charles Bulfinch.

By 1835 to 1840 Gothic was nearly as well established as Greek as a major style, as is evident in Cole's painting for Ithiel Town, *The Architect's Dream* [5.22]. The brightly illuminated classical modes on the right half of the canvas are balanced by the darker,

5.30. Maximilian Godefroy, St. Mary's Seminary Chapel, Baltimore, Maryland, 1806–8. A surviving example of the early Gothic Revival in the United States. (Photo: © Wayne Andrews/Esto.)

5.31. Alexander Jackson Davis, New York University, Washington Square, New York, New York, 1832–37. Gothic became a favored style for collegiate buildings, although not often in white marble, as in this example. (Courtesy of the New-York Historical Society.)

5.32. Henry Austin, Yale College Library, New Haven, Connecticut, 1842–46. Austin drew his inspiration from King's College Chapel at Cambridge University, but using a dark brown sandstone. (Photo: L. M. Roth.)

5.33. James Dakin, Louisiana State Capitol, Baton Rouge, Louisiana, 1847–49. Dakin's Gothic capitol was a rare exception to the prevailing use of Greek classicism. (Library of Congress, HABS LA 17-BATRO 6-1.)

5.34. J. E. Carver (from drawings by G. G. Place), St. James the Less, Philadelphia, Pennsylvania, 1846–49. Built under the supervision of architect, John E. Carver, the design was adapted from measured drawings by G. G. Place of St. Michael's, Long Stanton, Cambridgeshire, c. 1230. (Photo: © Wayne Andrews/Esto.)

more mysterious, Gothic building on the left. Indeed, the church shown there may refer specifically to the Gothic work already done by Town and Davis, such as the early Trinity Episcopal Church on the New Haven Green, built in 1814, and the new building for New York University at Washington Square, in New York, built in 1832–37. [5.31] Unlike Old Kenyon College, the New York University building was much more archaeologically correct, with a raised central chapel clearly based on King's College Chapel, in Cambridge, England, and interior vaulting patterned after Chapel Royal at Hampton Court. The exterior, however, was clad in white marble, an un-Gothic holdover from the firm's more prevalent Neoclassicism. A later building, the Yale Library (now Dwight Chapel) by Henry Austin, built in 1842–46, was even more like King's College Chapel, but with greater emphasis in the vertical line, and was built of dark brownstone. [5.32] One new state capitol, for Louisiana in Baton Rouge, built in 1847–49, was Gothic in its details; it was designed by James Dakin (1806–1852), a former assistant in the office of Town and Davis and better known as a Greek classicist (he had even prepared some of the plates for two of Minard Lafever's books). [5.33]

In church design the shift toward correct Gothic was in large measure the result of the revival in interest in liturgical services promulgated by the Cambridge Camden Society in England, and *The Ecclesiologist*, which it published, as well as by branch societies in the United States. The professed objective of fidelity to original architectural sources was unwittingly realized far beyond expectations in a small church in Philadelphia, St. James the Less, built in 1846–49. [5.34] The congregation wrote to the parent group in Cambridge asking for a set of approved plans for their proposed church and, inadvertently, were provided with a set of measured drawings of St. Michael's, in Long Staunton, Cambridgeshire, built early in the thirteenth century. The Philadelphia building committee followed the drawings to the letter.

This replication of a thirteenth-century model, of course, was the exception. Most churches were designed by architects according to the needs of a particular parish. Three churches that set the example were all built in the greater New York area and were all started between 1839 and 1844. These were James Renwick's Grace Church, in New York, built in 1843–46, Minard Lafever's somewhat more ornate Church of the Savior, in Brooklyn, built in 1842–44, but most especially Richard Upjohn's Trinity Church, in New York, built in 1839–46. All of these architects benefited from the number of publications on Gothic architecture that had appeared during the preceding decades, such as Thomas Rickman's *Attempt to Discriminate the Styles of English Architecture*

5.35. *Richard Upjohn, Trinity Church, New York, New York, 1839–46, lithograph. This view of 1847 shows the surrounding neighborhood consisting of residences and small* businesses. (*J. Clarence Davies Collection, Museum of the City of New York.*)

5.36. Trinity Church, New York.
*The pulpit shows Upjohn's attention
to detail down to the smallest element.
(Sandak, courtesy of the University
of Georgia.)*

(London, 1817), but specially Augustus Charles Pugin's *Examples of Gothic Architecture* (London, 1831), and the subsequent books by his more famous son, A. W. N. Pugin. Less well known but also important was the American study *Essay on Gothic Architecture: Designed Chiefly for the Use of the Clergy* (Burlington, Vermont, 1836), by the Reverend John Henry Hopkins.

Richard Upjohn (1802–1878) was born in England and trained as a cabinetmaker; he emigrated in 1829 and set up an architectural practice, spending periods in New Bedford and Boston before settling in New York. His main concern was ecclesiastical building (though he built many important urban and country houses), and it is significant for his architecture that he was an Episcopalian who happened to be an architect rather than the reverse. His masterwork is Trinity Church, which, like a medieval master mason, he personally supervised from a shed on the grounds. [5.35] While the design for this brownstone church is synthetic in that it draws from a number of English Gothic sources, Upjohn was careful to restrict himself primarily to fourteenth-century prototypes, relying heavily on the publications of A. C. Pugin. Upjohn firmly believed in Episcopal high church ritual, so one

finds in Trinity Church a deep chancel (though it does not have a lower roof as in A. W. N. Pugin's churches). Deviating from the purism of the younger Pugin, Upjohn was more interested in the symbolic forms, and used suspended plaster vaults to give the appropriate Gothic effect; such sham construction Pugin deplored. Nevertheless, in such intricate and consummate details as the pulpit [5.36], Upjohn more than compensated for his deceptive vaults; the total visual effect is controlled and absolutely convincing, enhanced by the high quality of material and workmanship.

Upjohn's shed in the work yard might suggest that he was not the professional as defined by Latrobe, but in fact Upjohn was very much the professional architect, and it was at his invitation and in his office, in 1857, that the American Institute of Architects was formed. Moreover, he helped establish the legal right for the architect to receive payment for his preliminary designs, after he took the town of Taunton, Massachusetts, to court in 1850 when he received no fee for drawings he had been engaged to make for a new town hall.

Although Upjohn built several important large urban churches in New York City, he was also called

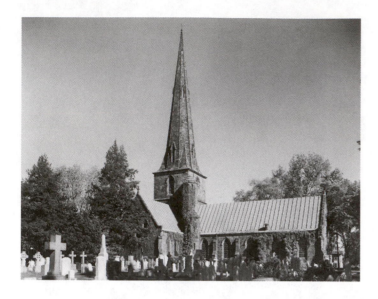

5.37. Richard Upjohn, St. Mary's, Burlington, New Jersey, 1846–54. This is perhaps Upjohn's closest evocation of the small English country parish church. (Photo: © Wayne Andrews/Esto.)

5.38. Richard Upjohn, design for a rural church. To enable congregations to build appropriate small churches in areas where trained architects were rare, Upjohn published a number of small church plans, suitable for building in wood. (From Upjohn's Rural Architecture, New York, 1852, courtesy of Avery Library, Columbia University.)

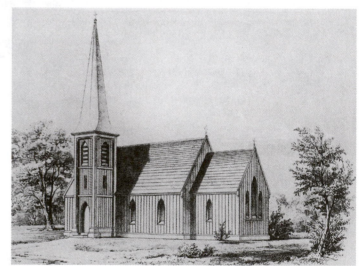

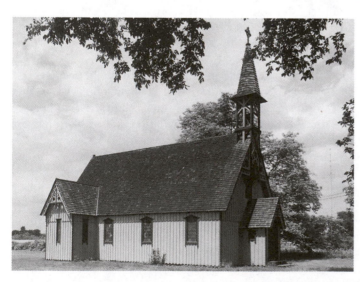

5.39. Richard Upjohn, St. Luke's, Clermont, New York, 1857. Located in upstate New York, this is one of several small rural churches built under Upjohn's supervision. (Photo: © Wayne Andrews/Esto.)

upon to design many smaller churches, such as St. Mary's, in Burlington, New Jersey, built in 1846–54, which was closely patterned after the English Gothic church of St. John the Baptist, in Shottesbrook, Berkshire, at the pointed request of its rector, the Right Reverend G. W. Doane, Bishop of New Jersey.[6] [5.37] In addition Upjohn also drew up plans for small frame churches—on average about one a year. Among these are St. Paul's, in Brunswick, Maine, built in 1845; St. Thomas's, in Hamilton, New York, built in 1847; Trinity Church in Warsaw, New York, built in 1853–54; and St. Luke's in Charleston, New Hampshire, built in 1863. Some of these plans he published in *Upjohn's Rural Architecture* (1852), which he hoped would help meet the need for good, properly designed rural churches.[7] [5.38] One of the simpler designs is St. Luke's in Clermont, New York, built in 1857. [5.39] St. Luke's combines a concern for plan based on liturgy with Downing's simplicity of construction, using vertical board and batten siding with intricately carved bargeboard trim. In the steeple there is a particular emphasis on expression of the structural skeleton, especially the diagonals, and these aspects of frame building were to be more fully exploited after the Civil War in what became the Stick Style.

Gothic Revival Houses

While the Greek Revival was the prevalent style for residences during the 1820s and 1830s, by the mid-1840s Gothic had begun to challenge it, largely due to the influential publications of Andrew Jackson Downing (1815–1852). The son of a nurseryman in Newburgh, New York, Downing began as a horticulturist, coming to architectural criticism later. As a result he viewed the house as a function of the landscape in which it was placed. The plan of the house, he argued, should be arranged so as to take advantage of the views of the landscape, making it as irregular as need be. The grounds themselves should be enhanced and modified so as to augment their inherent picturesque qualities. His first book, *A Treatise of the Theory and Practice of Landscape Gardening* (1841), was primarily concerned with horticulture and landscape architecture, as the title indicates, with a brief passage on building at the end.[8] Extremely popular, it went through eight editions up to 1879. His next book, *Cottage Residences* (1842), was even more popular and went through thirteen editions up to 1887.[9] *Cottage Residences* was concerned solely with rural houses, their construction, conveniences, appointments, and furnishings. Nothing escaped his attention.

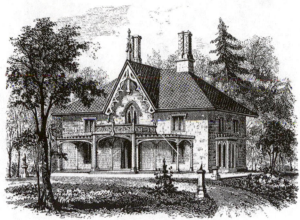

DESIGN II.

A COTTAGE IN THE ENGLISH OR RURAL GOTHIC STYLE.

Fig. 9.

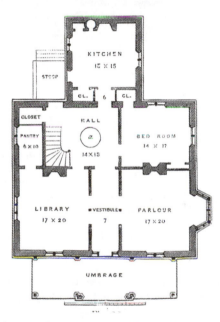

5.40. *Andrew Jackson Downing, Design II, "A Cottage in the English or Rural Gothic Style," 1842. One of twenty-six house designs, each with its own appropriate landscape arrangement, this one was especially popular across the continent. (From A. J. Downing,* Cottage Residences, *New York, 1842.)*

The approach to the house, he suggested, should meander through the surrounding planting so as to alternately expose and hide the house, exposing different aspects of the building. In his last book, *The Architecture of Country Houses* (1850), with nine editions to 1866, he expanded on his ideas and published house designs by various architects extrapolated from

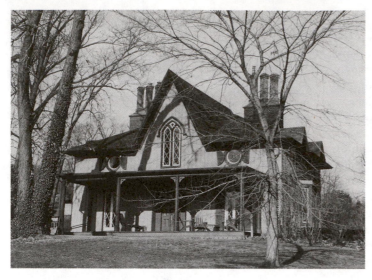

5.41. Alexander Jackson Davis, Edward W. Nichols house, Llewellyn Park, Orange, New Jersey, 1858–59. This house designed by A. J. Davis shows the strong debt Downing had to the architect in many of his published designs. (Photo: © Wayne Andrews/Esto.)

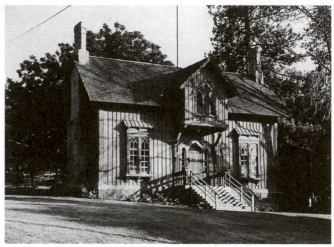

5.42. Louis Scholl, Army Surgeon's Headquarters, Fort Dalles, The Dalles, Oregon, 1857. A dramatic example of how far-flung Downing's influence was, this is just one of what were scores of Downing cottages in Oregon. (Photo: L. M. Roth.)

suggestions in his previous book. Much of the reason for the great popularity of Downing's work was the profusion of woodblock illustrations showing simple house types, details, interiors, and landscape plans. [5.40] In every instance, however, he reminded the reader that these were only suggestions and that the builder should adapt such designs to his own needs and site.

Many of Downing's house designs were supplied by A. J. Davis and were based on houses actually being erected by Town and Davis. Some were Gothic, or based on Italian villas, while others were simply conjectural designs in various picturesque modes. Seemingly digressing from his earlier classicism, Davis became a staunch advocate of the Gothic style after Town's death, his work ranging from complex country houses to simple cottage designs. This work, pub-

lished in many of Downing's books, inspired countless cottages across the central states; for some of these Davis actually drew up plans or sent preliminary designs to local builders, who made final drawings and supervised construction. One of the houses Davis himself supervised was the cottage built for the landscape painter Edward W. Nichols in Llewellyn Park, in Orange, New Jersey, built in 1858–59. [5.41] Characteristic of these houses are the steeply pitched roofs and gables, often trimmed with heavy carved bargeboards (or vergeboards) along the eaves, pointed lancet windows with diamond-shaped glass panes, clustered elongated chimney pots, Tudor-detailed porches, varied window shapes, and, frequently, vertical board and batten siding, to which Downing resorted when masonry was beyond the client's means. In plan many of these houses were cross-

shaped, with the facade centered on the tall central gable, but irregularity in the plan and massing was common and encouraged by Downing.

The influence of this house type was extensive, because Davis himself built many in scattered locations, among them the Henry Delameter house in Rhinebeck, New York, built in 1844; the C. B Sedgwick house in Syracuse, New York, built in 1845; and the W. J. Rotch house in New Bedford, Massachusetts, built in 1850. The details and structural materials varied, but the general configuration was the same. Derivatives, closely imitating Davis's own work and inspired by the published designs in Downing's books, include many richly embellished examples such as the Neff cottage in Gambier, Ohio, built in 1845; the Bonner-Belk house in Holly Springs, Mississippi, built in 1858; the Mann-Foster house in Marshall, Michigan, built in 1861; the Lace House in

Blackhawk, Colorado, of about 1860; and the Tea House of Lachrymae Montis, in Sonoma, California, built in about 1850. Another superb and distant example is the Army Surgeon's house in The Dalles, Oregon [5.42], based directly on Design III in *The Architecture of Country Houses*, and built in 1857 by Louis Scholl.[10]

When circumstances allowed, Town and Davis built larger, more elaborate, and more archaeologically correct Gothic villas, such as Glenellen outside Baltimore for Robert Gilmore in 1832, or Belmead for Philip St. George Cocke in Powhatan County, Virginia, in 1845. Destined to be even larger and more elaborate was Lyndhurst near Tarrytown, New York, begun in 1838 for wealthy New York merchant William Paulding. [5.43] Inspired by Lowthar Castle, it is a carefully calculated asymmetrical mass in stone, surrounded by clusters of shrubbery and trees that alternately frame

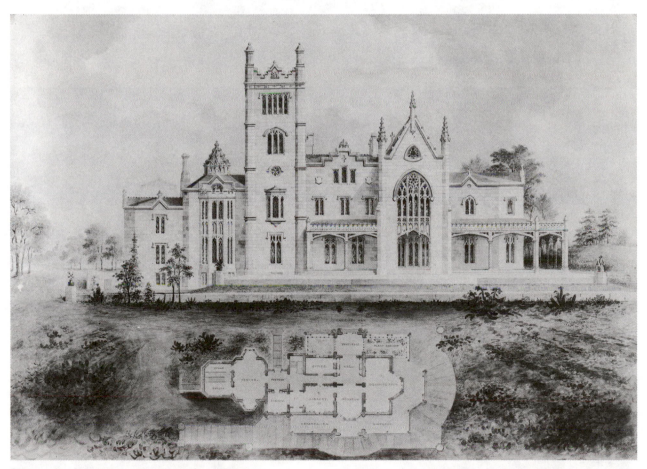

5.43. *Alexander Jackson Davis, William Paulding house, Lyndhurst (as expanded for George Merritt), near Tarrytown, New York, 1838–42. As shown in Davis's* delicate watercolor (18 3/4 by 26 3/4 inches), this was a more formal and elaborate Gothic villa. (The Metropolitan Museum of Art, Harris Brisbane Dick Fund, 1924.)

5.44. *Alexander Jackson Davis, Lyndhurst, Tarrytown, New York, 1864–67. For a new owner, George Merritt, Davis enlarged Lyndhurst, adding this richly detailed dining room. (Photo: Louis H. Frohman, courtesy of the National Trust for Historic Preservation.)*

5.45. *Richard Upjohn, Noble Jones house, Kingscote, Newport, Rhode Island, 1841. Upjohn successfully modified medieval architecture for the demands of American informal private residences. (Library of Congress, HABS RI 3-NEWP 61.8.)*

and obscure views of the house. Davis's rendering shows his accomplished technique and the rich ornamentation he intended for the house. The plan (visible in the lower half of 5.43) has an order and clarity that reveals Davis's neoclassical debt to Town, but the silhouette is the essence of picturesque irregularity. The interiors designed by Davis were lavishly executed by Richard H. Byrnes. In 1864, when new owner George Merritt built an addition to the house, this too was designed by Davis, enhancing the irregularity and complexity of the house. [5.44]

As Davis's rendering shows, different elements from the medieval period could be combined in any single building, and the same is true of the interiors of such houses. One example is the entry hall in Kingscote, summer house for Noble Jones, in Newport, Rhode Island, begun in 1841 after designs by Richard Upjohn. [5.45] Early English and Tudor Gothic are mixed with pure invention to create complex visual effects, and the medieval aspect is intensified by deep earth colors, dark stained wood, and stained glass.

A MISCELLANY OF STYLES

Romanesque

The classic Greek Revival and its medieval counterpart, the Gothic Revival, were only the more visible and widely employed of many historical references. American architects were as fascinated as their European counterparts with exploring and exploiting the whole range of historical architecture, Western and exotic Eastern styles alike. We need to remember nowadays that the understanding of the history of architecture was evolving among these early nineteenth-century architects. No wonder they were drawn into these experiments. One of the less frequently used modes was a kind of free Romanesque style, perhaps most freely interpreted in the Smithsonian Institution, in Washington, D.C., built in 1846–55, by James Renwick. [5.46] The suggestion of regularity in the plan is played against a capricious irregularity in the silhouette. Every tower is different in shape, and the variety of projections breaks the red

5.46. James Renwick, the Smithsonian Institution, Washington, D.C., 1846–55. Renwick's aggregation of Romanesque elements results in a very picturesque pile. (From R. D. Owen, Hints on Public Architecture, 1849.)

5.47. Henry Austin, Railroad Station design project, New Haven, Connecticut, 1848–49. Austin's curious fantasy shows how architects struggled with what a railroad station should look like. (Courtesy of the Yale University Library, from the Henry Austin Papers, Manuscripts and Archives Collection.)

sandstone surface into splinters of light and shadow. One of the most scenographic designs of the period, it is a mixture of Lombard, Norman, and Byzantine devices, interlaced with pure Renwick invention. It demonstrates Renwick's broad knowledge of historical architecture, shown also in his more archaeologically correct Gothic churches in New York, Grace Church and St. Patrick's Cathedral.

With a capriciousness equal to that of its outline, the Smithsonian Institution was placed close to the middle of L'Enfant's mall, breaking the open sweep of the space westward from the Capitol. This clearly indicated that by 1846 the expansive continuities of L'Enfant's grand design were no longer appreciated, nor were they understood. To many people—even Downing—this "vacant" land seemed to invite development. In 1850 President Buchanan engaged Downing to relandscape the Capitol and White House mall. Downing was a natural choice, since by

this time he had established his reputation as the most prominent landscape gardener in the country. Downing proposed to break up the spaces of the malls with copses of trees and winding paths, shaping a landscape in which Renwick's craggy Smithsonian would have been the perfect picturesque garden ornament. Work proceeded very slowly, and only the circle (the "Ellipse") south of the White House, the most formal part of the whole scheme, was carried out before the Civil War erupted and brought work to a halt.

Since the historical associations of Romanesque were not so rigidly fixed as were those of Gothic, this style could be used for new building types whose functions suggested no obvious associations.[11] The railroad station was one. As a building type, the station had developed in New England during the 1830s and by the late 1840s had become one of the largest of nineteenth-century buildings. Yet what it should

5.48. Thomas Tefft, Union Passenger Depot, Providence, Rhode Island, 1848. Tefft, active in Providence in midcentury, turned to Romanesque for his train station. (Courtesy of the Rhode Island Historical Society.)

look like and what it should express were perplexing problems, and architects trained to think in historical terms attempted to use expressions whose connotations were not already fixed. Henry Austin used a highly inventive expression in his station in New Haven, Connecticut, built in 1848–49, which has been variously described as Moorish or Oriental. [5.47] A somewhat more conventional approach was to use Romanesque, as was done by Thomas A. Tefft (1826–1859) in his Union Depot, in Providence, Rhode Island, built in 1848. [5.48] The masses were large and simple, with twelfth-century Lombard ornament. The arcaded wings were angled back, following the curve of the tracks, and the covered areas proved to be advantageous for sheltering passengers and baggage. Another early user of Romanesque round arches was Leopold Eidlitz (a native of Prague, trained in Vienna, Austria, and then in the New York office of Richard Upjohn). Eidlitz used Romanesque

in his St. George's Church, in New York City, built in 1846. Eidlitz was said by Montgomery Schuyler to have been a great enthusiast of the German Romanesque revival architecture in Munich, and indeed the contemporaneous German work of Friedrich von Gärtner was one source of Eidlitz's American Romanesque.[12]

Early Medieval

Another popular historical style was a kind of generic early medieval. The massive density of castellated early medieval architecture was especially suitable for prison building and helped to convey the image of confinement as well as the penal reform being attempted early in the century. Egyptian forms, in their massiveness, also suggested solidity, but usually connoted rehabilitation in contrast to the dungeon-like castellated medieval. Both modes were used effectively by John Haviland. His Eastern State

5.49. John Haviland, Eastern State Penitentiary of Pennsylvania, Philadelphia, Pennsylvania, 1823–25, engraving by Fenner, Sears & Co. Designed by Haviland to incorporate new ideals of convict reform, the image was of massive medieval fortresses. (Courtesy of the New-York Historical Society.)

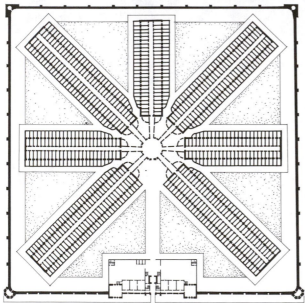

5.50. Eastern State Penitentiary. Haviland's plan of radial arms for the solitary confinement cells allowed for easy central administration; it influenced hundreds of prison designs in the United States, Europe, and even Asia. (L. M. Roth, after Haviland.)

Penitentiary of Pennsylvania in Philadelphia, built in 1823–25, was castellated medieval. [5.49] Following this example, many later prisons across the country used windowless castellated medieval masonry. Even more important than this stylistic choice, however, was Haviland's plan arrangement for the Eastern Penitentiary (thereafter given his name), consisting of seven cell-block buildings arranged radially around a central control station. [5.50] Prisoners were assigned to individual cells with small exterior balcony courts; they were never allowed out of their cells, since solitary confinement was then believed to be reformatory. It was the radial arrangement of the cell blocks and the resultant ease of control that attracted great attention, and Haviland's plan was studied by English and French penal experts who published reports that were to redirect the planning of important European prisons.[13] Thus Haviland's prison was one of the first American buildings to influence the design of European buildings, reversing a trend in which American architecture followed European models. Especially in the areas of planning, building technology, and mechanical equipment, European architects now began to study American developments closely.

Egyptian

Egyptian architecture, at the time recently "rediscovered" as a result of Napoleon's expedition to the fabled land, was intriguing and exotic. Quite naturally, it was easily invested with funerary associations. In addition, its massiveness also seemed to make it appropriate for prisons. John Haviland seized on this association and exploited Egyptian forms for several prisons. Haviland's best-known Egyptian prison was the Halls of Justice, in New York, built in 1836–38 [5.51], known locally as "The Tombs," partly because of its funerary appearance and partly because it was said that those who entered were never more to be seen. Egyptian motifs were occasionally used for churches—one example is Strickland's First Presbyterian Church, in Nashville, Tennessee, built in 1848–51—but their use was more common in funerary structures. In the Grove Street Cemetery, in New Haven, built in 1845–48, the obvious relationship to Egyptian mortuary architecture is embroidered by the inscription over the entrance: "The Dead Shall Be Raised."[14] [5.52]

5.51. John Haviland, Halls of Justice ("The Tombs"), New York, New York, 1836–38. For the Halls of Justice prison in New York, Haviland turned to massive Egyptian forms. (Photo: J. S. Johnston, 1894, courtesy of the New-York Historical Society.)

5.52. Henry Austin, Gate, Grove Street Cemetery, New Haven, Connecticut, 1845–48. Austin effectively drew on the association of Egyptian architecture with death for this gate to a nineteenth-century cemetery. (Library of Congress, HABS CONN 5-NEWHA 3-2.)

5.53. John Notman, Philadelphia Athenaeum, Philadelphia, Pennsylvania, 1845–47. Notman's Athenaeum marks an early use of true Italian Renaissance motifs in American architecture. (Library of Congress, HABS PA 51-PHILA 116-1.)

Renaissance

Yet another popular historical style before the Civil War was Italian Renaissance, used somewhat infrequently with true historical fidelity but much more often in the abstracted and asymmetrical Italian villa. This historical revival originated in England, most notably in the London clubs built by Sir Charles Barry during the 1830s and 1840s. The Renaissance palazzo mode was well adapted for use in American urban houses, such as Upjohn's Pierrepont residence in Brooklyn, built in 1856–57, and even for mercantile and office blocks, as seen in Upjohn's Corn Exchange Bank, in New York, built in 1854. One of the earliest manifestations of a correct historical use of the palazzo mode was John Notman's Philadelphia Athenaeum, built in 1845–47 [5.53] when such educational clubs were usually designed as Greek temples. Notman's Athenaeum is important for its accuracy

and restraint of detail, since most Renaissance adaptations at this time were only as developed as Gothic had been nearly a half century before.

As early as 1844 Boston architect Arthur Gilman observed in the *North American Review* that Greek buildings were the "offspring of a remote age, an antagonistic religion, an obsolete form of government, and a widely different state of society than our own," suggesting that his fellow architects would do better to look instead to the Renaissance work of Bramante, Palladio, and Michelangelo, or what he called the "palazzo style."[15] Gilman in fact emulated Barry's Renaissance palazzolike clubs in his Boston Athenaeum, built in 1846–49. In his later Arlington Street Church, in Boston, built in 1859–61—one of the first buildings on the new landfill of Boston's Back Bay— Gilman turned not to Italian Renaissance but to the Georgian Neo-Palladian classicism of Gibbs and based his brownstone church on St.-Martin's-in-the-Fields, the model for so many Colonial churches. The Arlington Street Church, as it turned out, was the beginning of New Englanders' growing appreciation of their Colonial architectural heritage.

The more inventive and fancifully interpreted nonarchaeological Renaissance mode was popular for suburban and country houses; this so-called Italian villa style, with its irregular massing and off-center tower, had also been advocated by Downing, inspiring thousands of adaptations. [5.54] In *Cottage Residences* he reproduced an example that inspired Henry Austin's John P. Norton house, in New Haven, built in 1848–49, and in *The Architecture of Country Houses* he illustrated the Edward King villa in Newport by Upjohn, built in 1845–47. A later and more elaborately embellished example is Henry Austin's Morse-Libby house, in Portland, Maine, built in 1859. [5.55, 5.56] Enriched with elaborate and heavily scaled ornament at the cornices, windows, door, and porch, it is based on an asymmetrical **L**-shaped plan.

Just as the exterior embellishment became larger and more bulbous during the late 1850s, so too did interiors. Furniture became more convoluted and extravagant in form and material. Compare the fullness of detail in the music room here to the spare elegance of the Grecian parlor designed by Davis only a few years before. Assertive decorative elements abound in the carved fireplace, the gilt frame of the mantel mirror, and the multiple carved moldings of the coved ceiling. Such opulence came to characterize the interiors of the next two decades, and if it was

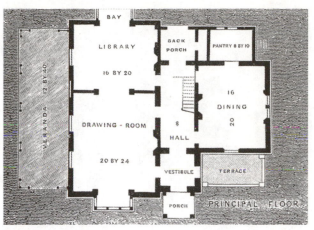

5.54. *"An Irregular Villa in the Italian Style, bracketed,"
Design VI, from Andrew Jackson Downing,* Cottage
Residences *(New York, 1842). Downing offered this design
because it was decidedly picturesque; "it is highly irregular,"*
he wrote, appealing to people who "have cultivated
an architectural taste, and who relish the higher beauties
of the art growing out of variety."

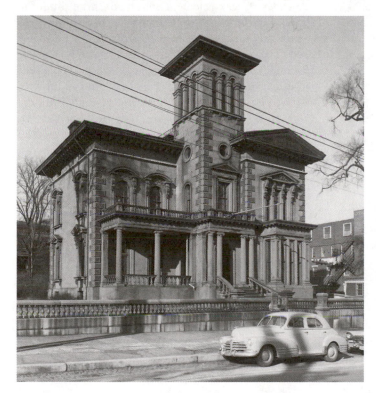

5.55. *Henry Austin, Morse-Libby
house, Portland, Maine, 1859.
Encrusted with elaborate
ornamentation, inside and out, this
house exemplifies the love of excess on
the part of client and architect in the
age of Queen Victoria. (Sandak,
courtesy of the University of Georgia.)*

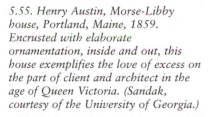

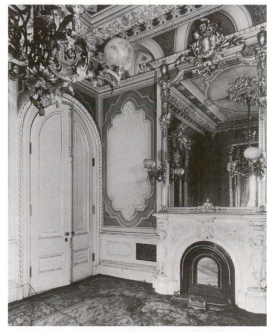

5.56. *Morse-Libby house, 1859, music
room. Austin's design for the music
room of the Morse-Libby house is
representative of the heavily
embellished and bulbous Italianate
architecture of midcentury. (Library of
Congress, HABS ME 3-PORT 15-7.)*

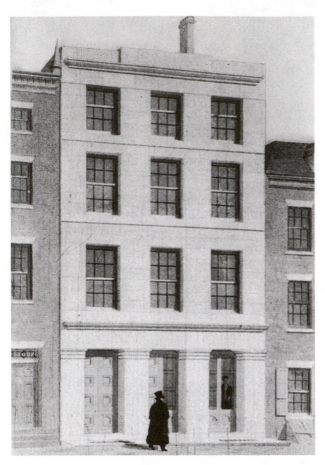

5.57. *Town (and Davis?), Tappan Store, New York, New York, 1829, watercolor on paper. This small commercial block, nominally classical in its massive piers, provided the model for thousands of small businesses across the country in the 1830s through the 1850s. The upper floors might provide residential space for the owner or storage space. (Visual Resources Collection, University of Oregon.)*

sometimes tasteless and blatant, it boldly demonstrated the new wealth of the broadening middle and merchant classes.

Commercial and Industrial Building

Grecian details and elemental geometries were adopted for many building types besides residences, including many kinds of commercial and industrial structures. An early adaptation was a small astylar (without columns) business block developed in 1829 by Ithiel Town for the Tappan store in New York City. [5.57] This was a relatively simple four-story block, not so different from the granite-framed stores built by Parris in Boston. The street level of the Tappan store consisted of four massive stone piers treated as

Doric pilasters carrying a simplified massive Doric entablature. One of the open bays provided the entrance, while the other two bays had large display windows. Both the door and windows could be protected by hinged iron shutters that folded flat against the depth of the massive piers. The upper floors were built of brick with a heavy internal wood frame.

This simple motif was quickly adapted for long rows of commercial blocks, as can be seen in old photographs of the original riverfront of Cincinnati, Ohio, and as can still be seen in the surviving small stores and office blocks of gold rush towns in California and in Jacksonville, Oregon. The same idea could be enlarged for commercial buildings that occupied whole blocks, like the Washington Buildings, formerly in Providence, Rhode Island, by James C. Bucklin (1801–1890), built in 1843.

Another Greek element used in large building blocks was the giant corner pilaster carrying a proportionately large encircling entablature. In buildings based on this scheme entrances were graced by smaller but nonetheless massive Grecian porticoes. This was well illustrated in the large Tremont House Hotel, in Boston, built in 1828–29, by Isaiah Rogers (1800–1869). [5.58] Luxurious in its provision of large internal lounges, a spacious dining room, and many mechanical appliances, it quickly established a new standard for this particularly American building type and was emulated by European hoteliers.[16] Numerous similar hotels soon followed, such as the Maxwell House, in Nashville, Tennessee, built in 1859–69, also by Rogers, which became particularly famous for the coffee served there (the name is used today by a brand of packaged coffee).

In some instances entire temple blocks were employed for commercial buildings, as in the Providence Arcade building, in Rhode Island, designed in 1828 by James C. Bucklin to run between two parallel streets. With massive Grecian porticoes at each end, it is a glass-covered street or gallery, with small rental shops on either side of the longitudinal passage, and other shops and professional offices on the set-back upper balconies connected at the upper levels by bridges.

The temple form also provided a bold, assertive presence for major public commercial and civic buildings, such as banks and customhouses. This was not as gratuitous as it may seem, for such early-nineteenth-century buildings closely paralleled the temple-form treasury buildings in ancient Greek sacred precincts, as at Delphi and Olympia. A Greek temple

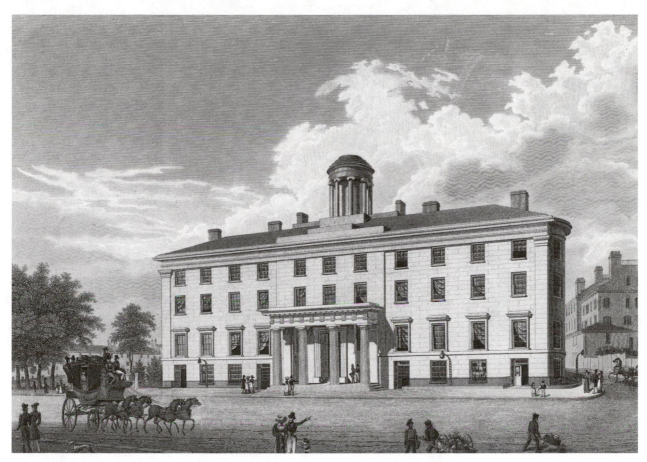

5.58. Isaiah Rogers, Tremont House Hotel, Boston, Massachusetts, 1827–29. Although well-proportioned and graced with correct Grecian details, this hotel was widely influential, even in Europe, for its interior planning and amenities. (From William Eliot, A Description of the Tremont House, *Boston, 1830, courtesy of the Houghton Library, Harvard University.*)

was used by Town and Davis for the austere octastyle prostyle (eight columns across each end) white marble Customs House, in New York, built in 1832–44, which opened up into a round internal rotunda covered by a low dome. Across Wall Street was the equally bold Merchant's Exchange, by Isaiah Rogers, with a twelve-column Ionic portico built of Quincy granite in 1836–42. Fireproof, and vaulted in brick throughout, Rogers's Merchant Exchange had a circular trading floor covered by a coffered brick dome 80 feet in diameter that rose above the roof but was not visible from the street. Clearly visible, however, was the Roman dome that rose over massive Doric temple of the U.S. Customhouse in Boston, built by Ammi B. Young in 1847–48. Young's Boston Customhouse is a good example of the preference among some clients for the most austere and massive Doric order for

banks and financial institutions, perhaps to suggest probity among its officers and economic strength in troubled financial times. Other clients, however, preferred the refinement and grace of the more delicate Ionic order, and a splendid surviving example is the Bank of Louisville of 1836, designed by James H. Dakin drawing on the very latest published information on the Greek orders and details. [5.59]

Grecian temple banks quickly became standard across the eastern half of the country, thanks to the details newly available in pattern and plan books, such as the later editions of Asher Benjamin and the new books by Minard Lafever. Emulating specific Greek forms down to the smallest component was now relatively easy, but copying details was not always accompanied by a theoretical understanding of Greek design. This can be readily seen in the beauti-

5.59. James Dakin, Bank of Louisville, Louisville, Kentucky, 1834–36. Dakin's Bank of Louisville shows the assured and graceful Grecian details being introduced to the western regions by well-trained architects. (Library of Congress, HABS KY 56-LOUVI 1-3.)

5.60. Old Shawneetown Bank, Old Shawneetown, Illinois, 1836. By an unknown designer, the Shawneetown bank has five massive Doric columns; although the columns are well detailed, the odd number betrays the hand of an untrained designer. (Photo: L. M. Roth.)

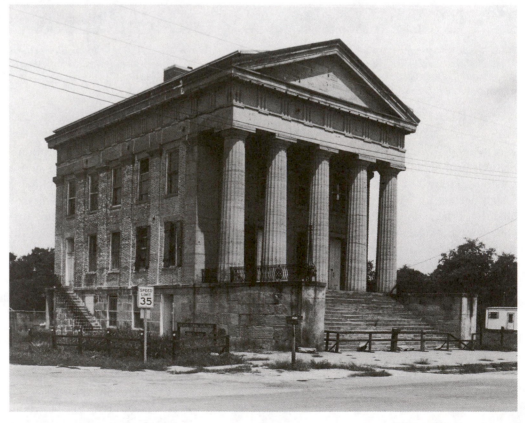

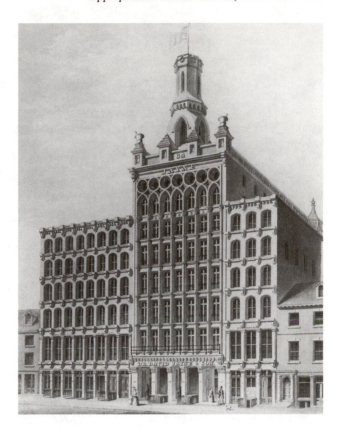

5.61. *William Johnston and Thomas Ustick Walter, Jayne Building, Philadelphia, Pennsylvania, 1849–51. The Jayne Building introduced the taller office tower to the American skyline, even if built with a solid stone frame. (Courtesy of the Library Company of Philadelphia.)*

fully proportioned and solidly built Doric prostyle Old Shawneetown Bank, in Illinois, built in 1836, but with an uncanonical front colonnade of five columns that made a centrally placed entry impossible. [5.60]

By the 1840s, however, as land values rose in the densely built-up city centers; economic pressures began to change the face of the American city; commercial buildings pushed ever higher, especially once introduction of the passenger elevator made the greater height practical. One example was Tower Hall in Philadelphia, built in 1855–57. Only three bays wide, its five tall stories rose a full story over adjoining older commercial buildings, but it had two additional stories in a penthouse and tower, all trimmed in blocky medieval battlements. Although tall, it did not really celebrate its greater height. A better example of organizing the exterior of such a tall commercial building is seen in the Jayne Building, in Philadelphia, designed by William Johnston in 1849 and finished by Thomas Ustick Walter. [5.61] Particularly important was the skeletonized granite frame of the seven-story facade, for it was not expressed as separate floors stacked one atop the other with strong horizontals separating each floor, but instead it had continuous, emphatically projected vertical piers, with details

based on Venetian Gothic sources. Here appeared the tripartite formula later developed by Sullivan and Burnham. The building was divided into functionally and visually significant parts consisting of base with its stout piers, midsection with its shaft of closely spaced piers, and top with its interlaced Venetian arches and cornice.

This abrupt jump in height in the 1850s, beyond the four or five stories that had characterized urban commercial buildings for centuries, greatly troubled some observers, such as Philadelphia historian John Watson, who was concerned that the former line of equality and beauty had been broken: "all is now self-exalted, and goes upon stilts," he lamented.[17] (What would he have said of the later Chicago skyscrapers of the 1880s that jumped to twice this height, of those in New York of the 1920s that doubled it again, or even those of New York and Chicago of the mid-twentieth-century that rose to sixty and one hundred floors? Mies van der Rohe's Seagram Building truly did rise on the stilts of its exposed exterior columns.)

Gothic verticality may have been one way of handling extremely large or tall buildings, but there is a late drawing by A. J. Davis showing that classical forms might have potential for very large commercial

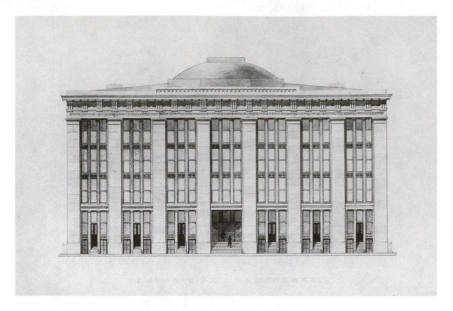

5.62. *Alexander Jackson Davis, project for a Commercial Exchange, c. 1860. Davis, a highly imaginative designer, devised this large office block using Grecian motifs. (Courtesy of the New-York Historical Society.)*

buildings as well. This is a project of about 1860 for an exchange. [5.62] The elevation shows a building of five tall stories, counting the shops in the semisubterranean English basement. The structural scheme consists of tall piers carrying a proportionately large Doric entablature, all of this apparently in masonry. The wall between the piers is divided into large windows held in frames so thin that they must have been conceived in cast iron. What Davis designed was in effect a curtain wall between the piers. Here again is a tripartite arrangement with the articulated base at the ground floor, midsection of repeated floors, and terminating entablature with cornice.

THE IMPACT OF INDUSTRY AND THE EXPLOITATION OF CAST IRON

The middle class of the 1840s and 1850s was created by burgeoning industrial growth and the commerce it generated. With mass production and mass distribution of goods came the department store, a new concept in merchandising based on impulse buying. To meet the demand for retail stores and the warehouses that supplied them, architects and builders turned to the use of iron cast in small, identical, easily assembled parts. Whole stores could be built of prefabricated cast-iron panels and sheets of glass in as short a time as two months, as James Bogardus demonstrated in the Laing stores, in New York, in 1849. Although cast-iron and wrought-iron members had been used for

some time—by Strickland for columns and in panels by John Haviland for the facade of the Miner's Bank in Pottsville, Pennsylvania, built in 1829–30—what Bogardus did in the late 1840s was to systematize mass production, enabling him to fabricate whole buildings, including both exterior shell and interior framing, and ship them around the world where the parts could be bolted together on site.[18] Besides the Laing stores and his own offices in New York, Bogardus also manufactured the frame for the Harper brothers' building, in New York, built in 1854. [5.63] Bogardus, like most iron manufacturers, was not a designer, nor was his contemporary Daniel Badger, also of New York, who cast the members of the Haughwout Building, in New York, built in 1857, a department store designed by architect John P. Gaynor. [5.64] Gaynor used a simple bay unit of Corinthian columns, framing an arcade, repeating throughout the building except on the ground floor, where a simpler treatment permitted larger show windows. The Renaissance style, whether relatively restrained, as here, or more elaborate, lent itself readily to iron construction, since the repetition of arcades fit mass production economics well, and the sharp details were relatively easily cast. Although only five stories high, the Haughwout store was prophetic of important developments for American commercial architecture, for in it was installed the first practical steam-driven passenger elevator. Thus the Haughwout store contained in embryonic form all the necessary elements of the skyscraper: metal construction, glass walls, and a passenger elevator.

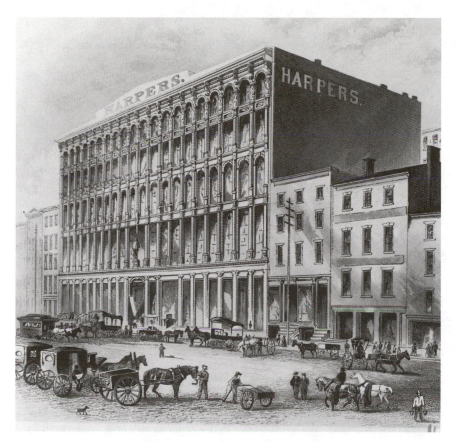

5.63. *John B. Corlies, designer, James Bogardus, manufacturer, Harper Brothers Building, New York, New York, 1854. In the Harper Brothers building, manufacturer James Bogardus demonstrated how a few repeated prefabricated parts could be used to create large buildings. (Courtesy of the Museum of the City of New York.)*

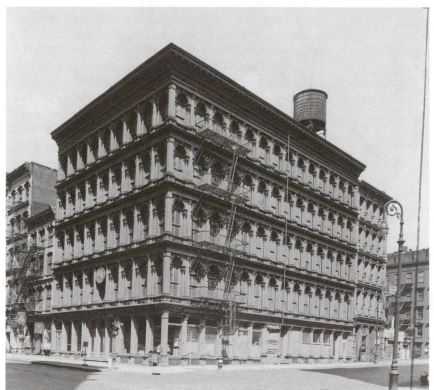

5.64. *John P. Gaynor, architect, Daniel Badger, manufacturer, Haughwout Building, New York, New York, 1857. The Haughwout building was most notable for exploiting the new safe passenger elevator. (Photo: © Wayne Andrews/Esto.)*

It should be noted, too, that Elisha Graves Otis's safe passenger elevator (the same as that incorporated in the Haughwout Building) was first demonstrated in 1853 in a large building itself made almost entirely of cast-iron columns and girders—the American version of the Crystal Palace, built in New York at what was then the northern edge of the city, at Fifth Avenue and Forty-second Street.

Comparable technical changes were beginning to change domestic construction radically as well. Mass production of machine-cut lumber introduced the standardized stud, the now common two-by-four, which could be quickly assembled into frames using cheap mass-produced wire-cut nails instead of the hand-forged spikes. Thus freed of the intricate joinery of the traditional heavy timber frame, a mechanic of midcentury, using a handbook, could assemble a house frame in a day. Such houses were said to have "balloon frames," perhaps because of the speed with which they went up. The term was in popular use in Chicago by 1835; Caroline Clark wrote her sister: "The houses now are mostly small, and look as though they have been put up as quickly as possible, many of them are what they call here Balloon houses, that is built with boards entirely—not a stick of timber in them except the sills."[19] Traditionally, St. Mary's

5.65. William E. Bell, Carpentry Made Easy, plate 6, 1858. Bell's is only one of many manuals showing the details of balloon frame construction; with books such as these, nearly anyone could put up a house. (Courtesy of the Art Institute of Chicago.)

Church in Chicago, built in summer 1833 by Augustine D. Taylor, has been considered among the first balloon-frame structures built there, but it is likely that several individuals were developing this form of light framing simultaneously throughout the Midwest. It is certain that, without the balloon frame, Chicago and other mushrooming Midwest towns and cities could not have experienced the phenomenal growth they underwent in that decade. Thereafter use of the balloon frame spread quickly. In 1855 Gervase Wheeler published *Homes for the People in Suburb and Country*, showing construction details of the frame, followed three years later by William E. Bell's *Carpentry Made Easy*, with its straightforward diagrams.[20] [5.65] (Bell, it should be noted, had lived and built in Ottawa, Illinois, not far from Chicago, for fifteen years before publishing his builder's manual.) Through the numerous reeditions of such manuals and handbooks, the balloon frame almost completely replaced the hewn frame for domestic construction by about 1865.

The net effect of this growing industrialization was to bring "good" building within the reach of more people. There was one other development that had a similar aim—the octagon mode, which if it could have been similarly industrialized might also have had a profound effect. Buildings with hexagonal or octagonal shapes had been built in the United States since the eighteenth century. Jefferson had favored this form, and Dr. William Thornton had designed "The Octagon" to fit one of the angled corners in L'Enfant's Washington. The widespread obsession with octagonal houses, however, began in the 1840s. In 1844 Joseph Goodrich built a hexagonal house for himself in Milton, Wisconsin, and for the walls he used a rudimentary form of poured concrete. This came to the attention of lecturer and phrenologist Orson Squire Fowler and so impressed him that he built his own octagonal concrete house in Fishkill, New York, in 1848–53. [5.66] Thereafter Fowler devoted himself to proselytizing for what he believed to be the home of the future. The octagon, he argued, was a most efficient form, and the materials for concrete could be found everywhere. In 1848 he published A *Home for All: or, The Gravel Wall and Octagon Mode of Building*, which was successful enough to warrant a new edition every year thereafter through 1857. Octagons began to appear throughout the country, in San Francisco, Maine, Vermont, upstate New York, and in Wisconsin, where the John Richards house was built in Watertown in 1854–56. All used the geomet-

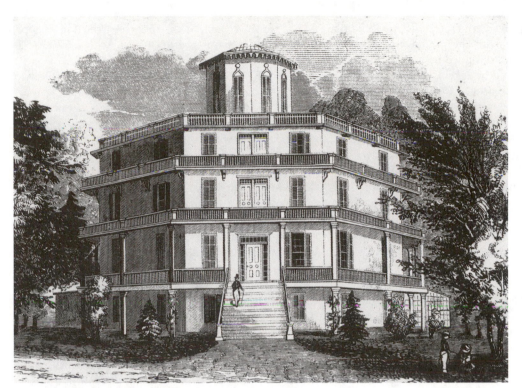

5.66. Orson Squire Fowler house, Fishkill, New York, 1848–53, frontispiece. Like a prophet of later designer R. Buckminster Fuller, Fowler preached the superiority of the octagon shape for its efficiency in enclosing space. (From O. S. Fowler, A Home for All, *rev. ed., 1854.*)

5.67. Samuel Sloan, Haller Nutt house, Longwood, Natchez, Mississippi, 1861. Left incomplete at the start of the Civil War, this was perhaps the grandest octagon house ever attempted. (Sandak, courtesy of the University of Georgia.)

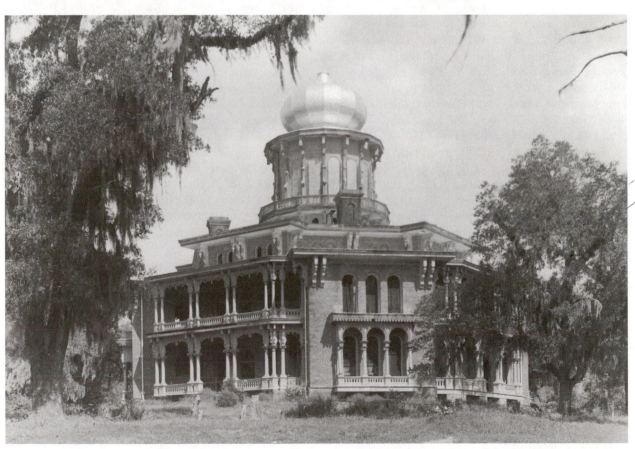

ric form but few employed concrete, since the binding cement was still expensive. The grandest octagon of them all was Longwood, designed by architect Samuel Sloan of Philadelphia and built by Dr. Haller Nutt just outside Natchez, Mississippi. [5.67] Begun in 1861 and left unfinished at the start of the Civil War, it was three full stories high, surmounted by a central tower carrying a great bulbous onion dome. Even if Fowler's octagon mode proved to be only a fad, his advocacy of concrete was prophetic, and a number of architects began to use the material for foundation work. In 1864, eleven years after Fowler's house was finished, Peter B. Wight used concrete for the foundations of Street Hall, erected to house the newly organized art department at Yale University.

Urban Growth

The rapid growth of American cities and of American industry generated wealth for the growing middle class who built and furnished the urban mansions and suburban villas designed by Upjohn and Downing. The total population of the United States more than tripled from over 9.6 million in 1820 to 31.4 million in 1860. A snapshot of important cities in 1820 shows that metropolitan New York was already the largest American city, with 196,100 inhabitants, and not even Boston's 43,300 combined with Philadelphia's 63,800, could equal it. Another city that was quickly becoming a major commercial center was Baltimore, Maryland, the farthest point north in the Chesapeake Bay where oceangoing vessels could dock; this city was a small village when the first census was taken in 1790; by 1829 it had 62,700 residents. Washington, D.C., although thirty years old, was far smaller than nearby Baltimore, with only 23,300 residents. In the South, Charleston, South Carolina, remained a significant center, with 30,300 people, but its growth was slowing considerably. Savannah, Georgia, was still quite small in 1820, with only 7,500 settlers. To the west, along the major rivers and the Great Lakes, new cities were emerging as trading centers; in 1820 Pittsburgh boasted 7,200 residents, while down the river the much younger Cincinnati, Ohio, already had 9,600 people. Louisville, Kentucky, had 4,000 residents in 1820. To the north, the tiny settlements of Buffalo, Cleveland, and Detroit together had just over 4,000 residents in 1820. Chicago hardly existed as a settlement, with perhaps fewer than two dozen permanent year-round residents. The once-French settlement of St. Louis, on the far western frontier, had 5,600 inhabitants when Missouri joined the Union in

1821. New Orleans, at the mouth of the Mississippi, was already a major southern port, with 27,200 residents in 1820.

Not only were most cities still relatively small in 1820, the national economy was divided into numerous virtually independent regional economic units. Without an expansive system of hard roads or canals as yet, it was difficult to move materials to distant factories or products to rural consumers.

All this was to change rapidly in the next four decades. By 1860, on the eve of the Civil War, the national population had grown by over a factor of three, to 31.4 million. New York was a major industrial center and the first American city to pass 1 million with its 1.39 million metropolitan inhabitants. The cause of New York's phenomenal growth was the funneling-in of products from the West by canal—especially the Erie Canal, completed in 1825—and then by railroads. Philadelphia had grown to 565,500 and Baltimore to 212,400; corporate Boston had only 177,800 residents but already it was ringed with large and important suburbs. Along the western rivers the trading centers had become major industrial and cultural centers; Pittsburgh now had almost 78,000 occupants, Louisville had 68,000, Cincinnati had mushroomed to 161,000, and St. Louis 160,800. And what had been in 1820 a swampy midcontinent canoe portage, with only thirty hard-bitten permanent occupants, had grown to become Chicago, a hub of factories and rail lines, with 109,300 residents.

This urban growth was fueled by dramatic changes in transportation, first canals and then railroads, carrying bulk goods like grain and lumber, but also large numbers of passengers. Several relatively short canals had been built in the eastern states between 1793 and 1818, but the great impetus for canal building was the completion of the 350-mile-long Erie Canal, which connected Albany, New York, on the Hudson (with its connections to the Atlantic Ocean), to Buffalo on Lake Erie, with its connections to the Great Lakes and rivers flowing into them. Started in 1818 and opened with great ceremony in 1825, this waterway in one stroke opened up the interior of the continent to easy trade; it caused the rapid growth of cities along the canal—Utica, Syracuse, Rochester, Lockport—and made Buffalo a port for inland commodities and wares. By 1860 Buffalo had 81,100 inhabitants, and Cleveland and Detroit had around 44,000 each.

By 1860 other canals had been built linking mid–New York to central Pennsylvania, connecting there with a major canal that linked Philadelphia with

Pittsburgh and the Ohio River. Still other canals criss-crossed Ohio and Indiana, connecting with the Ohio River and its many tributaries. By 1860 there were 3,600 miles of canals linked with the nation's navigable rivers.[21]

On July 4, 1828, two ground-breaking ceremonies had been held near Washington, D.C.; one, the beginning of the Chesapeake and Ohio Canal aiming to connect the Potomac and Ohio Rivers, and the other the start of the Baltimore and Ohio Railroad. The canal was never finished because it was quickly overshadowed by the completed Baltimore and Ohio Railroad, which flourished; by 1860 the Baltimore and Ohio was part of a dense network of 30,600 miles of rails, reaching to Chicago; from there a fan of tracks stretched farther to the north, west, and south.[22] The quiet, languid heyday of canal travel, when one drifted sleepily for days along tree-draped waterways listening to the rhythmically hypnotic clip-clop of tow mules, was now replaced by mere hours of speeding train travel in clattering cars pulled by loud, smoke-spewing, steam-hissing engines. The pace of American life was unalterably quickening.

The cities, too, felt this change: horse-drawn omnibuses appeared in the 1820s, soon to be replaced by horse-drawn cars on rails in 1832. The pedestrian cities, in which nearly everyone walked from home to market or work, had become by the 1850s cities with increasingly distinct "downtown" business centers, and "uptown" upper- and middle-class residential urban enclaves. In portions of the larger cities, already, residential districts abandoned by the wealthier classes were deteriorating into slums. And around all the larger cities appeared rings of idyllic commuter suburbs, linked to the urban core by railroads.

There was money to be made in city building, as the New York commissioners had recognized early. The way to stimulate growth was to use an uncomplicated grid plan, for it is easy to buy and sell parcels of land when they are described by a conventional Cartesian grid. The whole of the Northwest Territory was subdivided in this way, as were most of the new cities in it, such as Columbus, Ohio, in 1815, and Wisconsin City, in 1836. Also gridded were the many towns platted by the railroads, such as Mattoon, Kankakee, and Natrona, Illinois, from 1851 to 1857, along the Illinois Central Railroad (their grids, however, ran parallel to the tracks rather than being oriented to the compass). The grid was likewise used for the new towns that appeared almost overnight in California during the gold rush. San Francisco, begun with a

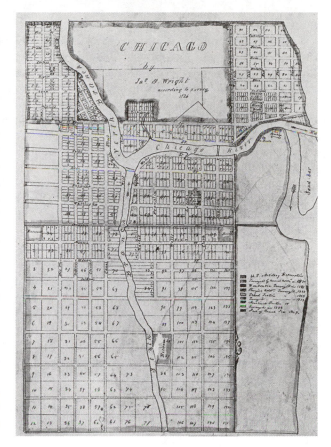

5.68. *Plan of Chicago, 1833; James Wright, Map of Chicago, 1834. On the flat prairie land at the mouth of the sluggish Chicago River, it was easy to lay out a city in a regular grid. (National Archives.)*

modest grid of a few blocks in 1839, expanded explosively in 1849 and the decades following. Also laid out on a grid in 1848–49 was Sacramento, near the California gold finds.

The most typical and telling example of grid planning, perhaps, is Chicago. Of all the western cities that rose to prominence in this period, perhaps most significant was Chicago, for it came to typify the speculation in land and single-minded insistence on industrial development that has long characterized the nation. [5.68] The building of this city at the base of Lake Michigan, in hindsight, might seem inevitable, for here was a flat four-and-a-half-mile portage between the Great Lakes watershed (connected to the St. Lawrence River and the Atlantic) and the Mississippi watershed (via the Des Plaines and Illinois Rivers connecting to the Gulf of Mexico). Because of its strategic importance, the site was bitterly con-

tested, first by the native inhabitants, then the French, the English, and finally the United States. Even before the city was platted and incorporated, in 1829 the Illinois state legislature set up a canal commission to develop a scheme for connecting the two continental water systems. In 1830 the first plat was drawn up of the proposed city by James Thompson; it was an unmodulated grid, with alternate squares in the checkerboard set aside for public sale with the proceeds to be used to build the canal. Even before the canal was started, speculation in buying and selling lots began; indeed many of the early leaders of the city came to Chicago to handle transactions for eastern speculators and then decided to stay and make their own fortunes.

So, in ways more pronounced than in any other city, Chicago came into being on the crest of a speculative bubble. Land became a commodity to be bought in anticipation of appreciation in value, like futures in wheat, corn, or hog-bellies, relatively irrespective of any inherent value. It was a practice that, in Chicago and in other cities, was to accelerate growth and yet destroy the cohesiveness of the city at the same time. No recognition was given to features in the landscape except as they served to enhance commercial prospects. The city, as Chicago and like developments suggested, was not, like new suburbs such as Glendale or Llewellyn Park, a haven for civil discourse and the nurturing of families, but solely a generator of revenue.

Chicago expanded westward during midcentury by simply extending its original grid out into the open prairie. Boston, however, originally virtually an island in Massachusetts Bay, faced a very different problem. In order to expand, it continued to fill its surrounding marshy coves with soil obtained by leveling its hills. The biggest project, however—and one that rivaled the grandest of Roman engineering projects—was the filling in of the Back Bay; in this way an area of 450 acres was added to the original 783-acre peninsula. Railroad tracks that already crossed the Back Bay provided the critical transportation. Beginning in 1857, and continuing around the clock for almost twenty years, day and night, long trains of thirty-five gondola cars each were filled with gravel by steam shovels in Needham and pulled to Boston, where the gravel was dumped in the Back Bay; year by year, acre after acre of new land was made, gradually extending southwest from Arlington Street and the Public Garden. Five broad new streets were laid out in an orderly grid extending to the southwest from the Public Garden.

Commonwealth Avenue, in the center, was over 200 feet wide and graced by a broad landscaped parkway down the middle, a linear park. In 1883, at the approximate center of the infill, the city set aside Copley Square. Around this open space a number of new public buildings and churches would eventually rise, making the Back Bay the cultural center of the expanding city. After 1865 prominent families who had formerly occupied Bulfinchian Federalist houses on Beacon Hill began to move to large new town houses they had built in the Back Bay.

Urban Open Space

The imperative for the commercial growth of American cities in the early nineteenth century overpowered all other planning considerations; not until the late 1850s did a few alert individuals in New York City, where the increasing congestion was most severe, begin to call for setting aside parcels of open land and the creation of public parks.[23] (Because the actual construction of these first parks took place largely after the Civil War, however, they are discussed in the next chapter.)

Another, seemingly unusual response to this problem of urban crowding and lack of recreation space was the creation of a new kind of cemetery in the 1830s. Its purpose was not only to be a repository for the bodies of the dead, but also to serve as a place of peaceful relaxation, contemplation, and recreation for the living. An early model was the burial ground in New Haven, Connecticut, later renamed the Grove Street Cemetery. Laid out in a regular grid in 1796, it incorporated extensive landscaping with trees, so as to form a wooded glen; later it would be given its magisterial Egyptian gate by Henry Austin. The first of the so-called rural cemeteries that served as true "pleasure grounds" was the Mount Auburn Cemetery, outside Boston, begun in 1829–30. The plan for this seventy-two-acre site was laid out by General Henry A. S. Dearborn, who patterned it after the Père Lachaise cemetery in Paris, with curving paths and carriageways that generally followed the contours of the rolling land, winding around copses of trees and ponds in the lower places. [5.69] Like the Grove Street Cemetery, Mt. Auburn also received an Egyptian gate and a Gothic chapel. In 1836 in Philadelphia, a similar though smaller landscaped burial ground, Laurel Hill, was designed by architect John Notman. And in 1838 work began on the large 178-acre Green-Wood cemetery in Brooklyn, New York. The plan was devised by civil engineer Major David B. Douglass,

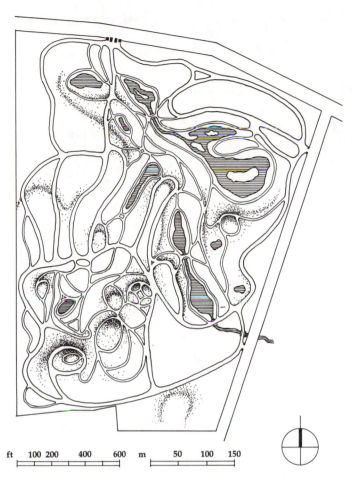

5.69. Gen. Henry A. S. Dearborn, designer, Mount Auburn Cemetery, Cambridge, Massachusetts, 1829–30. This first romantically landscaped or "rural" cemetery in the United States marked a dramatic shift from crowded churchyards; Mount Auburn was as much a garden for nurturing the living as it was a resting place for the dead. (L. M. Roth, after A. Wadsworth, Plan of Mount Auburn, *1831.)*

ft 100 200 400 600 m 50 100 150

with six lakes, twenty-two miles of roads, and thirty miles of footpaths. Eventually, in 1861 Green-Wood would receive an elaborate Gothic entrance gate and lodge by Richard Upjohn. Other similar landscaped "pleasure ground" cemeteries were created in St. Louis, Missouri (Bellefontaine, 1848); in Cincinnati, Ohio (Spring Grove, 1845); and in Chicago, Illinois (Graceland, 1860).

But "rural" cemeteries were usually in outlying areas and hence were accessible only to those who owned horses and carriages. Such romantic landscapes did not help the working poor at the city centers; for them, parks would need to be set aside within the existing urban fabric, and that would be the great cause of Frederick Law Olmsted in the next half century.

The Appearance of the Suburb

In the older eastern cities, as traffic congestion and industrial development increased, the affluent few sought escape from the city to the still verdant and quiet suburbs. By the 1840s rail lines were offering special trains that did nothing but carry passengers with "commutable" tickets (hence "commuters") to and from rural suburban communities. Perhaps the very first was Glendale, Ohio, founded in 1851 and laid out by Robert C. Phillips about ten miles due north of central Cincinnati.[24] [5.70] As in the landscaped cemeteries, Phillips avoided linear streets, preferring circular and curved streets winding through the wooded landscape, although the use of drafting instruments is perhaps too evident in Glendale's street arrangement. The connecting commuter railroad was nearly the only straight line among its curved streets.

The Nichols house by A. J. Davis noted earlier [see 5.41] is doubly important, since it is also one of the original residences of a group of about fifty houses built in what is probably the second planned romantic landscaped suburb. This is Llewellyn Park, developed by Llewellyn Haskell, a New York chemical and drug manufacturer, and built west of the Hudson in Orange, New Jersey. This idealistic community was

5.70. Robert C. Phillips, *Plan of Glendale, Ohio, 1851.*
Located about ten miles north of Cincinnati, Ohio, Glendale
was perhaps the very first of the American romantic

landscaped garden suburbs. (Courtesy of Cincinnati
Historical Museum.)

laid out in a landscaped garden park, and situated next to a commuter rail line that connected with ferries to Manhattan. The street plan was devised by Haskell himself (according to tradition), perhaps with Davis's advice and following suggestions previously made by Downing.[25] [5.71] The first streets were laid in 1852–53, and construction continued over the next sixteen years. Some of the later extensions were designed by landscape architects Eugene A. Baumann and Howard Daniels. The streets generally followed the topography, and the uncommonly large lots were sold with covenants that prevented the introduction of hedges or fences separating the houses to avoid breaking the continuity of the landscape. The original houses, all designed by Davis, varied in style from the fanciful rubble masonry gatehouse [5.72] and a large residence for Haskell, to the simpler cottage for Nichols. Davis's own house was here as well. The view of the gatehouse indicates the importance of planting

in the overall plan. In fact, through the center of the complex ran a communal park strip along a stream that descended over several waterfalls to a pond and the gatehouse at the bottom of the hill.

One other romantic suburb should be noted—Lake Forest, Illinois, on Lake Michigan about twenty-eight miles north of Chicago. With this spot selected as the site of their denominational college, a group of energetic Presbyterians purchased fourteen hundred acres and engaged David Hotchkiss, a St. Louis surveyor, who laid out a system of winding streets that avoided any suggestion of a monotonous grid.

Imbued with Jefferson's views on anti-urbanism and agrarianism, Glendale and Llewellyn Park were, like all romantic conceptions, places of retreat from the increasing congestion and squalor in the industrial cities. Nonetheless, Glendale and Llewellyn Park marked a radical change in urban planning in the nineteenth century because of their comprehensive

5.71a. Llewellyn Haskell, with A. J. Davis with
A. J. Downing, with later additions by E. A. Baumann and
Howard Daniels, plan of Llewellyn Park, Orange,
New Jersey, 1852–69. More fully developed as a landscape
plan than Glendale, this idyllic suburb of New York City had
houses designed by A. J. Davis (including one for himself).
(Courtesy of Avery Library, Columbia University, New York.)
5.71b. Plan drawing by L. M. Roth.

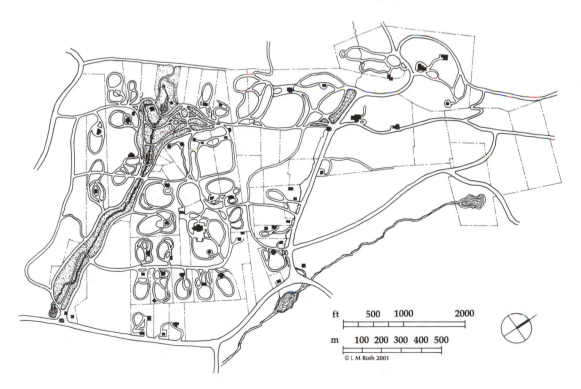

5.72. Alexander Jackson Davis, gatehouse, Llewellyn Park, Orange, New Jersey, 1853. The rough stone gatehouse to Llewellyn Park introduced the romantic imagery used in all the original buildings designed there by Davis. (Sandak, courtesy of the University of Georgia.)

plans and the great importance given to landscape elements and parkland. Both, too, provided an important foundation for the work of Frederick Law Olmsted in Central Park, New York, and his plan for Riverside, Illinois.

Hygeia, Kentucky, if it had prospered, would have been yet another important example. A purely speculative land scheme for a new town on the Ohio River opposite Cincinnati, it was the project of William Bullock, designed by John B. Papworth in 1827. [5.73] Features of many English villages and London's residential squares appeared in the plan; the varied housing included detached villas, semidetached houses (duplexes), town houses, and residential squares. There were provisions for gardens, parks, and promenades, and features of the terrain were reflected to a degree in the street pattern. The design for circulation was perhaps not the best, and there was no clear communal center, but the plan showed imagination. Unfortunately, because of poor financial support, Hygeia never became more than a city on paper.

Without question Glendale, Llewellyn Park, and Hygeia were the exceptions to the rule of city planning by the grid that spread throughout the country. Another, even more radical alternative was to reject capitalism and speculative enterprise altogether and build a social utopia. A number of these developments appeared in the United States during the 1840s, as industrialization first began to make itself felt. Among these were the small but celebrated Brook Farm near West Roxbury, Massachusetts, which prospered from 1841 to 1846; Hopedale, Massachusetts, 1841–52; the Fourieresque North American Phalanx at Red Bank, New Jersey, 1843–55; and the Oneida Community in upstate New York, which survived longest, from 1847 to 1879. For the most part all of these adapted existing building conventions to radically new social patterns. One community in which a new architectural model was suggested as well was the settlement established by Robert Owen at New Harmony, Indiana, in 1825. [5.74] The basis of the town had already been created in Indiana in 1814 by George Rapp and his followers as a religious commune. When the Rappists decided to return to Pennsylvania in 1825, they sold the entire town site to Owen, who planned to establish there a model industrial town based on the theories of social reorganization he had developed at New Lanark, Scotland. Owen's New Harmony was to consist of about twelve hundred people living in a large rectangular enclosure

5.73. John B. Papworth, *planner, plan of Hygeia, Kentucky,*
1827. Proposed for a site across the river from Cincinnati,
this imaginative town was never realized. (From William

Bullock, Sketch of a Journey through the Western States
of North America, *London, 1827.)*

5.74. Stedman Whitwell, *with Robert Owen, aerial view of*
New Harmony, Indiana, c. 1825, lithograph. This proposed
community building would have housed all residents in one

extended structure; a predecessor to apartment houses.
(Courtesy of the New-York Historical Society.)

west by settlers was what has come to be called the I house. Originating in western Virginia and first built in large numbers west of the Appalachians in the first decades of the nineteenth century (as noted in chapter 4), the form of the I house was carried in the minds of pioneers who made the long trek over the continent on the Oregon Trail late in the 1840s; an interesting example is the William Parker house, built in about 1853 in Marion County, Oregon. It was photographed for the Historic American Buildings Survey in the 1930s just prior to its demolition. What makes this example even more interesting is the incorporation of returned eaves, corner pilasters, and other elements that indicate Parker's desire to make the house stylishly Grecian. To the fullest extent possible these frontier house builders attempted to introduce details fashionable in houses "back east," such as the suggested entablature and the returned cornices at the corners, which recall the popular Greek Revival. Such modernization also occurred throughout Kentucky and other parts of the original Northwest Territory. The basic I-house form could be trimmed with broad classical entablatures, or with dripping Gothic bargeboards.

Log cabins, too, would later be encased in sawn clapboards and their roofs similarly encased with fashionable cornices so that the fact that they were log houses became obscured.

An intriguing regional variation was the New England connected house-barn, which became prevalent in Maine, New Hampshire, and Vermont from 1800 to 1870. Typically, a farmer would erect a compact initial dwelling, and then extend behind the original house block a "back house" storage building as a link to a connected barn. Later, when prosperity was better assured, a larger, more stylish front house would be added, creating an arrangement similar to that seen in the Sawyer-Black farm in Sweden, Maine. [5.75] The arrangement of buildings was noted in a refrain chanted by farm girls as they skipped rope: "Big house, little house, back house, barn."[26] Often the front house (the last section to be added) would be built with the latest fashionable details, with corner Doric pilasters, a broad Doric entablature, and massively framed front and side doors (in the manner of Lafever), with pilasters, a heavy entablature, and side lights flanking the recessed door. Not only was the connection between the buildings cost-effective, it also permitted family members to go about their many tasks during the worst winter weather and to move freely from house to barn.

Into the rich farmlands of the developing states in

5.75. Sawyer-Black farmhouse complex, Sweden, Maine, early to mid-1800s. In the northern New England "big house, little house, back house, barn" complex, all the structures are contiguous to facilitate work activities in the depths of winter. (From Thomas Hubka, Big House, Little House, Back House, Barn: The Connected Farm Buildings of New England, Amherst, Mass., 1990.)

containing all communal facilities, with the stables and industrial mills spaced around the housing block in the countryside. The whole complex was then to be surrounded by farmlands, providing a rudimentary greenbelt. The drawing of a proposed ideal residential block, prepared by Stedman Whitwell, was only a dream, and no such structure was ever built even though many Owenites settled in New Harmony. By 1830 Owen's idealistic project had begun to disintegrate. Nevertheless, Owen's ideals of communal ownership of services, centralization, and preservation of open space in a surrounding greenbelt were important concepts and nearly a century later they would be incorporated into garden city proposals.

Vernacular Building

Although factory production in the lumber and nail industries made the balloon frame possible, this new technique did not immediately replace older conventions, nor did it change the shape or appearance of houses in and of itself. One house type that was carried

the Old Northwest Territory and the South, settlers from Pennsylvania and the Piedmont brought their traditional barn types. Although gradually balloon framing might be used for the houses, the barns themselves, well past the end of the nineteenth century, continued to be framed with massive heavy timbers fastened in mortice and tenon joints. One recognizable new barn type has been called the Wisconsin porch barn, derived from German Pomeranian sources, although it appeared frequently in Ohio as well. A frame barn (no stone side walls) built on a slight slope, it was five to seven bays wide, with an overhang on the downhill side supported by wooden posts. In the flatter farmlands of the Midwest, the English barn was often built on a stone or brick base, with an earth ramp running up to the side entrance. A major innovation was in moving the entry door to the end under the gable, sometimes called a traverse frame barn. Long sheds could then added along the sides. If small aisles were inserted between barn and the added outer sheds, the result was the beginning of the Midwest three-aisle or three-portal barn.

Highly revealing socially and architecturally is the history of the Ainsworth farm in Mason County, Illinois.[27] Thomas J. Ainsworth was born in Blackburn, Lancashire, England, in 1814 and emi-grated with his wife and children to the United States in 1842, settling in Lynchburg Township, Mason County, Illinois, where he was joined by his brothers Richard and William. By midcentury the Ainsworths had assembled a 480-acre farm complex, and the younger brother, William, had completed the group of buildings illustrated in an atlas of Mason County published in 1874. [5.76] The residence (now demolished) was a good example of a typical I house with the addition of a front porch; it was built in about 1860, probably by local builders following established patterns. The barn is a enlarged version of an English barn (with Dutch doors on the long side). The Ainsworth story is noteworthy because it was on these 480 acres that the family developed specialized hybrids of seed corn that helped to establish Indiana and Illinois as the corn belt of the nation and made Ainsworth Corn Seed Company a major agricultural firm by the early twentieth century.

IN SEARCH OF AN AMERICAN ARCHITECTURE

The period from 1820 to 1865 was one of great architectural activity and ingenuity, for during these years the transition was auspiciously begun from an agrari-

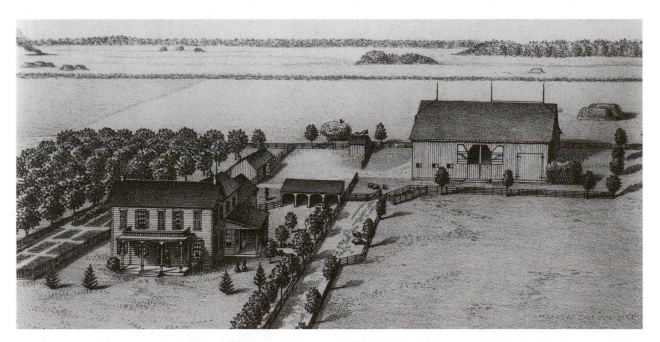

5.76. *Ainsworth farm complex, Mason County, Illinois, c. 1860, detail of plate from* Mason County Atlas, 1874. *A good example of a midwestern farm complex, the Ainsworth farm was also where corn hybridization was begun. (Courtesy of the Illinois State Historical Library, Springfield, Illinois.)*

an to an industrialized nation. Scores of new architectural problems were confronted and solutions devised—large public hotels, prisons, stores, warehouses, railroad stations, courthouses, state houses, and urban town houses. Since this coincided with the outburst of American romanticism and the fascination with things considered exotic simply by virtue of being distant in space or time, the buildings—both traditional types and new types—were cast in those forms whose emotional and historical associations were seen as enhancing their functions. If the romantically minded architects could not find immediate original solutions to the flood of problems confronting them, they demonstrated no lack of creative adaptation as they surveyed the rich and varied history of building. Looking back over the history of architecture, being discovered and described in these same years, the architects attempted to isolate ideograms or conventionalized images that would bring a sense of familiarity and meaning into an increasingly complex world. American architects were so captivated by their newly acquired knowledge of the past that they were as yet unconcerned with trying to create a wholly original American architecture. They were content for the moment to ape the past.

Some observers, however, were troubled that American architects seemed to lack the creative ingenuity shown by their contemporaries in devising clipper ships or sleek buggies. In 1841 Ralph Waldo Emerson mused on the relationship between form and function in his essay "Thoughts on Art."[28] He proposed the theorem that "whatever is beautiful rests on the foundation of the necessary. Nothing is arbitrary, nothing is insulated in beauty. It depends forever on the necessary and the useful. . . . The most perfect form to answer an end is so far beautiful." In another essay, "Self-Reliance," Emerson further complained of houses "garnished with foreign ornaments" and asked "why need we copy the Doric or the Gothic model?" He suggested that if the American architect would only analyze the functions required in his designs, "considering the climate, the soil, the length of day, the wants of the people, the habit and form of government, he will create a house in which all these find themselves fitted, and taste and sentiment will be satisfied also."[29]

At nearly the same time, another American living in Italy came to similar conclusions. Horatio Greenough, best known today as a skilled neoclassical sculptor, was also watching the development of American architecture and saw with dismay that great energy being devoted to copying ancient forms. In the *Democratic Review* of August 1843, Greenough published an essay, "American Architecture," with this stern advice: "Instead of forcing the functions of every sort of building into one general form, adopting an outward shape for the sake of the eye or of association, without reference to the inner distribution, let us begin from the heart as a nucleus and work outward." Americans should study Greek art, he agreed, "but let us learn principles, not copy shapes; let us imitate them like men, not ape them like monkeys."[30]

Similar ideas were expressed by Louisa C. Tuthill in the first book on American architecture carrying the inclusive title *History of Architecture from the Earliest Times; Its Present Condition in Europe and the United States* (Philadelphia, 1848). Written in New Haven as early as 1841, and buttressed by extended study in the large architectural library of her friend Ithiel Town (and also illustrated with images from Town's collection), Tuthill's essay touched on several questions that would trouble American architects for the next century. She noted absurdities that resulted from following French dress fashions too strictly and suggested that "in adopting the domestic architecture of foreign countries, we may be equally ridiculous." Like Emerson she argued that an American architecture must be indigenous: "an American architect must possess the power to adopt what is suitable to our soil, climate, manners, civil institutions and religion without servile imitation."[31] Tuthill's challenge would be met in one way by creative architects after the Civil War. It is, in fact, still being struggled with today.

BIBLIOGRAPHY

Bannister, Turpin. "Bogardus Revisited, Part 1: 'The Iron Front,'" *Journal of the Society of Architectural Historians* 15 (March 1956): 12–22.

Bender, Thomas. *Community and Social Change in America.* New Brunswick, N.J., 1978.

———. *Toward an Urban Vision: Ideas and Institutions in Nineteenth-Century America.* Lexington, Ken., 1975.

Bluestone, Daniel. "Civic and Aesthetic Reserve: Ammi Burnham Young's 1850s Federal Customhouse Designs," *Winterthur Portfolio* 25 (Summer–Fall 1990): 131–56.

Bogardus, James. *Cast Iron Buildings: Their Construction and Advantages.* New York, 1856; reprinted 1970.

Bryan, John M., ed. *Robert Mills, Architect.* Washington, D.C., 1989.

Bunting, Bainbridge. *Houses of Boston's Back Bay: An Architectural History, 1840–1917.* Cambridge, Mass., 1967.

Cantor, Jay E. "A Monument of Trade: A. T. Stewarts and the Rise of the Millionare's Mansion in New York," *Winterthur Portfolio* 10 (1975): 165–98.

Cavanagh, Ted. "Balloon Houses: The Original Aspects of Conventional Wood-Frame Construction Re-examined," *Journal of Architectural Education* 51 (September 1997): 5–15.

Condit, Carl W. *American Building Art: The Nineteenth Century.* New York, 1960.

Darnall, Margaretta J. "The American Cemetery as Picturesque Landscape: Bellfontaine Cemetery, St. Louis," *Winterthur Portfolio* 18 (Winter 1983): 249–70.

Davies, Jane B. "Llewellyn Park in West Orange, New Jersey," *Antiques* 107 (January 1975): 142–58.

Davis, Alexander Jackson. *Rural Residences.* New York, 1837; reprinted 1980.

Downing, Andrew Jackson. *The Architecture of Country Houses.* New York, 1850; reprinted 1969.

———. *Cottage Residences.* New York, 1843; 1873 ed. reprinted as *Victorian Cottage Residences*, New York, 1981.

———. *A Treatise on the Theory and Practice of Landscape Gardening*, 7th ed. New York, 1865; reprinted as *Landscape Gardening and Rural Architecture*, New York, 1991, with a new introduction by George Tatum.

Early, James. *Romanticism and American Architecture.* New York, 1965.

Gallagher, Helen. *Robert Mills, Architect of the Washington Monument, 1781–1855.* New York, 1935.

Gilchrest, Agnes A. *William Strickland, Architect and Engineer, 1788–1854.* Philadelphia, 1950.

Gillman, Arthur D. "Architecture in the United States," *North American Review* 58 (April 1844): 436–80.

Greenough, Horatio. *Form and Function: Remarks on Art.* ed. Howard A. Small. Berkeley, Calif., 1949.

Hamlin, Talbot. *Greek Revival Architecture in America.* New York, 1944.

Handlin, David. P. *The American Home: Architecture and Society, 1815–1915.* Boston, 1979, esp. 3–88.

Hayden, Dolores. *Seven American Utopias: The Architecture of Communitarian Socialism, 1790–1975.* Cambridge, Mass., 1976.

Hitchcock, Henry-Russell. *Rhode Island Architecture*, 2nd ed. New York, 1968.

Hitchcock, Henry-Russell, and William Seale. *Temples of Democracy: The State Capitols of the U.S.A.* New York, 1976.

Jefferson, Williamson. *The American Hotel.* New York, 1930.

Kahn, David M. "Bogardus, Fire, and the Iron Tower," *Journal of the Society of Architectural Historians* 35 (October 1976): 186–203.

Kennedy, Roger G. *Greek Revival America.* New York, 1989.

Lancaster, Clay. *Antebellum Architecture of Kentucky.* Lexington, Ken., 1991.

Landy, Jacob. *The Architecture of Minard Lafever.* New York, 1970.

Linden-Ward, Blanche. "Cemeteries." In *American Landscape Architecture: Designers and Places*, ed. W. H. Tishler. Washington, D.C., 1989.

Loth, Calder, and Julius T. Sadler Jr. *The Only Proper Style: Gothic Architecture in America.* Boston, 1975.

McMurry, Sally. "City Parlor, Country Sitting Room: Rural Vernacular Design and the American Parlor, 1840–1900," *Winterthur Portfolio* 20 (Winter 1985): 261–80.

Meeks, Carroll L. V. *The Railroad Station.* New Haven, Conn., 1956.

———. "Romanesque before Richardson in the United States," *Art Bulletin* 35 (March 1953): 17–33.

Newton, Roger H. *Town and Davis, Architects: Pioneers in American Revivalist Architecture, 1812–70.* New York, 1962.

Patrick, James. "Ecclesiologial Gothic in the Antebellum South," *Winterthur Portfolio* 15 (Summer 1980): 117–38.

Pierson, William H., Jr. *American Buildings and Their Architects, vol. 2, Technology and the Picturesque, the Corporate and the Early Gothic Styles.* New York, 1978.

———. "Richard Upjohn and the American Rundbogenstil," *Winterthur Portfolio* 21 (Winter 1986): 223–242.

Roberts, Warren E. "German American Log Buildings of Dubois County, Indiana," *Winterthur Portfolio* 21 (Winter 1986): 265–74.

Rothman, David. *The Discovery of the Asylum.* Boston, 1971.

Schuyler, David. *Apostle of Taste: Andrew Jackson Downing, 1815–1852.* Baltimore, 1996.

Scully, Vincent. "Romantic Rationalism and the Expression of Structure in Wood: Downing, Wheeler, Gardner, and the 'Stick Style,' 1840–1876," *Art Bulletin* 35 (June 1953): 121–42. This reprinted as the opening section of the 2nd ed. of Vincent Scully, *The Shingle Style and the Stick Style* (New Haven, 1972).

Smith, J. Frazer. *White Pillars: Early Life and Architecture of the Lower Mississippi Valley Country.* New York, 1941.

Sprague, Paul. E. "The Origin of Balloon Framing," *Journal of the Society of Architectural Historians* 40 (December 1981): 311–19.

Stanton, Phoebe B. *The Gothic Revival and American Church Architecture: An Episode in Taste, 1840–1856.* Baltimore, 1968.

Tishler, William H. "Fachwerk Construction in the German Settlements of Wisconsin," *Winterthur Portfolio* 21 (Winter 1986): 275–92.

Tucci, Douglass Shand. *Built in Boston, City and Suburb.* Boston, 1978.

Tuthill, Louisa C. *History of Architecture from the Earliest Times: Its Present Condition in Europe and the United States.* Philadelphia, 1848; reprinted 1988.

Upjohn, Everard M. *Richard Upjohn, Architect and Churchman.* New York, 1939.

Upton, Dell. "Pattern Books and Professionalism: Aspects of the Transformation of Domestic Architecture in America, 1800–1860," *Winterthur Portfolio* 19 (Summer–Fall 1984): 107–50.

Wade, Richard C. *The Urban Frontier: Pioneer Life in Early Pittsburgh, Cincinnati, Lexington, and St. Louis.* Chicago, 1964.

Weaver, William W. "The Pennsylvania German House: European Antecedents and New World Forms," *Winterthur Portfolio* 21 (Winter 1986): 243–64.

Williams, Michael Ann. "Pride and Prejudice: The Appalachian Box House in Southwestern North Carolina," *Winterthur Portfolio* 25 (Winter 1990): 217–30.

Winter, Robert. "Fergusson and Garbett in American Architectural Theory," *Journal of the Society of Architectural Historians* 17 (Winter 1958): 25–29.

Wischnitzer, Rachel. *Synagogue Architecture in the United States.* Philadelphia, 1955.

NOTES

1. Arthur Gilman's essay "Architecture in the United States" (1844) and Luisa Tuthill's *History of Architecture . . . in Europe and the United States* are discussed at the end of this chapter.
2. Quoted in Agnes A. Gilchrist, *William Strickland, Architect and Engineer, 1788–1854* (Philadelphia, 1950; reprinted 1969), 53.
3. Haviland's Miner's Bank was illustrated by an engraved plate in a new edition of Owen Biddle's *Young Carpenter's Assistant* that Haviland published in 1830, adding twenty new plates.
4. Lincoln's comment arose in a conversation with John Eaton in 1863. Eaton, newly arrived in Washington, spoke of the construction of the dome, whereupon Lincoln observed that some in Congress objected to the continuing work. Recounted in John Eaton, *Grant, Lincoln, and the Freedmen* (New York, 1907), 89. The story is retold in Carl Sandburg, *Abraham Lincoln: The War Years* (New York, 1939), 535.
5. The description of a romantic, secluded burial area for Monticello, from Jefferson's Memorandum Book of 1771, is given in William Howard Adams, *Jefferson's Monticello* (New York, 1983), 67.
6. St. John the Baptist, Shottesbrook, Berkshire, a fourteenth-century example of English decorated Gothic, was measured by William Butterfield, and his drawings, with accompanying essays, were published by the Oxford Architectural Society in 1846. Bishop Doane also visited England and inspected St. John the Baptist for himself. See Phoebe B. Stanton, *The Gothic Revival and American Church Architecture: An Episode in Taste, 1840–1856* (Baltimore, 1968).
7. Upjohn's introductory remarks, and drawings for a small wooden rural church, are reproduced in *America Builds*, 50–52.
8. The opening section, discussing the principles of landscape design, and the difference between the "Graceful" mode of landscape design (subtly varied and pastoral) versus the "Picturesque" mode (ruggedly irregular and wild) is reprinted in *America Builds*, 131–43.
9. The preface and large sections of descriptive text from *Cottages Residences*, including text and plates for house Design V, is reprinted in *America Builds*, 151–71.
10. See Priscilla Knuth, *"Picturesque" Frontier: The Army's Fort Dalles*, 2nd ed. (Portland, Ore., 1987). Scholl designed more than ten Downing-style houses for the staff of Fort Dalles; all but the Surgeon's house were destroyed by fire. Scholl also designed Downing-style buildings and residences for Fort Simcoe, Washington, which survive.
11. Romanesque architecture was praised as having "fewer members and less complication of details" than Gothic by Robert Dale Owen in his *Hints on Public Architecture* (1849). For examinations of the American interest in Romanesque architecture prior to 1865 see Carroll L. V. Meeks, "Romanesque before Richardson in the United States," *Art Bulletin* 35 (March 1953): 17–33; and William H. Pierson, "Richard Upjohn and the American Rundbogenstil," *Winterthur Portfolio* 21 (Winter 1986): 223–42.
12. Cited by Montgomery Schuyler in the first installment of his three-part essay on Leopold Eidlitz, *Architectural Record* 24 (September 1908): 164–79; reprinted in M. Schuyler, *American Architecture and Other Writings*, 2 vols. (Cambridge, Mass., 1961), 1:140–41.
13. See William Crawford, *Report on the Penitentiaries of the United States* (London, 1834), and F. A. Demetz and G. A. Blouet, *Rapports à M. le comte de Montalivet . . . sur les penitenciers des Etats Unis* (Paris, 1837).
14. See Ibid.
15. Arthur D. Gilman, "Architecture in the United states," *North American Review* 58 (April 1844): 436–80.
16. See William H. Eliot, *A Description of Tremont House* (Boston, 1830). For the international impact of these luxurious early American hotels, see Henry-Russell Hitchcock, "American Influence Abroad," in *The Rise of an American Architecture*, ed. E. Kaufmann, Jr., (New York, 1970), 3–50.
17. John Fanning Watson, *Annals of Philadelphia and Pennsylvania, in the Olden Times*, 2 vols. (Philadelphia, 1868), ii, 591, noted in Dell Upton, *Architecture in the United States* (New York, 1998), 211.
18. An excerpt from Bogardus's catalogue of building parts, *Cast Iron Buildings: Their Construction and Advantages* (New York, 1856), is reprinted in *America Builds*, 68–74.

19. Ted Cavanagh, "Balloon Houses: The Original Aspects of Conventional Wood-Frame Construction Re-examined," *Journal of Architectural Education* 51 (September 1997): 5–6. Cavanagh cites Charles Dwyer, who wrote that *balloon* had been applied to this kind of construction as a term of derision due to its fragile appearance: Charles P. Dwyer, *The Economic Cottage Builder, or Cottages for Men of Small Means* (Buffalo, N.Y., 1856), 33. Caroline Clark seems clearly to have meant that boards were wooden pieces of minimal or thin dimension, whereas timbers were large hewn or sawn members. The controversy surrounding the invention of the balloon frame is discussed in Paul E. Sprague, "The Origin of Balloon Framing," *Journal of the Society of Architectural Historians* 40 (December 1981): 311–19. Cavanagh cites a transfer deed of property near Sainte Genevieve, Missouri, in 1804, in which the house on the property is described as "une maison en Boullin" or a house made of small pieces of wood as might be used for a fence. He also shows a surviving Franco-American house near St. Louis, Missouri, dating from 1807, that suggests an early form of light wood framing, and notes that French *poteaux-sur-sole* construction could have been one source for balloon framing.

20. In *Homes for the People in Suburb and Country* (New York, 1855), Gervase Wheeler reprinted virtually verbatim an article from the *New York Tribune*, January 18, 1855, itself a reprint of a comments made earlier by a Mr. Robinson before the American Institute of Farmer's Club on "a novel mode of constructing cheap wooden dwellings." This section of Wheeler's book discussing the balloon frame is reprinted in *American Builds,* 53–56.

21. See John S. McNown, "Canals in America," *Scientific American* 235 (July 1976): 116–24, with maps and bibliography.

22. See John F. Stover, *American Railroads* (Chicago, 1861).

23. For the editorials in the *Horticulturalist* by A. J. Downing calling for the creation of public parks, see *America Builds*, 143–51.

24. Long overlooked in the history of American suburbia, Glendale, Ohio, is discussed in Alexandra McColl Buckley, "Glendale, Ohio: A Study of Early Suburban Development in America" (master's thesis, University of Oregon, 1993). Two earlier mentions occur in Spiro Kostof, *America by Design* (New York, 1987), 27; and Spiro Kostof, *The City Shaped* (Boston, 1991), 74.

25. See Jane B. Davies, "Llewellyn Park in West Orange, New Jersey," *Antiques* 108 (January 1975): 142–57; and Richard Guy Wilson, "Idealism and the Origin of the First [sic] American Suburb: Llewellyn Park, New Jersey," *American Art Journal* 1 (October 1979): 70–90.

26. The refrain was used as the title for Thomas C. Hubka's important study, *Big House, Little House, Back House, Barn: The Connected Farm Buildings of New England* (Hanover, N.H., 1984).

27. Data derived from interviews with Harold William and Mary K. Mangold, and Ruth Ainsworth, Mason City, Illinois, August 1990; and from Ruth Wallace Lynn, *Prelude to Progress: The History of Mason County, Illinois, 1818–1968* (Mason City, Ill., 1968), 169–72, 347–48, 358–64, 380.

28. Ralph Waldo Emerson, "Thoughts on Art," The Dial 1 (January 1841): 367–78; reprinted in America Builds, 90–99.

29. Ralph Waldo Emerson, "Self-Reliance," in *Essays, First Series* (Boston, 1841); this idea was developed in a series of lectures delivered in 1836 through 1839.

30. Horatio Greenough, "American Architecture," *The United States Magazine, and Democratic Review* 13 (August 1843): 206–10. Large portions of this essay and portions of Greenough's *The Travels, Observations, and Experience of a Yankee Stonecutter* (New York, 1852) are reprinted in *America Builds*, 77–90. It is possible that Greenough's views may have been shaped by reading the work of the eighteenth-century Italian theoretician and architect Carlo Lodoli (1690–1761). The American architect Edward Lacy Garbett (d. 1898) also severely criticized the imitation of ancient models. His views appeared in his book *Rudimentary Architecture for the Use of Beginners and Students, the Principles of Design in Architecture as Deducible from Nature and Exemplified in the Works of the Greek and Gothic Architects* (London, 1850) and also "Preliminaries to Good Building," in *Papers and Practical Illustrations of Public Works of Recent Construction* (London, 1856).

31. Louisa C. Tuthill, *History of Architecture from the Earliest Times: Its Present Condition in Europe and the United States* (Philadelphia, 1848; reprinted with interpretive introduction by Lamia Doumato, 1988), viii, 275. See also Lamia Doumato, "Louisa Tuthill's Unique Achievement: First History of Architecture in the U.S.," in *Architecture: A Place for Women*, ed. Ellen Perry Berkeley (Washington, D.C., 1989), 5–13.

6.1. *James Renwick, Corcoran Gallery (now Renwick Gallery), Washington, D.C., 1859–61, 1870–71. An early* *example of a fully developed Second Empire Baroque building. (Photo: © Wayne Andrews/Esto.)*

ARCHITECTURE IN THE AGE OF ENERGY AND ENTERPRISE, 1865–1885

PARVENU TASTE IN AN EXPANDING ECONOMY

Building activity declined in the United States after a depression in 1857. Shortly after, civilian construction nearly halted during the Civil War and did not fully resume until 1866. During this hiatus numerous changes had occurred in several areas: in the prevailing public taste, in architectural developments in Europe influencing American taste, in architectural theory, and in building technology. Thus, when civilian building did resume, there were significant differences between what had been done around 1856 and what was now deemed current and fashionable around 1866.

What distinguishes the period from 1865 to 1885 in particular was the boundless energy and self-assured confidence that pervaded American culture. The general enthusiasm and the public attitude that change was possible, desirable, and inevitable were invigorating even if ultimately short-sighted. Indeed, historian Howard Mumford Jones called this era "The Age of Energy," and novelist Horatio Alger summed up the spirit of the period when he wrote in 1867, "There's always room at the top."[1] In architecture there was an intensity of experimentation with many new structural techniques and in various modes of building—public, commercial, religious, and domestic. Furthermore, this was also a period of vigorous economic growth and exploitation; most of the great American family fortunes were started in these twenty years. It was also a period that saw the final stages of the full "democratization" of the marketplace as manufactured goods were distributed to the far corners of the country. The mail-order catalog and mail-order business activity, with its networks of warehouses at the nodes of rail transportation, are the symbols of this democracy in the marketplace. In business and government, laissez-faire and social Darwinist policies enjoyed an authority from 1865 through the rest of the century that they were not to have afterward; as a result, material utilitarianism gained a solid grip on the public mind, so that functional utility and income potential were considered to be more important in a building than psychological or artistic considerations. Commerce and the profit to be made through buildings, and the land they stood on, became the paramount considerations.

ARCHITECTURAL EDUCATION

Because of the rapidly accelerating pace of technological change, architects (and other professionals) could no longer simply apprentice to enter their profession. Colleges and universities developed curricula concentrating on the sciences, including architecture. The Massachusetts Institute of Technology was the first to be opened, in 1861, but was followed by several private institutions and by public land-grant colleges beginning in 1862. Many of the new engineering departments began to offer classes in architectural drafting, design, and structural methods, and full programs in architectural education were soon established, first at MIT in 1868, followed by the University of Illinois in 1870, Cornell in 1871, Syracuse University in 1873, the University of Pennsylvania in 1874, and Columbia University in 1881. Such programs added significantly to the professional position of the architect, but for the remainder of the century his primary role was that of an

artist rather than of an engineer. These initial architectural curricula were closely patterned after the famous teaching program at the École des Beaux-Arts in Paris, and by the 1880s many of the schools had appointed French design instructors trained at the École des Beaux-Arts to ensure that their pupils had sound compositional theory and classical design instruction.

CREATIVE ECLECTICISM

The unbridled energy of the age, its confident enthusiasm, and its brash parvenu taste resulted in an architecture that consciously attempted to be modern, vigorous, and more energetic than the previous expressions. The idea that historical allusions could enhance architectural function and communicate sentiments to the user remained very much alive, but now the objective was to create a deliberately new and modern expression based imaginatively on classical or medieval forms, without copying specific details or replicating whole buildings. The impulse toward eclecticism continued, but now the emphasis was on creative interpretation of historical source material. The organization of plans became more attuned to specialized modern functional requirements, and the exteriors became increasingly intricate and complicated—a roof line was never simple. Seldom in the United States has there been a profession or a clientele that better understood, and more eagerly sought, complexity and multiplicity of form. The variety of building shapes and outlines was further enriched by a use of natural polychromy through building materials of contrasting colors. At the same time, however, there was a growing divergence between public architecture and domestic architecture. Previously a Greek Revival house (Andalusia) and a Greek Revival bank (the Second National Bank, Philadelphia) could appear from the exterior to be interchangeable, but in the 1870s and 1880s such buildings became two very different expressions.

SECOND EMPIRE BAROQUE

During the two decades after the Civil War public and private architecture continued to be dominated by two major styles, one generically classical and the other generically Gothic. The classical mode was a consciously "modern" expression, based on contempo-

rary work in Paris, specifically on the additions to the Louvre of 1852–57, done for Louis Napoleon by architects Louis Visconti and Hector-Martin Lefuel. In their attempt to integrate the new portions with the original Renaissance and Baroque sections of the Louvre, the architects devised a heavily embellished expression that was not merely a revival of French Baroque but a newly interpreted style, hence the name now given it, Second Empire Baroque, due to its popularity in the Paris of Napoleon III.[2] Second Empire Baroque was rich in horizontal layering using classical orders, with the building mass divided into dominant center pavilions flanked by end pavilions, separate mansard roofs atop each section, and multiple overlays of elaborate classical ornament and sculptural enrichment. Probably the single most distinctive feature of this style was the tall, truncated pyramidal mansard roof, inspired by those that had been used so often and so effectively in seventeenth-century France by architect François Mansart (after whom this roof form was named).

Since the Louvre in Paris had functioned as government house, imperial palace, art gallery, and museum all at once, it became the prototype for specialized buildings with any of these functions in France, England, Germany, the United States, and elsewhere. Just prior to the Civil War a few houses with mansard roofs had been built by European-born and -trained architects Charles Lemoulnier and Detlef Lienau (1818–1887) in Boston and New York. Lienau's Hart M. Shiff house, in New York, built in 1850–52, was perhaps the first. James Renwick quickly adopted this new idiom and used it in his Charity Hospital on Blackwell's Island, New York, built in 1854–57, for the long main building housing Vassar College, in Poughkeepsie, built in 1860 (a new institution created to educate women), and also for an art gallery in Washington, D.C., the Corcoran Gallery, whose construction was begun in 1859, halted in 1861, and finished in 1870–71. [6.1] In fact, Renwick and William W. Corcoran had traveled together to Paris in 1855, and Renwick had the New Louvre specifically in mind when he designed the Corcoran Gallery. Renwick's interpretation was typically American in its color, with dark red brick walls and brownstone trim, in contrast to the cream-colored limestone of the New Louvre.

The real impact of Second Empire Baroque in the United States did not occur until after 1865. One reason for its national popularity was that Alfred B. Mullett (1834–1890), supervising architect for the federal government from 1866 through 1874, used it

6.2. *Alfred B Mullett, State, War, and Navy Building (Executive Office Building), Washington, D.C., 1871–75. One of the largest example of Second Empire Baroque architecture, this set the standard for government building across the continent. (A. Lewis and K. Morgan,* American Victorian Architecture, *1975.)*

for the numerous government buildings his office erected across the country. An early example was the State, War, and Navy Building (now the Executive Office Building), west of the White House, in Washington, D.C., built in 1871–89. [6.2] The enormous size of this building dramatically illustrated the growth in the federal bureaucracy brought about by the Civil War. The repetitious detail, some cut by machine, is extremely sharp, partly because of the use of dense granite and partly because of the mechanized process. Due to mechanization Mullett was able to achieve the incredible profusion of column upon column and molding upon molding that makes Second Empire Baroque distinctive. In few other examples is multiplicity of detail so well demonstrated. Mullett's post offices, like those in St. Louis (1873–84) or New York (1869–80), spread this style to every major city; other architects took it up as well, and it became the "official" style of civic, municipal, educational, and commercial buildings.

Second Empire Baroque was also used for railroad terminals, as in the Grand Central Depot, in New York, built in 1869–71, by Snook and Buckhout. [6.3] The building of this station for Cornelius Vanderbilt marked his amalgamation of several rail lines serving Michigan, New York, and the suburban traffic of New York and Connecticut. Though centralized, the three lines was strictly segregated on different tracks, and, as if to emphasize this, the architect of the head house, John B. Snook (1815–1901), kept each pavilion of the building isolated, requiring through-passengers to exit and reenter the station through another door to continue their journey. The compartmentalized Second Empire Baroque style was well suited to this kind of articulation. Surviving photographs show the bulbous curved roofs and suggest the polychromy of window frames contrasted with darker walls. Behind the elaborate head house was one of the most outstanding American train sheds. [6.4] Designed by engineer Isaac C. Buckhout, it was a vast barrel-vaulted space 600 feet long, roofed by arched iron trusses spanning 200 feet, covering twelve tracks, carrying a relatively light sheet-iron and glass roof.

Between head house and shed there was absolute dichotomy, for while the shed covered a large space with the simplest and most economical and utilitarian means available, the terminal house spoke the language not of science but of symbolic aesthetics. Because it was meant to convey a "corporate" image there was no expense spared nor any effort to minimize material.[3] There was evident here an impending split between architecture and structure, between symbolic ideogram and the skeletonized shed. Though architect and engineer were often trained in the same

6.3. John B. Snook, architect, and Isaac Buckhout, engineer, Grand Central Depot, New York, New York, 1869–71. In this instance, each of the three tall mansard-roof pavilions represented one of the rail lines merged into the New York Central system. (Courtesy of the Museum of the City of New York.)

6.4. Isaac Buckhout, engineer, Grand Central Station, train shed, New York, New York. One of the largest clear-span train sheds in the United States, this structure provided dry conditions for baggage and passengers. (Courtesy of the New-York Historical Society.)

universities (but most often in discrete departments), there soon developed a gulf between them that persisted for nearly a century.

Among the multitude of public buildings that employed Second Empire Baroque were a number of city halls, beginning with the Boston City Hall, built in 1862–65, by Gridley J. F. Bryant and Arthur C. Gilman. One splendidly elaborate example is the Philadelphia City Hall, by John MacArthur (1823–1890), built in 1871–1901. [6.5] The building

is in the form of a huge square with a spacious court at the center; rising from one of the sides is a 548-foot tower. Here too the growth in urban government required a far larger building than had been common before. Placed in the centermost public square of Penn's plan, the building covers about fourteen acres. The great bulk is emphasized by the doubling or trebling of motifs, as in the paired columns in the pavilions, and the telescoped sections of the central pavilions, with their multiple overlaid mansard roofs.

6.5. John MacArthur, Philadelphia City Hall, Philadelphia, Pennsylvania, 1871–1901. Filling the center square in Penn's plan, the city hall represents one of the fullest expressions of Second Empire Baroque design. (Courtesy of the City of Philadelphia.)

6.6. Warren H. Williams, Villard Hall, 1885–86, and William W. Piper, Deady Hall, 1873–76 (left to right), University of Oregon, Eugene, Oregon. These two adjacent buildings illustrate the popularity of Second Empire Baroque for educational buildings in the last third of the nineteenth century. (From West Shore, Portland, Ore., August 1886, courtesy of Special Collections, Knight Library, University of Oregon.)

Fortunately, city officials remained true to the original designs during the long process of construction; Second Empire Baroque was definitely out of fashion by 1890, but the design was not changed in the final years of construction.

Other government buildings, especially county courthouses built during the 1870s and 1880s, were also designed in the fashionable Second Empire Baroque style. Examples abound from ocean to ocean, from the richly embellished Davis County Court House, in Brookfield, Iowa, built in 1877–78 to the Cabarrus County Court House in Concord, North Carolina, built in 1875–76. State capitols, however, held closer to the classical model provided by the United States Capitol, with its recently completed huge iron dome. Only Thomas Fuller and Arthur Gilman's early proposals for the New York State Capitol in Albany, of 1871, had true mansard pavilions (it was finished in a very different style later). The new Illinois State Capitol in Springfield, built in 1867–88, by Alfred H. Piquenard, does have de-emphasized mansard roofs dominated by a tall dome.

Since the museum sections of the New Louvre had served a public educational function, for a time many new American collegiate buildings were in this mode, and there was hardly a college or university, particularly among the new land-grant universities, that did not boast a mansard "Old Main" or "University Hall." Wealthy brewer Matthew Vassar helped to initiate this trend when he had Renwick design the building for his new women's college in Poughkeepsie, New York, built in 1861–65; the extended horizontal range of Vassar College, with its multiple mansard roofs,

looked very much like the Palace of the Tuileries at the east end of the New Louvre. Two adjacent collegiate examples in the Pacific Northwest show both the geographical spread of this style and its continued popularity even through the late 1880s: Deady Hall, built in 1873–76, and Villard Hall, built in 1885–87, for the University of Oregon were designed by William W. Piper (c. 1827–1886) and Warren H. Williams (1844–1888), respectively. [6.6]

HIGH VICTORIAN GOTHIC

Sharing dominance with the fanciful Baroque was High Victorian Gothic, derived from English sources. The major physical inspiration came from the work of William Butterfield (1814–1900), especially his All Saints' Church, on Margaret Street, London, built in 1849–59, significant for its unorthodox plan and the extremely rich coloring of its brickwork and interior materials and finishes.[4] The theoretical basis was provided by John Ruskin in his books *The Seven Lamps of Architecture* (1849) and *The Stones of Venice* (1851–53). Ruskin conceived of seven conditions or "lamps" essential to great architecture: "Sacrifice" through the creation of extensive didactic ornament, "Truth" through the exclusion of sham construction in favor of the expression of materials, "Power" through massing of forms, "Beauty" through the observation of laws of nature, "Life" through expression of complex human activity, "Memory" through building for posterity, and "Obedience" through adherence to various Gothic styles that manifested all

the preceding six characteristics.[5] All of these injunctions were studied by American architects and architectural enthusiasts and taken very much to heart; to a large extent they have influenced subsequent architecture, whether Gothic-inspired or classically derived, up to the present, although the first, sixth, and seventh lamps now flicker dimly if at all. In his book on Venice, Ruskin argued that of all the Gothic forms, Venetian had the most to offer to the nineteenth century. He also argued that Gothic was good because Gothic workmen had been both Christians and contented workmen, building with their hearts as well as with their hands.[6] Their work gave them pleasure and so it was done beautifully.

There was another "lamp," so to speak, that resulted from Ruskin's writing: the lamp of Color (actually a subelement, perhaps, of the lamp of Beauty, since nature itself presents many colors). The late Victorians loved displays of color: deep, dark, rich colors, boldly contrasted against each other. The technical term for such kaleidoscopic display is *polychromy*, the use of many colors or chroma. Ruskin's persuasive arguments, along with the examples of Butterfield's strong color contrasts, quickly helped to establish a highly interpreted Gothic, not a revival but a mode of design that relished elaborately composed and stridently polychromatic forms, a strong counterpart to the classical formality of Second Empire Baroque.

A preview of the boldly contrasting color to come, with the full impact of Ruskin's influence, appeared in New York City just before the Civil War. Newly arrived English architect Jacob Wrey Mould (1825–1886), a pupil of colorist Owen Jones, was given the commission for All Soul's Unitarian Church and Parsonage, built in 1853–55 (now demolished). Designed in an Anglo-Italianate Romanesque style, its detailing was rather minimal, but overpowering everything were the dramatic horizontal layers of light yellow Caen stone alternating with dark red brick. This was the first such polychromatic building in the United States and made such an impression on two young New York students—Russell Sturgis and Peter Bonnett Wight—that they resolved to become architects themselves.

High Victorian Gothic, having been created in church architecture in Great Britain, was of course used extensively for churches in North America. Of hundreds, one particularly good example, recently restored and cleaned to reveal its wealth of colors inside and out, is the church designed by the Boston firm of Cummings and Sears to accommodate the Old South Church congregation. It was built in 1874 in the developing and fashionable Back Bay area of Boston. [6.7] The various sections are all sharply articulated, including the projecting corner porte cochere. A rich color palette is made up of walls in tan stone

6.7. *Charles A. Cummings and Willard T. Sears, New Old South Church, Copley Square, Boston, Massachusetts, 1874. Recently restored and cleaned, the New Old South Church is a good example of the colorful use of building materials. (Photo: L. M. Roth.)*

6.8. Peter Bonnett Wight, National Academy of Design, New York, New York, 1863–65. One of the first examples of fully developed High Victorian Gothic in the United States. (Courtesy of the Museum of the City of New York.)

6.9. Russell Sturgis, Farnum Hall, Yale College (University), New Haven, Connecticut, 1869–70. The straightforward moral clarity of high Victorian design, as preached by Ruskin, was considered especially appropriate for educational buildings. (New-York Sketch Book, vol. 3, September 1876.)

with dark brownstone trim, gray and red slate bands in the roof, and a cupola covered with a copper roof now a bright verdigris green.

Wight and Sturgis, in particular, championed the cause of Ruskin's High Victorian Gothic in their National Academy of Design, in New York, designed by Peter Bonnett Wight (1838–1925). Wight won the competition for the Academy in 1861, but the building was erected in 1863–65 (now demolished) with Sturgis's assistance. [6.8] This was a small but almost literal inter-

pretation of Ruskin's theory, for it was a near copy of portions of the Palace of the Doges, in Venice. The pink and white polychromy was particularly vivid. Wight followed this with the simple but colorful Mercantile Library in Brooklyn, built in 1867, also a good example of Ruskinian Gothic with its brightly painted interior structural columns. The various buildings that Wight did alone or in collaboration with his partner, Russell Sturgis (1836–1909), have almost all disappeared except for his Farnum and Durfee Halls at Yale University, built

in 1869–70, and 1871, [6.9], and the Battell Chapel at Yale, built in 1874–76, all of which show a severe, simplified, and functionally composed Gothic. In their later years both men individually curtailed active practice, turning toward criticism and writing, and although both exerted great influence on the later development of modern architecture they always remained in the background.

One of the most resplendent High Victorian Gothic buildings in America is Memorial Hall, at Harvard University, in Cambridge, Massachusetts, by William Robert Ware and Henry Van Brunt, built in 1870–78 as a memorial to Harvard graduates who had died in the Civil War. [6.10] Its external appearance seems to suggest a church, but actually the exterior clearly reflects special interior functions. To the west is a large

rectangular hall for dining, assemblies, and other large functions, covered by an immense roof carried on exposed hammer-beam trusses; in the center is a large hall for circulation—the memorial hall—capped by a tall tower, recently restored; and to the east is a large semicircular auditorium that has the external appearance of an apse. Inside and out the various materials are openly expressed: the dark wood members of the large roof trusses, dark-stained wood paneling and interior trim, deep red brick with horizontal courses of black brick at particular levels, bands of light sandstone, alternated voussoirs of dark and light stone in the pointed arches, and bands of red, green, gray, and black slate that break the huge flat roof surfaces into horizontal stripes. Rising high above the square base is a tall truncated pyramid, bristling with crockets and

6.10. *Ware & Van Brunt, Memorial Hall, Harvard University, Cambridge, Massachusetts, 1870–78. The red and black brick, cream-colored stone, and colored bands of* slate make this one of the best examples of expressed building materials, as advocated by John Ruskin. (Architectural Sketch Book, Boston, 1874.)

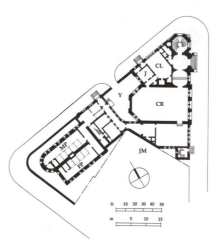

6.12. Jefferson Market Courthouse, plan. The plan shows how external forms were expressive of internal functional spaces. (L. M. Roth, after American Architect and Building News.*)*

finials, with gables on each side containing large circular clock faces, the flattened top terminated in an elaborate metal filigree cresting, with tall metal masts at each corner. As this, and the various buildings at Yale by Wight and Sturgis indicate, High Victorian Gothic was eminently adaptable to collegiate structures, especially since it carried on the earlier collegiate Gothic tradition of the 1840s.

Another good example of this churchlike appearance is the Third Judicial Courthouse, Prison, and Firetower (popularly called the Jefferson Market Courthouse) in lower Manhattan, New York, built in 1874–78, by Calvert Vaux (1824–1895) and Frederick Clarke Withers (1828–1901). [7] [6.11, 6.12] Although the prison block has been demolished, the restored courthouse section shows how High Victorian Gothic could be used in a difficult triangular site to reveal and express the presence of the various enclosed rooms and functions; the corner tower was incorporated as a fire watchtower for this neighborhood. This is a good example of Ruskin's lamp of Life, expressing externally the internal functions.

Like Second Empire Baroque, High Victorian Gothic was adaptable to and expressive of a wide variety of uses. A good example of High Victorian Gothic is the Syracuse Savings Bank, in New York, built in 1876, by Joseph Lyman Silsbee (1845–1913), who a few years later would resettle in Chicago. [6.13] The bank is colorful but not strident, tall and vigorous without being splintered into overassertive details, bold and sharp. A somewhat atypical form for High Victorian Gothic—a domed rotunda using pointed arches—was employed by Edward T. Potter in the highly polychromatic Nott Memorial Library finally added to complete Ramée's focused campus plan at Union College, in Schenectady, New York, in 1872–78. [8]

FRANK FURNESS

Of all the architects of this post–Civil War period, the most audacious in his exploitation of color and dramatic building masses—in many ways the embodi-

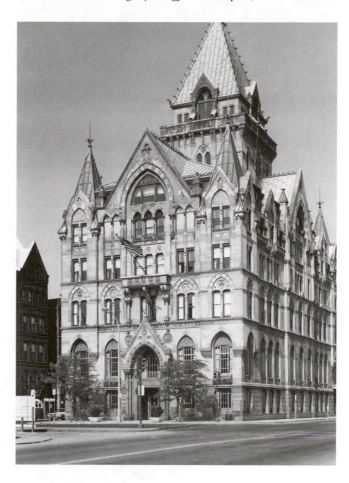

6.13. Joseph Lyman Silsbee, Syracuse Savings Bank, Syracuse, New York, 1876. High Victorian Gothic was also employed for commercial structures. (Photo: © Wayne Andrews/Esto.)

ment of Ruskinian design principles and of High Victorian Gothic design practice—was Frank Furness, of Philadelphia. At the same time, Furness was very much an individual whose work is difficult to place into any stylistic category. Furness's work is the product of a vigorous imagination combined with a profound understanding of the physical and psychological functions of architecture. In part Furness's dramatic expression of structural action came from his teacher, Richard Morris Hunt, with whom Furness studied from 1859 to 1861.

Frank Furness (1839–1912) was born in Philadelphia, the youngest child of a Unitarian minister, the Reverend William Henry Furness, an extremely well read man who wrote and lectured widely for such causes as abolition, as well as the advancement of the arts. Indeed, in 1870 William Henry Furness was asked to give the closing address at the fourth annual meeting of the American Institute of Architects in New York.[9] Frank Furness studied drafting in his school years in the office of John Fraser and through his brother, William Henry Furness Jr., a

painter, came to know Hunt. Furness entered Hunt's atelier in 1859 and, no doubt with Hunt's urging, planned to go to Paris to complete his architectural education at the École des Beaux-Arts. With the outbreak of the Civil War in 1861, however, Furness felt obliged to join the Union army; in any case Hunt closed his atelier and returned to Europe for the duration of the war. After the conclusion of the war, Furness returned to Philadelphia, to marry and to establish his own architectural practice.

Furness's first major mature work, the Academy of Fine Arts in Philadelphia, built in 1871–76, not only demonstrates what he had learned from Hunt but also incorporates the elements that made Furness's own work distinctive. [6.14] There is in the facade something of the symmetry and formal order of the pavilions of Second Empire Baroque, but the openings employ pointed arches. Particularly curious is Furness's tendency to insert support columns in the middle of doorways, as here, forcing the user to move to left or right. There is a rich, even raw polychromy of red brick, brownstone, light limestone, and black

brick. Some of the ornament, such as the tympanum panels in the arches, has foliate motifs of a highly stylized angular character, while other elements are sharp and geometrical, like machine parts. The polished columns, especially, look more like steam engine pistons than traditional supports. Inside, the building is carefully arranged on its difficult long narrow site to incorporate long bands of north-facing skylights to illuminate the drawing studios below; large roof skylights illuminate the exhibition galleries in the upper floors. Where broad passages were required between the galleries, Furness openly exposed built-up iron girders supporting boldly geometric cast-iron columns, all brilliantly painted in deep reds and blues, with the yellow-painted bolts and flower petal–like washers to fasten the iron sections that make up the girders. [6.15]

Furness was especially adept at handling buildings whose functions resulted in irregular, asymmetrical exteriors. The Thomas Hockley house, on Twenty-

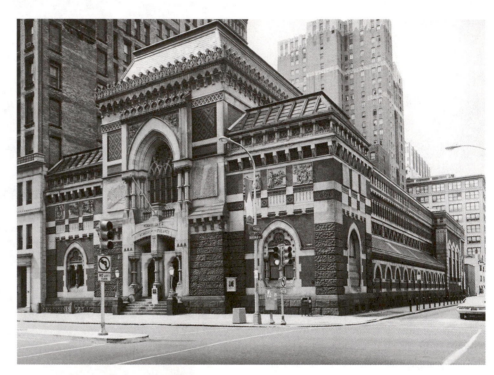

6.14. Frank Furness, Pennsylvania Academy of Fine Arts, Philadelphia, Pennsylvania, 1871–76. Furness's highly personal architecture combined aspects of Second Empire formality with the dramatic color contrasts of high Victorian Gothic. (Photo: Harris/Davis, courtesy of the Pennsylvania Academy of Fine Arts.)

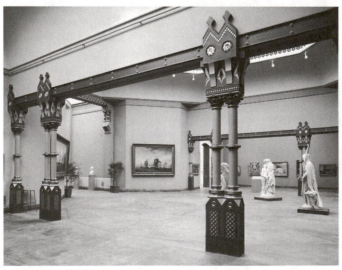

6.15. Pennsylvania Academy of Fine Arts, interior of the "Rotunda." This shows the use of openly exposed built-up iron girders as lintels in the large openings, supported on cast-iron columns. (Courtesy of Hyman Myers, Vitetta Group.)

6.16. *Frank Furness, National Bank of the Republic, Philadelphia, Pennsylvania, 1883–84. This asymmetrical composition and structural accentuation is among Furness's most picturesque work. (Historical Society of Pennsylvania.)*

6.17. *Frank Furness, Provident Life and Trust Company, Philadelphia, Pennsylvania, 1876–79. Now destroyed, this facade showed Furness's powerful massing of building forms to suggest great weight. (Penrose Collection, Historical Society of Pennsylvania.)*

first Street, Philadelphia, built in 1875–76, is a good example, with its recessed entrance at one corner played off against a projecting second-story bay window on the opposite side. The National Bank of the Republic, in Philadelphia, built in 1883–84 (now demolished), is also a good small example, its narrow facade a collision of ramped and semicircular arches, various windows, and opposing roof lines, all jostling around a dominating off-center turret. [6.16]

Some of Furness's buildings were more balanced and symmetrical in composition, such as the boldly scaled Guarantee Trust and Safe Deposit Company, in Philadelphia, built in 1873–75 (now demolished), which somewhat resembled the academy in character except that it had two projecting pavilions flanking the entrance. Another compact bank that typified Furness's work was the Provident Life and Trust Company, in Philadelphia, built in 1876–79 (now demolished). [6.17] In this design too Furness used dramatically exaggerated angularity, with large, heav-

ily proportioned building parts that press and slide into each other as if being pulled down by force of gravity. One of Furness's last major buildings survives, serving now as the library for the School of Architecture at the University of Pennsylvania; this is the large building designed to house the entire university library, built in 1888–91. The building's dramatic massing clearly reflects, in its dissimilar forms, the original functional areas within—entry and circulation tower, reading room, book storage—all of this heightened by acid-red brick and matching terra-cotta trim, boldly overscaled. [6.18] The plans of all these buildings were carefully if unconventionally composed, and the interiors were strongly geometric as well as heavily scaled, enhanced by deep rich colors, but it was the exteriors especially, with their compressed, interpenetrating elements, that spoke, especially to some later generations of architects like Robert Venturi, of tough creative power. Before that expression of creative energy could be fully rediscov-

6.18. Frank Furness, Library, University of Pennsylvania, Philadelphia, Pennsylvania, 1888–91. This asymmetrical composition is dictated by the original internal functions. (Courtesy of the University of Pennsylvania.)

ered and appreciated in the mid-1960s, however, one after another of Furness's buildings were wantonly, sometimes seemingly deliberately destroyed.[10] As historian David Handlin has suggested, perhaps the way that Furness made the discordant flux of American urban life the very essence of his architecture was simply too difficult for many people to bear.[11]

RICHARD MORRIS HUNT

While appreciation of Furness's great influence would not come until more than eighty years after his work was built, another architect came to prominence during this period whose broadly felt influence was immediate. Richard Morris Hunt (1827–1895) was educated primarily in Europe and spent nearly nine years studying architecture at the École des Beaux-Arts, from 1846 to 1855, the first American to do so and the one student of that era who stayed there longest. He entered the office of H.-M. Lefuel toward the end of his studies in Paris, and such was the level of his absorption of French taste and design principles that he assisted in designing the Pavilion de la Bibliothèque on the north side of the New Louvre. Although Hunt could well have remained in France, he believed it important to return to the United States and elevate the state of architecture in his native land. His Parisian experience, however, had not prepared him for the hard-nosed speculative character of American clients,

and Hunt had to take Dr. Eleazer Parmly, one of his early clients, to court to get payment for professional services that included supervision of construction.[12]

Apart from his early buildings in New York—including the first Parisian-style apartment houses, such as the Stuyvesant (1869–70), which were instrumental in persuading middle- and upper-class New Yorkers to live in such facilities—Hunt's greatest influence came through the atelier that he conducted along the lines of the ateliers associated with the École des Beaux-Arts.[13] It was through Hunt, and the students of his atelier, that the impact of mid-nineteenth-century French rationalism in design was first felt in American architecture. Henry Van Brunt wrote later in an obituary article on Hunt that the structured training in the atelier came at a time "when sentiment [among architects] was keen aroused, but discipline was silent."[14] Hunt's atelier in New York was the first of its kind in the United States to offer systematic instruction in architecture. Gathered in Hunt's atelier were Furness, Van Brunt, William R. Ware, and George B. Post, among others, nearly all of whom were to play significant roles in their profession during the next third of a century.

Among Hunt's earliest works that show a decidedly rational approach to design was the Tenth Street Studio (where the atelier met), in New York, built in 1857–58. [6.19] This plain brick building had stout piers connected by broad segmental brick arches over large expanses of glass to light the studios within.

Ornament was simple, consisting of large-scale panels and banded moldings. One of Hunt's last buildings in this mode was the Lenox Library, in New York, built in 1870–75. [6.20] The structural expression of bearing members employed by Hunt, in the form of stout compressed columns and flattened segmental arches, and the emphasis of both by means of bold inventive geometric ornament, had been developed in France in about 1840 by such architects as Henri Labrouste and E.-E. Viollet-le-Duc. This approach came to be called "néo-grec" because it attempted to express the direct logic of the trabeated, bearing-wall construction of the Greeks. The Lenox Library (one of the forerunners of the New York Public Library) filled the end of an entire block on Fifth Avenue from Seventieth to Seventy-first Streets, and had a recessed center court that looked out across the avenue to Central Park. Also opened up by broad arched windows to light the reading rooms within, the library's monochrome limestone walls were articulated like the those of the studio, with bold geometric patterns that stressed the structural nature of the arches and wall. Both of these buildings are now gone, but Hunt's later massive stone and concrete base of the Statue of Liberty, in New York, built in 1881–86, is a reminder of the massive and individual character of Hunt's early work.

6.19. *Richard Morris Hunt, Tenth Street Studio, New York, New York, 1857–58. One of the few examples in the United States of the structurally logical style called in France "néo-grec." (MCNY-Bernice Abbott photo.)*

6.20. *Richard Morris Hunt, Lenox Library, New York, New York, 1870–75. This example of Hunt's version of néo-grec design used the large arched windows to bring in abundant light into the upper reading rooms. (*New York Sketch Book of Architecture, *vol. 3, April 1876.)*

6.21. Oakgrove, workers' housing, Willimantic Linen Company, Willimantic, Connecticut, 1865–84. Built by the company for rent to the workers, such industrial housing was provided to allay worker unrest. (Eighth Special Report, Commissioner of Labor, Washington, D.C., 1895.)

By the time the base of the Statue of Liberty was finished, Hunt had taken up an entirely new style, and had become the architect of choice for the wealthiest clients in New York, the founders and operators of some the largest businesses in the nation. In 1879 he was engaged by Mr. and Mrs. William Kissam Vanderbilt to design for them a showpiece house on Fifth Avenue as a means for them to gain entry to the most prestigious (and most exclusive) levels of New York society. In the years immediately following, Hunt was called upon to design expansive urban and country residences for many other industrialists (including members of several branches of the Vanderbilt family), such as Biltmore, in Asheville, North Carolina, built in 1890–95 for George Washington Vanderbilt. Beginning with the Vanderbilt house on Fifth Avenue, however, these later buildings were done in reinterpreted versions of clearly recognizable historical period styles, ranging from early French Renaissance to the sculpturally massive classicism favored at the École des Beaux-Arts in the mid-nineteenth century. Because of this shift toward historical authenticity, this second phase of Hunt's career is discussed in the following chapter.

INDUSTRY BUILDINGS AND HOUSING

The age of England's Queen Victoria, and the writings of Ruskin, is characterized by a pervasive moralism. At the same time, however, it was the age of rapacious "Robber Barons," whose interests focused on maximizing profits and enlarging their economic empires,

whatever the effects on others, including their employees. Nonetheless, a few industrialists took a different view, hoping that providing amenities for their workers would forestall unionization, prevent strikes, and ultimately increase corporate profits. In New England, especially, a number of new industrial villages were started, and existing industrial communities enlarged. Hopedale, Massachusetts, having collapsed as a Socialist commune, was purchased by the Draper Company, and by 1856 a loom-manufacturing business had been established there. During the 1870s a number of row houses were put up by the company for skilled workers, and a decade later duplexes were being built. In a number of company towns, duplexes or single-family houses (instead of the previously favored row houses) were built between 1865 and 1870. One such housing complex was built at Cumberland Mills, Maine, by the S. D. Warren Company. Another was the Oakgrove housing group at Willimantic, Connecticut, begun by the Willimantic Linen Company about 1865 [6.21], and another was the group of houses erected by the Ludlow Manufacturing Company in Ludlow, Massachusetts. This shift away from the industrial tenement blocks and row houses built earlier in the century (as in Lowell, Massachusetts, and a number of other New England factory towns) reflects the efforts of some industrialists to satisfy the desires of employees who wanted individual homes. Although the new housing was built to provide some income for the company, another purpose was to reduce the transience in the skilled workforce (with a hoped-for increase in production). Hence attention was given to good design,

sound construction, and to the provision of extensive utilities. In general, the workers' housing reflected current vernacular building practices rather than avant-garde experiments, and as a rule industrial housing was not designed by noted architects before about 1885. Rents were kept relatively low and profits to the company were small; workers customarily paid less than 15 percent of their wages for rent in the very best of these housing developments, and the companies typically realized 2 to 3 percent on their investments.[15]

Pullman, Illinois

Certainly the best-known company-built town of this period is Pullman, twelve miles south of Chicago on Lake Calumet. There, in 1879–80, at a strategic junction of the national networks of rail and water transport, George M. Pullman built new shops for the assembly of his famous palatial railroad sleeping cars. In addition to this, however, Pullman built an entire city for the workers in his plants, providing housing, parks, recreational space, shopping and worship facilities, and cultural amenities such as a library and

music hall. Believing in the civilizing effect of beauty, Pullman engaged landscape architect Nathan F. Barrett (1845–1919) and architect Solon S. Beman (1853–1914) to design the entire complex. [6.22] Work started on the town early in 1880, and by 1884 it was nearly complete; its population then was 8,500 and by 1893 it had grown to 12,600. The factories were on the north side of town, above 111th Street, the dividing line between shops and housing. Immediately to the south of 111th Street was a large hotel for visitors. Next to this was a small park, which was fronted by the Arcade, a multiuse building (actually an early shopping mall) containing various shops, offices, the library, and the music hall. South of this were the town stable and the Methodist Church. Farther to the east, roughly in the center of the residential area as initially built, was the Market House, where meat and produce were sold, much of it raised on farms south of the town, which received treated sewage from the town as fertilizer. The row houses offered a variety of plans and facade designs, and the units were separated at intervals so as to mitigate the spread of contagious diseases and fire. For perma-

6.22. Solon S. Beman and Nathan F. Barrett, plan of Pullman, Illinois (now part of Chicago), 1879–93. With parks, recreational facilities, and well-constructed brick town houses, Pullman was one of the best-designed company towns of the period, even if rents were high and workers had no say in town governance. (Harper's Magazine, February 1885.)

6.23. William Field and Sons, Riverside Apartments, for Alfred T. White and the Improved Dwellings Company, Brooklyn, New York, 1890. This was one of the largest and best-designed workers' housing blocks of the period. (Eighth Special Report, Commissioner of Labor, Washington, D.C., 1895.)

6.24. Plan of apartment complexes built by the Improved Dwellings Company, Brooklyn, New York, c. 1870 to 1900. (L. M. Roth, after G. H. Gray, Housing and Citizenship, New York, 1946.)

nence and reduced maintenance, Pullman stipulated that all buildings be made of brick.

Since the town was built as a profitable commercial venture, the Pullman company owned everything and rented space to shopkeepers in the Arcade and to workers in the row houses. Pullman even attempted to rent the church to the congregation, but, as the rent was too high, the building often stood empty. Furthermore, to prevent indolence and disruption Pullman allowed no taverns in his town.

Much of what later troubled the town grew out of this well-intentioned stern paternalism, for workers had no say whatever in running the town. During the depression of the mid-1880s rents were reduced in several eastern textile mill towns to match cuts in wages, but in 1893, when Pullman was forced to reduce wages he retained rents at their already exceptionally high level (roughly 30 percent). Workers' protestations went unheeded; the workers went on strike; the strike was joined by railroad workers, bringing movement of the U.S. mail to a halt. This, in turn, led to the intervention of federal troops at the order of President Grover Cleveland, and a riot ensued in Pullman, resulting in numerous deaths. The Pullman riot, and the unyielding and oppressive paternalism that caused it, produced a social stigma that soon was attached to every company town. Nonetheless, other company towns, beneficiaries of

more relaxed management, continued to function, and their factories continued to operate comparatively smoothly, well into the twentieth century.

The bloodshed and resulting negative public reaction caused by the Pullman riot unfortunately clouded perception of the positive achievements of George Pullman and his designers, for as a planned town Pullman was well designed; it could have been a self-generating community, containing industrial, commercial, residential, and recreational facilities, and all the other basic attendant services. What it lacked was self-government.[16]

MODEL URBAN TENEMENTS

While this concern for good housing was becoming more evident in a few industrial locations, a similar concern for economically productive housing was arising in the cities, most notably in New York, where overcrowding was particularly acute. Though sincere concern over poor living conditions in the increasingly crowded New York slums had first been voiced in 1834, no steps were taken to improve increasingly unhealthy conditions. Even caustic essays such as Walt Whitman's "Wicked Architecture," published in July 1856, with its sharp indictment of tenement slums, spurred little action.[17] In 1876, however, Alfred T. White formed the Improved Dwellings Company to undertake the construction and management of model tenements that would provide open space and better sanitary conditions. The first unit built, the Home Building on Hicks Street, Brooklyn, was erected in 1877 from designs by William Field and Sons. In 1884 this was followed by the Tower Apartments on adjacent Baltic Street. The last and largest were the Riverside Apartments, built in 1890. [6.23, 6.24] Also designed by William Field and Sons, the Riverside Apartments covered a full block along Hicks Street between Baltic and Warren Streets. Within the **U**-shaped block of apartments was an enclosed park with play lots for children and a garden for older residents. Though there had been earlier similar ventures by philanthropists and municipal authorities in England and on the Continent, this was one of the earliest efforts toward good "public housing" in the United States. White's experiment, though inspired by social concern, was nevertheless a capitalist venture intended to return a modest profit to its investors. Always well maintained and well occupied, the Home, Tower, and Riverside Apartments repaid from 5 to 7

6.25. James E. Ware, "Dumbbell Apartment," 1878. The dumbbell apartment plan was designed to provide a degree of light and air to urban tenement housing. (R. DeForest and L. Veiller, The Tenement House Problem, New York, 1903.)

percent from the start, indicating that such housing, when well designed and maintained, was not necessarily a drain on the communal purse.

Spurred by the example of Alfred White's Improved Dwellings Company, investors formed other companies, and the city and state legislatures began to give serious attention to the slum problem. In December 1878 the *Sanitary Engineer* announced a competition for the best tenement house design, and out of the 206 entries submitted from across the United States and Europe, the prize was awarded to James E. Ware for his "dumbbell apartment," so called because with its pinched center it resembled a weightlifter's dumbbell. [6.25] This scheme provided light and air, which even in limited quantities were luxuries virtually unknown in older tenements. As a result of this public attention to the problem, a Tenement House Law was passed in 1879 requiring new tenements to cover only 65 per-

6.26. *Frederick Law Olmsted, with Calvert Vaux, Central Park, New York, New York, 1857–c. 1880. The plan of Central Park featured several crosstown thoroughfares that passed through the park under viaducts while allowing walking and bridle paths to pass overhead. (From Fabos, Milde, and Weinmayer,* Frederick Law Olmsted, Sr., *Amherst, Mass., 1968.)*

cent of their lots and to have plans like Ware's. Even with additional legislation in 1887 and 1895, however, most new tenement apartment building covered 75 to 90 percent of their lots.[18] Such changes were simply the first of many efforts, both political and architectural, to improve housing conditions of blue-collar workers and the poor (some of these are discussed further in the next chapter). One might imagine that the whole of New York was transformed by the chain of events set off by the Home, Tower, and Riverside tenements, when in fact the few model apartments actually built represent only a fraction of new construction; moreover, all the old windowless, unheated, and overcrowded buildings were still occupied. Nevertheless, despite limited overall effects, the work of White and the humanitarian concern it manifested served as inspiration to later generations of social humanitarians.

FREDERICK LAW OLMSTED AND THE PUBLIC PARKS MOVEMENT

Social concern lay at the very heart of the work of Frederick Law Olmsted (1822–1903). In the 1850s, at a time when the country was largely rural, Olmsted already foresaw that the relentless development of urban America would require the preservation of areas of natural scenery as a foil to urban density. Yet Olmsted was not a preservationist in the narrowest sense of the word; rather, he saw husbandry of the natural environment as a corollary and antidote to industrial growth. Olmsted was born in Hartford, Connecticut, and because of illness as a child had a rather intermittent formal education. For a time he studied engineering and surveying, and he attended some lectures at Yale University. His father helped him establish a model farm on Staten Island, where he experimented with horticultural techniques and plant materials, learning much that later helped make his parks practical realities. He toured England to study agricultural methods and inspected Sir Joseph Paxton's Birkenhead Park, in Liverpool, where he saw open landscaped spaces as part of a planned urban fabric.

Meanwhile, New York City was growing rapidly, and among its more concerned observers, such as the poet William Cullen Bryant, there arose the fear that development would eventually cover the entire island of Manhattan, that piers would line its shores from tip to tip, leaving no open space for its citizens and pro-

viding no ready means for workers and their families to reach the countryside. Access to nature was vital to Bryant. As he had already written in his "Inscription for the Entrance to a Wood" in 1821, the salve for the city's "sorrows, crimes, and cares" could be found only in "the haunts of nature" where the sweet breeze "shall waft a balm to thy sick heart."[19] A. J. Downing also saw the pressing need for creation of a public park in New York City, and published a number of editorials in The Horticulturist refuting the prevailing American notion that public places, where people of all sorts and classes mixed, were dangerous; he too urged that land on Manhattan be acquired before it was all built over.[20] There was no time to lose in saving what little was left of Manhattan's natural scenery.

With support from the state legislature, a vast tract was purchased running through the center of the island, and in 1857 a competition was held for designs for developing the land. The plan submitted under the code name "Greensward" was judged the winner; it was the entry of Olmsted and his partner Calvert Vaux, an English architect and landscape designer who had originally come to the United States to be Downing's partner. [6.26] With Downing's untimely death, Vaux had begun an association with Olmsted. Olmsted recognized that eventually the city would surround the park and that circulation between the east side and west side would be vital. Consequently, at intervals he placed major crosstown streets running through the park, but depressed them below park level so that the heavy traffic would not endanger movement above. [6.27] Separate paths for carriage drives and pedestrian walkways wound through the park, passing over the crosstown streets on viaducts so that the various kinds of traffic were kept separate.

The true beauty of the park lay in the ordered irregularity of its terrain and its planting.[21] Where the land was low, Olmsted depressed it still more, installing drainage tiles and creating ponds and low meadows. Natural outcroppings of schist were emphasized; clumps of trees were planted to contrast with broad meadows. Bisecting the park strip were the existing Croton aqueduct reservoirs holding the city's water supply. Using this as a dividing element, Olmsted laid out the southern half as a more developed area, adapted to groups of people and sports activities, while the northern half was developed as a nature preserve.

The public success of Central Park was immediate, and soon led to the design of Prospect Park, in 1865–88, in Brooklyn, in which Olmsted and Vaux were able to improve on their work in Central Park, adding a proposal for a broad tree-lined drive or parkway extending into the town of Brooklyn. After the Civil War Olmsted was engaged to design more than thirty such urban parks outside New York and several more within that city, and these alone would have assured his reputation, but he was equally busy designing the grounds of numerous public buildings, planning campuses, small communities, and estates,

6.27. *Crosstown thoroughfare in Central Park, 1860. This early illustration shows the street running east and west in a tunnel, with the park and its paths continuing uninterrupted above. (From Third Annual Report of the Board of Commissioners of the Central Park, New York, 1860.)*

6.28. Olmsted & Vaux, plan of Riverside, Illinois, 1868. Riverside exploited the gently rolling landscape, with park land along the Des Plains River, and landscaped boulevards stretching out from the town center (the blank area in the drawing is a parcel of land not yet owned by the developers when Olmsted and Vaux prepared the plan; it was later acquired and integrated into the plan). (From C. E. Beveridge and P. Rocheleau, Frederick Law Olmsted: Designing the American Landscape, New York, 1995.)

and campaigning for conservation areas and national parks—beginning with Yosemite Valley in 1864.[22] He began in 1869 to urge that the area around Niagara Falls be preserved, at a time when it was just beginning to become despoiled as an industrial slum and tourist trap. Finally in 1880, through Olmsted's unrelenting efforts, the State of New York and the Dominion of Canada purchased large tracts of land above the falls and the islands in the rapids, restoring indigenous plant materials to portions of the preserve that had been stripped for paper mills and other factories. Olmsted's most extensive planning undertaking also turned out to be one of his last. In and around metropolitan Boston Olmsted designed a ring of interconnected parks and landscaped boulevards, the "Emerald Necklace"; completed in 1895, this was one of the first instances of regional planning.

Olmsted's urban parks and institutional landscaping initiated new trends in American landscape design. He also made important contributions to the field of urban planning, particularly with his plan for Riverside, Illinois, an idyllic suburban village about eleven miles west of Chicago, planned in 1868 for a group of eastern developers. [6.28] Like Llewellyn

Haskell and other eastern industrialists, the investors in Riverside were concerned by the growing density of cities, the lack of open space for recreation, especially places for children to play. A brochure promoting Riverside, published in 1871, described the advantages of living in the new town, explaining how it combined the best of being in the country with the conveniences of city living, such as paved streets, good drainage, and water and gas service provided by the town.[23] The site was a relatively flat area of about seventeen hundred acres cut in two by the Des Plaines River, which meandered through it. The site was connected to Chicago, eleven miles away, by the Burlington Railroad, a link that was essential to the viability of such a suburb. Here Olmsted and Vaux planned a romantic landscaped suburban village. Olmsted sketched out a curvilinear web of streets, generally following the slight topographical features, subtly depressing the hard-paved streets so they did not intrude into the landscaped views; he also included curbs and drains to carry off rainwater. Centermost in his thoughts was the preservation of the shores of the river. A low dam was created to raise the level slightly so as to allow greater recreational

use, but no lots were laid out at water's edge; instead, the river frontage was turned into a communal park strip. This linear riverside park, plus the double-lane boulevards and small parks scattered throughout the town, account for about a quarter of the village's land area. Except for the small blank area shown in the plan, Riverside was laid out as Olmsted planned it, and development continued according to his proposals. Trees were planted along the parkways, and homeowners were obliged to keep at least two living trees on the property between their houses and the sidewalks. Houses, spaced on wide lots, were set far back along uniform lines.[24] Moreover, Olmsted hoped to build a landscaped carriage drive, a precursor to the landscaped automobile parkways built outward from eastern cities fifty years later, connecting Riverside with Chicago, but this was never built. Time has been relatively gentle to Riverside; its plan survives virtually intact. Periodic replacement of the houses has changed the appearance little, and some of the original buildings by Vaux remain, sheltered under the dense umbrella of trees that make the development an oasis in the unrelenting grid of urban sprawl engulfing it.

URBAN GROWTH

Compare the plan of Riverside, with its varied paths, open spaces, and surprises, with a view of Chicago in 1892. [6.29] Here is the dense, endless patchwork, the product of unchecked speculation in land, that Olmsted's planning covenants and visual amenities sought to counteract. Shown in this Currier and Ives print is a city that in 1871, twenty-one years earlier, had suffered a fire that destroyed nearly the entire area pictured in the foreground. Not a trace of this destruction remains in this view. While this may be due in some small measure to the artist's license, it accurately reflects the driving business enterprise that, in the pursuit of the ultimate dollar from every square foot, left little open space for recreational enjoyment.

Wasting a superb opportunity to develop a lakeshore park, in 1850 the city sold all of the land south of the mouth of the Chicago River to the Illinois Central Railroad for a token price. The transaction was viewed at the time as a shrewd business maneuver, for it ensured that Chicago would become a national railroad center, and it meant that the city would be spared the municipal expense of building a

6.29. *Aerial view of Chicago, c. 1892. This lithograph by Currier & Ives, 1892, shows the expansion of the nearly* unmodulated street grid to the horizon. (Courtesy of the New-York Historical Society.)

6.30. George E. Woodward, House
Design No. 6, plate 22, 1868.
Woodward's plan books were among
the first to appear following the Civil
War. (Woodward, National Architect,
New York, 1868.)

breakwater (the railroad would now be forced to do it), but physically it impoverished the southern half of the city, leaving it with no access to the water. Chicago was not unique in this, for thousands of other cities did likewise, selling or giving away their natural legacies to encourage the railroads, seen as economic lifelines, to lay track through their communities. The federal, state, and city governments all groveled obsequiously before railroad interests, just as they had done forty and fifty years earlier before the canal builders (and as they would do again in another two generations to placate air transport and automobile interests, and highway planning authorities). While these steps did nourish immediate industrial growth, the ecological and social costs extending into the next two centuries could not have been anticipated. Due to the continuing Jeffersonian anti-urban sentiment, few people other than Olmstead thought about making cities pleasant and wholesome places to live.

Meanwhile, the cities throughout the country continued to grow—almost exponentially in the Midwest. As Olmsted correctly foresaw, greater New York City grew almost two and a half times from 1860 to 1890, from 1.39 million to 3.23 million. Even Boston, hemmed in by water, filled in its tidal basins and expanded from 177,800 souls to 448,500. Philadelphia doubled in size from 565,500 residents to 1.05 million; Baltimore and New Orleans also doubled their populations. River towns like Louisville grew by little more than two times,

but railroad industrial centers like Pittsburgh and the northern Great Lakes cities exploded in size, spurred in large part by the Civil War: Pittsburgh went from 78,000 to 344,000; Buffalo from 81,000 to 256,000; Cleveland from 43,000 to 261,000; and Detroit from 46,000 to 207,000. Most dramatic by far was Chicago, which had only 30,000 people in 1850. In ten years it had 109,000, and within another thirty years had grown ten times, to become one of the largest cities in the world with a population of 1.1 million. Along the transcontinental rail lines and their branches extending westward into the high plains, new cities appeared from virtually nothing, becoming major regional rail centers by 1890: Minneapolis with 298,000 people, Kansas City with 133,000, Omaha with 140,000, and Denver with 107,000. Railroads everywhere brought economic prosperity to hub cities, and in the South the rail hub of Atlanta grew from 9,600 before the war to 66,000 in 1890. Dallas went from a handful of residents to 61,000. In the far West, San Francisco had exploded in size during the gold rush of 1848–49, going from a handful of permanent residents to 35,000 in 1850, growing to 57,000 in another ten years, and reaching a population of 299,000 by 1890. In the Pacific Northwest, Portland, Oregon, which had 2,900 people in 1860, expanded to 46,000 by 1890; the village of Seattle had only 3,500 residents in 1880 but jumped to nearly 43,000 in just ten years. Los Angeles, the terminus of the Santa Fe railroad, went

6.31. Palliser, "Country House," plate 30. The books of the Palliser brothers proved to be even more popular than those by Woodward. (From Palliser's American Cottage Homes, *Bridgeport, Conn., 1877.*)

from a sleepy village of 1,600 to a substantial 50,000 people by 1890.

All in all, between 1860 and 1890, the entire nation more than doubled its total population, going from 31.4 million to almost 63 million, much of this through immigration of northern and central Europeans, with the central Europeans tending toward the eastern industrial cities. Many of the northern Europeans and Germans were enticed to the open prairie lands of the West, adjacent to the railroads, where, to their utter delight, they could obtain 160 aces of free land through the provision of the Homestead Act of 1862. Of course few of the new European arrivals, or those who enticed them, were troubled by thoughts that indigenous peoples already lived on these western lands. Their ancestral lands taken through stealth and deception, their numbers decimated by disease, their traditional food base destroyed, disenfranchised and disheartened, the original Americans were confined to reservations and forgotten by the newly arrived Americans.

THE EMERGENCE OF AMERICAN ARCHITECTURAL PUBLISHING

Domestic building was vigorous after the Civil War, particularly in and around rapidly expanding cities like Chicago and in the fast-growing suburbs around every major city. The seemingly endless appetite for

residential designs was fed by a flood of pattern and plan books for both architect and builder. Gervase Wheeler's *Homes for the People in Suburb and Country* (New York) had first appeared in 1855, and went through six editions by 1868, but this was surpassed by his *Rural Homes* (New York), which came out in 1851 and went through nine editions by 1868.[25] In 1857 Calvert Vaux published *Villas and Cottages* (New York), and this was brought out in five more editions up to 1874. Henry Hudson Holly published *Holly's Country Seats* (New York) in 1863 and *Modern Dwellings in Town and Country* (New York) in 1878. George E. Woodward was especially busy, publishing nine separate titles, of which *Woodward's Country Homes* (New York, 1865) and *Woodward's National Architect* (New York, 1868) were the most popular, enjoying repeated new editions through the 1870s. [6.30] A. J. Bicknell also produced a small library of plan books, publishing at least ten titles from 1870 to 1886, such as *Bicknell's Village Builder* (Troy, N.Y., 1870). Also highly prolific were Palliser and Palliser, with twelve titles from 1876 through 1883, among them *Palliser's American Cottage Homes* (Bridgeport, Conn., 1877). [6.31] One of the lesser-known venues for house plans was a special supplement, the *Scientific American Architects and Builders Edition*, published from 1880 through 1905. This regularly featured large chromolithograph color plates.[26] For the most part, these books were put together by entrepreneurs rather than

by architects, and the compliers incorporated whatever house types were popular at the time. Woodward, Bicknell, and the Pallisers changed the house designs in each of their successive editions. Today a number of these books are still being published in facsimile editions. Indeed, it has become something of a hobby today for people to take these books in hand and find one of the thousands of built examples in towns across the continent.

Analytical and critical essays on architecture had been appearing in such literary magazines as the *North American Review* since the 1840s. *Harper's Magazine* (started in 1850) also carried articles on architecture, many of which were illustrated with wood engravings. Before this, as early as 1830, John Haviland had circulated a prospectus for a magazine devoted entirely to architecture, but the project was never realized. The first professional architectural journals tended to be short-lived.[27] First was *The Architects' and Mechanics' Journal* (New York), which appeared in 1859 but was squelched by the war in 1861. *Sloan's Architectural Review and Builder's Journal* (Philadelphia) lasted only three years (1868 to 1870). The beautifully illustrated *New-York Sketch Book of Architecture* also lasted only three years (1874 through 1876), as did the *Architectural Sketch Book* of Boston (1873 to 1876), but the *American Architect and Building News* (Boston), which started in 1876, prospered until 1938 when it finally ceased publication. By the 1890s *American Architect and Building News* had a circulation of 7,500 copies. Similar in layout, but focusing on the Midwest was *The Inland Architect and Builder* (Chicago), which appeared in 1883 and folded in 1908. *Architectural Record* (New York), which appeared in 1891, emerged as one of the strongest professional journals; it is still among the preeminent architectural journals today. *Brickbuilder* (Boston; *Architectural Forum* after 1917) first appeared in 1892, and continued until 1964. In San Francisco the first professional journal was the *Quarterly Architectural Review*, issued in 1879, and then renamed *California Architect and Building News*.

For the contractor-builder there were more practical journals such as the *American Builder and Journal of Art* (Chicago, 1868 through 1895 under varying titles); the *Architectural Review and American Builder's Journal* (Philadelphia, 1868 to 1870); *Building Budget* (Chicago, 1885 to 1890); and *Building: An Architectural Monthly, Treating on All Matters of Interest to the Building Trades* (New York, 1882 to

1932). As a consequence of all this publication both the professional architect and the contractor-builder had a wealth of information presented to them.

THE CENTENNIAL EXPOSITION, 1876

In the early 1870s the United States was swept up in the nineteenth-century passion for grand expositions initiated by the world's fair held in London in 1851. Although there had been an American exposition, with its own "Crystal Palace" in New York in 1853, the Civil War had put a temporary end to such festivities in the United States. With the impending centennial of American independence, however, public interest began to focus on hosting an even greater event in 1876. The city selected was Philadelphia, and the specific site was Fairmont Park. Several proposals for enormous and fanciful exposition pavilions were published by architects in some of the new journals during the mid-1870s. Although several large structures were eventually erected in Fairmont Park in 1875–76, little consideration was given to positioning them or the many other state and national pavilions in accordance with any sort of master plan devised to direct and coordinate public circulation. Many individual buildings, however, exemplified current stylistic fashions, while others hinted at architectural developments to come. For example, the New Jersey pavilion by Carl Pfeiffer, with its intricate basketwork of structural framing, and its picturesque massing of projecting porches, sharp gables, and sharply pointed tower, was the perfect example of the Stick Style then reaching its peak in the East. Also of importance was the Art Gallery (now called Memorial Hall), designed in a highly interpreted Renaissance manner by self-taught Philadelphia civil engineer and architect Hermann J. Schwarzmann (1846–1891), who had designed the grounds of Fairmont Park in 1871 and who laid out the exposition (as well as over thirty other buildings for the exposition).

A number of smaller pavilions at the Centennial Exposition were also to have long-range implications. The Japanese pavilion, assembled from parts shipped from Japan by Japanese carpenters using traditional tools and building techniques, attracted significant public attention. This interest in traditional Japanese architecture was to be further excited a decade later by the publication of Edward S. Morse's *Japanese Houses and the Surroundings* (Boston, 1886).[28] The three domestic structures that made up the English

6.32. Donald G Mitchell, Connecticut State Pavilion, Centennial Fair, Philadelphia, Pennsylvania, 1876. Although far from accurate in its form and details, this comfortable little building helped create a love of Colonial architecture. (From International Exhibition Philadelphia, *Connecticut Guild-Catalogue, Middletown, Conn., 1876.)*

exhibition complex were also much admired. Designed by English architect Thomas Harris, they were close approximations of sixteenth-century half-timbered Elizabethan houses.

This reference by Harris to recent English vernacular traditions was paralleled by recent interest among a few American architects who began to look with renewed appreciation at their own recent vernacular traditions. Indeed, the centennial encouraged many Americans to think of the momentous events of 1776 and, by extension, of buildings such as Independence Hall in which events in the early history of the nation had taken place. The Connecticut pavilion designed by Donald G. Mitchell, although not very historically correct in its details, was enormously popular and did much to link the idea of Colonial architecture with comfortable living. [6.32] Colonial buildings and those of the early years of the republic were suddenly being reevaluated as ancient and venerable models to be closely studied. By the end of the 1870s they were being recorded, preserved, and soon would serve as the inspiration for an American Colonial architecture revival.[29]

SUBURBAN AND COUNTRY RESIDENCES

After the disruption of the Civil War, construction of all sorts boomed, particularly residential construction in the growing suburban communities. Many of these houses were of the type shown in 6.30 or 6.31, one of many popularized by G. E. Woodward, the Pallisers, and their contemporaries in the 1870s and 1880s,

though this example is somewhat restrained in its ornamentation. What was most significant was the new emphasis on freestanding single-family homes, most often in the suburbs springing up around the industrial cities. A number of houses, designed by architects for specific clients with greater means, were more elaborate, and good examples once existed in such suburbs as Brookline outside Boston; Orange, New Jersey, outside of New York City; or Evanston, north of Chicago.

One of the most elaborate of all the houses of this period was the William M. Carson house in Eureka, California, built after designs by San Francisco architects Samuel and Joseph Cather Newsom in 1884–85. [6.33] The Newsoms drew up highly elaborate designs in general, and the Carson house, on its prominent position on a small rise overlooking Eureka, was clearly a demonstration of Carson's self-aggrandizement and a statement of his position as the major redwood lumberman of the region. But the Carson house may have been especially full of detail since the house was built by Carson to keep his employees busy during a business recession of the mid-1880s.

The houses of this period became ever more generous in scale not only because of a change in clients' aspirations and their financial means but also because of the many advances in heating that had been made since the early part of the century. The important step had been to take Franklin's iron stove, wrap it in a metal or masonry shell, and conduct the air heated inside this shell by means of ducts to the upper rooms of a house. In some cases, the simpler solution was to

6.33. *Samuel and Joseph Newsom, William M. Carson house, Eureka, California, 1884–85. This especially elaborate house was built for the owner of a major redwood* *lumber company, partly as self-aggrandizement and partly as a works project during a business recession. (Library of Congress, HABS CAL 12-EUR 6-2.)*

place large wood or metal grills in the ground and second floors and let the warmed air rise in a single column. This initial step seems to have been taken in Connecticut during the 1840s, when the heated air was moved by convection, but by 1860 large fans powered by steam or gas had been added to bulky heating systems to create forced air heating. By 1860 in many homes various gravity systems had begun to be used, and in *The American Woman's Home* (New York, 1869), Catherine Beecher and Harriet Beecher Stowe discussed central heating, showing a warm air furnace in the basement augmented by small Franklin stoves in each room.[30] The only step that remained was the development of small electric-powered fans to make modern forced air heating possible. Such electric fans were available in 1882 after Thomas A. Edison

developed his distribution system for direct current electricity. Even more efficient was the alternating current electric motor developed by Nikola Tesla in 1888 and in wide use by 1897–1900.

The Eastlake Style

One of the distinctive styles developed for residences in the 1870s and 1880s was named for Charles Locke Eastlake, an English interior designer, writer, and taste-maker, best known for his book *Hints on Household Taste*, first published in London in 1868 and then in an even more popular American edition in 1872. Eastlake decried heavy, bloated midcentury furniture, providing designs of lighter pieces fashioned of straight wood members, often somewhat mechanical in appearance, with scroll-sawn decoration and rela-

tively delicate incised linear ornamental motifs. Eastlake's plea for the expression of the natural colors and the texture of materials, and for form following function, was a counterpart to what architectural theorists were writing at this time, and, in fact, some architects and builders enlarged Eastlake's lathe-turned spindles, straight flat structural members, and incised ornament to true architectural scale, and an Eastlake variant of domestic design was created. Examples of these house designs were published in plan books such as A. J. Bicknell's *Wooden and Brick Buildings with Details* (New York, 1875). This Eastlake architectural style proved especially popular in California, where John Pelton published a number of newspaper articles on "Eastlake" houses, eventually gathering his designs together in a small book, *Cheap Dwellings* (San Francisco, 1882). [6.34] When Charles Eastlake was contacted in England by some Californians researching the origins of the style, he responded, "I now find, to my amazement, that there exists on the other side of the Atlantic an Eastlake style of architecture, which, judging from the [California] specimens I have seen illustrated, may be said to burlesque such doctrines of art as I have ventured to maintain." Personally Eastlake felt the houses bearing his name too "extravagant and *bizarre*."[31] Perhaps no better aggregation of Eastlake houses exists than that found in San Francisco, where they have been lovingly painted, by successive generations, in colors sometimes garish and sometimes more restrained and historically appropriate.

The Stick Style

Akin to the flat wall panels and emphatic linear "framing" timbers (mostly decorative) of the Eastlake style was what Vincent Scully termed the Stick Style, with this importance difference: Eastlake houses tend to be boxy, with distinctly separated rooms and minimal entry porches. The Stick Style houses of the Northeast, in comparison, tended to be more spatially experimental and open, with rooms loosely grouped around a large central stair hall, and with the entire arrangement wrapped with porches that extended along two or three sides of the house. The flat wall panels, with heavy-scaled decorative framing elements, became larger and more dramatic. In the wrap-around porches, especially, the sticklike structural members were multiplied and elaborated to form complex patterns.[32]

The largest and most innovative of these houses were built in the summer social capitals, first in Long

Branch and adjacent Elberon, New Jersey, during the early 1870s, and then in Newport, Rhode Island, which by the close of the 1870s began to attract the New York and Boston elite and gained ascendancy as the place of summer residence. These clients were the wealthiest and least restrained by building conventions, and the architects they engaged were the most eminent and inventive. Pretending simplicity, the millionaires often called their summer mansions "cottages." Although these houses were occupied only two or three months of the year (and hence, often not equipped with central heating), the freedom and extremely generous budgets granted to the architects allowed them to experiment with new methods of

6.34. *John C. Pelton Jr., Eastlake Style house design, c.1881. As shown in Pelton's example, offered in the plan books he published in San Francisco, the Eastlake Style used elaborately incised wood members and trim pieces. (From John C. Pelton, Jr.,* Cheap Dwellings, *San Francisco, 1882).*

plan organization, coordination of masses, and spatial configuration, which were later to be taken up by other architects across the country.[33] Within twenty-five years, by the turn of the century, the form and function of the American home had been fundamentally reshaped.

For the most part these fashionable architects of the 1870s and 1880s were concerned not with explicit expression of genuine structure on the exterior, but rather with the organization of the plan to provide large spaces well disposed for the informal, relaxed atmosphere of the suburb or the resort. The results were highly irregular plans, discontinuous and asymmetrically massed forms, combined with the manipulation of surfaces and varied textures. Roofs were high and punctured by many variously shaped dormers, revealing a debt to High Victorian Gothic. Most striking was the treatment of the exterior wall surfaces and the gable ends of the roofs, where the architects delighted in breaking up the surface with the basketwork of sticklike members.

To some extent this exploitation of stick-work came from Downing and also from Upjohn's rural churches such as St. Luke's, but the earliest fully developed expression of the Stick Style appeared in summer houses by Richard Morris Hunt. His J. N. A. Griswold house, Newport, Rhode Island, of 1862, is a good illustration of this new type. [6.35] The house has a rambling asymmetrical shape whose massiveness is partially neutralized by the encircling porch. The relatively steep roofs and projecting gable ends convey

a quasi-medieval flavor; so too does the complex frame of sticks, which resembles French medieval half-timbering (which Hunt knew well). Here, however, it serves to divide the wall surfaces into discrete panels, making the house more visually and structurally comprehensible. So, in a fashion, the Stick Style attempts rationality, reflecting one of its sources in Viollet-le-Duc's drawings of medieval French carpentry. But there is no attempt at strict or archaeological historicism, and the panels are filled with clapboards in the local New England tradition. Also American is the expansive porch, where the dramatic knee braces of the frame epitomize the structural expressionism of the Stick Style.

An even clearer example of the Stick Style of the 1870s is the Jacob Cram house, in Middletown, Rhode Island, of 1872, attributed to local architect and builder Dudley Newton. [6.36] In plan and in appearance the house is a study of discontinuous elements held together by the strongly expressed frame. The plan consists of various parlors and chambers arranged loosely around a pivotal center hall containing the main staircase. [6.37] On three sides this accumulation of rooms is surrounded by a continuous veranda. Heightening this multiplicity, the roof erupts into a variety of dormers, each with its own roof shape. Everywhere the frame is exploited—in the exposed supports of the porch, in the clapboard-paneled wall, and especially in the attic gable where the roof is pushed out to reveal a truss.

The architects of the period spoke of assertive, mas-

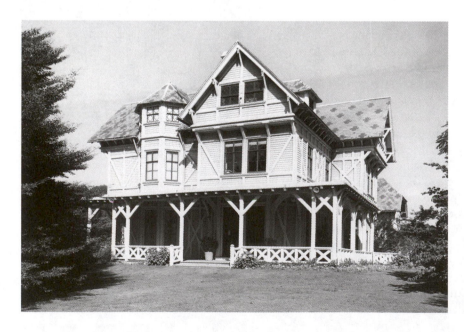

6.35. Richard Morris Hunt, J. N. A. Griswold house, Newport, Rhode Island, 1862. Hunt's seaside country house exemplifies the Stick Style that became popular for summer retreats after the Civil War. (Library of Congress, HABS RI 3-NEWP 36-1.)

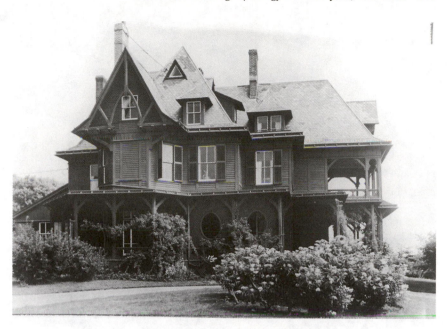

6.36. Dudley Newton (attrib.), Jacob Cram house, Middletown, Rhode Island, 1872. The varied roof line, the numerous different dormers, the wraparound porch with its basketry of wood supports make the Cram house one of the best examples of the Stick Style. (Courtesy of The Preservation Society of Newport County.)

6.37. Jacob Cram house. The plan of the Cram house illustrates well the easy arrangement of rooms around the stair hall. (L. M. Roth, after Scully and Hitchcock.)

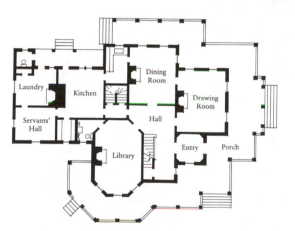

culine architecture, and the Jacob Cram house is a good example of what they meant. While visual attention may be captured by the eccentricities of the exterior, it is important to remember that the form is a general reflection of internal functional arrangements.

The Queen Anne Style

Residential architecture in the late nineteenth century comprises a kind of spectrum, with Eastlake and Stick Style representing one end marked by a multiplicity of sharp angular forms and interrupted surfaces. While Eastlake houses typically showed little interest in interior spatial connections, the Stick Style designers were interested in the flow of space from room to room. The spectrum continues with Queen Anne, which also exploits interconnections of interior spaces, with a

free play of exterior forms subjected to somewhat more geometrical control. Most significant, the Queen Anne style uses modified classical details such as columns or swan-neck pediments. Like *Eastlake*, the term *Queen Anne* was one coined at the time (unlike Stick Style and Shingle Style, which were labels devised by Vincent Scully in the early 1950s). And just as Charles Eastlake noted that the American residential style named for him was distant from what he was trying to promote, so too the Queen Anne had no real resemblance to the architecture built during the reign of the last English Stuart monarch. In the case of Queen Anne residential architecture, American architects and builders were drawing from recent English work, (sometimes referred to as "Free Classic" in England) that was also loosely inspired by seven-

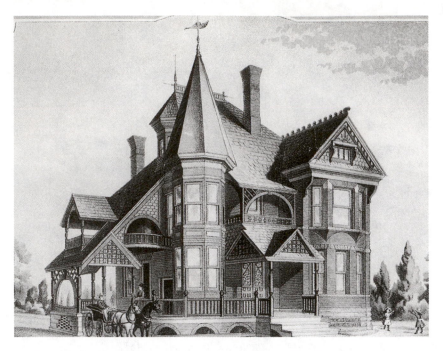

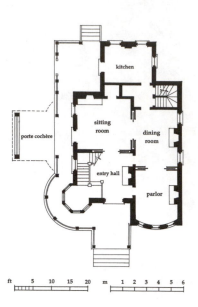

6.38. Robert Beatty Jr., James W. Bryan house, Kansas City, Missouri, c. 1886–87. This brilliantly colored chromolithograph perspective shows one variant of the enormously popular Queen Anne residence. (From E. Mitchell, American Victoriana: A Gallery of Color Plates, from Scientific American Architects and Builders Editions, 1880–1905, San Francisco, 1979.)

6.39. James W. Bryan house, plan. Queen Anne house plans, like Stick Style plans, were freely arranged and emphasized convenience. (L. M. Roth, after Beatty.)

teenth-century English sources. What American architects did, however, was to take the English use of tiles (which they rendered as wood shingles) and isolated classic details and fuse such elements with Stick Style residential plans and massing. In particular they focused on corner towers capped by tall conical roofs. The result was American Queen Anne, a stylistic term much abused by realtors in the late twentieth century.

One can frame a general definition of what is Queen Anne, using the James W. Bryan house in Kansas City as an example. [6.38, 6.39] The Queen Anne house has a free plan, with (in this case) sitting room, dining room, and front parlor arranged around a reception hall that also serves as a spacious stair hall. The main public rooms open to each other by means of broad sliding doors that slide back into pockets in the walls, so that the entire interior can either be interconnected spaces or discrete rooms. The kitchen to the rear is connected to one or two servant's rooms upstairs by means of a tight back stair. There is almost always a wrap-around porch of some sort, in this case running across the front and all the way to the rear. And there is almost always some sort of corner tower, either round or polygonal, capped by a tall spirelike roof.

The interior is finished with elaborate wooden trim, especially in the stair hall and public rooms downstairs. And the exterior is more richly embellished in a variety of materials, with stone and brick base and lower walls, usually with framed upper walls covered with clapboards and shingles cut in various patterns.[34] Turned spindle work appeared in railings and screens. The *Scientific American Architects and Builders Edition* (July 1887), which published the Bryan house in a vivid chromolithograph plate, reported that the house, which cost $7,500, had central heating augmented by fireplaces in the lower rooms.

In the two decades after 1885, Queen Anne houses became one of the most popular residential types, spreading across the continent. Even small farm towns of one or two thousand people had at least one grand Queen Anne house, the home of the principal businessman. Suburbs around the larger cities had whole blocks filled with these shingled, towered, porch-skirted houses. Enormously popular all across the United States, Queen Anne houses were illustrated in several of the later plan books published by Palliser and Palliser, and especially in the eleven plan books published by Robert W. Shoppel that appeared from 1883 through 1890.

The Shingle Style

Houses like those for Jacob Cram and James Bryan, in rural or suburban settings, took advantage of their freedom by celebrating with great exuberance contrasts of form and color. The Shingle Style, identified and named in about 1950 by Vincent Scully, was Queen Anne subjected to a rigorous controlling intelligence, reduced in its extravagant contrasts of materials, with the entire design composed of carefully arranged geometries. The connections of interior spaces were even more important, with a new influence in the shaping of these spaces being traditional Japanese architecture, newly available in the book published by Edward S. Morse, *Japanese Homes and Their Surroundings* (Boston, 1886). The external sheathing material of preference was wood shingling, sliding and rippling from surface to surface, wall to porch roof.

The Shingle Style appeared fully developed in the work of young McKim, Mead & White in 1879 when they were engaged by James Gordon Bennett Jr. to design the Newport Casino. They were not to build a self-important freestanding monument, but rather a street-front block on Bellevue Avenue in Newport, in the center of the small business area for the Newport summer colony, next to the long Stick Style commer-cial Travers block by Hunt. On the inside McKim, Mead & White arranged the tennis courts, verandas, restaurant, club rooms, and clock tower of the casino in a studied composition of great freedom and controlled irregularity. But on the public Bellevue Avenue front they arranged the eight shops and upper level of offices in strict bilateral symmetry around the center entrance arch. [6.40] Each shop front is subtly but separately expressed, and though there are slight projections in the second level and in the multiple gables in the attic, the dominant motif throughout is horizontal continuity. Across the entire facade the horizontal line is dominant and controlling, introducing a new motif in a period when architectural expression was still basically vertical and discordant in emphasis. The bilateral formality of the public street front also marked a new direction, and so too did the use of shingles for wall surfaces and roofs. By covering the frame with shingles, in figured bands, the horizontal continuity of the wall surfaces was even further emphasized.

The emphatic triangular forms and continuous horizontals of the Newport Casino had been foreshadowed in the work of Henry Hobson Richardson, in whose office McKim and White had worked as young assistants. One of Richardson's most important con-

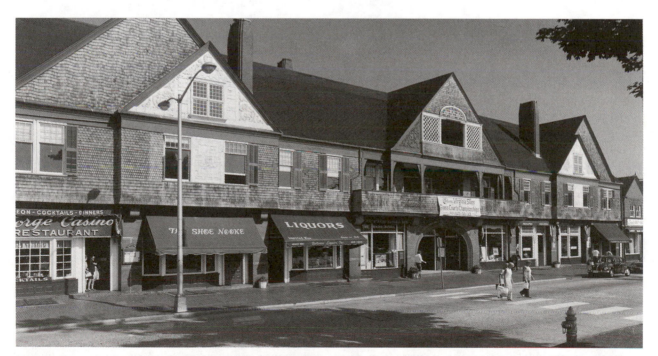

6.40. McKim, Mead & White, Newport Casino, Newport, Rhode Island, 1879–80. Very quickly in the 1880s, the varied irregularity of the Stick Style was replaced with the regularity and linear extension of the Shingle Style. (Photo: L. M. Roth.)

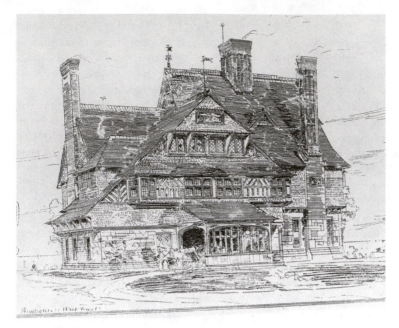

6.41. *Henry Hobson Richardson, William Watts Sherman house, Newport, Rhode Island, 1874–75. Although the published drawing (attributed to Richardson's assistant Stanford White) stresses irregular textures, the design is highly controlled and emphasizes geometrical control and continuous planes.* (The New York Sketch Book of Architecture, vol. 2, May 1874.)

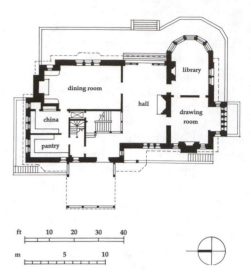

6.42. *William Watts Sherman house. The plan of the Sherman house shows the increasing focus on a large living hall at the center of the house.* (L. M. Roth, after J. K. Ochsner and T. Hubka, "H. H. Richardson: The Design of the William Watts Sherman House," Journal of the Society of Architectural Historians 51 [June 1992].)

tributions to the emerging Shingle Style was his summer cottage for William Watts Sherman in Newport, built in 1874–75. [6.41, 6.42] To the rear the projections and multiple sharp gables recall the Stick Style, but the front facade is highly disciplined and pulled under one extremely broad single gable. The windows are grouped in long horizontal bands, reflecting the strong English influence of Richard Norman Shaw's country houses of the late 1860s. Wood shingles cover significant portions of the wall surfaces, as well as the roof.

Richardson's Stoughton house, in Cambridge, Massachusetts, built in 1882–83, is one of the best shingled houses of the period. [6.43] The plan is both free-flowing and carefully controlled, with large rooms arranged in an L around a stair hall that protrudes at the corner in a swelling short tower. The porch, instead of standing free against the house, is formed in a recess carved out of the mass of the house so that the basic geometry is not weakened. As his former students, McKim and White, were beginning to do, Richardson emphasized the horizontals, but here the continuity of spaces inside and of the surfaces

outside is much more pronounced. Large cypress shingles cover the entire house, from the ridge all the way down to the outward-swelling water table where the house seems to hug the earth. Even at the inside corners, where the flat walls intersect the circular stair tower, the shingles do not form a sharp corner but curve around from wall to tower to wall. The wall surface seems to flow from part to part, concealing the frame but expressing its necessary presence. In its horizontal sweep and continuity, the Stoughton house is the antithesis of the Jacob Cram house of only ten years before; where the former was all angular contrast and collision, the Stoughton house is all harmonized continuity.

In the Isaac Bell house, in Newport, built in 1881–83, McKim, Mead & White show a somewhat more playful approach than Richardson's. [6.44, 6.45] Where Richardson employed a simpler monumentality, McKim, Mead & White (with White in charge, as with the casino) broke up the exterior of the Bell house into separate but carefully coordinated shapes. Window openings are played off against one another, and the tower swelling out from one side is

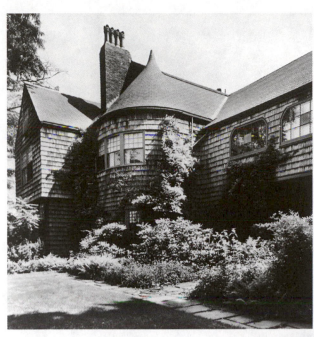

6.43. Henry Hobson Richardson, M. F. Stoughton house, Cambridge, Massachusetts, 1882–83. Especially clear where the stair tower meets the facade wall, the wood shingles bend and curve from one wall to the other. (Photo: © Wayne Andrews/Esto.)

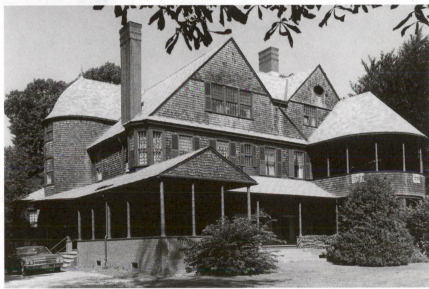

6.44. McKim, Mead & White, Isaac Bell house, Newport, Rhode Island, 1881–83. In the studied geometry of its repeated gables, the tower capped with a curved bell-cast roof, together with the bamboo-shaped porch posts, the Bell house sums up the Shingle Style exterior. (Library of Congress, HABS 3-NEWP 44-1.)

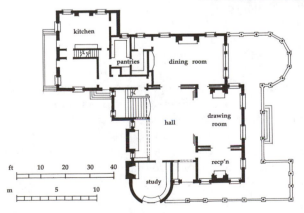

6.45. Isaac Bell house. In the Bell house, the living hall is the largest room of the house, made to seem even bigger through the use of multiple sliding doors that open to the surrounding rooms. (L. M. Roth, after George Sheldon, Artistic Country Seats, and HABS plans.)

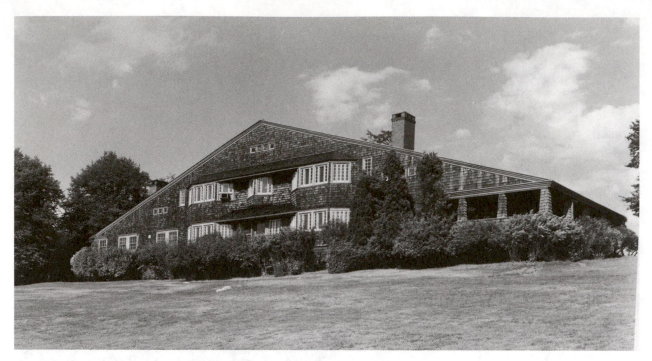

6.46. McKim, Mead & White, William G. Low house, Bristol, Rhode Island, 1886–87. Although little known in its own time, the Low house has come to represent the high mark of the Shingle Style. (Library of Congress, HABS RI 1-BRIST 18-3, photo by Cerwin Robinson.)

balanced by the two-story semicircular veranda protruding from the other. Everywhere, however, the swelling, shifting surface is of shingles. The first-floor plan can almost be said to consist of one vast room, divided into various spaces around a huge central stair hall. The door openings range from five to sixteen feet across and can be opened or closed by huge sliding doors. While the shingles and various minor decorative motifs are derived from colonial precedents (so much on the minds of architects following the Centennial), the plan and the manipulation of space through the use of sliding doors indicate the influence of Japanese architecture. On the porch this appears in the curious posts, lathe-turned to resemble bamboo. Seldom afterward were American architects able to make of such disparate influences so harmonious, playful, and integrated an expression; in these Shingle Style houses one finds eclecticism at its best.

From the beginning, however, there was implicit in the Shingle Style a formality that was gradually to grow and reshape it from within. In this development, McKim, Mead & White were the leaders. While the Shingle Style had developed largely as a result of renewed study of Colonial building forms and materials (combined with Japanese references), as it matured

a desire for formal discipline began to assert itself. Horizontality and simplified masses had already appeared; bilateral symmetry was next. In the William G. Low house, in Bristol, Rhode Island, built in 1886–87, McKim, Mead & White reached the apogee of formal clarity in the Shingle Style. [6.46] The entire house, including the porch, is subsumed within one broad, massive gable. Within the limits of functional practicality, the windows are symmetrically disposed, but bound together by the horizontal hoods that stretch across the shingled surface. Though the shingles are a symbol of the country house and the informality that connotes, the form of the Low house in its simple grace and archetypal geometry has a fundamental classic clarity.

This interest in formal clarity took two directions. One (as in the case of the Low house) was toward an abstract clarity and simplification of form, with no obvious historical references. The other direction was toward more direct reference to classical models that had ancestral and national significance. This meant references to the earliest classical architecture brought to the English colonies—to Colonial architecture. The result was the beginning of the Colonial Revival. One of the most decisive demonstrations of

this fondness for Colonial models was designed and built by McKim, Mead & White very near the Low house, in Newport, Rhode Island. The H. A. C. Taylor house, built in 1882–86, was an oversized but somewhat archaeological reproduction of an eighteenth-century house (it was, apparently, the first such "archaeologically" accurate neo-Georgian Colonial Revival house); in fact, paneling salvaged from an eighteenth-century Newport house that had been recently demolished was incorporated into the Taylor house interiors. [6.47] This Colonial Revival would grow in national popularity around the turn of the century and continue well into the middle of the twentieth century.

The residential work of McKim, Mead & White, Richardson, and a score of other highly skilled East Coast architects marked the artistic high point of the Shingle Style in the hands of high-profile professional architects. Like the Queen Anne style, a modified Shingle Style swept across the country, popularized in scores of plan books, such as the later editions of Palliser and Palliser, and also by R. W. Shoppell. In the 1887 edition of *Palliser's New Cottage Homes*, plate 122 presented a large Shingle Style house, with a massive stone chimney and sweeping shingled roof that curved down to cover the porch. The plate was accompanied by a caption that claimed that this design "brings us forcibly back to the days of our great grandfathers and at once puts us in mind of the

times of the revolution. . . . The style of architecture here illustrated is termed by many 'Old Colonial.'"[35]

Like the work of well-known professional architects like McKim, Mead & White, Bruce Price, William Ralph Emerson, and Arthur Little, the house plans published by Palliser and Palliser, and Shoppell, stressed long continuous and curved shingled surfaces. On the West Coast the Shingle Style was popularized by Samuel and Joseph Cather Newsom, brother architects of San Francisco, whose practice extended from Eureka in the north to Los Angeles in the south. Their plan book, *Modern Homes of California*, published in San Francisco in 1893, was filled with plans for Shingle Style houses, bearing names appropriate to the region—"Escondido," "Faralone," "Pacific Heights," and "El Dorado," among many others.[36]

The Shingle Style was also dispersed across the country by architects who relocated westward, taking the fashionable new East Coast styles with them. One of the best-documented instances of this was the relocation of Joseph Lyman Silsbee from Syracuse, New York, to Chicago in around 1882. In the mid-1880s he used a fusion of Queen Anne and Shingle Style in many of the residences he designed around the city, particularly in a group of modest houses he designed for a new suburban community called Edgewater, about seven and a half miles north of the center of Chicago on the shore of Lake Michigan, built by developer John L. Cochran. Silsbee's shingled Queen

6.47. McKim, Mead & White, H. A. C. Taylor house, Newport, Rhode Island, 1882–86. Perhaps the first historically based neo-Colonial house in the United States, the Taylor house even incorporated salvaged eighteenth-century paneling in its interiors. This photo shows the house closed and shuttered for the winter months. (From American Architect and Building News, *July 23, 1887.)*

6.48. Joseph Lyman Silsbee, speculative house for John L. Cochran, in Edgewater (now part of Chicago), Illinois, 1886–87. Silsbee brought the fully developed Queen Anne/Shingle Style to Chicago, greatly influencing his young assistant Frank Lloyd Wright. (Photo: Charles Allgeier, Chicago, c. 1887–88; author's collection.)

Anne houses in Edgewater, built during 1886–87, were massed in large broad triangles, and employed many variations in shingled patterns. [6.48] These houses, with their dramatic and dominant gables, were to have a strong influence on the young Frank Lloyd Wright, who worked for Silsbee while they were under construction.

TRANSPORTATION AND THE IMPACT OF TECHNOLOGY

Behind this great upsurge of residential building, both in posh summer watering holes and hundreds of suburbs, was a vigorous business boom and the expansion of a transportation network that enabled the middle class to move about as never before. The driving energy of this industrial growth, plus the deepening gulf between architects and engineers, created problems in giving appropriate forms to new building types. And the buildings and other structures created by the rapidly changing modes of transportation in the late nineteenth century only made this problem more perplexing. The Brooklyn Bridge illustrates this well. As the pressure of traffic between Brooklyn and New York taxed ferry capacity, and as it became desirable to connect the two cities by streetcar, the need for a bridge became clear, but it had to span an unprece-

dented distance of nearly 1,600 feet, at a distance well above the river to allow commercial sailing vessels to pass beneath. Begun in 1869 by John Augustus Roebling (1806–1869), it was continued by his son Washington Augustus Roebling (1837–1926), with construction supervised by Washington's wife, Emily, after Washington became incapacitated. [6.49] The cause of Washington's near total physical collapse was due to the long hours he spent in the caissons used in sinking the bridge piers to bedrock. This was only the second time such technology had been used in the United States, and never before on such a huge scale. Caissons had just been used for the piers of the Eads Bridge across the Mississippi at St. Louis, in 1868–74. As employed by the Roeblings, a large inverted airtight box, open at the bottom, was floated over the site for each bridge pier and then pushed into the mud below by the weight of granite blocks being piled on top (the growing base of the bridge pier). [6.50] Meanwhile, men who came to be called "sandhogs" worked by lamplight in the pressurized air chamber inside the caisson, under the growing pier, excavating the rock and soil from under the slowly descending caisson.[37] The then unknown ailment that crippled Roebling was called "caisson disease"; we now know he nearly died of the bends.

The caissons were only one of many innovations the Roeblings used; within two decades this technique

6.49. John Augustus and Washington Augustus Roebling, *Brooklyn Bridge, Brooklyn, New York, 1869–83. The Brooklyn Bridge, one of the most important engineering accomplishments of its period, combined mathematical* *precision with romantic historical references in the masonry piers; note the Stick Style ferry house in the foreground. (Courtesy of The Long Island Historical Society.)*

would be reduced in size for the construction of deep piers for tall office building foundations. Perhaps the most significant innovation was the elder Roebling's development of the "spider" that laid the cables of steel wire in place, running back and forth, from anchor to anchor. The huge masonry piers supporting the steel wire cables of the Brooklyn Bridge are plain, with a molding at the level of the deck and a terminal cornice where the cables rest at the top. The openings are simple Gothic lancet arches, giving the piers historical associations. The cables and deck, however, were determined entirely by structural logic, and incorporate the elder Roebling's perfected technique for spinning high-tensile steel cables, radiating stays for aerodynamic stability, and deck-bracing against wind and vibration. Perhaps the piers were intended to convey strength through their mass, but their heavy mass and historicism contrasts with the delicate structural web. An even greater contrast, however, appears between the daring bridge and the copiously paneled Stick Style–Second Empire Fulton Ferry terminal in the foreground built in 1871. Perhaps nowhere else at this time was the contrast between the prevailing historicist architectural allusions and daringly pragmatic functional design so evident.

The same incongruity between associationalism and utility has already been noted in the head house and shed of Snook and Buckhout's Grand Central Station, in New York. The needs of the transportation system presented extraordinary challenges to late-nineteenth-century architects. Trackage, for instance, doubled nearly every twelve years, reaching a peak of 254,037 miles in 1916. The volume of passenger and freight traffic increased at an even greater rate. The same was true for urban mass transit, which had begun a half century before with horse-drawn omnibuses. A major improvement was made by putting the cars on rails in the 1830s, but the greatest improvements came with cable-drawn cars in 1867, steam-powered traction in the 1860s, and then electric traction in 1888. Such mass transit was both necessitated by and a stimulus for centralization of businesses, services, goods, and people in the urban core. Indeed, the application of motorized power to the horizontal movement of people (elevated railways, subways, and trolleys) made the modern city possible, just as mechanical vertical transportation (elevators) made the office skyscraper possible. The two systems were symbiotic, for improvements in one system induced improvements in the other. But what appearance these transportation

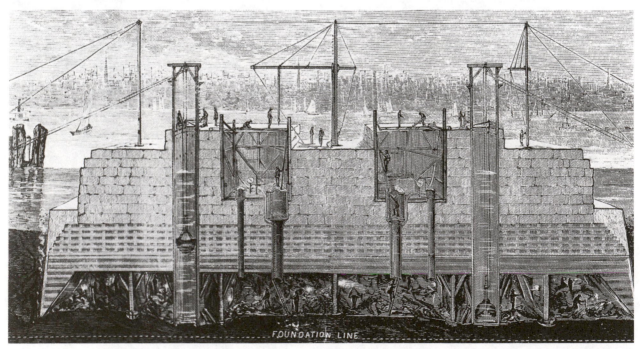

6.50. *Brooklyn Bridge, tower caisson. This cross section shows the hollow working space at the base of the caisson, pushed ever lower into the muddy banks of the East River* by the granite blocks being piled on top. (From Harper's Weekly, *December 17, 1870.*)

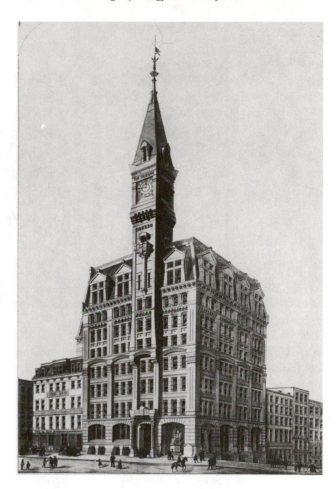

6.51. *Richard Morris Hunt, Tribune Building, New York, New York, 1873–75. Although decidedly tall and vertical in its proportions, Hunt's Tribune Building has a traditional solid stone and brick outer wall. (Courtesy of the Museum of the City of New York.)*

facilities should have was still a complicated matter, as suggested by the elaborate interiors of Pullman's Palace Car (introduced in 1864), or the design by landscape painter and amateur architect Jasper Cropsey for the Metropolitan Elevated Railroad stations, in New York, of about 1878. Cropsey's crocketed station is an example of the picturesque application of Victorian decorative effects in iron in an attempt to accommodate the new industrial age.

The High-Rise Office Building

As mass transit spread, and as population grew, the use of land in the urban core grew ever more intensive, land costs rose, and taxes increased, making it mandatory for office buildings to reach higher so as to generate greater rental income. This desire for ever greater height was also fed by the mystique of the corporate image; the tall building was a status symbol. In New York the pressure resulted in the first skyscrapers or "elevator buildings" (as they were called then). In a city in which the average building height was five

stories, at 60 feet, the Equitable Life Assurance Building by Gilman, Kendall, and Post, built in 1868–70, must have seemed gargantuan with its seven floors rising 130 feet. Soon it was dwarfed by George B. Post's Western Union Building, built in 1873–75, rising 230 feet, and even more by Richard Morris Hunt's Tribune Building, built in 1873–75, with nine stories rising 260 feet. [6.51]

In spite of their height these buildings were constructed in a traditional manner, with massive exterior bearing masonry walls and partially iron-framed interiors. Architects had great difficulties in the 1870s trying to handle the expression of this increased height, for they were conditioned to think of Renaissance or Baroque palace blocks and thus they had little precedent for a building over three stories. One solution was to pile up successive two- or three-story units, as Hunt did in the Tribune Building. Nonetheless, Hunt did attempt to express the bearing nature of the wall by employing certain néo-grec devices such as the broad segmental arches in the stone base, the heavy

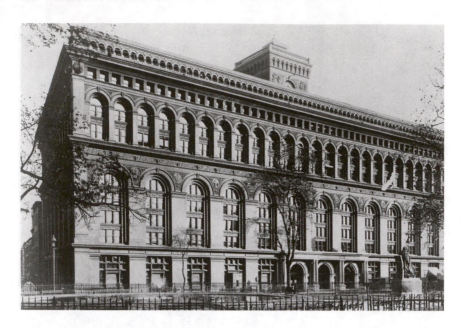

6.52. *George Browne Post, Produce Exchange, New York, New York, 1881–85. Brown adopted continuous Renaissance-style arcades to organize the great bulk of this building; the horizontal division corresponds precisely with a major change in internal functional activities. (Courtesy of the Museum of the City of New York.)*

major piers connected by segmental arches, and the comparatively light curtain wall of the banks of windows. Furthermore, in the tall tower Hunt introduced a form that continued to shape New York skyscrapers for sixty years.

In one commercial building in New York, George B. Post (1837–1913) came very close to using true skeletal construction; this was the Produce Exchange, built in 1881–85, a huge rectangular block with a light well in the center. [6.52] To one side was a tall square-topped tower housing mechanical equipment. The entire interior was carried on a frame of cast-iron columns and wrought-iron beams and joists. The outermost columns of the frame were embedded in the outer brick walls, as were spandrel girders for the windows, but the brick wall supported its own weight plus some adjacent floor loads. The iron columns embedded in the outer wall carried only floor loads and not the weight of the wall itself. In organizing the exterior Post used Italian Renaissance elements. The tall arcades correspond to internal arrangements, for above the ground floor was a vast four-story trading room 220 by 144 feet, the center of which was covered by an iron and glass skylight. Above the periphery of the trading room wrought-iron trusses carried nearly three hundred offices in the encircling upper floors. Thus the imposing lower four-story arcade indicates the trading room, the cornice is coincident with the ceiling and skylight, and the quickened upper rhythms indicate the cellular offices in the upper floors. Besides the novel iron frame, Post also used

terra cotta for ornamental sections showing well its potential for crisp, finely modeled detail.

The evolution of the tall office skyscraper would continue, with changes in how the skyscraper was structurally supported, in how the skin over the structure was articulated, and in how the volumetric mass should be modeled, but these changes during the next phase of development—1885 through 1915—were to a large degree influenced by the sweeping and long-lasting influence of the one of the greatest architects America has produced: Henry Hobson Richardson.

HENRY HOBSON RICHARDSON

Despite his creative innovations, Post did not exert lasting influence; nor was Hunt's influence widespread, even though he had enormous prestige among his colleagues during his lifetime as the acknowledged dean of American architects. The most truly influential figure of this period was without question Henry Hobson Richardson (1838–1886). Born at Priestley Plantation, in St. James Parish, Louisiana, to a family of some means, he was sent to Harvard University and seems to have been influenced by the austere granite warehouses and residences in Boston by Alexander Parris. Richardson decided on a career as an architect but since in 1860 there were as yet no schools of architecture in the United States, Richardson went to the École des Beaux-Arts, in Paris, where he studied for two years. Fluent in French, he studied in the atelier of

Jules-Louis André before family support was cut off due to the Civil War. For the next four years he worked in the office of Théodore Labrouste. Thus his academic and office experience gave Richardson the best of French academic theory and practical discipline. He learned to examine a building's functional program for the suggestion of a comprehensive solution, to give careful attention to the development of the plan to provide optimum utility, to create stylistic details sympathetic to the functional and social purpose of the building, and to build in the most solid, durable way.

Richardson returned to the United States in 1865, established a practice in New York, and settled on Staten Island near Olmsted, with whom he soon began to collaborate. His practice was growing at a moderate rate when two designs in the mid-1870s propelled him into the center of architectural attention: his competition-winning entry for Trinity Church, Boston, and the summer house for William Watts Sherman in Newport, Rhode Island.

In Trinity Church, built in 1872–77 [6.53], the general vertical massing and polychromy revealed traces of High Victorian Gothic, but the strong geometric order and the French Romanesque ornamental motifs were new. The tower would have been taller, but structural problems, due to the spongy gravel fill of Boston's filled Back Bay, necessitated a shorter, lighter tower. Richardson decided to pattern the lantern of the tower after that of the Cathedral of Salamanca, Spain, so that to many observers it seemed that Richardson had added a new style to the historical repertoire already in use, and that he had made reference to specific historic monuments especially desirable. Such a revivalist assessment, however, completely missed the continuity and unity based on a carefully studied plan that were Richardson's most important contributions.

In the field of residential design, too, Richardson was shifting away from purely High Victorian Gothic

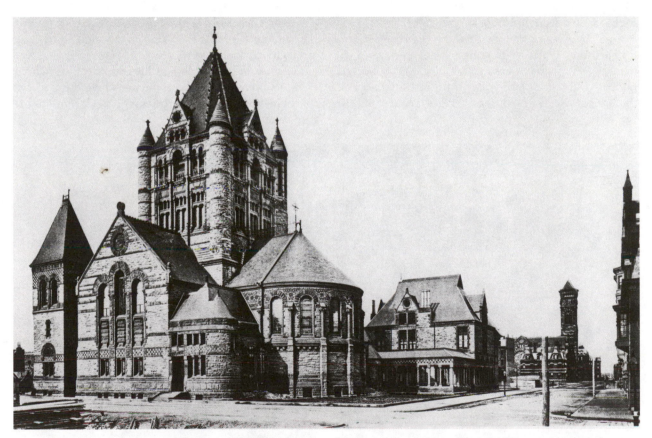

6.53. Henry Hobson Richardson, Trinity Church, Boston, Massachusetts, 1872–77. In the distance on the right is the tower of Richardson's Brattle Square Church, 1870–72, with its relief sculpture by F.-A. Bartholdi. (From M. G. Van Rensselaer, Henry Hobson Richardson, *Boston, 1888.)*

complexity toward greater clarity of form. In his Sherman house, built in 1874–75 [see 6.41, 6.42], he looked at contemporary English work, such as that of Richard Norman Shaw, but devised a spacious plan with rooms clustered about a generous central stair hall. Just as Trinity Church showed an interest in more continuous integrated form, so too did the Sherman house with its long sweeping roof planes and the large frontal gable (the progenitor of the gable of McKim, Mead & White's Low house).[38] To this organized form was added a new interest in texture, especially evident in the published rendering drawn by Stanford White, who was then in Richardson's office. Above the masonry of the first floor, shingles, small half-timbered panels, and textured stucco are used. Even the diamond-panel windows continue the overall texture. What could have become cacophonous was held superbly in check by grouping windows in horizontal bands so that although this is a tall house, it is the horizontal line that predominates. Here is the beginning of the Shingle Style later carried to maturity by McKim, Mead & White and crystallized by Richardson's Stoughton house. [see 6.43]

One can appreciate the expansiveness in Richardson's work by looking at the staircase of the Robert Treat Paine house in Waltham, Massachusetts, built in 1884–86.[39] [6.54] Part of a much larger hall, the staircase ascends by easy stages around built-in

seats. The structure of stair and ceiling is integrated and openly expressed, ornamented with delicate low-relief carved foliate and geometric clusters. The stair hall also demonstrates the splendid craftsmanship of the Norcross brothers, who built not only much of Richardson's work but many of the best-known buildings of the next thirty years as well. It was, in fact, Richardson's practice to leave much to the discretion of the contractor, and the clause in building contracts, "to be finished in a workmanlike manner," expressed what was to builders like the Norcross brothers a sacred duty that they executed with exacting care.[40]

Perhaps Richardson's most representative building is the Crane Memorial Library, in Quincy, Massachusetts, built in 1880–83, [6.55, 6.56], one of scores of small public libraries built across Massachusetts through private benefactions. What the Stoughton house meant for Richardson's Shingle Style, this small library signified for his masonry public buildings. The general form of the building is reduced to one enveloping, comprehensive shape with a minimum of elements. Each form or detail denotes a particular interior function: the window wall reveals the reading room; the powerful, low-slung, yawning arch dramatically forms the entrance; the tower encases a staircase leading to librarian's offices behind the second-story gable; and the raised windows above the high-shouldered wall express the stack room to the

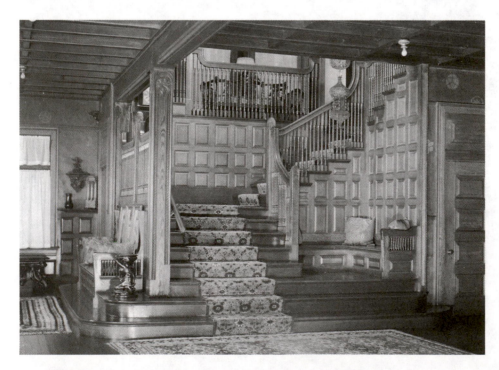

6.54. Henry Hobson Richardson, Robert Treat Paine house, Waltham, Massachusetts, 1884–86. Placed in the large central living hall of the house, the broad stair rises in gentle stages with several intermediate landings. (Sandak, courtesy of the University of Georgia.)

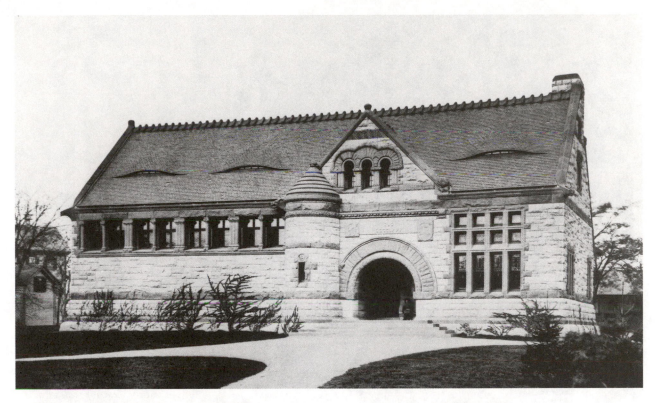

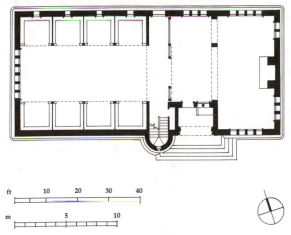

6.55. Henry Hobson Richardson,
*Crane Memorial Library, Quincy,
Massachusetts, 1880–83. The Crane
Library is a good example of
benefactions by industrialists to
promote civic life. (From Van
Rensselaer,* Henry Hobson Richardson,
Boston, 1888.)

6.56. *Crane Memorial Library, plan.
The plan is simple, with each major
functional activity clearly indicated
on the exterior. (L. M. Roth, after
Van Rensselaer,* Henry Hobson
Richardson.*)*

left. Horizontal bands of brownstone, contrasting with the warm gray Quincy granite, organize the composition. The ornament, though inspired by French Romanesque and by Byzantine sources, is broadly scaled and inventive rather than archaeological. The walls are a continuous textured surface of quarry-faced granite and brownstone, creating a visual continuity comparable to the textured shingles in the houses.

Richardson had an intense interest in all areas of building and devoted considerable thought even to utilitarian buildings. Toward the end of his short life he remarked to his friend and biographer, Mariana van Rensselaer, that "the things I want most to design are a grain-elevator and the interior of a great river-steamboat."[41] An early instance of his focus on utilitarian buildings was the Cheney Block, in Hartford, Connecticut, built in 1875–76. [6.57] Thinking perhaps of warehouses in Bristol, England, Richardson used superimposed arcades forming a base, midsection, and terminating story, each successive arcade

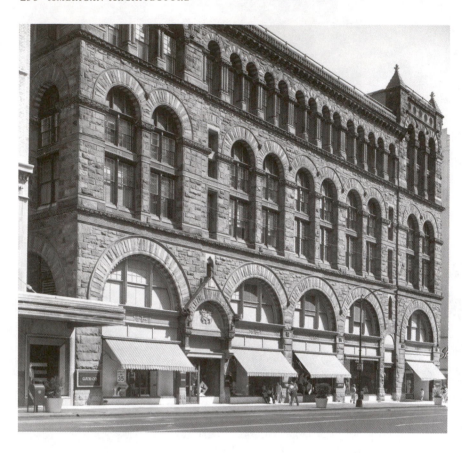

6.57. Henry Hobson Richardson, Cheney Block, Hartford, Connecticut, 1875–76. In this store and office block, Richardson organized the exterior wall into a series of superimposed arcades. (Photo: © Wayne Andrews/Esto.)

rhythm quickened. (G. B. Post may well have been touched by Richardson's influence in the arcades of his Produce Exchange of 1881.)

By 1885, when Richardson was engaged to design the Marshall Field Wholesale Store and Warehouse in Chicago, he had eliminated nearly all overt historical detail in his work, emphasizing mass and proportion, but doing so in a way that carried the authority of historical paradigms. The Field Wholesale Store was a huge single huge block, 325 by 190 feet and rising 125 feet in height, unbroken by tower or projected pavilion.[42] [6.58] A utilitarian building serving the salesmen of the wholesale division of Marshall Field's Department Store business, its interior consisted of open loft spaces. Richardson expressed this through the uninterrupted rhythm of arcades along each side. Instead of specific historical details, Richardson used the textured monochromatic surface of the granite and brownstone masonry, modulated by modest moldings and belt courses, to provide visual interest, supplemented by a chamfer at the corners and an enriched terminal cornice. [6.59] Simple though it appears, the Marshall Field Wholesale Store demon-

strated clearly that a huge commercial block could be expressed as a single integrated unit of great force and authority. No longer were meretricious historical ornament or a ponderous roof obligatory. Large-scale coherent forms, graced with plain walls, could be just as effective. Though structurally the Field building was conservative, with massive bearing exterior walls and cast-iron and wood columns for internal supports, the visual expression was highly advanced and pointed in a new direction that many critics and architects, both in the United States and Europe, interpreted as being distinctly American. Louis Sullivan, who was powerfully affected as he saw the walls rise, wrote later:

stone and mortar, here, spring to life, and are no more material and sordid things, but, as it were, become the very diapason of a mind rich-stored with harmony. . . . Four-square and brown, it stands, in physical fact, a monument to trade, to the organized commercial spirit, to the power and progress of the age, to the strength and resource of individuality, and source of character; spiritually, it stands as the index of a mind, large

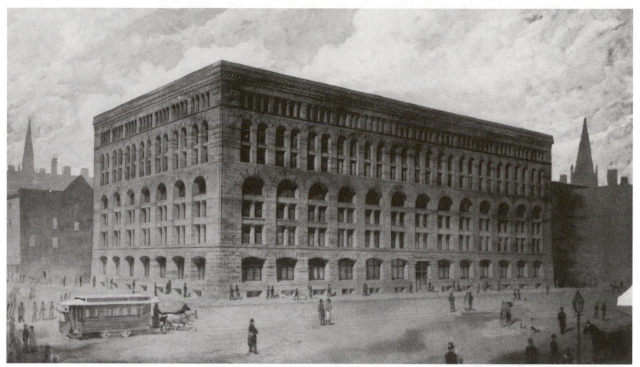

6.58. *Henry Hobson Richardson, Marshall Field Wholesale Store, Chicago, Illinois, 1885–87. This huge warehouse filled an entire Chicago city block, yet was expressed with utmost* simplicity. (From Van Rensselaer, Henry Hobson Richardson.)

enough, courageous enough to cope with these things, master them, absorb them and give them forth again, impressed with the stamp of large and forceful personality; artistically, it stands as the oration of one who knows well how to choose his words, who has somewhat to say and says it—and says it as the outpouring of a copious, direct, large and simple mind.[43]

Seldom before (or since) had one American architect given such high praise to another.

It should be noted that the Field Wholesale Store, in the loft and warehouse district on the west side of Chicago's downtown, close to the south branch of the Chicago River, was designed to serve the *men* who worked in the wholesale division of the Field mercantile empire. This masculine clientele and the comparatively utilitarian purpose of the Wholesale Store were appropriately expressed by the simplified character of Richardson's design. In contrast, the downtown retail store for Marshall Field, whose primary appeal was to *women* shoppers enticed to buy on impulse from among the many the items attractively displayed, was a far more ornamented building by Chicago architects

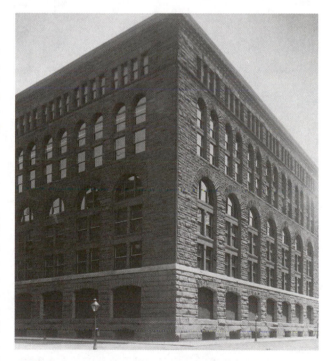

6.59. *Marshall Field Wholesale Store. The view from street level demonstrates the sculptural power of this enormous block. (Photo: Charles Allgeier, Chicago, c. 1887–88; author's collection.)*

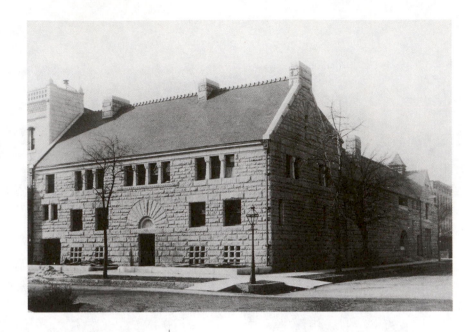

6.60. *Henry Hobson Richardson, John J. Glessner house, Chicago, Illinois, 1885–87. The massive closed exterior of the Glessner house is lightened by the texture of the stonework. (Photo: Charles Allgeier, Chicago, c. 1887–88; author's collection.)*

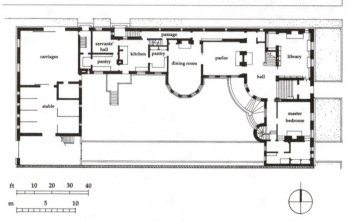

6.61. *Glessner house, plan. With its back to the noise of the street, the house opened to a court, allowing southern light into the major rooms. (L. M. Roth, after Harrington and HABS.)*

Burnham and Root, although it too was influenced in the logic of its wall articulation by Richardson's example. Gender roles and characterizations seem to have played an important part in shaping the design of each of the Field buildings.

As Richardson completed the designs of the Field Wholesale Store, he also finished drawings for a residence in Chicago, for John J. Glessner, built in 1885–87. Shaken by the Haymarket Riot in Chicago only a few years before, and having just recently confronted a thief in their home, the Glessners instructed Richardson to make the house fairly closed off from the street for security (although the family tempered the forbidding castlelike character of the house by frequently and most graciously entertaining friends and neighbors). [6.60, 6.61] The Glessner house was turned with its back to the street, so to speak, but this arrangement created an open court south of the principle rooms, allowing plenty of light to flood into these rooms in the dark, overcast winter. As in the Marshall Field Wholesale Store, historical ornament is reduced to an absolute minimum, with the rough surface texture of the granite masonry and the carefully studied proportions providing visual relief.

Even as he was designing these masterworks, at the peak of his creative powers at age forty-eight, Richardson knew he was dying of Bright's disease, a progressive failure of the kidneys. He would die before construction of the Glessner house and the Field Wholesale Store was completed. He was also at work preparing drawings for his most important public building, the Allegheny County Courthouse and Jail,

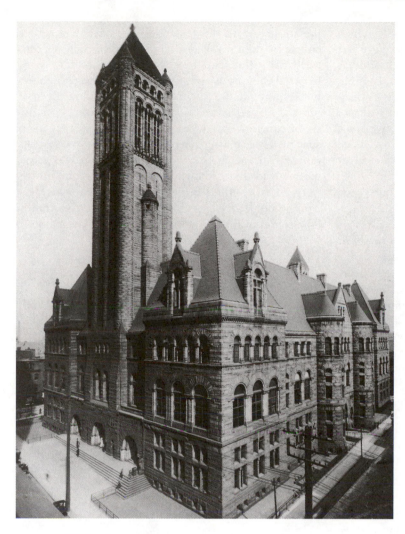

6.62. Henry Hobson Richardson, Allegheny County Courthouse and Jail, Pittsburgh, Pennsylvania, 1884–88. Filling an entire block, and open to a large central court, Richardson's courthouse has a massive permanence relieved by the varied roughness of its stone construction. (Carnegie Photo, Northwestern University.)

6.63. Allegheny County Courthouse and Jail, overall plan. While the jail plan is adjusted to an irregular block shape, the courthouse plan shows how the exterior disposition of windows and masses (such as the projecting towerlike bays) accommodate the various interior functions, with the courtrooms set at the corners for the best ventilation. (L. M. Roth, after Van Rensselaer.).

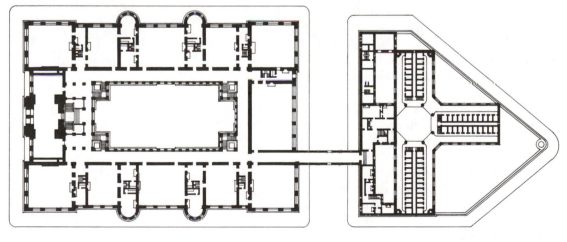

in Pittsburgh, Pennsylvania, built in 1884–88, which Richardson himself felt was his very best. [6.62, 6.63] The courthouse and jail are two separate buildings linked by a bridge over the intervening street. In both, masonry is exploited for maximum expressive effect; some of the individual blocks in the prison wall are nearly eight feet long and weigh well over five tons. The courthouse is a large rectangular hollow block with a large central light court; externally the great bulk of the building is divided into component elements revealing the organization of the courts and chambers at the principal floors. Because of the significant public function of the building, more attention is given to elaborating the details here than in the Field store, as in the capitals of the colonnettes carrying the massive round arches and the dormers of the corner pavilions, and in the detailing of the huge arches of the expansive public staircase. Particularly impressive is the tall tower that not only establishes a strong presence for this public building but also accommodates elevated intakes for the building's ventilation system. Yet despite the building's size and many elements, everything works together for the benefit of the whole and no individual part becomes discordant or overly assertive.

Richardson was the first American architect to dramatically affect the course of architecture across the continent within his own lifetime, to receive the approbation of his fellow architects, and to be recognized by the general public. His influence even spread to England and northern Europe. When in 1885 the members of the American Institute of Architects drew up their list of the ten best buildings in the United States, five of them were by Richardson.[44] Although initially inspired by the masses of round-arched Romanesque architecture of southern France, Richardson created an architecture that was his own, that grew out of a clear understanding of internal utilitarian and psychological function, and that used discreet and integrated ornament, to greater or lesser degree, to articulate and enhance those functions. He developed a method of design that enabled him to take on an incredible range of buildings, both small and large, functional and symbolic, private and public, city and suburban, in New England and the Midwest.

Regrettably, most other architects and clients saw only the round arches and specific Romanesque details; they missed the essential lessons of scale, mass, and reduction of detail, and made out of Richardson's architecture merely a Romanesque revival. Like all the previous revivals, this Romanesque revival had run its course by the turn of the century. In this quarter century of influence, however, Richardson's work inspired hundreds of Romanesque county courthouses, city halls, and collegiate buildings. Even if most of these derivatives lacked the penetrating analysis of function, or the expansive scale and generous spaces of the master's work, nonetheless the lessons inherent in Richardson's work—that plan was paramount, and that ornament should clarify a building's purpose rather than being an end in itself—were his continuing legacy for his followers in the United States, and in England, Scandinavia, and Germany.

BIBLIOGRAPHY

Baker, Paul R. *Richard Morris Hunt*. Cambridge, Mass., 1980.

Barlow, Elizabeth. *Frederick Law Olmsted's New York*. New York, 1972.

Beveridge, C. E., and P. Rocheleau. *Frederick Law Olmsted: Designing the American Landscape*. New York, 1994.

Buder, Stanley. *Pullman: An Experiment in Industrial and Community Planning, 1880–1930*. New York, 1967.

Bunting, Bainbridge. *Houses of Boston's Back Bay*. Cambridge, Mass., 1967.

Chafee, Richard. "Richardson's Record at the Ecole des Beaux-Arts," *Journal of the Society of Architectural Historians* 36 (October 1977): 175–84.

Condit, Carl W. *American Building Art: The Nineteenth Century*. New York, 1960.

Cromley, Elizabeth C. *Alone Together: A History of New York's Early Apartments*. Ithaca, N.Y., 1990.

Eaton, Leonard K. *Architecture Comes of Age: European Reaction to H. H. Richardson and Louis Sullivan*. Cambridge, Mass., 1972.

Fabos, Julius G., Gordon T. Milde, and V. Michael Weinmayr. *Frederick Law Olmsted Sr., Founder of Landscape Architecture in America*. Amherst, Mass., 1968.

Fein, Albert. *Frederick Law Olmsted and the American Environmental Tradition*. New York, 1972.

Garvin, James L. "Mail-Order House Plans and American Victorian Architecture," *Winterthur Portfolio* 16 (Winter 1981): 309–34.

Handlin, David. *The American Home: Architecture and Society, 1815–1915*. Boston, 1979.

Hitchcock, Henry-Russell. *The Architecture of H. H. Richardson and His Times*, rev. ed. Cambridge, Mass., 1966; original ed. New York, 1936.

Hubka, Thomas C. "H. H. Richardson's Glessner House: A Garden in the Machine," *Winterthur Portfolio* 24 (Winter 1989): 209–30.

Jackson, John B. *American Space: The Centennial Years, 1865–1876*. New York, 1972.

Kaufmann, Edgar, Jr., ed. *The Rise of an American Architecture*. New York, 1970.

Kidney, Walter C. *The Architecture of Choice: Eclecticism in America, 1880–1930*. New York, 1974.

Kowsky, Francis R. *The Architecture of Frederick Clarke Withers*. Middletown, Conn., 1980.

Kramer, Helen. "Detlef Lienau," *Journal of the Society of Architectural Historians* 14 (March 1955): 18–25.

Lancaster, Clay. *The Japanese Influence in America*. New York, 1963.

———. "Oriental Forms in American Architecture, 1800–1870," *Art Bulletin* 29 (September 1947): 83–93.

Landau, Sarah Bradford. *Edward T. and William A. Potter: American Victorian Architects*. New York, 1979.

———. *George B. Post, Architect: Picturesque Designer and Determined Realist*. New York, 1998.

———. *P. B. Wight: Architect, Contractor, and Critic, 1838–1925*. Chicago, 1981.

Landau, Sarah Bradford, and Carl W. Condit. *Rise of the New York Skyscraper, 1865–1913*. New Haven, Conn., 1996.

Larson, Paul C., and Susan M. Brown, eds. *The Spirit of H. H. Richardson on the Midland Prairies: Regional Transformations of an Architectural Style*. Minneapolis, Minn., and Ames, Iowa, 1988.

Lewis, Arnold. "A European Profile of American Architecture," *Journal of the Society of Architectural Historians* 37 (December 1978): 265–82.

Lewis, Arnold, and Keith Morgan. *American Victorian Architecture: A Survey of the 70s and 80s in Contemporary Photographs*. New York, 1975.

McClaugherty, Martha Crabill. "Household Art: Creating the Artistic Home, 1868–1893," *Winterthur Portfolio* 18 (Spring 1983): 1–26.

McKelvey, Blake. *The Urbanization of America, 1860–1915*. New Brunswick, N.J., 1963.

McMurry, Sally. *Families and Farmhouses in Nineteenth-Century America*, rev. ed. Knoxville, Tenn., 1997.

Meeks, Carroll L. V. "Creative Eclecticism," *Journal of the Society of Architectural Historians* 11 (December 1953): 15–18.

———. "Picturesque Eclecticism," *Art Bulletin* 32 (September 1950): 226–235.

Mumford, Lewis. *The Brown Decades*, 2nd ed. New York, 1955; original ed. New York, 1931.

Ochsner, Jeffrey K. *H. H. Richardson: Complete Architectural Works*. Cambridge, Mass., 1982.

O'Gorman, James F. *The Architecture of Frank Furness*. Philadelphia, 1973.

———. *Henry Hobson Richardson and His Office: Selected Drawings*. Boston, 1975.

———. *H. H. Richardson: Architectural Forms for an American Society* Chicago, 1987.

———. "The Marshall Field Wholesale Store: Materials Toward a Monograph," *Journal of the Society of Architectural Historians* 37 (October 1978): 175–194.

———. *Three American Architects: Richardson, Sullivan, and Wright, 1865–1915*. Chicago, 1991.

Rifkind, Carole. *Main Street: The Face of Urban America*. New York, 1977.

Roper, Laura Wood. *FLO: A Biography of Frederick Law Olmsted*. Baltimore, 1973.

Rosenzweig, Roy, and Elizabeth Blackmar. *The Park and the People : A History of Central Park*. Ithaca, N.Y., 1992.

Schuyler, Montgomery. *American Architecture and Other Writings*, 2 vols., ed. William H. Jordy and Ralph Coe. Cambridge, Mass., 1961.

Scully, Vincent. "Romantic Rationalism and the Expression of Structure in Wood: Downing, Wheeler, Gardner, and the 'Stick Style,' 1840–1876," *Art Bulletin* 35 (June 1953): 121–142.

———. *The Shingle Style*. New Haven, 1955; rev. ed. New Haven, 1971 (includes "Stick Style" article reprinted from *Art Bulletin*).

Stein, Susan R., ed. *The Architecture of Richard Morris Hunt*. Chicago, 1986.

Sullivan, Louis. *The Autobiography of an Idea*. New York, 1924.

————. *Kindergarten Chats and Other Writings*, ed. Isabella Athey. New York, 1947.

Sutton, S. B. *Civilizing American Cities: A Selection of Frederick Law Olmsted's Writings on City Landscapes*. Cambridge, Mass., 1971.

Thomas, George E., Jeffrey A. Cohen, and Michael J. Lewis. *Frank Furness: The Complete Works*. New York, 1991.

Turner, Paul V. *The Founders and the Architects: The Design of Stanford University*. Stanford, Calif., 1976.

Upton, Dell. "Pattern Books and Professionalism: Aspects of the Transformation of Domestic Architecture in America, 1800–1860, *Winterthur Portfolio* 19 (Fall 1984): 107–50.

Upton, Dell, and John Michael Vlach, eds. *Common Places: Readings in American Vernacular Architecture*. Athens, Ga., 1986.

van Rensselaer, Mariana Griswold. *Henry Hobson Richardson and His Works*. Boston, 1888; reprint 1969.

van Zanten, David. "Jacob Wrey Mould: Echoes of Owen Jones and the High Victorian Styles in New York," *Journal of the Society of Architectural Historians* 23 (March 1969): 41–57.

Weingarden, Lauren S. "Naturalized Nationalism: A Ruskinian Discourse on the Search for an American Style of Architecture," *Winterthur Portfolio* 24 (Spring 1989): 43–68.

Weisman, Winston, "The Commercial Architecture of George B. Post," *Journal of the Society of Architectural Historians* 31 (October 1972): 176–203.

————. "New York and the Problem of the First Skyscraper," *Journal of theSociety of Architectural Historians* 12 (March 1953): 13–21.

Zaitzevsky, Cynthia. *Frederick Law Olmsted and the Boston Park System*. Cambridge, Mass., 1982.

NOTES

1. Howard Mumford Jones, *The Age of Energy: Varieties of American Experience, 1865–1915* (New York, 1970).

2. The term *Second Empire Baroque* seems to have been coined by Henry-Russell Hitchcock, who came close to using it in his *Modern Architecture* (London, 1929); it was used as a definite descriptor in his epochal study *Architecture: Nineteenth and Twentieth Centuries* (Harmondsworth, 1958).

3. This split between aesthetics and engineering is paralleled in the design of the St. Pancras railroad station in London, with a lean and efficient train shed behind (measuring 689 feet long and having a clear span of 234 feet) designed by engineers (Barlow and Ordish), and a most elaborate, symbolic, and picturesque Gothic station house and hotel front or "head house" designed by a celebrated English architect (G. G. Scott). In the London example the two parts were even built at different times: the shed first in 1863–65, and head-house station and hotel in 1868–74. See L. M. Roth, *Understanding Architecture* (New York, 1993), 434–38; and also C. L. V. Meeks, *The Railroad Station* (New Haven, 1956).

4. *High Victorian Gothic* is also a late-twentieth-century critical term. Charles L. Eastlake simply used the phrase *Gothic Revival* in discussing the work of Butterfield, G. G. Scott, and Waterhouse in his book *A History of the Gothic Revival* (London, 1872). Again Henry-Russell Hitchcock seems to be the coiner, using "High Victorian Gothic" as early as 1957 in an article, and then as a clear stylistic descriptor in his *Architecture: Nineteenth and Twentieth Centuries*.

5. Excerpts from Ruskin's *Seven Lamps of Architecture* are reprinted in *America Builds*, 99–114.

6. Portions of Ruskin's *Stones of Venice* are also reprinted in *America Builds*, 114–22.

7. Both of these architects were born and received their training in England but emigrated early to the United States, where they practiced. Vaux had previously been associated with Frederick Law Olmsted in the design of Central Park (Manhattan), Prospect Park (Brooklyn), and Riverside, Illinois.

8. In *Edward T. and William A. Potter, American Victorian Architects* (New York, 1979), Sarah Bradford Landau notes that the foundations for a neoclassical library were laid under Potter's direction in 1858–59, but construction was halted; the building was completed only much later, in 1872–78, according to E. T. Potter's much revised Ruskinian design. Also of note is that the interior has an exposed iron skeleton.

9. William Henry Furness's address is reprinted from *Proceedings of the Fourth Annual Convention of the American Institute of Architects, November 8–9, 1870* (New York, 1871), 247–54, in Don Gifford, ed., *The Literature of Architecture* (New York, 1966), 390–404.

10. Not that Furness's work alone suffered from such willful destruction; Second Empire Baroque buildings also were destroyed left and right.

11. David Handlin, *American Architecture* (New York, 1985), 115.

12. An edited transcript of this famous trial, which helped to establish the professional status of the American architect, is reprinted in *America Builds*, 216–31; the Parmly-Rossiter house, the subject of the disputed charges, is illustrated there. Among the New York architects who testified on Hunt's behalf were George Bradbury, James S. Wightman, Richard Upjohn, Frederick A. Peterson, and Jacob Wrey Mould.

13. For the acceptance of these first true apartment houses, see Elizabeth Collins Cromley, *Alone Together: A History of New York's Early Apartments* (Ithaca, N.Y., 1990).

14. Henry Van Brunt, "Richard Morris Hunt," *Proceedings of the American Institute of Architects* 29 (1895): 71–84; reprinted in William A. Coles, ed., *Architecture and Society: Selected Essays of Henry Van Brunt* (Cambridge, Mass., 1969), esp. 332.

15. See John S. Garner, *The Model Company Town: Urban Design through Private Enterprise in Nineteenth-Century New England* (Amherst, Mass., 1984); for the statistics cited here, see L. M. Roth, "Three Industrial Towns by McKim, Mead & White," *Journal of the Society of Architectural Historians* 38 (December 1979): 317–47.

16. Both the design strengths and the social shortcomings of Pullman were analyzed in a critical essay by Richard T.

Ely, "Pullman: A Social Study," *Harper's Monthly* 70 (February 1885): 452–66; large excerpts from this are reprinted in *America Builds*, 202–16, with many of the original woodblock engravings.

17. Walt Whitman, "Wicked Architecture," *Life Illustrated* (July 19, 1856), reprinted in *The Annals of America* (Chicago, 1968), 8:407–10.

18. See Mardges Bacon, *Ernest Flagg: Beaux-Arts Architect and Urban Reformer* (New York, 1986), 237.

19. William Cullen Bryant, "Inscription for the Entrance to a Wood," 1821; reprinted in Robert McHenry and Charles Van Doren, eds., *A Documentary History of Conservation in America* (New York, 1972), 43–44.

20. Downing's essays in *The Horticulturist*, already noted in chapter 5, are discussed and partially reprinted in *America Builds*, 143–51.

21. Olmsted and Vaux's "Description . . . of the Central Park" is reprinted in part in *America Builds*, 174–82.

22. Olmsted's definitive essay on "Public Parks and the Enlargement of Towns," 1870, is reprinted in *America Builds*, 182–91.

23. "[T]he improvements now perfected at Riverside combine the conveniences peculiar to the finest modern cities, with the domestic advantages of the most charming country, *in a degree never before realized*," it was claimed in the booklet put out by the Riverside Improvement Company, *Riverside in 1871 with a Description of Its Improvements Together with Some Engravings of Views and Buildings* (Chicago, 1871; reprint 1974, Frederick Law Olmsted Society of Riverside), 6.

24. The report by Olmsted and Vaux to the Riverside developers is reprinted in *America Builds*, 192–202. See also the promotional pamphlet *Riverside in 1871*.

25. An indispensable aid in studying the impact of architectural publication is Henry-Russell Hitchcock, *American Architectural Books, New Expanded Edition* (New York, 1962, 1976). This covers the years 1775 to 1895, but a sequel study bringing the survey up to about 1950 is forthcoming from Keith Morgan and Richard Cheek.

26. See Eugene Mitchell, ed., *American Victoriana: Floor Plans and Renderings from the Gilded Age* (San Francisco, 1979).

27. For an extended discussion of architecture periodicals, see Michael Tomlan, "Architectural Press, U.S.," in *Encyclopedia of Architecture, Design, Engineering, and Construction*, ed. J. A. Wilkes and R. T. Packard (New York, 1988).

28. Morse's book, filled with line drawings of carpentry techniques, furniture, lighting fixtures, and other details, was to be a major contributing influence in the development of the Shingle Style in the 1880s.

29. For the importance of the Centennial celebration in the formation of the Colonial Revival see Vincent Scully, *The Shingle Style and the Stick Style*, rev. ed. (New Haven, 1971); and William B. Rhoads, *The Colonial Revival* (New York, 1970).

30. Portions of Beecher and Stowe's *The American Woman's Home* (New York, 1869), with illustrations, are reprinted in *America Builds*.

31. Eastlake quoted in Harold Kirker, *California's Architectural Frontier: Style and Tradition in the Nineteenth Century* (Salt Lake City, Utah, 1960), 106.

32. Vincent Scully, "Romantic Rationalism and the Expression of Structure in Wood: Downing, Wheeler, Gardner, and the 'Stick Style,' 1840–1876," *Art Bulletin* (June 1953): 121–42.

33. The house plans published by the Pallisers, Bicknell, the *Scientific American,* and most of the plan books of the 1880s cost anywhere from $1,500 to $3,500 to build; by contrast Hunt's summer retreat known as Marble House for Alva Vanderbilt in Newport, Rhode Island, built in 1892–95, cost around $2 million for the house alone and another $9 million for the interiors and furnishings; the large shingled house called Southside, in Newport, for Robert Goelet, designed by McKim, Mead & White, cost a comparatively modest $82,488 in 1882–84, while the firm's white terra-cotta Rosecliff for Herman and Tessie Oelrichs in Newport cost $298,043 in 1897–1902. To put these figures into proper context today multiply by a factor of at least fifty ($82,488 would become nearly $4.2 million; $298,043 would exceed $15 million).

34. The Bryan house is reprinted in color in Eugene Mitchell, ed., *American Victoriana.*

35. The Palliser plate and text are reproduced in *America Builds.*

36. For the Newsom brothers and family see David Gebhard, "Samuel Newsom and Joseph Cather Newsom," *Macmillian Encyclopedia of Architects* (New York: 1982), 3:292–98; and also David Gebhard et al., *Samuel and Joseph Cather Newsom: Victorian Architectural Imagery in California, 1878–1908* (Santa Barbara, Calif., 1979).

37. See Davis McCullough, *The Great Bridge* (New York, 1972); and The Brooklyn Museum, *The Great East River Bridge, 1883–1983* (New York, 1983).

38. Thomas Hubka and Jeffrey Ochsner have also suggested that the outline of the front gable, almost exactly that of a seventeenth-century saltbox, may be evidence of the growing interest in Colonial American architectural forms then developing among Richardson and his young assistants Charles Follen McKim and Stanford White; see their essay "H. H. Richardson: The Design of the William Watts Sherman House," *Journal of the Society of Architectural Historians* 51 (June 1992): 121–145.

39. See Margaret Henderson Floyd, "H. H. Richardson, Frederick Law Olmsted, and the House for Robert Treat Paine," *Winterthur Portfolio* 18 (Winter 1983): 227–48.

40. See James F. O'Gorman, "O. W. Norcross: Richardson's 'Master Builder,'" *Journal of theSociety of Architectural Historians* 32 (May 1973): 104–13.

41. Quoted by van Rensselaer in *Henry Hobson Richardson and His Works* (Boston, 1888), 22.

42. See James F. O'Gorman, "The Marshall Field Wholesale Store: Materials toward a Monograph," *Journal of the Society of Architectural Historians* 37 (October 1978): 175–94.

43. Louis Sullivan, from "Oasis," *Kindergarten Chats* (1901–2); quoted here from the Wittenborn edition (New York, 1947), 29–30.

44. "The Ten Best Buildings in the United States," *American Architect and Building News* 17 (June 13, 1885): 282.

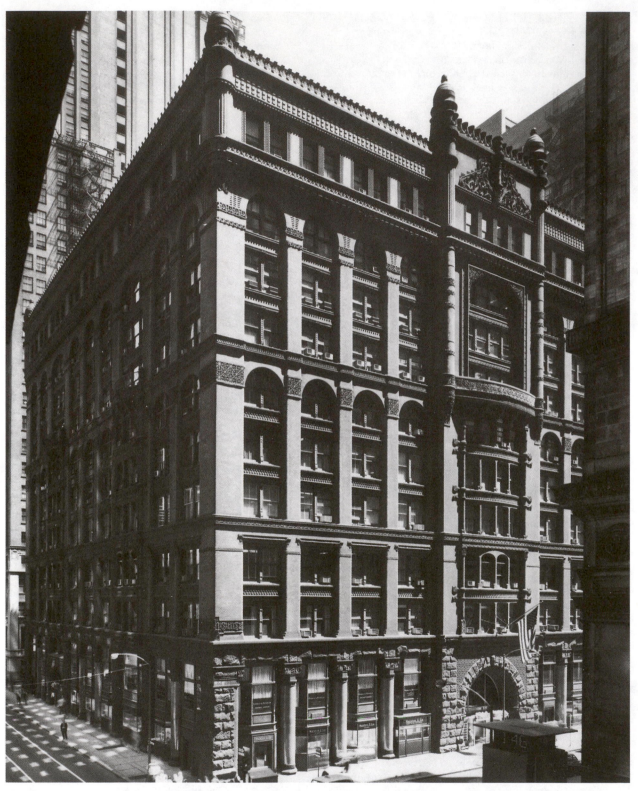

7.2. Burnham & Root, Rookery Building, Chicago, Illinois, 1884–86. Because this was to be a prestigious office block in the heart of Chicago's financial district, the clients agreed to a richly embellished design. Burnham & Root had their offices in one of the upper floors. (Library of Congress, HABS ILL 16-CHIG 31-1.)

THE ARCHITECTURE OF THE AMERICAN CITY AND SUBURB, 1885–1915

THE SEARCH FOR ORDER

Since building construction is so vitally dependent on periods of strong economic growth, the course of development of American architecture has often been shifted by strong economic and political changes. This has been especially the case during periods of prolonged military campaigns when the nation's energies were nearly or almost wholly devoted to the war effort. During the Civil War from 1861 to 1865 civilian construction was significantly curtailed although not completely stopped; and again during 1916–1918 and 1940–45 when the United States became involved in international conflicts civilian construction gradually slowed and then virtually stopped. In each of these situations, when building resumed it took off in a new direction.

In the mid-1880s, however, in the midst of a time of peace and relative economic calm, there was nonetheless a dramatic shift in the professional and public view of both public and private architecture. This shift marked a break between a period of rampant individualism, represented by conflicting diversity in both business and architectural design, and a new period marked by the emergence of rational and abstract standards applied nationwide in both business and design. The architecture of the years from 1865 to about 1884–85 was markedly irregular in plan and profile, splintered into disjointed elements by sharp angular forms and boldly contrasting colors; whereas after 1885 American architecture became increasingly marked by harmony, balance, and repose, its components knitted together by muted coordinated colors in building materials and integrated mural painting and sculpture. In the economic and business sphere, the years from 1885 to 1915 were similarly marked by growing consolidation and the application of a controlling discipline so as to achieve economy of effort and optimum profits. In industry, in particular, after a moderate recession in 1884, there was a decade and a half in which all of the major business enterprises were gathered into great conglomerates, the trusts. The major railroads were expanded by acquiring control of smaller branch and parallel lines, particularly by E. H. Harriman and James J. Hill; the need for national standards in business was made especially evident by the example of the railroads, which adopted a standard track gauge, the four national time zones established in 1883, and the strict adherence to a precise published time schedule that radically altered how Americans thought about time. The steel industry was consolidated by Andrew Carnegie in Pittsburgh by 1880, and on an even grander scale later by the United States Steel Corporation in 1901 in Gary, Indiana, where a new industrial city was built. The electrical industries coalesced into two great giants—the General Electric Company and Westinghouse—by the mid-1890s. The oil-producing and -refining business was dramatically consolidated by John D. Rockefeller, and even the manipulation of money and securities came to be dominated by J. P. Morgan at the end of the century—so much so, in fact, that in 1895 and again in 1907 it was Morgan alone who averted disastrous runs on the nation's banks as the federal government made ineffective gestures. Labor, too, became consolidated in the American Federation of Labor in 1886 under the leadership of Samuel Gompers.

So, it is not difficult to see why several historians—for example, Robert Wiebe—have seen a dominant theme in this period to have been a search for order in a culture that was becoming more and more complex.[1] The leaders of industry, in the absence of any help from the federal government, attempted to set up their

own standards for business enterprises carried out on a national and even continental scale, and if these efforts sometimes led to excesses, the federal government enacted controls at least on the worst overindulgence of monopoly. And, as will be shown, architects at this same time also sought a clearer sense of order in their work, and looked to find a truly national and modern architecture.

Just as utilitarianism fostered a growing standardization in business and industry, so too a wish for common standards appeared among architects during the 1870s. The centennial of 1876 and the concurrent focus on the national architectural heritage rekindled in architects an appreciation of the order and restraint of classical Georgian-Federalist architecture. This interest in adapting colonial elements and returning to classical decorum first appeared in domestic architecture, especially in the design of country houses, as is evident in the summer houses by McKim, Mead & White from 1879 to 1886. It was the beginning of a widespread return to a classical idiom that came to full force after 1893.

WOMEN AND
THE AMERICAN ARCHITECTURAL PROFESSION

Architecture was still almost exclusively a male profession, although for the first time women began to make names for themselves in American architecture.[2] The impact of women, first as arbiters of taste and then as practicing designers, began as early as the 1840s. One of the first women to have a truly national impact (although not an architect herself) was Catherine Beecher (1800–1878), who directed her writing largely to women. As early as 1841 she produced her first self-help book, *Treatise on Domestic Economy* (New York), which eventually culminated in her single most effective work, written in collaboration with her sister, Harriet Beecher Stowe: *The American Women's Home* (New York, 1869).[3] The purpose of these works was to make the woman's operation of the home more scientifically organized, even though, as twentieth-century critics have complained, Beecher's impact was to reinforce the traditional idea that a woman's place was in the home. However, Beecher also published articles on the design of apartment houses and exerted considerable influence on the practical design of houses after 1870.

Meanwhile, during the 1860s and 1870s other women were preparing themselves for careers in architectural practice or criticism, studying in private architecture offices, and enrolling in professional programs at home and in Paris, though their impact would be felt largely after 1880. The professional interest in establishing norms in design, and the growing academic study of historical architecture was not simply the concern of the male fraternity, for women began to make their presence felt in the profession. Mariana Griswold van Rensselaer (1851–1934) emerged in the 1880s as a major writer and critic on contemporary architecture, in her essays both in the popular literary *Century Magazine* and in the professional journal *American Architect and Building News*, and through her biographical study of H. H. Richardson, the first of its kind to appear in the United States.[4] As Lisa Koenigsberg has pointed out, van Rensselaer created for herself the important role of intermediary between the increasingly professional fraternity of architects and the lay public.

A number of women were also becoming practicing architects, overcoming great resistance from the male profession. Among the very first was Louise Blanchard Bethune (1856–1913). The few architectural schools that existed were reluctant to enroll women, so Bethune opted to get training in the office of Richard A. Waite of Buffalo. This proved to be a wise choice, as she got not only theoretical education but extensive practical experience on the building sites. In about 1877 she opened her own office in Buffalo, and in 1881 was joined by Robert Armour Bethune, her husband and partner. Perhaps her most significant accomplishment came in 1888, when she was formally elected to the American Institute of Architects, which was rapidly becoming the national professional organization. Among her buildings was the Union High School in nearby Lockport, New York, but much better was her Hotel Lafayette, in Buffalo, built in 1902–4, one of the most advanced such facilities of the time.

Another important architect was Minerva Parker Nichols (1861–1948), who also obtained her training through apprenticeship, with Philadelphia architect Frederick Thorn Jr. She attended classes at the Philadelphia Museum and eventually took over Thorn's practice when he retired in 1888. Sophia Hayden (1868–1953) took a different path, becoming the first woman to graduate from the architectural program at MIT. She had perhaps a more complete theoretical education, and a better grasp of the nuances of formal design as taught at the École des Beaux-Arts and MIT, but she had no practical experience outside

the design studio. Due no doubt to her superior knowledge of design she won the competition for the design of the Women's Building for the World's Columbian Exposition in 1891. But, having no practical field experience, when she had to take on the many details involved with construction of the building she was completely overwhelmed and suffered a mental collapse. This, of course, simply reinforced the prejudices of the male profession. Theodate Pope (1868–1946) became an architect via another unconventional route, taking some art classes at Princeton and working closely with the office of McKim, Mead & White in the design of her family's home, Hill-Stead, in Farmington, Connecticut, built in 1898–1901. She became a registered architect in 1910, was made a member of the AIA in 1918, and was elected a fellow of the AIA in 1926. A strong-minded, independently wealthy woman, she built relatively few buildings but was undaunted by the details of on-site job supervision. Perhaps her most complete and intriguing creation was Avon Old Farms School, near Farmington, Connecticut, its handcrafted buildings inspired by the vernacular architecture of the English Cotswold region; the buildings were begun in 1909.

The most successful of this generation of women was Julia Morgan (1872–1957).[6] A native of San Francisco, small of stature, and quiet, she was the first woman to earn an engineering degree at the University of California, Berkeley, in 1894. She worked in the office of Bernard Maybeck for a year and then headed to Paris, where she entered the École des Beaux-Arts in 1898, earning her Certificat d'Étude in 1902. Returning to San Francisco, she opened her own office and became a licensed architect. She operated a small independent practice for forty-six years, completing over eight hundred buildings, including structures for Mills College, Oakland, numerous YWCA buildings in the western United States and Hawaii, as well as homes and churches in the Bay Area. Her most famous, if perhaps atypical work, is the fanciful palatial retreat built for William Randolph Hearst, San Simeon, near San Luis Obispo, California, in 1920–37.

Meanwhile, during the 1890s the male profession established increasingly rigorous standards, and became a truly national professional organization. The American Institute of Architects established standards of practice and a uniform schedule of fees for its members. One after another, states began to institute licensing laws, so that architects now had to meet certain minimal standards to ensure that buildings were safe; soon this also meant that individuals could no longer simply hang up a sign and assume the title "architect." One element that increasingly bound professional architects together was their common educational experience at the École des Beaux-Arts in Paris, where increasingly Americans went to complete their theoretical education. Even those architects unable to get to Paris experienced a version of that Parisian esprit de corps in the design studios conducted in American universities patterned so closely on the École.

In addition, the AIA pressed Congress for passage of legislation that would set up competitions for new government buildings (with the terms somewhat tilted in favor of AIA members). Prior to 1893, competitions were so riddled by graft that many well-known AIA members, such as McKim, Mead & White and Daniel Burnham, flatly refused to participate. Passed in 1893 (but not put into effect until 1897), the Tarsney Act produced a large body of excellent federal buildings, including courthouses, post offices, and other structures, prompting many states and cities to organize similar competitions for their own buildings.[7] Although repealed early in the twentieth century, the Tarsney Act established standards of operating competitions that continued in effect through the Works Progress Administration (WPA) and the Public Works Administration (PWA) programs during the Great Depression. To further their national interests and to maintain a presence before Congress, the AIA leased William Thornton's Octagon house in Washington, D.C., in 1898, and purchased it as their national headquarters in 1902.

COMMERCIAL ARCHITECTURE

The Invention of the Office Skyscraper

It was clearly the increasing level of formal and theoretical education among American architects, coupled with careful reading of theoretical studies—both American and European—that instigated dramatic changes in building design from 1883 to 1885. Perhaps most significant, American architects focused their creative energies on what had previously received limited serious attention—the design of the speculative office building. Never before had the American economy and American architecture been so dominated by the quest of ultimate economic performance, becoming a mechanism for generating maximum profit. Fortunately for the succeeding generations who

have had to live with the buildings created from 1885 through 1930, architects then were individuals of artistic discrimination, trained to regard architecture as an art, and their patrons were willing and able to give them the freedom and the budgets to shape and embellish works of high distinction. This combination of conditions would largely disappear well before the end of the twentieth century.

Many technical forces also came together to reshape the American commercial high-rise building—economic, technological, and architectonic. As the central business districts of American cities became filled with buildings, the market value (and the taxes) on downtown property soared. Simultaneously, numerous technical innovations (such as the elevator) rendered obsolete the traditional arrangement and structure of commercial buildings; socially and culturally, the perception of how an office building should look changed. Steel, which had been available only in limited quantities prior to Bessemer's discoveries in 1856, began to be produced in larger and larger quantities by means of the Siemens-Martin open hearth furnace (developed in 1856 and then improved by the Thomas alkali process in 1878), so that by about 1885–90 the price per ton of steel was low enough to permit entire buildings to be framed with steel members specially produced for that purpose. At the same time, businesses quickly adopted the telephone (developed in 1876), typewriter (1868), mimeograph (1876), and inexpensive reliable incandescent lighting (1879), which for a time had competition in the Welsbach gas lamp mantle introduced in 1885. The synergetic effect of all of these developments was to radically change the nature of business communications and building illumination, to concentrate business management in dense masses in urban centers instead of at the point of production. Within a few short years these inventions had become basic to American business and urban culture, and at the same time American businesses were being transformed from small individual or family proprietorships into national corporations with ever growing numbers of managers and assistants who needed to be housed in compact, efficient office buildings. Coupled with the increasing pressure of urban populations and the concomitant intensive use of land, these innovations made the development of the tall, self-contained office skyscraper desirable, possible, and perhaps inevitable.

Inevitable, in the United States, that is. Although similar land and economic pressures had long been at work in European cities, raising soaring office or business towers there was strongly inhibited because such buildings would have been considered a blight on the urban cityscape, a gesture of poor manners that demonstrated a lack of consideration for the common good and the common cityscape. In the United States, however, no such polite or public restraints existed; the common good was served by maximizing private profit. As President Calvin Coolidge would say somewhat later, "The business of America is business." A bold, assertive, and aggressive demonstration of individual or corporate strength, of braggadocio, in a building was considered most appropriate and desirable.

The urgency to build higher and bigger in the 1880s was nonetheless tempered by a simultaneous desire among several architects to express the structural and functional realities of the building more clearly and more harmoniously. The desired clarity and harmony were in some instances achieved through the development of a rigorously analyzed personal design idiom, as was done by Sullivan, but it was more common to return to the more commonly understood, and systematically taught, stylistic language that embodied principles of balance, harmony, and decorum—the classical architecture of the Renaissance and of ancient Rome (and by extension ancient Greece). It was a gradual development growing out of a broad cultural predisposition, for there was no single persuasive propagandist for this classicism, as Downing had been for Gothic or Lafever for Greek a half century before. As the pace of technological and cultural change quickened and intensified, so the need for emotional security through historical associationalism in architecture became more insistent. Thus, in the turbulent years in which modern American society emerged, and in the two decades that followed, from 1915 to 1935, there flowered a traditional architecture that is still unsurpassed in its exploitation of fine building materials, sensitive and interpretive use of historical detail, and ingenuity in planning. This creative academic eclecticism, a resurgence of the eclectic spirit of the nineteenth century, was a search for both formal order and psychological reassurance.

Meanwhile, metal framing was beginning to change the way prospective clients and their architects looked at large buildings, especially office buildings. For decades there had been buildings in England and France, and then in the United States, that used cast-iron and wrought-iron members to support masonry enclosing walls, one example being by James Bogardus, who erected a shot-making tower in New

York City in 1855, using a light cast-iron frame whose beams carried brick wall panels through all eight stories. The problems inherent in this building approach were the brittleness of crystalline cast iron, especially in beams (this could be corrected by using wrought-iron members), but more serious was the danger of rapid collapse of iron structures if the supporting iron members were not protected and insulated from the softening heat of fires. Nor were these early iron frames particularly rigid. As already noted, in his New York Produce Exchange George B. Post had come very close to devising a freestanding ferrous metal skeleton to carry all building loads—exterior walls as well as the interior floors.

William Le Baron Jenney (1832–1907) made slight changes in his use of iron supporting members in his Home Insurance Building, in Chicago, of 1883–85, but he did not develop a true skeletal frame in that building as has often been claimed.[8] He and other Chicago architects were taking incremental steps as they approached the creation of a true and complete iron skeletal framing system. Jenney's engineering training and experience were especially good for an American of this period, for he had studied engineering at Harvard's Lawrence Scientific School for two years, followed by three years in Paris at the École Centrale des Arts et Manufactures; there Jenney was taught building design as a branch of general engineering, not as one of the fine arts, but he did absorb some of the feeling for néo-grec structural expression, employing this general approach in his masonry Portland Block, in Chicago, built in 1872.[9] Very much like Post in the New York Produce Exchange, Jenney placed an internal slender iron pilaster against the outer wall piers of his First Leiter Building, in Chicago, built in 1879, using an internal frame of slender cast-iron columns to support thick wood girders. The peripheral-wall iron pilasters carried the floor loads only, while the surrounding brick and stone piers were self-supporting, and the iron lintels resting on these masonry piers carried only the weight of the windows. The use of the outer-wall iron supports meant that the masonry piers could be made extremely narrow (certainly in comparison to buildings using masonry alone in their outer walls), and this in turn allowed for larger windows and the admission of more light that became common in the work of Chicago architects.

The next cautious step was to rest the iron lintels of the exterior wall directly on the iron columns embedded in the outer wall, which Jenney did in the Home

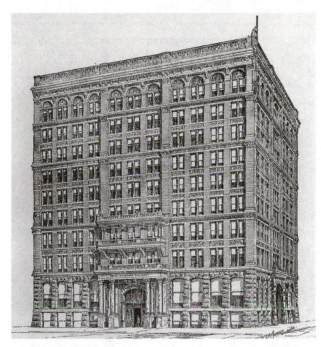

7.1. *William Le Baron Jenney, Home Insurance Building, Chicago, Illinois, 1883–85. Forced by a bricklayers' strike to switch to full metal framing, Jenney completed the first skyscraper in modern structural terms. (A. T. Andreas,* History of Chicago, *Chicago, 1884–86.)*

Insurance Building (but he used iron wall columns only from the third floor upward in this building). [7.1] The iron wall lintels were not fastened to the cast-iron columns, nor were the intermediate iron mullions attached by bolts or rivets; this allowed some rotational flexibility among the wall elements as the building settled after construction. In essence, the cast-iron columns were a kind of reinforcement in the outer structural masonry piers. Even if there was a kind of continuous cage of iron members above the second floor, Jenney was not concerned about expressing its presence or structural purpose through any unique or novel detailing of the encasing masonry. Although the ways in which Jenney used iron supporting members in the exterior walls of the Home Insurance Building were fairly well known in Chicago from 1883 to 1885, no other architect immediately seized on this technique.

Jenney would take the next step by making a complete cast-iron and wrought-iron skeletal cage (with some steel as well), supporting all internal floor loads and all outer encasing wall and window loads, in his Fair Store in Chicago, built in 1890–91, and his Manhattan Building in Chicago, built in 1889–91,

working with engineer Louis E. Ritter. Built with twelve stories, the Manhattan Building had another four stories added a few years later, making it, briefly, the tallest office building in the world. Because the Manhattan Building's tall broad sides were subjected to considerable wind pressure, Jenney incorporated numerous forms of wind bracing to resist these lateral forces; Ritter claimed that this was the first office building to deal with wind forces. At about the same time, in 1889–90, architects Burnham & Root designed and built the second Rand McNally Building (destroyed two decades later) using complete skeletal steel construction. As these examples suggest, within six years Chicago architects had moved from traditional structural masonry to full steel structural skeletons.

In making this step to a full metal frame, Jenney and other Chicago architects and engineers also solved another problem most troublesome in Chicago. Unlike the builders of New York or Boston, who could put their massive bearing-wall office blocks on the solid rock that lay only feet below the ground surface (and still today must be laboriously blasted away), Chicago architects had to deal with multiple layers of sand, gravel, clay, and other compressible deposits left by many thousands of years of glaciation; bedrock might lay anywhere from 100 to 150 feet down. Moreover, the compressibility of Chicago's soil varied from place to place, even within a single building site, and dense clay layers might lay above highly compressible layers below. The substitution of a metal frame for traditional thick masonry bearing walls

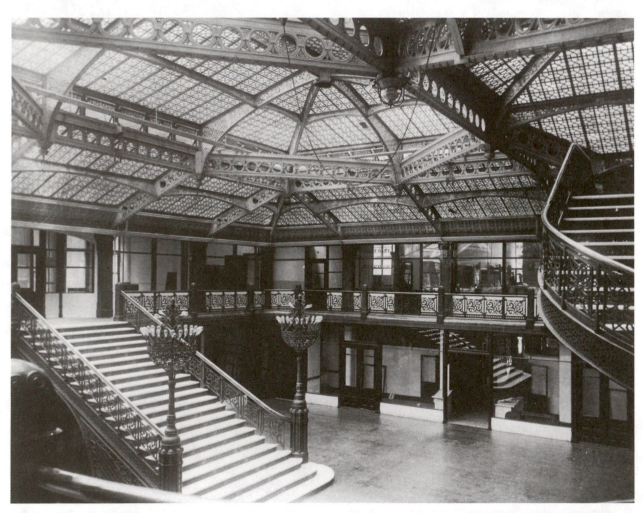

7.3. Rookery Building. The large glass-covered court is at the base of the hollow inside the square building (this view shows it as completed by Burnham & Root and before the alterations made by Frank Lloyd Wright in 1904). (Photo: Charles Allgeier, Chicago, c. 1887–88; author's collection.)

could easily reduce the weight of a building by 50 percent, and careful design could increase the weight reduction another 10 percent. In such difficult soil, this weight reduction was greatly needed.

As illustrations of the Home Insurance Building show, the multitude of elements Jenney employed in the facade did not clearly express the radical nature of the structure or internal operations within. Nonetheless, although originally only ten stories high, this skeletal metal-framed building made the potential for height in commercial building seemingly unlimited. Furthermore, the clear logic of Jenney's work attracted young people to his office, and during his career Jenney trained an entire school of Chicago architects, including Louis Sullivan, Daniel Burnham, William Holabird, and Martin Roche.

After leaving Jenney's office, Daniel Burnham (1846–1912) worked briefly in the office of Carter, Drake, and Wight—the same Peter B. Wight who had earlier designed the National Academy of Design in New York, and who later moved to Chicago, promoting there terra-cotta fireproofing of iron skeletal frames. Burnham then formed a partnership with John Wellborn Root (1850–1891), who had been raised in Georgia and who had studied architecture, art, and engineering in England. After the Civil War Root had earned a bachelor of science degree in civil engineering at New York University, working for Renwick and Snook in New York City before moving to Wight's office in Chicago and then entering Burnham's office. In their partnership, Burnham designed, attended business matters, and managed the office, while Root functioned as the principal designer and engineer. Root was both a rational pragmatist and an artist, and had his career not been cut short in 1891 by pneumonia, American architecture would surely have profited by his synthesis of these two seemingly antithetical forces.

Among the first fruits of Burnham and Root's collaboration was the simple but exceedingly well planned and detailed Montauk Block, in Chicago, built in 1881–82, for Peter and Shepard Brooks of Boston. This was followed by another Chicago commission for the Brookses, the Rookery, built in 1884–86, which employed the typical Chicago scheme of a large hollow square block around an internal light court. [7.2 on p. 264, 7.3] The exterior masonry wall, employing stylized Romanesque motifs, was self-supporting, but along the narrow alleys to the rear, the need for large windows persuaded Root to use a metal frame, resulting in very thin structural piers. In the firm's Monadnock Building, in Chicago, built in

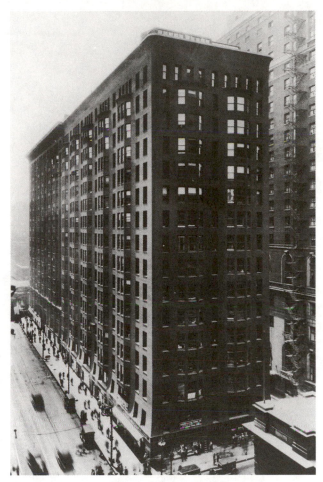

7.4. *Burnham & Root, Monadnock Building, Chicago, Illinois, 1884–85, 1889–92. Desiring a very simple building, the clients urged Root to strip away ornamental detail. (Condit Archive, Northwestern University.)*

7.5. *Monadnock Building, plan. This lower-floor plan shows the thick outer brick bearing walls, compared to the compact built-up iron H columns in the internal metal frame. The ground floor walls were 6 feet thick. (L. M. Roth, after HABS.)*

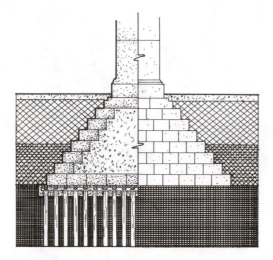

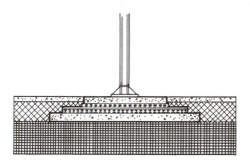

7.6. Comparison of a masonry pyramidal foundation pier (on wooden pilings) with a Chicago floating raft concrete foundation pad.

Henry Hobson Richardson, Trinity Church, Boston, Massachusetts, front wall foundation, c. 1873–74. Richardson's construction drawings for the foundations under the Trinity Church front towers—with a section on the left half and elevation on the right half—show massive stone and concrete foundation piers resting on a grill of wood timbers laid on numerous wood pilings driven into the loose gravel fill of Boston's Back Bay. (L. M. Roth, after Richardson, in J. F. O'Gorman, ed., Selected Drawings: H. H. Richardson and His Office, Boston, 1974.)

7.7. William Le Baron Jenny, Fair Store, Chicago, concrete foundation pad, 1890–91. Jenny's foundation pad takes up only a few feet of depth, and is reinforced by closely spaced steel railroad rails (visible in section in alternate layers); a large cast-iron shoe distributes the steel column load to the concrete pad. (L. M. Roth after W. L. Jenny in Engineering & Building Record 24, November 14, 1891: 388.)

1884–85 and 1889–92, also for the Brooks brothers, Root reduced the building to an elemental statement. [7.4] Finished after a hiatus of several years, the building had been stipulated by the Brooks brothers to be of traditional bearing-wall construction, but with an unprecedented height of sixteen stories. Root therefore confronted several problems. One technical problem was how to support the enormous weight of such a solid masonry building on the soft Chicago soils without it sinking. An aesthetic problem was how to articulate such a tall exterior, rendering it unified and harmonious. His original idea was an ideogram of the Egyptian papyrus column, but over the long period of design he gradually stripped away historical detail, leaving only a massive brick pile with a slightly curved base and an outward-curving cavetto cornice at the top. No stringcourse or projection breaks the upward rush of line: the tapered mass of the Monadnock Building becomes its own ornament. In spite of Root's artistic achievement in making this tall building a unified, coherent statement, it was structurally traditional, employing cast-iron and wrought-iron framing only for window spandrels and the internal frame. Consequently the exterior walls at ground level had to be six feet thick to carry the upper floors. [7.5] The massive bulk of the walls then rested on straight piers supported by broad flat iron-reinforced-concrete rafts or pads, evenly distributing the weight to the compressible soils. If tall buildings were to be economical to build and profitable to rent, valuable ground-floor and basement space could no longer be thus given over to thick bearing walls; the metal skeletal frame on flat pads was the logical alternative.

Many of Root's most important innovations were never visible, for his engineering training enabled him to solve foundation problems. Traditionally when building on soft subsoils (as Richardson had done on the fill of the Back Bay for his Trinity Church), builders first pounded wood piles into the soil to a level below the normal water line, the tops of the wooden piles were leveled off and covered with a grillage of wood timbers, capping the grillage with a broad stone or stone-concrete cap. On top of this a broad masonry footing was built, often filled with concrete, tapering upward and inward at roughly 45 degrees up to the line of the base wall. Under isolated columns this technique produced fat pyramids carrying loads down to a square pattern of piles. [7.6] This was how the great weight of Richardson's Trinity Church was carried by the relatively loose gravel fill of Boston's Back Bay.[11] Root's major change, quickly

adopted by other Chicago architects such as Jenny, was to use a flat pad over the pilings, or even on the subsoil itself, consisting of crisscrossed iron or steel rails (often actual railroad rails) encased in concrete—in other words a relatively thin but strong reinforced-concrete raft or pad. [7.7] This meant that a whole floor of usable space was recovered from what formerly had been a basement level consumed by massive pyramidal foundations. This technique and many others Root published and illustrated in highly readable papers.[13] Varying the size of these rafts in accordance with the weight applied to them, and to the bearing capacity of the soil at any particular point under a building, Root was able to ensure that as a building compressed the soil beneath it, it would settle evenly. Other civil engineers who made significant, but invisible and hence often unheralded contributions to highrise building in Chicago include Frederick Baummann (1826–1921), William Sooy Smith (1830–1916), and Corydon T. Purdy (b. 1859).

In another office building started while the Monadnock design was being developed, Burnham & Root worked out the quintessential expression of the steel frame. The Reliance Building, in Chicago, was built in 1889–91 and 1894–95. [7.8] This building, for William Ellery Hale, was built in two stages: the ground floor, with its great banks of plate glass designed entirely by Root before his death, was finished first; the upper floors were completed later, adapted from Root's designs by Charles B. Atwood (taken on as Root's replacement by Burnham). Because of the conditions of the site, a complete steel frame was used to carry the sixteen floors. [7.9] The upper floors, sheathed in white glazed terra cotta, are opened up through wide expanses of glass forming the characteristic "Chicago window" with one wide fixed pane flanked by narrow double-hung sashes. Nowhere is there the suggestion of a traditional bearing wall; instead the building consists of a transparent skin over the structural skeleton. The terra-cotta pieces, protecting the metal from oxidation and fire, are visually broken down into small elements by the delicate Gothic detailing designed by Atwood (a touch of historicism that Root probably would have avoided), minimizing the sheathing while emphasizing the vertical lines. Typical also of the Chicago skyscraper is the undulating wall with its projecting oriel bays, recalling Holabird & Roche's Tacoma Building of 1887–89. It is also significant that in the upper floors by Atwood there is a shift away from Root's original dark brown hues toward an ivory white.

7.8. *Burnham & Root, Reliance Building, Chicago, Illinois, 1894–95. Exploiting the strength of a thin steel skeleton, Burnham & Root opened up the outer walls with broad sheets of glass; to observers at the time, such buildings seemed to be as transparent and insubstantial as bubbles. (Library of Congress, HABS ILL 16-CHIG 30-2, photo by J. W. Taylor, c. 1892.)*

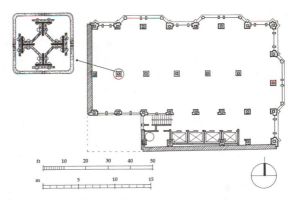

7.9. *Reliance Building, plan. A typical upper office floor plan of this building indicates the small point supports that steel columns made possible, freeing up significant interior space. (L. M. Roth, after HABS. The built-up steel columns were shown in a detail published in J. K. Freitag,* Architectural Engineering, *New York, 1912.)*

Burnham & Root was one of a number of firms then active in Chicago; the best known is certainly Adler & Sullivan. Dankmar Adler (1844–1900), born in Lengsfeld, Germany, immigrated with his parents to Detroit, where he worked in the office of engineer E. Willard Smith. After moving to Chicago, Adler enlisted in the Union Army, serving with the corps of engineers; this was the extent of his "formal" training. Beyond this experience, Adler was largely self-taught, yet he acquired a vast knowledge of structural techniques, building methods, and acoustics, which he made his particular specialty. Louis Sullivan (1856–1924) was born in Boston; the summers of his youth were spent with grandparents in South Reading, Massachusetts, where Sullivan developed an almost pantheistic adoration of nature and a marked independence of spirit. In 1872 he enrolled in the relatively new architectural program at the Massachusetts Institute of Technology, but, chafing under what he thought sterile instruction, he left at the end of the academic year. On the advice of Richard Morris Hunt, Sullivan went to work for Frank Furness in Philadelphia, Hunt's former pupil, but he could be kept on for less than a year due to the poor business conditions of the severe depression in 1873. Venturing to Chicago, where his family had moved, Sullivan worked in Jenney's office during 1873–74, making many acquaintances that later were important for his career (Chicago continued to build, to replace buildings destroyed in its catastrophic fire of 1871). Nonetheless, recalling Hunt's accounts of his days in Paris and perhaps urged by Furness, Sullivan set out for Paris in summer 1874 to complete his education at the École des Beaux-Arts. Ever impatient, however, Sullivan soon left Paris and the atelier of Émile Vaudrémer in 1875, but while at the École he absorbed the basic discipline of academic architecture with its focus on functional planning, sound construction, articulation of a building's exterior to express its internal function, and sensitive embellishment to enhance a building's character and to indicate its function.[14]

Sullivan's mind was one of the most searching and analytical of his day; he was perhaps the first American architect to consciously explore the relationships between architecture and American culture. In his addresses, papers, and published articles he spoke eloquently but abstrusely, always passionately, about the urgent need to create a new architecture of democracy. His theory also became one of structural rationalism, based on ideas of the sculptor Horatio

Greenough, Ralph Waldo Emerson, and Gottfried Semper. In "Thoughts on Art," written in 1841, Emerson proposed that "whatever is beautiful rests on the foundation of the necessary," an idea concurrently being developed by Greenough, who expressed it most succinctly in *The Travels, Observations, and Experience of a Yankee Stonecutter* (New York, 1852): "Beauty is the promise of function." Both agreed too that "all beauty is organic," as Emerson wrote in "Beauty" in 1860; or as Greenough put it in "American Architecture" (published separately in 1843 and then incorporated into *Travels*), beauty "is the consistency and harmony of the parts juxtaposed, the subordination of details to masses, and of masses to the whole."[15] Sullivan also drew upon his reading of the work of Darwin and Owen Jones, which, coupled with his innate love of nature and plant life and the example of Furness's boldly inventive idiosyncratic ornament, formed the basis for Sullivan's delicate foliate ornament. Infusing everything he did was a penetrating vision of the functional requirements of each building, so that element led to element with a logical inevitability; this he learned from his experience at the École.

This synthesis is only partially apparent in the building that first attracted national attention to the firm of Adler & Sullivan, the Chicago Auditorium, built in 1886–90. [7.10] What the auditorium indicated, however, was that a huge building, occupying an entire block, could be harmonized and expressed as one great unit, an idea that Sullivan drew from such examples as Richardson's Field's Wholesale Store, 1885–87, and Root's slightly earlier McCormick Offices and Warehouse, 1884–86 (now demolished) in Chicago. The auditorium was built for a syndicate of businessmen to house a large civic opera house; to provide an economic base it was decided to wrap the auditorium with a hotel and office block. Hence Adler & Sullivan had to plan a complex multiple-use building. Fronting on Michigan Avenue, overlooking the lake, was the hotel (now Roosevelt University), while stacks of rental offices were placed to the west along Wabash Avenue. [7.11] The entrance to the auditorium is on the south side beneath the tall, blocky seventeen-story tower. The rest of the building is a uniform ten stories, organized in the same way as Richardson's Field's Wholesale Store with a massive arcaded base, taller multilevel narrow upper arcades, and a terminating attic level. The interior embellishment, however, is wholly Sullivan's, and some of the details, because of their continuous curvilinear foliate

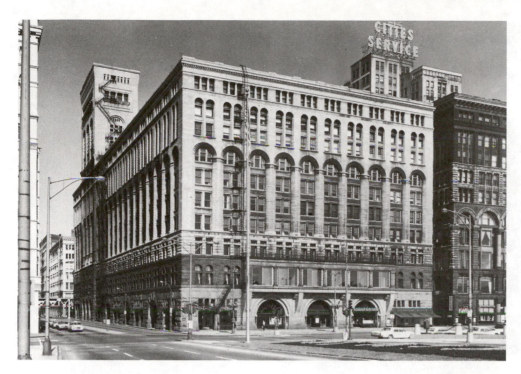

7.10. *Adler & Sullivan, Auditorium Building, Chicago, Illinois, 1886–90. Like Richardson's Marshall Field Wholesale Store (which inspired this), Sullivan's massive multifunctional building was organized by means of tall window arcades. (Library of Congress, HABS ILL 16-CHIG 39-1.)*

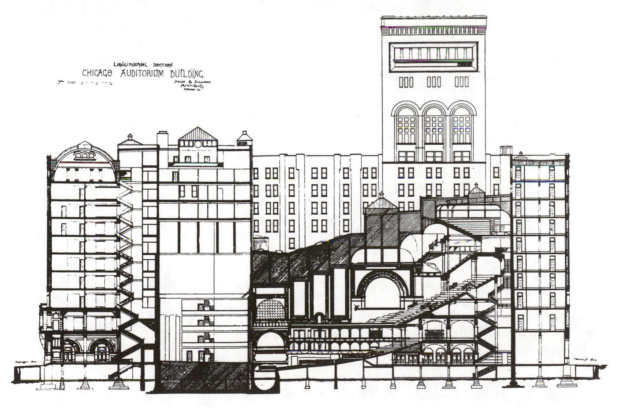

7.11. *Auditorium Building, plan. The section shows how Adler placed the large auditorium in the center, with the hotel on the east (left) and the hotel to the west (right); it also shows Adler's attention to providing the best acoustics by using dramatically upward-sloping floors. (From* Inland Architect and News Record, *July, 1988, courtesy of the Burnham Library, Art Institute of Chicago.)*

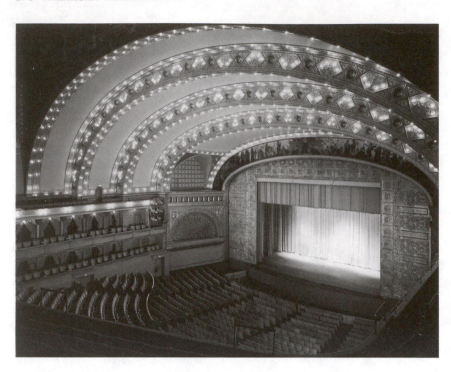

7.12. *Auditorium Building, interior view of the Auditorium theater. The concert hall employed ranks of elliptical arches to disperse sound throughout the hall. (Photo: Hedrich-Blessing, Chicago Historical Society.)*

motifs, are among the nearest equivalents to European Art Nouveau architecture. Both Adler's and Sullivan's attentions were focused on the auditorium room. The floor slopes up steeply, designed to provide optimum acoustics for every seat in the house, while the dropped plaster ceiling of four broad elliptical arches and cove vaults is proportioned to sustain reverberations while minimizing echoes. Despite its huge size (once up to 3,156 seats), the Chicago Auditorium is acoustically one of the best large concert halls in the world. The surfaces of the auditorium are enriched by low-relief plaster panels of interlacing foliate forms studded with the newly invented electric light bulbs. Also incorporated in the ornamental patterns are outlets for the ventilation and heating systems designed by Adler that included a rudimentary system for cooling (but not dehumidifying) the air in the summer. [7.12] Structurally traditional, the auditorium employed massive masonry bearing walls on the exterior with a complex iron and steel frame supporting the interior and the auditorium balconies and vaults.

The functional promise of the auditorium was fully realized by Sullivan in the Wainwright Building, in St. Louis, Missouri, built in 1890–91. [7.13] In this building all the elements of structure and form of the modern skyscraper were developed: the entire building is carried on a steel frame fireproofed by brick and terra-cotta sheathing; reinforced-concrete raft foundations support the column loads. All partitions in the office floors are movable since all loads are carried by the steel frame. All these are technical considerations; what is even more important is how Sullivan analyzed and gave clear expression to the external elements of this tall office building. At ground level, where shops are located, are wide plate-glass windows for display, with a second-level mezzanine of broad windows for shop offices. Above all this, in an uninterrupted upward rush of seven stories, are the narrow windows of the office cells, with terra-cotta spandrel panels set back from the face of the narrow brick piers so that the vertical emphasis is not compromised. At the top is a foliate frieze of high-relief terra cotta, and a bold cornice slab. To bring light to all offices, the building is **U**-shaped, with an internal light court. [7.14]

The Wainwright Building demonstrates Sullivan's views about the interrelatedness of form and function. He wrote that "if a building is properly designed, one should be able with a little attention to read through that building to the reason for that building."[16] Form, in other words, should follow function. In this Sullivan drew from the ideas Gottfried Semper had expressed in his essay "Development of Architectural Style," which had just been translated by John Root and published in the *Inland Architect* in 1889.[17] A true style, Semper argued, arose from needs growing out of the conditions of life, a view previously articulated by Greenough in his "American Architecture," in which he said character and expression resulted from an

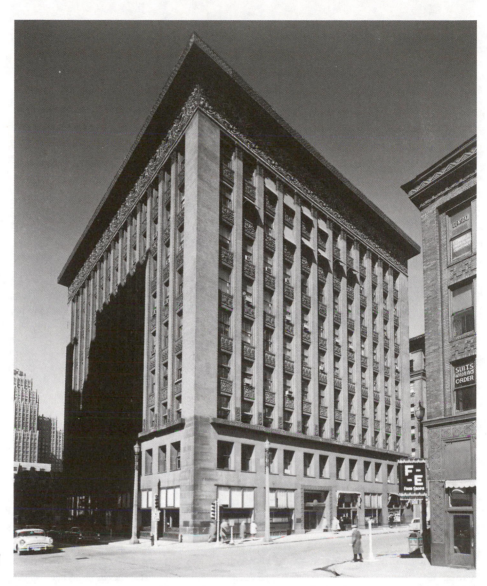

7.13. Adler & Sullivan,
Wainwright Building, St.
Louis, Missouri, 1890–91.
In the Wainwright Building,
for the first time, Sullivan
dramatically stressed the
vertical elements to
emphasize the height of the
new office block. (Photo: Bill
Hedrich, Hedrich-Blessing.)

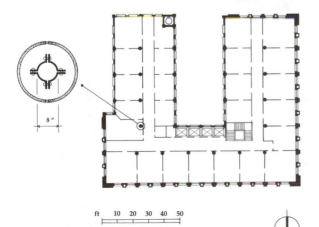

7.14. Wainwright Building, typical
upper-floor arrangement, plan. The
plan of the Wainwright Building
illustrates how Chicago architects
hollowed the center of tall office
blocks, providing an internal light
court. (L. M. Roth, after D.
Hoffman, Frank Lloyd Wright,
Louis Sullivan, and the Skyscraper,
Mineola, N.Y., 1998. The distinctive
built-up round steel Phoenix
columns, illustrated by Hoffman,
were only 8¹/₂ inches in diameter.)

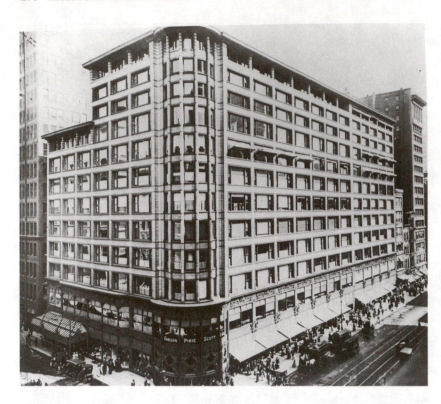

7.15. Louis Sullivan, Carson, Pirie, Scott & Company Store (Schlesinger & Mayer), Chicago, Illinois, 1898–1904; extension, 1906, by D. H. Burnham and Co. In the Schlesinger & Mayer Store, in contrast to an office block, Sullivan emphasized the horizontal line because of the large horizontal display floors within. (Library of Congress, HABS ILL16-CHIG 65-1.)

"unflinching adaptation of a building to its position and use." As the proper method of procedure Greenough had suggested that "instead of forcing the functions of every sort of building into one general form, . . . let us begin from the heart as a nucleus and work outward." This is exactly what Sullivan did, analyzing simply and cogently the functional activities in the modern commercial high-rise in his essay "The Tall Office Building Artistically Considered," published in *Lippincott's Magazine* in 1896.[18] The essay summarizes what he had already done in the Wainwright Building where he emphasized and differentiated each of the three major visible sections— ground-floor shops, midsection offices, and uppermost mechanical equipment—each with its own separate expression. To augment the verticality of the building, its great distinguishing characteristic, Sullivan doubled the number of vertical piers, giving the bulk of the building a vertical thrust similar to that achieved by fluting on classical columns. In fact, the tripartite division of the building into base, shaft, and capital is an analog to classical forms and reflects the logic Sullivan had absorbed in Paris. Sullivan perfected this basic form in the Guaranty Building, in Buffalo, built in 1895, where the exterior is completely sheathed in terra cotta whose foliate designs

increase in relief from the ground floor to the thirteenth-story attic. In this way all parts can be read and understood from the street.

There were other office buildings by Adler & Sullivan, such as the Stock Exchange, in Chicago, built in 1893–94 (now demolished), in which some of the support columns were themselves supported by caisson foundations—the first time they were used for any purpose other than under bridge piers. All of these office blocks were organized according to the same basic tripartite formula, with a stack of office cells above a ground-floor shop area.[19] When Sullivan came to design the Schlesinger and Mayer Store (later Carson, Pirie, Scott, and Co.), he had to deal with a radically different function. Instead of a stack of undifferentiated office rooms, the department store required broad horizontal open spaces where goods could be displayed before a customer's sweeping view; at the ground floor the windows were to be showcases highlighting selected wares. Thus in the finished building, constructed in two phases in 1898–1904 and 1906 [7.15], the horizontal line, rather than the vertical, is dominant, with the broad spandrel panels brought up flush with the narrow vertical piers. Nevertheless, the tripartite division is present with: (1) ground-floor windows richly encrusted with cast-iron

frames by Sullivan and his assistant george Grant Elmslie, (2) midsection, and (3) the terminating attic and cornice slab. As in Burnham & Root's Reliance Building, there is a change in color, away from the deep reds and browns, to glazed white terra cotta, with green paint, highlighted with discreet flecks of gold and red, protecting the cast-iron window frames.

The depression of 1893 sharply cut back the commissions of Adler & Sullivan; eventually Adler had to leave the firm to provide support for his family. Alone, Sullivan was given fewer and fewer commissions. Even so, some of his finest work is from these last years. He finished the small but elaborately embellished Bayard (Condict) office building in New York City, built in 1897–99. Circumstances brought to Sullivan a series of small banks in prairie towns in the first decades of the new century. All are simply modeled spaces— essentially boxes—encrusted with some of the most expressive and delicate ornament Sullivan ever designed; much of the credit for this embellishment is due to Sullivan's lone assistant, Elmslie. Arguably the best of

these banks is the National Farmers' Bank in Owatonna, Minnesota, built in 1907–8. [7.16] Though much smaller in scale than the earlier skyscrapers, the bank is just as clearly expressed in its parts. The main banking room is a single cubical box whose expansive space is expressed by the wide stained-glass lunette windows. The base is of red sandstone, with textured dark red brick walls. Ornamentation is concentrated in panels of bronze-green terra cotta, with intricate cast-iron escutcheons at the corners; the cornice is simply corbeled brick courses. To the rear is a separate lower block housing rental offices and shops, a speculative venture by the bank, but clearly related to the bank in materials and design. The other scattered small banks were basically similar, with clearly expressed banking rooms, colorful textured materials, and pockets of dense, intricate ornamentation. They were modest works that held fast to the architect's expression of function through form.

Sullivan was both creator and prophet of the modern commercial skyscraper, and is recognized as the

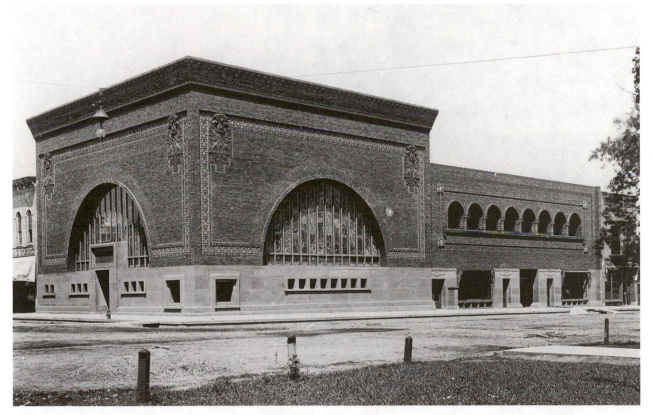

7.16. *Louis Sullivan, National Farmer's Bank, Owatonna, Minnesota, 1907–8. Just as in his office and department store designs, Sullivan always allowed internal operations to* *determine external masses and fenestration. (Chicago Architectural Photographing Company, c. 1909.)*

father of modern architecture. There were, however, other firms at work in Chicago who systematized and perfected the work that Sullivan was doing, continuing his approach later when Sullivan's career was in collapse. Chief among these was the firm of William Holabird (1854–1923) and Martin Roche (1853–1927), who had met while apprentices in the office of William Le Baron Jenney, and formed their own office in 1881. Their work shows a steady development of building technology with direct external expression of internal function. Their early Tacoma Building, in Chicago, built in 1886–89, exploited numerous technical innovations in its foundations and frame and used cantilevered window oriels to express the lightness of the frame, as well as to capture more light and air. More typical of their mature buildings is the Marquette, in Chicago, built in 1893–94. [7.17] Commissioned by Peter and Shepard Brooks, the

building benefited from a clear and rational program, the result of the Brookses' many ventures in speculative building. The building is hollow around a light court, its plan in the shape of an E with the long strokes representing rows of offices and the short center stroke representing the elevator banks. Externally the tripartite facade organization is clear. It begins with a rusticated base of ground floor and mezzanines. Above this are eleven stories of offices between slightly projected rusticated corner piers; in this middle zone no horizontal lines break the upward movement. An upper intermediate floor, an attic floor, and a heavy cornice terminate the building. This formula, incorporating transitional stages between each of the three zones, became typical of Holabird & Roche's work; so too did the Chicago window, which they used repeatedly. And though the Marquette Building uses many classical ornamental features, most notably

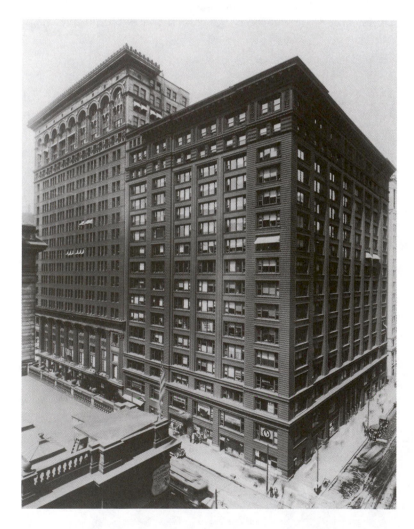

7.17. Holabird & Roche, Marquette Building, Chicago, Illinois, 1893–94. In such office blocks as the Marquette Building, Holabird & Roche established a clear expression of internal functions; note the traditional classical elements used in later flanking office towers. (Condit Archive, Northwestern University.)

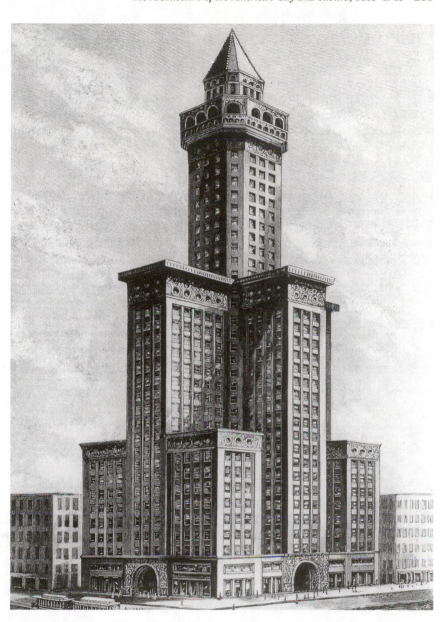

7.18. *Louis Sullivan, Odd Fellows Temple Building Project, 1894. In extremely tall buildings Sullivan proposed light courts opening to the streets. (From Wim de Wit, ed.,* Louis Sullivan: The Function of Ornament, *New York, 1986.)*

a Renaissance cornice, the near-irreducible logic of its straightforward expression of internal arrangements maximizing comfort and use makes it a paradigm of the Chicago School skyscraper.

Burnham & Root's Rookery Building, a square doughnut with a light court at the center, established a pattern for Chicago office blocks. Whether a hollow square, or **E**-shaped like the Marquette, or **U**-shaped such as Adler & Sullivan's Guaranty, these Chicago office blocks had glass-covered courts as elevator lobbies. There was a practical limit, however, as to how high such buildings could rise before light could no longer penetrate down to the ground-floor glazed-

over lobby. Sullivan realized this clearly, and in his project for an office tower of more than thirty-six stories of 450 feet, the Odd Fellows Fraternity Temple project of 1891, he turned the model inside out. He devised a square lower mass of ten stories shaped like two Es back to back, opening up four light courts to the streets. [7.18] From this a central section, cruciform in plan, would rise ten more stories, and from this a single tower shaft would rise some fourteen more stories. Never built, this seems to have been the first true setback skyscraper proposal.

For a decade or so in the 1880s and early 1890s, Chicago architects and their colleagues in

Minneapolis built a number of hollow office blocks with delightful glazed courts, some of them like the Rookery glazed at the lobby level, and others—like Burnham & Root's Richardsonian Society for Savings, Cleveland, built in 1887–90, their twenty-story Masonic Temple Building in Chicago, built in 1890–92; or E. Townsend Mix's Guaranty Loan Building in Chicago, built in 1888–90—were glazed at the very top of the central court, creating great interior light wells ringed with open balconies, very much like those used eighty years later in John Portman's hotels. Similar top-glazed courts can be found in the Palace Hotel, in San Francisco, built in 1874–75; the Chamber of Commerce Building in Chicago, built in 1888–89; and the Brown Palace Hotel in Denver, built in 1892.

Another of these top-glazed court office blocks shows the interest in new building materials and techniques on the edge of the West Coast. This example seems to have had little local impact. This is the Bradbury Building of 1893 in Los Angeles, California, designed by George Herbert Wyman. [7.19] The interior of this building consists of tiers of offices opening on an internal glass-covered court running the full height. Connecting the circumferential balconies at each floor are open staircases and exposed open-car elevators made up of cast iron and wrought iron. Each of the materials—buff brick, iron, and glass—is exploited for maximum expressive and decorative effect, but most important is the expansive interior court and the celebration of vertical movement through that space.

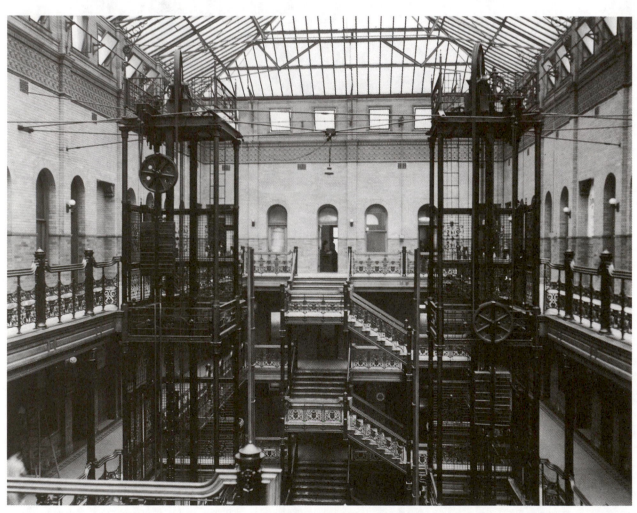

7.19. George H. Wyman, Bradbury Building, Los Angeles, California, 1893. The Bradbury Building had its light court glazed at the top, allowing the corridors to become open balcony shelves. (Photo: © Wayne Andrews/Esto.)

Of particular interest, too, was the Hallidie Building in San Francisco, by Willis Polk (1867–1924), built in 1915–17. In some respects here the structural implications of Chicago School skyscrapers were pushed to their logical conclusion. [7.20] The wall of glass is held in the thinnest of steel sash cantilevered in front of the structural concrete columns; it seems to be an entirely glass skin. In compensation the filigreed fire escapes become framing elements at each end of the building. Some historicism remains, however, in the Gothic tracery of the metal embellishments at the roof. As with Wyman's Bradbury Building, there was no appreciable influence on local architecture, nor was there any similar expression in Polk's own subsequent work. Despite the intriguing parallels to contemporary work by Gropius in Germany, the Hallidie Building was an important but isolated phenomenon.

In New York City, meanwhile, commercial building flourished in the early years of the twentieth century, and new skyscrapers quickly set height records. Though the basic technology of the steel frame had been worked out in Chicago, New York buildings soon eclipsed those in Chicago in size and conveniences, if not in direct functional expression. While Chicago architects had focused on frank expression of the frame through banks of broad windows, in New York the emphasis was on expressive height and on the adaptation of historical modes to ever taller buildings. A good example of a columnlike New York skyscraper was the American Surety Building, by Bruce Price, built in 1894–96, which rose to 312 feet and twenty-one stories, with a two-story Ionic colonnade at the base. The seven-story top, made up of repeated single- and two-story mezzanines, colonnades, and culminating attic story and a huge cornice at the top, showed one way of dealing with a very tall office tower in classical terms.

Particularly troublesome were the old, extremely narrow streets at the southern tip of Manhattan where the city's skyscrapers first began to appear. In their obsession for getting the maximum number of rentable floors, and in trying to outdo their neighbors in height, New York clients and the architects they engaged raised huge masses that put the streets below in perpetual darkness. Criticism began to be voiced regarding the lack of concern for the streets and lower adjoining buildings. The last straw was reached with construction of the second Equitable Building, designed by Burnham's successor firm, Graham, Anderson, Probst, & White in accordance with the classical tripartite formula adopted for many office

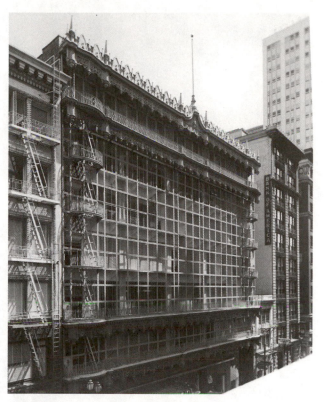

7.20. *Willis Polk, Hallidie Building, San Francisco, California, 1915–17. A curtain wall entirely of glass set the Hallidie Building apart from all its American contemporaries. (Sandak, courtesy of the University of Georgia.)*

towers. Built in 1912–15, it rose directly from the sidewalk lines to a height of forty stories; it was one of the bulkiest and densest office blocks ever built, with 1.2 million square feet or a floor area more than thirty times its site area. What was worse, at the lowest point of the sun in winter, the building threw a shadow covering seven and a half acres. Little more than a year after the Equitable Building was occupied, the city of New York passed the first ordinance that required large office towers to be set back as they rose to provide a minimum of light and air to the streets and surrounding buildings.[20]

To achieve the greatest sense of height while attempting to ensure a measure of light and air to the street below, some New York architects began to employ the local tradition of the tower even before it became mandated in 1916. Introduced in Hunt's Tribune Building, this called for concentrating the upper stories in a slender shaft rising from a solid block, terminating in a graduated spire. The Singer Building, built in 1906–8 by Ernest Flagg

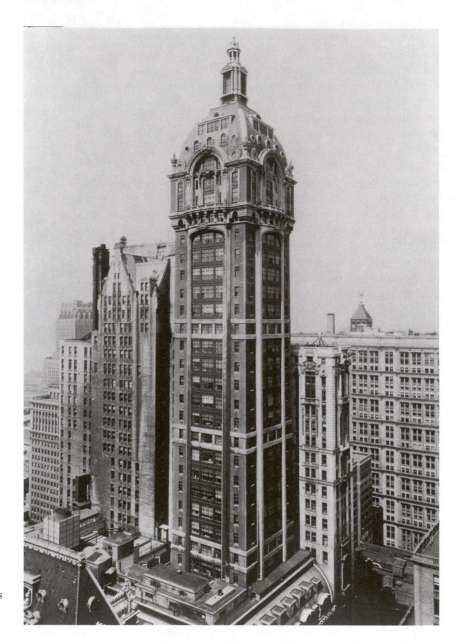

7.21. *Ernest Flagg, Singer Building, New York, New York, 1906–8. The solution to bringing some light to the narrow Manhattan streets was to concentrate the upper levels in a slender tower rising from a broad base. The Singer Building, with its distinctive French Baroque tower of forty-seven floors, rising 612 feet, was dismantled in 1968 (Courtesy of the Singer Company.)*

(1857–1947), is a good example of this New York type. [7.21] The forty-seven stories far exceed in height what was being done in Chicago, and the slender proportions of the tower were remarkable. To brace the slender tower against turbulent harbor winds, heavy crossed diagonals were used at the corners, indicated by the heavy corner wall piers framing the glass curtain-walls. Flagg, recently returned from the École des Beaux-Arts, used the exaggerated French Baroque then fashionable in Paris for the Singer Building, and this suggests a further connection to Hunt's Second Empire Tribune Tower.[21]

Though the historicist and stylish confections used to terminate these spires came under virulent attack during the 1950s and 1960s, they did serve a very necessary visual function. At a distance of forty to sixty stories from the sidewalk, these overblown, colorful ornaments served as a rich visible flourish terminating the upward movement. If the architect was to carry the observer's eye upward, he or she then had to provide ample visual reward. This is especially true of the Woolworth Building, in New York, built in 1911–13, by Cass Gilbert (1859–1934). [7.22] Designed to reach the then incredible height of fifty-five stories, it

rises just short of 761 feet at the top of the pyramidal spire. Until the surge of high-rise office building construction in 1929–31, the Woolworth Building remained the tallest office building in the world, utilizing to the fullest the latest innovations in steel-frame technology. Like the contemporaneous Chicago high-rises by Holabird & Roche, Gilbert's Woolworth Building was covered with white-glazed terra cotta, with darker background glazes used to set off the higher-relief decorative elements. As in Flagg's building, Gilbert's has a tower shaft that rises from a supporting block base, but to maximize the expression of height (and to provide associations with other historic tall buildings) Gilbert used Gothic motifs. The piers at the corners of the supporting block and the main tower piers are widened, but nowhere are they entirely stopped by horizontals. At the top the Gothic finials and crockets are vastly overscaled so that they can be read from the street and provide the proper visual termination to the upward movement. Such an achievement in height, of course, was based on the exploratory work of Jenney, Adler, and Sullivan, but the monumental impulse was much different from that in Chicago. The American shift in values was proudly boasted in the popular name for the Woolworth Building—"The Cathedral of Commerce." The nearby towers of eighteenth-century St. Paul's Chapel and early-nineteenth-century Trinity Church at the head of Wall Street, once the dominant landmarks of the city, were now completely engulfed and rendered invisible by combative office and corporate towers.

As the expatriate American writer and social observer Henry James quickly realized when he returned to his native country in 1904, as grand as these towering commercial behemoths were, they were little more than temporary stage sets. The tall buildings, seen from the water, seemed "like extravagant pins in a cushion already overplanted, and stuck in as in the dark, anywhere and anyhow," he wrote in *The American Scene.* "Consecrated by no uses save the commercial at any cost," they struck James as utterly expendable.

> They never begin to speak to you, in the manner of the builded majesties of the world as we have heretofore known such—tower or temple or fortresses or palaces—with the authority of things of permanence or even of things of long duration. One story is good only until another is told, and sky-scrapers are the last word of economic ingenuity only until another word is written.[22]

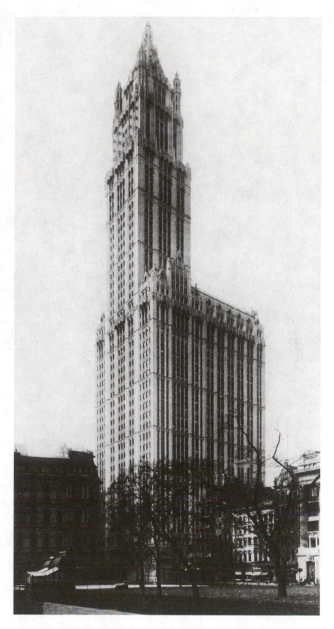

7.22. *Cass Gilbert, Woolworth Building, New York, New York, 1911–13. Even though double the height of previous office towers, the Woolworth Building was made to look even taller and more impressive by Gilbert because he used generic Gothic forms and emphasized the vertical lines everywhere possible. (Condit Archive, Northwestern University.)*

How prophetic were James's comments, for in 1968 Platt's picturesque and deftly modeled Singer Tower was demolished to make room for a faceless if productive and momentarily profitable "economic ingenuity." Meanwhile, in Chicago two of Sullivan's best office buildings also came down—the Shiller Building

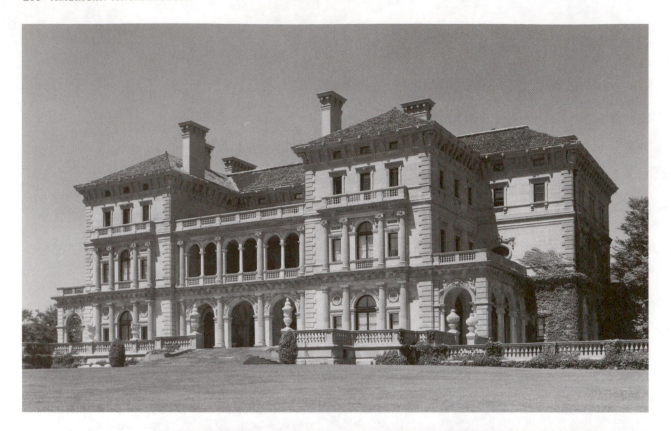

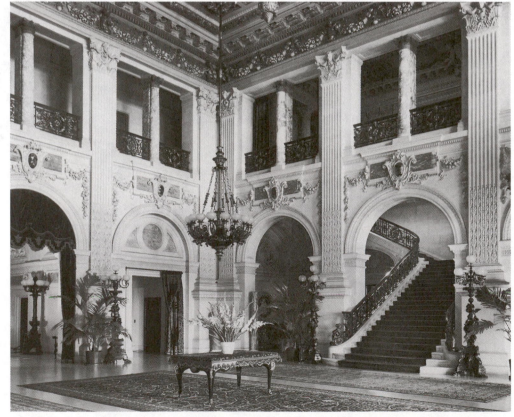

7.23. Richard Morris Hunt, Cornelius Vanderbilt house, the Breakers, Newport, Rhode Island, 1892–95. The exterior of this enormous summer house was based on palaces of maritime merchants of Renaissance Genoa, Italy. (Photo: © Wayne Andrews/Esto.)

7.24. The Breakers. The vast central hall (useful as a ballroom) is the central organizing space, with all other rooms opening from it. (Photo: John Hopf, Newport.)

7.25. *Richard Morris Hunt, G. W. Vanderbilt estate, Biltmore, Asheville, North Carolina, 1888–95. Pursuing a motif introduced earlier for this family, Hunt repeated here his use of early French Renaissance motifs in this Vanderbilt residence. (Photo: © Wayne Andrews/Esto.)*

and the Stock Exchange—the Exchange for a big, bland economic ingenuity and the Shiller Building for a parking garage.

CLASSICISM AND THE SEARCH FOR ORDER

Richard Morris Hunt

The widespread desire to rationalize and standardize commercial building was one facet of a pervasive movement beginning in the 1880s to bring visual order to the constructed environment. While in commercial architecture this was done in an empirical way, quite different methods were used by other architects and designers. All of them, however, sought to create an environment that was harmonious in the interrelationship of all its elements.

Bringing order to the constructed environment means designing comprehensively and thinking on a grand scale. Such had been the principles of academic instruction at the École in Paris since the time of Blondel and Boullée in the eighteenth century.

Consequently, the few Americans who studied there during the nineteenth century were the first to bring coherence to American building after the Civil War. It is significant that Jenney and Sullivan had both studied briefly in Paris and that Post had secondhand instruction from Hunt, the first professional American architect to go to Paris. The great hall at the center of the summer home called the Breakers, designed by Hunt for Cornelius Vanderbilt Jr., in Newport, Rhode Island, built in 1892–95, is a good example of comprehensive design unity. [7.23, 7.24] Around this vast hall all the rooms are arranged with a clarity that makes the plan seem inevitable, and the ornamental elements of the hall are so disposed as to create a sense of unity rather than disparity. Even the colors of the materials used in the hall—various marbles, onyx, alabaster, bronze, and gilding—are carefully orchestrated to contribute to the overall harmony.

Perhaps the grandest of Hunt's integrated and controlled designs was the summer house for George Washington Vanderbilt, Biltmore, near Asheville, North Carolina, built in 1888–95. [7.25] The house

7.26. *Richard Morris Hunt, Metropolitan Museum of Art, New York, New York, 1895. Interior view of the grand entry hall, providing a suitable gateway to one of the largest art museums in the world. (Photo: Scott Francis/Esto.)*

was a vast French chateau in the manner already used by Hunt for other Vanderbilt projects, beginning with the early French Renaissance city residence in New York for William K. Vanderbilt, built in 1879. The house at Asheville, however, was far bigger; including stables it was over a thousand feet in length. Ultimately more important, however, was the estate in which the mansion was placed. Beginning in 1888 under the direction of Frederick Law Olmsted, Vanderbilt acquired 120,000 acres of woodland, with the site for the house at the center. His purpose was to develop an operation that would turn the forest into a productive enterprise. Out of this experiment came the contributions of Gifford Pinchot, chief of the Bureau of Forestry under Presidents McKinley, Roosevelt, and Taft, and father of the National Forest Program, as well as the first American School of Forestry, established at Biltmore by Carl A. Schenck in 1897.

The last of Hunt's designs, his magisterial new entry pavilion of 1895 for the Metropolitan Museum of Art in New York, also demonstrates how Paris-trained architects focused on movement into and through a building. [7.26] Like the Roman architects who shaped the huge ancient baths, these modern architects created vast spaces where movement slowed and where the user felt awe through the sheer grandeur of scale.

7.27. *McKim, Mead & White (Stanford White), General Sherman Monument, New York, New York, bronze figure by Augustus Saint-Gaudens with base design by Charles Follen McKim, 1902–03 Not only did such handsome sculptural monuments serve to commemorate Civil War heroes, they were also designed to be civic ornaments and conveniences, with built-in seating so the public could sit and rest. (Photo: Paul Rocheleau)*

McKim, Mead & White

Biltmore is just one example of the collaboration between architects and artists that was prevalent during the closing years of the nineteenth century. Trained together in Paris where they could see many buildings created by French architects, mural painters, and sculptors working together, these École-trained American architects, painters, and sculptors likewise began to work with each other when they came back home.[23] One subject of frequent collaborative work was the monument, both funereal and public. One excellent example is the Adams Memorial in Rock Creek Cemetery, in Washington, D.C., built in 1886–91. The historian Henry Adams commissioned

Augustus Saint-Gaudens to sculpt a bronze figure as a memorial to his wife. Working with Stanford White, whom he asked to design the base, Saint-Gaudens fashioned a seated figure symbolizing the timeless peaceful oblivion of nirvana. While this figure was evolving, White began to sketch out designs for a setting incorporating seating opposite the figure, a polished marble base, a seat for the bronze, and a surrounding bower of holly. It is this incorporation of seating that distinguishes White's work with Saint-Gaudens, for it involves the spectator as a participant in a larger public work of art. The same is true of the seat incorporated around the red granite base for Saint-Gaudens's magisterial equestrian figure of

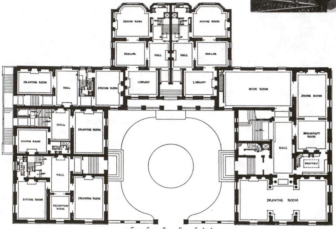

7.28. McKim, Mead & White, Henry Villard house group, New York, New York, 1882–85. Although appearing to be one large palatial residence, this was actually six town houses arranged around a common entry court. (Monograph of the Work of McKim, Mead & White, 1879–1915, New York, 1914–20.)

7.29. Villard houses. Close study of the plan shows that what looks externally like a single residence is actually a cluster of five individual town houses. (Monograph of the Work of McKim, Mead & White, 1879–1915.)

General William Tecumseh Sherman opposite the southeast corner of Central Park, in New York City, finished and dedicated in 1902–03. [7.27] Here the encircling seat positions people facing outward, making them observers of the pageant of city life. Seldom before or since have American sculptors and architects worked so closely to create embellishments in the urban fabric, ornaments that have become vital components in the everyday life of their respective cities.

One way of giving individual buildings a clear sense of order and unity was to employ the classical styles that emphasized balance, symmetry, and restraint, qualities that had been increasingly absent in American architecture since the 1850s. In 1880 there began to emerge a return to Neoclassicism as a means of making urban buildings more harmonious with one another. Classic Greek forms were now usually avoided in favor of Roman and Renaissance proto-

types because the latter offered greater flexibility of expression in accordance with functional use. What the classically minded architects attempted to do, using the accumulated archaeological and historical knowledge of the previous century, was to design new buildings, accommodating new functions, while using traditional historicist vocabularies.

This resurgence of a restrained Italian Renaissance classicism was heralded by a group of six town houses built for railroad entrepreneur Henry Villard in New York in 1882–85 by McKim, Mead & White. [7.28] Built in conventional New York brownstone, the building was closely patterned after Italian Renaissance palaces, most specifically the Cancelleria, in Rome. Much of its crisp and historically correct detailing was worked out by Joseph Morrill Wells, a skilled office assistant. Wells developed a morbid dislike of the picturesque excesses of the architecture of

the 1870s, writing in his journal: "the classic ideal suggests clearness, simplicity, grandeur, order, and philosophical calm—consequently it delights my soul. The medieval ideal suggests superstition, ignorance, vulgarity, restlessness, cruelty, and religion—all of which fill my soul with horror and loathing." The individual component units of the group were so unified by this Renaissance detailing that the building, U-shaped around a central courtyard, appears to be one single house. [7.29] The Villard house group was widely admired by architects, partly because it was so chaste and refined while at the same time being large in scale and grand in conception. The interiors of Villard's own apartments were sumptuously finished with rare marble veneers, mosaic inlay, and delicate low-relief sculpture by Augustus Saint-Gaudens, but little of this enrichment was pompously displayed externally; this civic decorum appealed to a younger generation of architects. Another distinguishing quality was the way in which the sober brownstone block, through its emphatic solidity and horizontal emphasis, gave clear and certain definition to the street.

The architects of the Villard house complex comprised one of the first large American architectural partnerships; this by definition made them also the largest architectural firm in the world, for their European counterparts tended to work individually.[24] From about 1882 to 1893 McKim, Mead & White was the largest architectural firm, with about a hundred employees in total; it was surpassed in about 1900 by the office of Daniel H. Burnham in Chicago. As in other smaller architectural firms, the partners tended to have specialties. Charles Follen McKim (1847–1909), educated at Harvard's Lawrence Scientific School, at the École des Beaux-Arts, and in H. H. Richardson's office, tended to handle corporate clients and to design public buildings; William Rutherford Mead (1846–1928), educated in Amherst College, in Sturgis's office, and in Florence, Italy, focused on plan development and on managing the large office. Stanford White (1853–1906), trained in H. H. Richardson's office as his principal assistant, tended to deal with socially prominent New York clients and to design residences.

Because of their success in the Villard house group, McKim, Mead & White were soon given the coveted commission for the Boston Public Library, built in 1887–98. [7.30] The functions to be served by the library were several. First, it was to house the largest public circulating collection in the world, something

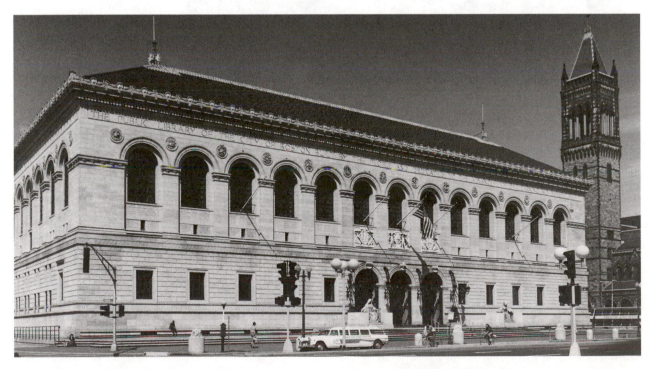

7.30. McKim, Mead & White, Boston Public Library, Boston, Massachusetts, 1887–98. The long facade along Copley Square was so designed to form a defining wall on the southwestern side of the open space. (Photo: L. M. Roth.)

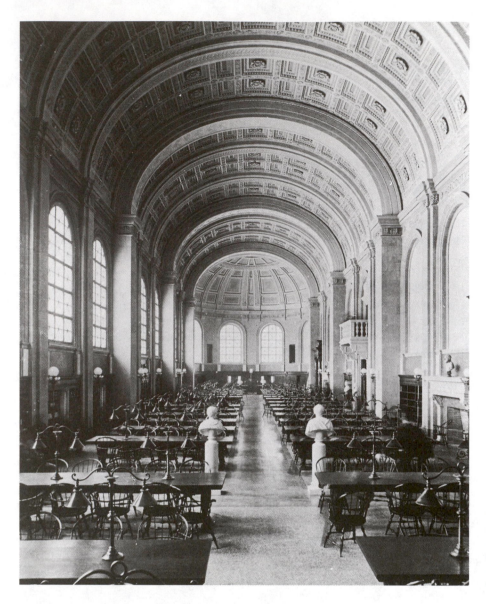

7.31. Boston Public Library.
With large repeated arched
windows, ample natural light
could be brought into the
main reading room.
(Courtesy of the Trustees of
the Boston Public Library.)

that no one then understood clearly, and therefore the architects were without specific prototypes (and the library trustees kept changing their minds as to the program's specifics). Second, it was to symbolize Boston's cultural heritage, and to be, as the trustees specified, "a palace for the people."[25] Third, the library had to visually control the open expanse of Copley Square, bringing together the varied, colorful, Gothic buildings around the square, including the new Old South Church and Richardson's Trinity Church on the east side of the square. A horizontal and classical motif seemed to be the answer, and the architects (with McKim in charge) based their design in part on the library of Ste. Geneviève, in Paris, by Henri

Labrouste, but they made it more massive and more imposing in scale, articulated with carefully designed Renaissance ornament. With its internal reading court inspired by Italian Renaissance palace courtyards, its carefully selected marble paneling, and its commodious public spaces, the library was meant to be as much a sensory experience as an intellectual one. [7.31] Especially significant was the collaboration of many artists who provided mural painting and sculpture embellishing the exterior and interior. Panels above the entrance were by Augustus Saint-Gaudens, the bronze doors were by Daniel Chester French, mosaic work in the vestibule was by Maitland Armstrong, the memorial lions in the stair hall were by Saint-

Gaudens's brother Louis, and the mural painting in the arcaded wall above was by the Frenchman Pierre Puvis de Chavannes (the only murals by him for an American building). In addition, in the book delivery room was a richly colored mural of the Holy Grail by Edwin Austin Abbey, and in the dimly lit third-floor hall was a complex mural sequence depicting the development of religion by John Singer Sargent; this was his finest mural work. Further enrichment throughout the building was provided by other artists. Never before had American architects and artists worked so closely and harmoniously together. It was fitting that this happy collaborative effort should face Trinity Church across Copley Square, for it was there

in the joint decorative efforts of Richardson and John La Farge that this cooperative creativity among American artists had been born.

Aside from the impressive integration of allied arts, the Boston Public Library was also significant for its widespread use of thin monolithic shell vaults for its flooring, a technique developed by the Catalan builder Rafael Guastavino (1842–1908), who had recently arrived in the United States expressly to perfect his vaulting process.[26] [7.32, 7.33] After 1890 Guastavino vaults were widely used to frame the various domical and vaulted forms popular in churches and public buildings before the depression of the 1930s. The exploitation of the extraordinarily strong Guastavino

7.32. *Boston Public Library.* *Photograph of worker standing on the thin rib of an unfinished Guastavino vault. Spanning between the ribs would be a thin domed square vault. (Photo: L. M. Roth, from snapshot in Archives of the Trustees, Boston Public Library.)*

7.33. *Boston Public Library. The period photo of the original Newspaper Room, made just after the building was completed, shows the distinctive shape and herringbone tile pattern of the Guastavino vaults. (Courtesy of the Trustees of the Boston Public Library.)*

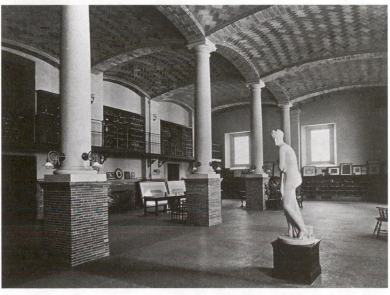

7.34. McKim, Mead & White, John F. Andrew house, Boston, Massachusetts, 1883–86. With classical details based on Italian Renaissance sources, this brick house in the Back Bay, with its bowed bays, clearly refers to the brick houses in Beacon Hill. (Photo: L. M. Roth.)

system indicates that McKim, Mead & White, among other traditionalist architects, used new technological methods to achieve the spaces they desired, but their goal always was to base their designs on popularly understood and accessible traditional prototypes, rather than to develop a literal expression of new structural systems such as steel, as Sullivan was then doing.

McKim, Mead & White proved to be especially skilled at understanding the character of the developing American urban architecture, bold in scale but the heir to European style and culture. They also understood the American public's need for an architecture that embodied a national character, rooted in their ancestral architecture of the eighteenth century. The architects' urban town houses in Boston, New York, Chicago, and other cities provided for a formal way of living that incorporated all the latest advances in technology. The exterior surfaces of these urban houses were conceived in Italian Renaissance terms, but more often in original variations of late-eighteenth-century American Colonial classicism and that of early Federalist architects such as Bulfinch. An early example was the new residence in Boston's Back Bay for John F. Andrew, built in 1883–86; although some of its specific details owed much to Italian Renaissance models, the overall form, especially the oval corner

bays, referred to Bulfinch and Louisberg Square. [7.34] Several years later, a more refined Bulfinchian classicism was employed in their residence for Percy Pyne on upper Park Avenue, in New York City, built in 1906–12. [7.35] With their restrained details and strong cornices, these residence make good urban neighbors.

McKim, Mead & White developed many models of appropriate urban decorum. One example, widely admired, was their strongly detailed Knickerbocker Trust, a bank in New York, built in 1904–07. [7.36] Critic Montgomery Schuyler approved of the way the marble was used to express structural support (even though it was a protective cladding for the underlying steel frame), while the walls in-between were expressed as nonbearing curtains of metal and glass. The details were made deliberately massive since this was intended as the base of a taller office skyscraper that was never carried out. Banks all across the continent followed this example, two of which were the Bank of California in San Francisco, built in 1907, by Bliss and Faville, former office assistants in the office of McKim, Mead & White, and the U.S. National Bank of Portland, built in 1917–25, by A. E. Doyle, an admirer of the work of McKim, Mead & White.

The remarkable ability of McKim, Mead & White to fuse boldly detailed classical form with the elabo-

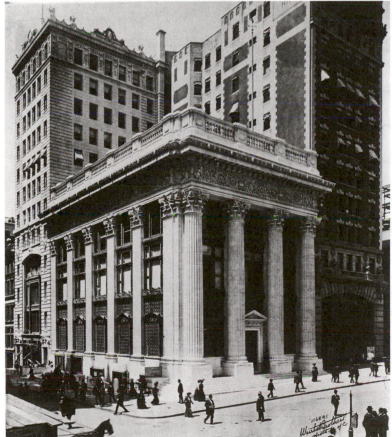

7.35. McKim, Mead & White, Percy
Pyne house, New York, New York,
1906–12. *The restrained Georgian-
Federal classicism of the Pyne house
is a good example of the urban
decorum of the town houses by
scores of architects in this period.
(Photo: L. M. Roth.)*

7.36. McKim, Mead & White,
Knickerbocker Trust Company, New
York, New York, 1904–7. *Heavily
scaled in anticipation of an upper
section that was never built, the
Knickerbocker Trust provided an
example for banks built across the
continent early in the twentieth
century. (Archives of McKim, Mead
& White, the New-York Historical
Society.)*

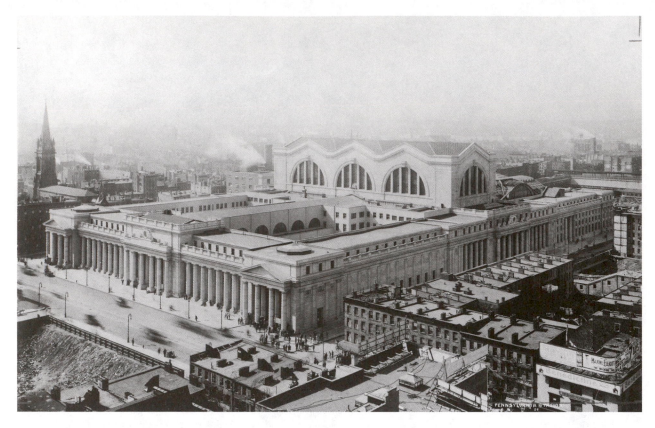

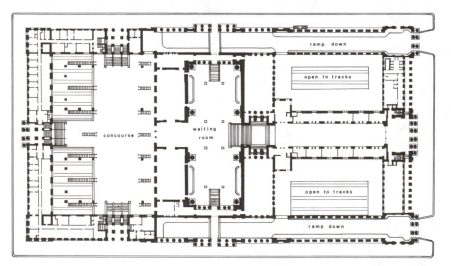

7.37. McKim, Mead & White, Pennsylvania Station, New York, New York, 1902–10. Now surrounded by tall skyscraper office blocks, Penn Station originally stood among buildings not much higher than it was. One of the grandest railroad stations ever built, this combined numerous modern technical innovations in a transcendent gateway to the modern city. (L. H. Dreyer construction photo, March 4, 1910, courtesy of Avery Library, Columbia University.)

7.38. Pennsylvania Station, plan of concourse level. The main waiting room level was one story below the street; taxis and carriages delivered and picked up passengers by means of long ramps that descended from Seventh Avenue. (M. Waterman and L. M. Roth.)

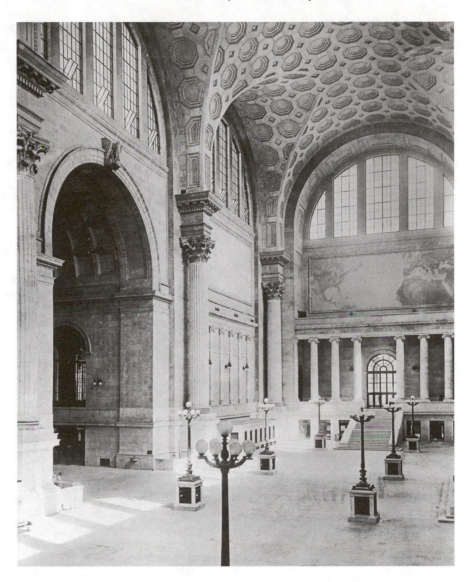

7.39. *Pennsylvania Station.*
The soaring main waiting room
was 25 percent bigger than the
tepidarium of the ancient Roman
Baths of Caracalla; the high
lunette windows provided good
ventilation for the entire station
as well as providing abundant
light. (Archives of McKim, Mead
& White, New-York Historical
Society.)

rate demands of modern technology was nowhere more evident than in their Pennsylvania Station, New York, designed in 1902–5 and built in 1905–11. [7.37, 7.38] Dazzling statistics—such as the fact that this was the largest building operation undertaken since the pyramids—obscure an appreciation of the complex overlay of functions served by the building. This was the largest rail station of its day, serving through trains from Chicago and Philadelphia to New York (and eventually to New England), as well as scores of commuter trains of the Long Island Railroad. All the rail lines were nearly 45 feet below the street in tunnels that extended under the Hudson and the East Rivers; hence the building had to be impressive in its own right, for no trains were visible from the street.

To bring unity to the vast building, which covered two city blocks, McKim employed a continuous heavy Tuscan Doric colonnade around the exterior, and where large spaces were required internally for waiting rooms and for boarding trains, he pushed the ceilings to great heights, opening up great lunette windows, which had become the symbol of train stations in Europe and the United States (they also proved to ventilate the station well). Like many of his contemporaries, when faced with the problem of articulating such a huge space, McKim turned to the large public meeting places of Rome for solutions; the vast waiting room was patterned after the tepidarium of the Baths of Caracalla in Rome but enlarged by about 25 percent. [7.39] As originally planned, pat-

7.40. Warren & Wetmore, with Reed & Stem, Grand Central Station, New York, New York, 1903–10. Section through the principal public spaces showing the multiple levels connected by pedestrian ramps. (Scientific American, December 7, 1912.)

terns of traffic for passengers, commuters, baggage, and freight were carefully separated but synchronized through the use of overpasses, ramps, separation of levels, and mechanical carriers. Where movement was swift, spaces were small and low; where movement slowed and stopped, spaces were large and high. Before the station was abused, it functioned, as Lewis Mumford wrote in 1958, with "the effortless inevitability of a gravity-flow system."[27]

Symbolically the strength and position of the railroad were expressed by the seemingly massive masonry of the granite exterior and travertine interior, but all of this was hung on a steel skeleton whose slender columns threaded through the maze of tracks below the station. And while McKim used historicist Roman elements in the waiting room, over the concourse he placed intersecting barrel vaults of glass carried by open steel arches and columns—traditional forms built with modern materials. Utilizing every known technological device, Pennsylvania Station (and the new Grand Central Station that followed soon after) are significant not only because they were the largest constructions to be undertaken by private capital, but, as Carl Condit notes, because they incorporated so many amenities vital to civic building art.[28]

One of the great losses to New York City was the senseless destruction of Pennsylvania Station in 1963–65. Its disappearance, however, has continued to prompt a stiff public resolve to preserve the other great public room in the city, the waiting room of Grand Central Station. Built in 1903–1913 to meet the competition of the rising Pennsylvania Station, the new terminal for the New York Central Railroad was, in many ways, an even better engineering and architectural solution to the problems encountered on its site. The basic organization scheme was devised by the chief engineer for the New York Central, William J. Wilgus. [7.40] Here, too, the tracks would be buried beneath the station, but Wilgus's great achievement was to create an enormous fan of tracks much broader and longer than the station itself, with the provision that in the air space over the tracks new steel-framed office skyscrapers could be built. The architectural organization of the station's complex interior, its many operational levels linked by pedestrian ramps, was worked out by railroad station specialists Reed & Stem of St. Paul, Minnesota. The detailing of the interiors, however, with its many Guastavino vaults, and

the heroically scaled exterior with its emblematic sculpture, was created by École-trained New York architects Warren & Wetmore. Both Grand Central and Pennsylvania Station were superb portals to the city—dignified, integrated despite vast scale, and well ordered. Newly cleaned and restored, Grand Central Station shows the public benefit of carefully detailed design and sound construction using durable and visually pleasing materials.

AMERICAN ART NOUVEAU AND ARTS AND CRAFTS

To a large extent McKim, Mead & White employed machine prefabrication of details and new structural methods whenever possible, though there were still important elements of precise assembly and hand finishing in their work, as in that of Adler & Sullivan or Holabird & Roche. In contrast the intricate and complex interiors designed by Louis Comfort Tiffany (1848–1933) and the furnishings especially fashioned for them required handwork down to the smallest detail. Instead of entering and assuming control of the large jewelry business established by his father, Tiffany formed a workshop where he and his assistants designed fabrics, lamps, glassware, jewelry, and countless other objects with motifs derived from plant forms. Enhancing the undulating curvilinear forms are the colors: iridescent violets, mauves, ochres, and greens. Though most of his production consisted of objets d'art, particularly glassware, Tiffany also designed a number of stained-glass windows and several interiors, including the dark and brooding studio for himself that occupied the upper stories and roof of a large house in New York built by McKim, Mead & White; on the floors below were separate apartments for Tiffany's father and sister. Yet, as hauntingly beautiful and coherent as Tiffany's work was, it was highly idiosyncratic, expensive, and hence accessible only to a small circle of progressive enthusiasts. Nonetheless, the subtle curves and delicate color contrasts in Tiffany's work were perhaps the closest any American designer came to the new art in Europe, what the French called l'Art Nouveau.

Another approach, aimed at putting finely designed and constructed home furnishings and interiors within the economic reach of the broad middle class, was the Arts and Crafts movement, associated with and patterned after the parent movement in Great Britain. Originally rooted in the writing of English designers and critics such as Pugin and Ruskin, who endeavored to reunite designer and craftsman as they had been in the preindustrial age, the English Arts and Crafts movement was shaped by the design work and writing of William Morris. In the United States local enthusiasts promulgated Morris's teaching, especially Elbert Hubbard and Gustav Stickley. Inspired by C. R. Ashbee's Guild of Handicraft, in which a group of English artisans and students banded together to produce objects of simple design but high-quality craftsmanship, Hubbard created the Roycroft community outside Buffalo, New York. Similar, often utopian production communities or workshops were created across the continent: Arthur Stone's metalwork shop in Gardner, Massachusetts, the Matthews Furniture Shop of San Francisco, the Byrdcliffe Colony in Woodstock, New York, and William L. Price's Rose Valley shops outside Philadelphia, where over a hundred artisans produced furniture, pottery, and hand-bound books, all promoted in a journal entitled *The Artsman*, whose subtitle summarized in five words the objectives of the Arts and Crafts movement: "The Art that is Life." As in Britain, the goal was to unify simplicity, utility, and the democratization of art; in particular, the artist-craftsman was to be in control of the entire design and production process, from conception to finished product. Arts and Crafts societies were established across the United States, beginning with the Society of Arts and Crafts in Boston in 1897. Architects, furniture makers, potters, metalworkers, stained glass artists, weavers, type designers and bookbinders, and many other kinds of artists joined efforts to produce interior furnishings, objets d'art, books, electric lamps, art glass—virtually everything used in the home.[29]

Gustav Stickley (1848–1942) took a slightly different approach. Not only did he wish to produce simply made yet artistic furnishings and products for the home, but he also endeavored to make artistic but moderate house designs available to people of moderate means, houses that were designed as a unified wholes, including furniture and fittings. What Stickley wanted was to foster an art that embodied a way of living, truthful, simple, honest, without sham or pretense, machine-produced where possible, hand-made where need be, revealing the handwork of the craftsman. To make this practicable he simplified elements so as to make his own furniture designs suitable for machine-assisted production. Not a practicing architect himself, Stickley began by designing furniture in 1898 and three years later, in 1901,

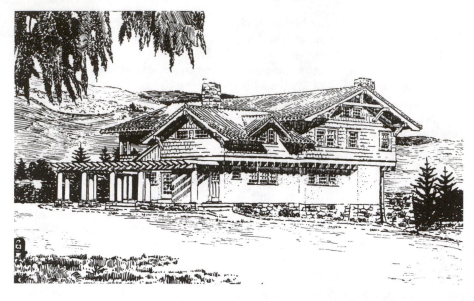

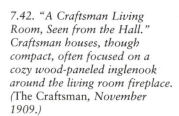

7.41. *Craftsman house. Perspective view of a house (*The Craftsman, *January, 1909). Such houses were planned for comfort and ease of living.*

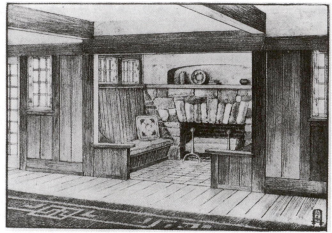

7.42. *"A Craftsman Living Room, Seen from the Hall." Craftsman houses, though compact, often focused on a cozy wood-paneled inglenook around the living room fireplace. (*The Craftsman, *November 1909.)*

he started publication of *The Craftsman*, a monthly journal aimed at promulgating the belief, as he wrote in the first issue, "that beauty does not imply elaboration or ornament." His general attitude toward simple, directly revealed craftsmanship owed a great deal to William Morris and the Arts and Crafts movement in England, which was frequently discussed and the products of which were illustrated in the magazine. Morris's aim had been to revive the handcrafts so as to improve the quality across the whole range of residential design, from tableware and furniture to the house itself. This was Stickley's objective as well, but he was able to embrace aspects of mechanized production.

It was the middle-class home that became the particular focus of Stickley's energies. He reproduced in *The Craftsman* designs for houses and interiors that epitomized his philosophy. Moreover, he also published plans and construction drawings of compact single-family houses especially designed for the magazine; on paying a small membership fee, readers could join a Craftsman's club and receive full working drawings of these houses. [7.41, 7.42] Thus, through the influence of the magazine and through the dissemination of the house plans, Stickley came to exert a strong influence on the development of the American bungalow in domestic architecture. Sadly, he was driven into bankruptcy in 1916 by furniture makers producing imitative Craftsman furniture, but the influence of *The Craftsman* and of the Craftsman bungalow became widespread, partly through the influence of mass-market magazines such as the *Ladies' Home Journal*, which reprinted much *Craftsman* material.

FRANK LLOYD WRIGHT

To Frank Lloyd Wright, as to Louis Sullivan, the historicism of such buildings as McKim, Mead & White's Pennsylvania Station seemed to have nothing to do with American life (at least as they perceived it). Both Sullivan and Wright focused intensely on selected aspects of American culture. Sullivan took on the problem of the modern commercial office skyscraper, while Wright turned his attention to the freestanding suburban house, reshaping it around the changing social patterns of the American family. Wright's sources were classic, romantic, exotic, eclectic to a high degree, but his goal was an ordered unity that eventually made Queen Anne and Shingle Style houses (his immediate sources) seem like ill-digested aggregations by comparison. His unique achievement was the creation of a coherent synthesis, a personal style and a modern architecture that was different from any strain of modernism being developed abroad. In many ways, Wright's individual search for a more ordered, coherent, integrated architecture paralleled that of the more traditional American neoclassicists. In fact, during 1890–95 Wright himself designed several classical buildings but soon abandoned this historicism and set about inventing his own architectural language. As Vincent Scully observed, the neoclassicists relieved the pressure while Wright struck out in new directions.[30]

Frank Lloyd Wright (1867–1959) was born in Richland Center, Wisconsin. His mother was of Welsh extraction, his father was an itinerant preacher. From Richland Center the family moved to New England, and young Wright spent his earliest years in Rhode Island and Massachusetts. The family returned to Wisconsin, where Wright passed long summers with his mother's family on farms around Spring Green. There grew in him a love of the soil that led, in later life, to his championing of Jeffersonian agrarianism.

Many influences came together to shape Wright's architecture. The first and most crucial one was the impact of his mother, who, convinced that her unborn child would be an architect, hung prints of cathedrals in the nursery. Later, when she saw the Froebel kindergarten equipment on display at the Centennial Exposition in Philadelphia, she purchased the "toys" for her son. Much of Wright's characteristic massing and geometric patterning was influenced by structured play with the modular Froebel blocks.

Particularly important was Wright's love of the land, nurtured during the summers in Spring Green. He came to view architecture as subject to the same rules that govern the organic growth and development of plant life, with each part related to every other part so as to form a functionally complete organism. Like plants, buildings should grow out of the soil and be a part of it. This love of nature led him to the writing of John Ruskin; the lamp of Truth became Wright's cause also. There could be no sham construction, no artifice, but rather each element was to be exploited to reveal its inherent color, texture, function, and shape. One should build, as he said, "in the nature of materials."[31]

In 1885–86 Wright attended classes at the University of Wisconsin at Madison, studying French and drawing, and though later he had little good to say of the experience, he discovered then the writing of Viollet-le-Duc. The Frenchman's insistence on structural determinism and expression was to affect Wright so deeply that later this was one of the very few sources he acknowledged and recommended to disciples.

Wright knew the Shingle Style, and when he set out on his own in Chicago in 1887 he went directly to the office of Joseph Lyman Silsbee, a prominent residential architect who used this idiom. Wright may have worked, in fact, on some of the houses designed by Silsbee for Edgewater, north of Chicago. [see 6.48] Through Silsbee, Wright may also have been exposed to Japanese art, for Silsbee's cousin was Ernest Fenellosa, curator of Asian art at the Boston Museum of Fine Art and a major advocate of Japanese art, especially Japanese woodblock prints. Staying with Silsbee only a short time, Wright left to enter the office of Adler & Sullivan in 1888, where his draftsmanship was put to good use completing drawing of interiors of the Chicago Auditorium. Soon he had gained a responsible position in the office and, because Sullivan wished to concentrate on the larger commercial work, many of the residential commissions were put in Wright's care. The important position Wright quickly achieved in the firm is evident in the floor plans of the Adler & Sullivan office published in June 1890; a large corner office is labeled "Mr. Wright's room."[32] A good example of Wright's responsibility for residential work is the James Charnley house on Astor Street in Chicago, built in 1891, conceptually designed by Sullivan but supervised in construction by Wright.

Taking an advance on his salary in 1889, Wright built for himself and his bride a house in Oak Park, a Chicago suburb then a haven for intellectuals and reformers. [7.43,] In this early house Wright showed his debt to the Shingle Style architects, especially to Bruce Price, whose houses at Tuxedo Park, New York, partic-

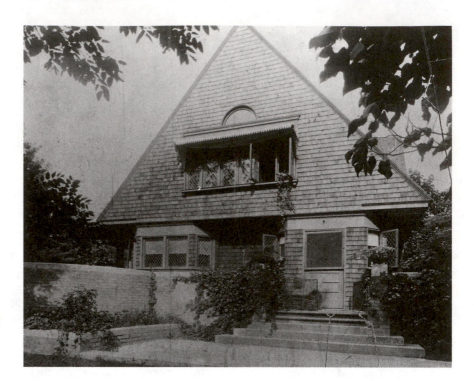

7.43. Frank Lloyd Wright, Wright house, Oak Park, Illinois, 1889. The west front, with its broad triangular gable, shows Wright's debt to Silsbee as well as published examples of East Coast Shingle Style houses. (Courtesy of the Museum of Modern Art.)

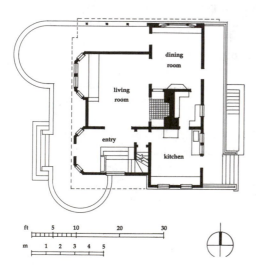

7.44. Wright house/studio, plan, 1894. The plan of Wright's house is focused on the central hearth with inglenook, a theme that repeated through all his residential designs. (L. M. Roth, after HABS.)

ularly the Chandler house, served as models. Even so, Wright simplified the forms of his models, reducing the house to a single broad gable on a low base. The entire surface is covered in shingles. In the gable window is the barest hint of the Palladian sources of colonial American houses; inside too are subtle classical details. The innovative character of the interior, however, comes from the grouping of rooms around the central fireplace. Furthermore, the walls are treated as though they are sliding panels giving something of the impression of a traditional Japanese house.

In 1893 Wright was able to see an actual Japanese building firsthand, the Ho-o-den, a half-scale adaptation of the Ho-o-do, a Buddhist temple at Uji. Prefabricated in Japan, it was disassembled, shipped to Chicago, and reassembled by Japanese workmen on the Wooded Isle of the Columbian, serving as the Japanese pavilion at the fair. The crossed axes, stressed horizontals, cantilevered hovering roofs, and dark-stained frame construction of the Japanese pavilion were to make a lasting impression on Wright.

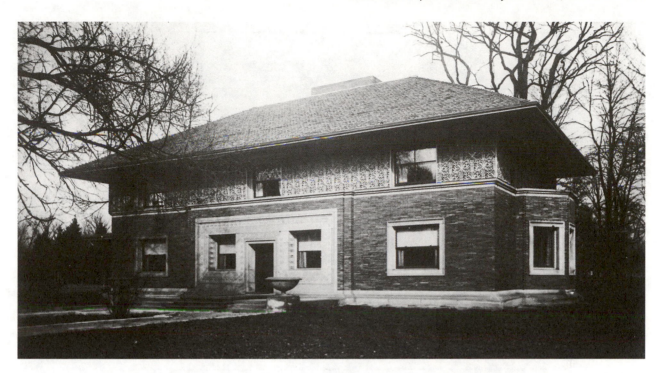

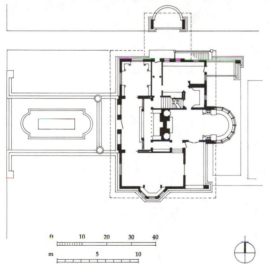

7.45. Frank Lloyd Wright, William H. Winslow house, River Forest, Illinois, 1893–94. While suggesting ancestral Georgian houses in its frontal formality, the Winslow house has some elements inspired by the Turkish pavilion at the Columbian Exposition. (Rosenthal Archive, Northwestern University.)

7.46. Winslow house, plan. The first-floor plan shows how, to the street, the Winslow house presents a formal image, suggesting what Wright called "a box with little boxes inside," while to the rear the rooms project out or are cut back in accordance with internal functional requirements. (L. M. Roth, after Wright.)

Wright's growing family, and the resultant proliferating bills, plus his passion for collecting Asian art (particularly Japanese prints), led him to take on work outside Sullivan's office, violating his contract. When this moonlighting was discovered Wright was acrimoniously dismissed. Fortunately Wright was well enough established to continue on his own, and one of the first commissions following the break secured his practice. This was the house for William H. Winslow in River Forest, Illinois, built in 1893–94. [7.45, 7.46] In this house one can see Wright's flirtation with clas-

sical formality and the compositional rules he was soon to turn from. The Winslow house presents two faces, a formal front to the street and an informal face to the rear, where the house is shaped around the functions of family life. The street facade is bilaterally symmetrical, with carefully studied proportions, but the rear is highly irregular, with a recessed porch, a projecting breakfast room, and a vertical stair tower. The plan is focused on a central chimney mass, perhaps inspired by Colonial house plans, and the heavy cantilevered eaves suggest Asian comparisons. Thus in the

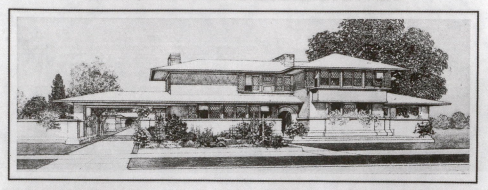

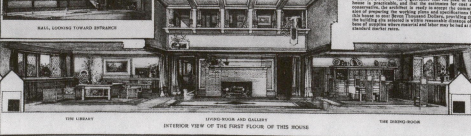

7.47. *Frank Lloyd Wright, "A Home in a Prairie Town,"* Ladies' Home Journal, 1901. *This full page from the* Ladies' Home Journal *shows the first of three model houses designed by Wright for that magazine; the term* Prairie house *is stressed here.* (Ladies' Home Journal, *February 1901, 17.*)

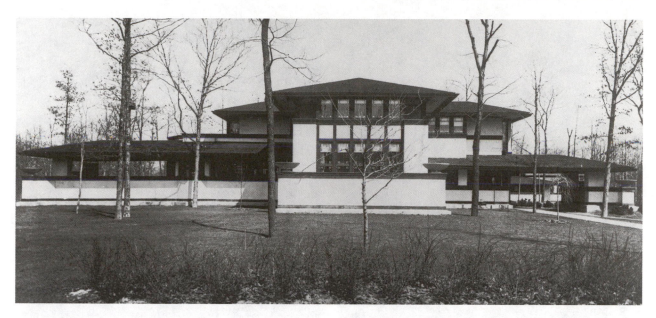

7.48. *Frank Lloyd Wright, Ward W. Willitts house, Highland Park, Illinois, 1900–2. In the Willitts house, Wright exploited the large building site by exploding the rooms outward in a pinwheel. (Rosenthal Archive, Northwestern University.)*

Winslow house one can perceive synthesis underway, in the combination of Neoclassicism, Sullivan's work, Colonial sources, and perhaps even a touch of the Turkish pavilion at the Columbian Exposition in the high-waisted brick wall with a dark second-story stucco frieze. Out this disparate collection of references Wright eventually forged his Prairie Style.

By 1900 this assimilation was complete; the box of the Winslow house was broken and the Prairie house was born. This term, and what it meant architecturally, was introduced by Wright in a model house design, "A Home in a Prairie Town," published in the *Ladies' Home Journal* in February 1901.[33] [7.47] The long, stretched roof planes and extended eaves protecting extended bands of grouped windows of this project were being incorporated in other houses being built by Wright at the same time. The best built example is the Ward W. Willitts house, in Highland Park, Illinois [7.48, 7.49], designed as early as 1900 and completed in 1902. Where the earlier Winslow house had been tightly contained, the Willitts house is explosively open, its plan a pinwheel of spaces moving out from the central fireplace mass. (Virtually the same pinwheel plan arrangement as in the Willitts house was used simultaneously by Wright in a more compact second project in the *Ladies' Home Journal* published in July 1901, as the Willitts house was being built.) Vincent Scully has described the Willitts house as embodying a sense of both rootedness and protection, and freedom and mobility: it is pinned to the earth by its clustered chimneys and its ceilings are low and inti-

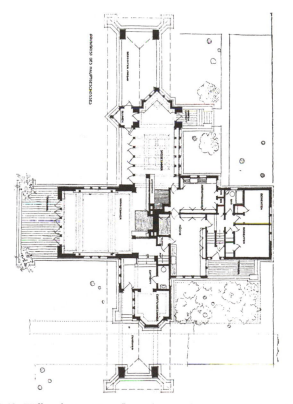

7.49. *Willitts house. First-floor plan, as shown by Wright in his early publications (north is up, so the living room faces west). (Frank Lloyd Wright,* Ausgeführte Bauten, *Berlin, 1911.)*

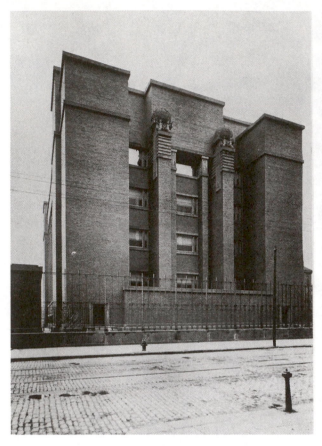

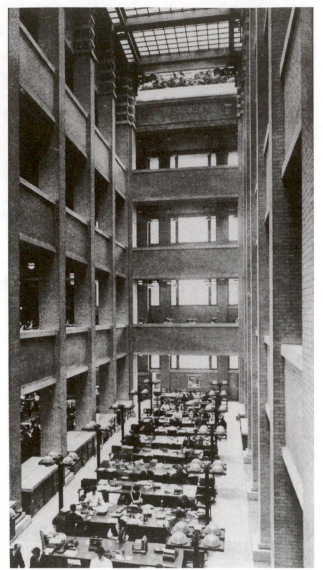

7.50. *Frank Lloyd Wright, Larkin Administration Building, Buffalo, New York, 1903. Seen from the street, the Larkin building was closed and inward-looking. (Rosenthal Archive, Northwestern University.)*

7.51. *Larkin Administration Building. The great workroom was a soaring space, covered with a skylight. (Rosenthal Archive, Northwestern University.)*

mate, yet they extend far beyond the serried windows under long cantilevered roofs. To Wright the house was no longer a collection of isolated rooms but interwoven spaces, thus the hovering roofs seem to penetrate the block of the house. Everywhere the horizontal line dominates, pulling the house close to the earth, making it seem part of the prairie. This tie is strengthened by the terraces extending from the house that make the transition from interior space to exterior space gradual rather than abrupt as in the Winslow house.

In these frame suburban houses Wright gave expression to the straightforward use of the machine, just as

in the irregular interwoven plans he captured the freer spirit of modern family life. He was able to go beyond this, however, to demonstrate how the principles of "Organic Architecture," as he called it, could reshape the office block and the church. The Larkin Building, in Buffalo, New York, built in 1903 [7.50, 7.51] (now demolished), contradicted conventional office building norms in much the same way that the Willitts house had done for the typical house. Where the Prairie house opened out to the landscape, however, the Larkin Building was introverted, with circumferential balconies of office space overlooking an internal rectangular court, so arranged in hopes of fostering a

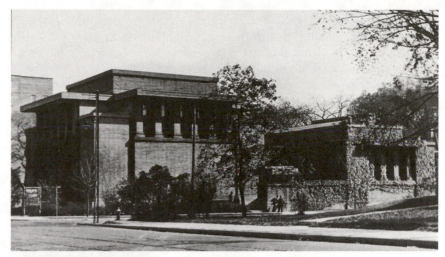

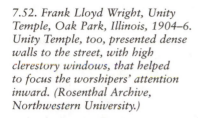

7.52. Frank Lloyd Wright, Unity Temple, Oak Park, Illinois, 1904–6. Unity Temple, too, presented dense walls to the street, with high clerestory windows, that helped to focus the worshipers' attention inward. (Rosenthal Archive, Northwestern University.)

7.53. Unity Temple. The sanctuary is, in essence, a cube, focused inward, lit by skylights and clerestory windows above. (Library of Congress, HABS ILL 16–OAK 3-4.)

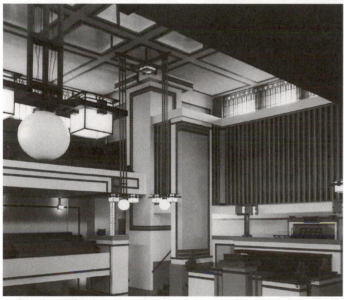

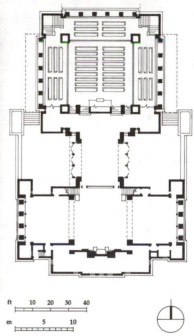

7.54. Unity Temple, plan. The path leading into the church is similar to searching for truth, turning in ever new directions in an unfolding process of discovery. (L. M. Roth, after HABS.)

ft 10 20 30 40

m 5 10

sense of community among the workers. The entire building was a great machine, a union of structure, space, and mechanical equipment. In the projecting corner piers, for example, were stairs, and the hollow walls of the towers contained ducts for ventilation. Hollow too were the sphere-topped piers that likewise performed double duty as ventilation shafts. The elaborate built-in ventilation system was necessitated by the location in a heavy industrial area; hence the building was hermetically sealed against soot and fumes. Like Sullivan's office skyscrapers, the Larkin Building is expressive of its internal function, for each element of the exterior refers to the internal organiza-tion.

In a similar way Wright expressed the important interior space in the external massing of his Unity Temple, in Oak Park, Illinois, built in 1904–6. [7.52, 7.53, 7.54] Unity Temple consists of two units, the Temple auditorium and the Unity House social hall, with the entrance to the building under a low hood on the side between the two blocks. (One also entered the Larkin Building at the side.) Each part of the exterior of Unity Temple discloses an internal function, so that the cubical space of the auditorium is clearly indicated, as are the stair towers in the corner piers. The interior is lit by clerestory windows on three sides and

by twenty-five square skylights piercing the flat roof.

To keep within the limits of the budget, Wright used a square plan with identical forms for the poured concrete on three sides of the auditorium block. Care was taken that the pebble aggregate of the concrete be exposed on the exterior, expressing the material and giving the building a distinctive textured surface.[34] This extensive use of poured concrete in Unity Temple as well as its surface treatment were significant technical innovations.

In April 1907 Wright published plans in the *Ladies' Home Journal* for a third model house, designed to be built of poured concrete. The splendid published perspective drawing was done by Marion Mahoney. Like Unity Temple, this too had a compressed square plan to economize on the expense of concrete formwork. Although the best known of Wright's houses were expensive productions created for independent-minded wealthy businessmen, the designs Wright published in the *Ladies' Home Journal* were meant to be within the range of the middle class. A modest square frame house, with a plan nearly identical to that of the concrete house for the *Ladies' Home Journal*, was built for Charles E. Brown in Evanston, Illinois, in 1905, and Wright designed several speculative houses for E. C. Waller around 1910.

In his public buildings Wright was moving toward an architecture of spaces articulated by structure supports and mechanical services. The clearest residential realization of this system is seen in the Darwin D. Martin house, in Buffalo, New York, built in 1904. [7.55, 7.56] Walls as traditional confining opaque planes virtually disappeared (at least in the published plan as drawn by Wright and his assistants), so that the volumes of the house appear as spaces defined by banks of windows and isolated brick piers. Integrated into the clusters of piers that support the house are lighting elements and heating, so that the forms that punctuate the spaces at regular intervals also contain mechanical services. To emphasize the sense of inter-connectednesss between exterior and interior, the brick of the structural piers is exposed instead of being covered with plaster. In his masonry Wright used thin Roman brick with wide, deeply raked horizontal joints that subtly stressed the horizontal line. The living room of the Martin house illustrates well the comprehensive design impulse that shaped every part of the house, including lighting units, built-in and free-standing furniture, artwork (as in the glazed brick mural over the central fireplace), and rugs and hangings; the only significant items not designed by Wright

were the hanging vertical Japanese prints sold to the Martins by Wright and placed on the brick support piers. In this integration of building, artwork, furnishings, and utilities Wright was influenced by the ideals espoused by William Morris and the English Arts and Crafts movement and perhaps even by Gustav Stickley's *Craftsman* magazine.

The Prairie house embodied a union of nine essential principles described by Wright.[35] First, the number of parts of the house were reduced to a minimum to achieve greatest unity. Second, the house was integrated with its site by extending the horizontal planes. Third, the room as a box was eliminated in favor of spaces defined by screens and panels. Fourth, the damp basement was eliminated by raising the house up off of the ground, placing the major living quarters up one flight with a better view of the landscape. Fifth, windows became banks of "light screens" rather than holes cut in walls. Sixth, the number of materials was reduced to a minimum with ornamentation expressive of the materials and designed for machine production—hence the propensity for straight lines. Seventh, all heating, lighting, plumbing, and mechanical fixtures were incorporated into the fabric of the building and made architectural features. Eighth, all furnishings were made one with the building. And ninth, the "fashionable decorator" was eliminated.

The house in which all of these principles found their fullest realization was perhaps that for Frederick C. and Lora Robie, designed by Wright in 1906 and built in 1908–9. [7.57, 7.58, 7.59] Possibly because Wright had to contend with a narrow city lot, he was forced to clarify each of the nine points. One enters through a dark, recessed vestibule on the shaded north side of the house, and, following a circuitous route, ascends a winding stair to the main level. At the top of the stair is a single enormous room, indicated by the long continuous bank of windows along the south side. The spaces for living room and dining room are subdivided by the mass of the fireplace, which pushes up through the center of the space. Even this mass, however, is not allowed to interrupt the space completely, for at the top it is opened up to form two piers; through the opening the ceiling and lights of the adjoining room can be seen so that one is constantly aware of the continuity of space. The lights themselves are part of the ceiling, and the vertical upstands along which they march enclose the hidden steel beams that span the length of the house and carry the incredible cantilevers at each end. Incorporated into the same ceiling upstands are indirect lighting and a ventilation

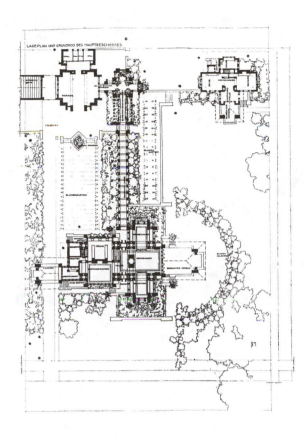

7.55. Frank Lloyd Wright, Darwin D. Martin house, Buffalo, New York, 1904. As shown by Wright in this drawing, the plan of the Darwin house seems to be composed of numerous freestanding piers and banks of glass. (Frank Lloyd Wright, Ausgeführte Bauten.)

7.56. Darwin D. Martin house. Although the scale is more horizontally expansive than in most of his other houses, here too Wright focuses on a central hearth. (Frank Lloyd Wright, Ausgeführte Bauten.)

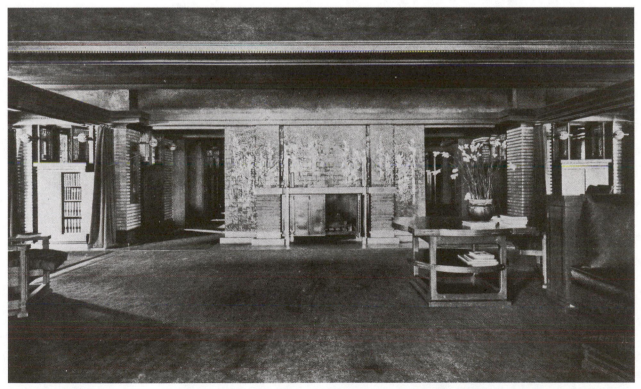

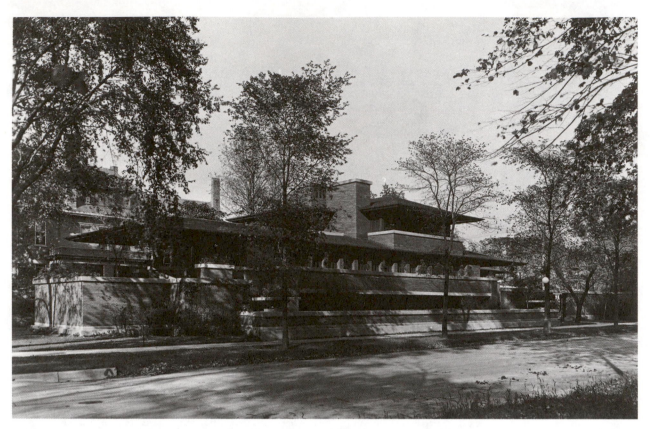

7.57. Frank Lloyd Wright, Frederick C. Robie house, Chicago, Illinois, 1906–9. The Robie house exploited and emphasized stretched horizontal planes as none of Wright's houses had done before. (Frank Lloyd Wright, Ausgeführte Bauten.)

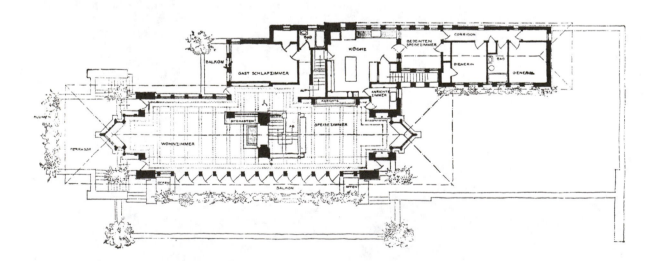

7.58. Robie house. In the Robie house, as Wright proposed for all Prairie houses, the main living level is on the second floor, eliminating the damp basement and providing visual privacy for the residence; the living and dining rooms are one long single space punctuated by the fireplace mass just off center. (Frank Lloyd Wright, Ausgeführte Bauten.)

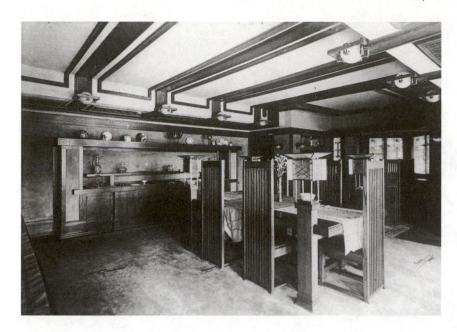

7.59. *Robie house, dining room, showing original fixtures, furniture, and carpet designed by Wright. (Rosenthal Archive, Northwestern University.)*

7.60. *Robie house. A section through the upper-level living room shows how Wright carefully calculated the roof overhang to provide warmth through sunlight in the winter, but kept the sunlight blocked in the summer. (L. M. Roth, after HABS.)*

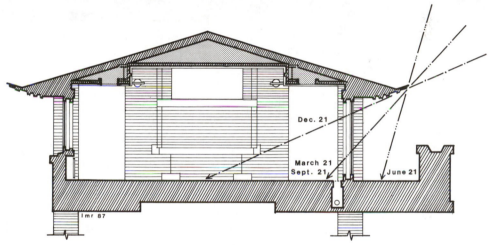

system that carries stale air to the central chimney and vents it to the exterior through a grill in the upper chimney brickwork. Externally, the horizontal planes and extended roofs create long shadows that make the masses of the house seem to float. Rugs for the house, integrated lighting fixtures, and all the furniture was designed by Wright, creating a pervasive unity that binds all parts of the house together. Although the heating systems of the day, combined with the long expanses of floor-to-ceiling glass, made the house impossible to keep warm in the winter, Wright carefully controlled summer heat gain by proportioning the extended southern eave of the roof so that it projected just far enough to keep the sun off the glass in the summer, but allowed the low winter sun to sweep into the living and dining room and warm the floor; and the huge western cantilever of the roof, a roof that seems to float outward forever, keeps the searing afternoon summer sun off the west end of the house until near sunset. [7.60] Summer breezes could be brought into and through the house by means of casement windows and the long row of glazed French doors that make up nearly the entire south wall.

Wright hoped his work might form the beginning of a new American architecture. Instrumental in advancing this reform, he anticipated, would be two publications soon to be issued by the Wasmuth publishing company of Berlin, Germany. During 1909–10 the

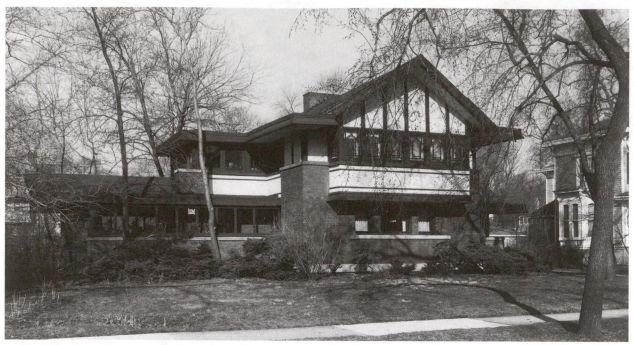

7.61. Walter Burley Griffin, Frederick B. Carter house, Evanston, Illinois, 1909–10. The Carter house illustrates how Wright's pupils expanded the Prairie Style. (Photo: L. M. Roth.)

drawings for the portfolio section of this effort were begun in the Oak Park studio, the most intricate and evocative of the perspectives being prepared by Marion Mahoney, Wright's most accomplished draftsperson. The publication was to be in two parts, an oversized portfolio of loose plates, drawings of selected projects and completed buildings (*Ausgeführte Bauten und Entwürfe*, 1910), and a second part, a much smaller paper-bound volume of text and half-tone photographs (with a few plans) of completed buildings (*Ausgeführte Bauten*, 1911). For the larger portfolio, Wright himself wrote an introductory essay, but for an essay in the smaller book Wright contacted his good friend, the English architect C. R. Ashbee, a leader in the Arts and Crafts movement in England.[36] Unfortunately, Wright's dream of the Wasmuth publications effecting sweeping changes in his native country were unrealized; the copies brought home for distribution were destroyed when Wright's home in Wisconsin burned in 1915. Wright's greater initial impact was made through the Wasmuth portfolio in Germany and Austria.

The Prairie School

In 1910 Wright experienced concurrent domestic and professional crises; his home life and career both disintegrated just as the Wasmuth publications were fin-

ished. During the next quarter century Wright's work would be overshadowed by that of lesser architects. Yet his influence did not abruptly come to an end, for during the good years in Oak Park Wright had gathered about him in the studio a group of young men and women who now began to exert influence of their own. This was the Prairie School, so called by later critics. One of Wright's principal assistants was Walter Burley Griffin (1876–1937), who grew up in Oak Park, studied architecture at the University of Illinois, and then worked in Wright's studio in Oak Park from 1901 to 1905. In Griffin's house for Frederick B. Carter, in Evanston, Illinois, built in 1909–10, one can see a good example of the impact of Wright's ideas. [7.61] The basic design is wholly Griffin's and is marked by his characteristic vertical details, open gable ends, and flattened eaves; but in the open plan, with rooms clustered around a central fireplace mass, in the general horizontal emphasis, and in the simple, plain surfaces one sees the influence of Wright. In the Carter house Griffin also combined more materials than did Wright, using stone, dark red brick, wood, and stucco, but with the masonry restricted to simple supporting masses at the ground floor.

Two other architects often associated with the Prairie School (although they never worked directly

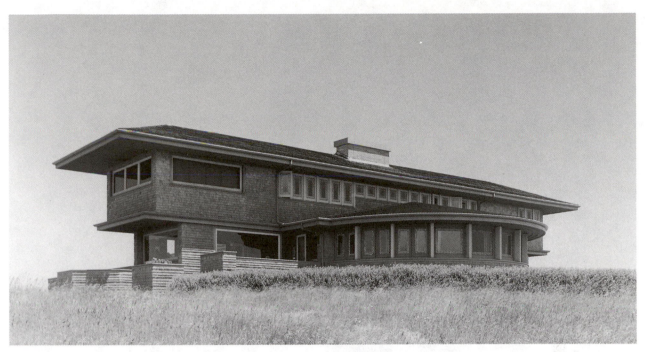

7.62. *Purcell & Elmslie, Harold C. Bradley house, Woods Hole, Massachusetts, 1911–12. Perched on a knoll rising from the Woods Hole harbor, the strong lifting horizontals* of the Bradley house bring the Prairie Style to the edge of New England. (Photo: © Wayne Andrews/Esto.)

for Wright) were William Gray Purcell (1880–1965) and George Grant Elmslie (1871–1952). Purcell grew up in Oak Park and studied architecture at Cornell before working briefly for Sullivan, where he met Elmslie. Elmslie was a native of Scotland and had little formal training, but he spent nearly twenty years in Sullivan's office as a devoted assistant and collaborator on the Carson Store and the later banks. Of the residences by Purcell & Elmslie, one of the most striking is the Harold C. Bradley house at Woods Hole, Massachusetts, built in 1911–12. [7.62] In the manner of Wright, the house accentuates a splendid site, a narrow peninsula jutting out into the Atlantic Ocean; it sits on a slight rise, making its greatly cantilevered floors appear to hover like wings. The T-shaped plan has at its core a large fireplace mass, which, like the semicircular dining conservatory, is derived from Wright's work. The boldly projecting floors are distinctive and were even more dramatic before the ground-floor porches were enclosed with screens, making the base appear to be solid. Particularly important is the shingle covering, for it brings the Shingle Style component in Wright's work back to its original eastern seaboard source.

THE SAN FRANCISCO BAY AREA TRADITION

Wright's unique individual achievement was closely paralleled by that of a number of architects working in the area of San Francisco. Only recently, however, has their equally fresh and inventive work been given proper attention.[37] One of the first of these architects was A. Page Brown (1859–1896), who trained in the office of McKim, Mead & White before settling in San Francisco. His friend and associate, A. C. Schweinfurth (1864–1900), came out of the office of Peabody & Stearns in Boston before joining Brown. His hacienda for Phoebe Hearst at Pleasanton, California, built in 1895–96, was an early essay in incorporating references to local Spanish Colonial traditions, but his truly innovative side was demonstrated in his simple, geometrically severe shingled First Unitarian Church, in Berkeley, built in 1898. Another new arrival to San Francisco was Ernest Coxhead (1863–1933), originally from Eastborne and London, England. His work could be inventively classical, the equal in many ways to that of Sir Edwin Lutyens, or innovative shingled residential work, as demonstrated in his house for William E. Loy, in Berkeley, built in 1892, and in several churches in the region.[38]

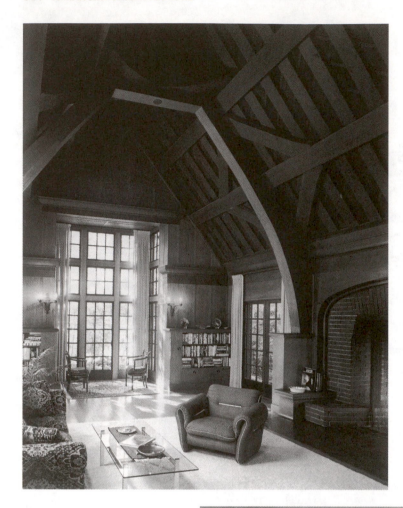

7.63. Bernard Maybeck, S. H.
Erlanger house, Forest Hill area, San
Francisco, California, 1916. Interior of
the living room. Maybeck's Bay Area
houses, adapted to the often steeply
sloped sites, had an emphatic vertical
character, and exploited wood
construction and shingled sheathing in
strikingly original ways. (Photo:
Richard Barnes, from S. Woodbridge,
Bernard Maybeck, Visionary Architect,
New York, 1992.)

7.64. Julia Morgan, St. John's
Presbyterian Church, Berkeley,
California, 1908–1910. Morgan's
innovative use of wood, particularly in
structural trusses, was an important
contribution to the unique Bay Area
tradition of design. (Photo: Morley
Baer, from S. Woodbridge, ed., Bay
Area Houses, 2nd ed., Layton, Utah,
1988.)

A central figure in the creation of what has sometimes been called the "Bay Area School" was Bernard R. Maybeck (1862–1957), a maverick who drew upon a full range of academic and industrial sources for his inimitable work. Born in New York City and trained by his family as a cabinetmaker, he studied architecture at the École des Beaux-Arts in Paris, returning to New York and entering the office of Carrère & Hastings, where he was instrumental in creating the highly interpreted Spanish details of the firm's Ponce de Leon Hotel in St. Augustine, Florida, built in 1888. In 1890 he relocated to San Francisco, first working for A. Page Brown and then setting up his own practice. He began producing a series of craggy, heavy-lidded wood shingled houses, adapted to the step terrain of Berkeley. His house for Charles Keeler in Berkeley, built in 1895, had an intricacy of wood framing members that reflected his early crafts training. This emphasis on wood construction and strongly articulated framing is apparent in the interior of his S. H. Erlanger residence, built in 1916 in the Forest Hill area of San Francisco. [7.63] His later buildings, such as the Christian Scientist Church, in Berkeley, built in 1910–12, demonstrated a remarkable creative imagination, combining massive overscaled Gothic detailing, and Asian-looking low-pitched, broadly projecting roofs, with walls constructed of industrial cement-asbestos panels and industrial metal window

sashes, and intricate wood trusses over the auditorium. Much the same combination of tradition and invention is seen in his later Packard automobile showroom on Van Ness Avenue, San Francisco, built in 1926, whose pairs of Corinthian columns are grouped between enormous banks of plate glass presenting the cars within.

Regrettably, many of Maybeck's best shingled houses in Berkeley have disappeared as the result of fires, and the same is true of many of the nearly one hundred redwood shingled houses built in Berkeley by Julia Morgan in the early years of her career (she had also worked briefly for Maybeck). Her residence for August F. Hockenbeamer in Berkeley, built in 1913, fortunately, survives Also standing is her elegantly restrained shingled St. John's Presbyterian Church, built in 1908–10, its delicate open wood trusses over the sanctuary bearing witness to Morgan's engineering training [7.64].

Greene & Greene

While Wright and his followers were reshaping residential architecture around Chicago, as the Bay Area architects were likewise doing around San Francisco, significant developments were also taking place in southern California that visually, at least, seem related, but in fact were the fruit of developing local traditions and the growing influence of Japanese building

7.65. Greene & Greene, David B. Gamble house, Pasadena, California, 1907–8. One of the largest houses designed by the Greene brothers, this combines elements of the Shingle Style, a strong Japanese sensibility, and the articulated *framing of the Stick Style; it survives with nearly all of the furnishings and interior detailing provided by the architects. (Sandak, courtesy of the University of Georgia.)*

techniques. In Pasadena the brothers Henry M. and Charles S. Greene (1870–1954 and 1868–1957) developed a mature and highly complex expression in about 1902–3 that combined elements of the eastern Stick Style, Stickley's work, the English Arts and Crafts movement, and even Japanese techniques of carpentry and joinery. One can see in this highly developed carpentry the influence of the brothers' early training in manual arts. The David B. Gamble house, in Pasadena, built in 1907–8 [7.65] as a winter escape for the Cincinnati soap magnate, is one of the brothers' best, with large rooms clustered in a seemingly random pattern about a broad central hall. The low roofs, carried on elaborate brackets, form a series of parasols shading large parts of the house. Every part of the frame, while structurally necessary, is lovingly exploited for maximum visual effect, with all corners and edges softly rounded, as though worn and smoothed over the course of time. As in Wright's houses, all interior finishes and furnishings were designed by the Greene brothers, including a special case for the piano. Also like Wright's, the Greene brothers' furniture was essentially rectilinear, incorporating bits of stained glass, leather, and inlays of exotic woods and seashells, but the overall effect was more softly rounded. The Greenes' houses often rose slowly, for the architects themselves were directly involved in the building process, combing local ravines for stones and directing the cutting and fitting of the complex joinery. This consummate craftsmanship was in part inspired and encouraged by Stickley through *The Craftsman* (where much of their work was published) and to a degree it is even more carefully refined in detail than the contemporary work of Wright. Charles Robert Ashbee (the English Arts and Crafts leader who wrote the introduction for Wright's Wasmuth portfolio) toured the United States and spent time with both Wright and the Greene brothers. He greatly appreciated Wright's abstract perfectionism, but he found in the Greene's interiors and furniture "more tenderness, more subtlety, . . . more repose."[39] He enjoyed visiting Wright's houses, but to live in, he preferred those by Greene & Greene.

Irving Gill

The nearby work of Irving Gill (1870–1936) could hardly be more different. Gill was born in Syracuse, New York, the son of a building contractor, and this early experience inspired Gill's later experiments in simplifying the building process. Gill was in Chicago in Sullivan's office during the same period that Wright was there, working principally on the Transportation Building for the Columbian Exposition, but in 1892 Gill was forced to go to southern California for his health. He built up a practice centering in San Diego, and his early designs there in stucco resemble those of C. F. A. Voysey, Otto Wagner, and Adolf Loos in their severely reduced forms. Gill's large residence for

7.66. *Irving Gill, Lewis Courts, Sierra Madre, California, 1910. Gill designed a cluster of twelve modest houses* around a central landscaped court, intended for rental for workmen and their families. (Courtesy of Esther McCoy.)

Walter L. Dodge in Los Angeles, built in 1914–16, was one of the best examples of his mature work, revealing a functional asymmetry whose "ornament" was derived largely from the studied geometry of the sharply incised openings in the otherwise plain walls, and in the exquisite detailing of the wood cabinetry inside.[40] Regrettably, the house was demolished so that its extensive surrounding gardens could be more profitably "developed." Although the Dodge house was for an extremely well-to-do client, Gill also had a deep concern for practical housing for workers. Using pre-fabrication construction techniques developed by the U.S. Army, Gill assembled whole wall segments of reinforced concrete, casting them flat on the floor slab, then tilting them upright into place to form completed buildings. Such a process, demanding simplified details and sharp edges, was used for the Lewis Courts, in Sierra Madre, California, built in 1910. [7.66] As in many of his other designs, Gill incorporated rounded arched openings, an abstracted reference to the Spanish Colonial architecture of the southern Californian missions. The Lewis Courts housing venture consists of eleven units around a court terraced with play areas and covered sidewalks. The Lewis Courts, in particular, were quite successful—so much so that the developer raised the rents, infuriating Gill, who had designed them as worker's housing.

URBAN PLANNING

Although there was rapid expansion of cities following the Civil War, for the most part this was unplanned growth. Especially in the developing western states—once the native peoples had been "pacified" and forced onto reservations—cities sprang up along the transcontinental railroads as they pushed ever westward. The broad sweep of the flat high plains was divided up in the national grid, and the cities mushrooming there were likewise laid out as grids, sometimes on the lines of the compass and sometimes shifted to align with the railroad tracks. Omaha, Kansas City, and Denver, which hardly existed in 1860, had populations of almost a quarter of a million each by 1910. The length of total track across the United States increased from 53,000 miles in 1870 to 240,000 miles by 1910; in the next decade only 13,000 additional miles were added when trackage was at its greatest. The West Coast cites where the transcontinental railroads terminated also exploded in size; Portland and Seattle both reached almost a quar-

ter of a million people each by 1910, San Francisco grew from 150,000 people in 1870 to 417,000 by 1910, and Los Angeles reached more than 319,000 by 1910.

The older eastern cities expanded as well, particularly those that emerged as regional rail centers. Chicago, which had almost 300,000 people after the Civil War, boasted well over a million when it was host city for the Columbian Exposition in 1893, and had more than doubled again to 2.2 million by 1910. New York City increased in density and size, ballooning from 1.8 million people in 1870 to 6.5 million in 1910.[41] Boston expanded from 251,000 to 671,000 people, and Philadelphia almost tripled in population from 674,000 to 1.5 million.

This unruly urban growth, unequaled in scope until about 1950 (again following a major war), caused concern among some architects, for it was completely unplanned. In miniature, this blind urban expansion was paralleled by the lack of concern for comprehensive planning shown in laying out the buildings and grounds of the Philadelphia Centennial Exposition in 1876. In the years following, the rapid increase in number of École-trained or Paris-influenced professional architects, with their broader view of buildings in ensembles, would foster a growing interest in urban design and urban planning. Their demonstration piece would be the next major world's fair held in the United States, celebrating the four-hundredth anniversary of Columbus's stumbling into the New World while searching for a water route to China. Compared to the rampant jerry-building of the 1870s and 1880s, the carefully organized plan and architecture of the World's Columbian Exposition in Chicago would seem like a dream, its harmonized architectural groups in sharp contrast to the grittily utilitarian industrial city that had produced it.

In 1890, Frederick Law Olmsted suggested several possible sites for the fair in Chicago, but urged selection of a lake site and incorporation of water features in the fairgrounds; moreover, he stressed that there should be harmony between buildings and grounds. The concept was quickly taken up by the architects appointed by Daniel Burnham to design the various main buildings of the fair. Since the vast scale of the proposed exposition made it impossible for any single architect or firm to design all the buildings in the time remaining, Burham & Root (who had been appointed to direct architectural development of the exposition) selected several well-known eastern and midwestern architectural firms, as well as a number of established

Chicago architects or firms. Each of the architects selected the building of his preference in consultation with Burnham, who directed the whole operation but who designed nothing himself. The architects of the buildings around the Court of Honor to the south were R. M. Hunt, McKim, Mead & White, and George B. Post, all from New York, and Peabody & Stearns of Boston, while the buildings in the middle zone were done by Jenney, Sullivan, and other Chicago architects. At the north of the winding lagoon was Charles B. Atwood's magisterial Palace of Fine Arts, the most academic of the group and based on Emile Bénard's Prix de Rome first-place-winning design of 1867; it has been restored to house the Chicago Museum of Science and Industry and is the only surviving building of the fair.

7.67. *World's Columbian Exposition, Chicago, 1891–93. Plan of the fairgrounds, showing major buildings. (L. M. Roth, after John J. Flinn,* Official Guide to the World's Columbian Exposition, *Chicago, 1892.)*

ft 1000 2000 3000

m 100 300 600 900

7.68. *Columbian Exposition view of the Court of Honor looking west. In the foreground, left to right: Agriculture Building by McKim, Mead & White; the Republic by Daniel Chester French; Manufactures and Liberal Arts Building by* George B. Post. *In the distance, the Administration Building by Richard Morris. (Courtesy of the Chicago Historical Society.)*

At their first joint meeting in 1891, the architects resolved that there would be unity of expression in all the buildings. To achieve this goal it was further decided that all participating architects would use a classical style since that was the only idiom all of the architects had studied and knew equally well. Moreover, it was a modular system of design, one suited to subdivision of detail and to enrichment by means of sculpture and mural painting. In addition a uniform arcade width and cornice height were fixed.

Meanwhile, following suggestions by Olmsted, the general plan of the fair was worked out by his assistant Henry S. Codman with Burnham & Root. Sadly, a cold John Wellborn Root contracted during these early meetings quickly developed into pneumonia; the infection quickly overtook him and in four days he was dead. In profound despair, and frantic with the work of the fair that had to be completed, Daniel Burnham readily accepted a new partner recom-

mended by his eastern colleagues, architect Charles B. Atwood. Although neither the theorist nor the experimenter that Root had been, Atwood was capable and well organized. The site selected, a marshy morass south of Chicago's center, was dredged to create lagoons, and the reclaimed soil was placed behind retaining walls, resulting in the formal character of the southern portion of the fair. [7.67]

The Columbian Exposition changed the course of urban building in the United States, largely for the better. There were many reasons for this strong influence. One was the evident benefit resulting from careful study and planning of the entire complex well before the individual buildings were designed and constructed. [7.68] Another was the clear coherence and consistency of the style and character of the principle buildings, although this also had the unfortunate result of persuading many visitors that the only appropriate style for new public buildings was Roman clas-

7.69. *Bernard Maybeck, Palace of Fine Arts, Panama-Pacific Exposition, San Francisco, California, 1911–15. Preserved by the citizens of San Francisco, Maybeck's building and enclosing colonnade were intended to create a brooding setting to arouse romantic contemplation. (Courtesy of the Bancroft Library, University of California, Berkeley.)*

sicism. [42] Another aspect of the fair that influenced visitors was the remarkable clarity of organization and the axial relationships connecting the many buildings. There was a hierarchical arrangement of spaces that seemed to lead people from one area to the next with a logical inevitability. The spaces between the buildings had been just as carefully planned as the buildings themselves to facilitate easy crowd movement and to permit viewing the buildings in groups. In addition, visitors were brought to the exposition largely by systems of mass transit that deposited them at the very heart of the fair and from which they could easily fan out. The movement of people was greatly facilitated by the many ways that electricity was put to work: in the elevated railway that circled the grounds and passed through some of the buildings, in the battery-powered boats that plied the lagoons, and in the double-loop moving sidewalk that extended the length of the pier reaching out into Lake Michigan. Especially important, though largely hidden from public view, were the interconnected utilities and services, the fire alarm system, and electrical and telephone wiring, all installed below ground in large conduits well before construction of the buildings was started. There was also a remarkably high degree of finish and cleanliness of the grounds, for at night work crews scoured the grounds making small repairs and sweeping up; each morning the fair reopened looking virtually the same as the day it first opened. Furthermore, water was used extensively in lagoons and fountains, exploiting the location on Lake Michigan, making this one of the first large-scale demonstrations in the United States of the public use of water. Workaday American cities looked nothing like this.

Although there were some dissenting voices, most critics and the general public lauded the fair and its design, not so much for the classical style but for its visual order, clarity, and consistency. They were also dazzled by the omnipresent electrical displays and appliances. Many visitors noticed, too, that the major buildings had been clustered together according to type of use, making this one of the first demonstrations of functional zoning. There were four principal areas: a formal area to the south for the primary educational exhibits, a more informal lagoon in the middle, an irregularly laid-out area to the north for the national and state pavilions, and an entertainment midway extending to the west for the public amusements.

Quite naturally the artistic success of the Chicago Fair spurred the creation of subsequent international expositions, most notably those in Buffalo (1901), St. Louis (1904), and especially the Panama-Pacific Exposition in San Francisco in 1915. In the San Francisco Fair the exhibition facility was essentially one large rectangular building opened up by several spacious courtyards; consequently the architects designed the spaces rather than the building proper. At

the end of the long main building in San Francisco was a Palace of Fine Arts designed by Bernard Maybeck. It consisted of a round temple next to a reflecting lagoon enclosed in a curving colonnade and gallery where the exhibits were displayed. [7.69] Maybeck, once a student at the École des Beaux-Arts in Paris, was a creative, eclectic architect of the best kind. His Palace of Fine Arts, particularly its focal temple, is instructive because it reveals the eclectic's attitude toward design; Maybeck described his intent in designing this frankly Roman bauble, saying that the building was to be a "conveyor of ideas," meant primarily to induce intellectual and emotional associations in the mind of the observer.[43] This the temple certainly did extremely well, to such an extent that it fixed itself in the self-image of San Franciscans. Although intended as a temporary ornament, it was rebuilt in permanent materials after the fair closed and then restored in 1969; today it is the centerpiece of a public park. Although Maybeck is perhaps best remembered for his more experimental work in the San Francisco Bay Area, such as his houses or the Christian Science Church in Berkeley, this traditional design helps to illustrate the persuasive popularity of the classical architecture of these exhibitions.

The City Beautiful Movement

It was such world's fairs that brought what came to be called the City Beautiful movement to scores of cities. At the same time, across the nation the high-minded political goals of Progressivism gained popularity, leading to reform campaigns to eliminate graft and corruption in city government. The physical manifestations of this Progressivism were planning and building campaigns to replace aged civic buildings as a visual symbol of underlying civic pride and desire for improvement. As a result, in scores of American cities planning commissions were appointed and hundreds of new classical buildings were built to house museums, libraries, art galleries, courthouses, city halls, and other public institutions. Often these were clustered together in civic or cultural centers forming the terminal elements of grand new monumental boulevards. The civic center of Cleveland, to name just one example, was designed in 1902–3 and completed by stages during the next half century, generally following a plan prepared by Burnham working with Arnold Brunner and John M. Carrère. [7.70]

As a direct result of the Columbian Exposition, in 1901 the United States Senate appointed Burnham, McKim, and Frederick Law Olmsted Jr. to a commis-

7.70. *Daniel Burnham, with Arnold Brunner and John M. Carrère, Civic Center plan for Cleveland, Ohio, 1902–3. A landscaped axis connects a group of city and state buildings with federal buildings, pointing toward a projected new railroad station on the shore of Lake Erie. (From* Architecture 8 *[September 15, 1903].)*

7.71. *Senate Park Commission, plan of proposed changes to the Mall, Washington, D.C., 1901–2. After a century of neglect and abuse, the strong controlled geometry of* L'Enfant's plan was restored. (*Archive of McKim, Mead & White, the New-York Historical Society.*)

sion to study the park system of the District of Columbia and to recommend improvements. At least this was the way the enabling legislation read officially, but the real objective of the commissioners was nothing less than replanning the entire city so as to restore the clarity and order of L'Enfant's original plan and to solve modern circulation problems. Over the decades L'Enfant's grand scheme had been dismantled piecemeal by insensitive presidents and short-sighted congresses. The first and most obvious digression had been Andrew Jackson's decision to place the Treasury next to the White House, blocking L'Enfant's "reciprocity of sight" between the executive and legislative branches of government. Next came the necessary shifting of the Washington Monument obelisk well off the crossing of the mall axes to a place where the subsoil could support its great weight. This was followed by the construction of Renwick's Smithsonian Institution too near the center of the Mall, Downing's start at the romantic relandscaping of the White House grounds for President Fillmore, and last and most serious, the construction of a railroad station across the middle of the Mall. All this the Senate Park Commission set out to correct. After touring colonial Williamsburg and nearby southern plantations, the commission left for Europe to inspect the leading capital cities and land-

scaped estates that had served as L'Enfant's models. Upon their return, gathering a small army of illustrators and architectural draftsmen, the commission prepared a large exposition clearly demonstrating their proposals. Their extensive models and drawings were shown to Congress and the public when the commission made its report in January 1902.

Drawing upon the lessons of the Columbian Exposition, the Senate Park Commission offered proposals in three general areas: the reclamation of the Mall, the planning of government and district office buildings around the White House and Capitol, and the development of an extensive network of interconnected parklands throughout the city. Elaborate colored drawings were prepared to show how the Mall could be redeveloped by slightly rotating the axis so that it ran through the Washington Monument. [7.71] This new alignment would then be further strengthened by new public buildings lining the edges of the Mall and by the construction of a major memorial to Abraham Lincoln at the west end on new land reclaimed from the Potomac River. Furthermore, in a gesture of civic munificence, the railroads agreed to build a new station north of the Capitol, abandoning their old right-of-way across the Mall. Thus the open sweep that L'Enfant had envisioned could be restored. This work of reclamation and redefinition has been

continued, generally adhering to the spirit of the Senate Park Commission's report, though details have been changed as needs and conditions have shifted over the last century.

As the new century began Burnham focused his energies increasingly on city planning, such as the civic center he devised for Cleveland, with Brunner and Carrère. In 1905 he drew up plans for Manila and for Baguio, a new summer capital of the Philippines. In 1902 he began preparation of a comprehensive plan for San Francisco that was finished in 1905, but that unfortunately was largely disregarded in the rush to rebuild the city after the earthquake and fire of April 1906. Much more successful in the long run was Burnham's plan for Chicago begun in 1906 under the auspices of the Commercial Club. Burnham began by making a comprehensive examination of the region around Chicago extending nearly seventy miles in radius. His goal was to integrate the interrelated transportation, industrial, and commercial networks for the greatest efficiency, while at the same time making the city physically, artistically, and culturally a better place to live. These latter ends he met by urging the development of a far-flung system of city and county parks, by reclaiming the entire lake shore as a linear park, and by building a cultural and civic center on the lakeshore in the center of the city. The report, published in 1909 with many illustrations in color [7.72, 7.73], moved from considerations of Chicago in relationship to its raw materials supplies, to such specifics as a proposal for the architectural treatment of the Chicago River embankment. [7.74]

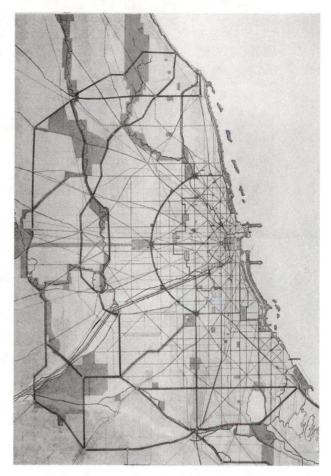

7.72. *Daniel H. Burnham, Plan of Chicago, metropolitan plan. This metropolitan plan shows relationship of traffic arteries, existing recreational facilities, and parkland augmented by new-made land reclaiming the lakeshore for public use. (From D. H. Burnham,* Plan of Chicago, *Chicago, 1909.)*

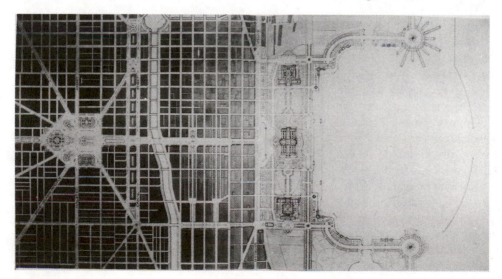

7.73. *Plan of Chicago, rendered plan of the central business and governmental district, 1904–9. Burnham's plan for the city center called for rebuilding the lakeshore east of the existing train tracks for an arts complex; the commercial-mercantile district would be between Michigan Avenue and the river, and a new government complex would be created west of the river. (From D. H. Burnham,* Plan of Chicago.*)*

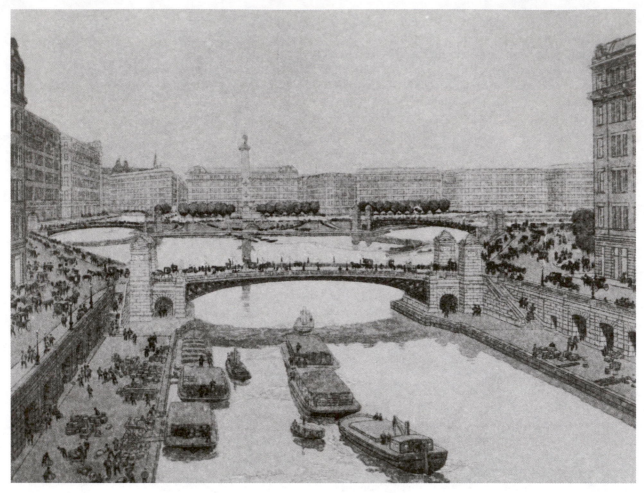

7.74. Proposed double-level drive along the Chicago River. Detail showing development of two-level street system and new quays along Chicago River. (From D. H. Burnham, Plan of Chicago.)

Over the next half century many of Burnham's proposals were gradually realized. The lakefront was filled out eastward from the Illinois Central tracks to form a new park strip from Grant Park to Jackson Park to the south. In addition, to further the development of the city's parks, large tracts of land were set aside to form the Cook County Forest Preserve. Portions of the Chicago River were to be lined with quays, inspiring the construction of double-decked Wacker Drive in the 1920s, as proposed by Burnham. And though the civic center with its huge and ill-proportioned domed city hall was never built, the cultural amenities of the city were soon grouped at the heart of the city, in Grant Park on the lake, rather than being relegated to an isolated cultural compound.

HOUSING REFORM

Urban Tenements

It is significant that the Columbian Exposition and Burnham's planning appeared at the moment when the urban network and business systems had been completed and attention began to turn toward improving the social and physical environment. Still, in the hearts of the major cities, workers were most often forced to live in squalid, overcrowded tenements that rapidly deteriorated into slums. Though diatribes against such living conditions had been published for half a century, written language alone had lost sufficient power to convey the awful facts. In the 1880s, police reporter Jacob Riis taught himself the rudiments of photography and began to probe the worst

slums of New York, taking flash pictures of the conditions he found. His photographs, published first as engravings in 1890 in *How the Other Half Lives*, proved to be even more powerful when they were reproduced as halftones in the subsequent editions. The stark, unflinching photographs told more than a generation of impassioned written descriptions had, and within two years of publication of Riis's book reform movements had started work in New York and numerous other cities.

Despite the demonstrated success of the A. T. White apartment blocks in Brooklyn, they were not widely emulated, for the law still permitted construction of narrow dumbbell apartments. One of the most remarkable aspects of this period is that young architects from families of considerable wealth and privilege devoted their professional energies to designing workers' housing. From having lived in tenements as a youth, Ernest Flagg knew all too well what conditions were like. One of the problems was insufficient open space in the individual dumbbell units, so Flagg regrouped apartment units in an ideal tenement he designed to create a much more generous court in the center, while still providing an outside window in every room. He was soon able to put this plan into effect in the Alfred Corning Clark model tenements, on West Sixty-ninth Street, New York, built in 1896–98. This was followed by other model tenement apartment buildings he erected in New York and Boston around the turn of the century.

Even more remarkable was reformer Isaac Newton Phelps Stokes (1867–1944), known as Phelps Stokes or I. N. Phelps Stokes, born in New York City, the son of an extremely wealthy family. Raised in gracious luxury, he was also trained in the family tradition of enlightened philanthropy. He was educated at prestigious private schools, and obtained his bachelor's degree from Harvard in 1891. In accordance with his father's wishes he entered the banking business, but by 1893 had persuaded his family to let him study architecture, beginning at Columbia University and finishing at the École des Beaux-Arts. In 1897 he returned to the United States and went into partnership with John Mead Howells, and in that year they submitted the winning design of the University Settlement building. Their better-known public work consisted of restrained classic works such as Woodbridge Hall at Yale University, built in 1901, designed to form an ensemble with the adjoining bicentennial building complex by Carrère & Hastings. But from the beginning Stokes had a special interest in housing reform. In

1896 Stokes submitted a design in a model tenement house competition sponsored by New York's Improved Housing Council. Two years later he helped form the Charity Organization Society's Tenement House Committee, which in turn led to the creation of the Tenement House Commission by then governor Theodore Roosevelt. Attacking the cramped conditions of the ubiquitous dumbbell apartment, Stokes developed an alternative apartment block design, realized in the construction of the Tuskegee Houses, a six-story apartment block intended for Negroes, built in 1901 and financed by the Stokes's wealthy sisters. Also in 1901, he wrote the draft of the New York Tenement House Law. His innovative Dudley model tenement block, in New York City, was built in 1910. After the partnership was dissolved in 1917, Stokes devoted himself to housing reform, particularly to lowering the cost of workers' housing through the Phelps-Stokes Fund created by his sisters in 1911. He continued to believe that the most practical solution to housing reform lay in making construction of improved apartment units profitable for private speculators rather than through direct government subsidy.

Industrial Workers' Communities

While prominent architects such as Flagg and Stokes attempted to improve the standard of urban tenement design, other eminent architects turned their attention to the design of planned workers' communities in industrial towns. By far the largest of all of the company towns started in this period was Gary, Indiana, begun in 1905 by the United States Steel Company and named for the corporation's lawyer. A choice location at the foot of Lake Michigan was obtained, but nearly all of the shore was set aside for industrial use, with the large housing and commercial district to the south laid out in an unmitigated grid. The scale was vast, aimed at an ultimate population of as many as 200,000 people, but the company exercised no comprehensive housing program (an overreaction to the Pullman scandal), and the inevitable result was overcrowded and poor-quality housing.

Gary was representative of the kind of company town in which the company engineer laid out a conventional grid and housing was built by private speculators. A second type, in which the company laid out a grid but the buildings were designed by recognized architects, is exemplified by Echota at Niagara Falls, New York, built for the first electric power company there, with the powerhouses, public buildings, and houses designed by McKim, Mead & White and built

in 1893–95. A third type, in which a recognized planner laid out the streets but in which the company, speculative contractors, or individual workers built the houses, is well represented by Vandergrift, Pennsylvania, planned for the Apollo Steel Company by Frederick Law Olmsted in 1895. [7.75] In this, one sees the curving streets and emphasis on varied prospects that had marked Olmsted's earlier plan for Riverside, Illinois.

What was most significant in this period, however, was the emergence of a new tradition in company town construction—the planning of street, land-use pattern, and housing by recognized and skilled professionals. In some cases all was done by the same individual or firm, in others an accomplished planner would collaborate with a well-known architect. Important examples are the additions to Hopedale planned by Arthur A. Shurtleff with duplex houses by Robert A. Cook in 1910 [7.76]; Kohler, Wisconsin, planned by Hegemann & Peets and the Olmsted brothers, with buildings by Brust & Philipp, of 1913; Warren, Arizona, a copper mining town planned by Warren H. Manning with buildings by Applegarth and Elliott, begun in 1906–8; and Tyrone, New Mexico, another copper mining community, designed and planned by Bertram Grosvenor Goodhue in 1914–15.

Tyrone has attracted the interest of students of town planning history because it was done by one of the most prestigious architects of the period. Goodhue was engaged apparently because the Phelps Dodge Company, developers of the Burro Mountain mine,

wanted to construct a model mining community. Just over a mile from the mouth of the mine tunnel, Goodhue placed the central plaza of the town in an arroyo, with the houses for workers and supervisors on the crests of the ridges above. [7.77, 7.78] The public buildings around the plaza, particularly the church, were designed in the colonial Spanish-Mexican Baroque that Goodhue was using at the same time for the theme buildings for the Panama-California Exposition in San Diego, California, but for the workers' residences he studied local native American adobe structures. The houses of both the Mexican workers and the American supervisors were built of hollow clay tile blocks, covered with several layers of tinted stucco. The plaza, perhaps somewhat grand in view of the projected population of the small town, was to have a full range of facilities—shops and offices, company store, theater, workers' club, hotel, garage, post office, public school, and railroad station. In the hills above was a hospital. Unfortunately, less than half of this development was completed: a collapse of the copper market after the First World War, coupled with the very low grade of the Burro Mountain ore, forced Phelps Dodge to close Tyrone after it had been in operation only three years.[44] Still, though truncated, Tyrone was an important experiment and it was a significant influence on the career of the young assistant in Goodhue's office who supervised the Tyrone drawings—Clarence Stein.

Tyrone is the exception in Goodhue's work, which largely came to be concerned with public buildings and commercial structures, but one architect came to

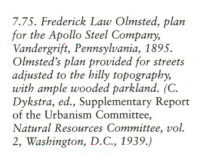

7.75. Frederick Law Olmsted, plan for the Apollo Steel Company, Vandergrift, Pennsylvania, 1895. Olmsted's plan provided for streets adjusted to the hilly topography, with ample wooded parkland. (C. Dykstra, ed., Supplementary Report of the Urbanism Committee, Natural Resources Committee, vol. 2, Washington, D.C., 1939.)

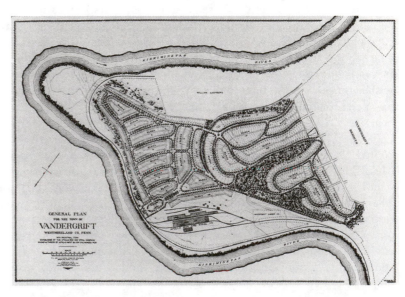

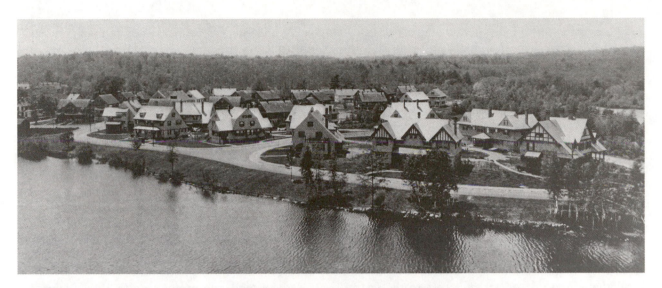

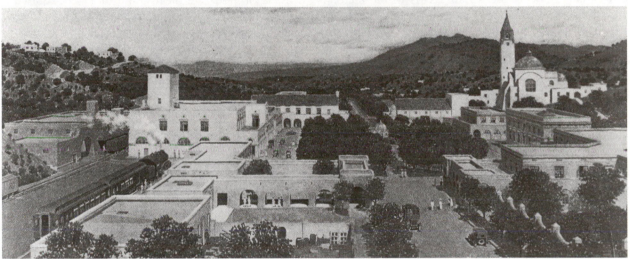

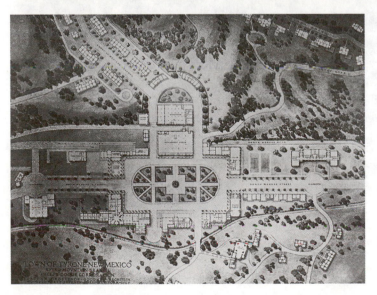

7.76. *Robert A. Cook, architect, Arthur A. Shurtleff, planner, Lakeside Group, 1910. The Lakeside housing addition to Hopedale provided assorted duplex units, arranged along winding streets, that overlooked the factory millpond.* (Architectural Review 28 [April 1918].)

7.77. *Bertram Grosvenor Goodhue, view of the village piazza, as planned, Tyrone, New Mexico, 1914–15. An ambitiously planned model company town for the Phelps-Dodge Company, Tyrone had a distinct town center or plaza defined by public buildings in a southwestern Spanish Colonial style.* (Architectural Review 28 [April 1918].)

7.78. *Plan of Tyrone. At the top of the plaza is the company store, with a hotel and movie house in the opposite corners; a large public school appears to the right, with a church on the hillside opposite.* (Architectural Review 28 [April 1918].)

public attention during this period almost entirely for his design of workers' housing complexes; this was Grosvenor Atterbury (1869–1956). Initially Atterbury, like so many other young architects, busied himself with the design of comfortable country houses for wealthy clients, but at the same time he lectured on the design of good, commodious, soundly constructed workers' housing. Soon he was given commissions for such housing groups, and often acted as both planner and architect. Most attractive was his industrial village, Indian Hill, for employees of the Norton Grinding Company, outside Worcester, Massachusetts, begun in 1915. On a gentle hillside adjacent to the factory, Atterbury laid out a system of streets curved to fit the topography, focusing on a square lined with shops and leading to a bridge over the railroad that provided pedestrian access to the factory. [7.79] On the 116 wooded acres fifty-eight freestanding houses were built under the canopy of trees—the antithesis of Gary, Indiana. Moreover, the frame houses were highly conservative and traditional in expression, basically Dutch Colonial gambrel-roof houses with large dormers. The individual rooms were well disposed for ventilation and were amply propor-

tioned. Indeed, the evidence accumulating in such industrial villages as Hopedale, Ludlow, and Whitinsville in Massachusetts; Willimantic, Connecticut; Leclaire, Illinois; and the much larger Erwin, Tennessee (which Atterbury planned and designed in 1916), was that the more traditional the design of the buildings, the more successful the enterprise, and the more appreciated by workers.

Today Atterbury's reputation as a social progressive rests largely on his design of the buildings for the suburban community of Forest Hills Gardens, now part of Queens, New York. In an effort to improve the practicability of good middle-class housing, the Russell Sage Foundation (established in 1907 for the "improvement of social and living conditions") determined to build a model commuter suburb for office workers of moderate means, and in 1909 acquired a tract of 142 acres next to a branch of the Long Island Railroad that led to the new Pennsylvania Station in Manhattan. The railroad was to be the all-important link to the city. Frederick Law Olmsted Jr., was engaged as planner, and Atterbury as architect. The plan they devised had a fan of winding major streets focused on a plaza and the commuter railroad station.

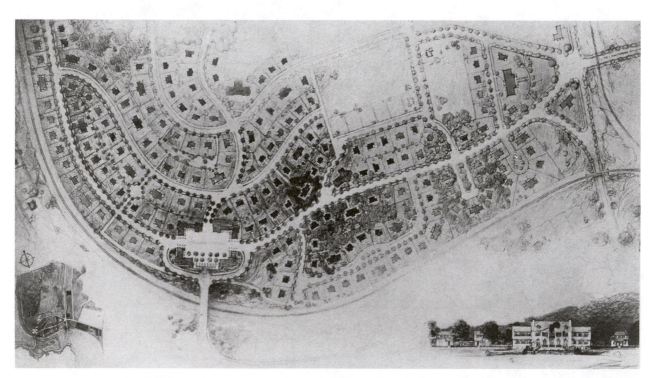

7.79. Grosvenor Atterbury, Indian Hill, Worcester, Massachusetts, 1915. Indian Hill, built for the Norton Grinding Company, provided for several dozen single-family houses in a wooded village environment. (Architectural Record 41 [April 1918].)

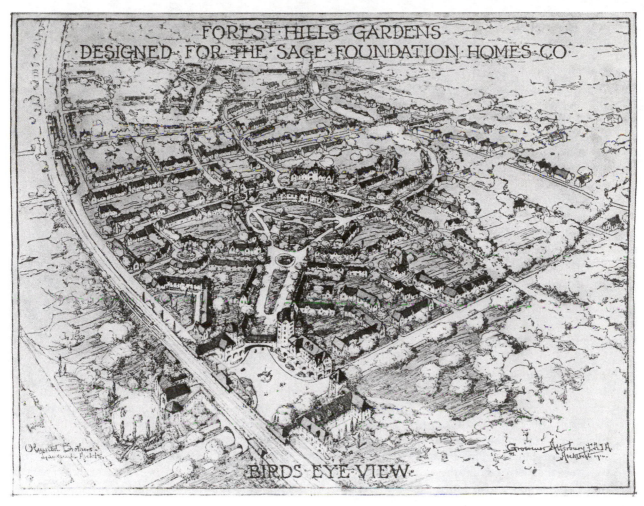

FOREST HILLS GARDENS
DESIGNED FOR THE SAGE FOUNDATION HOMES CO.

BIRDS EYE VIEW.

7.80. *Grosvenor Atterbury, architect, Frederick Law Olmsted Jr., planner, Forest Hills Gardens, New York, New York, 1909–12. Planned as a workers' village just outside New York City, Forest Hills Gardens had a graduated street plan that focused on the public square and the commuter railroad station.* (American Architect 102 [October 1912].)

7.81. *Station Square, Forest Hills Gardens. This view encompasses some of the apartment units and apartment tower east of the public square; through the archway can be seen the commuter railroad station in the distance.* (American Architect 102 [October 1912].)

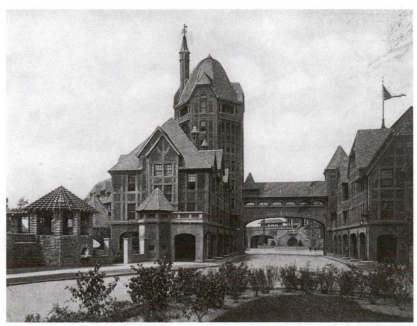

[7.80, 7.81] Around the plaza and framing it was an apartment tower flanked by lower apartment wings with street-level arcaded shops; bridges spanned the streets connecting the apartment blocks and the station. Beyond this public square were town house clusters and single-family houses, all built of brick and stone with standardized precast concrete elements. The surprising aspect is that Atterbury wanted the modern prefabricated buildings to look old, like those in a medieval English village. The experimental community proved a modest success, returning about 3 percent to the foundation funds, but rising construction costs and increased demand for such well-constructed housing soon made Forest Hills Gardens the enclave of a much more affluent group than it had been planned for. Still, Forest Hills Gardens set a new standard of improved community planning and the design of buildings in groups.

VERNACULAR ARCHITECTURE

As the discussion of Wright's designs published in the *Ladies' Home Journal* has suggested, some architects were attempting to bring the benefit of their design experience to a broad public. A number of mass-market magazines were publishing model house designs and making working drawings available to readers. So effective were these efforts that the publication of plan or pattern books, so popular in the 1870s and 1880s,

dropped significantly. Among other magazines making plans available were, of course, *The Craftsman*, *The House Beautiful*, and *The Delineator*, among others. All of them attempted to provide a variety of house designs that could be built for $1,000 to $6,000, the range possible for the middle class. None of these journals, however, ever exceeded a circulation of about 45,000, whereas the *Ladies' Home Journal* had a circulation of 1,600,000 by 1915. Hence the designs published in the *LHJ* had not only a widespread national impact but also reached Canada, Australia, and New Zealand. The *LHJ* also had a long-running program of distributing model house plans, starting in 1895 and continuing until about 1919. The *LHJ* either had its own "in-house" architects provide designs, or solicited designs from prominent young architects, especially those around Philadelphia, where the magazine was published. The Philadelphia architects commissioned by the *LHJ* included Frank Miles Day, Wilson Eyre, Milton B. Medary, and William L. Price. Besides Wright, other Chicago architects published in the magazine were Watson & Buck and Charles E. White; other nationally prominent architects and designers included Guy Lowell, Bruce Price, Will Bradley, Ralph Adams Cram, Aymar Embury, Elmer Grey, and Keen & Mead. Still another Chicago architect who contributed several model house designs to the *Ladies' Home Journal* was Robert C. Spencer, a very close associate of Wright. Spencer developed seven model

7.82. Sears Roebuck & Co., gambrel-roof barn, Montpelier, Virginia, 1920s. During the 1920s the DuPont family, owners of the large Montpelier estate, added several horse barns using prefabricated kit barns manufactured by Sears Roebuck. (Photo: Courtesy of Montpelier Estate.)

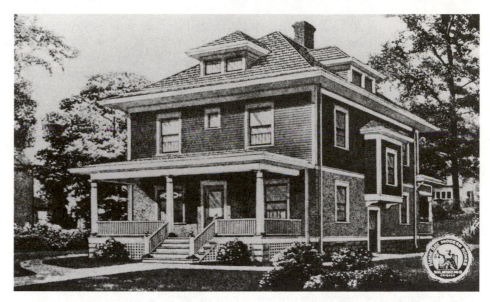

7.83. *Sears Roebuck & Co., four-square house, "The Chelsea."* One of many four-square house designs, this model was popularized by Sears Roebuck and other prefabricated house manufacturers; this model first appeared in a Sears house catalogue in 1908 and last appeared in 1922. (From Sears Roebuck & Co., Honor Bilt Modern Homes [house catalogue], Chicago, 1926.)

farmhouses adapted to climatic conditions in various parts of the country. Although the cost of these houses was relatively modest, ranging from $2,500 to $3,500, they were nonetheless probably beyond the reach of most farm owners of the time.

Another reason that the *Ladies' Home Journal* exerted such a phenomenal influence was that it published large numbers of bungalow designs, some of the material published with the permission of *The Craftsman*, and photo spreads of many California bungalows built in Pasadena and the Los Angeles area. Hence the great national popularity of the bungalow may well have been due the widespread dissemination of photographs through the *LHJ*.

The illustration of model houses and the publication of construction drawings by the *Ladies' Home Journal* and similar magazines dropped off after 1910, largely due to the appearance of prefabricated, precut houses that could be ordered from illustrated catalogues. A number of companies appeared between 1910 and 1920 manufacturing these houses. The most successful companies included Aladdin, Gordon-Van Tine, the Huttig Sash & Door Co. of St. Louis, and Sears & Roebuck, better known as the largest mail-order department store but also a major provider of prefabricated houses.

Barns and Farmhouses

In the area of farm building design, two major changes were introduced in the 1880s and 1890s. One was the widespread use of the familiar double-pitch gambrel roof for barns. [7.82] This first appeared in the Midwest where the large framing timbers previously used for roofs became rare due to clear-cutting of the forests of Michigan, Wisconsin, and Minnesota. With long massive timbers less available, smaller members were used to frame gambrel roofs, with the added benefit of additional storage space in the upper lofts.

The other major change was the introduction of the familiar tall cylindrical silo as an adjunct to the barn. The process of storing moist green corn, technically called ensilage or simply silage, is quite recent, having been developed in France and Germany during 1862–77. At the same time, experiments in ensilage were being conducted at the University of Illinois. The process involved storing the entire corn plant, chopped in pieces, in airtight pits or cylindrical chambers, fostering fermentation, which preserved the chopped material (the end result, in a way, is a kind of corn "sauerkraut"). The chamber in which the silage was stored came to be called a silo. In the 1870s early silos were built by Francis Morris in Maryland and C. W. Mills in New Jersey, with the results being published. There was initial resistance to the use of silos, and according to the U.S. Department of Agriculture, only ninety-one existed in the entire United States in 1882. These were scattered from New England south to North Carolina and west to Iowa.[45] The advantages of ensilage quickly became apparent, however, particularly because feeding milk cows on silage made possible year-round dairy production. By 1903 there were more than half a million silos in service, with the great concentration in the upper Midwest, the center of dairy production. By 1924 Wisconsin had more than

100,000 silos, more than any other state and almost twice the number in New York, the nearest in number.

The early silos were sealed pits, but tall vertical square wood silos were soon being built next to barns to facilitate moving the silage to the cattle. Circular and octagonal silos followed; the majority of them were round and made of wood staves (vertical slats) bound with iron rods joined by threaded turnbuckles (a technique that had been used for railroad and municipal water tanks). Silo roofs might be simple gables, or more likely cones, but double-pitch gambrel-like roofs also became common, perhaps for no other reason than to match the roof of the adjacent barn. Around 1915 a major change occurred with the introduction of poured reinforced-concrete and even concrete stave silos. By the 1920s these durable, airtight concrete silos came to dominate.

At the same time, the houses of these turn-of-the-century farms increasingly tended to be built from mail-order kits or constructed by local contractors based on the designs published in the mail-order catalogues. One particular house design, popular both in the city suburbs as well as on farmsteads, with minor variations, was widely illustrated in the mail-order house catalogues; because of its dominant character and dimensions it has been dubbed the "four-square." [7.83] The plan, with a broad front porch, had four or five first-story rooms, four or five bedrooms above, and a generous attic under a hip roof, often with generous dormers on all four sides. By 1915–20, the archetypal image of the American Midwest farm, with its red gambrel-roof barn, flanked by one or two silos, and nearby four-square farmhouse was well established.

The search for order that began in 1885 brought structural logic and formal clarity to the American commercial high-rise by 1895, and concurrently led to a reappraisal of the prevailing view of laissez-faire in urban growth, leading toward planned development. At first this meant classicizing civic centers, patterned after the example of the Chicago World's Fair, but gradually the scope of City Beautiful planning expanded to embrace and coordinate entire regions, as in Burnham's Chicago Plan. While this was going on, architects such as Wright and Stickley sought to rationalize the modern house, attempting to make it more expressive and better adapted to modern living patterns and the influence of the machine. With little fanfare a revolution was effected in modern architecture, resulting in the creation of entirely new commercial and residential building conventions, and in the firm establishment of town planning as a profession.

After 1914 the United States gradually became embroiled in the war in Europe, and by 1917 private building construction had nearly ceased. When the war ended there was a pervasive desire to return to the normal order of things, but this was not to be, for in the meantime another revolution had occurred in transportation. The isolation of small towns and farms was quickly ending. Millions of people began to move about at will, mobile as no people had ever been during the entire history of humankind. They owed their freedom of movement to Henry Ford. American cities and American architecture were in the process of being completely reshaped by the impact of the private automobile.

BIBLIOGRAPHY

Andrew, Davis S. *Louis Sullivan and the Polemics of Modern Architecture*. Urbana, Ill., 1985.

Applebaum, Stanley. *The Chicago World's Fair of 1893: A Photographic Record*. New York, 1980.

Bacon, Mardges. *Ernest Flagg: Beaux-Arts Architect and Urban Reformer*. Cambridge, Mass., 1986.

Baker, Paul R. *Richard Morris Hunt*. Cambridge, Mass., 1980.

———. *Stanny: The Gilded Life of Stanford White*. New York, 1989.

Baldwin, Charles C. *Stanford White*. New York, 1931; reprint 1976.

Bluestone, Daniel. *Constructing Chicago*. New Haven, Conn., 1991.

Bolon, Carol R., Robert S. Nelson, and Linda Seidel, eds. *The Nature of Frank Lloyd Wright*. Chicago, 1988.

Bosley, Edward R. *Greene & Greene*. London, 2000.

Boutelle, Sara Holmes. *Julia Morgan, Architect*. New York, 1988.

Breisch, Kenneth A. *Henry Hobson Richardson and the Small Public Library in America: A Study in Typology*. Cambridge, Mass., 1997.

Brooks, H. Allen. *The Prairie School: Frank Lloyd Wright and His Midwest Contemporaries*. Toronto, 1972.

Burnham, Daniel H., and Edward H. Bennett. *Plan of Chicago*. Chicago, 1909; reprint 1970 and 1992.

Bush-Brown, Albert. *Louis Sullivan*. New York, 1960.

Cardwell, Kenneth H. *Bernard Maybeck, Artisan, Architect, Artist*. Salt Lake City, Utah, 1983.

Chafee, Richard. "The Teaching of the Ecole des Beaux-Arts." In *The Architecture of the Ecole des Beaux-Arts*, ed. Arthur Drexler. Cambridge, Mass., 1977.

Clark, Robert Judson. *The Arts and Crafts Movement in America, 1876–1916*. Princeton, N.J., 1972.

Condit, Carl W. *The Chicago School of Architecture: A History of Commercial and Public Building in the Chicago Area, 1875–1925*. Chicago, 1964.

Connors, Joseph. *The Robie House of Frank Lloyd Wright*. Chicago, 1984.

Crawford, Margaret. *Building the Workingman's Paradise: The Design of American Company Towns*. London and New York, 1995.

Cummin, Elizabeth, and Wendy Kaplan. *The Arts and Crafts Movement*. London and New York, 1991.

Current, Karen. *Greene & Greene, Architects in the Residential Style*. Fort Worth, Tex., 1974.

Diehl, Lorraine B. *The Late, Great Pennsylvania Station*. New York and Boston, 1985.

Eaton, Leonard K. *Two Chicago Architects and Their Clients: Frank Lloyd Wright and Howard Van Doren Shaw*. Cambridge, Mass., 1969.

Egbert, Donald D. "The Idea of Organic Expression and American Architecture." In *Evolutionary Thought in America*, ed. Stow Persons. New Haven, Conn., 1950.

English, Maurice, ed. *The Testament of Stone: Themes of Idealism and Indignation from the Writings of Louis Sullivan*. Evanston, Ill., 1963.

Ericsson, Henry. *Sixty Years a Builder: The Autobiography of Henry Ericsson*. Chicago, 1942.

Flagg, Ernest. "The Ecole des Beaux-Arts," *Architectural Record* 3 (January–March, April–June 1894): 302–13, 419–28; 4 (July–September 1894): 38–43. An insightful personal account of Flagg's years at the École des Beaux-Arts.

Floyd, Margaret Henderson. *Henry Hobson Richardson: A Genius for Architecture*. New York, 1997.

Freeman, John C. *The Forgotten Rebel: Gustav Stickley and His Craftsman Mission Furniture*. Watkins Glen, N.Y., 1965.

Gebhard, David. "Louis Sullivan and George Grant Elmslie," *Journal of the Society of Architectural Historians* 19 (May 1960): 62–68.

———. *The Work of Purcell and Elmslie, Architects*. Park Forest, Ill., 1965.

Geraniotis, Roula M. "German Architectural Theory and Practice in Chicago, 1850–1900," *Winterthur Portfolio* 21 (Winter 1986): 293–306.

Gill, Brendan. *Many Masks: A Life of Frank Lloyd Wright*. New York, 1987.

Handlin, David. "The Context of the Modern City," *Harvard Architectural Review* 2 (Spring 1981): 76–89.

Hildebrand, Grant. *The Wright Space: Pattern and Meaning in Frank Lloyd Wright's Houses*. Seattle, Wash., 1991.

Hines, Thomas. *Burnham of Chicago, Architect and Planner*. Chicago, 1974; reprint 1979.

Hitchcock, Henry-Russell. "Frank Lloyd Wright and the 'Academic Tradition' of the Early Eighteen Nineties," *Journal of the Warburg and Courtauld Institutes* 1 (January–June 1944): 46–63.

Hoffmann, Donald. *The Architecture of John Wellborn Root*. Baltimore, 1973.

———. *Frank Lloyd Wright's Robie House: The Illustrated Story of an Architectural Masterpiece*. New York, 1984.

Kaplan, Wendy, ed. *"The Art that is Life": The Arts and Crafts Movement in America, 1875–1920*. Boston, 1987.

Kaufmann, Edgar, Jr. "'Form Became Feeling': A New View of Froebel and Wright," *Journal of the Society of Architectural Historians* 40 (May 1981): 130–33.

King, Anthony D. *The Bungalow: The Production of a Global Culture*. New York, 1995.

Lancaster, Clay. *The American Bungalow, 1880–1930*. New York, 1985.

Larson, Gerald R. "The Iron Skeleton Frame: Interactions between Europe and the United States." In *Chicago Architecture, 1872–1922*, ed. J. Zukowsky. Munich, 1987.

Larson, Gerald R., and Roula Mouroudellis Geraniotis. "Toward a Better Understanding of the Evolution of the Iron Skeleton Frame in Chicago," *Journal of theSociety of Architectural Historians* 46 (March 1987): 39–48.

Levine, Neil. *The Architecture of Frank Lloyd Wright*. Princeton, N.J., 1996.

Longstreth, Richard. "Academic Eclecticism in American Architecture," *Winterthur Portfolio* 17 (Spring 1982): 55–82.

——. *On the Edge of the World: Four Architects in San Francisco at the Turn of the Century*. Cambridge, Mass., 1983.

Los Angeles County Museum. *Irving Gill, 1870–1936*. Los Angeles, 1958.

Lubove, Roy. "I. N. Phelps Stokes: Tenement Architect, Economist, Planner," *Journal of the Society of Architectural Historians* 23 (May 1964): 75–87.

——. *The Progressive and the Slums: Tenement House Reform in New York City, 1890–1917*. Pittsburgh, 1962.

Makinson, Randall L. *Greene & Greene: Architect as a Fine Art*. Salt Lake City, Utah, 1977.

——. *Greene & Greene: Furniture and Related Design*. Salt Lake City, Utah, 1979.

——. *Greene & Greene: The Passion and the Legacy*. Salt Lake City, Utah, 1998.

Manson, Grant. *Frank Lloyd Wright: The First Golden Age*. New York, 1958.

McCoy, Esther. *Five California Architects*. New York, 1960.

Menocal, Narciso G. *Architecture as Nature: The Transcendentalist Idea of Louis Sullivan*. Madison, Wis., 1981.

Moore, Charles. *Daniel H. Burnham, Architect, Planner of Cities*. Boston, 1929.

——. *The Life and Times of Charles Follen McKim*. Boston, 1929.

Morgan, Keith N. *Charles A. Platt: The Artist as Architect*. Cambridge, Mass., 1985.

Morgan, William. *The Almighty Wall: The Architecture of Henry Vaughan*. Cambridge, Mass., 1983.

Morrison, Hugh. *Louis Sullivan, Prophet of Modern Architecture*. New York, 1935.

Mumford, Lewis. *Sticks and Stones*. New York, 1924; reprint 1955.

Noble, Allen G. *Wood, Brick, and Stone: The North American Settlement Landscape, vol. 2, Barns and Farm Structures*. Amherst, Mass., 1984.

Noffsinger, James P. *Influence of the Ecole des Beaux-Arts on the Architecture of the United States*. Washington, D.C., 1955.

O'Gorman, James F. *Living Architecture: A Biography of H. H. Richardson*. New York, 1997.

——. *Three American Architects: Richardson, Sullivan, Wright, 1865–1915*. Chicago, 1991.

Oliver, Richard. *The Making of an Architect, 1881–1981: Columbia University in the City of New York*. New York, 1981.

Peisch, Mark. *The Chicago School of Architecture: Early Followers of Sullivan and Wright*. New York, 1964.

Peterson, Jon A. "The City Beautiful Movement: Forgotten Origins and Lost Meanings," *Journal of Urban History* 2 (August 1976): 415–34.

——. "The Mall, the McMillan Plan, and the Origins of American City Planning," *Studies in the History of Art* 30 (1991): 100–15.

——. "The Nation's First Comprehensive City Plan: A Political Analysis of the McMillan Plan for Washington, D.C., 1900–1902," *American Planning Association Journal* 51 (Spring 1985): 131–88.

Pfeiffer, Bruce Brooks, and Gerald Nordland. *Frank Lloyd Wright: In the Realm of Ideas*. Carbondale, Ill., 1988.

Quinan, Jack. *Frank Lloyd Wright's Larkin Building: Myth and Fact*. Cambridge, Mass., 1987.

Randall, Frank A. *History of the Development of Building Construction in Chicago*. Urbana, Ill., 1949.

Riley, Terence, ed. *Frank Lloyd Wright, Architect*. New York, 1994.

Roth, Leland M. *The Architecture of McKim, Mead & White, 1870–1920: A Building List*. New York, 1978.

——. "Getting the Houses to the People: Edward Bok, the *Ladies' Home Journal*, and the Ideal House." In *Perspectives in Vernacular Architecture, vol. 6*. Columbia, Mo., 1991.

——. *McKim, Mead & White, Architects*. New York, 1983.

——. *Shingle Styles: Innovation and Tradition in American Architecture, 1874 to 1982*. New York, 1999.

——. "Three Industrial Towns by McKim, Mead & White," *Journal of the Society of Architectural Historians* 37 (December 1979): 317–47.

——, ed. *A Monograph of the Work of McKim, Mead & White, 1879–1915*. New York, 1974; original ed. New York, 1915–1920.

Saylor, Henry H. *Bungalows: Their Design, Construction, and Furnishing*. New York, 1917.

Scully, Vincent. *Frank Lloyd Wright*. New York, 1960.

Siry, Joseph. *Carson, Pirie, Scott: Louis Sullivan and the Chicago Department Store*. Chicago, 1988.

Smith, Bruce. *Greene & Greene: Masterworks*. San Francisco, 1998.

Starrett, Paul. *Changing the Skyline: An Autobiography*. New York, 1938. Starrett was the builder of Burnham's Flatiron Building, among many other major New York skyscrapers.

Stern, Robert A. M., with Gregory Gilmarten and John Massengale. *New York, 1900: Metropolitan Architecture and Urbanism, 1890–1915*. New York, 1984.

Stevenson, Katherine C., and H. Ward Jandl. *Houses by Mail: A Guide to the Houses from Sears, Roebuck and Company*. Washington, D.C., 1986.

Sullivan, Louis H. *The Autobiography of an Idea*. New York, 1926.

——. *Kindergarten Chats on Architecture, Education, and Democracy*, with an introduction by Claude Bragdon. Lawrence, Kans., 1934.

——. *What Is Architecture: A Study in the American People of Today*, with an introduction by William Gray Purcell. Minneapolis, Minn., 1944.

Twombly, Robert C. *Frank Lloyd Wright: An Interpretive Biography*. New York, 1973.

——. *Louis Sullivan: His Life and Work*. New York, 1986.

——, ed. *Louis Sullivan: The Public Papers*. Chicago, 1988.

Ware, William Robert. *The American Vignola*. Scranton, Penn., 1906; reprint 1977.

Weingarden, Lauren S. "The Colors of Nature: Louis Sullivan's Architectural Polychromy and Nineteenth-Century Color Theory," *Winterthur Portfolio* 20 (Winter 1985): 243–60.

———. *Louis H. Sullivan: The Banks*. Cambridge, Mass., 1987.

Weisman, Winston. "A New View of Skyscraper History." In *The Rise of An American Architecture*, ed. E. Kaufmann Jr. New York, 1970.

———. "Philadelphia Functionalism and Sullivan," *Journal of the Society of Architectural Historians* 20 (March 1961): 3–19.

Wilson, Richard Guy. *The American Renaissance*. New York, 1979.

———. "Architecture and the Reinterpretation of the Past in the American Renaissance," *Winterthur Portfolio* 18 (Spring 1983): 69–97.

Wilson, William H. *The City Beautiful Movement*. Baltimore, 1989.

Wilson, Stuart. "The Gifts of Friedrich Froebel," *Journal of the Society of Architectural Historians* 26 (December 1967): 238–41.

Winter, Robert. *The California Bungalow*. Los Angeles, 1980.

de Wit, Wim. *Louis Sullivan: The Function of Ornament*. New York, 1986.

Wodehouse, Lawrence. "Stanford White and the Mackays: A Case Study in Architect-Client Relationships," *Winterthur Portfolio* 11 (1976): 213–33.

———. *White of McKim, Mead & White*. New York, 1988.

Woodbridge, Sally. *Bernard Maybeck: Visionary Architect*. New York, 1992.

Wright, Frank Lloyd. *Ausgeführte Bauten und Entwürfe von Frank Lloyd Wright*. Berlin, 1910; reprint 1968, 1982.

———. *Autobiography*. New York, 1932; 2nd ed. 1943; 3rd ed. 1977.

———. *Frank Lloyd Wright: Ausgeführte Bauten*. Berlin, 1911.

Wright, John Lloyd. *My Father Who Is on Earth*. New York, 1946 (reprinted as *My Father Frank Lloyd Wright*, 1992).

Zukowsky, John, ed. *Chicago Architecture, 1872–1922: Birth of a Metropolis*. Munich, 1987.

Note: The literature on Frank Lloyd Wright has become voluminous, as interest in Wright has had a great resurgence since about 1980. Robert Twombly notes in *Power and Style: A Critique of Twentieth-Century Architecture in the United States* (New York, 1995), 113, that more books were published on Wright in 1992 than on Palladio, Le Corbusier, and Mies van der Rohe combined.

NOTES

1. See Robert Wiebe, *The Search for Order, 1877–1920* (New York, 1967); H. Wayne Morgan, *Unity and Culture: The United States, 1877–1900* (London, 1971); John Tomsich, *A Genteel Endeavor: American Culture and Politics in the Gilded Age* (Stanford, Calif., 1971); Alan Trachtenberg, *The Incorporation of America: Culture and Society in the Gilded Age* (New York, 1982); and David C. Huntington, ed., *The Quest for Unity: American Art between World's Fairs, 1876–1893* (Detroit, 1983).

2. For preliminary studies of women in American architecture, see Susanna Torre, ed., *Women in American Architecture: A Historic and Contemporary Perspective* (New York, 1977). This includes essays on figures such as Catherine Beecher, Sophia Hayden, Marion Mahoney Griffen, Julia Morgan, and many others. See also Ellen Perry Berkeley, ed., *Architecture: A Place for Women* (Washington, D.C., 1989), which includes essays on many of the figures already mentioned as well as Louisa Tuthill, Louise Blanchard Bethune, Mariana Van Rensselaer, Julia Morgan, and others.

3. Portions of Catherine Beecher's *American Woman's Home* are reprinted in *America Builds*, 57–68. See also Kathryn K. Sklar, *Catherine Beecher: A Study in American Domesticity* (New York, 1973); and Dolores Hayden, *The Grand Domestic Revolution: A History of Feminist Designs for American Homes, Neighborhoods, and Cities* (Cambridge, Mass., 1981). Although Beecher's influence was most significant after 1869, the house design illustrated in her *American Woman's Home* is based directly from Downing's and Davis's work of thirty years earlier.

4. Selections from van Rensselaer's essays on American residential architecture from the *Century* are reprinted in *America Builds*, 242–62.

5. Lisa Koenigsberg, "Mariana van Rensselaer: An Architecture Critic in Context," in *Architecture: A Place for Women*, ed. Berkeley, 41–54.

6. See Sara Holmes Boutelle, *Julia Morgan, Architect* (New York, 1988).

7. For the Tarsney Act, see Lois Craig et al., *The Federal Presence: Architecture, Politics, and Symbols in United States Government Building* (Cambridge, Mass., 1978), 149, 202–3; and Charles Moore, *Daniel H. Burnham, Architect, Planner of Cities* (Boston, 1929), 1:95–96, 106–9.

8. The structural techniques used by Jenney in these early partially metal-framed buildings have been carefully studied by Gerald Larson. See his essays: "The Iron Skeleton Frame: Interactions between Europe and the United States," in *Chicago Architecture, 1872–1922*, ed. J. Zukowsky (Munich, 1987); and also "Toward a Better Understanding of the Evolution of the Iron Skeleton Frame in Chicago," *Journal of the Society of Architectural Historians* 46 (March 1987): 39–48, written with Roula Mouroudellis Geraniotis.

9. See Theodore Turak, "École Centrale and Modern Architecture: The Education of William Le Baron Jenney," *Journal of the Society of Architectural Historians* 29 (March 1970): 40–47.

10 The idea for attaching or hanging all external glazing and stone cladding to an internal metal skeleton was also proposed by Minneapolis architect Leroy S. Buffington (1847–1931), who obtained patent rights for such a system in 1888; he never actually built one, however. Evidence revealed when the Home Insurance Building was demolished in 1931 clearly established that Jenney had put the rudiments of this concept to work five years before Buffington obtained his patent. Jenney published his use

of iron shelf angles to support the masonry of the Home Insurance Building in "Construction of a Heavy Fireproof Building on Compressible Soil," *Sanitary Engineer* 13 (December 10, 1885): 32–33. The first partially metal-framed office building in New York City was the Tower Building, designed by Bradford Lee Gilbert in 1887 and built in 1888–89; see the essay "The Evolution of the Sky-Scraper," first published by critic Montgomery Schuyler in 1909, reprinted in *America Builds*, 310–23.

11. So long as wood piles and grillages were kept covered by water, they were not likely to rot. What has plagued so many older buildings recently has been construction of even bigger neighbors, necessitating temporarily pumping down the surrounding water table. Once the water table is lowered, the pilings under adjoining buildings begin to rot, causing severe structural problems. This occurred to Richardson's Trinity Church as a result of building the Hancock Tower across the street (see ch. 10).

12. Root did not "invent" such pad or floating raft foundations, although he did discuss them in several articles; a number of engineers also developed these and other foundation solutions: particularly important were the contributions of Frederick Baummann, born in East Prussia, Germany, and given a thorough engineering education in Berlin. See Roula Mouroudellis Geraniotis, "German Architectural Theory and Practice in Chicago, 1850–1900," *Winterthur Portfolio* 21 (Winter 1986): 293–306.

13. Many of these illustrated articles are reprinted in Donald Hoffmann, *The Meanings of Architecture: Buildings and Writings by John Wellborn Root* (New York, 1967). See Root's essay, read before the architecture class at the Art Institute of Chicago in June 1890, "A Great Architectural Problem," published in *Inland Architect and News Record* 15 (June 1890): 67–71; reprinted in *America Builds*, 286–301.

14. The essence of design theory, as taught at the École des Beaux-Arts during the time Sullivan was there, is suggested by the later publication of the lectures of Julien-Azaïs Guadet (1834–1908) in *Éléments et Théories de l'Architecture*, 4 vols. (Paris, 1901–04). Some critical passages from the initial lectures are translated in *America Builds*, 323–34.

15. These sources of Sullivan's theory are noted in chapter 5. Important essays by Gottfried Semper are now available in English. See also Leopold Eidlitz's comments on form and function in architecture from his *The Nature and Function of Art, More Especially Architecture* (London, 1881), reprinted in America Builds, 274–86.

16. Louis Sullivan, "Function and Form," part 2 of *Kindergarten Chats* (New York, 1947), 46; reprinted in *America Builds*, 346–56, along with other portions of the book.

17. *Inland Architect and News Record* 14 (December 1889): 76–78, and 15 (February 1890): 5–6. Root's attention was drawn to Semper by the engineer Frederick Baummann, who quoted Semper at a symposium in Chicago. See D. Hoffmann, *The Architecture of John Wellborn Root* (Baltimore, 1973), 91.

18. Sullivan's essay is reprinted in *America Builds*, 340–46.

19. The caisson foundation was an adaptation of the technique used for the piers of both the Eads Bridge across the Mississippi at St. Louis, built in 1868–74, and the Brooklyn Bridge, in New York City, built in 1869–83. As employed by the Roeblings, a large inverted airtight box, open at the bottom, was pushed into the soil by the weight of granite blocks piled on top (the growing base of the bridge pier) while men worked by lamplight in the pressurized chamber below excavating the rock and soil from under the slowly descending caisson. See Davis McCullough, *The Great Bridge* (New York, 1972).

20. See Sarah B. Landau and Carl W. Condit, *Rise of the New York Skyscraper, 1865–1913* (New Haven, 1998), 392–95.

21. See Mardges Bacon, *Ernest Flagg: Beaux-Arts Architect and Reformer* (New York, 1986), 209–33.

22 Henry James, *The American Scene* (New York, 1907; reprint 1987), 55–56.

23. H. H. Richardson, also a student at the École des Beaux-Arts, had incorporated integrated sculpture created by Frédéric Bartoldi in the tower of his Bratelle Square Church, in Boston, built in 1870. In his Trinity Church, in Boston, built in 1872–77, Richardson worked with painter John La Farge and a team of young artists in creating the rich muted mural painting that covers the interior walls. Richard Morris Hunt also worked with other artists, particularly in the design of pedestals for sculptor John Quincy Adams Ward.

24. Around the turn of the century, English architect Charles Herbert Reilly began to send his students from the architecture school in Liverpool, England, to the McKim, Mead & White office to gain valuable experience.

25. This phrase was used by one of the Library Trustees; see L. M. Roth, *McKim, Mead & White, Architects* (New York, 1983), 116–30.

26. For this important designer-builder, as well as his successor son, also named Raphael Guastavino, see George R. Collins, "The Transfer of Thin Masonry Vaulting from Spain to America," *Journal of the Society of Architectural Historians* 37 (September 1968): 200–1. The close collaboration between McKim, Mead & White and the Guastavinos is discussed in Roth, *McKim, Mead & White, Architects*.

27. See Lewis Mumford, "The Disappearance of Pennsylvania Station," *The New Yorker* 34 (June 7, 1958): 106–11; this is reprinted in *America Builds*, 528–34.

28 See Carl W. Condit, *American Building*, 2nd ed. (Chicago, 1882), 178–83; *American Building Art: The Twentieth Century* (New York, 1961), 70–74; and particularly his *The Port of New York: A History of the Rail and Terminal System from the Beginnings to Pennsylvania Station* (Chicago, 1980), 239–96.

29. For an introduction to the Arts and Crafts movement in the United States, see Elizabeth Cummin and Wendy Kaplan, *The Arts and Crafts Movement* (London and New York, 1991); and Wendy Kaplan, ed. *"The Art that is Life": The Arts and Crafts Movement in America, 1875–1920* (Boston, 1987).

30. See Vincent Scully, Frank Lloyd Wright (New York, 1960).

31. The expression "in the nature of materials" was much used by Wright; Frederick Gutheim notes in *Frank Lloyd Wright on Architecture* (New York, 1941) that in 1925 Wright began to sketch out a series of articles under the general title "In the Nature of Materials." This expression was also used as the title of the illustrated catalog of Wright's work edited by Henry-Russell Hitchcock, *In the Nature of Materials: The Buildings of Frank Lloyd Wright, 1887–1941* (New York, 1942). Another phrase often used by Wright was "In the Cause of Architecture," and under this general title he published a series of articles in *Architectural Record*, 1908 through 1928; these articles were collected and reprinted in Frederick Gutheim, ed., *In the Cause of Architecture: Frank Lloyd Wright* (New York, 1975).

32. *Engineering and Building Record* 22 (June 7, 1890): 5.

33. For a brief introduction to the range of model house designs published by this magazine, see Leland M. Roth, "Getting the Houses to the People: Edward Bok, the *Ladies' Home Journal*, and the Ideal House," in *Perspectives in Vernacular Architecture, vol. 6* (Columbia, Mo., 1991).

34. As in many other cases, Wright's innovative ideas, such as revealing the aggregate, caused problems. Scrubbing the incompletely cured concrete to expose the aggregate left the concrete porous; during Chicago winters water entered the porous surface and damaged the concrete wall. It was soon covered with stucco to protect the underlying wall structure. In 1977 the stucco was removed and a new pebble surface applied with an epoxy resin binder. As many of Wright's houses now pass the century mark, the problems of their rehabilitation and preservation are becoming pronounced and extremely costly.

35. Wright elaborated on these nine points in his *Autobiography*; the passage entitled "Building the New House" is reprinted in *America Builds*, 377–82.

36. Ashbee's essay was translated into German for publication, but sections apparently were added by an editor in Berlin. Both Wasmuth publications have been reissued several times. The large *Ausgeführte Bauten und Entwürfe* appeared in a large facsimile (New York, 1963), and in smaller book form (Palos Park, Ill., 1975, and again New York, 1986), and also in an inexpensive paperback edition (New York, 1983). The small, originally paper-bound *Ausgeführte Bauten*, was reprinted as *The Early Work of Frank Lloyd Wright* (New York, 1968) with the original Ashbee text minus the German additions, and in an inexpensive paper-bound edition (New York, 1982) missing the Ashbee text. The entire Ashbee essay, with editorial additions, is reprinted in English in *America Builds*, 391–99. Also included there is an essay on Wright by the Dutch architect H. P. Berlage.

37. See the publications by Boutelle, Cardwell, Freudenheim, and Longstreth listed in the bibliography at the end of this chapter.

38. The best treatment of these strikingly original San Francisco Bay Area architects is Richard Longstreth, *On the Edge of the World: Four Architects in San Francisco at the Turn of the Century* (Cambridge, Mass., 1983).

39. Ashbee, in a statement of 1909, quoted in Randal Mackinson, *Greene and Greene: Furniture and Related Designs* (Salt Lake City, Utah, 1979), 150.

40. The Dodge house is discussed at length in William H. Jordy, *American Buildings and Their Architects, vol. 4, Progressive and Academic Ideals at the Turn of the Twentieth Century* (New York, 1972), 246–74.

41. There was a major reorganization of New York City in 1898 when the surrounding areas of the Bronx, Queens, Brooklyn, and Staten Island were merged with Manhattan Island to form the metropolitan city of greater New York. For the sake of clearer comparison, the population figures for New York City cited earlier in this work have been based on the combined populations of these areas later merged with Manhattan.

42. The critical review of the Columbian Exposition by Montgomery Schuyler, published in *Architectural Record* in 1894, is reprinted in *America Builds*, 427–39.

43. Maybeck's comments are quoted in Jordy, *American Buildings, vol. 4,* 275–300.

44. The mine was later reopened using pit-mining techniques; as the pit grew it yawned under the town, which disappeared, forcing the post office to be moved to a new location. For a discussion of this model mining town, see Margaret Crawford, *Building the Workingman's Paradise: The Design of American Company Towns* (London and New York, 1995), 129–51.

45. For the development and dispersion of the silo, see Allen G. Noble, *Wood, Brick, and Stone: The North American Settlement Landscape, vol. 2, Barns and Farm Structures* (Amherst, Mass., 1984), 69–80.

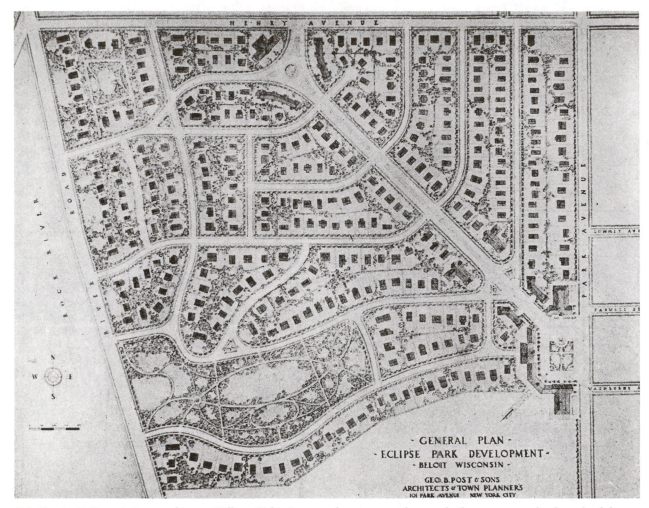

8.1. George B. Post & Sons, architects, William Pitkin Jr., planner, Eclipse Park, Beloit, Wisconsin, 1916–17. As production of war materiel drew more workers to the Fairbanks-Morse Company factory, this new workers' housing complex was built on company land north of the plant; only a quarter of what is shown here was carried out. (American Architect 112 [May 22, 1918].)

NOSTALGIA AND THE AVANT-GARDE, 1915–1940

ARCHITECTURE FOR A NEW CENTURY

The years between 1915 and 1940 were the years between "the war to end all wars" (the First World War) and the even more catastrophic global conflict that came to be called the Second World War. After the end of the first global conflict, during the 1920s and 1930s while Europe roiled with political intrigue, the United States withdrew into a shell of isolationism and endeavored to return as quickly as possible to business as usual.

Historical periods are often defined by economic shifts coinciding with major military conflicts. Although this period between the wars is one time period, it is nonetheless divided into two diametrically different episodes by an economic disaster unprecedented in scale and impact—the Great Depression. The first half, from roughly 1919 to 1930, is characterized by the expansive growth of private enterprise, nurtured by the precepts of the conservative ideology of the dominant Republican political party, while the second half, roughly 1930 to 1940, was the decade of the Depression, characterized by the emergence of a broad range of public welfare programs fostered by the more socially conscious Democratic party, which struggled to put Americans back to work. The dominant public policies of the two decades could hardly have been more different, the first concerned solely with the expansion of big business, and the second concerned with government activities for general public benefit. These dramatic political and economic swings also had corresponding shifts in architectural trends: in the 1920s traditional, one might even say escapist historical trends in private or corporate building were embraced, while in the following decade deliberately modern expressions in public works were often favored.

THE FIRST WORLD WAR AND INDUSTRIAL HOUSING

The United States Congress seems always to have strongly resisted getting involved in the business of authorizing, much less subsidizing, the building of housing—perhaps due to pressure from realtors and private builders. The fact is, however, that the private building industry is slow to react to economic or social emergencies. Such was the case during both of the world wars when housing for war-industry workers was desperately needed near plants producing war materiel. For a time during 1915 and 1916 American citizens and Congress fervently hoped that the United States could avoid "foreign entanglements" and not become involved in the war in Europe. At the same time, however, many American manufacturers saw business opportunities in producing war materiel for the European combatants, and as they expanded production they enlarged their workforces, creating intense demands for housing in communities that had no surplus of housing units. As a result, several corporations began private programs of building industrial housing villages adjacent to their factories, one example of which was Atterbury's Indian Hill outside Worcester for the Norton Grinding Company, started in 1915. Atterbury, now well known through his designs for Forest Hills Gardens, designed both the picturesque street plan and also the single-family gambrel-roof houses. Tyrone, New Mexico, also appeared because of the war, for the demand for copper suddenly made the low-grade ores of the Burro Mountains of New Mexico profitable to mine.

8.2. George B. Post & Sons, typical generic Dutch Colonial house for Eclipse Park, 1918. Instead of repeating a single house type, the Post firm developed a dozen or more distinctive single-family house designs. (American Architect 112 [May 22, 1918].)

Among the other communities begun to accommodate workers in war-related industries was Allwood in Passaic, New Jersey, built by the Brighton Mills Company; Goodyear Heights in Akron, Ohio, for employees of the Goodyear Company; and the nearby Firestone Park in Akron for employees of the rival rubber company. One of the largest towns started by private industry was Alcoa, Tennessee, the site of an extensive new aluminum production plant for the Aluminum Company of America. All of these new industrial communities were started in 1916 and virtually all were the work of the most prestigious professional planners and architects. Warren H. Manning (a student of Frederick Law Olmsted) and architects Mann & MacNeille designed Goodyear Heights, and noted planner John Nolen, together with architects Murphy & Dana, designed Allwood, for example.

Another community, Eclipse Park in Beloit, Wisconsin, begun late in 1916, is a particularly good example, undertaken by the Fairbanks-Morse Company, which was building small gasoline engines. [8.1] On fifty-three acres north of the factory, the Fairbanks-Morse Company hired William Pitkin Jr., landscape architect, and George B. Post & Sons, architects, to lay out a workers' village of about 360 freestanding Dutch Colonial houses for the employees added when the plant began to expand production of internal combustion engines for the war effort. The plan had a clear focus on a community center, with major and minor traffic arteries, and ample open space with a park that featured a golf course. The res-

idences, available in up to twenty different designs, were freestanding single-family houses, traditional Dutch Colonial and generic Georgian in style. [8.2] Only the northwestern quadrant of houses were built, since the war ended in November 1918; the community center was never completed.

When it became clear by the start of 1917 that the United States would inevitably become a participant in the war, and that industrial production would of necessity be increased even more—greatly exacerbating the housing shortage—several planners and architects became convinced that adequate housing had to be created immediately for the swelling numbers of workers. Soon after the United States declared war in April 1917, the American Institute of Architects sent Frederick L. Ackerman to England to inspect workers' housing construction there. On his return Ackerman suggested that housing boards be formed to develop permanent, well-landscaped and -planned villages, rather than relying on the rapid construction of impermanent barracks. Worker morale would be higher, he argued. Since in 1917 there was every indication that the war would continue for several more years, it was thought that this would prove the most economical solution in the long run. Moreover, the new housing complexes would be sold to the residents after the war ended. In this proposal Ackerman was supported by many prominent planners and architects, including Frederick Law Olmsted Jr. and Otto M. Eidlitz. There was protracted deliberation, for many in Congress objected to government intervention in building private housing, but by spring 1918 three agencies had numerous housing projects under way: the Ordnance Department (explosives manufacturing communities), the Emergency Fleet Corporation (shipbuilding), and the U.S. Housing Corporation, an agency of the Department of Labor (miscellaneous manufacturing).

Just as these agencies began the first phase of their work, however, the armistice was signed in late 1918. Nonetheless, in their four months of activity these three agencies were responsible for building more than 33,000 housing units, putting new roofs over 138,000 people. According to an estimate by Manuel Gottlieb, a total of 169,000 housing units were built in those four months in 1918, meaning that war-industry housing constructed by those three boards and by industry itself made up nearly 20 percent of the national total.[1] Although complete and precise figures are difficult to assemble, the number of housing units built through the efforts of the war housing boards during those few months in 1917–18 appears to have nearly equaled the

total of all worker housing built by industry since 1800. However one measures this accomplishment, the achievement of industry, government, and the architectural and planning professions working together during those four months was truly significant.

What makes this work particularly important was the high caliber of design and planning; as in the best industrial communities planned during the preceding two years, the most accomplished talent available was engaged. Of the scores of communities designed and begun, one can serve as an excellent example of the type. Initially called Yorkship Village (now called the Fairview area), it was a new addition to the industrial city of Camden, New Jersey, directly across the river from Philadelphia, Pennsylvania.[2] Built on the former Coopers Farm of 225 acres, it was designed to house the families of workers being hastily added by the New York Shipbuilding Company; because of this connection it was part of the many Emergency Fleet

Corporation housing ventures. With Ackerman as overall design head, Yorkship Village was planned and its buildings designed by a team made up of Electus Litchfield, Pliny Rodger, and Henry Wright (who would later emerge as a major architect-planner in the Greenbelt city movement). [8.3] Altogether fourteen hundred homes were constructed. As in the plan of Eclipse Park, Yorkship Village had differentiated streets, with major diagonal landscaped boulevards focusing on a central square around which shops and public facilities were placed, with churches nearby. Off one side of the central square was the public school for the community. Beyond this central area the streets narrowed and curved in adjustment to the topography. Following the prevailing local tradition, the bulk of the housing was in two-unit or three-unit row houses, in a generic Georgian style.

When the war ended, many in Congress strongly objected to the high quality of design and workman-

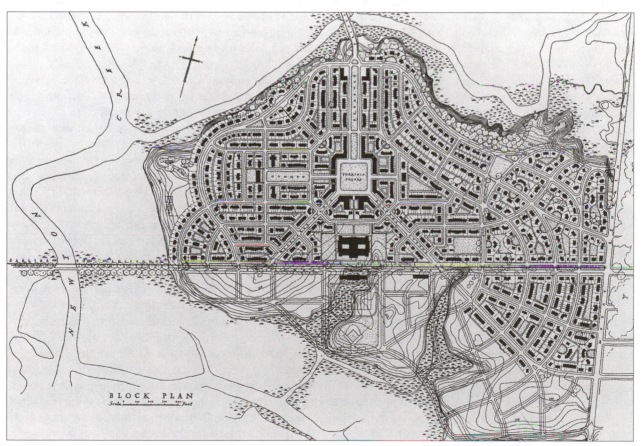

8.3. Electus D. Litchfield and others, Yorkship Garden Village (Fairview), Camden, New Jersey, 1918. Almost completely built, this housing village was sponsored by the Emergency Fleet Corporation for shipbuilders. (Report of the United States Shipping Board Emergency Fleet Corporation, Washington, D.C., 1919.)

ship evident in these planned industrial communities, because, they said, it made the housing efforts of the private sector look rather shabby and miserly by comparison. Yet the value of this concerted and high-minded professional effort is evident in the fact that of all the neighborhoods of Camden, today a depressed industrial community with some of the lowest property values in the United States, Fairview has successfully resisted decline. In the long run, good design pays off—certainly socially, and even in the bottom line.

Many other industrial housing communities were built or at least begun near cities across the country. Morgan Park next to Duluth, Minnesota, for the United States Steel Corporation, was planned by Morell & Nichols, with buildings designed by Dean & Dean (and it corrected all the mistakes of the earlier Gary, Indiana). Hilton, Virginia, near Portsmouth, was planned by H. V. Hubbard with buildings by Francis Y. Joannes. Other communities had both street plans and buildings designed by architects; among these were Perryville, Maryland, planned and designed by Mann & MacNeille, and Craddock, outside Portsmouth, Virginia, planned and designed by G. B. Post & Sons. The small community of Union Park Gardens, at the edge of Wilmington, Delaware, was superbly designed and landscaped by John Nolen, with row house units by Ballinger & Perrot; it too has managed to survive the dilapidation of engulfing neighborhoods. The immense town of Nitro, West Virginia, a munitions manufacturing town, was planned and designed by Graham, Anderson, Probst, & White, the successor firm to D. H. Burnham & Company.

THE SUBURB AND THE AUTOMOBILE

Some of these planners and architects, most notably John Nolen, continued planning new towns, both industrial and satellite suburbs, after the war, but most of the professionals quickly turned their attention to commercial urban and residential suburban work, and indeed in the decade after the war the suburb became the focus of intense building activity. Before the war, from 1904 through 1916, approximately 485,000 housing units had been built each year (varying from a high of 507,000 in 1905 to a low of 315,000 in 1904); but after 1920, when the volume of construction reached prewar levels, it climbed quickly, from 716,000 units in 1922 to a high of 937,000 units in

1925. The great bulk of this housing was concentrated in the expanding suburbs.[3]

The years between the wars were marked by strong contrasts, for it was a period of both ingenious invention and looking backward. There developed a dichotomy between seemingly contradictory passions for modernity and historical nostalgia. The drive toward modernity led to the creation of a new industrial aesthetic, while the continuing nostalgia produced historicism's finest flowering. Especially in the suburbs this nostalgic historicism was concentrated in the 1920s, and in the years following the war there followed a great flight to the countryside around the cities. Initially this urban exodus was led by the well-to-do, but the desire to escape the city was present throughout the middle classes. At first the move to the suburbs proceeded along the lines of the commuter railroads and rapid mass transit. Like the radiating spokes of a wheel there sprang up corridors of apartments along these rail lines, with nodes of shops and offices developing at the station points. The apartments were often of the court type, U-shaped blocks framing entrance courtyards, sometimes elaborately landscaped with terraces, trees, shrubbery, and fountains. [8.4]

Quickly, however, the private automobile replaced trains and rapid transit as the most significant mover of people, and subtly but decidedly it began to reshape the city and the way Americans took their new mobility for granted. Mobility had always been the American dream, but for the most part it had been the privilege of the rich; now it became a reality for millions. It began in the 1890s with a craze for bicycles, which literally paved the way for the automobile. Due to lobbying pressure from organized cyclists' groups, roads were graded and given a weatherproof macadamized surface. Had it not been for such all-weather roads the automobile would have been helplessly mired in the mud, but ironically in thirty years it virtually pushed the bicycle off the road.

This revolution in private transportation was created by Henry Ford. Before 1903 the automobile was essentially an expensive toy of the wealthy, and Ford began by trying to enter this exclusive market, competing with many other automobile manufacturers. *Manufacture*, in its original Latin sense meaning "making by hand" (*manus* + *factura*), is absolutely correct, for these early horseless carriages were meticulously crafted by hand, part by carefully handcrafted part. Typically, early wealthy automobile aficionados employed mechanics as part of their household staffs

8.4. *Richard H. Marr, Douglas Apartments, Detroit, Michigan, 1928. Court apartment blocks, especially when not more than four stories, gave a measure of community* *with privacy at reasonable cost. (From R. W. Sexton,* American Apartment Houses, Hotels, and Apartment Hotels of Today, *New York, 1929.)*

to keep their playthings in repair, hand-tooling replacement parts. Unsuccessful in this rarified and exclusive market, Ford decided to make much simpler and cheaper vehicles within the reach of a mass market. His solution was to put automobiles together from masses of identical parts. He took the method of butchering hogs on a moving "disassembly" line, in which individual meat cutters removed one particular segment each—and turned it around. On a moving assembly line, he had mechanics, each trained to do just one task, add a particular piece or assembly to the emerging automobile. Experimenting with very simple models—each successive model labeled with a letter of the alphabet—by 1907 Ford had achieved his goal in the Model T and he began large-scale production. This Model T was a huge commercial success. In 1910 the Ford works moved to a new plant in Highland Park, Michigan, specially designed by Albert Kahn to accommodate Ford's innovative moving assembly line. By exploiting the assembly line, by using stock identical parts, and by making every car identical to every other, and hardly changing the design, year after year, Ford steadily reduced the price

of the car. In 1908 the cost was $850, in 1914 $490, and in 1926 it reached its lowest figure, $260. Moreover, Ford was a pioneer in extending credit so that individuals could buy his automobiles on time. The Model T was economically placed within the reach of nearly every worker.

Soon other inexpensive automobiles had appeared, and the geometric rise in automobile registrations illustrates the dramatic change taking place; in 1900 there had been only 8,000 automobiles running in the entire United States, but by 1915 there were 2,491,000. In just two more years that number more than doubled to 5.1 million automobiles (when it is estimated that there were barely 719,000 in the rest of the world). By 1930, 26.7 million automobiles were registered in the United States, and on the eve of the Second World War in 1940 there 32.6 million. On June 15, 1924, the Ford company celebrated making its 10-millionth automobile, but only three years later it had produced 5 million more.[4] It is true that Ford put the nation on wheels, and in the process radically altered American culture and its architecture.[5] The automobile made suburbs easy to reach.

8.5. *Howard Van Doren Shaw, Market Square, Lake Forest, Illinois, 1913. Next to the commuter rail station, Shaw* *created a village center, with shops and professional offices around a small landscaped park. (Photo: L. M. Roth.)*

Early Suburbs

The dream of the first romantic landscaped suburbs had arisen parallel to the emergence of industrialization, and in fact it was the railroad that had made such early satellite communities as Llewellyn Park and Riverside possible, linking them with New York and Chicago. Another influential suburban development was Roland Park, developed by Edward H. Bouton just outside the northern edge of Baltimore, Maryland. Comprised eventually of four large sections, Roland Park began in 1891 with a parcel of 380 acres laid out initially by George Kessler and continued by Frederick Law and John Charles Olmsted in 1897. The winding streets generally followed the contours of the undulating land, with cul-de-sacs that preserved much of the wooded landscape in the lower ravines. Two additional sections were developed by Bouton: Guilford beginning in 1913 (296 acres) and Homeland beginning in 1924 (391 acres). An additional section of 530 acres, called Northwood, was acquired in 1930, but the Depression severely slowed development. Toward the end of the Depression in 1939, approximately 10,000 people lived in the four sections. The elements that made the Roland Park development important were the consistent planning vision of the Bouton and Olmsted firms over a third of a century, as well as the incorporation of single-family homes, row house apartments, and shopping complexes, all in various architectural styles that included the Shingle Style, Queen Anne, Colonial, English Tudor, and other revival styles.

Early in the twentieth century the railroads and automobiles made landscaped suburbs possible near every large city in the United States. Boston had its seaside retreats on the north shore, such as Beverly, Pride's Crossing, and Manchester-by-the-Sea, and its suburbs to the south, such as Brookline. New York was surrounded by Tuxedo Park to the northwest, Harrison, Rye, Greenwich, and Cos Cob to the northeast, and Glen Head and Roslyn to the east on Long Island. Philadelphia had Chestnut Hill and the string of suburbs along the Pennsylvania Railroad's Main Line: Merion, Ardmore, Bryn Mawr, and Radnor. East of Cleveland, along Lake Erie, was Bratenahl, while to the southeast was Shaker Heights, carefully developed by the Van Sweringen brothers to exploit a wooded landscape with a series of lakes. Stretching northward from Chicago along Lake Michigan were Evanston, Wilmette, Winnetka, Glencoe, Highland Park, and farther north, Lake Forest. While it is true that many of these communities were founded during the nineteenth century, their period of greatest expansion, and the creation of the most engaging architecture, was from 1910 to 1940.

Most of the suburbs where these houses mushroomed, though often graced with abundant trees and perhaps spaciously laid out, deviated little from the standard grid of their parent cities. Except for places like Roland Park or Shaker Heights, few made any pretense of augmenting existing landscape features. Lake Forest, Illinois, was one exception. The community itself had actually been established in 1855 by Presbyterians as a site for a new college, for the sake of the students, who would be able to study far from the corrupting influence of Chicago; the curvilinear streets were planned by David Hotchkiss of St. Louis and generally followed the contours of the lakeshore site. Because of the twenty miles separating it from Chicago, Lake Forest became a retreat for the wealthy of the city, but the rate of growth was modest until about 1890. The decade between 1920 and 1930 was the period of its most vigorous growth, and much of this growth occurred when architect Howard Van Doren Shaw, a highly skilled traditionalist designer, built his own home there in 1897 and subsequently built many large and generically medieval houses. What makes Lake Forest distinctive among many such elegant early suburbs is the communal focus given it by the market square designed by Shaw in 1913. [8.5] Commissioned by the Lake Forest Improvement Association, the square faces the Chicago and Northwestern Railroad tracks with the commuter station forming the fourth side of the enclosure. The two-story, pitched-roof arcaded buildings framing the central park are based on Austrian village prototypes, with clock towers rising on each side. At ground level are numerous stores and offices, while the upper floors originally had twenty-five apartments.

Equally interesting is the development of a suburban enclave just outside Kansas City, the Country Club district developed in 1908–24 by entrepreneur J. C. Nichols, who hired landscape architect George Kessler to do the overall plan. Here, too, streets avoided the monotonous grid and followed the gentle curves of the landscape. [8.6] Particularly important was the large shopping district designed for Nichols

8.6. George Kessler, overall plan for the Country Club District, Kansas City, Missouri, 1908–24. The Country Club District at the edge of Kansas City provided a landscaped oasis for well-to-do homeowners, complete with a Spanish Colonial–style shopping area at the northern edge of the community; the shopping district, like the entire development, was planned to reflect the use of the private automobile. (C. Dykstra, ed., Supplementary Report of the Urbanism Committee, Natural Resources Committee, vol. 2, Washington, D.C., 1939.)

by architect Edward B. Delk in 1922, which resembled a fantastic bazaar in eighteenth-century Spain. What made this commercial area especially interesting was the careful provision for parking of large numbers of private automobiles, including off-street parking lots. Also included in the plan were gasoline filling stations. By the time the Country Club area was nearing completion in 1920–22, its developer and planner, Nichols and Kessler, were engaged by the former Kansas City resident Robert A. Long to design a new industrial community at Longview, Washington, downriver from Portland, Oregon, to house the Long-Bell lumber company and other industries, and to provide an attractive community for a target population of 50,000 people.

THE ARCHITECTURE OF REASSURANCE: HISTORICISM IN THE JAZZ AGE

Suburban Houses

As the comfortable and traditional character of the nineteenth century was swept aside by the increasingly fast-paced and iconoclastic culture of the twentieth, many of the families who flocked to the expanding suburbs wanted houses that spoke to an earlier, supposedly less puzzling age. The suburban houses tended to follow historical models—but of course with automobile garages, electricity, plumbing, and other modern conveniences. That the suburban house was a major concern of the architectural profession and building industry can be gauged by the intensive treatment it received in the professional journals, and also the enormous success enjoyed by companies selling prefabricated mail-order houses. Frequent issues of the architectural journals were devoted wholly to the subject of suburban residences, as for instance the *Architectural Record* of October 1919. One could find in such magazines extensive illustrations of the latest examples, such as the house in Hartford, Connecticut, by Goodwin, Bullard, & Woolsey of New York, treated in the August 1919 issue.

Careful attention was given to the interiors of such houses, and although there was great freedom in the selection of historical period, the majority tended to be classical, combining various Renaissance elements (whether Italian or English Georgian), or medieval (with a preference for the English Tudor style). There was an enormous breadth of style to choose from, reaching from Mediterranean and Spanish vernacular classicism to Cotswold medieval cottages. In the inte-

riors of these houses, as in the public buildings of the period, strict attention was paid to scale and to the use of the best materials. The architects, however, increasingly well schooled and well traveled, held to one historical period or style in the exterior and in each of the major rooms of these houses.

Far too many people wanted attractive and well-planned houses in the suburbs for architects to design them all. To meet this pressing need a number of stratagems were devised. The companies offering precut houses through catalogues (noted in chapter 7) did especially well after the First World War, particularly the Radford Architecture Company (Chicago), Gordon–Van Tine Company (Davenport, Iowa), and the Alladin Company (Bay City, Michigan), among many others. One of the most successful in merchandising single-family houses (not surprisingly, perhaps) was Sears, Roebuck & Co., beginning in about 1907 and continuing until 1940. For a time, customers could walk into a Sears retail store, peruse a house design catalogue, and purchase a house kit on the spot.

The houses offered by all these companies covered the full range of design options, in size and style, from bungalows, neo-Elizabethan half-timbered cottages, gambrel-roof Dutch Colonial, to imposing colonnaded Colonial or southern mansion. Typically such houses bore evocative names such as "The Winona," "The Beaumont," "The Del Rey," "The Windermere," "The Magnolia" (for a colonnaded southern mansion), or "The Alhambra" (for a Mission Revival house). One could even find an occasional Wrightian or Prairie Style house, like "The Aurora," referring possibly to the western suburb of Chicago. For a time even the staid American Institute of Architects entered the field, establishing the Architects' Small House Service Bureau in 1920. The bureau also published house designs in a series of catalogues, but in 1935, fearing degradation of profession dignity, the AIA rescinded its endorsement, and the bureau was disbanded in 1942.[6]

In the hectic years following the First World War, amid the disillusionment and dislocation that conflict brought about—when women (now liberated in their movement by the private automobile) bobbed their hair and took to wearing blousy chemises, when couples abandoned the sedate rhythms of the waltz in favor of the gyrating Charleston—many people craved the cultural reassurance of established architectural styles, with their connotations of tradition and achievement. With building and material costs rela-

8.7. *J. W. Hersey, with William Mooser and Company, Santa Barbara County Courthouse, Santa Barbara, California, 1927–29. The design for the Santa Barbara County Courthouse was carefully studied and modified to break up the components around the rear court to achieve maximum picturesque effect. (Courtesy of the Santa Barbara Historical Society.)*

tively low, skilled labor abundant, and fortunes being made in new industries such as chemicals, oil, and automobile manufacturing, historical architectural styles enjoyed a popularity combined with an assuredness of detail they have seldom had since.

Historical styles were a means of providing connection and identity, particularly regional identity.[7] This was especially true in the Southwest and in Florida. Mission architecture had been revived in California as early as the 1890s, and grew in popularity, followed by an interest in the more decorated Spanish Colonial Baroque. The great surge in popularity of Spanish Colonial Baroque, supposedly representing an inherently (but incorrect) old California style, began in earnest with the Spanish theme buildings designed for the San Diego World's Fair of 1915 by Bertram Goodhue. At the same time, Goodhue was designing Spanish Colonial houses in the Los Angeles area, such as the Herbert Coppel house in Pasadena, built in 1915–16. Public buildings also were given Spanish Colonial touches. In Los Angeles, the Biltmore Hotel,

built in 1923, by Schultze & Weaver, was Italo-Spanish Renaissance (in brick) externally, but its spacious entry lobby was emphatically Spanish neo-Baroque, with a grand divided staircase inspired by the great stair, the Escalera Dorada or Golden Staircase, built by Diego de Siloe in the Cathedral of Burgos in 1524. The inventive zenith, perhaps, of combined Mission and Spanish Colonial elements was reached perhaps in the playful and romantic picturesqueness of the Santa Barbara County Courthouse, in Santa Barbara, California, of 1927–29, designed by J. Wilmer Hersey and built under the direction of architect William Mooser. [8.7] Equally inventive in creating unusual picturesque massings, with broadly interpreted Spanish Mission details, was architect George Washington Smith (1876–1930), who was born and educated in the East, at Harvard and Philadelphia, but who embraced Spanish Colonial when he moved to Montecito, California, in 1916. He pursued a highly successful career designing picturesque houses throughout the

Los Angeles–Santa Barbara area.

Even more self-consciously scenographic and artistically composed, perhaps, was the work of Addison Mizner in Florida. Mizner (1872–1933) knew Spanish Baroque well, having studied at the University of Salamanca, Spain. After working as a designer and antiques importer in New York City, he moved to Florida in 1918 for his health. There he met Paris Singer, heir to the Singer Sewing Machine fortune, and began undertaking architecture designs for him, beginning with the Palm Beach Everglades Club, built in 1918–19. Soon Mizner was besieged with requests for winter homes for other wealthy easterners, and he rode the crest of the real estate boom in Florida in the mid-1920s. His houses and clubs were boldly irregular and picturesque in plan and massing, with abundant Saracenic-Spanish details, often with Venetian bits thrown in. [8.8] Never exactly duplicating historical models, Mizner's houses fulfilled perfectly his clients' desire for playful retreats from their serious work environments in Philadelphia or New York. So

financially successful was Mizner that he undertook the development of an entire resort community—Boca Raton—in 1925, building a hotel and starting the construction of numerous houses when the boom in Florida collapsed following the disastrous hurricane that swept across south Florida in 1926.

As the railroad was built down along the east coast of Florida, real estate ventures boomed and small villages became large cities almost instantly. Miami is one good example. Another real estate development just west of Miami was Coral Gables, started in about 1916 by landowner George Merrick. Merrick envisioned a completely planned residential community, with architecturally distinct neighborhoods, beginning with Spanish Mediterranean–style houses, but then adding Colonial, French Norman, French Provincial, Dutch South African, and even Chinese neighborhoods. The initial planning was done with the help of artist Denman Fink and landscape architect Frank Button. Many of the early houses and business buildings were designed by Fink as well as by Phineas Paist, among many other architects. The periphery of the development was marked by elaborate gates at each entering street, and spaced throughout the community were numerous plazas graced with fountains, all designed by Fink and Button. The major landmark was the Biltmore Hotel, by Schultze & Weaver, built in 1925–26, whose twenty-six-story tower was patterned after the Giralda tower in Seville, Spain. Perhaps the most engaging of all the constructions is the Venetian Pool, a municipal bathing pool built by Fink and Paist in 1924–25 in an abandoned oolitic limestone quarry from which much of the stone for the first houses came. [8.9] Fink and Paist turned the ugly hole into a fantasy of Italian Venetian architecture, replete with striped gondola mooring poles, its picturesque building elements adjusted to the irregular profile of the quarry, creating an idyllic dreamworld that prefigured Orlando's Walt Disney World by a quarter century.

In New Mexico, aspirations were a bit more pragmatic. In Santa Fe, a romantically austere adobe style was deliberately adopted as early as 1913 for the imaginative "restoration" of the Palace of the Governors. Bypassed by the main line of the Atchison, Topeka, and Santa Fe (despite the railroad's name), the city of Santa Fe decided to create an attractive and unique ancestral image for itself and the state, distinct from the emerging Spanish Colonial style of California. The city's invention of a largely mythical architecture and a romantic past was meant to attract

8.8. Addison Mizner, Daniel H. Carstairs house, Palm Beach, Florida, 1923. Like all of Mizner's houses and resort buildings, the interior patio is a focal point, here including a reflecting pool. (Photo: © Craig Kuhner.)

8.9. *Fink and Paist, Venetian Pool, Coral Gables, Florida, 1924–25. To build the many new houses in Coral Gables, quarries were opened in the underlying cocina limestone; this one was soon lined with concrete and allowed to fill with natural springwater to create a public swimming pool, enclosed in a historical confection of Venetian architecture for the changing rooms, snack pavilion, and administration offices. (From G. H. Edgell,* The American Architecture To-Day, *New York, 1928.)*

8.10. *I. H. Rapp and W. M. Rapp, Museum of Fine Arts, Santa Fe, New Mexico, 1917. To create a distinctive Santa Fe and southwestern architectural style, the Rapp brothers composed the Museum of Fine Arts of elements inspired by several old adobe mission churches in the region. (Courtesy of the Museum of New Mexico.)*

tourists, despite its distance from the main Santa Fe railroad line. Chief among the architects who made this a phenomenal success were the brothers of the more famous Chicago theater designers—Isaac Hamilton Rapp (1854–1933) assisted by his brother William Morris Rapp.[8] This second pair of Rapp brothers had designed an adobe-style missionlike New Mexico Pavilion for the San Diego fair (1915) and then immediately after used this as the basis for their picturesque Museum of New Mexico, Museum of Fine Arts built in 1917 on one corner of the old plaza in Santa Fe. [8.10] This was followed in 1919 by I. H. Rapp's romantic tourist hotel, La Fonda, at the opposite corner of the plaza. The hotel was sensitively

enlarged by John Gaw Meem in 1926–29, continuing the massive and plain-surfaced adobe-style idiom.

Meem (1894–1983), an engineer who went to New Mexico in 1919 to undertake the tuberculosis cure, reeducated himself as an architect and developed a distinguished practice in New Mexico, beginning with adobe-style residences highly accurate in period detail. Gradually, during the 1920s, Meem developed a more abstract personal architectural idiom clearly inspired by the ancestral regional adobe architecture but with traditional historical details abstracted and reworked in modern materials. The evolution of this personalized idiom is seem in Meem's Laboratory of Anthropology at the University of New Mexico,

Albuquerque, built in 1929–31, with its abstracted but still historical detailing, and the Zimmerman Library at the University of New Mexico, Albuquerque, built in 1933–36, even more abstracted in its picturesque cubic forms and detail. [8.11] This process of refinement and simplification reached its culmination in Meem's Fine Arts Center, in Colorado Springs, Colorado, built in 1931–36 of poured concrete. Also of concrete, but more traditionally adobelike in detail, was the Franciscan Hotel in Albuquerque, built in 1920–21, by Trost & Trost.

The "Period House"

The years between the wars were marked by strong and vivid historical associations in much American architecture. The difference between the historicism of the 1920s and earlier historicist movements was the restraint and assuredness of the detailing that resulted from the later architects' far more extensive knowledge of the historical sources, whether American Colonial, or European. As a result of their extensive academic training, coupled with extensive travel, this younger generation of architects could design altogether original plans, based on contemporary living arrangements and their clients' desires, and yet make these houses look authentic, as if they had come from a particular historical "period," perhaps English Tudor, or Jacobean, late French medieval or early Renaissance, or even the American Georgian Colonial. Although architects (at the urging of their clients) might use one historical period for massing and detailing the exterior a house, in the individual rooms they might draw on totally different periods, but seldom if ever did they mix two or more time periods in a single room. This emphasis on free-ranging accuracy in historical detailing has led some to use the term *period houses* to describe the historicist residences of the early twentieth century. This design practice, coincidentally, was occurring during the time when art museums around the country were acquiring and installing "period" rooms and furnishings of historic houses being destroyed.

Spanish Colonial Baroque, with its related adobe or Mission styles, or a kind of generic Mediterranean Renaissance style, were all popular house styles, even in suburbs of northern cities with most un-Mediterranean-like climates. Also especially popular and viewed as quite romantic were the various evocations of late medieval vernacular houses, from English Cotswold stone "cottages" to Elizabethan, Jacobean, or French Norman farmhouses. A good representative example is the C. Heatley Dulles house, in Villanova, Pennsylvania, to the west of Philadelphia, built in 1916–1917, by Mellor, Meigs, & Howe. [8.12] Planned around the needs of the client, and incorporating the latest innovations in the design of the kitchen and bathrooms, as well as innovations in heating, the house is couched in terms of English medieval vernacular houses. What one sees in such work of Mellor, Meigs, & Howe is a picturesque and romantic eclecticism constructed of the flinty fieldstone that had long been a building tradition in this area west of Philadelphia.

This romanticism was so persuasive that it sometimes reshaped houses already under way. A striking

8.11. John Gaw Meem, Zimmerman Library, University of New Mexico, Albuquerque, New Mexico, 1933–36. From the plain walls and masses of ancient adobe architecture, Meem derived a modern style. (Courtesy of the University of New Mexico.)

8.12. *Mellor, Meigs & Howe, C. Heatley Dulles house, Villanova, Pennsylvania, 1916–17. The Dulles house is a good example of the popular medieval vernacular period house popular in such upscale suburbs as Villanova, west of Philadelphia. (Photo: © Wayne Andrews/Esto.)*

example is the Arthur E. Newbold house at Laverock, Pennsylvania, a rural community north of Philadelphia. Begun in 1914 as a severe Colonial Revival retreat, it was reshaped after 1921 by architects Mellor, Meigs, & Howe as a medieval Norman sheep farm. Further additions followed, beginning with extensive remodeling of the house itself that lasted until 1924, and ending with the installation of a Gothic swimming pool in 1928. [8.13] The rambling complex was a retreat but also a working "gentleman's farm," and there were few restraints imposed by budget on the architects' whimsy or imagination. A blend of English, Spanish, and Norman French medieval sources, it was inspired by the Manoir d'Archelles at Arques-la-Bataille, near Dieppe, and reflected Arthur Meig's infatuation with French provincial architecture developed during his tour of duty in the First World War. Nonetheless, the Newbold farm was functional, perhaps not in the narrow mechanistic sense that was then being defined by Gropius and the Bauhaus in Europe, but in a broader psychological way, so as to restore a forgotten "imaginative interpretation of use," in the words of George Howe's biographer, Robert A. M. Stern.[9]

Clearly architects during this period were of many minds. Some, such as Howe, gradually moved from historicism toward a modern geometrically severe expression, felt to be more appropriate to an industrialized culture, while others such as Albert Kahn (1869–1942) could produce excellent buildings of both types simultaneously. Albert Kahn can rightly be described as the originator of the modern factory. He

8.13. *Mellor, Meigs, & Howe, Arthur E. Newbold house, Laverock, Pennsylvania, 1919–24. For suburban gentlemen farmer Newbold, Meigs and Howe devised a romantic extravaganza, making a new house look very old, emphasizing the animals in the published photographs. (From A. I. Meigs,* An American Country House, *New York, 1925.)*

8.14. Albert Kahn, Alvan Macauley residence, Grosse Pointe Shores, Michigan, 1928. The living room of the Macauley house extended as a separate wing from the main block of the house, allowing the raised vaulted ceiling. (Courtesy of Albert Kahn Associates.)

built his first in 1903, whereas Gropius's Fagus shoe factory at Alfeld, Germany, was begun in 1910. At the same time, however, Kahn also produced some of the most strikingly romantic eclectic public buildings and houses of the period. Particularly well detailed are the several houses he designed for automobile manufacturers in the fashionable suburbs north of Detroit. A favored style was a kind of restrained English Cotswold "cottage" such as the Horace E. Dodge house in Grosse Pointe, built in 1910, with its carefully studied Jacobean interiors, and his expansive house for Alvan Macauley of 1928, at Grosse Pointe Shores, with its paneled and vaulted living room at one end. [8.14] Even more elaborate and yet still controlled is Kahn's Edsel Ford house, in Grosse Pointe, built in 1927. [8.15] In his radically innovative designs for factories (such as his Ford, Packard, Dodge, and Chrysler plants) Kahn adhered to a lean, gleaming industrial utility, but in the private houses, office blocks, and public buildings commissioned by the owners of these factories, Kahn employed a historicism that was unequaled at that time for its archaeological accuracy and careful attention to detail, texture, and subtle color. The Edsel Ford house is a rich blend of medieval sources fused on a basically Cotswold-Tudor base, set low and seemingly hugging the earth. The rooms within are in various period

styles, the drawing room in Louis XV, the library and dining room in eighteenth-century French classical, while the bedrooms are Art Deco, designed by Walter Dorwin Teague. Perhaps the best quality of the house is its setting: the comfortable external appearance is created by the landscaping of Jens Jensen, foremost of the landscape architects in the Midwest.

No expense was spared in these expansive suburban houses, in the quest for a comfortable environment. The forms employed were in some ways the most exactly correct and traditional ever in American architecture, all the more appealing, perhaps, in an era in which technological and financial changes, as in the case of the making and marketing of the Model T, were reshaping the whole of American culture. Such houses were a defense against what is now sometimes called future shock; they were safe and secure refuges in a culture in rapid flux.

In the eastern states, quite understandably, the American Colonial Georgian Revival style was highly popular. By 1920 a number of scholarly books on Colonial and Federalist architecture had been published, and manuals were also being published on how to design an authentic yet modern Colonial house. In Jaffrey, New Hampshire, architects Frost & Killam designed the Emory house, replicating the saltboxes of Massachusetts. In Sparkill, New York, architect

Aymar Embury designed an adaptation of the early-seventeenth-century Dutch gambrel house for Mrs. W. H. Fallon. Gibbsian meetinghouses also were extremely popular for churches in many regions of the country, as illustrated by the steepled red brick Georgian building designed by Thomas Tallmadge for the Congregation Church in Evanston, Illinois, just north of Chicago, built in 1927, only one of many hundreds of such churches built in the 1920s. Public schools and college buildings, public libraries, government buildings—all were designed in the Colonial Revival styles, especially late Georgian and Federalist forms. These buildings were to play an educational role, Americanizing the prodigious numbers of immigrants coming from central, southern, and eastern Europe. Seen as being somehow inherently American in nature, Georgian and Federalist architecture served a decidedly didactic and propagandistic purpose.

Furthermore, the impetus for much of the Colonial Revival in the 1930s, beyond being a kind of wistful, reassuring nationalism during the trying years of the Depression, came from the enormous restoration project under way at Williamsburg, Virginia.[10] Soon after the Virginia state government moved into Jefferson's Roman temple in Richmond, the village of Williamsburg quickly became a sleepy commercial and cultural backwater. Except for the College of William and Mary, there was little economic activity. During the nineteenth century, eighteenth-century buildings were replaced as needed, or made up-to-date

8.15. *Albert Kahn, architect, Jens Jensen, landscape architect, Edsel Ford house, Grosse Pointe, Michigan, 1927. Edsel Ford's suburban residence, carefully and picturesquely composed, was set in an informal landscape planned by Jens Jensen. (Photo: © Wayne Andrews/Esto.)*

8.16. Governor's Palace, Williamsburg, Virginia, 1706–20, 1930–35. Totally destroyed at the end of the eighteenth century, this building was completely rebuilt on the basis of early drawings and the evidence of minute fragments. (Courtesy of the Colonial Williamsburg Foundation.)

by adding Italianate brackets or Second Empire mansard roofs as fashions changed.

In 1923 Dr. William A. R. Goodwin, a former rector of the Bruton Parish Church in Williamsburg, returned to the quiet town to teach at William and Mary. A great admirer of the old architecture of Williamsburg, which he called "the Cradle of the Republic" and "the birthplace of her liberty," he conceived of a plan to restore not just the college and the church (which he had already undertaken while rector), but to restore the entire town. Consumed with a dream of making Williamsburg an educational force in American life, he chanced to meet John D. Rockefeller Jr. in 1924. Describing how the automobile and its service industries had precipitated the destruction of the old buildings in Williamsburg, he gently persuaded Rockefeller that he could atone for those unseemly intrusions by funding the restoration of the entire town. In 1925 Goodwin independently was able to start restoration of the George Wythe

house while he spoke to these and other potential major donors. Eventually in 1926, Rockefeller agreed first to pay for sketches of restoration of the entire town, but soon he agreed to finance the rebuilding as well. The distinguished Boston architect William G. Perry, of Perry, Shaw, & Hepburn, was hired to begin the restoration.

Slowly at first, building by building, starting with the college, the town was remade. In some cases, it was simply a matter of burying phone and electric lines and of removing porches or trim from buildings that retained much of their original character. The houses and workshops that had undergone extensive renovation were stripped, gutted, and remade. But once the decision was made to fix 1770 as the cutoff date, buildings erected after that date were demolished or moved away. The numbers are surprising: 731 buildings destroyed or removed, 81 renovated, and 413 entirely rebuilt on their original sites. The most remarkable of the reconstructions was what had once

been the most resplendent of all the houses—the Governor's Palace of 1706–20, destroyed by fire in 1781 and then demolished. In fact, another building had later been erected over its foundations. This later structure was torn down, and on the basis of some measured sketch plans done by Thomas Jefferson when he was governor of Virginia, and examination of fragments of the original building that had been dumped into the burned-out basement, and drawing on the imperfect view given in the Bodleian plate, the Governor's Mansion and its dependencies were entirely rebuilt in 1930–35, complete with a steel-framed roof. [8.16] Also heavily damaged by repeated fires was the capitol, and here too the Bodleian plate was the basis of extensive reconstruction and the re-creation of the extraordinarily tall cupola. Recent reexamination of the documents used in the restorations, however, suggests that the Beaux-Arts predispositions of the restoration architects caused them to make mistakes. Despite the very best motives on the part of Goodwin, Rockefeller, Perry, and all the others involved, Williamsburg was not so much a restoration as a thematic rebuilding inspired by what they imagined eighteenth-century architecture to have been. Some of the buildings were later significantly re-restored in the 1940s and 1950s in light of later research. Reinterpretation and correction of earlier restorations continues to this day.[11]

Ralph Adams Cram and the Gothic Revival

Ralph Adams Cram (1863–1942), who had helped to inaugurate a scholarly yet modern Gothic Revival at the close of the nineteenth century, continued to champion this cause. The Gothic he wished to see reestablished was not to be a dry replication but instead a vigorously resurgent Gothic architecture, adapted to the changing needs of modern society. Cram was an ardent latter-day Ruskinian, extolling the virtues of Gothic for a Christian society. His artistically enriched and carefully planned Gothic churches were directly inspired by the earlier work of Henry Vaughan, who had revitalized the Gothic style just as McKim, Mead & White had reinvigorated classicism. Cram saw the Gothic idiom not as a dead style but one interrupted in its development by the interjection of Renaissance classicism; Gothic architecture was not so much a collection of details as it was the embodiment of principles of truth in responding to function and structural integrity. The path on which he would strike out was demonstrated in the powerfully original All Saints Church, Ashmont, begun in 1892 in the Boston suburb of Dorchester. Cram's best work combined the finest construction (whether traditional solid masonry or augmented with supplemental steel), vaults of Guastavino tile construction, excellent carved detail, and stained-glass windows of intense saturated hues. Cram came to national attention in 1904 with his firm's winning entry in the competition for a master plan and new buildings for the U.S. Military Academy at West Point. Some of the older existing West Point buildings had been generically medieval or Gothic (although a recent building by McKim, Mead & White had been austerely classical). Cram's West Point Chapel (significantly influenced by his partner Goodhue) was an assertive, muscular, free adaptation of English Gothic chapels and parish churches, heavy in its proportions, rising over the parade ground at West Point as a constant reminder of militant Christianity.

Cram followed this success with the equally acclaimed design for St. Thomas's on Fifth Avenue in New York, built in 1906–16. [8.17] Because of the restricted narrow urban site, and because taller buildings surrounding the church were inevitable, Cram decided to emphasize size and mass in a tall corner tower, basing the overall design on French late Gothic or flamboyant sources. Moreover, to make the church work better for the sung and spoken word (and because of the site restrictions) Cram opted not to have broad side aisles, except for a short section on the side aisle that formed, in effect, a parallel side chapel. To further improve the acoustics of the church, in which choral singing is of prime importance, Cram worked with engineer Wallace Sabine to develop a new acoustically porous tile used in the Guastavino vaulting. The overall plan and external elements were Cram's, with the profuse interior detailing placed in Goodhue's hands. Sculptors Lee Lawrie and the firm of Irving & Casson carved the stone and woodwork of the interior, while the stained glass was produced by Whitefriars of London. As St. Thomas's was under construction, however, Cram and Goodhue amicably ended their partnership, Cram remaining in Boston and focusing largely on church design, and Goodhue establishing his office in New York City. Church officials hired Goodhue to supervise the completion of St. Thomas's.

For the first three decades of the twentieth century, with his persuasive arguments presented in numerous addresses, articles, and books, Cram's modernized but authoritatively correct neo-Gothic was widely popular for ecclesiastical and collegiate building.[12] Good examples include his Euclid Avenue Church, in

8.17 . Cram, Goodhue, & Ferguson, St. Thomas's Church, New York, New York, 1906–14. While remaining truthful to late Gothic forms and details, Cram and Goodhue designed this church in accordance with its very constricted urban site, while incorporating the work of many highly skilled decorative craftsmen. (Photo: L. M. Roth.)

8.18. Ralph Adams Cram, Cathedral Church of the New Jerusalem, Bryn Athyn, Pennsylvania, 1913–17. Using a range of English medieval elements in his design, Cram endeavored to build this church using a new manifestation of the medieval guild system. (Courtesy of the Cathedral Church of the New Jerusalem, Bryn Athyn.).

Cleveland (1907–41), the Princeton University Chapel (1911–29), the Fourth Presbyterian Church, in Chicago (1911–37), the Mercersberg Academy Chapel, in Mercersberg, Pennsylvania (1916–31), and the St. George's School Chapel, in Newport, Rhode Island (1920–28). One of the most extensively and lovingly detailed of Cram's churches was the Cathedral Church of the New Jerusalem (the Swedenborgian Church) in the northern Philadelphia suburb of Bryn Athyn, Pennsylvania (1913–17). [8.18] In building this church Cram had the enthusiastic support of a generous client, John Pitcairn, and together they undertook an intriguing experiment of re-creating the medieval guild system. In the expansive grounds around the church building site, Cram set up workshops for the all the construction and artistic trades. As Cram related in his autobiography:

What I tried to do was to make all the workmen of every sort joint partners with the architects in producing a building that should be wholly personal in its structural qualities and its craftsmanship, and also to establish, all around the projected cathedral, workshops and studios for the production of sculpture and stone-carving, cabinetwork and joinery, metalwork and stained glass. This entire force of workmen, craftsmen, and artists was to be knit together into a real building guild, one in heart and mind and work.[13]

Moreover, Cram and Pitcairn also decided to experiment with incorporating the visual refinements that were then being discovered in the details of medieval churches. For example, the floor of the nave at Bryn Athyn slopes up toward the chancel, giving a sense of elevation and lift to the area where the altar is located. The intercolumniation varies for each bay, and the moldings and stringcourses are not absolutely horizontal but have a slight camber. These and other refinements proved to be extraordinarily expensive, however, and although the experiment proved that the optical refinements had a definite if subliminal psychological effect, Cram was never able to exploit them in subsequent church designs. As Cram notes in his autobiography, "the present standardization of the building trades and the lack of sympathy on the part of the trades-unions simply makes it impossible." In fact, Cram's experiment in making the construction of the church a truly dynamic and cooperative effort was so enthusiastically embraced in this one instance that Cram was dismissed as supervising architect and the on-site supervision was carried out by a small corps of draftsman hired from his office. Yet Cram viewed this situation with great equanimity, as the logical and natural extrapolation of his objectives, and the final result, he wrote, "is not only unique but one of the most picturesque and romantic architectural compositions in the country. It is a sort of epitome of English church-building from the earliest Norman to the latest Perpendicular; learned, scholarly, poetic; a real masterpiece of reminiscent yet creative art."

In his expansion and perfection of Gothic, perhaps Cram's grandest and culminating achievement was his proposal for completing the huge Church of St. John the Divine in New York City (1915–41). Cram's contribution was the design of the enormous nave for the incomplete building. Because the extreme nave width had already been determined by earlier construction, Cram opted in favor of a sexpartite vaulting system, with heavy cross ribs at the ends of each long bay. Then, to accommodate the tremendous lateral forces generated by the wide bay and its vaulting, Cram devised an original modern system of doubled slender external buttresses.

The independent work of Bertram Goodhue, Crams's former partner, also included Gothic, but his churches tended to be heavier in mass and reduced in detail compared to Cram's. One good example is his Gothic Rockefeller Chapel for the University of Chicago, built in 1918–28. Another successful neo-Gothic architect in the Cram tradition was James Gamble Rogers, who built quadrangles, towers, and the new main library at Yale University from 1917 until 1930, and then similar buildings at Northwestern University, Evanston, Illinois, soon after.

MOVIE PALACES: THE ARCHITECTURE OF ILLUSION

The houses and churches discussed so far all drew from long-established models and familiar functions. In the period from 1910 through the 1920s, however, a wholly new building type was being developed in cities large and small—the movie palace. In these grandiloquent theaters motion pictures portrayed tales of romance and escape, providing an emotional release for the working and middle classes. Beginning with a few experimental films in the 1890s, the motion picture industry had exploded in production and social impact by 1915. The escapism and illusionism of the motion pictures themselves were enhanced by the romantic flourishes of the architects who designed the motion

picture palaces in the 1920s and early 1930s. Theaters had existed for centuries, but greater in scale and artistic hedonism were the theaters devoted to motion pictures. Ranging from modest movie houses to enormous motion picture palaces, these buildings were most often floridly Italian and French Renaissance or Baroque in detail, generally in the form of enlarged Baroque opera houses, such as the Capitol Theater, in New York, by Thomas W. Lamb, built in 1919 (now demolished). Other movie house auditoriums took the form of Italian or Spanish town plazas, the stage being placed in a "building" at one end, with balconied "houses" all around; the ceiling of such "atmospheric" theaters was a smooth vault painted to resemble the night sky with tiny light bulbs above the plaster vault twinkling like stars through small holes. The Olympia Theater, in Miami, Florida (now the Gusman Center), built in 1926, by John Eberson, is a good example of such an atmospheric theater, which became Eberson's acknowledged specialty. [8.19]

The movie palaces exploited exotic architectural expressions to the fullest, and enclosed spaces that created an almost palpable atmosphere. This can be seen in photographs of the lounges of William Lee Woollett's Grauman's Metropolitan Theater, in Los Angeles, built in 1923, tucked under the long sloping ceiling of the large balcony. Exotic styles were used to

maximum visual effect. Loews's Seventy-second Street Theater, in New York, by T. W. Lamb, built in 1932, was Cambodian Buddhist in detail; Grauman's Chinese Theater, in Los Angeles, by Meyer & Holler, built in 1923, was flamboyantly Asian; and the Aztec Theater, in San Antonio, Texas, built in 1926, was complete with sacrificial altar. Los Angeles still has its Mayan Theater, built in 1927, by Morgan, Walls, and Clements, every inch of its exterior covered with glyptic ornament in bright colors. Even small cities and towns such as Kalamazoo, Michigan, and Coos Bay, Oregon, had exotic theaters. Kalmazoo had the State Theater, built in 1927, a charming Eberson-designed Spanish Colonial atmospheric theater, now closed. Coos Bay boasts of its Egyptian Theater, still replete with brightly painted hieroglyphs, cavetto cornices, Pharonic statues, and Egyptian lounge chairs and divans. It was designed by Lee Arden Thomas in 1925, architect of numerous theaters in the region. Moreover, the Coos Bay Egyptian Theater is also fortunate to still have its Wurlitzer-Hope June Unit Orchestra pipe organ, as does the Olympia Theater in Miami. These huge instruments, once common, were fitted out with all manner of pipe ranks and sound effects devices, all played from the keyboard, filling the auditoriums with music and sounds that made the flickering moving images anything but silent pictures.

8.19. John Eberson, Olympia Theater, Miami, Florida, 1926. Eberson specialized in "atmospheric" theaters in which the auditorium was made to look like a Mediterranean village plaza under the night sky. (Courtesy Theatre Historical Society of America, Elmhurst, Ill.)

8.20. *Rapp & Rapp, Chicago Theater, Chicago, Illinois, 1921. With its 3,800 seats, multiple balconies, and elaborate French Baroque decoration, this was the first major American downtown movie palace. (Courtesy Theatre Historical Society of America, Elmhurst, Ill.)*

8.21. *Rapp & Rapp, Tivoli Theater, Chicago, Illinois, 1921. For this large movie palace, the spacious, soaring lobby was patterned after the Royal Chapel at Versailles. (Courtesy Theatre Historical Society of America, Elmhurst, Ill.)*

The large theaters were truly immense; the Roxy in New York, by W. W. Ahlschlager, built in 1927, had 6,250 seats, while the comparatively "small" Chicago Theater, built in 1921, by Cornelius and George Rapp, accommodated 3,880. [8.20] The hundreds of people entering and exiting these theaters when the films were replayed caused circulation problems that were solved by spacious lobbies, galleries, and balconies. Especially noteworthy were the enormous entry lobbies, as richly decorated as the front facades and the auditoriums. The lobby of the Tivoli Theater, in Chicago, built in 1921, done in richly ornamented French Baroque by Rapp and Rapp, and the first theater to have a clearly charted traffic pattern, had a soaring lobby based on the royal chapel at Versailles. [8.21] The Chicago Theater was one of the earliest large elaborate movie palaces, and its lush overlays of French Baroque ornament were carefully calculated for visual and emotional effect. The reason for providing such lush embellishment was simple, said architect George Rapp in 1925:

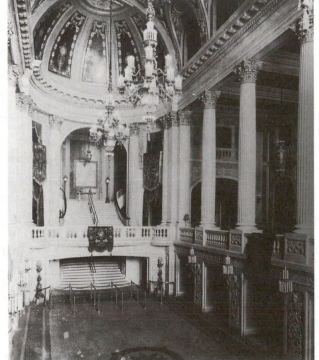

Watch the eyes of a child as it enters the portals of our great theaters and treads the pathway into fairyland. Watch the bright light in the eves of the tired shopgirl who hurries noiselessly over carpets and sighs with satisfaction as she walks amid furnishings that once delighted the hearts of queens. See the toil-worn father whose dreams have never come true, and look inside his heart as he finds strength and rest within the theater. There you have the answer to why motion picture theaters are so palatial.[14]

AMERICAN MODERNISM

The many historical forms so prevalent in private residences, churches, and theaters had their counterpart in expressions of modern architecture created by American architects independent of influence from Europe. Conventional wisdom suggests that Modernism was a style imported into the United States. Part of this misunderstanding may have been caused by the critical success of the epochal exhibition at the new Museum of Modern Art in New York, organized in 1932 by Philip Johnson, Henry-Russell Hitchcock, and Alfred Barr. All three had been touring Europe for several years and were profoundly impressed by the new architecture they saw rising. It owed nothing to the past (or so it seemed) and celebrated industrial production and the machine. The three young men were convinced that this was the architecture of the future. In a small book accompanying the exposition, entitled *The International Style: Architecture since 1922*, Johnson and Hitchcock sketched out the basic definition of Modernism, discussing its rejection of historical styles and its focus on pure utilitarian functionalism, its emphasis on the enclosed spatial volumes rather than opaque enclosing materials, its exploitation of smooth industrial finishes (especially metals and glass), its open, nonsymmetrical, nonaxial plans, and its absolute rejection of any applied ornament. Of the seventy-four buildings and interiors illustrated in the book, sixty-eight were by European architects. American architects seemed to be clearly outpaced by their European colleagues. Nonetheless, a few American architects were creating their own unique manifestations of Modernism based on their own analysis of building problems and contemporary needs. Although they may have been aware of developments in Europe, they had no desire merely to copy that architecture.

Richard Buckminster Fuller (1895–1983) was not an architect in the conventional sense. Born in

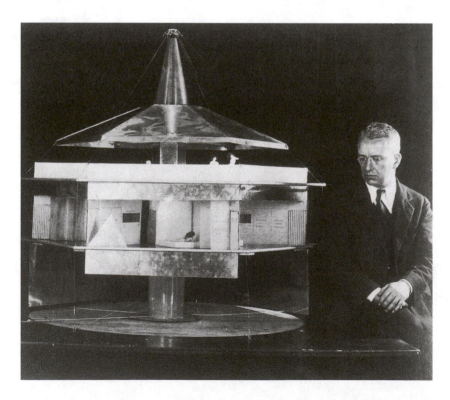

8.22. R. Buckminster Fuller, Dymaxion House No. 1, 1927. In his quest for the most efficient house, Buckminster Fuller devised what he called the Dymaxion House, built of aluminum and capable of being factory-built and delivered to the building site by dirigible. (From D. Upton, Architecture in the United States, *New York, 1998.*)

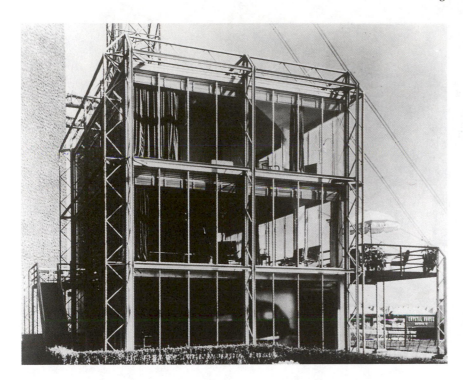

8.23. George Fred Keck, Crystal House (House of Tomorrow), Century of Progress Exhibition, Chicago, Illinois, 1933. Built with light open-web metal support on the exterior, the walls of this house were almost entirely of glass. Visible at ground level is the outline of Buckminster Fuller's Dymaxion automobile. (Hedrich Blessing photo, Condit Archive, Northwestern University.)

Massachusetts to a family steeped in the Transcendental tradition, he was encouraged to create his own universal values. Although he studied briefly at Harvard, he had no interest in long formal academic education. After serving in the navy in the First World War, he started a company producing light building materials. He endeavored to develop building systems that used minimal material for maximum effect, what he called a "minimal dimensional energy system." In 1927 he designed what he called the "Dymaxion House" (a word he coined from *dynamic* and *maximum*), a dwelling to be built of prefabricated hexangular metal modules suspended from a central utility mast. [8.22] A design for a prefabricated modular bathroom followed in 1929. He built several prototypes of a streamlined three-wheel Dymaxion car in 1932–33, essentially a total living environment on wheels (not unlike recreational vans of the late twentieth century). In 1946 he developed a second Dymaxion house, with a stressed aluminum skin, drawing on aircraft construction technology, yet none of these proved popular enough to warrant the expensive tooling up required for economical mass production. After these disappointments in designing housing units, Fuller shifted his attention to cartography (inventing a new polyhedral projection technique) and to large-scale structures built with small structural units (discussed in chapter 9).

George Fred Keck (1895–1980), later assisted by his brother William Keck (born 1908), developed his version of Modernism in Chicago as a result of work on two model Houses of Tomorrow for the Century of Progress exhibition held in Chicago in 1933. One of the houses was a two-story octagon of glass incorporating an airplane hanger in the base (the expectation was that everybody would have a private aircraft by the next century!). The other house was an austere glazed cube, framed of externalized open-web steel posts and joists with walls entirely of glass. [8.23] During construction in the dead of winter, in 1932, the architects noticed that the workmen inside had stripped down to shirtsleeves because the glass box acted as a greenhouse and was pleasantly warm with no heat being supplied.[15] Keck quickly seized upon this free energy source and developed a technique of passive solar heating that exploited southerly orientations moderated through carefully calculated roof overhangs. These overhangs permitted the sun to heat the interiors in the winter but kept sunlight off southerly window walls in the summer. Keck and his brother employed variations on this theme in their house designs from the mid-1930s through the 1970s. One example is G. F. Keck's house for Hugh D. Duncan, in Flossmoor, Illinois, built in 1941, which also incorporated radiant hot water heating in the concrete floor slab. [8.24] Although well known in the Chicago area

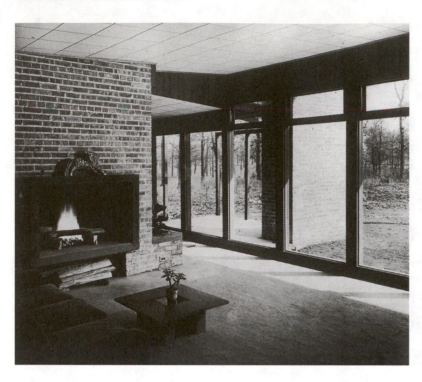

8.24. George Fred Keck, Hugh D. Duncan house, Flossmoor, Illinois, 1941. Carefully calculated roof overhangs allow the sun to heat the interior during the winter, but block sunlight in the summer. (Hedrich Blessing photo, Condit Archive, Northwestern University.)

in the 1940s and 1950s, the Keck brothers did not receive much attention elsewhere until they were rediscovered in the 1970s.

One modernist designer whose work was highly praised in the 1940s and early 1950s (although his best work was frequently credited to another architect) was John Yeon of Portland, Oregon. Born in Portland, Yeon (1910–1994) had a privileged upbringing: his father, once a penniless immigrant from Ontario, Canada, had made a fortune in the lumbering business that he later multiplied in Portland real estate development. Yeon, who finished only one year of study at Stanford, had been pursuing study in architecture for several years in various Portland architects' offices, including that of A. E. Doyle (headed in the 1930s by Pietro Belluschi, who retained the original firm name). Yeon had traveled in Europe and had been impressed by modern design he saw in Scandinavia (although he said or wrote little about what he may have seen in Germany). Asked in 1936 by his good friend, Aubrey Watzek (who had also become wealthy in the lumber business), to design a house, Yeon selected a high promontory then just outside Portland with a magnificent view of Mt. Hood to the east. He decided to create a thoroughly modern residence, but one designed in response to the local climate rather than adhering to abstract international formulas, and he decided to exploit wood as

a building material rather than steel or concrete. The result was a clustering of rooms around a central court, with low-pitched roofs carried on wood supports protecting the large expanses of glass from winter rains. [8.25] The house was featured in several exhibitions and publications produced by the Museum of Modern Art, but too often credited to Doyle or Belluschi (the construction drawings were prepared in Belluschi's office and bore his stamp for the purposes of being approved by the building department).

Pietro Belluschi was pursuing a parallel course in the development of his own residential designs, and after 1938 used many of the details first developed by Yeon in the Watzek house, further confusing the authorship of the Watzek house. Yeon never pursued a true professional career, although he designed several houses in his unique Northwest regional modernist idiom after the Second World War. Gradually, however, as he shifted his interest to regional planning and architectural and landscape preservation, his highly original architectural work was largely forgotten outside of Portland and the Pacific Northwest.[16] Belluschi, however, vigorously pushed his professional practice, developing in the late 1940s and 1950s a regional style parallel to that of Yeon in numerous residential and church designs in the Pacific Northwest. While developing his own independent Modernism,

Belluschi was nonetheless greatly influenced by the work of his friend John Yeon, as can be seen in the Jennings Sutor house built in 1938 across the street from the Watzek house.

In the San Francisco Bay Area of California, another architect was developing a modern idiom, unique to that region, by taking indigenous vernacular architecture and stripping it to its essentials. A native of Stockton, California, William W. Wurster (1895–1972) studied architecture at the University of California, worked briefly in San Francisco, traveled in Europe, and then returned to San Francisco in 1924 to set up his own practice. His radically simplified and straightforward approach to residential design was announced in his Warren Gregory Farm, near Santa Cruz, done in 1926–27. Between 1927 and 1942, he designed over two hundred houses in the Bay Area, all of them bare of historical details but abstracted from Anglo-Spanish ranch houses. For the most part these houses had low-pitched roofs, often broad verandas opening to courts or deep "living porches." Wurster's Mackenzie house, in the Pasatiempo Country Club and Estates complex in the foothills of the Santa Cruz mountains, of 1931, shows this Anglo-Spanish inspiration. Redwood became his preferred material, with shingles on the roofs, and flush-fitted planks for the sheathing, sometimes running vertically. His large Chickering house, in Woodside, California, built in 1941, had a central living area or loggia positioned between the public area of the house and a cluster of bedrooms, with large panels of glass on both sides that could be rolled aside to open the loggia to the soft dulcet climate and broad terraces. Wurster's was a Modernism drawn from local sources and perfectly adjusted to the relaxed way of indoor-outdoor living in the Bay Area. Wurster gained a national reputation that led to his appointment as dean of architecture at MIT in 1944, and then to his selection as dean of architecture at the University of California in 1951. After the Second World War, in partnership with Theodore Bernardi and Donn Emmons (and together with his wife, the planner Catherine Bauer), Wurster had an active practice in all areas of building design, but his small houses—with their directness and uncomplicated forms—remain some of his best work.

Two additional architects who developed modern expressions of their own should also be noted in this context—Rudolph M. Schindler and Richard J. Neutra. Both were Austrian emigrés who came to the United States intending to study the work of Frank Lloyd Wright, perhaps work in his office, and then return to Europe. As it happened, both remained in his country and settled in Los Angeles, where they introduced a sleek, elemental Modernism that rivaled anything being done in Europe. However, because both did, in fact, spend time in Wright's office, they are discussed below following the discussion of Wright's work in the 1920s and 1930s.

8.25. John Yeon, Aubrey Watzek house, Portland, Oregon, 1936–38. Yeon's Modernism used sloped roofs to better suit local climate conditions and exploited wood construction. (Sandak, courtesy of the University of Georgia.)

8.26. Bertram Goodhue, Tribune Tower Competition Entry, 1922. In his competition entry, Goodhue developed a nonhistoricist scheme, with multiple setbacks, crowned with a squat pyramid. (From The International Competition for a New Administration Building for the Chicago Tribune Tower, Chicago, 1923.)

Bertram Goodhue

Of the architects who attempted to forge a truly modern expression extrapolated from creative eclecticism (similar to what John Gaw Meem was then doing), the most promising perhaps was Bertram Grosvenor Goodhue (1869–1924). Had he not died at fifty-five he might truly have accomplished this synthesis. Goodhue had little formal architectural education but had served an apprenticeship in Renwick's office, developing an amazing drafting and sketching skill. In 1891 he entered the Boston office of Ralph Adam Cram, rapidly became a key member of the firm, and was made a partner in Cram, Goodhue, and Ferguson

before the century was out. He became a principal designer in the firm but in 1914 he established an independent practice in New York City. His individual work was less reliant than Cram's on scholarly Gothic form and detail; in fact his St. Bartholomew's Church, in New York, built in 1914–23, was a colorful variant of Byzantine architecture, and its round arch motifs blended well with the Romanesque portal by Stanford White from the former church, which was incorporated into Goodhue's new structure. Goodhue's designs varied from Spanish Colonial Revival (which he was instrumental in popularizing in California through his work on the Panama-California Exposition in San

8.27. Bertram Goodhue,
with Carleton Winslow,
Los Angeles County Public
Library, Los Angeles,
California, 1921–26.
Goodhue used graduated
setback massing in his
concrete Los Angeles County
Public Library; now dwarfed
by surrounding soaring office
towers, the library has been
restored, including the
reading gardens shown in
this view of the late 1920s.
(From O. Reagan, ed.,
American Architecture
of the Twentieth Century,
New York, 1927.)

Diego and several private residences in southern California) to the boldly muscular modernized Gothic chapel at the University of Chicago, built in 1924–28, named in honor of John D. Rockefeller. Most promising were his commercial and civic buildings, such as his entry in the Tribune Tower competition in 1922, which received an honorable mention. [8.26] It was a sheer tower, almost completely devoid of applied historicist ornament, modeled by a series of major and minor sharp angular setbacks at the crown and topped by a square pavilion with a brightly colored tiled pyramidal roof. It was direct and businesslike, yet well modulated, and free of meretricious ornament, but it

was not what owner Colonel McCormick wanted. Nonetheless, in abbreviated form, drawn out horizontally, and rendered in buff-colored concrete, the basic scheme was realized in the Los Angeles County Public Library, in Los Angeles, California, built in 1921–26. [8.27] Integrated sculpted figures of notable literary, philosophic, and historical writers accentuate salient points, and this theme is completed by the finial that rises from the polychrome pyramidal crown—a hand holding aloft the flaming torch of illumination. The cubic concrete off-white masses were set off against a landscaped outdoor reading garden with fountains west of the building. Following a disastrous arson fire

8.28. Bertram Goodhue, Nebraska State Capitol, Lincoln, Nebraska, 1919–20, 1922–32. Although there is a small gilded dome at the very top, Goodhue's inspiration for the Nebraska State Capitol was the modern American skyscraper office tower. (Photo: L. M. Roth.)

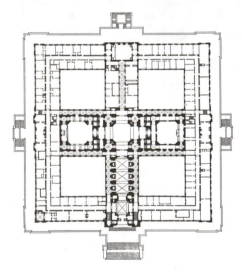

8.29. Nebraska state capitol. The plan of the main floor shows the formal clarity of Beaux-Arts planning (even though Goodhue never studied in Paris). (From Reagan, ed., American Architecture of the Twentieth Century.*)*

in 1987, the building and garden have been most sensitively restored, with a large new wing, complementary to the original building, added to the east side in 1987–93 by Hardy Holtzman Pfeiffer Associates.

Even before these two designs were drawn up, Goodhue started what was to be the crowning achievement of his truncated career—the Nebraska State Capitol, won in a celebrated competition of 1919–20 and built in 1922–32. [8.28, 8.29] Initially it was surprising to some that Goodhue had won at all, for he shunned the serene white domed classical image still popular for state capitols in 1919, as seen in the Washington State capitol, or the West Virginia capitol, both of which were then being completed. Goodhue's plan, a square divided into quadrants by crossed central wings, clearly derives from Beaux-Arts plans, but instead of focusing on a central domed rotunda, there rises from the crossing an immense skyscraper tower. It is massively buttressed at the corners, with narrow

vertical window strips between; the top consists of a setback octagonal stage carrying a further setback dome sheathed in tile. To some extent Goodhue's serried setbacks are based on contemporary work in Europe, especially on the setback towers designs of the Finns Lars Sonck and Eliel Saarinen, but to American eyes Goodhue's design brilliantly combined a greatly stylized classicism, which connoted public building, with the skyscraper, which connoted the modern age. The soaring tower of the building still dominates the broad landscape around Lincoln, clearly announcing the presence of the state capitol.

Albert Kahn

In such designs as Goodhue's Nebraska state capitol there was a remarkable fusion of Beaux-Arts composition, symbolism, and expressive detail with modern materials and severity of form. Most architects of the period, however, were more comfortable staying with one or the other approach. The contrast can be strikingly illustrated by the studied Gothic richness of St. Thomas's Church, in New York, built in 1908–14, by Cram, Goodhue, & Ferguson, and by the starkly modern Ford plant at Highland Park, Michigan, by Albert Kahn, built in 1910, which frankly revealed its reinforced-concrete frame. An even better example of Kahn's industrial work is his later Dodge truck plant of 1937. [8.30] While the later date might suggest a marked evolution in expression during the intervening twenty-seven years, the Dodge plant is not very far removed stylistically from Kahn's Packard factory addition of 1911, with its sophisticated sawtooth glass roof and steel truss-work spanning seventy-two feet. What had changed in Kahn's factories from 1906 to 1940 was the impact of electrification of the work environment. The early factories had been vertically planned, like the Highland Park facility, with materials and parts being lifted to the upper floors, gradually being lowered as subassemblies through the middle floors, and emerging as finished Model Ts on the ground floor. As each workstation came to be powered with individual electric motors, the reliance on gravity decreased, and the factories spread out into one horizontal level. The urgent problem then became lighting the interiors of such horizontally extended work areas, and Kahn's solution was long ranks of sawtooth light monitors or other forms of overhead natural lighting extending the breadth of the factories.

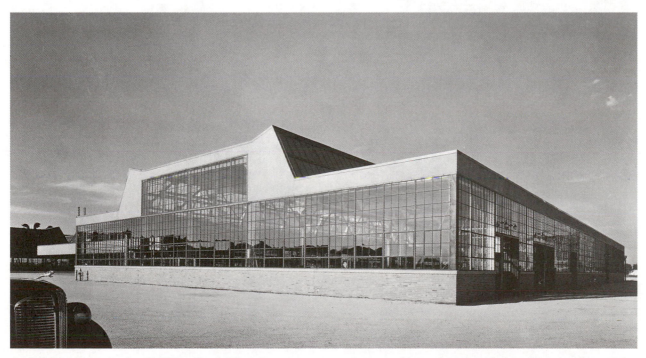

8.30. *Albert Kahn, Dodge Half-Ton Truck Plant, Detroit, Michigan, 1937. Albert Kahn's factories, from 1903 into the 1940s, were based on the utmost utility, providing the* maximum usable workspace with the minimum of material and the best natural lighting. (Courtesy of Albert Kahn Associates.)

As it turned out, this abundant natural lighting, coupled with extremely long clear structural steel spans, made these factories excellent sites for the assembly of more than automobiles. After 1941 they were quickly refitted for making airplanes and other war materiel. Kahn's factories became what Winston Churchill called the arsenals of democracy.

Albert Kahn (1869–1942) is that most intriguing of architects, one who (to later generations of modernists) seemed to be of two seemingly antithetical frames of mind. He rigorously analyzed the problem of modern factory design (he built more than two thousand during his long career) and considered such work a legitimate province of the trained architect, publishing a book of his industrial work in 1917. He believed that the expression and character of a building were determined by function; hence factory buildings, the embodiment of utility, were appropriately lean and mechanical in form, whereas university and public buildings that embodied humanistic values were appropriately done in historically correct traditional modes. Private homes, too, were high among his priorities, and perhaps none of his residences surpassed his Edsel Ford house in Grosse Pointe, which illustrates

well Kahn's exacting historicist standards. Kahn's traditionalist emphasis becomes clear when we consider that, of all his work, he said he wished to be remembered by the small Italian Renaissance–style William L. Clements Library, in Ann Arbor, Michigan, built in 1923 [8.31], patterned closely on McKim, Mead & White's Renaissance pavilion for the Morgan Library, in New York, of 1902. Albert Kahn's work, therefore, is of critical importance in understanding both the end of one phase of creative eclecticism in America and the simultaneous rise of utilitarianism.

Paul Phillipe Cret

Goodhue's plan for the Nebraska state capitol could be described as incorporating the essence of formal plan arrangement as taught at the École des Beaux-Arts in Paris, with its crossed axes and clear directional flow of movement. The irony is that Goodhue never went to Paris to study, nor did he serve an apprenticeship with an architect who had trained there. Many American architects had been to Paris, of course, and the impact of the logical planning they learned there remained with them and their students well into the twentieth century. The influence of the

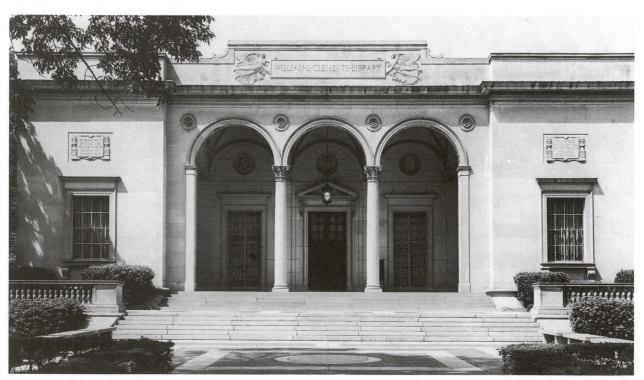

8.31. Albert Kahn, William L. Clements Library, University of Michigan, Ann Arbor, Michigan, 1923. For his public and residential building, Albert Kahn employed a broad range of thoroughly studied historical references, such as the Italian Renaissance motifs used in this library. (Photo: © Wayne Andrews/Esto.)

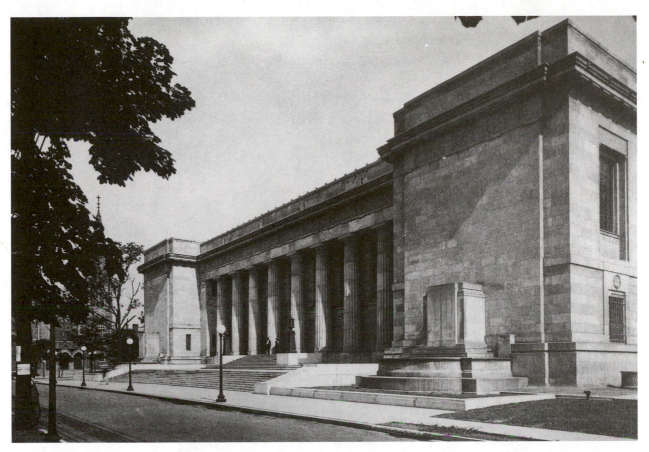

8.32. *Paul Philippe Cret (working with Zantzinger, Borie, & Medary), Indianapolis Public Library, Indianapolis, Indiana, 1914–17. Cret's clarity of room arrangement demonstrates the rationalism he was taught at the École* des Beaux-Arts, *a logic paralleled by the severely simplified and stripped classicism he favored. (From Reagan, ed.,* American Architecture of the Twentieth Century, *New York, 1927.)*

École was felt in the United States in another way, too: through the many French instructors brought to America to run the design studios in American schools of architecture. Nearly all American architectural schools sought French instructors, partly to teach their students the techniques and tricks of École drawing so as to make it easier for their students to win the design prizes offered by the Beaux-Arts Institute of Design, considered most prestigious at the time.[17]

Of the French teachers enticed to come to the United States, perhaps the most influential was Paul Phillipe Cret (1876–1945). A native of Lyon, France, he studied architecture at the École des Beaux-Arts from 1897 to 1903. The winner of several design competitions at the École, he did not compete for the grandest award of them all—the Prix de Rome, which would have given him four to five years of expense-paid advanced study at the French Academy in Rome. Instead Cret accepted a position as professor of design at the University of Pennsylvania in 1903, soon giving the architecture program there a national reputation for excellence. He educated many architects who later became important themselves, but the best known would be Louis I. Kahn. Cret's design work in the United States—the many competitions he won and his completed buildings—was marked by a clear logic and clarity of form and detail. His work also illustrated that superior and critically acclaimed design was not reliant on the replication of historical detail. A building on the Washington Mall, the International Bureau of the American Republics, built in 1907–10, which he won in a competition of seventy-eight entries, was classical in its overall design, freely and intelligently combining French Renaissance elements, but over time Cret gradually simplified and abstracted this classicism to create bolder, less ornamented masses. This is well illustrated by his Indianapolis Public Library, built in 1914–17, which he also won in competition.

8.33. *Alfred Alschuler, London Guarantee and Accident Building (now the Stone Container Building), Chicago, Illinois, 1922–23. This exemplifies the so-called traditional or classical office skyscraper of the 1920s. (Photo: Raymond Trowbridge, c. 1925–30, Chicago Historical Society.)*

8.34 *(facing page). Howells & Hood, Tribune Tower, Chicago, Illinois, 1922–25. To achieve the most beautiful skyscraper in the world (as required by the competition program), architects Howells and Hood based their design on the late Gothic tower built by the butter guild for the cathedral of Rouen begun in 1485. (Photo: L. M. Roth.)*

[8.32] More severe still were his Folger Shakespeare Library, built in 1928–32, and his Federal Reserve Board Building, built in 1935–37, both in Washington, D.C., which gave rise to the term *stripped classicism* to describe their austerity of form and detail. In all of his buildings, and especially his public libraries and art museums, the logical clarity of the plan in directing the movement of people was a testament to the intellectual training he had received in Paris and which he passed on to his students.

SKYSCRAPERS, 1915–1940

The "Traditional" Skyscraper

From the European perspective in the early years of the twentieth century, Americans were shaping the epitome of modern architecture in their skyscrapers. In 1926, when German movie director Fritz Lang wanted to show the city of the future in his film *Metropolis* the image he depicted was an extrapolation of New York, with massive towering skyscrapers

standing side by side, connected by aerial roadways. In fact, Lang presciently showed geometrically modeled skyscrapers very similar to the Art Deco office skyscrapers that would rise in the next several years.

Following the line sketched out by Sullivan, Burnham, & Company, Holabird & Roche in Chicago, and picked up by Bruce Price, Cass Gilbert, and other architects in New York, the ever taller office skyscrapers accentuated their verticality. Unlike Sullivan's skyscrapers, however, the later examples did not do this in radical ways, but by modifying the traditional classically based paradigm. These three-part, or tripartite, office buildings had base sections delineated by two- or three-story pilasters or columns, capped by an entablature, then a transitional mezzanine story, followed by the relatively undifferentiated stacked-up office floors. The composition was terminated at the top by a reprise of what was seen at ground level: a two- or three-story colonnaded or arcaded crown capped with an even larger classical cornice, proportioned with respect to the total height of the building. What differentiated these post–First World War office buildings, however, were the slender towers that rose over the upper cornice in response to the building ordinances passed to ensure that some modicum of light and air reached the streets below. Burnham's successor firm in Chicago, Graham, Anderson, Probst, & White, built a number of such office buildings there, most notably the white-terra-cotta-sheathed Wrigley Building, of 1919–24. Of the many buildings that could be picked, one example in Chicago can serve to illustrate the type. Built in 1922–23 from designs by Alfred Alschuler, the London Guarantee and Accident Building stands beside the Chicago River and differs from other office skyscrapers of this kind only in the curve of its main facade in response to its irregular building site. [8.33] The base uses three-story engaged Corinthian columns to frame the entry arch, and at the top somewhat smaller Corinthian columns and an emphatic entablature and cornice crown the building.

Within a few years after the war this conservative approach began to be replaced in a shift made very clear in 1922 by the numerous entries submitted in the competition for the design of the Chicago Tribune Tower. The essential requirement, as stated in the competition program, was that the Tribune Tower be "the most beautiful and distinctive office building in the world."[18] This beautiful form had to be achieved, moreover, within the guidelines of the building ordinance requiring setbacks in the upper level. The com-

petition jury, composed of conservative journalists, city politicians, and a conservative architect, selected the design of John Mead Howells and Raymond Hood from among the 259 entries that came from around the world. [8.34] Built in 1923–25, it is a combination of the New York tower form, using Gothic elements similar to those of Cass Gilbert's Woolworth Building, combined with the tripartite organization of Chicago skyscrapers. It has a four-story base, a soaring and much plainer midsection shaft, and a setback, highly

8.35. Eliel Saarinen, Tribune Tower competition entry, 1922. Saarinen's entry in the Tribune Tower competition was felt by many architects to be superior to the design given first prize. (From The International Competition for a New Administration Building for the Chicago Tribune Tower, Chicago, *1923.)*

enriched Gothic crown. The setback crown, required by the new zoning law, was given the shape of a diminishing Gothic steeple and was largely based on the Tower of Butter of the Cathedral of Rouen, of 1485. At the top the Gothic details were greatly enlarged so as to be readable from the street and are to a large extent gratuitous since the steel-framed fly-ing buttresses support nothing, but the Gothic theme allowed for the easy natural emphasis of the vertical piers. The historically detailed limestone exterior veneer covers and protects the steel frame, marking a shift away from glazed terra cotta, up to then the preferred sheathing material. The Tribune Tower characterizes the ambivalence of the early 1920s, for both its planning and its structural frame were among the most sophisticated and advanced of the period, while the exterior skin is one of the most historically and carefully detailed envelopes. As a "traditionalist" skyscraper, however, the Tribune Tower has few equals. And as it turned out, the northern Gothic details proved just as effective in shedding water from this Chicago building as they had been originally in France. By the 1970s neighboring skyscrapers of the 1950s and 1960s, minimally detailed and badly aging, demonstrated that the historical detailing of buildings like the London Guarantee or the Tribune Tower served important and quite practical functions.

The Modern Skyscraper

There were Tribune Tower competition entries that attempted to express the unique nature of a modern office tower. For the most part these came from Europe, and particularly interesting, because of its clear derivation from the work of Sullivan and other Chicago School architects, was the submission by Walter Gropius and Hannes Meyer (with some added touches inspired by the Dutch De Stijl movement). Of all the entries, however, the one most highly regarded by critics, including Louis Sullivan, was that of the Finnish architect Eliel Saarinen, which was at once somewhat traditional and yet progressive. [8.35] Much of the carefully placed ornament was loosely inspired by Gothic precedents, and the emphasis of the vertical piers was likewise Gothic. Yet the numerous gentle setbacks, inspired by recent buildings in Europe, were arranged by Saarinen to begin at a level lower than that required by law, to effect a gradual diminution of the tower and create a mass that gave the appearance of having the sheer eroded planes of a man-made mountain.

Ironically, Saarinen's entry, which was awarded second prize, exerted a far greater influence on subsequent skyscraper design than did Howells and Hood's winning design, beginning almost immediately with Raymond Hood's own American Radiator Building, in New York, built in 1924, which moved dramatically beyond the old models with its covering of dark green marble at the base, and green-glazed terra cotta

8.36. *Raymond Hood, American Radiator Building, New York, New York, 1924. Even while the Tribune Tower was being finished, Hood based his next office tower, for the American Radiator company, on Saarinen's Tribune competition entry, with the addition of deep rich colors. (From Reagan, ed.,* American Architecture of the Twentieth Century.*)*

8.37. *Knud Lönberg-Holm, Tribune Tower competition entry, 1922. One of the most abstract entries in the Tribune competition was this one by the Danish architect Lönberg-Holm. (From A. Sartoris,* Gli elementi dell' architettura funzionale, *1935.)*

with gold metallic accents in the setback crown. [8.36] This, coupled with such books as Hugh Ferriss's *The Metropolis of Tomorrow* (1929), changed the image of the modern skyscraper from corniced classical block to tapered, soaring ziggurat.

Another even more daring but less celebrated Tribune Tower entry was that of the Dane Knud

Lonberg-Holm that combined such elements of the De Stijl movement in the Netherlands (flat planes and primary colors) with Constructivist expression of parts according to internal use rather than structural. [8.37] Accordingly, the floors are expressed as horizontal trays of continuous space, with bands of ribbon windows. Through the center of the horizontal floor tiers

runs a vertical shaft, corresponding to the vertical circulation inside, culminating in a series of interlocked cubes at the top, where gigantic letters (prefiguring later "supergraphics") spell out "Tribune." Of all the entries, Lonberg-Holm's was most representative of the European modern movement, what Hitchcock, Johnson, and Alfred Barr would label the International Style in 1932. It had stark geometry, vivid color, precisionist minimal detail, and the suggestion of horizontal trays of space, but in 1922 it was far from what most Americans considered beautiful and was essentially ignored by the judges; it was not even included in the publication of all the submitted entries. Lonberg-Holm later immigrated to the United States, incorporating in his designs of enameled steel panels for gas stations some of the concern for industrial production and the stark cubical geometries that had distinguished his Tribune Tower design.

ART DECO AND *MODERNE*

The Modernism of Fuller, Keck, Yeon, Belluschi, and Wurster, only marginally influenced by European developments, was indigenous to the United States. One might describe it as "high-style Modernism," the product of professional architects and high-minded designers. There were also more vernacular versions of Modernism that proved to be enormously popular, and spread across the country in a matter of months during 1925–26: the Art Deco (and soon after, streamlined *moderne*) styles; before the onset of the Great Depression examples were being built in virtually every American town or community where there was building activity.

Art Deco was a purely decorative style originally developed in Europe as a kind of delayed geometricization of the earlier European Art Nouveau. Like Art Nouveau, Art Deco first appeared in furniture, room furnishings such as pottery and metalwork, and interior architecture. But where Art Nouveau stressed delicacy and softness, Art Deco stressed hard-edged, strong geometric patterns, either sharply angular or curvilinear (but never mixed), augmented by strong, bold colors. Animal and plant forms, when used, were greatly stylized to form flat linear patterns. An exhibition was held in Paris in summer 1925, officially called the Exposition Internationale des Arts Décoratifs et Industriels Modernes, and from this the term *Art Deco* was coined. Originally conceived in 1907 for an opening in 1915, the exposition was

delayed and then postponed as a result of the war; this was a government-sponsored project aimed specifically at developing export markets for French decorative and applied arts, especially luxury goods. From the American perspective, the furniture, objets d'art, even the geometrically abstract buildings that housed the exhibits, provided an ornamental language that seemed ideal for the early twentieth century. Metalwork, ceramics, furniture, mural painting, and other arts, done by skilled craftspeople, could be incorporated in buildings, totally avoiding classical details. The figurative arts could, moreover, incorporate modern objects, such as planes, trains, and automobiles, that would always look out of place inserted into classical architectural details.

The immediacy and strength of the appeal of the Paris exposition is nowhere better illustrated than in the Oviatt Building in downtown Los Angeles, built in 1927–28. James Oviatt visited the exposition in 1925 and fell in love with the new style. On returning to the United States he immediately commissioned local architects Walker & Eisen to design the Oviatt Building, an upscale men's store and haberdashery, with offices on the upper floors. He sent designers to Paris and imported all the fixtures, carpets, draperies, and stairways; René Lalique was commissioned to design and make all the decorative glass. Restored in 1976, a restaurant now occupies the former men's store at street level.

Style moderne was the term preferred in France, and this gave rise to the American offshoot of Art Deco that stressed smooth rounded forms and surfaces; in the United States this *moderne* design language merged with the new science of streamlined design, giving rise to American streamlined *moderne* (using the French spelling and pronunciation to distinguish it as a distinct style). This was also the period in which industrial designers rose to prominence, achieving broad name recognition—designers such as Norman Bel Geddes, Raymond Loewy, and Henry Dreyfuss The streamlined *moderne* they devised for automobiles, locomotives (such as Raymond Loewy's GG-1 electric locomotive of 1935), and for airplanes was intended to reduce air turbulence around moving objects, but these designers also used streamlining for all manner of stationary objects as well, including refrigerators, table radios, and clocks. Architects and designers began using the same style for things that could never possibly move, such as office buildings, factories, automobile filling stations, and houses. This was a pragmatic and utilitarian American Modernism rather than one advancing a polemical

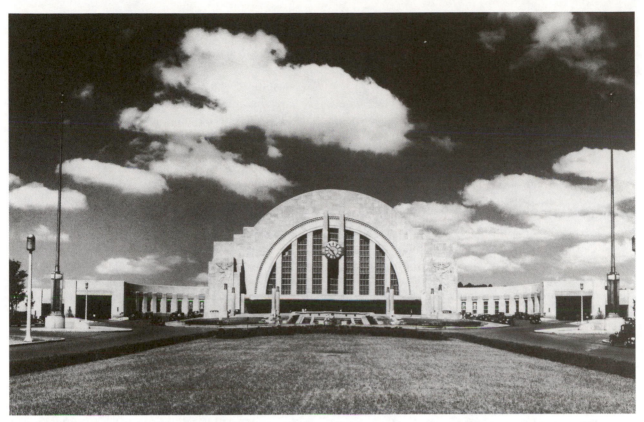

8.38. *Fellheimer & Wagner, Cincinnati Union Terminal, Cincinnati, Ohio, 1933. Using sweeping concentric circles in the elevation, the architects adapted the strong geometric* *character of the moderne style to a large public building. (Rosenthal Archive, Northwestern University.)*

position. Smooth white plastered walls, horizontal ribbon windows, chrome and stainless steel, and dramatic colors might be employed (paralleling work of Bauhaus-trained designers in Germany), but facades and plans were often symmetrical, a feature assiduously avoided by Bauhaus designers. Residential examples ranged from the boldly rounded Earl Butler house by architects Kraetsch & Kraetsch in Des Moines, Iowa, built in 1935–37, to the refined and minimal elegance of the William Lescaze town house, in New York City, built in 1934, and the Richard H. Mandel house in Mt. Kisko, New York, built in 1935, by Edward Durell Stone with Donald Deskey.[19] Public buildings of all sorts were also done in both Art Deco and *moderne* styles. One of the most visually striking of the *moderne* public buildings is the Cincinnati Union Terminal, built in 1933, designed by Fellheimer & Wagner, recently remodeled for commercial use. [8.38]

In Miami Beach, on the Atlantic shore east of the city of Miami, streamlined *moderne* and Art Deco shaped an entire district of small tourist hotels and small apartment blocks built up between 1926 and 1940. The district abounds in examples, standing side by side, replete with elongated vertical masts or extended horizontal window bands, corner windows or rounded corners, smooth white walls set off with mustard yellow, flamingo pink, aqua blue, or lime green, and featuring panels of flattened foliate and geometric designs. The group of small hotels beside the Colony Hotel, built in 1935, by Henry Hohauser, is emblematic of Miami Beach Art Deco. [8.39]

Movie theaters after the late 1920s also embraced the popular Art Deco and *moderne* styles. The biggest was Radio City Music Hall in Rockefeller Center, in New York, built in 1932, with 5,960 seats, but perhaps the most sumptuously detailed is the Art Deco Hollywood Pantages Theater, in Los Angeles, built in 1930, designed by B. Marcus Priteca. A small gem among Art Deco movie houses is the Washoe Theater, in Anaconda, Montana, 1936, one of the last designs by Priteca to survive virtually intact. The Pan-Pacific Auditorium, in Los Angeles, built in 1935–38, by

Plummer, Wurdeman, and Becket, should be mentioned because of its emphasized and streamlined horizontal banding, its rounded corners, and its four dramatic masts punctuating the entry marquee; sadly it was destroyed by fire in 1984.

Aside from the movie house, one other place where millions of Americans first encountered modern (or *moderne*) architecture was the neighborhood diner, the precursor of the fast-food restaurant. The first diners in the 1870s were simply horse-drawn wagons fitted out as moving kitchens, but by the turn of the century the wagons had been put up on blocks in permanent locations. By the 1920s numerous companies such as the Worcester Lunch Car and Carriage Manufacturing Company, the Patrick J. Tierney Company, or Jerry O'Mahony, Inc., specialized in manufacturing diners, one of the first large-scale applications of modular, industrialized building production. Two other manufacturers soon added to this number; the Paramount and Silk City companies began producing sleek *moderne* diners of stainless steel in the 1930s. As with the Art Deco–*moderne* hotels in Miami Beach, so many examples abound that singling out one as an example is difficult. Bob's Diner in Philadelphia, an O'Mahony diner built in the 1930s and moved to its present site in 1941, has a particularly photogenic setting and has been used in several commercials and films.

The Art Deco Skyscraper

As noted, the linear decorative language and contrasted colors of Art Deco and the rounded surfaces of *moderne* were instantly viewed as appropriate for the architecture of the Jazz Age. Raymond Hood illustrated how this could work at urban architectural scale in his McGraw-Hill Building, in New York, of 1929–30. [8.40] Beginning with the American Radiator Building in New York, Hood quickly shed the historicism that had so marked his Tribune Tower. Eventually, in his Daily News Building, in New York, of 1930, Hood reduced the office tower to a tall, white setback slab characterized by slender, closely spaced vertical piers that expressed the structural frame. In the McGraw-Hill Building, however, he introduced more variety by devising a central shaft rising from a ziggurat base, with vertical piers juxtaposed with horizontal window bands. The vertical piers accord with the vertical circulation shaft at the core, while the horizontal bands and ribbon windows express the tiers of floors. The cladding of the structural columns is recessed and has a black color, making the floors appear to be cantilevered, especially at the corners, where the structural columns seem to disappear. At the top is a geometrically sculpted crown. As in Hood's American Radiator Building, the cladding is highly colored, of black and dark green terra cotta sheathing with golden glazed accents. Through the bold Art Deco colors there seems

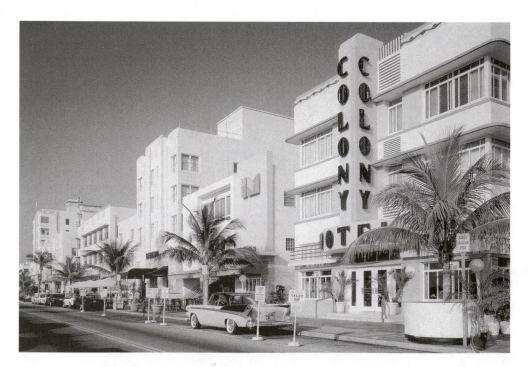

8.39. Henry Hohauser, Colony Hotel, Miami Beach, Florida, 1935. Built up in the 1930s and early 1940s, despite depression and war, Miami Beach is filled with diminutive examples of Art Deco exuberance. (Photo: Steven Brooke.)

to be a hint of Lonberg-Holm's Tribune Tower design.

In many ways the archetypal American Art Deco skyscraper could be said to be William Van Alen's Chrysler Building, in New York, built in 1926–30, whose seemingly columnless corners mirror the cantilevers of the International Style. [8.41] Here the setback regulations are no hindrance but result in a building that rises and reaches upward, diminishing in size by stages. Every portion of the building is tellingly embellished, as one sees on entering the lobby; even the elevator doors and the interiors of the elevator cabs have distinctive curvilinear patterns in metal and wood inlay that recall the curves of the building's shining metal crown. On the exterior of the building are curvilinear patterns in the brick cladding that mimic automobile fenders and wheels, and the corners at each setback level are embellished with enormous metal sculptures that echo radiator caps and automobile hood ornaments.

The distinctive Chrysler Building spire, in fact, is a monument to the quest for insurmountable height that reached fever pitch in New York in the late 1920s. Stock prices were spiraling ever upward in the mid-1920s, and it seemed there were no practical limits to building height either. Raymond Hood claimed: "the height of a building is nothing at all"; with the laws then in force one could "build a tower seven thousand feet high . . . the elevator companies are ready."[20] Once Walter Chrysler and the Chrysler Corporation had decided in 1928 to build a corporate headquarters in New York, Chrysler's instructions to architect Van Alen were simple: design a tower that would be the tallest in the world. In fall 1929, as construction on the Chrysler building began to near its top, Van Alen learned that the Bank of Manhattan headquarters, under construction on Wall Street, was to be two feet higher than his building. H. Craig Severance, architect of the Manhattan Bank Building, and Van Alen then entered a race to see who could build higher, who would claim the prize for height. The sky war was on. Back and forth the architects added story after story to out-top the other. Severance added ten penthouse floors, then a lantern, and finally a fifty-foot flagpole. Meanwhile, Van Alen devised a secret strategy. Surreptitiously, inside the nested curves of the shining metal crown of the Chrysler Building, a needlelike spire of 185 feet was secretly assembled. On October 16, 1929, in just ninety minutes, the spire was jacked up from below. When fully elevated and bolted into place, the spire put the height of the Chrysler Building at 1,046 feet—117 feet higher than the Manhattan Bank Building.

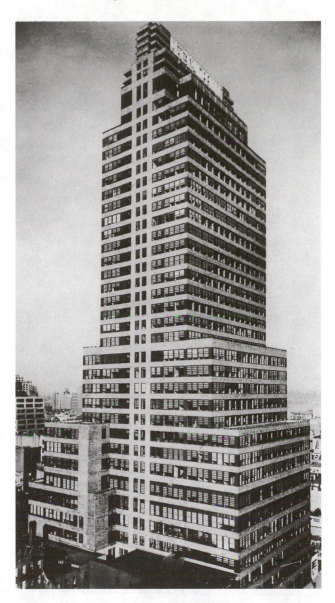

8.40. Raymond Hood, McGraw-Hill Building, New York, New York, 1929–30. Hood merged the horizontal ribbon window of Modernism with the setbacks and geometric flourishes of Art Deco in this dark green office tower. (Condit Archive, Northwestern University.)

That record for height, however, would stand for only a year and a half, until the soaring pylon and mooring mast of the Empire State Building, a few blocks away, was finished at 1,239 feet (eventually the addition of television antennae would push the building's height to 1,454 feet to the tip of the lightning rod). Though not so experimental technologically as the Philadelphia Saving Fund Society Building nor as dramatic in color as the McGraw-Hill Building, the

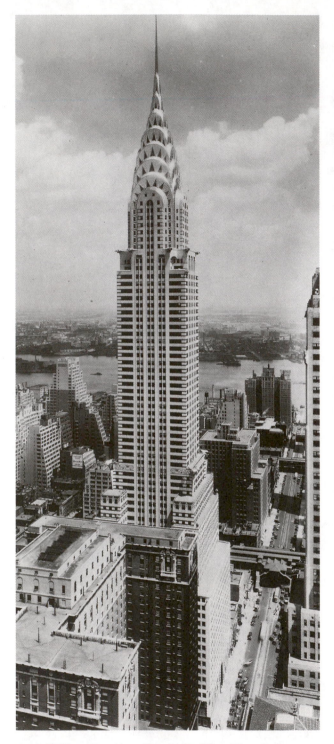

8.41. *William Van Alen, Chrysler Building, New York, 1926–30. With its International Modernist treatment of horizontal window bands, Van Alen's design combines Art Deco decorative touches with references to automobile parts. (Photo: Wurtz, Museum of the City of New York.)*

huge Empire State Building is certainly the preeminent symbol of the period. [8.42] Built in 1929–31 from designs by Shreve, Lamb, & Harmon, and engineer H. G. Balcom, the building represented the climax in the steady refinement of steel construction begun in Chicago almost a half century before. A project initiated by Wall Street financier John Jacob Raskob, the Empire State Building's importance lies in the solutions to the thousands of logistical problems created in raising a building of 102 stories, and doing so in an incredibly short time; the entire steel frame was erected in only six months. The building was finished five months ahead of schedule and $5 million under budget. Primary contractor William A. Starrett declared that "building skyscrapers is the nearest peacetime equivalent of war." Accordingly, the erection of the Empire State Building was planned like a complex military operation. The schedule for delivery of the 57,000 tons of structural steel from the mills in Pittsburgh was precisely planned and choreographed, moving in a steady stream; piece by piece by train to New Jersey, by barge across the Hudson River, by truck on carefully selected routes across Manhattan, by crane to the appointed position, with tolerances of less than an eighth of an inch, fitted into place, many still warm to the touch since they had left the mill only eight hours before. Over one ten-day period the work crews completed the framing of fourteen floors. The stepped ziggurat base, the sheer planes of the limestone-clad shaft, the interlocked setbacks of the crown, and the grandly overscaled Art Deco metal spire are not, perhaps, innovative individually, but they are so well integrated in the great mass of the building that it has a distinction all its own. The building's physical strength was vividly demonstrated on July 28, 1945, when a B-25 bomber, lost in dense fog, slammed into the seventy-ninth floor, killing the crew and several people inside but causing the building only minor damage.[21]

While the Tribune competition entries reflecting European International Style (most notably Gropius and Meyer's submission) were dismissed, Philadelphia gained the distinction of having the first skyscraper based directly on International Style ideals: the Philadelphia Saving Fund Society (PSFS), by Howe and Lescaze, built in 1929–32. [8.43] The adoption of European Modernism for the PSFS is particularly significant, since both the architect and client up to 1929 had been highly conservative in their views. George Howe's early career designing neo-medieval suburban houses around Philadelphia has already been

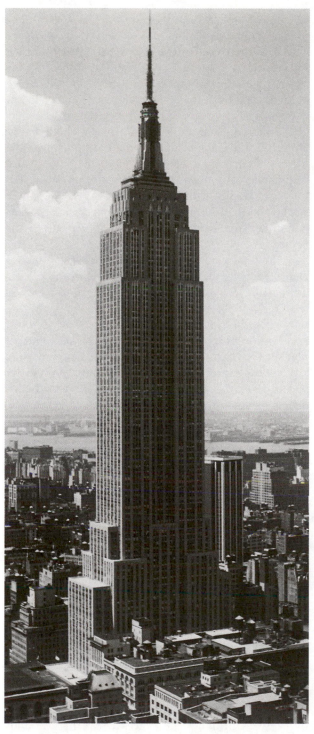

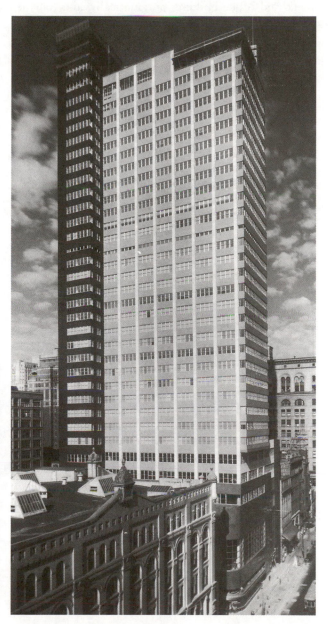

8.42. *Shreve, Lamb & Harmon, Empire State Building, New York, New York, 1929–31. For decades the tallest building in the world at 1,239 feet, the Empire State Building was begun just at the beginning of the Great Depression; when finished in 1931, so little office space was rented that a popular name for it was "The Empty State Building." (Courtesy of the Empire State Building.)*

8.43. *Howe & Lescaze, Philadelphia Saving Fund Society, Philadelphia, Pennsylvania, 1929–32. With its smooth polished surfaces, horizontal bands of ribbon windows, and utter avoidance of historical reference, the PSFS Building was the first international modernist skyscraper in the United States. (Photo: R. T. Doones, Condit Archive, Northwestern University.)*

sketched. In fact, a house much like those by Mellor, Meigs, & Howe had been built in suburban Radnor, from designs by Howard Van Doren Shaw, for James M. Willcox, president of the Philadelphia Saving Fund Society. Both Wilcox and George Howe, being practical men, approached the problem of designing a new bank and office building pragmatically, and together they devised a scheme well suited to the activities and needs of the bank. This was an institution whose clientele consisted not of wealthy investors but of working people in the city's mercantile district. Hence this bank would assert itself in the bustling activity of department stores, not in the stolid financial district. Rather than a low classical treasure box, it would be a working office tower, with the banking room lifted to the second floor so as to allow rental space below, accessed directly from the sidewalk. While numerous banks had already been built with rental offices above, placing the banking room itself one level up with shops below was not common. The specifically modern character of the design was clarified by Howe's partner, William E. Lescaze (1869–1969), a Swiss architect well trained in the severity of the new modernist idiom and no doubt aware of the Tagblatt Building in Stuttgart, Germany, by Otto Oswald, built in 1927–28, which served as a distant and much smaller model.[22] At the bottom, on the ground floor, are small shops, with the large banking room above, reached by a bank of escalators to the side. On the exterior this banking room is indicated by the continuous bank of tall windows that curve around the corner. A floor of office suites completes the base element. Above this rises the slab of cantilevered rental office floors, which terminates in an asymmetrical crowning mass accommodating penthouses, mechanical equipment, and an air-conditioning plant. The PSFS Building was the second office structure to offer full air-conditioning as a standard feature in its rental space (having been preceded by the Milam Building in San Antonio, Texas, in 1928–29). In addition the bank's offices had a dropped ceiling of acoustical tile held in a suspended metal frame. Both of these innovations were to become standard in the office tower of the twentieth century.[23]

Rockefeller Center

Eminently noteworthy because of its intensive, layered mix of uses and of spaces was Rockefeller Center, initiated in 1928 by the Metropolitan Opera, which desired a new opera house. With the financial assistance of John D. Rockefeller, a huge block of land in Midtown Manhattan was assembled. The first designs for the complex, calling for a central focal opera house, fronted by a plaza and surrounded by office towers, were sketched out by Benjamin Wistar Morris. Subsequently the work was put in the charge of architects Reinhard & Hofmeister, who engaged as design consultants two of the most esteemed architects of the period—Harvey Wiley Corbett and Raymond Hood. With the financial crash of 1929, however, the Metropolitan Opera withdrew from the project and its pivotal position was taken by a tall thin office slab for the Radio Corporation of America. Since Rockefeller had become increasingly personally committed to supporting the project, it was given his name.

In the final plan of 1930 three adjacent city blocks were bisected by a new cross street, with the centermost half block to the east opened up into a pedestrian mall. [8.44] With Fifth Avenue as the front, low slab office blocks were placed running east to west, framing the pedestrian approach and focusing attention on the central RCA tower. Along Sixth Avenue, slab blocks were turned north to south, forming a backdrop for the entire composition. All of the buildings were fractured slabs, with graduated gentle setbacks; the rhythm of the closely spaced limestone vertical wall panels is uniform through the group, and, together with the harmonized Art Deco embellishments, creates a strong sense of unity. This remarkable unity in the ensemble, the first to appear since the Columbian Exposition and the City Beautiful civic centers it inspired, was especially important.

Important, too, was the complex interrelationship of superimposed subterranean levels. Below sidewalk level is a network of pedestrian passageways connecting all parts of the complex; these were lined with small shops and restaurants, making them in effect all-weather streets that connected the office blocks to the subways. Below this subterranean concourse is another level of tunnels for deliveries by truck so that this heavy traffic and its attendant congestion were removed from the city streets. Initially, too, there was to have been an elevated pedestrian level, with roof gardens on top of the lower office blocks connected by skyways bridging the spaces between the buildings; these were never executed. One embellishment that was carried out, however, was the sunken ice-skating rink and restaurant terrace at the end of the pedestrian mall at the foot of the RCA Building. This release of potential commercial space to civic activity, a radical innovation in the American urban land-

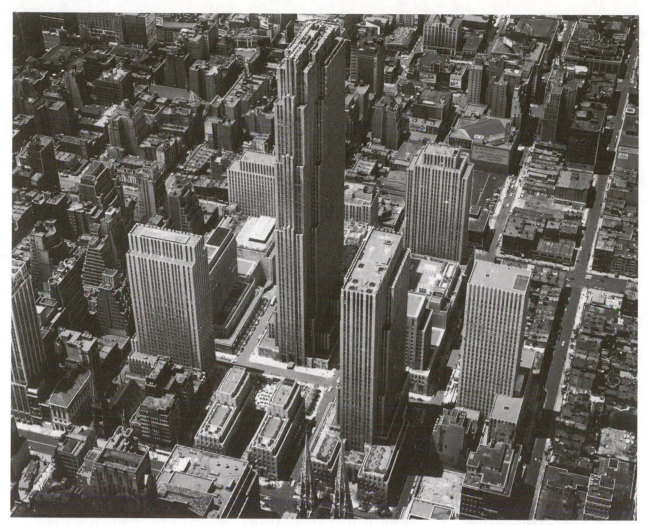

8.44. *Reinhard & Hofmeister, with H. W. Corbett and R. Hood, Rockefeller Center, New York, New York, 1927–35. One of the earliest efforts at designing a group of office* towers as a coherent ensemble, Rockefeller Center is equally *significant for its service facilities placed below street level.* (Rockefeller Center.)

scape, was not so much a harbinger of things to come, perhaps, as a last expression of the Beaux-Arts emphasis on public spaces.

FRANK LLOYD WRIGHT, THE MIDDLE YEARS

Aside from Kahn's factories, the PSFS Building, and a few dozen other modern buildings, progressive architecture seemed to be in eclipse in the United States between the wars. Frank Lloyd Wright's work fell off sharply after 1910; between the wars he seemed to abandon his own integrated Prairie Style to flirt briefly with a kind of abstracted historicism. This was for

Wright a period of intense introspection and reanalysis, forced on Wright by a public and press that would not forgive him for having deserted his family in Oak Park in 1910 to go to Europe with a client's wife, there to supervise the publication of a folio of designs by the Wasmuth Verlag in Germany. When this folio and its accompanying smaller volume of photographs appeared in 1910–11, however, they helped to spur the development of the modern movement in Europe among such architects as Gropius, Mies, Richard Neutra, and Rudolph Schindler.

Meanwhile, unable to return to his family in Oak Park and his practice in Chicago, Wright withdrew to the forested moraines of central Wisconsin and settled

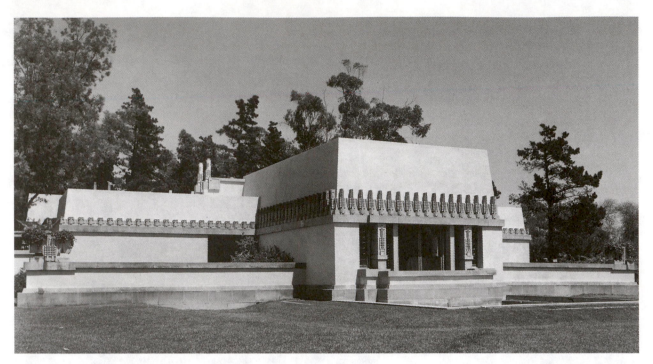

8.45. Frank Lloyd Wright, Aline Barnsdall house, Hollyhock House, Los Angeles, California, 1917–20. In the period from about 1915 through the 1920s Wright found in ancient *Mayan architecture a point of departure for a new American architecture. (Photo: © Wayne Andrews/Esto.)*

in Spring Green with his mother's family, building a new home, Taliesin, wrapped around and set into the brow of a low hill. Wright literally dug in, venturing forth only to carry out the selected commissions that came his way through devoted clients and friends.

In Japan he completed the large Imperial Hotel in 1915–22, for the royal family. Traveling to Japan, seeing the architecture that had so influenced him, Wright passed through California and received there commissions for several private residences in the early 1920s. In these houses Wright broke away from the extended horizontals, wood framing, and elegant glazed brickwork that had come to characterize his Prairie Style. Instead Wright explored forms based on the architecture of ancient Mesoamerica, as in his large residential complex for Aline Barnsdall, Hollyhock House, in Los Angeles, built in 1917–20. [8.45] He also began to explore new methods of construction that were more structurally integrated.

The little house he designed in a shallow landscaped ravine in Pasadena for Mrs. George M. Millard, built in 1923, was one of the first to exploit his new concrete block technique. [8.46] The Millard house, La Miniatura, was built of standardized square concrete blocks molded at the building site in several geometric patterns. In three following houses in Los Angeles, Wright expanded on this concrete block idea, incorporating grooves in the edges of the square blocks. The blocks were laid without mortar, with strands of steel inserted horizontally and vertically through the grooved joints; grout was then forced into the hollow joints around the steel, binding the metal strands and the concrete blocks into an integral whole. Because the blocks were knitted together by the steel rods Wright called this "textile construction," and it certainly would have seemed to possess a structural coherence not possible in the hybrid steel and wood frame Prairie houses. Unfortunately, rather than have the blocks industrially produced, with a moist mix vigorously compressed in the forms, Wright opted to use hand-squeezed wood molds on the building site, with a dry mixture incorporating sand and crushed stone from each individual site. This formulation, especially when accompanied by high-acid local soils, has caused the fragile porous concrete blocks to disintegrate over time. This problem in turn has been exacerbated in recent years by high rainfall in the Los Angeles basin, which has caused the hillside sites, so favored by Wright, to slide, causing pressure within the tall substructure bases that has made them burst. Moreover,

recent strong earthquakes in the 1980s and 1990s have further injured the buildings.

In designing these concrete block houses Wright introduced vertical motifs that worked better than horizontal ones with the square module of the concrete blocks. In fact in La Miniatura one sees an almost European cubism; the house has three stories with the entrance in the middle level leading to a two-story living room similar to those being used by Le Corbusier at the same time. Despite these apparently European influences (which Wright vehemently denied), the Millard house has a very strong relationship to the ground.

The reemergence of Wright as a major figure in American architecture was the result of two commissions given him in the 1930s: the Edgar J. Kaufmann house, Fallingwater, on Bear Run creek, in Fayette County, Pennsylvania, begun in 1935, and the Johnson Wax Administration Building, in Racine, Wisconsin, begun in 1936. Particularly in the Kaufmann house [8.47, 8.48], it is evident that Wright had not, in fact, abandoned the principles of Prairie architecture, but had reshaped them, giving this reinvigorated expression a new force and authority. As in the Robie house, there is in this weekend retreat a careful integration of space, form, structure, mechanical equipment, and site, forming a coherent unit that seems to have grown out of the rock ledges as if by some process of internal and intrinsic biology. When first meeting with Edgar Kaufmann to discuss the proposed house, Wright was taken to the idyllic wooded site, southeast of Pittsburgh, luxuriant with indigenous laurel and rhododendron. Wright learned that Kaufmann liked to rest and enjoy the sun on the rock ledge above the water, listening to the water and to family and guests splashing in the pools below.

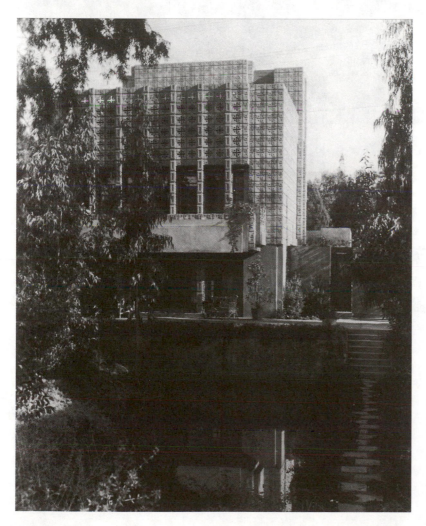

8.46. Frank Lloyd Wright, Mrs. George M. Millard house, La Miniatura, Pasadena, California, 1923. Desiring an organic unity of design and construction process, Wright devised a way of using site-made structural concrete blocks for decorative effect. (Rosenthal Archive, Northwestern University.)

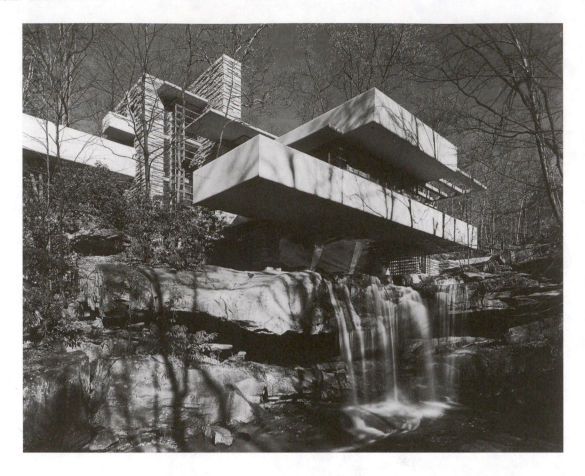

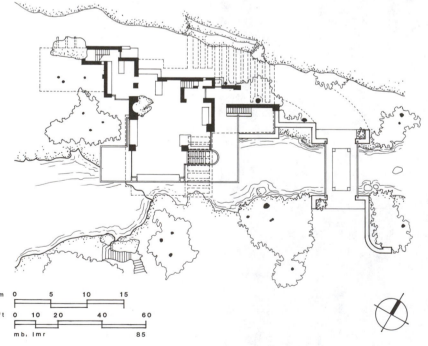

8.47. Frank Lloyd Wright, Edgar J. Kaufmann house, Fallingwater, on Bear Run, Fayette County, Pennsylvania, 1935–37. With his striking design for this summer house, Wright reestablished himself as one of America's most innovative architects. (Photo: Hedrich-Blessing.)

8.48. Fallingwater, plan. Wright carefully placed Fallingwater directly on the rock from which Edgar Kaufmann liked to look out on the forest. (L. M. Roth and M. Burgess, after Wright.)

m 0 5 10 15

ft 0 10 20 40 60

mb, lmr 85

Kaufmann assumed that Wright would place the house opposite the waterfall, so that the cascade would be an object to view. Instead, when Kaufmann first saw the drawings at Taliesin he was surprised to find that Wright had placed the house directly when Kaufmann most liked to rest and hear the waterfall. One of Wright's assistants, Byron Keeler Moser, remembered that when asked about this Wright responded to Kauffmann: "I want you to live with the waterfall, not just look at it, but for it to become an integral part of your lives."[24] He wanted the family to hear it, feel it, not just view it, and to this end Wright included a stair that descends from the living room to the water. In a parallel way Wright wanted the house to become part of the landscape, so the horizontal mass of the large rock ledge over which the water tumbles is echoed by the long horizontal line of the cantilevered concrete balcony hovering over it, held up on four massive pylons that recede into the shadows. And in a similar way the stone (quarried not far from the building site) is laid in variegated layers in the various piers throughout the house, appearing to be smaller versions of the surrounding rock ledges.

In the plan there are no walls in the conventional sense, but panels of masonry to the rear, enclosing kitchen and workspaces, and screens of glass to the front that open onto a sweeping view of the densely wooded ravine. There is a sharp contrast between the smooth concrete horizontal balconies that hover over the water and the rough masonry piers. Wright's governing idea was to combine in the house the traditional security of the hearth with the artifices of modern civilization, so the sleek finishes of the ceiling, with its concealed fluorescent tubes, and the banks of glass are set off against the rugged layered masonry of the fireplace, which rests on an outcropping of bedrock pushing up through the floor—the very spot favored by Kaufmann. Although Wright denounced the International Style, the smooth concrete upstands of the balconies, the thin steel sash of the windows that open to reveal the absence of a corner post, and the abstract grouping of planes, seem to suggest the influence of Europe on Wright. It is, in fact, the completion of a cycle, for the linear abstraction prevalent in Wright's Wasmuth folio had inspired the European modern movement, which in turn then helped to sharpen and clarify the hovering planes of Fallingwater.

Of the several crises that impinged on Wright from 1910 to 1915, one that seems to have deeply affected him, was the realization that while his individual Prairie houses were well integrated in themselves and with their sites, when placed in a group of other houses the ensemble did not necessarily hold together well. This fragmentation was a symbol of a larger problem, for while Wright wished to reshape domestic architecture totally and to make this new "democratic" architecture available to the middle classes,

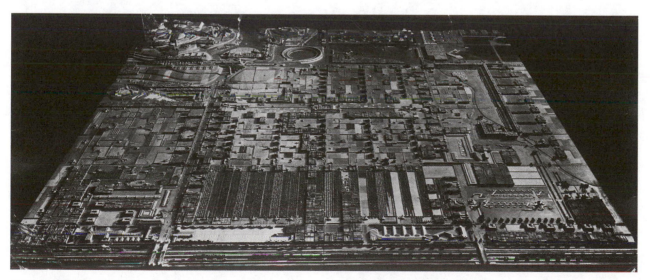

8.49. *Frank Lloyd Wright, model of Broadacre City. Developed between 1931–35, Broadacre City represented Wright's vision of a transformed American society, of single-* *family houses scattered across the landscape, exploiting the freedom of movement made possible by the private automobile. (Rosenthal Archive, Northwestern University.)*

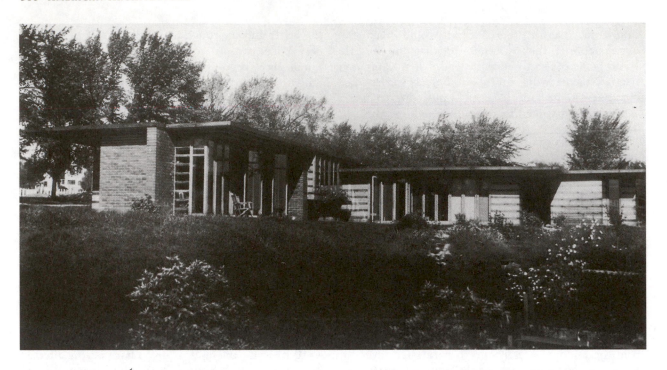

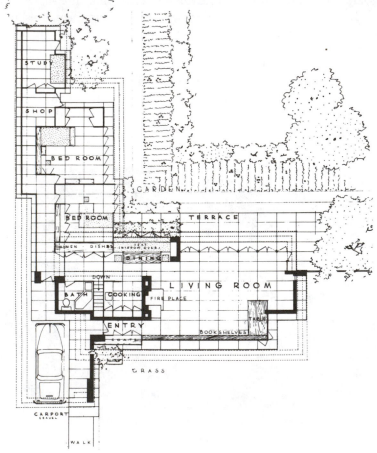

8.50. Frank Lloyd Wright, first Herbert Jacobs house, Madison, Wisconsin, 1936. Built at the edge of Madison, the Jacobs house was designed to be inexpensive and to provide a private landscape at the rear of the house. (Rosenthal Archive, Northwestern University.)

8.51. First Herbert Jacobs house, plan. Although the Jacobs house was compact, Wright maximized the sense of space by combining areas of use and eliminating enclosing walls. (F. L. Wright, The Natural House, 1954.)

8.52. *First Herbert Jacobs house. Wright also aimed to reduce costs by using natural brick and wood as interior finishes and eliminating time-consuming plasterwork. (Rosenthal Archive, Northwestern University.)*

what he was actually being called on to do was to design isolated homes of wealthy businessmen. During the lean years of the Depression Wright set about to devise a new social system in which all citizens lived on the land, in compact model houses that fully incorporated mechanized prefabrication, thus making them available to all. Between 1931 and 1935 this visionary Broadacre City took shape. It was a wholly decentralized living environment, totally reliant on the private automobile; theoretically Broadacre City could spread across the breadth of the continent. Broadacre City had individual single-family houses on one-acre sites, with scattered industries and public services made accessible by automobile. [8.49] A detailed color model of Broadacre City and some of its individual component buildings was exhibited during the 1930s and discussed in print.[25] What Wright had succeeded in doing was merging the agrarian Jefferson myth with a growing pervasive desire to escape the city, and, though he had little to do with it directly, after the Second World War his Broadacre City became a sprawling reality around every major urban area, as we shall see.

Crucial to this new social order envisioned by Wright was the Usonian house, in which unnecessary elements were eliminated through technical innovation. The basement and garage, for instance, disappeared, for furnaces were now clean and compact, and modern automobiles needed little protection from the weather. The first of this new type was the house for Herbert Jacobs, near Madison, Wisconsin, begun in 1936. Turning its back on the street, it had the shape of an **L**, with the arms enclosing a private rear yard. [8.50, 8.51] At the pivot were a carport, kitchen, and bath clustered around a masonry utility core. To one side stretched a living room with a dining alcove next to the kitchen; perpendicular to this extended the wing of bedrooms. The house was built on a concrete slab that incorporated pipes providing radiant heat; the walls were formed either of full-length glass doors opening to the yard or of sandwiched panels of plywood whose prefinished inside surfaces eliminated costly and time-consuming wet plaster work. [8.52] The only masonry in the house was reserved for the utility core. As the plan indicates, the entire house was designed on a module that tended to reduce special cutting and fitting while giving coherence to the arrangement of parts. The accumulated economies were such that Wright boasted that the Jacobs house cost only $5,500 when completed in 1937, including the architect's fee. By comparison the relatively compact Robie house had cost $35,000 in 1909.[26]

Such houses Wright called "Usonian," a term he coined from *USA* to express a broad domestic American agrarianism. He hoped to build these houses in numerous groups, though the only group he

actually got to build (in part) was a development for several instructors at what is now Michigan State University; seven houses were to be built at Okemos, Michigan, spaced in a semicircle around the edge of a bluff, enclosing a communal park. [8.53] Though varied in design, the houses were to share common features such as flat roofs, simple massing, and accentuated horizontal lines. Only one of the houses was actually finished according the original plans, for Alma Goetsch and Katherine Winkler, in 1939, and because of its small size and simplicity it well represents the Usonian ideal. [8.54, 8.55] The carport, kitchen, dining "el," spacious living room, and small bedrooms form rectangular spaces that slide past one another, achieving great continuity in a simple linear movement. The alcove at one end of the living room exemplifies the Usonian interior, with its clerestory windows supplementing the bank of full-length casements to the left. Besides contributing to a more even light distribution, they provide convenient ventilation at the ceiling. The oiled plywood panels of the ceiling and the scored grid of the concrete slab floor are further examples of Wright's desire to eliminate costly

and extraneous interior finishes. Despite its relatively small size, the Goetsch-Winkler house seems large because of the built-in furniture and shelves. Seldom in his larger works—and not even in his own home-studio, Taliesin West, near Scottsdale, Arizona, begun in 1938—did Wright achieve greater coherence or authority.

For the sake of clarity and economy both the Prairie house and the Usonian house were rectilinear compositions, but increasingly during the 1930s Wright was drawn to the hexagon and circle as planning modules and to the helical ramp as a spatial form. He turned to a circle-in-square as the generating element for the S. C. Johnson and Son Administration Building, in Racine, Wisconsin, built in 1936–39, the second major commission to reinvigorate his practice. [8.56] The internal functional requirements were in many ways similar to those of the Larkin Building of 1903, calling for various offices and auxiliary spaces clustered around a large secretarial staff room, but including now an adjacent parking facility. Wright placed the large single room for the secretarial staff to one side of a driveway, with the auxiliary services on the

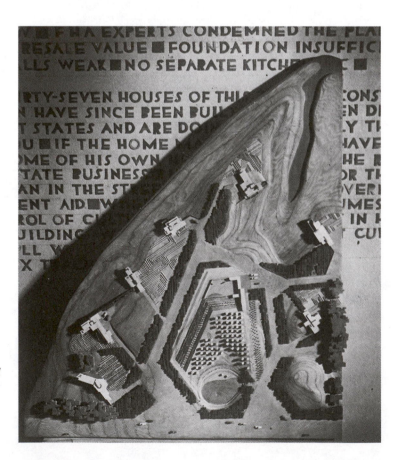

8.53. Frank Lloyd Wright, house group, model, Okemos, Michigan, 1939. This model shows a very small realization of the ideals of Broadacre City, with seven proposed residences around a jointly owned communal facility. (Rosenthal Archive, Northwestern University.)

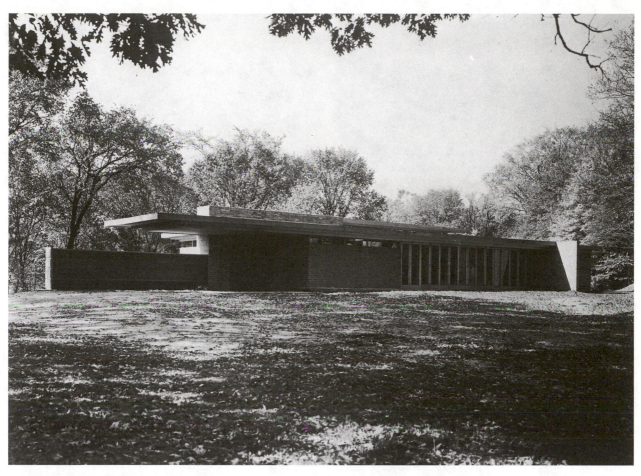

8.54. *Frank Lloyd Wright, Goetsch-Winkler house, Okemos, Michigan, 1939. One of the few houses of the Okemos group to be completed, the Goetsch-Winkler house* exemplifies what Wright called his Usonian House, a new type of house for the USA (from which Wright derived the term Usonian). (Photo: Leavenworth; author's collection.)

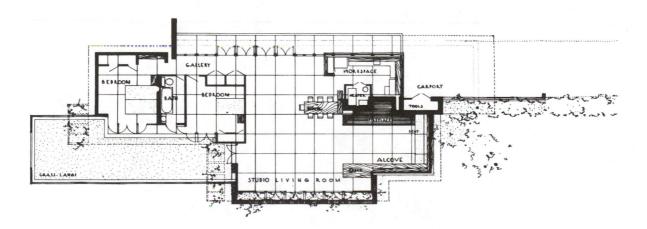

8.55. *Goetsch-Winkler house. The Goetsch-Winkler house plan also illustrates how Wright merged inglenook and* fireplace with living and dining areas into a series of open, interwoven spaces. (Wright, The Natural House.)

8.56. Frank Lloyd Wright, S.C. Johnson Wax Company Administration Building, Racine, Wisconsin, 1936–39. The second major commission to reestablish Wright's significance was the new office complex for the Johnson Wax Company; this unusual view at dusk reveals the back-lit Pyrex glass tubing used as edges and bands throughout the building to admit filtered sunlight during the day. (Rosenthal Archive, Northwestern University.)

8.57. S.C. Johnson Wax Company Administration Building, interior. The major space of the building recalls the theme of the Larkin building, with an expansive single space, top-lit, providing a kind of cathedral for work. (Rosenthal Archive, Northwestern University.)

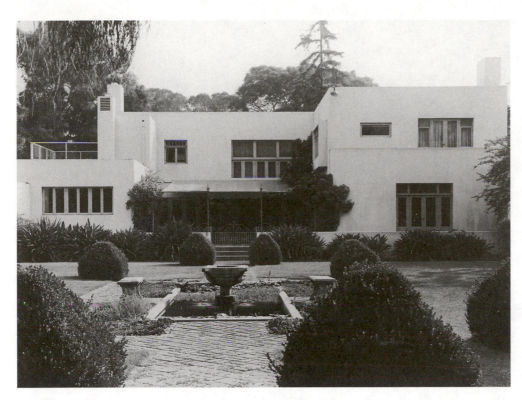

8.58. *Irving Gill, Walter L. Dodge house, West Hollywood, Los Angeles, California, 1914–16. Garden facade. Perhaps Gill's most important work, this large house employed an utter reduction in form to massed cubes, with interiors superbly detailed and paneled in Honduras mahogany. By the time this house was finished, the romantic swing to Spanish Colonial historicism had begun in southern California, and Gill's career soon came to an end. (Library of Congress, HABS CAL 19-LOSAN 27-4.)*

other side, and offices bridging the roadway. One enters by way of the drive into a dark, low space, turns, and then reaches a huge room suffused with light. Throughout, the circle dominates; even the desks and chairs (which Wright designed) have rounded tops with circular seats and cushions. For the structural supports Wright devised dendriform (tree-shaped) concrete columns with elongated tapered shafts rising to broad flat concrete disks. Forming the roof of the secretarial staff room is a forest of these columns, three stories high; looking up at the clustered disks, with suffused light filtering through the glass tubing filling the spaces between the disks, one has the sensation of being underwater and seeing giant lily pads from below. [8.57] Identical columns are used throughout the building but with shafts of different lengths so that in the low covered drive the thick stunted columns take on something of the character of toadstools. In addition to changing the structural norms, Wright also played with the admission of light. In the secretarial staff room skylights fill the spaces between the ceiling disks, and where the ceiling meets the exterior wall there is a curved skylight of bundled Pyrex glass tubes, emphasizing the fact that the outer walls do not hold up the roof. This curvilinearity extends to the exterior brick walls, which curve and

angle inward so as to eliminate sharp corners. Thus every element contributes to a feeling of movement and fluidity that culminates in the expanding volume of the secretarial pool. In a sense, the recurring curves of the Johnson Wax building represent Wright's closest approach to streamline *moderne*. As in the Larkin Building and Unity Temple, Wright internalized the building, focusing the view of the occupants on one another, hoping to generate a greater sense of community. Wright wrote of the Johnson Wax building: "Organic architecture designed this great building to be as inspiring a place to work in as any cathedral ever was in which to worship."[27] Work would be the liturgy of this communal corporate life.

RICHARD NEUTRA AND RUDOLF SCHINDLER

Though Wright's Modernism was particularly his own, it was also much influenced by Europe. A small part of this influence may have been due to two Austrian architects who spent several years in the Taliesin atelier before pursuing their respective careers in California; both had been seized with the desire to meet and work with Wright after seeing the Wasmuth portfolio: Rudolph M. Schindler (1887–1953) and

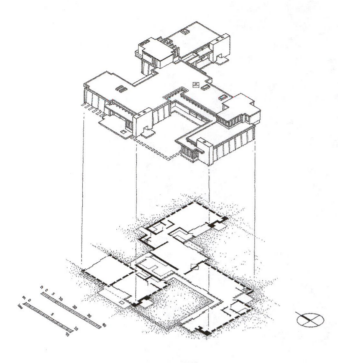

8.59. R. M. Schindler, Schindler-Chase house, West Hollywood, Los Angeles, 1921–22. A house for two families living jointly, this one-story complex had two wings sharing a common kitchen. Each family unit has an outdoor living terrace with a fireplace. (L. M. Roth, after HABS.)

Richard Neutra (1892–1970). Yet both of these new arrivals to California were greatly inspired to pursue their own development of a modern architecture by the example of Irving Gill, who was busily shaping his own image of a new architecture freed of trapping from the past in San Diego and Los Angeles. Gill's flat-roof, crisply rectilinear apartment complex called Horatio West Court in Santa Monica, built in 1919, is still occupied. Undoubtedly Gill's masterwork was the Walter L. Dodge house in West Hollywood, Los Angeles, designed in 1914 and completed in 1916. [8.58] For Dodge, who had made a fortune in patent medical nostrums, Gill devised a large house of carefully modulated white concrete planes punctured by dynamically balanced window openings, with flat roofs. The spacious entry hall was paneled in meticulously fitted boards of Honduras mahogany. Hard-edged and suffused with light, the interior rooms with their fine craftsmanship revealed Gill's origins in the Arts and Crafts movement, now abstracted in a way that only Mies van der Rohe would equal, and then only two decades later. Most regrettably, the house was later destroyed, but the bold, sharply delineated white forms of this and other Gill buildings would inspire Schindler and Neutra.

Of the two Viennese emigrés, R. M. Schindler was somewhat older and had been a student of engineering and architecture under Otto Wagner in Vienna. In 1914

he came to Chicago in answer to an advertisement for draftsmen for the firm of Ottenheimer, Stern, & Reichert. He worked in Chicago for a brief time and then spent five years with Wright, becoming chief assistant during the difficult years from 1916 to 1921. Much of this time he spent in California supervising construction of the various Barnsdall commissions while Wright was in Japan at work on the Imperial Hotel. Schindler's original intention had been to return to Vienna but this faded as his practice in Los Angeles grew.

One of Schindler's earliest independent works was a two-family house for himself and his wife, Pauline, and also Clyde Chase and his family. [8.59] The Schindler-Chase house, in Los Angeles, built in 1921–22, used Gill's technique of concrete tilt-slab construction for the outer walls, with the wall panels cast flat on the finished concrete floor slab and then tilted upright. The slabs of these outer walls were about 4 inches apart, allowing for narrow vertical slits of glass between them. The house was turned out toward two separate courts, each with dining patios and adjoining gardens; there were separate private quarters for each family, joined at the center by a common kitchen and dining area. Light for these rooms came primarily from the walls of glass that overlooked courts. The roofs were virtually flat, with two narrow stairs that rose to rooftop sleeping porches enclosed in light basketworks of wood with canvas sides.

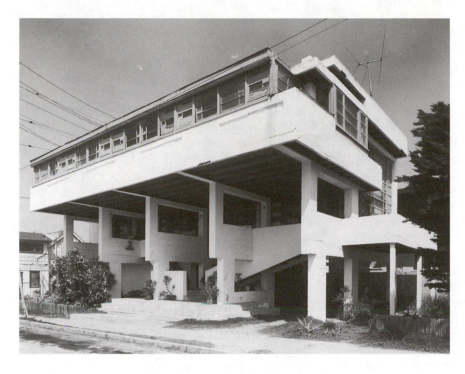

8.60. *R. M Schindler, beach house for Dr. Phillip Lovell, Newport Beach, California, 1922–26. Working independently of European modernists, Schindler arrived at very similar results, emphasizing space and the structural elements used to define space; here, Schindler used repeated identical reinforced-concrete frames to lift the Lovell house up for better exposure to sea breezes and for better views. (Library of Congress, HABS CAL 30-NEWBE 1-1.)*

The Schindler-Chase house was a most intriguing experiment in communal living, and the emphasis on outdoor dining patios and sleeping porches shows the influence of Dr. Phillip M. Lovell, author of a highly popular newspaper column on health that extolled outdoor living and physical exercise, coupled with eating natural "unprocessed" food. The Schindlers and the Lovells soon became very close friends.

The year Schindler finished his own house, he received a commission from Dr. Lovell for a beach house about thirty-five miles southeast of downtown Los Angeles at Newport Beach. [8.60] Built during 1922–26, the Lovell beach house was generally overlooked for nearly forty years after its construction, but it is a landmark in American architecture because it represents a parallel to De Stijl and International Style developments in Europe. It was also an early demonstration of the structural and visual potential of unadorned reinforced concrete. The Lovell beach house was conceived as two rectangular volumes, a large open living space facing the ocean and a smaller cluster of enclosed bedrooms lifted up and nestled under a common roof. Supporting the building, and providing space for a garage underneath the house, are five identical concrete bents or frames, spaced not quite 12 feet apart. The vertical members of the frames are kept outside of the walls so that the interior spaces are uninterrupted, and essentially the inte-

rior elements are suspended from the concrete frames. In its abstraction of form and clear structure and enclosing membranes, and even in its recovery of the ground area for use by lifting the living area overhead (as Le Corbusier was then suggesting in France), the Lovell beach house is equal to anything the champions of Modernism were doing in Europe.

Besides working for wealthy entrepreneurs Schindler also designed several apartment complexes, beginning with the Pueblo Ribera in La Jolla, near San Diego, built in 1923–25. The twelve one-story units were arranged to provide privacy in each of the outdoor patios, as well as views of the Pacific. Later town house complexes, such as the A. L. Bubesko apartments in Los Angeles, built in 1937–38, made excellent use of the hillside site to provide privacy for each unit. Because of the complexity of the hillside triangular site for the S. T. Falk apartments in Los Angeles, built in 1940, Schindler employed two overlapping grids to arrange the volumes on the difficult site. The three-dimensionally interlocked cubic masses of these apartments, with their white stuccoed surfaces, somewhat resemble European Modernism but are adjusted to a more complex and more lush landscape.

In contrast to the often overlooked Lovell beach house, another commission for Dr. Lovell has long been recognized as a modern masterwork—the Lovell home in the Hollywood Hills of Los Angeles, built in

1927–29, by Richard Neutra. [8.61] Neutra had been influenced by Adolf Loos and Wagner while in Vienna, and also, especially, by Wright's Wasmuth portfolio. In 1923 he came to the United States, working first for Holabird & Roche in Chicago and then briefly for Wright at Spring Green. In 1926 he went to California and worked in collaboration with Schindler; the most ambitious of their joint works was an entry in the League of Nations competition in 1926. The next year Dr. Lovell asked Schindler to begin sketches for the Hollywood house, on a most difficult site atop the crest of a steep hill, but when the commission was actually given it went to Neutra not Schindler. This was the beginning of a rift between the two architects.

As with Schindler, Neutra's European training had stressed volume and form over structure, but his experience in Chicago and with Wright modified that. In Neutra's Lovell house the volumes are clear and crisp, formed by the logic of the building's thin structural steel skeleton (it was one of the first private houses framed in steel). Like Wright's Fallingwater, it has balconies—some of them cantilevered, some of them structurally suspended from the steel hangers fastened to the roof frame—but unlike Fallingwater it is not so much embedded in the earth as it is boldly lifted free on slender piloti-like stilts similar to those then being used by Le Corbusier, with cubic volumes descending the hill. The levels of terraces below the house provided for a swimming pool and exercise yards; there was ample provision for living outdoors as Dr. Lovell advocated. The house is not low and pyramidal as Wright's houses tended to be; instead the Lovell house expands as it rises. Yet with all of its orthogonal and abstract manipulation of flat planes, the Lovell house has a strong relationship to the hillside through the terraces that were quickly overgrown with lush vegetation, and through the diagonal of the staircase. If the smoothly faced balconies of Fallingwater show any influence of European Modernism on Wright, surely the relationship of the Lovell house to the hillside suggests the reverse influence of Wright on Neutra.

Even more than Schindler, Neutra worked on apartment and housing complexes. Both his Strathmore Apartments, in Los Angeles, built in 1937, and his Kelton Apartments, in Los Angeles, built in 1942, exploit the spatial and compositional possibilities of their sloping hillside sites. [8.62] He designed several large housing developments as well for the National Youth Administration, commissions that led to one for the Avion Village in Grand Prairie, Texas, built in 1941, and the even larger defense shipyard workers' housing complex called Channel Heights in San Pedro, south of Los Angeles, built in 1942. In Channel Heights Neutra

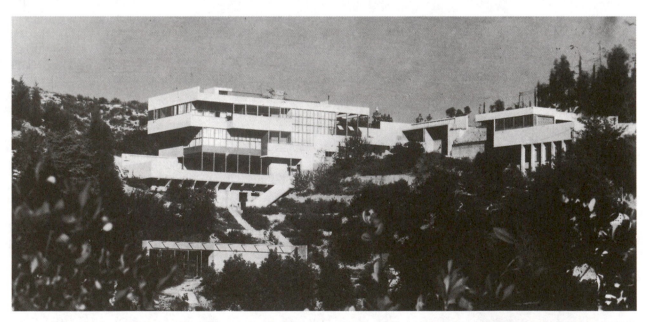

8.61. Richard Neutra, Dr. Phillip Lovell house, Hollywood Hills, Los Angeles, California, 1927–29. In the hills overlooking Hollywood, Neutra built a steel-framed residence, arranged in a series of descending volumes and terraces. (Photo: Luckhouse Studio, Rosenthal Archive, Northwestern University.)

8.62. *Richard Neutra, Strathmore Apartments, Los Angeles, 1937. Visible in the distance are Neutra's Landfair Apartments, 1937. Both apartment buildings show Neutra's use of sharp white planes and long bands of windows for moderate-cost multiunit housing. (Rosenthal Archive, Northwestern University.)*

was working on 150 acres, designing 222 building to house 600 families. This was in many ways a complete village community, with a store and market, a crafts center, schools, and a community center.

URBAN PLANNING AND HOUSING

Schindler's and Neutra's apartment complexes touch on the field of multiunit housing—and by implication, in the instance of Channel Heights, the discipline of urban planning, which was emerging as a new profession. After 1930, with the deepening Depression, and most especially in the late 1930s as another world conflict threatened to involve the Unites States, the planning and construction of housing complexes and even whole new communities took on strategic national importance. Planning is based on controlled use and development of land, the concept of zoning according to use. This concept has been rooted on a legal decision rendered by the US Supreme Court in

1925, a decision that has prompted legal challenges ever since.

During the nineteenth century towns and cities had grown according to the desires and whims of private enterprise; it was an era of absolutely unbridled laissez-faire capitalism. Questionable building construction, extremes in building height, the mixing of uses such as residential and industrial—no rules were in effect to prevent anyone from doing what they pleased. Only in the largest cities were stringent building ordinances enacted and enforced late in the century, particularly regarding building materials, in the hope of precluding more catastrophic fires like those that had ravaged Baltimore, Boston, and Chicago.[28] Early in the twentieth century, however, cities began to establish restrictions on the mixing of uses or to prevent certain kinds of uses in specified areas. Most such zoning laws were promptly challenged in court, property owners alleging that these municipal restrictions amounted to a "taking" of property without just compensation, forbidden by the Fourteenth Amendment

8.63. *Park Avenue, New York, New York, 1929. Before increasing traffic required changes, upper Park Avenue was lined with tall apartment blocks overlooking a central linear park strip; the great terminus was the New York Central Building by Warren & Wetmore; the large arched openings through its base allowing automobiles to pass through the building to roadways that wrapped around Grand Central Station and descended in long ramps to lower Park Avenue. (Wurts Brothers photo, courtesy of the Museum of the City of New York.)*

to the Constitution. Some zoning laws were overturned by the courts. The Ambler Realty Company took the city of Euclid, Ohio, to court in 1925, successfully asserting in the lower courts that residential zoning lowered the value of their lands and thus constituted a "taking." The city of Euclid then appealed the decision, taking the matter to the U.S. Supreme Court. In a narrow ruling in November 1926, the court decided in favor of Euclid, laying the basis for all zoning and land-use planning ever since.[29] But as the twentieth century draws to a close, attacks on land-use planning favoring the public welfare are again on the rise.

For the most part urban building development proceeded along quite traditional lines in the 1920s, given the prevailing business and speculative mindset of the period. The building-up of Park Avenue in New York City, shows this well. [8.63] Before 1910 and the rebuilding of Grand Central Terminal, the area north

of the station was undesirable. As long as steam locomotives were used to draw the trains into the station, north Fourth Avenue (as it was then called) was undesirable because of the steam, smoke, and noise. When electrification of the lines was begun in 1903 and the open track cut was roofed over and landscaped, the broad expanse of Park Avenue (as it was renamed) suddenly became choice property. Continuing improvements in foundation engineering and steel frame technology made it possible to erect large office and apartment blocks over the wide subterranean track fan, though here and there an occasional church or club made a dent in the otherwise fairly uniform canyon of the street.

Though large, the Park Avenue apartment houses shared a common tripartite facade treatment, giving the street a pedestrian two-story scale at the sidewalk. The relatively uniform height of twelve to sixteen stories was well scaled to the inordinate breadth of the

street. Especially important visually was the park strip running down the center of the avenue; originally wider, it was narrowed in 1927 due to increasing automobile traffic. Yet even in its truncated form the park serves as a very important buffer. Important also was the focus on the office tower of the New York Central Building by Warren and Wetmore, finished in 1929, to house the offices of the New York Central Railroad. Penetrated at its base by tunnels carrying vehicular traffic through and around the tower and station to lower Fourth Avenue, and blessed by a marvelously excessive decorative crown, the tower was tall enough to control the avenue while still suggesting the continuation of the street beyond. As a group, the buildings lining the avenue and the terminal tower were a diverse lot, but they shared an underlying similarity of style so that the minor contrasts reinforced the sense of the whole. Ironically the prestige associated with the tenants of these masonry cliffs later attracted corporate clients during the 1960s who, anxious to aggrandize themselves with the established image of the place, succeeded only in destroying the character of Park Avenue as they built their towering

and endlessly mirroring glass shafts.

There were a few attempts to bring a sense of community to the urban core in special apartment complexes built during the 1920s. One large example was 277 Park Avenue, New York, built in 1925, by the younger succeeding partners of McKim, Mead & White, so large as to be a virtual town in itself. Even bigger complexes covered one or more blocks. London Terrace Apartments, in New York, built in 1929–30, covered the entire block from Ninth to Tenth Avenues, Twenty-third to Twenty-fourth Streets, and contained 1,670 apartments arranged around a central garden court. Within the building complex were a swimming pool, stores, a bank, and a post office. On the roof terraces were further gardens arranged around water tanks enclosed in decorative belvederes.

Larger still was Tudor City on New York's East Side, on either side of Forty-second Street at First Avenue. The name itself indicates that what was intended was a city within the city. Here twelve brick apartment towers of varying heights—all with tan terra-cotta Tudor Gothic embellishment—were built

8.64. *Fred French Company, Tudor City, New York, New York, 1925–28. This aerial view shows the arrangement of the tall apartment slabs to the east, with lower apartment buildings north and south forming a U around small parks;* *Forty-Second Street drops under a bridge that connects the two halves of Tudor City. (From R. W. Sexton,* American Apartment Houses, Hotels, and Apartment Hotels of Today, *New York, 1929.)*

around two small parks in 1925–28 by the Fred F. French Company. [8.64] Altogether there were three thousand apartments in the complex, plus stores, restaurants, a church, and a hotel. Even more important than its sheer size and mixture of uses was its circulation plan. Both Forty-first and Forty-third Streets are ramped up to meet Tudor Place, a new cross street forming a bridge over Forty-second Street and linking the two halves of Tudor City. The ground level of Tudor City therefore is actually above Forty-second Street, which passes underneath uninterrupted.

Such inner-urban court apartments and deluxe apartment-cities, however, were accessible only to the most privileged. Most architects and planners recognized that to make a more realistic impact they would need to build at the urban periphery, and would need to incorporate as much landscaped open space as possible. In large measure these planners were hoping to achieve the goals described two decades earlier by Ebenezer Howard. Howard, an English legal clerk, had become fired with the dream of creating an ideal living environment that combined the advantages of both city and country. In 1898 he published *Tomorrow, a Peaceful Path to Real Reform* (retitled in subsequent editions *Garden Cities of Tomorrow*). In this book he posited the building of small light-industrial satellite communities that preserved and enhanced the beauty of nature while providing social opportunity, low housing costs, and high wages. Satellite garden cities, he reasoned, could be carefully designed to incorporate extensive open space, keeping them at optimum size by controlling speculation in land through communal or municipal ownership of land. The buildings on the land would remain private property. Furthermore, such cities should be surrounded by productive greenbelts of farms and forests that would act as insulation against encroachment by outside development while providing recreational space. With the founding of the Garden City and Townplanning Association, Howard began the realization of his dream in the building of Letchworth outside London in 1902. This was eventually followed by another town, Welwyn, begun in 1919.

Through these English examples and Howard's writing, the garden city ideal came to the attention of American planners and architects. Though there had been a few early excellently planned suburban developments, such as Forest Hills Gardens on Long Island, none of these attempted true economic self-sufficiency as urged by Howard. Two men particularly responsible for transmitting Howard's ideas to the United States were Henry Wright (1878–1936) and Clarence S. Stein (1883–1975), both of whom had been active in the federal war industry housing projects in 1916–18. Wright had been trained as a landscape architect and was both a visionary and a practical technician; Stein was trained as an architect and, as chief designer in the office of Bertram Goodhue, had been in charge of the plan for Tyrone, New Mexico. In their partnership Wright was the planner, and Stein dealt with clients and public officials, demonstrating a great organizational ability. Both were members of the Regional Planning Association of America formed in 1923; though it lasted only a decade, the association popularized many of the ideas of regional development and planning that later emerged in the federal projects for garden cities and the Tennessee Valley Authority. In 1924–28 Stein and Wright enlisted the aid of New York financiers to build Sunnyside in the borough of Queens, New York, on a site of seventy acres; this was the first garden city suburb in the United States based on Howard's ideas, with apartment blocks clustered around large communal gardens.

Hoping to build a truly self-sufficient community, Stein and Wright next formed a company in 1928 to build Radburn, New Jersey. After acquiring a site of 1,258 acres, they laid out a town for a target population of 25,000, adapting Howard's theories to this particular situation. [8.65, 8.66] The prospects were good, for the projected town was close to local industry, had good access to other nearby cities, and had open land on which to lay out the optimum plan. Unfortunately the Depression severely retarded development so that after two years only one of the three neighborhood areas was built up, and less than one-tenth of the projected population had been realized. Nevertheless, Radburn exerted profound influence because of its unique character and because of the several radical innovations in planning introduced here. First was the neighborhood planned as a self-sustaining social group, big enough to provide a base for schools and services yet small enough to be perceived by the individual and to promote self-identity. Second was the superblock concept, which disposed living units around the periphery of a large area ringed by major traffic arteries and penetrated only by short cul-de-sac streets. In these superblocks the elimination of cross-traffic opened up the interiors for use as landscaped communal parks with scattered play facilities for children, and meandering footpaths. Third was the clustering of housing in side-by-side duplexes and row

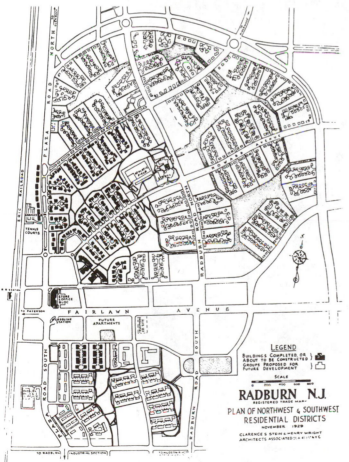

8.65. *Stein & Wright, Radburn, New Jersey, 1928–29. Today covered by a canopy of trees, this aerial view of the first section of Radburn, taken in 1929, shows the clusters of houses around cul-de-sacs and even the roadway overpasses that allowed children to walk to school without crossing streets. (Clarence Stein Papers, Cornell University Library.)*

8.66. *Radburn. The darkened buildings in the overall plan show the portion completed in 1929; the school is at the center of the large superblock, accessed by park strips and pathways that continue through culverts under the streets. (C. Stein, Toward New Towns for America, Cambridge, Mass., 1957.)*

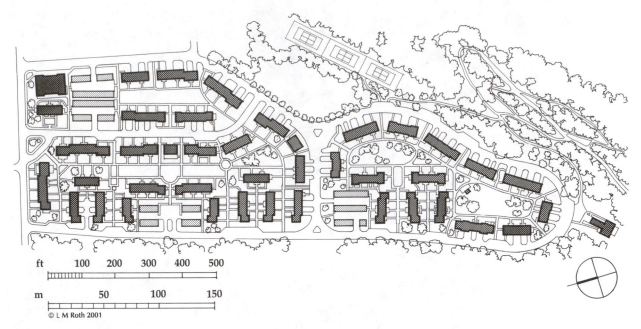

ft 100 200 300 400 500

m 50 100 150

© L M Roth 2001

8.67. Stein & Wright, Chatham Village, Pittsburgh, Pennsylvania, 1929–35. In this plan a series of staggered town house blocks are arranged loosely around central park strips; the entire complex sits astride a long hill and is surrounded by heavily wooded parkland that descends into the ravines on three sides. (L. M. Roth, after Stein, in George H. Gray, Housing and Citizenship, New York, 1946.)

8.68. Stein & Wright, planners, with Ingham & Boyd, architects, interior park strip, Chatham Village. Within each superblock runs a landscaped park strip. (Courtesy of The MIT Press.)

houses, which freed still more land for recreational space. Though the housing itself had no radically innovative planning or stylistic treatment, it was well designed with a view to function, and was well built. Fourth was the separation of traffic so that pedestrian and bicycle paths went underneath the major roads carried on overpasses. And fifth was planning for the automobile that made provisions for movement but— by partly closing off access to some areas—did not allow car traffic to dictate patterns of human interaction.

Somewhat more successful because of its smaller size and the higher design quality of its town houses was Chatham Village in Pittsburgh, Pennsylvania, planned in 1929 by Stein and Wright in collaboration with architects Ingham and Boyd. Financial backing was provided by a bequest, so there were no substantial reversals in this troubled year. The site was also particularly advantageous, an irregular oblong hillside overlooking Chatham Wood park; the steep, heavily wooded slopes of the ravines on three sides would ensure a surrounding greenbelt. [8.67] The division of the area into three large superblocks provided access to the projected 197 two-story units while space was

preserved for park strips through the center of each block. [8.68] The two- and three-bedroom houses were grouped in staggered rows of four to six units, their foundations rising and falling to follow the contours of the land. At one end was a market building, while at the other, overlooking the park, was a communal clubhouse. Of the many projects in which Stein and Wright participated, Chatham Village was one of the most financially successful and aesthetically engaging.

Far larger was the town of Mariemont, ten miles east of Cincinnati, Ohio, begun in 1923 as a philanthropic project by Mrs. Thomas J. Emery. [8.69] Patterned in concept after Letchworth, it was intended by Emery to be a community of "comfortable and attractive homes amid a favorable environment" so as to increase not only the residents' working efficiency but also to enable to residents to achieve "their best as human individuals apart from their work."[30] Moreover, there was to be a separate neighborhood for retired workers that incorporated a hospital. The plan was laid out by noted planner John Nolen assisted by Philip W. Foster and Justin R. Hartzog, on 365 acres, with 59 acres reserved for parks and 62

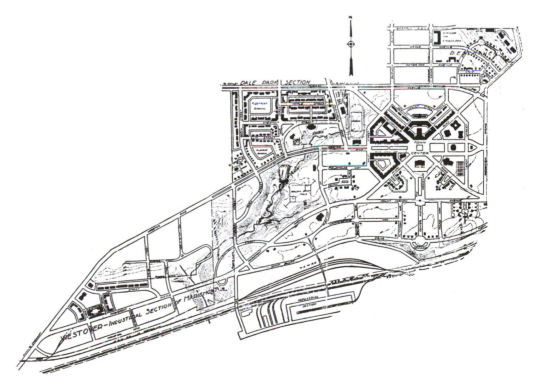

8.69. John Nolen, with Philip W. Foster and Justin R. Hartzog, Mariemont, near Cincinnati, Ohio, 1923 and after. This planned industrial community, begun with private financing, had a clear town center, with town houses and freestanding houses, a park that took advantage of a wooded ravine, and an industrial park. (C. Dykstra, ed., Supplementary Report of the Urbanism Committee, Natural Resources Committee, vol. 2, Washington, D.C., 1939.)

acres for an industrial district. Twenty-six architects contributed to the design of the houses arranged around a commercial center, from which the major streets radiated. A total population of 10,000 was proposed, but the community has stabilized at about 5,000.

THE GREAT DEPRESSION

These few planning projects, while admirable for their socially progressive character, arose from private enterprise and enlightened philanthropy. By 1930 such private agencies were unable to deal with an explosion of social problems resulting from the breakdown of the nation's economy. The carefree 1920s culture of the flappers and the dizzying anything-goes business speculation, came crashing down on Black Tuesday, October 29, 1929, with the collapse of the stock market. The onset of the Great Depression of the 1930s would soon make housing a major component of the public agenda.

It is difficult today, at the end of the twentieth century, in an age of general relative affluence, to imagine the full impact of the Great Depression. There had been nothing like it before in this country nor has there been since. Beginning with the financial panic of October 1929, American banks and businesses shut down one after another. By mid-1932 American industrial production was half what it had been in summer 1929, and the median personal income was cut in half as well. As the workmen labored to finish

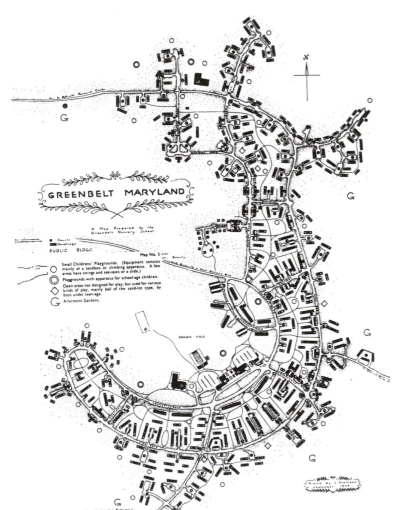

8.70. Hale Walker, planner, Greenbelt, Maryland, 1935. In Greenbelt, too, blocks of town houses were arranged in superblocks, with central park strips and paths connecting to the town center and schools by means of passages running the streets; today this is covered by a dense canopy of trees. (Stein, Toward New Towns for America.)

8.71. *Ellington & Wadsworth, architects, apartment blocks, Greenbelt, Maryland. An aerial view of some of the superblocks of Greenbelt taken immediately after construction, c. 1939. (Library of Congress.)*

the Empire State Building in 1931, they did so with care but also with apprehension, for they knew that once they were done there would be no more construction jobs to turn to. By 1933, more than 1.5 million people were homeless, and during that year only 93,000 new houses and apartments were built.[31] Neither private business nor the Republican administration had the power to stem the national economic disintegration. With the inauguration of Franklin D. Roosevelt in 1932 this paralysis began to change as government undertook the role of employer of last resort. For a later pessimistic age, it may difficult to grasp the sense of cautious optimism that swelled in 1932 as the nation joined in large communal construction projects. Within a matter of months, almost week by week or even daily, federal agencies were created by Roosevelt and his advisors to put people to work, among them the Civilian Conservation Corps or CCC (March 1932) to undertake public park development; the Tennessee Valley Authority or TVA (May 1933) to tame floodwaters and generate electricity for the rural South; the Federal Housing Administration (June 1934) to tackle housing and the setting up of national construction standards; and the Works Progress Administration or WPA (May 1935) to build public buildings across the country (part of this last venture included hiring jobless artists and sculptors to embellish these public buildings).

In 1932 President Roosevelt also initiated a program for the design and construction of satellite cities under federal auspices. One program operated by the Federal Emergency Relief Administration was the Division of Subsistence Homesteads, whose mission was to create small-farm villages outside major urban centers. These villages were to provide produce for the adjoining cities, creating employment and housing for displaced farmers. Another program, not put into full operation until 1935, was directed by Rexford G. Tugwell, a firm believer in the planning work of Ebenezer Howard. This program, the Resettlement Administration, was to construct suburban satellite industrial communities, designed, as Tugwell wrote, "to put houses and land and people together in such a way that the props under our economic and social structure will be permanently strengthened."[32] Only three of the projected eight "rural-industrial" communities materialized: Greendale, Wisconsin, about seven miles from Milwaukee; Greenhills, Ohio, five miles outside of Cincinnati; and Greenbelt, Maryland, between Washington, D.C., and Baltimore.

Greenbelt, Maryland, was begun in 1935 on a site of 3,300 acres of wooded land; the basic plan was devised by Hale Walker, planner, with Douglas D. Ellington and Reginald J. Wadsworth, architects, drawing on the conceptual ideas of Clarence Stein. Curved in the form of a giant fish-hook or J, and following a natural ridge, were six large superblocks enclosed by major roads; at their peripheries were clusters of row houses accessible by cul-de-sac drives. [8.70] The town house units were simply designed and

detailed so as to permit incoming residents to participate in the construction of the apartments they would occupy. Through the center of each superblock were park strips with pedestrian walks, with underpasses separating the pedestrian walkways from the roads. Figure 8.71 shows the most densely built-up section of Greenbelt adjacent to the community center. Along the residential spine were community buildings, shops, and schools, connected by roads and pedestrian underpasses. With woods on all sides and an artificial lake to the west, the setting was idyllic, all the more so because no industries were originally incorporated (so much for self-sufficiency). Subsequently, however, several federal agencies—the National Agricultural Research Center and the NASA Goddard Space Flight Center—located nearby, providing a needed employment base.[33]

The other major role of the federal government was as builder of public works. The badly affected construction industry desperately needed help, and the nation's states and beleaguered cities needed expanded or new facilities. Employing hundreds of architects and thousands of construction workers, the WPA program built 6,000 schools, 2,500 hospitals, and 13,000 playgrounds. The CCC cut trails, built lodges and shelters, making national forests and state parks accessible to millions of citizens. In the poverty-stricken Tennessee River Valley, the TVA built nine major dams, parkways, bridges, as well as the city of Norris, which was built in 1933–34 to house workers on the Norris Dam. The town was planned by Earle S. Draper, the most prominent urban planner in the South, with winding streets respecting the rolling terrain and including a circling greenbelt. Construction of the dam followed in 1934–36. A 1,872-foot-long straight concrete gravity dam, it was designed by engineer Arthur Morgan and architect Roland Wank; the architectural features by Wank were reviewed and approved by Albert Kahn of Detroit.[34] Particularly notable in the Norris Dam was Wank's use of checkerboard or basketweave textures in the wood formwork for the concrete. Wank intended this to provide better visual scale and diffuse reflections. [8.72] Even the corners were gently chamfered to soften the visual impact.

A similar program of dam building for flood control, irrigation water, and hydroelectric power was undertaken in the Pacific Northwest along the Columbia River, including the enormous Grand Coullee Dam in Washington (553 feet high and 4,173 feet long), built in 1933–50, and the smaller Bonneville Dam near Portland, Oregon, built in 1934–37 (90 feet high and 1,230 feet long), with turbines capable of generating in excess of half a billion kilowatts. For each project, adjoining towns had to be planned and built for construction workers and dam employees.

In terms of sheer visual impact, however, nothing has ever surpassed the Hoover Dam on the Colorado River, thirty miles southeast of Las Vegas, Nevada. Authorized by President Calvin Coolidge in 1928 before the Depression hit, the enormous plug of concrete in the Black Canyon was not started by the Bureau of Reclamation until 1931 under President Hoover and finished in 1935 under Roosevelt. An arch gravity dam of concrete, it measures 1,282 feet along its crest, but its height is 727 feet. Here, too, special attention was given to the *moderne* detailing of the four water intake towers. As with the other dam projects, the scale of the construction project was so huge that an adjoining community had to be planned and built to house the workforce.

In a study of the TVA and its accomplishments, Walter Creese wrote that "what was so daring about the TVA, in addition to its intelligent use of architecture and engineering and its multi-phased engagement with more aspects of American life than are usually encompassed, was the persuasion that human beings rightfully belong in the midst of their reconditioned earth."[35] It was a utopian undertaking, encompassing seven states, that attempted nothing less than the repair of decades of environmental damage, the provision of labor-saving energy, and the re-creation of a beautiful landscape in which people might again thrive.

The period between 1915 and 1940 witnessed what was perhaps the most radical change in American architecture. It opened at a point when the structural achievements of the Chicago School were essentially complete (although overlaid with a veil of symbolic historicist detail) and when tradition exerted an authority that seemed unquestionable. It was a period of pluralities in which good planning and sound construction were graced with a genuine concern for visual delight and variety. This was the period in which the very best public buildings were constructed, due to the fortuitous coming-together of several forces: low material and construction labor costs, plentiful highly skilled artisans in the building trades, municipal tax coffers as yet unburdened by myriad social programs, and highly educated architects. But it was also a period in which John Dewey's philosophical pragmatism

8.72. Roland Wank and Arthur Morgan, engineer, architect, Norris Dam, Norris, Tennessee, 1934–36. To visually soften and humanize this massive concrete structure, Wank designed the wood forms to leave a basketweave imprint. (Library of Congress.)

gradually began to foster architectural pragmatism, making colorful visual enrichment seem excessive and even suspect. A commercial culture that applied cost accounting, empiricism, and time-motion studies throughout industry and business eventually came to want an architecture of empiricism, stripped of superfluities. With the example of a few venturesome architects and their buildings, the new vocabulary was introduced, and in countless shops, diners, and restaurants the gleam of aluminum and stainless steel came to be customary, so that gradually the machine aesthetic became a part of a broad mass culture. It was also a period rent by a catastrophic economic collapse that plunged the nation and the world into economic (and, in some countries, political) chaos. With private funding nonexistent, and government funds stretched to their limit, the use of building materials became less extravagant and details became more minimal. The lean character of Modernism was thus enforced by necessity. And as this aesthetic of efficiency and modernity took hold, the Second World War erupted, further necessitating functional efficiency as a national defense strategy. After December 1941 and Pearl Harbor, nonmilitary building came to an abrupt halt. Perhaps this is why, when the economy returned to civilian production in 1946 after the war, the masterworks of American Modernism appeared so quickly: they had been in gestation for a long time.

BIBLIOGRAPHY

Arnold, Joseph L. *The New Deal in the Suburbs: A History of the Greenbelt Town Program, 1935–54*. Columbus, Ohio, 1971.

Blake, Peter. *Frank Lloyd Wright: Architecture and Space*. Baltimore, 1964.

Bletter, Rosemarie Haag. *Skyscraper Style: Art Deco New York*. New York, 1975.

Boyce, Rober. *Keck & Keck*. New York, 1993.

Bunting, Bainbridge. *John Gaw Meem, Southwestern Architect*. Albuquerque, N.M., 1983.

Christ-Janner, Albert. *Eliel Saarinen*. Chicago, 1948.

Cole, Doris, and Karen Cord Taylor. *The Lady Architects: Lois Lilley Howe, Eleanor Manning, and Mary Almy, 1893–1937*. New York, 1990.

Comey, Arthur C., and Max S. Wehrly. *Planned Communities: Supplementary Report of the Urbanism Committee, National Resources Committee*. Washington, D.C., 1939.

Condit, Carl W. *American Building Art: The Twentieth Century*. New York, 1961.

Coombs, Robert. "Norman Bel Geddes: Highways and Horizons," *Perspicua* 13–14 (1971): 11–27.

Clausen, Meredith. *Pietro Belluschi: Modern American Architect*. Cambridge, Mass., 1994.

Craig, Lois, et al. *The Federal Presence: Architecture, Politics, and Symbols in United States Government Building*. Cambridge, Mass., 1978.

Cram, Ralph Adams. *My Life in Architecture*. Boston, 1936.

Creese, Walter L. *TVA's Public Planning: The Vision, the Reality*. Knoxville, Tenn., 1990.

Curl, Donald W. *Mizner's Florida: American Resort Architecture*. Cambridge, Mass., 1984.

De Long, David. *Frank Lloyd Wright: Designs for an American Landscape, 1922–1932*. New York, 1996.

Dowling, Elizabeth M. *American Classicist: The Architecture of Philip Trammell Shutze*. New York, 1989.

Ferris, Hugh. *The Metropolis of Tomorrow*. New York, 1929.

Ferry, W. Hawkins. *The Legacy of Albert Kahn*. Detroit, 1970; reprint 1987.

Fishman, Robert. *Urban Utopias in the Twentieth Century: Ebenezer Howard, Frank Lloyd Wright, and Le Corbusier*. New York, 1977.

———. *Santa Barbara: The Creation of a New Spain in America*. Santa Barbara, Calif., 1982.

Gebhard, David. *Schindler*. London 1971.

———. "The Spanish Revival in Southern California," *Journal of the Society of Architectural Historians* 26 (May 1967): 131–47.

Gomery, Douglas. *Movie History: A Survey*. Belmont, Calif., 1991.

Gowans, Alan. *The Comfortable House: North American Suburban Architecture, 1890–1930*. Cambridge, Mass., 1986.

Grief, Martin. *Depression Modern: The Thirties Style in America*. New York, 1975.

Grossman, Elizabeth G. *The Civic Architecture of Paul Cret*. Cambridge and New York, 1996.

Gutman, Richard. *American Diner*. New York, 1979.

Hewitt, Mark A. *The Architect and the American Country House*. New Haven, Conn., 1990.

Hildebrand, Grant. *Designing for Industry: The Architecture of Albert Kahn*. Cambridge, Mass., 1974.

Hille, R. Thomas. *Inside the Large Small House: The Residential Design Legacy of William W. Wurster*. New York, 1994.

Hines, Thomas S. *Richard Neutra and the Search for Modern Architecture*. New York, 1982.

Hitchcock, Henry-Russell. *In the Nature of Materials: The Building of Frank Lloyd Wright, 1887–1941*. New York, 1942.

Hoffmann, Donald. *Frank Lloyd Wright's Fallingwater: The House and Its History*. New York, 1978.

Hudnut, Joseph. "The Last of the Romans: Comments on the Building of the National Gallery of Art," *Magazine of Art* 34 (April 1945): 169–73.

———. "The Post-Modern House," *Architectural Record* 97 (May 1945): 70–75.

Jackle, John A., and Keith A. Sculle. *The Gas Station in America*. Baltimore, 1994.

Johnson, Philip, and Henry-Russell Hitchcock. *The International Style: Architecture since 1922*. New York, 1932; reprint 1966 and 1995.

Jordy, William. "PSFS: Its Development and Its Significance in Modern Architecture," *Journal of the Society of Architectural Historians* 21 (May 1962): 47–83.

Kaufmann, Edgar. *Fallingwater: A Frank Lloyd Wright Country House*. New York, 1986.

Kaufmann, Edgar, and Ben Raeburn, eds. *Frank Lloyd Wright: Writings and Buildings*. Cleveland, Ohio, 1960.

Kilham, Walter H., Jr. *Raymond Hood, Architect: Form through Function in the American Skyscraper*. New York, 1973.

Krinsky, Carol H. *Rockefeller Center*. New York, 1978.

Lanmon, Lorraine W. *William Lescaze, Architect*. Philadelphia, 1987.

Levine, Neil. *The Architecture of Frank Lloyd Wright*. Princeton, N.J., 1996.

Lipman, Jonathan. *Frank Lloyd Wright and the Johnson Wax Buildings*. New York, 1986.

Lubove, Roy. "Homes and 'A Few Well Placed Fruit Trees': An Object Lesson in Federal Housing," *Social Research* 24 (Winter 1960): 469–86.

Maginnis, C. D. *The Work of Cram and Ferguson, Architects*. New York, 1929.

Marks, Robert W. *The Dymaxion World of Buckminster Fuller*. New York, 1960.

McKelvey, Blake. *The Emergence of Metropolitan America, 1915–1966*. New Brunswick, N.J., 1968.

Menocal, Narciso. *Keck & Keck, Architects*. Madison, Wis., 1980.

Mock, Elizabeth, ed. *Built in USA since 1932*. New York, 1945.

Moffett, Marian. *Built for the People of the United States: Fifty Years of TVA*. Knoxville, Tenn., 1983.

Mujica, Francisco. *History of the Skyscraper*. Paris, 1929; New York, 1930.

Naylor, David. *American Picture Palaces: The Architecture of Fantasy*. New York, 1981.

———. *Great American Movie Theaters*. Washington, D.C., 1987.

Nelson, George. *Industrial Architecture of Albert Kahn, Inc.* New York, 1939.

Newcomb, Rexford. *Mediterranean Domestic Architecture in the United States*. Cleveland, Ohio, 1928.

———. *The Spanish House for America: Its Design, Furnishing, and Garden*. Philadelphia, 1927.

North, Arthur T. *Raymond M. Hood*. New York, 1931.

Oliver, Richard. *Bertram Grosvenor Goodhue*. Cambridge, Mass., 1983.

Onderdonk, F. S. *The Ferro-Concrete Style*. New York, 1928.

Peisch, Mark L. *The Chicago School of Architecture: Early Followers of Sullivan and Wright*. New York, 1964.

Peters, Richard C. "William Wilson Wurster: An Architect of Houses," in *Bay Area Houses*, ed. Sally Woodbridge (Salt Lake City, Utah, 1988).

Pommer, Richard. "The Architecture of Urban Housing in the United States during the Early 1930s," *Journal of the Society of Architectural Historians* 37 (December 1978): 235–64.

Pratt, Richard. *David Adler*. New York, 1970.

Riley, Terence, ed. *Frank Lloyd Wright: Architect*. New York, 1994. Published in conjunction with a major retrospective exhibition at the Museum of Modern Art.

Robinson, Cerwin, and Rosemarie Haag Bletter. *Skyscraper Style: Art Deco New York*. New York, 1975.

Scully, Vincent. *Frank Lloyd Wright*. New York, 1960.

Sergeant, John. *Frank Lloyd Wright's Usonian Houses: The Case for Organic Architecture*. New York, 1976.

Sheppard, Carl D. *Creator of the Santa Fe Style: Isaac Hamilton Rapp, Architect*. Albuquerque, N.M., 1983.

Stein, Clarence. *Toward New Towns for America*. Cambridge, Mass., 1957.

Stern, Robert A. M. *George Howe: Toward a Modern American Architecture*. New Haven, Conn., 1975.

Striner, Richard. "Art Deco: Polemics and Synthesis," *Winterthur Portfolio* 25 (Spring 1990): 2–34.

Tauranac, John. *The Empire State Building: The Making of a Landmark*. New York, 1995.

Trieb, Marc, ed. *An Everyday Modernism: The Houses of William Wurster*. San Francisco, Calif., 1995.

Tucci, Douglass S. *Ralph Adams Cram, American Medievalist*. Boston, 1975.

———. *Ralph Adams Cram: Life and Architecture*. 2 vols. Amherst, Mass., 1995–96.

Twombly, Robert C. *Frank Lloyd Wright: An Interpretive Biography*. New York, 1973.

Urban, Joseph. *Theaters*. New York, 1929.

Weiss, Marc. "Developing and Financing the 'Garden Metropolis': Urban Planning and Housing Policy in Twentieth-Century America," *Planning Perspectives* 5 (September 1990): 307–19.

Whitaker, C. H., ed. *Bertram Grosvenor Goodhue: Architect and Master of Many Arts*. New York, 1925.

White, Theo B. *Paul Philippe Cret, Architect and Teacher*. Philadelphia, 1973.

Willis, Carol. *Form Follows Finance: Skyscrapers and Skylines in New York and Chicago*. New York, 1995.

Wilson, Richard Guy. "American Modernism in the West: Hoover Dam." In *Images of an American Land*, ed. Thomas Carter. Albuquerque, N.M., 1997.

———. *The Machine Age*. New York, 1986.

Woodbridge, Sally, ed. *Bay Area Houses, New Edition*. Salt Lake City, Utah, 1988.

Wright, Frank Lloyd. *Autobiography*. New York, 1932.

———. *In the Cause of Architecture*, ed. F. Gutheim. New York, 1975.

———. *Modern Architecture*. Princeton, N.J., 1931.

———. *On Architecture*, ed. F. Gutheim, ed. New York, 1941.

———. *An Organic Architecture: The Architecture of Democracy*. London, 1939.

NOTES

1. Manuel Gottlieb, "Estimates of Residential Building, United States, 1840–1939," Technical Paper No. 17, National Bureau of Economic Research, New York, 1964.

2. For a recent assessment of Yorkship Village, see Michael H. Lang, "The Design of Yorkship Garden Village," in *Planning the Twentieth-Century American City*, ed. M. C. Sies and C. Silver (Baltimore, 1996).

3. Figures from Bureau of the Census, *Historical Statistics of the United States, Colonial Time to 1957* (Washington, D.C., 1960), 393.

4. For these figures see G. Carruth, *Encyclopedia of American Facts and Dates* (New York, 1987), 441, 467, 475; and Bureau of the Census, *Historical Statistics of the United States, Colonial Times to 1957* (Washington, D.C., 1960), 462.

5. Some contemporary essays exploring the rapid social changes already occurring in the period from 1910 through the 1920s—urban sprawl, traffic congestion, parking problems—are reprinted in *America Builds*, 472–82.

6. For the enormously popular Sears houses, see Katherine C. Stevenson and H. Ward Jandl, *Houses by Mail: A Guide to Houses from Sears, Roebuck and Company* (Washington, D.C., 1986). The 1923 Gordon–Van Tine house catalogue has been republished by Dover Publications (New York, 1992), and the 1923 Architects' Small House Service Bureau catalogue has been reprinted, with an introduction by Lisa Schrenk, by the AIA, (Washington, D.C., 1992). See also Alan Gowans, *The Comfortable House: North American Suburban Architecture, 1890–1930* (Cambridge, Mass., 1986).

7. Revealing cross sections of esteemed architecture of the 1920s, private and public, can be glimpsed in histories of the period, such as G. H. Edgell, *The American Architecture of To-Day* (New York, 1928); and Talbot Faulkner Hamlin, *The American Spirit in Architecture* (New Haven, Conn., 1926).

8. Of the nine children of Isaac and Georgiana Rapp of Carbondale, Illinois, five became architects, causing considerable confusion for architectural historians. The two youngest, Cornelius Ward and George Leslie Rapp, both educated in the architectural program at the University of Illinois, established the better-known firm specializing in theaters in Chicago. The older Isaac Hamilton and William Morris Rapp worked in the Southwest and came to specialize in evocations of adobe architecture. It is significant that both teams of brothers focused on such scenographic and psychologically evocative design. See Carl D. Sheppard, *Creator of the Santa Fe Style: Isaac Hamilton Rapp, Architect* (Albuquerque, N.M., 1988).

9. Robert A. M. Stern, *George Howe: Toward a Modern American Architecture* (New Haven, Conn., 1975), 42–52.

10. President Franklin Roosevelt himself favored a kind of stripped-down and simplified Colonial that was adopted for numerous public works projects in the Depression years, resulting in what might be called Roosevelt Colonial Revival.

11. For the campaign to remake Williamsburg, see William B. Hosmer Jr., *Preservation Comes of Age, from Williamsburg to the National Trust, 1926–1949* (Charlottesville, Va., 1981), 1:11–73. For the details of the restorations, see Marcus Whiffen, *The Public Buildings of Williamsburg* (Williamsburg, Va., 1958). For the errors introduced, see Carl R. Lounsbury, "Beaux-Arts Ideals and Colonial Reality: The Reconstruction of Williamsburg's Capitol, 1928–34," *Journal of the Society of Architectural Historians* 49 (December 1990): 373–89. See also the comments regarding the Williamsburg restoration in Ada Louise Huxtable, *The Unreal America: Architecture and Illusion* (New York, 1997), 16–17.

12. Cram was also an active writer and speaker, publishing four major theoretical works plus scores of articles. One sample of his advocacy of Gothic for selected functions, "The Philosophy of the Gothic Restoration" (1913), is reprinted in *America Builds*, 454–65. Cram was no narrow Gothicist, however; he designed hundreds of buildings, many in Colonial or other classical forms. One of his best last buildings in the Art Deco Federal Building, in Boston, built in 1930.

13. Ralph Adams Cram, *My Life in Architecture* (Boston, 1936), 247–49.

14. Quoted in David Lowe, *Lost Chicago* (New York, 1975), 203.

15. Information based on interviews with both of the Keck brothers, June 1974.

16. Because Yeon had not formally completed his architectural education or obtained a professional license, he and Pietro Belluschi agreed that the working drawings for the Watzek house would be prepared in the A. E. Doyle (i.e., Belluschi) office and be signed by Belluschi, who was licensed, for approval by the Portland building department. Years later Yeon commented that he deliberately did not seek a professional license or set up an office because he would then be obliged to seek out a continual stream of commissions to provide an income for his employees, leading eventually to work hastily and poorly designed. It must be noted that during the 1950s and 1960s, when pointedly asked if he designed the Watzek house, Belluschi artfully fudged his answers, saying simply that all drawings had been prepared in the Doyle office under his supervision, leaving the inquirer to conclude that Belluschi was indeed the designer and not Yeon. This caused a bitter rift between the two designers that fortunately was resolved by the 1980s. See Meredith Clausen, *Pietro Belluschi: Modern American Architect* (Cambridge, Mass., 1995), 90–101, esp. 430, n. 23.

17. The Society of Beaux-Arts Architects (later the Beaux-Arts Institute of Design) was an organization created by Paris-trained American architects in 1894 to promote the design theory and standards taught at the École in Paris. It also sponsored design competitions, much like those given at the École, most notably the Paris Prize. Early in the twentieth century, architectural schools, in essence, were

obliged to support the Beaux-Arts Institute of Design and have students participate in these competitions in order to win accreditation. The first school of architecture to reject this competitive approach in design education was the University of Oregon, which in 1922 shortly after winning accreditation, embraced instead the approach to design education promoted by Eliel Saarinen in which students and faculty worked together in a cooperative way. For an introduction to the the Society of Beaux-Arts Architects/Beaux-Arts Institute of Design see Spiro Kostof, ed., *The Architect: Chapters in the History of the Profession* (New York, 1977).

18. See "Chicago *Tribune* Building Competition: Program and Jury Report," in *American Builds*, 465–72.

19. Good examples of early Modernism in the United States can be seen in James Ford and Katherine Morrow Ford, *The Modern House in America* (New York, 1940).

20. Hood quoted in Ric Burns and James Sanders, *New York: An Illustrated History* (New York, 1999), 368.

21. See John Tauranac, *The Empire State Building: The Making of a Landmark* (New York, 1995).

22. The Tagblatt Building, of only fifteen stories, was illustrated by a drawing published in *Architectural Record* in February 1929.

23. See the extended discussion and analysis of the PSFS Building in William Jordy, *American Buildings and Their Architects*, vol. 5, *The Impact of European Modernism in the Mid-Twentieth Century* (Garden City, N.Y., 1972), 87–164.

24. Bryon Keeler Mosher, in a reminiscence letter, January 20, 1974; noted in Donald Hoffmann, *Frank Lloyd Wright's Fallingwater: The House and Its History* (New York, 1978), 17.

25. Wright's essay on Broadacre City, first published in *Architectural Record* in 1935, is reprinted in part in *America Builds*, 483–88.

26. Putting the costs on the same basis (1935 dollars), the Robie house would then have cost $55,400 compared to the Jacobs house, at $5,500; put another way, the compact Jacobs house cost only 9.93 percent of what the Robie house had cost. Today (using the average building costs for the year 2000) the Robie house would cost something like $23,600,000 while the Jacobs house would likely cost $140,300. These building cost comparisons are based on the indexes maintained by *Engineering News-Record* since 1913; see *Engineering News-Record* 188 (March 23, 1972): 56–57 and the building cost index in the current issue available online at http://www.enr.com.

27. Frank Lloyd Wright, *Autobiography*, 2nd ed. (New York, 1943), 472. This was reworded slightly in the 3rd ed. (New York, 1977), 498.

28. There had been building regulations enacted even during the colonial period but they were not enforced in the same way as these regulations were at the end of the nineteenth century.

29. Discussed in Mell Scott, *American City Planning since 1890* (Berkeley, Calif., 1969), 237–41.

30. John Nolen's description of Emery's objectives, from his book *New Towns for Old*, quoted in Urbanism Committee, National Resources Committee, *Urban Planning and Land Policies* (Washington, D.C., 1939), 92–97. See also the discussion of Mariemont in Norman T. Newton, *Design on the Land* (Cambridge, Mass., 1971), 482–86.

31. Figures from Gary B. Nash and Julie R. Jeffrey, *The American People: Creating a Nation and a Society*, 3rd ed. (New York, 1994); and *Historical Statistics of the United States.*

32. R. G. Tugwell, "Housing Activities and Plans of the Resettlement Administration," *Housing Officials' Year Book, 1936*, 28; quoted in M. Scott, *American City Planning*, 337.

33. Given the American propensity to view open landscape as "undeveloped" or "unimproved," it should come as no surprise that the town of Greenbelt has been under increasing pressure to sell its wooded greenbelt lands for industrial and residential building.

34. Noted in Walter L. Creese, *TVA's Public Planning: The Vision, the Reality* (Knoxville, Tenn., 1990), 169. The civil engineering projects discussed here are treated in Donald C. Jackson, *Great American Bridges and Dams* (Washington, D.C., 1988); and especially Carl W. Condit, *American Building Art: The Twentieth Century* (New York, 1961).

35. Creese, *TVA's Public Planning*, 342.

9.1. Gropius & Breuer, New Kensington, near Pittsburgh, Pennsylvania, 1941. Because of the hilly Pittsburgh terrain, these row houses for war-industry workers were placed in accordance with the topography, and because of restrictions on materials, Gropius made extensive use of wood as exterior siding. (Rosenthal Archive, Northwestern University.)

THE EMERGENCE OF MODERNISM, 1940–1973

SOCIAL AGENDA OR THE LATEST AESTHETIC?

The four decades starting in 1940 witnessed the full-blown emergence of Modernism in the United States, its ascendancy and then, after the mid-1960s, a growing public feeling of its symbolic emptiness and even anti-human scale. To an important degree this embrace of Modernism was sanctioned by the arrival of hundreds of European intellectuals who fled Nazi oppression and the threat of death. The chief advocates of European Modernism were Walter Gropius and Mies van der Rohe, both of whom came to the United States in the late 1930s, and both of whom were appointed to head architectural schools: Gropius at Harvard and Mies at the Illinois Institute of Technology in Chicago.

The Modernism that Mies, and especially Gropius, taught was rooted in the liberal socialism of Europe. Defined during the decade following the First World War, European Modernism was an architecture driven by careful functional analysis and maximum structural efficiency, intended to provide inexpensive housing for everyone and to solve other social problems. One of Gropius's early students at Harvard, Chester Nagel, described the sense of mission he and other young men felt. "We were going to change the world," he related to Carter Wiseman. "Architecture was no longer going to be merely decorative. We were trying to separate ourselves from the bombast of the past. We were looking for the essence, and we found it."[1]

While Gropius and Mies came to the United States permanently, the Finnish modernist Alvar Aalto came to the United States as a visitor and to supervise the construction of his Finnish pavilion at the 1939 World's Fair in New York. While in the United States he visited Eliel Saarinen at Cranbrook and considered relocating his office to the United States just as Saarinen had done several years before. Aalto also taught briefly at MIT in 1940 before Finland's involvement in the expanding war persuaded him to return home. After the war Aalto would again return to MIT to teach, and then to build his Baker House dormitory. But before the influence of these three masters could be felt, before their students began to assume positions of influence, the Nazi threat that had driven Gropius and Mies from Europe had to be met head on and crushed. So, in significant ways, the first real impact of European Modernism was in the design of war-industry housing in the early 1940s.

HOUSING WAR WORKERS

At the start of 1942, as in 1916–18, there was sharp drop in civilian building as the United States entered the Second World War following the bombing of Pearl Harbor, Hawaii. This redirection of building was even more dramatic than before, for civilian construction almost ceased altogether. The war imposed a near absolute hiatus in civilian building, unlike anything experienced during previous conflicts. Because of the urgency, and the dearth of material and skilled labor, architects were put to work designing war-industry housing developments, training camps, and other essential facilities under conditions that forced the maximum utilization of material and the elimination of ornament. The lean efficiency of Modernism was not simply aesthetically progressive, but was now seen as patriotic as well.

Even before the attack on Pearl Harbor, many industries had increased production of war materiel

for the European allies as part of the lend-lease program, and hence the need for housing for the workers newly clustered at industrial sites became urgent in 1940. This time, however, the designers were not traditionalists or eclectics, unlike those who in 1917 attempted to use historical styles to foster a sense of communal and regional identity; in 1940 the architects were leaders of the avant-garde modernist movement. Among the first housing complexes begun was Audubon Park, outside Camden, New Jersey, built in 1940–41 less than a mile from the Yorkship Village housing complex built during the First World War. Planned by architects Oscar Stonorov and Joseph N. Hettle, Audubon Park also housed shipyard workers. Channel Heights, for shipyard workers at San Pedro, in Los Angeles, California, built in 1943, was one of the largest war housing groups. The six hundred apartments, designed by Richard Neutra, had flat roofs, and were arranged in tidy, serried rows on the irregular terrain. Better known, perhaps, and certainly better disposed on the rolling landscape, were the apartments at New Kensington, outside Pittsburgh, Pennsylvania, built in 1941, by Gropius and Breuer. [9.1] These too had flat modernist roofs, and in the buildings wood was used extensively due to wartime restrictions on the use of metal. For the FPHA housing complex McLoughlin Heights, in Vancouver, Washington, built in 1942, Pietro Belluschi designed a shopping center in addition to the housing units. Square, compact, gable-roof units were designed by young Hugh Stebbins for Windsor Locks, Connecticut, built in 1942. The larger Carver Court in Coatesville, Pennsylvania, built in 1944, by George Howe, Oscar Stonorov, and Louis Kahn, was especially severe, partly because of increased stringency imposed by the war, but also no doubt because this was housing for black workers and their families; separate-but-not-equal was still very much a part of segregationist attitudes before the civil rights movement of the 1960s. A generation later federal laws and judicial decrees were to make determined attempts at preventing such ghettos, but in 1944 segregation was still the practice, here sanctioned by the government.

By far the most extensive of the war towns were those built under great security for the secret project to build an atomic bomb. Los Alamos, New Mexico, and Hanford, Washington, were among them, but perhaps the single largest was Oak Ridge, Tennessee, designed by the office of Skidmore, Owings, & Merrill, and of this more will be said later when attention is given to the rise of this large and influential firm.

In all, almost 60,000 housing units for war-industry workers were begun during 1941 (before Pearl Harbor); but after the United States entered the war worker housing construction jumped enormously. During 1942 through 1946 almost 663,000 family housing units were built with government assistance or under government auspices, well over the number of units built in the few months of 1917–18.[2] This activity, plus the establishment of the Federal Housing Administration during the Depression, meant that henceforth the federal government would be intimately involved in American housing policy.

Economic readjustment after the Second World War was relatively quick, despite the prediction by some that the Depression would return. The high rate of employment during the war years, together with limited opportunities for discretionary spending, meant that workers accumulated significant savings during 1941–45. These savings, plus the memories of privation during the 1930s, resulted in enormous pent-up demand for consumer goods when the war ended in 1945. Industry boomed in 1946 in an effort to meet the pressure, producing automobiles, major appliances, and, of course, housing. There opened an era of unparalleled prosperity creating what John Kenneth Galbraith called in 1958 the "affluent society."[3] The United States became a nation of consumers, firm believers in annual obsolescence, in the idea that new and better products would appear every day, and that newer and bigger was always better. This notion extended to buildings as well. The ensuing abundance of consumer goods for the small nuclear family bred a callousness regarding larger social urban issues. This affluence applied nearly equally to corporations, businesses, and the white middle class. African Americans, Hispanics, native Americans, and other minority groups, however, felt little of this affluence. Increasing private splendor was mirrored by increasing public squalor, particularly at the core of American cities.

MODERNISM

The Corporate Office Tower

The years immediately after the war, which Americans had decisively won, were characterized by a buoyant confidence and a desire to get on with the business of progress. American corporations, flush with profits earned during the war, were further stimulated through the acquisition of smaller related businesses. The corporate heads wished to demonstrate their faith in the

future and progress. The ideals of the International Style, an architecture that idealized the rational industrial process, was perfect for expressing this confidence in American know-how and industrial might. What better way to give expression to the pragmatic utilitarianism that dominated the corporate community? Fortunately, many of the European creators of that architectural idiom, having fled Hitler, now worked in the United States. Although such emigrés as Gropius, Mies, and Marcel Breuer continued to expand on their own theoretical philosophies, their many American followers did not have this intellectual or theoretical underpinning and hence the many versions of Modernism that resulted carried the mannerist stamps of individual architects or particular decades.

Commercial architecture became an increasingly important form of public relations. International Style Modernism, originally conceived as an efficient design and construction methodology to solve social problems, was now co-opted by corporate America as a form of advertisement and aggrandizement. Following the war, corporate clients sought to establish their public images through building, and in the process gave architects like Mies, Philip Johnson, and Skidmore, Owings, & Merrill opportunities to realize the normative, universal, and technically pure architecture these architects had been promoting for twenty years. In the hands of Mies and his colleagues, this became an exercise in abstract beauty, but when attempted by others it often turned vapid. Architecture became a package in which the ambiguities and complexities of modern institutions were blithely wrapped in sleek, monotonous modernist continuities. Modern architecture became reductive and exclusive, eliminating untidy functions to conform to a vision of society as the architects thought it *ought* to be, rather than according to the way it *was*. This arrogant and exclusivist heroicism continued into the 1970s when, under the influence of a new generation of architects, it simply exchanged its bland reductivist uniformities for emphatic expressionist forms or decorative historical furbelows.

Equitable Building

The image of the modern American corporate tower was first devised not in New York but rather in Portland, Oregon, by Pietro Belluschi, who had come to the United States after the First World War and entered the office of the prominent (and very traditional) Portland architect Albert E. Doyle. Belluschi (1899–1994) had been educated as an engineer in

Italy, however, and always approached architecture in a very analytical and pragmatic way. His use of historical styles quickly disappeared as Doyle retired from the practice, and in 1931 Belluschi designed a modernist building for the Portland Art Museum. In a matter of months he had stripped the original ornate Georgian design down to severe brick and stone masses, its galleries lit by a highly innovative system of overhead monitors. Belluschi explained his thinking in a letter to museum officials, saying that the museum

> should be designed from the inside out, and that no good interior practical feature be sacrificed for a faked external appearance. Architecture should be a living thing and that to apply the externals of a past age when requirements were of an entirely different nature is a fundamental mistake. . . . The museum as we understand it today is a new institution with modern requirements, and a definitely new alive function. Let us not try to maim and twist the body to fit the suit but let us build a new suit consistent with the body.[4]

Thus was born perhaps the first museum in the United States using a modern idiom, eight years before the more famous Museum of Modern Art, New York, by Edward Durrell Stone.

Belluschi's architectural practice during the war was severely affected, but as the Allied victory seemed more certain, projects began to be discussed for construction after the war ended. Indeed, as early as 1943, *Architectural Forum* began work on a special issue devoted to the new office building to emerge after the war. Several architects were invited to submit designs, including Doyle's office (in fact Belluschi).[5] The design Belluschi published in *Architectural Form* was no fanciful dream but the outline of an office skyscraper he was, in fact, already working on. Belluschi was already talking with a potential Portland client about a postwar office block to be known as the Equitable Building; moreover, architect and client were discussing how to exploit aluminum in the design, since aluminum was then being produced in the Pacific Northwest in great quantity for aircraft as a result of the smelters attracted there due to inexpensive hydro electric power. With the basic Equitable Building design already worked out in 1944, Belluschi sought building permits in fall 1945, and simultaneously began making arrangements for the production of the aluminum panels and the oversized tinted glass sheets. In January 1946 the building site was cleared, construction commenced, and in January 1948 the new

9.2. Pietro Belluschi, Equitable Savings and Loan Association Building, Portland, Oregon, 1944–48. Planned during the closing year of the war, this was the first metal-and-glass-sheathed office building to be finished and occupied afterward. (Rosenthal Archive, Northwestern University.)

Equitable Building was completed and occupied. [9.2]

The innovations in the Equitable Building were many. Over the reinforced-concrete frame were fastened aluminum wall panels and thermopane green-tinted glass window units. Not visible but extremely important (as would be discovered much later) was the use of a reverse-cycle heating and air-conditioning system (a heat pump) made practical by the mild climate and the inexpensive electricity (this system was later awarded landmark status by the Society of Mechanical Engineers). With a wall surface that was virtually flush and made largely of glass, Belluschi devised a window-cleaning car suspended from a tram that operated on a track running around the periphery of the flat roof. Highly publicized and warmly praised at first by the architectural press, the

Equitable Building was soon eclipsed by the attention given to two subsequent glass towers not nearly so progressive in design.[6]

Lever House

The second of the glass towers was Lever House, in New York, built in 1951–52 [9.3], the product of an office that quickly became a leading force in American architecture: Skidmore, Owings, & Merrill. The project was supervised by Gordon Bunshaft, and his design made use of a recent change in New York's zoning laws that permitted construction of an unbroken rectangular vertical slab provided that a certain percentage of the ground area was either occupied by a low unit or left open altogether. Bunshaft did both, enclosing an open court with a

9.3. *Skidmore, Owings, & Merrill, Lever House, New York, New York, 1951–52. In the foreground, the New York Racquet and Tennis Club by McKim, Mead & White, 1916–19, contrasts with the seemingly weightless glass wall of the Lever House. (Photo: L. M. Roth.)*

one-story base element elevated on freestanding columns. At the north end of the site he placed the sheer vertical office slab, sheathed in green glass and vitreous spandrel panels set in narrow metal mullions. The structural columns supporting this curtain wall are entirely hidden so that the wall is a nonsupporting skin, just the reverse of the traditional heavy bearing wall of the neighboring Racquet Club, by McKim, Mead & White, built in 1916–19 [in the foreground of 9.3]. Bunshaft turned his shoulder to Park Avenue, so carefully defined by the older traditional buildings, carving out a hole in the wall of the street. By itself, in the early 1950s, this was a pleasant accent, but when every successive new office tower stood in a similar windswept plaza, the street as a defined space slipped away.

Lake Shore Drive Apartments

Lever House, though not the first, was perhaps the most famous of the new breed of skyscraper. It was a direct descendant of the pioneering skyscraper designs projected by Ludwig Mies van der Rohe in Germany during 1919–20. The son of a master mason, from his youth Mies was concerned with the precise assembly of building materials. This concern was intensified during Mies's apprenticeship with Peter Behrens and his careful study of the work of German neoclassicist Karl Friedrich Schinkel encouraged by Behrens; from Schinkel, Mies learned to appreciate precision in detail and the painstaking assembly of parts. Through Behrens, Mies was introduced to the Deutscher Werkbund and its dream of a functional purist architecture derived from the industrial process. Out of his

9.4. Ludwig Mies van der Rohe, plan, Illinois Institute of Technology, Chicago, Illinois, 1939–42. The pervasive 24-by-24-by-12-foot grid determined the placement of nearly every building of the Illinois Institute of Technology campus. The darker buildings are those completed by 1960; the lighter tone indicates projected buildings. (L. M. Roth, after A. Drexler, Mies van der Rohe, *New York, 1960.)*

participation in the Werkbund and the idealist Novembergruppe came Mies's prophetic glass tower projects in 1919–20. This radiant idealism, continued through the 1920s, found its fullest expression perhaps in the Weissenhof housing exhibition in Stuttgart in 1927 (planned by Mies), and was reduced to its essence in Mies's jewel-like German pavilion at the Barcelona International Exposition of 1929.

Hoping to realize the dream of a new social order through the universal application of technology in architecture and design, Mies became associated with Walter Gropius and the Bauhaus. As opposition to Bauhaus teaching increased among Nazi officials, Gropius left for England, placing the school under the direction of Mies in 1930. Within three years Mies had to close the school; there was no place for Mies or his normative universal architecture in the Third Reich.

Mies came to the United States in 1937 with the assistance of Alfred Barr, director of the Museum of Modern Art in New York, who secured for Mies a commission for the Resor summer house at Jackson Hole, Wyoming, which went unbuilt. Then in 1938 Mies was appointed director of the architecture department of the Illinois Institute of Technology in Chicago and the following year he began planning a new campus for the school on the city's south side. Since the plan would include many buildings, Mies began by laying out a comprehensive modular system across the entire site that would organize not only the buildings but also the spaces between them. [9.4] The three-dimensional module was 24 by 24 feet by 12 feet high. The projected individual buildings of the ensemble were likewise rationally ordered using a modularly determined black steel frame with the bays filled with

glass, buff glazed brick, or a combination of the two. [9.5] Each detail of the wall system was carefully studied so the industrial sash would fit precisely in the structural bays and so the brick panels would be separated from the frame by a narrow shadowed reveal; as Mies observed, "God is in the details." This careful articulation, especially at the corners, is analogous to the treatment of the classical corner piers in Schinkel's Old Museum in Berlin, but Mies reinterpreted this as a compilation of carefully arranged standard rolled steel sections to turn the corner. From the comprehensive plan down to smallest detail, a pervasive abstract technological ideal governs all.

This extension of the machine was more intellectually rigorous and complete than anything by Albert Kahn, for Mies saw it pervading all of society. As for the anonymity of this architecture, Mies felt that this paralleled modern life. Since the use of a building changed so frequently it was impossible to draw up a finite program and design for an indefinite and unvarying function. Modern architecture, Mies felt, should be adaptable to a broad range of functions; it must be universally functional. Instead of form following function, as Sullivan had described, Mies sought to realize perfect structural and construction ideals. He deliberately avoided fitting form to functions, saying "we reverse this, and make a practical and satisfying shape, and then fit the functions into it. Today this the only practical way to build, because the functions of most buildings are continually changing, but economically the building cannot change."[7] The ideal would be a single huge enclosed volume that could be subdivided by movable impermanent screens as patterns of use changed. Mies achieved this in

9.5. *Mies van der Rohe, Metallurgy and Chemical Engineering Building, Illinois Institute of Technology, 1942–46. Mies developed a standardized module, framed in steel holding the protective concrete around the true internal structural steel columns; in the intervening bays, he used varying combinations of glass and brick depending on the internal activity. (Photo: Bill Engdahl, Hedrich-Blessing.)*

9.6. *Mies van der Rohe, Crown Hall, Illinois Institute of Technology, 1950–56. Only in Crown Hall for the School of Architecture did Mies deviate from the standard structural module. (Rosenthal Archive, Northwestern University.)*

9.7. *Crown Hall. Because the roof and ceiling are suspended from the huge external plate girders, the interior is one spacious all-purpose room, divided into office cubicles and drafting studios. (Rosenthal Archive, Northwestern University.)*

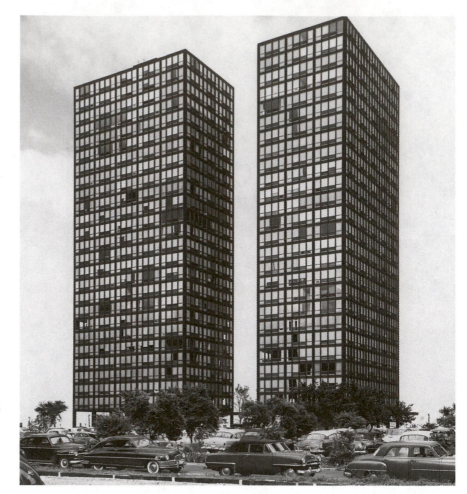

9.8. Mies van der Rohe, Lake Shore Drive apartments, 860–880 Lake Shore Drive, Chicago, Illinois, 1948–51. Seen here from the west (the lake is on the other side), it is apparent that the two Lake Shore Drive apartment buildings are identical. (Photo: © Wayne Andrews/Esto.)

9.9. 860–880 Lake Shore Drive apartments, site plan. The two identical towers are placed in an L within the trapezoidal lot; immediately east of Lake Shore Drive is the beach and the shore of Lake Michigan. (D. Rabbitt, after Mies van der Rohe.)

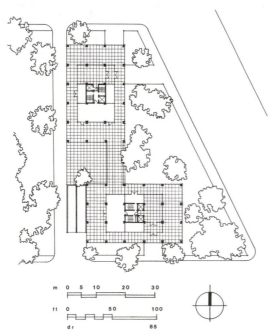

Crown Hall, built in 1956, in which the single internal space contrasts to his earlier compartmentalized campus buildings. [9.6, 9.7] Crown Hall is one large room, 120 by 220 feet, covered by a roof suspended from four immense transverse plate girders carried by eight major externalized structural columns. Between the horizontal roof and floor planes is a wall of glass. Two pipe chases break up the space of the room (these were necessary for plumbing flues and downspouts); aside from these and the small partitioned areas for offices and the two stairs leading to the basement classrooms, the vast space is uninterrupted. As did Wright, Mies wished to encourage a sense of community among the users of a building, but Mies did this by removing physical divisions altogether. His motto, "less is more," meant that through this simplification a better architecture would be created, one he believed was more realistically adapted to modern society and building methods.

The precision of detail developed in the early buildings for the Illinois Institute of Technology prepared the way for what may have been Mies's most influential buildings, his pair of apartment towers at 860–880 Lake Shore Drive, Chicago, built in 1948–51. [9.8, 9.9] Given a trapezoidal lot, Mies maintained geometric purity by using two identical rectangular slabs placed perpendicular to one another. The basic module is the bay of 21 feet, with each tower being three by five bays (nearly the golden section); each bay is further subdivided into four windows by intermediate mullions. At first it appears that one sees the actual structure, but the real structural columns are, in fact, encased by protective (and legally mandated) concrete inside this veneer of steel. The external steel plates actually made up part of the forms for the concrete. To this veneer, I-beams were welded both to brace the skin and to give the surface a third dimension, creating a play of light and shadow. What one sees, then, is applied ornament as symbolic structure.

Idealism pervades the complex. Each tower is raised on freestanding columns, with a small glass-enclosed lobby at the center of the ground floor, thereby deftly eliminating the variety of small shops that had once been accommodated in the bases of apartment blocks and that had come to be viewed as clutter (Belluschi had retained these ground-floor shops, however). While radiant slab heating was used with supplemental perimeter units, the psychological chill of winter was not lessened, and in the summer the apartments became hothouses since air-conditioning had not been included. Furthermore, lest residents break the perfectly symmetrical surface of the buildings, legal restrictions prohibited individual air-conditioning units that protruded from the wall. To maintain uniformity, standard gray draperies were hung at each window; behind these, should they care to, the residents might hang their own, but they could not remove the gray drapes. Originally Mies had planned large open spaces for the apartments—residential "universal spaces"—but was eventually persuaded by the developers to put in more conventional walls, subdividing the apartments into the usual rooms. The interiors, in fact, were not the most important feature of the buildings, wrote Arthur Drexler in a preface to the catalogue *Built in the USA: Post-War Architecture*. He argued that "an appraisal of 860 Lake Shore Drive, if it is to be relevant, should be concerned primarily with those abstractions of the building process which have preoccupied the architect."[8]

Finally, despite the varying orientations of the walls, and the widely differing thermal heat gains on the east, south, and west sides, there is absolutely no variation in the design of the four faces of the towers. They are fully interchangeable; these towers might be anything, anywhere, built for any purpose.

The Lake Shore apartments became the paradigm of aloof, anonymous freestanding glass boxes that began to appear in every American city, beginning with Bunshaft's Lever House and soon found in cities around the world. For one housing venture, however, Mies went beyond the image of the freestanding isolated tower, in a logical expansion of his IIT plan—Lafayette Park, a housing complex in Detroit, Michigan, designed by Mies in 1955 and built over the next eight years. It combines several multistory apartment towers with numerous two-story town house blocks, with shops and schools, dispersed in ordered irregularity over seventy-eight landscaped acres, with a nineteen-acre mall through the center designed by Ludwig Hilberseimer. Few such commissions came to Mies, but this single example helps to mitigate the exceptionally cold image presented by much of Mies's work.

Seagram Building

Frigid hauteur, of course, was exactly what was wanted by corporate clients, and the glass box immediately became the symbol of American business. Mies's Seagram Building, in New York, is the classic example. [9.10] Designed in 1954, in collaboration with Philip Johnson, it was finished in 1958. Basically it is similar to the Lake Shore apartments, but with several important differences. Though it too is raised on columns and has a glass-enclosed lobby, the need for additional space required a large service block to the rear. This extends upward along the back of the building to form a utility spine containing stairs, elevators, and washrooms. Consequently the upper floors have a plan in the shape of a stubby T, but from the front there is little hint of this; one is given the impression of a pure rectangular shaft. Attention is focused on the svelte tower, made all the more sheer by hanging the glass wall in front of the structural columns so that there is none of the complex varying rhythm of column and mullion seen in the Chicago towers. The elegantly uniform fenestration is of dark amber glass set in mullions of oiled bronze extrusions so that the building is a dense, opaque brown mass by day; its true transparency is evident at night when the internal lights turn it into a golden crystal. The original dark brown color of

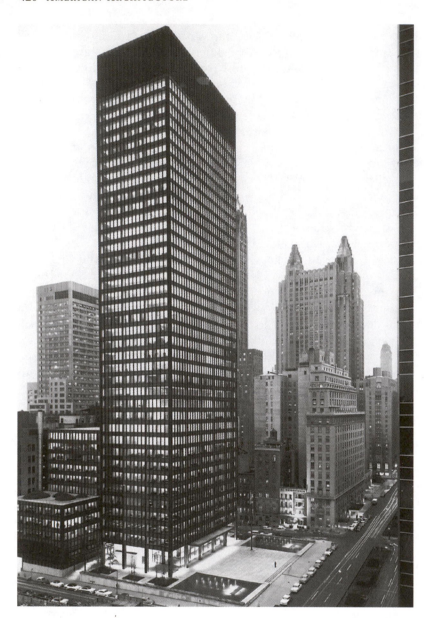

9.10. Mies van der Rohe and Philip Johnson, Seagram Building, New York, New York, 1954–58. Taking advantage of recent changes in zoning and building ordinances, Mies and Johnson created one big setback at the sidewalk, forming an open travertine-paved plaza, and shaping the building as essentially one unbroken rectilinear box; this photograph taken at dusk shows how utterly transparent to solar radiation this building is, and also suggests how freely heat leaks from the building during winter nights. (Photo: Ezra Stoller © Esto, courtesy of Philip Johnson.)

the bronze was rigorously maintained by the Seagram company, which keep it oiled and waxed as part of the annual program of window washing. The surface of the bronze, of course, would normally be transformed into copper sulfate by exposure to the atmosphere, forming the green patina customarily seen on bronze statuary and copper rain gutters. In the Seagram Building, however, this natural process is perpetually postponed; the aging process is defeated.[9] To be allowed absolute geometric purity within New York zoning regulations, Mies pushed the tower far back from Park Avenue, opening up a large travertine paved terrace with twin fountains. In this way he satisfied

municipal regulations with one single setback, lost a few square feet of rentable space, and, with the elegant building materials, achieved an unmatched regal corporate image. It is significant that in its exacting attention to structure, color, and sensual delight, the Seagram Building manifests a highly focused artistic energy that previously had been employed solely for buildings of the church or government.

Skidmore, Owings, & Merrill

Of the countless architects who took up the Miesian idiom, perhaps none was more energetic or more inventive than Louis Skidmore, Nathaniel Owings, and

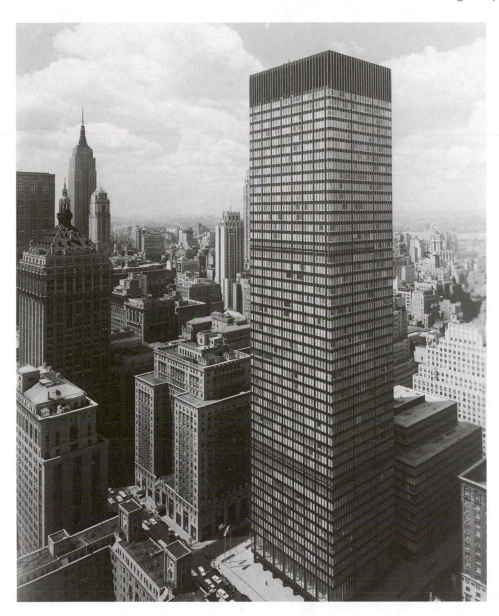

9.11. Skidmore, Owings,
& Merrill, Union Carbide
Building, New York,
New York, 1957–60.
Also placed back from
the sidewalk so it can rise
unbroken, SOM's Union
Carbide Building uses
columns projecting in front
of the window plane.
(Courtesy of the Union
Carbide Company.)

John Merrill. Their partnership had begun in 1936, and their early designs showed technological inventiveness and purity in advance of Mies's coming to Chicago. For example, in the Main Reception Building of the Great Lakes Naval Training Station, in Great Lakes, Illinois, built in 1942, Skidmore, Owings, & Merrill used inverted laminated wood trusses on narrow steel columns to support a broad shed roof. To this efficient use of industrial materials was added a marked organizational ability that enabled SOM to plan and build Oak Ridge, Tennessee, between 1942 and 1946, accommodating a population that went from zero to 75,000 people in just four years.

The SOM office staff grew steadily; by 1970 the firm comprised one thousand architects, twenty-one general partners, and forty-five associate partners in offices in Chicago, New York, San Francisco, Portland, Oregon, and Washington, D.C. National and international recognition came to the firm in 1952 with the completion of Lever House, and one of the firm's major contributions during the next fifteen years was the creation of a generic glass tower type for corporate headquarters, examples of which are the Crown Zellerbach Building in San Francisco, built in 1957–59, the Chase Manhattan Bank in New York, built in 1957–61, and the Union Carbide Building in

New York, built in 1957–60; the last example is, in its externals, the 860–880 apartments on an expanded scale. [9.11] Some of their smaller Miesian buildings are more hospitable and engaging, such as their Manufacturers Hanover Trust, in New York, built in 1953–54, which Lewis Mumford praised, calling it a crystal lantern.[10] [9.12] It is only four stories tall, its top marked by a balcony and a visible penthouse structure. The lower two floors house the banking space, while the shorter upper floors house offices. To connect the two banking floors visually the mezzanine floor is held well back from the glass curtain wall so that from the street, as well as from within, one senses the single space divided by the insertion of the mezzanine tray. From the street, too, one can see the escalators connecting the two levels and the massive vault door on the ground floor, so positioned that when it is swung back against the vault wall during the day its jewel-like polished internal machinery can easily be seen from Fifth Avenue. Total visual accessibility is the theme, for the image of the bank had changed from that of an opaque strongbox, keeping cash reserves inviolate, to that of a merchandising center where credit is sold in a competitive market. This mid-twentieth-century bank became a transparent lure, an advertisement.

The Giant Office Towers

During the mid-1960s the nature of urban economics changed. The twenty-one stories of Lever House were dwarfed as new buildings commonly reached heights of fifty to sixty stories in an effort to keep ahead of soaring costs and taxes. Nearly all the new giants were variants of Mies's deceptively simple-looking towers; most were mediocrities bereft of any sense of pleasure in their creation and providing little or no reward for close inspection. There appeared several enormous towers by SOM, one of which did possess at least some measure of aesthetic sensibility—the John Hancock Center, in Chicago, built in 1965–70. [9.13] William E. Hartman was the partner in charge, with Bruce Graham the chief designer, Fazlur Khan the structural engineer, and many other principals involved in the complex design. The project was an unusual combination (for the time) of business and residential uses on a relatively small lot on Chicago's north side. When problems arose in fitting all of the services on the lot it was decided to simply stack one atop the other, creating a single shaft of one hundred stories, 1,107 feet tall. Beginning at the plaza level, which contains a restaurant, skating rink, and miscellaneous shops, the building has five commercial floors for a large department store and a bank, seven floors for parking, twenty floors of office space, two mechanical floors, a double-level "sky lobby" with shops and a swimming pool. Above this are forty-eight floors of apartments ranging from efficiencies to four-bedroom units, concluding at the top with an observatory at the ninety-fourth floor, a double-level restaurant and bar, and four mechanical floors. One might note, however, that no visual clues indicate these internal changes in use.

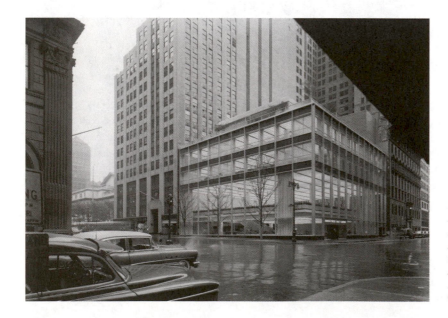

9.12. *Skidmore, Owings, & Merrill, Manufacturers Hanover Trust, New York, New York, 1953–54. Although not a glass tower, this relatively small transparent box seems a jewel of international Modernism. (Photo: Ezra Stoller © Esto.)*

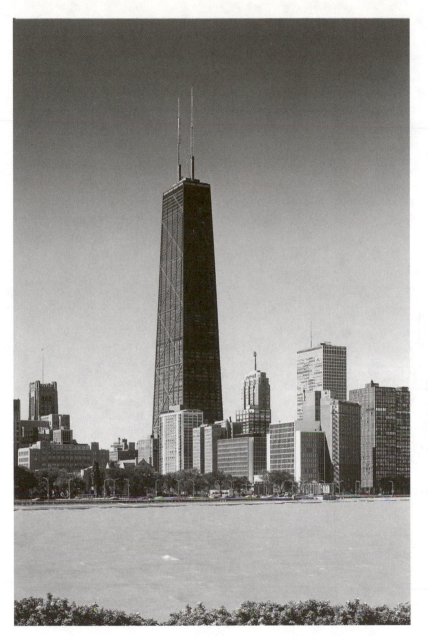

9.13. Skidmore, Owings, & Merrill, John Hancock Center, Chicago, Illinois, 1965–70. This photograph presents three generations of skyscraper-building in Chicago: to the right and behind the Hancock tower is the setback top of the Palmolive Building by Holabird & Root, 1928–29, and far to the right are just visible the Lake Shore Drive apartments by Mies van der Rohe, 1948–51. (Photo: Hedrich-Blessing, courtesy of Skidmore, Owings, & Merrill.)

Such height, given the slender proportions of the tower and the treacherous winds off Lake Michigan, precluded traditionally braced steel frame construction because the necessarily large amounts of steel would have consumed too much space and drastically increased the total weight and cost. Graham and Khan therefore decided to view the tower not as a braced frame but as a rigid tube securely fastened at its base, a form of vertical cantilever. Hence the cross-braced tapered sides, with all members so fastened together that they carry all of the gravity and wind loads and

thus free the interior of any structural elements except utility core and elevator shaft—Mies's universal spaces piled nearly a quarter of a mile into the air. The tower's mixture of uses and the provision of internal shops makes this a true city within the city. Happily this megastructure is divided into comparatively easily perceived visual units by the cross braces, and the tapered silhouette gives the prism a distinctive individual grace.

The same, unfortunately, was not so true of the Sears Tower, in Chicago, also by SOM, built in

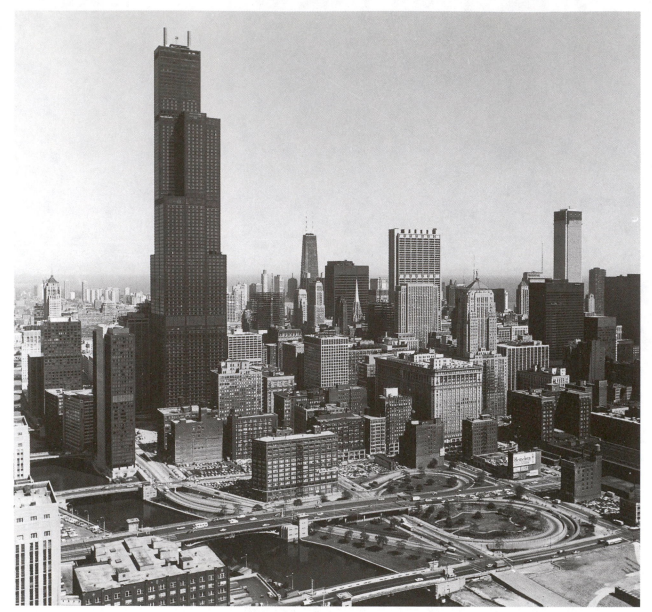

9.14. *Skidmore, Owings, & Merrill, Sears Tower, Chicago, Illinois, 1970–74. The great black bulk of the Sears Tower dominated the western edge of Chicago's downtown. (Photo:* *c. 1975 Hedrich-Blessing, courtesy of Skidmore, Owings, & Merrill.)*

1970–74. [9.14] A bigger building in footprint, this uses not one but nine clustered rigid tubes, each approximately 75 feet square, to achieve column-free interior spaces. Instead of combining many uses, so as to distribute traffic patterns and to minimize periodic congestion, the Sears Tower is wholly devoted to office space, nearly 4 million square feet, enough room for sixteen thousand workers including the seven thousand Sears employees. The original propos-

als prepared by the Sears company called for 104 stories, but under corporate pressure to surpass the Hancock tower, for the supremacy in height the architects redesigned the upper portion, trimming away some volume here and there and piling it up elsewhere to gain another six stories for a total height of 1,454 feet. The only apparent criterion was that this be the tallest building in the world, not necessarily the best or the most beautiful as had been the case with the

Tribune Tower in 1922. To minimize maintenance the building was sheathed in black aluminum, which, with the smoked gray glass, gives the building an ominous appearance. Structural and architectonic articulation was kept to a minimum, making this one of those unique buildings that gets distinctly less interesting the closer one comes to it. Given the prevailing economic conditions in most cities, this seemed to be the only kind of new building that appeared economically feasible for a time.

Other giants built during this period were the Standard Oil Building, in Chicago, of 1970–74, with 80 stories at 1,136 feet (by Edward Durrell Stone with Perkins & Will), and the twin towers of the World Trade Center, in New York City, of 1966–80, with 110 stories at 1,350 feet (by Minaru Yamasaki with Emory Roth & Sons). In terms of scale, elegance of form, and relationship to the street, perhaps the very best of the giants was the First National Bank Building, in Chicago, built in 1964–95. Given a curved taper, its 60 stories rise 850 feet; the architects were C. F. Murphy with Perkins & Will, Lawrence Perkins acting as conceptual designer.

The reasons for this megalomania were many. One was the desire to open up yawning plazas at street level (meaning more floors had to be piled on top of one another). Another was the presumptuous and arrogant hubris of building the tallest building, at almost any cost. Until someone else built something taller there was a certain public relations value to this stratagem, but it was ultimately a losing game. In part this compulsion for ever greater height arose because, given the general anonymity of Modernism, the only way to distinguish a new corporate headquarters was to make it taller than its neighbors; so the style tended to encourage a drive for the clouds and beyond.

Another reason (and the one most openly admitted) was the geometric increase in urban land taxes required by growing demands for municipal services; taxes in turn were exacerbated by the diminishing tax base as more and more land in the urban core was converted to public use. An example of this conversion is the Civic Center in Chicago, containing the Chicago city and Cook County courts; to provide space for this an entire city block was cleared. Architecturally, however, it is a splendid building, the aesthetic and structural high point of the Miesian idiom. [9.15] Jacques Brownson of C. F. Murphy Associates was in charge, working in collaboration with two other architectural firms, SOM and Loebl, Schlossman, & Bennett. The initial studies were made

in 1959, the final design prepared in 1962, and the building finished in 1965. The program was unlike that for the typical office building since this was to contain hearing rooms, conference rooms, judicial chambers, and 120 courtrooms, some of which were to be two stories high. Because of these requirements, the building has only 31 stories yet they rise 648 feet, with a floor-to-floor height of 18 feet. To maximize flexibility the bay width was fixed at an unprecedented 49 by 87 feet, requiring a floor structure nearly 6 feet deep. Accordingly, the cruciform external steel columns carry great weight, indicated visually by the increase in cross section at three points along their

9.15. C. F. Murphy Associates, with Skidmore, Owings, & Merrill, and Loebl, Schlossman, & Bennett, Civic Center (now the Daley Center), Chicago, Illinois, 1959–65. Because of the unusual spatial requirements of the courtrooms inside, the structural bay had to be made extraordinarily large so the rooms had no interior columns. In the distance at the right edge are the Marina City Towers by Bertram Goldberg. (Photo: c. 1966–70 Hedrich-Blessing.)

height. For the external members the architects selected a newly developed steel that forms a tenacious oxide coat similar to the way aluminum acts; its color gradually changes from rust to a deep bluish brown. This color scheme is complemented by amber-tinted glass. In the expansive plaza south of the building there was placed a large sculpture in the same steel, designed by Picasso with an enigmatic image that has made the otherwise barren plaza an urban place.

The pristine Miesian glass-clad rectilinear tower thus became the symbol of the postwar period, its mythical functionalism applied indiscriminately. Though the architectural ideal of Mies's youth was realized, the reformed society did not follow. What Mies had originally intended were isolated glass monoliths reflecting both neighboring older buildings and glimpses of the surrounding landscape; what had been envisioned as singular freestanding buildings quickly became a pervasive urban cliché. In postwar cities, as more and more traditional brick and stone buildings were replaced, and particularly after mirrored glass appeared in common use after 1970, the vacuous glass boxes stared at each other blankly, reflecting only each other.

The Domes of Buckminster Fuller

Always difficult to categorize, R. Buckminster Fuller (1895–1983) made a highly individual contribution to the development of American Modernism. After production of his earlier metal houses and automobile was stifled by entrenched business interests in the 1920s and 1930s, Fuller turned his attention to developing structural systems composed of relatively small parts but capable of great extension. The result was a technique of dome construction that he called "geodesic," a system of construction requiring minimal material used to maximum efficiency, what he called a "minimal dimensional energy system," achieving "more with less." His system was used to build a dome at the Ford River Rouge plant outside Detroit in 1953, and was also used for the domes protecting the Distant Early Warning radar installations along the Arctic Circle in 1954. Other domes followed, for a restaurant in Woods Hole, Massachusetts; for the Union Tank Car Company, in Baton Rouge, Louisiana; and the Botanical Garden of Saint Louis, among others. Fuller even proposed an enormous dome to cover virtually the whole of Manhattan. Perhaps his best-known dome was that built for the United States pavilion at the Montreal Expo, in 1967, 250 feet in diameter and 200 feet high. [9.16] The basic unit was a hexahedron of steel tubing, glazed with gray-tinted plastic acrylic panels that were graduated from clear at the bottom to a dark tint at the top. Inside the dome was an openwork of escalators and platforms holding the exhibits. Thermal control

9.16. R. Buckminster Fuller, U.S. Pavilion, Montreal Expo, Montreal, Quebec, Canada, 1967. Pursuing his objective of enclosing the maximum space with the minimum material, Buckminster Fuller devised the geodesic dome made up of many identical small structural parts; in this example, he added adjustable shades in each faceted bay, controlled by computer, to provide internal shade from the sun as it moved over the course of a day. (Photo: Ilse Friesmen, courtesy of R. Buckminster Fuller.)

9.17. *Harwell Hamilton Harris, Ralph Johnson house, Los Angeles, California, 1949–51. The relaxed plans of Harris's California houses and the clearly apparent framing of heavy timbers gave the houses an informality that helped define the California lifestyle. (Rosenthal Archive, Northwestern University.)*

of the bubble was provided by remote-controlled vents at the top and by a sophisticated system of blinds on rollers (part of the hexahedral frames), which were unrolled by motors controlled by a punched-tape computer program designed to follow the movement of the sun during the course of a day. Fuller's view was cosmic, and although his writings suggested ways in which man, the machine, and the environment might exist together in harmony, Fuller's buildings had only limited applications.

THE MODERN HOUSE

The private residence also underwent a conversion to Modernism although the lean and sometimes spartan modern style never became as generally popular for middle-class houses as did the revival styles of the period from 1910 through the 1920s. Wood remained the material of choice, most often within sloping—not flat—roofs. The earliest examples came just before the war, largely on the West Coast. They included a compact house in Fellowship Park, Los Angeles, built in 1935, by Harwell Hamilton Harris; the elegantly restrained Aubrey R. Watzek house, in Portland, Oregon, built in 1937, by John Yeon; and the Dunsmuir Apartment Flats, in Los Angeles, built in

1939, by Gregory Ain.[11] The West Coast was to be a kind of proving ground for the modern house. This cause was championed by John Entenza in *Arts and Architecture*. Hoping to encourage more innovative and progressive designs after the war, in 1945 Entenza worked with a number of architects to build "case study houses" that were then published in the magazine. These included designs by Richard Neutra, Charles Eames, and Raphael Soriano, among others.[12]

Harwell Hamilton Harris (1903–5) continued his development of the modern residence after the war. A native of California, Harris had grown up in Redlands, and knew the work of the Greenes as well as Wright's Barnsdall house. His early professional experience was in the office of Richard Neutra in Los Angeles. The parallels to Wright's work can be easily seen in the Ralph Johnson house, in Los Angeles, built in 1949–51. [9.17] Given a challenging sloping site, Harris stepped the three levels of the house using the garage as terrace for the living room. This and the interlocking pinwheel plan recall the flexibility of Wright, as does the three-foot grid. The exposed timber frame, the highly articulated roof structure, and the natural finishes, however, acknowledge a debt to the Gamble house and to the Orientalism of the California coast.

Among the houses most sensitive to materials and to site were those designed by John Yeon and Pietro

Belluschi in the region around Portland, Oregon, just before and after the war (up to the time Belluschi was appointed dean of the School of Architecture at MIT, in 1951). The houses that the two had begun to design in the late 1930s were among the most refined and sensitive of the period. They combined the direct expression of wood with natural finishes, the clarity and openness of space of Asian architecture, with the simplicity and directness of form of Oregon barns (which they actively sought out and studied), making these houses free of the preciousness that sometimes appears in the work of Wright or the Greene brothers. This developing Pacific Northwest regional Modernism can be seen in Belluschi's Peter Kerr beach house at Gearhart, on the Oregon coast, built in 1941[9.18], which incorporates a sun-bleached tree trunk as a porch column, seeming to make a reference to Arthur Little's shingled James L. Little house, in Swampscott, Massachusetts, of 1882. Belluschi's flexible openness of space is best seen, perhaps, in the D. C. Burkes house, perched high in the west hills overlooking Portland. Plans were begun in 1944 but serious work was not undertaken until 1947–48. Built for a doctor and his wife, the house is compact, with the owners' bedroom and a guest room and kitchen placed on either side of a large general space that is subdivided by the rough stone chimney mass into dining, living, and study areas.

The other area in which Belluschi specialized was church design, with numerous examples dispersed around the Pacific Northwest. In these, too, he exploited the use of wood, employing exposed wood trusses and also specifying the new curved laminated beams, as in the Zion Lutheran Church, in Portland, built in 1947–50. In some respects Belluschi's decision to exploit local products and technology, and the resulting delicate and intricate wood structures, parallels the work of Alvar Aalto in Finland at this time. Indeed, Belluschi's Central Lutheran Church, in Portland, of 1948–50 [9.19], might be fittingly compared to Aalto's civic center for Säynätsälo built in 1950–52.

In California Richard Neutra built houses less reliant on local materials, more impersonal in character, with the sharp planar geometries of the International Style, but as well attuned as Belluschi's to local climate and landscape. The "Desert House" for Edgar Kaufmann, near Palm Springs, built in 1945; the Moore house at Ojai, built in 1952; the Perkins house, in Pasadena, built in 1955; and the Singleton house, in Los Angeles, built in 1960—all show a remarkable adaptation to the desert and arid climatic conditions; all incorporate pools of water for swimming, for the cooling air, and for their purely psychological cooling effect.

The masters of European Modernism had relocated to the United States just before the outbreak of the

9.18. Pietro Belluschi, Peter Kerr house, Gearhart, Oregon, 1941. In the Kerr beach house, Belluschi pulled the building close to the dune and used exposed wood, which weathered to silvery gray. (Rosenthal Archive, Northwestern University.)

9.19. *Pietro Belluschi, Central Lutheran Church, Portland, Oregon, 1948–50. One of Belluschi's special concerns was the design of churches that also exploited wood, as in the open work of the tower of Central Lutheran. (Rosenthal Archive, Northwestern University.)*

war, but their impact in the area of house design was largely delayed until after the war. Both Gropius and Breuer had emigrated from Germany early in the 1930s, passing first through England. Gropius arrived in the United States in 1937 and assumed the position of professor of architecture at Harvard, where he helped to shape an entire generation of American architects (Philip Johnson and Paul Rudolph, for example, studied there during the 1940s). Gropius invited Breuer to join him on the faculty, for since the 1920s they had been colleagues, first at the Bauhaus and then in London. The two complemented each other in many ways, for Breuer's intense study of detail and construction techniques balanced Gropius's more sweeping planning approach. At first Gropius and Breuer maintained a partnership in Boston, but eventually Breuer withdrew to establish his own practice in New York. The two had collaborated in the design of the New

Kensington housing project during the war, and even on a weekend house for Gropius himself at Lincoln, Massachusetts, in 1937. Their best collaborative work is seen in the exquisitely simple weekend house for Henry G. Chamberlain, at Wayland, Massachusetts, built in 1940. To this same theme Breuer returned in 1947 when he built for himself a weekend home in New Canaan, Connecticut. The house has the simple cubical clarity of Breuer's early work combined with a new expression of materials. It is basically a box of wood, roof slightly sloped, with a boldly projecting terrace; it is lifted free of the earth on a masonry pedestal. Each element is defined as crisply as possible; the siding is turned on the diagonal to indicate its function as bracing and the frankly revealed diagonal cables supporting the terrace accentuates, by contrast, the sharp rectilinearity of the house. As with his furniture of the 1920s, this house showed Breuer to be a master of design on a small scale.

Two Glass Boxes

During the 1940s and 1950s the arch-advocate of Miesian purism in the United States was Philip Johnson (born 1906). He had been an admirer of Mies since the 1920s, and had met Mies in Germany in 1930, writing in a letter that "Mies is the greatest man we or I have met. . . . He is a pure architect."[13] Johnson even commissioned Mies (and his close associate Lilly Reich) to design interiors of his own apartment in New York. In 1932, in collaboration with Henry-Russell Hitchcock, Johnson wrote *The International Style* to accompany an exhibition at the Museum of Modern Art focusing especially on the work of Mies and the other European modernists. The title of the exhibition came to define the style of a generation, and the characteristics Hitchcock and Johnson delineated have ever since been the determining elements of the International Style: architecture as volume and space (rather than mass); the reliance on light metal or concrete frames; free plans purportedly determined by function; the use of thin wall membranes of glass, metal, or stucco; a preference for ribbon windows; the use of minimal texture in preference for smooth industrial materials; and regularity of cubic forms in an absolute avoidance of bilateral symmetry.[14] Soon after, Johnson was appointed to the Department of Architecture and Design of the Museum of Modern Art, eventually becoming its director. Later, while at the museum in 1947, Johnson published one of the first monographs on Mies.

As much as Johnson enjoyed being enfant terrible and arbiter of avant-garde taste, he also wanted to become a practicing architect and so in 1940 he entered the architectural program at Harvard, studying with Gropius. While in Cambridge he built for himself a small house featuring a wall entirely of glass, an idea he expanded in his famous "Glass House" in New Canaan, Connecticut, built in 1945–49, which marked the beginning of his career. This was soon followed by equally purist designs such as the Rockefeller guest house, in New York, built in 1950; or the Robert Leonhardt house on Long Island, built in 1956.

Mies's work can be fairly simply divided into multistory high-rise towers and low single-space designs. The latter were essentially the progeny of his Barcelona Pavilion of 1929, each one more simple and abstract, each a further demonstration of "less is more." The culmination of this process was the weekend house for Dr. Edith Farnsworth at Plano, Illinois, designed in 1945 but not built until 1950–51. [9.20, 9.21] Here the universal space is condensed and mod-ified to domestic scale. Because the rural site was large and screened from view by trees, Mies could use walls entirely of glass. Moreover, since the Fox River was subject to spring floods, the house had to be raised off the ground. Basically the house consists of two rectangular slabs measuring 29 by 77 feet, parallel to the ground. They are supported by eight steel columns, four to a side; each bay is 22 feet wide, leaving about 5 feet cantilevered at each end, a very efficient structural arrangement. One full bay at the end is an open veranda; the other bays are enclosed by great sheets of glass. Within this glass box is a single room interrupted by a rectangular utility core that houses a kitchen counter, bathrooms, flues, and a fireplace. By placing it off center toward one corner Mies divided the large room into unequal areas that serve as bedroom, kitchen, dining area, and living room. What characterize the house in particular are the exacting refinement of the design and the equally precise construction. Each of the eight columns was welded to the face of the horizontal edge beam, the weld seams ground down to a perfect fillet, the whole frame then sand-blasted, sprayed with zinc, and finally painted white with such care that the steel seems to be enameled; the end result is that no visual trace remained of its assembly. The floor is laid in travertine panels, measuring 2 feet 1 inch by 2 feet 9 inches, making the basic modular grid. The locations of the glass walls and the utility core, and even the position of the pieces of furniture, are seemingly dictated by this grid. The materials are commensurately elegant; besides the travertine flooring, the utility core is paneled in light yellow primavera wood, and the curtains are of raw silk. The house hovers in the air, seeming to disdain the ground; its purity and abstraction contrast sharply to the irregularity and unpredictability of the landscape. In many ways it is not designed to be a home at all but the realization of an architectural ideal, existing somewhere between the world of things and the world of dreams.

Compared to the Farnsworth house from which it was derived, the Philip Johnson house in New Canaan reveals how Mies's absolute purism was modified by an American architect. Johnson had contemplated building a house of glass since seeing Mies's Resor house project and, as has been noted, had actually built a small version in 1941–42 while living in Cambridge, with one wall entirely of glass. Johnson acquired five acres of heavily wooded land in New Canaan in 1946, although he seems to have already made sketches of a house with walls entirely of glass.[15]

9.20. *Ludwig Mies van der Rohe, Dr. Edith Farnsworth house, Plano, Illinois, 1945, 1950–51. Because the Fox River (just beyond the trees) often floods during the spring thaw, Mies raised this weekend house off the ground; although the* reason was purely practical, the end result nonetheless makes *the pure whiteness of the house seem separated from nature. (Photo: Bill Hedrich, Hedrich-Blessing.)*

9.21. *Farnsworth house, interior, viewed from the open porch. Reduced to the essentials, the Farnsworth house is a single volume, enclosed by enormous sheets of glass, between a floor slab (paved with travertine rectangles) and a flat* ceiling slab; the single space is subdivided by a single offset *mass that houses bathroom, fireplace, and kitchen workspace. (Rosenthal Archive, Northwestern University.)*

9.22. Philip Johnson, Johnson "Glass House," New Canaan, Connecticut, 1946–49. Conceived after seeing Mies van der Rohe's Farnsworth house plans, but finished and occupied before the Farnsworth house, Johnson's retreat in New Canaan is a similar glass-enclosed volume, but with important differences, such as the way it connects with the ground. (Photo: Alexandre Georges, courtesy of Philip Johnson.)

9.23. Johnson Glass House, plan. The single space in Johnson's Glass House is subdivided by the brick cylindrical mass of the fireplace/bathroom and a low cabinet/divider. (Courtesy of Philip Johnson.)

9.24. Johnson Glass House, interior. Instead of the prescriptive grid of the floor of the Farnsworth house, Johnson's floor is made up of a nondirectional herringbone brick pattern. (Photo: Bill Maris, © Esto, courtesy of Philip Johnson.)

After Mies showed him the designs for the Farnsworth house in that same year, Johnson began making definitive plans for his own house. Once land was acquired, the house was built and completed in 1949, just as construction belatedly began on the Farnsworth house. [9.22] Aside from the clear similarities—most obviously walls entirely of glass—there are a number of significant differences. Instead of being lifted free of the ground, the Johnson house is placed directly on the ground on a low brick base, roughly centered within a polygon-shaped terrace at the edge of a gentle hill. Doors on each of the four sides provide ventilation and give access to the tree-shaded lawn; Mies had only one door and one movable pane for ventilation. The Farnsworth house is determined by a modular grid to which everything is compulsively fixed, but Johnson's approach was somewhat more intuitive. He began with a simple rectangle with a width to length ratio of 1:1.75 (nearly the golden section). [9.23] The floor of this rectangle is of brick laid in a herringbone pattern so that there is no grid but rather a nondirectional, nonproportional field on which anything can be arranged (he has in fact often changed the arrangement of the furnishings). [9.24] Instead of a precisely aligned rectangular core, Johnson employed a bold brick cylinder to house the fireplace and bathroom; its placement is intuitive, not mathematical. Johnson later noted that the dramatic mass of the fireplace/bathroom cylinder was inspired by ruins he saw in Europe at the end of the war. Where Mies placed the structural columns outside the glass envelope, using the thinnest of symmetrical mullions at the corners, Johnson made the corner supports both columns and mullions, resulting in a complex asymmetrical corner articulation. [9.25] At one point, when Mies and Johnson were beginning to work on the Seagram Building, they had a heated argument regarding the corner detailing, with Mies saying that obviously Johnson did not know how to turn a corner.[16] If Mies represents High Renaissance precision, then Johnson represents Mannerist variation.

The cylindrical core, in particular, illustrates two marked departures from Mies's astringent purism. First, Johnson introduced a circle into a rectilinear scheme, a fillip Mies avoided since he said he had not yet perfected the straight line. Even more significant is the huge fireplace, for it throws into sharp relief one of the seven design crutches Johnson liked to ridicule—comfort. In a tongue-in-cheek talk with architectural students at Harvard in 1955, Johnson said that modern architects let ventilation engineers

9.25. *Johnson Glass House. Whereas the corners of the glazing in the Farnsworth house are made up of small metal angles, Johnson devised a complex, asymmetrical arrangement that also incorporates the structural steel* **H** *column. (Courtesy of Philip Johnson.)*

dictate the architectural environment as though a constant temperature of seventy-two degrees were sacrosanct. To them fireplaces are anathema because they throw thermostats off. Johnson said he preferred the beauty of the fireplace; he preferred to light a great fire, turn the thermostat down, and move back and forth to control his warmth. "Now that's not controlled environment," he admitted. "I control the environment. It's a lot more fun."[17] Mies used curtains to curb sunlight in his Farnsworth house, whereas Johnson was able to avoid them by a much simpler and more natural means, exploiting the large broadleaf trees around his house as sun screens. In the summer, especially in the afternoon, these prevent sunlight from penetrating the glass box (thus avoiding the hothouse effect), but on winter afternoons the light filters through the bare branches and warms the house.

A further departure from the implied axiality of the Farnsworth house was the arrangement of the main house and the nearby guest house to force an oblique approach creating a processional element that Johnson came to stress more and more. One might compare this, for instance, to the angled approach path Johnson choreographed up the hill to the Kline Biology Tower at Yale University. Still, for all its mannerist nuances, the Johnson house represents an exclusivist position, even if marginally more liberal than Mies's Farnsworth house.

FORM FOLLOWS FORM

Both the Johnson Glass House and the Farnsworth weekend house were ideological constructs, expressions of design ideals rather than houses to live in comfortably. In miniature they manifested the exclusivist approach of the canonical modern style, eliminating or hiding certain elements for the sake of purity of form. But even as this ascetic industrial idiom was beginning to take over the corporate world in the early 1950s, there was a reaction in favor of symbolism in building design. Refuting the claim made by many architects that their forms were dictated by function, other architects asserted that design was an art and that building form just as often arose from an artistic impulse. Matthew Nowicki, the Polish architect, newly resettled in the United States, put it bluntly: "We have to realize that in the overwhelming majority of modern design form follows *form* and not *function*."[18] [9.26] Surprising to some, perhaps, was the contemporaneous call by critic Lewis Mumford for a new humanistic symbolism and monumentality in modern architecture. In the late 1950s Mumford wrote of the abuse of the grand public spaces of Pennsylvania Station, and he also began to attack the public mania for freeway building.[19]

One architect, Frank Lloyd Wright, had never abandoned the use of form for its own expressive force. While Mies had been perfecting the technology of the rectilinear steel frame, Wright had probed the mysteries of the helix. In 1925 Wright had designed the Gordon Strong Automobile Objective and Planetarium, in which two spiral ramps wound around the outside of a hemispherical concrete dome. In the V. C. Morris Gift Shop, in San Francisco, California, built in 1948, Wright used an internal helical ramp to wrap and define the store's display space. This experimentation culminated in 1943–45 in the first design for the Solomon R. Guggenheim Museum in New York. During the next nine years the design was restudied and refined; construction began in 1956 and the building was dedicated in October 1959, six months after Wright's death. [9.27, 9.28, 9.29]

For the Guggenheim Wright used a helix that expanded as it rose, forming a pedestrian ramp in which the gallery became a single continuous spatial experience. Instead of traditional closed gallery rooms, Wright devised a single space that one glimpses from the bottom on entering but that is not fully revealed until one takes the elevator to the top of the spiral and begins the winding journey down the ramp. Unlike Wright's Prairie houses, which open out onto the landscape, the Guggenheim Museum seems turned in upon itself, having little relationship with Central Park or Fifth Avenue, yet the idea grew out of earlier inverted designs, such as the Larkin Building, of 1903; Unity Temple, of 1904; the project for the Spaulding Print Gallery, in Boston, of 1919; the Johnson Wax Administration Building, of 1936; and the Morris Gift Shop. As in each of these buildings, in the Guggenheim Museum Wright sought to make of the disparate inhabitants a "family" who viewed themselves across the room as they moved down the ramp. In choosing the spiral ramp, however, Wright introduced numerous problems.

The reinforced-concrete shell he wanted poured in one operation was unlike the structure of any building

9.26. *Matthew Nowicki and William Henley Deitrick, State Fair and Exposition Building (later J. S. Doreton Arena), Raleigh, North Carolina, 1950–53. One of his few buildings designed before an untimely death, Nowicki's Exposition Building used intersecting inclined concrete parabolic arches as an armature for suspended cables holding the roof; this dramatic form-making coincided with Nowicki's written call for allowing form to follow form and not be dictated by unimaginative functional thinking. (Author's collection.)*

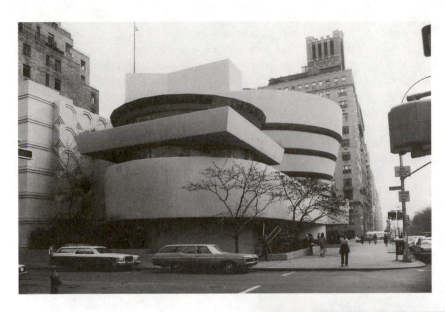

9.27. Frank Lloyd Wright, Solomon
R. Guggenheim Museum, New York,
New York, 1943–45, 1956–59.
*Instead of trying to make his museum
blend into the urban setting, Wright
turned his back on the context and
focused the museum inward, shaping
the exhibition space as a gigantic
helical ramp that expands as it rises.*
(Photo: L. M. Roth.)

9.28. *Guggenheim Museum, New York,
interior. As with so many of Wright's
buildings, both residences and public
buildings, one enters through a tight,
dimly lit area into the primary space that
suddenly expands and rises to the light.*
(Photo: L. M Roth.)

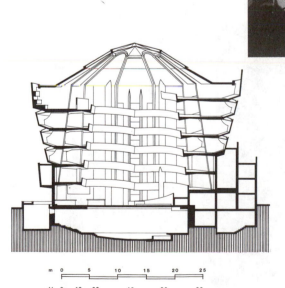

9.29. *Guggenheim Museum, New York,
cross section. Seen in cross section, it
becomes evident how the spiral ramp
expands in width as it rises, creating the
impression of even greater height
through forced perspective when one
looks up from the main floor.*
(L. M. Roth.)

ever built before, and at every turn it seemed he violated some provision of the conservative New York building code. It was largely for these reasons that the design had to be carefully studied and revised during the period from 1945 to 1956. Wright was determined to see this built, as was his contractor, George N. Cohen, who suggested many modifications to satisfy code requirements. Also important in solving the numerous problems were Professor Mendel Glickman and Wright's assistant William Wesley Peters. One of the problems they faced was an inability to build complex, intersecting rounded forms with smooth transitions; the result was sometimes awkward junctures. Wright had originally hoped to use exposed marble aggregate but this had to be changed to smooth painted surfaces whose irregularities were consequently exaggerated. Furthermore, the necessity of using flat plate glass in faceted segments conflicted with the otherwise smooth circular continuities of the concrete elements. Perhaps it is too easy to cite its faults; the Guggenheim Museum is a masterwork, a realized dream of unified space and purpose, an assertion of continuous movement and quest, and the visible record of human perseverance in the face of seemingly insurmountable obstacles. As a refutation of virtually every convention of museum design and of a building industry hidebound by the rectilinear grid, the Guggenheim Museum was a fitting end to Wright's long, unique, and individualistic career.

What Wright suggested in the Guggenheim Museum was that architecture was a potent vehicle for conveying expression and a powerful psychological force, functions that the adherents of Miesian purism disavowed and largely ignored. In restoring to mid-twentieth-century architecture something of its traditional mystical and psychological symbolism, Wright was joined by Eero Saarinen (1910–1961). Saarinen, the son of the second-place winner in the Tribune Tower competition, was born in Finland. At the age of thirteen Eero came to the United States when his father reestablished his family in Michigan. In Bloomfield Hills, Eliel was designing a series of schools and institutes, including the Cranbrook Academy, one of the most influential art schools in the country; among its faculty were Carl Milles, Charles Eames, and Harry Bertoia. Eero grew up in a home devoted to architectural design in its broadest interpretation, for his mother, Loja, was a weaver and designer who collaborated closely with her husband. Eero earned an architectural degree at Yale in 1931–34 at a time when it was still a stronghold of Beaux-Arts academicism. From this combination of familial and academic influences came a desire for an architecture that was both total in scope and consummately crafted, that simultaneously celebrated craft, utility, *and* symbolic function. Saarinen's would be a heroic, monumental architecture, but one freed of the literary and archaeological conceits of the previous two centuries.

9.30. *Ludwig Mies van der Rohe, Chapel, Illinois Institute of Technology, Chicago, Illinois, 1949–52. Symbolically indeterminate, the chapel's function is indicated only by the presence of the cross inside; the building employs the same building materials and expression as all other campus building by Mies. (Photo: Hedrich-Blessing.)*

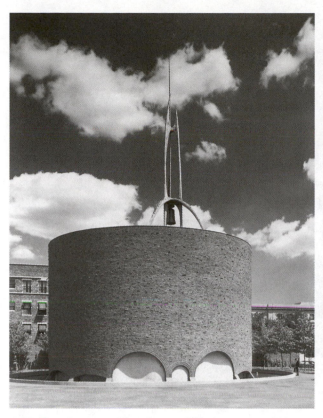

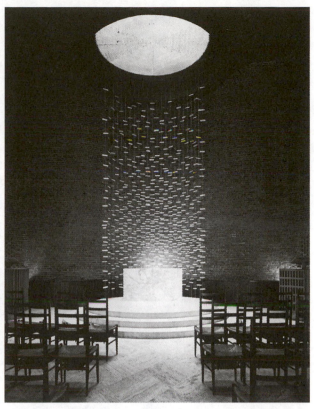

9.31. Eero Saarinen, Chapel, Massachusetts Institute of Technology, Cambridge, Massachusetts, 1953–56. In its sharp cylindrical form and its rough structural red brick, this building stands apart from the surrounding campus; the freeform spire and bell hint strongly at its functional use. (Photo: Ezra Stoller © Esto.)

9.32. MIT chapel, interior. Through the sheer manipulation of light and its focus on a blazingly white marble altar block, Saarinen created a place of mystic quiet. (Photo: Ezra Stoller © Esto.)

This monumental concern surfaced quickly in his work in the Jefferson Memorial competition, for St. Louis, which he won with his father in 1948, employing a huge parabolic arch rising 630 feet; built only much later in 1959–68, it is constructed of concrete covered with stainless steel plates. This new monumentalism can be seen as well in a subtle but revealing way in Saarinen's otherwise purely Miesian complex of glass boxes (inspired by the IIT campus) for the General Motors Technical Center, built in 1945–56. The dynamometer building is a rectilinear, flat-roof box, with a revealed steel frame and glass and glazed brick walls, but close to the exterior wall is a series of thick black columnar exhaust pipes that through their size and their carefully studied spacing become invested with a sculptural power. It appeared even more dramatically in Saarinen's Kresge Auditorium, at the Massachusetts Institute of Technology, built in 1952–56, in which he experimented with stark geome-

tries in reinforced concrete. This monumentalism reached maturity in his design for the Ingalls Hockey Rink, at Yale University, built in 1956–58, which combined a soaring parabolic concrete arch carrying a roof on suspended steel cables.

From this point on Saarinen took an increasingly anti-Miesian stance. The contrast between the two designers is neatly summed up in the contrast between the chapels they each built in the early 1950s for comparable technical universities, Mies for IIT and Saarinen for MIT. Mies's was a simple brick rectangular box, glazed at one end, with a curtained wall at the opposite end and a stone altar. [9.30] Saarinen's chapel was in the form of a closed cylinder of dark red clinker brick, with an inner undulating wall of brick to prevent sound from being focused in a "hot spot" at the center of the room. [9.31, 9.32] The only light is admitted by a circular skylight, placed off center. Below is a gleaming white marble altar block, with the

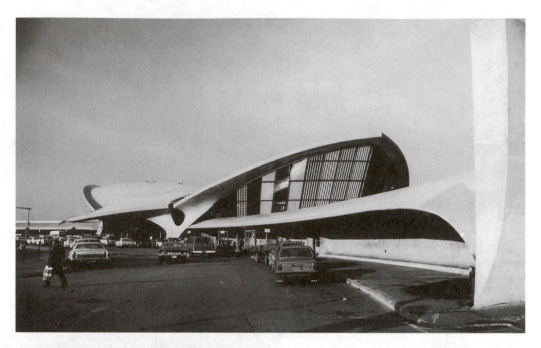

9.33. *Eero Saarinen, Trans World Airlines Terminal, Kennedy (then Idlewild) Airport, New York, New York, 1956–62. Exploiting the plastic and sculptural possibilities of concrete, Saarinen attempted to suggest the mystery and lift of flight in the two great cantilevered shells that form the roof of the TWA terminal building. (Photo: L. M. Roth.)*

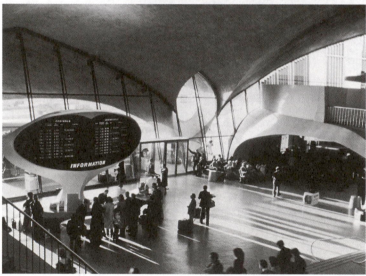

9.34. *TWA Terminal. The interior is formed of curving and merging surfaces. (Photo: L. M. Roth.)*

descent of the light captured by a light metal screen behind the altar, its random metal fins, attached to vertical rods, reflecting the light from above. The focus of brilliant light in an otherwise very dark room controls and focuses one's attention in the same way that the manipulation of light by Italian master architects does in Baroque churches, as in Bernini's Cornaro Chapel in Rome. Saarinen's chapel could be nothing other than a quiet place for meditation; Mies's could easily be converted into a handball court, and today is used for storage. Saarinen further believed that each building was unique in its internal require-

ments and in its relationship to its site; hence there could be no prototypical solution for potential application anywhere. Each part of a specific building was designed as a part of that building, just as the building in turn was designed as part of its site and environment. Each form, in other words, was designed in relationship to its next larger context.

Among Saarinen's most expressive work was his Trans World Airlines Terminal at Kennedy Airport, New York, built in 1956–62. [9.33, 9.34] The design process began with a study of the entire airport and its projected growth, including a projection of the proba-

ble development of aircraft and changes in patterns of air travel. Once this was done Saarinen developed a design based on a theme of motion and the excitement inherent in air travel. The initial scheme provided for two great soaring concrete shells, but these were split down the middle and slightly rotated so as to give the design a curved outline that fit the corner site. To make the terminal "one thing," totally resolved in all its parts (as he observed Wright's Guggenheim Museum was not), Saarinen closely supervised numerous studies with large-scale models. The result was a complex environment giving the appearance of a great clam shell, visually indeterminate. The several changes in level are made gentle and easy, as all lines curve and weave together. As Wright had done, Saarinen confounded every convention of the construction industry, and he worked closely with engineers Ammann and Whitney to ensure full integration of structure and sculptural form. Even mechanical equipment such as signboards and ventilation ducts were made to serve as sculptural accents.

Saarinen's contemporaneous design for the Dulles International Airport at Chantilly, Virginia, built in 1958–62 (about twenty-five miles west of Washington D.C.), was more regular in its geometry, and was made to allow additional bays to be added to each side as growing air traffic required. [9.35] The Dulles building was not for a single airline but was a general terminal meant to handle all international traffic in and out of Washington D.C.; hence it had to be capable of expansion over time. Saarinen and his design team devised an open-ended modular structural system, with a suspended roof that eliminated the need for any internal supports. Gracefully curved concrete arms extend up and out, carrying suspended edge beams along each side. From the edge beams, cables stretch across the central space, with heavy precast roof slabs laid on the cables, the weight preventing lifting due to aerodynamics. Although quite different from the TWA terminal, the Dulles building was equally graceful and also suggested flight while establishing a distinct image for the Washington airport.

In the affluent 1960s the airplane (along with the automobile) was the cynosure of public transit, a symbol of power and mobility. Thus the TWA and Dulles terminals were for the 1960s what Pennsylvania Station had been at the turn of the century. They were all monuments to public travel, in which function was accommodated with form, but Saarinen's air terminals were, even more, good demonstrations of what architect Matthew Nowicki meant when he asserted that "form follows form."

This heroic monumentalism, however, tended to be as exclusive as Miesian purism. Both approaches rejected messy realities, reducing programs and tightening buildings to fit a priori judgments; both favored simplistic, prototypical solutions. Mies's work certainly fits this description, as does that of Roche, Paul

9.35. Eero Saarinen, Dulles International Airport Terminal, Chantilly, Virginia, 1958–62. For this airport, Saarinen and his assistants devised a completely different solution, using outward-leaning piers and edge beams to lift a curved suspended roof. (Photo: © Wayne Andrews/Esto.)

Rudolph, and Johnson, at least to about 1965. To some extent this description also applies to Louis Kahn, but not entirely, for his work transcended these concerns in favor of an architecture in search of what it "wanted to be," designed for beings of spirit as well as corporeality. Kahn believed that human experience is made up equally of the measurable and the immeasurable, that human being are always greater than their works.

"SILENCE AND LIGHT":
THE ARCHITECTURE OF LOUIS I. KAHN

Born in Estonia, Louis I. Kahn (1901–1974) was brought to the United States at the age of four and manifested a marked artistic ability as a boy. After obtaining his architecture degree from the University of Pennsylvania in 1924, Kahn first worked in the office of the Philadelphia city architect, where he was particularly concerned with housing design, and then in the office of Paul Cret, where his university-nurtured Beaux-Arts formalism was strengthened. Yet Kahn moved far beyond pure formal concerns; during the Depression he devoted much of his energy to WPA housing projects in the Philadelphia area, and during the war he worked on housing complexes; his collaboration with Howe and Stonorov in Carver Court has already been noted. Kahn's mature work appeared quite late. After a long period in which he absorbed and sifted each of the major theoretical movements of the day, he gradually shaped a theory of his own. This process was focused by his teaching at the Yale School of Architecture from 1947 to 1957. It was during this time that he designed the Yale University Art Gallery.

In approaching a design, Kahn first probed the nature of the activities to be physically accommodated as well as the concepts implied by each activity; he endeavored to find what the building wanted to be. "How to do it," the design, was a matter of finding the space appropriate for each component activity, a space that not only was big enough, but that also evoked its particular use. The end result of such study would be that the building's spaces would be naturally harmonious and would also embody a psychological, symbolic truth. Finally came the harmonious integration of the necessary structural and mechanical systems, always with a clear view of the distinction between the "served" spaces for human activity, the primary use areas, and the "servant" spaces providing mechanical and support systems—stairs, bathrooms, storage, and other nonprimary functions.

This process is vividly demonstrated in Kahn's Alfred Newton Richards Medical Research Building at the University of Pennsylvania, Philadelphia, built in 1957–60. [9.36, 9.37] The commission was to provide biological research facilities on a very constricted, narrow site. This suggested to Kahn some sort of vertical stacking to meet the requirements, but instead of using the typical loft spaces filled with tangles of piping and flues, Kahn set about analyzing the basic humanist function. His solution provided three towers of superimposed, glass-enclosed research studios clustered around a central fourth mechanical tower. The governing idea was that each scientist be isolated and yet be able to see his colleagues at work, to be alone with his own thoughts and yet united in the communal experience; the human beings would come first and the apparatus second. Perhaps this is most fittingly illustrated by the way in which the towers are placed to look over the lush wooded landscape to the south, so that the scientists are constantly presented with a view of the external feral world in all its complexity and flux.

In each tower the constituent elements are vigorously articulated. The central service tower contains elevators, stairs, major plumbing, storage rooms for experimental animals, and, along the rear wall, four large projecting flues for air intake. Each of the studio lab towers, with their glazed cantilevered corners, has large external flues for fume exhaust; the stair towers terminate in tall fin walls to differentiate them from the exhaust ducts. As a result, through the intensive study of the physical and empirical realities of the program, each of the elements expresses its own nature and function. Similarly each part was constructed in the way best suited to its form and function. The towers and air ducts are of monolithic poured concrete using slip forms and covered with a brick veneer so as to blend with older neighboring brick buildings by such architects as Cope & Stewardson. The studio lab towers are constructed of precast and post-tensioned concrete members interlaced Chinese puzzle–fashion and left exposed as a record of the construction process. This pioneering structure, combining elements of the Vierendeel truss and the space frame, was worked out by Kahn and engineer Dr. August E. Komendant of the University of Pennsylvania. Its assembly pointed out to Kahn the importance that the derrick would come to play in the future as whole sections of buildings could be lifted into place so that weight would no longer be an obstacle to the use of large prefabricated assemblies. One is reminded of the use of the derrick to lift preassembled roof sections

9.36. *Louis I. Kahn, Alfred Newton Richards Medical Research Building, University of Pennsylvania, Philadelphia, Pennsylvania, 1957–60. The towers to the left with the cantilevered office cubicles at the top are the Biological Research Building addition, 1961–64. (Photo: J. Ebstel, New York.)*

into place in the Audubon Park housing units.

The Richards Medical Research Building, later enlarged by a biology addition [on the left in 9.36], became quickly overcrowded, however, as research programs expanded; its assertive boldness was even disconcerting to some scientists conditioned to working in minimal architectural environments. Yet it demonstrated the power of an architecture fully expressive of its use, whose primal forms had no pretense of transient fashion.

With a simpler, more fixed program the results could approach visual poetry, as Kahn proved in the First Unitarian Church, in Rochester, New York, built in 1959–69. [9.38, 9.39] Here the quintessential experience was the meeting, so at the center of the plan Kahn placed a large severe rectangular room, covered by four light-catching monitors. Around it he grouped rooms of various configurations—classrooms, committee rooms, minister's office, women's workroom, a library with a projecting reading nook, and an entrance lobby. Each element is distinct, sharp-edged, molded by recesses that catch the light and bounce it into the rooms, for "no space is really an architectural space," said Kahn, "unless it has natural light."[20]

As Kahn's geometry became increasingly more assertive, his work assumed a timeless monumentality and authority. Certainly his was among the best work

9.37. *Richards Medical Research Building. Plan of the original cluster of Richards research lab towers. (L. M. Roth, after H. Ronner,* Louis I. Kahn: Complete Works, 1935–1974, *Boulder, Colo., 1977.)*

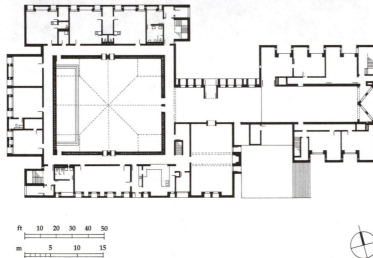

9.38. Louis I. Kahn, First Unitarian Church, Rochester, New York, 1959–69. Visible are three of the large monitors that illuminate the center room; the vertical recesses are windows in the surrounding rooms. (Photo: J. Ebstel, New York.)

9.39. First Unitarian Church, plan. Kahn set out to create a place for discussion, a place defined by natural light and protected from distractions of the outside world, so the center room, top-lit, is surrounded by classrooms and service elements. (L. M. Roth, after Ronner, Louis I. Kahn.)

ft 10 20 30 40 50

m 5 10 15

of the 1960s, and perhaps of the century; especially good were his Residence Hall at Bryn Mawr College, built in 1960–65, his governmental buildings at Dacca, built in 1962–66; and particularly the Salk Institute at La Jolla, California, built in 1959–65. In the Salk Institute, Kahn had a much larger site than in Philadelphia, so he was able to separate and more sharply define each of the three basic components— the housing of the scientists, the research facility, and a community center. [9.40] The three elements formed a **U**, with the housing and community center on projecting cliff bluffs overlooking the Pacific, and the laboratories behind them at the base of the **U**.

The laboratories themselves also are arranged in a **U**-shaped block, opening out onto the ocean. [9.41, 9.42] Instead of using towers and threading the utilities through the exposed structure, Kahn used a sandwich of floors, mechanized floors alternating with research floors, so that changes in the supply of utilities can be made for any given lab area from above or below without interfering with other experiments. Even more important, in the courtyard on the alternating floors are projecting studies or private offices for researchers, each with a view of the ocean. Whereas the building is of carefully detailed reinforced concrete, the studies are fitted with natural teak

9.40. *Louis I. Kahn, Jonas Salk Institute for Biological Studies, La Jolla, California, 1959–65, vertical view of study model, c. 1963. This view shows the three zones of activity: living quarters, laboratories and studies, and community center, known as the "Meeting House." (Photo: George Pohl, Philadelphia, courtesy of the University of Pennsylvania.)*

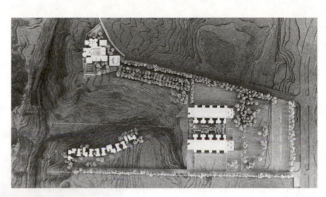

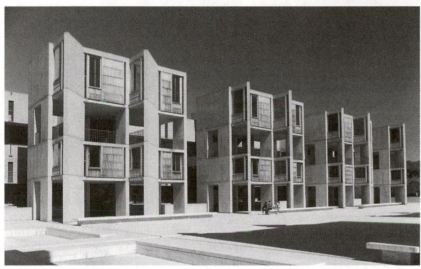

9.41. *Salk Institute. The central laboratory building, the only portion completed, is like a monastery for scientific research, with the individual studies projecting in the central court, their angled windows facing west to the ocean. (Photo: L. M. Roth.)*

9.42. *Salk Institute, plan. The research laboratories are large open spaces, uninterrupted by columns or walls, allowing for maximum flexibility in adjusting to changing needs. (L. M. Roth.)*

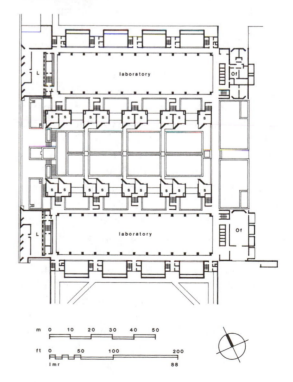

wood. The work area is thus divided into two parts—one for active investigation and one for contemplative analysis of the work in hand, one for the rational scientist and one for the reflective human being. Perhaps nowhere else was Kahn's concern for the whole of the human experience so carefully and patiently realized.

Kahn's interest in shaping spaces with natural light was less a determinant in the Salk laboratories, perhaps, than his interest in enriching functional use and creating the right psychological atmosphere for scientific research. Shortly after finishing the Salk laboratories, however, Kahn started on two commissions in 1965–66 in which reliance on natural light would become a primary generator of form. One was his library for Exeter Academy, in Exeter, New Hampshire, built in 1965–72, and the other was the Kimbell Art Museum, in Forth Worth, Texas, built in 1966–72. The Exeter Library is a large brick cubic box whose outer walls are formed of broad brick piers connected with slender brick spandrel panels. The openings in the outer walls are filled with glass and wood panels with paired narrow vertical slits. Inside, the books are shelved on four levels around a large square internal atrium, illuminated by a broad square light monitor covering the atrium. The side walls of the atrium are of poured concrete, opened on each side by an enormous circular opening that draws the four floors together and creates one enormous room. The wood balcony parapet walls around the court, just behind the circular openings, are all topped with a sloping reading surface, where one can lay a book for quick examination in the soft light filtering down from the monitor above. Along the outer edges of the book stack floors, at each of the openings in the brick wall, are back-to-back study carrels, so that the paired slits seen from the outside are narrow windows that throw light across the carrel desks inside. The essence of the library is protective storage of books, but even more it is how people use books within. As Kahn wrote, "a man with a book goes to the light. A library begins this way."[21] So, along each edge of the book stacks, inside and out, are areas provided by Kahn for what he saw as the instinctual human use of books, places for laying the book down to read it in the light.

The other design on which Kahn started during that year was to house the relatively new collection of art being assembled by Kay and Velma Kimbell of Fort Worth. The client, in practical fact, was the director they had appointed, Richard F. Brown, who drew up a detailed document describing the collection and what was desired in the new building; above all it was to be comfortably human in scale and it was to exploit natural light. The site was to be a portion of Will Rogers Memorial Park, adjacent to other museums. A series of studies of what was clearly to be a one-story facility led to a building defined by a series of long vaulted spaces, measuring overall 468 by 202 feet, set behind a grove of trees. The building was divided into three broad bays, with slender concrete columns supporting extraordinarily long curved "vaults." These are, in fact, not true barrel vaults as they might appear, but facing pairs of curved beams that together describe a cycloidal curve at their ends (a cycloid is the curve generated by a spot on a circle that moves, as though rolling on a flat surface, through space, exactly like the line formed by a reflector on the wheel of a moving bicycle). Each pair of curved beams makes a "vault" measuring 22 feet across and spanning 154 feet. The long curved beams do not touch at the top, where there is a long glazed slit; the slit admits light that is bounced by reflectors back up against the curved concrete vault shells, so that the light that filters into the intimate viewing spaces is a soft diffused light, its damaging ultraviolet elements completely absorbed by the reflecting surfaces. Complementing the soft light are the warm tones of the ivory-colored travertine stone panels that make up walls and part of the floor, and of the oak used for most of the floors. It was the need to admit light to all parts of the gallery floor, and to soften and diffuse it, that generated the graceful cycloid-curved vaults. Seen from the side, the repeated vaults of the Kimbell Museum seem to dance lightly, bounding from support to support, where rigidly semicircular vaults would have seemed heavy and hard.

As the clear separation of functions in the Salk Institute points out, Kahn preferred neat and straightforward building programs. Although the Kimbell Museum had many component functions—permanent display galleries, galleries for changing exhibits, auditorium, lounges, and restaurant—they all related to the museum's primary exhibition function. When Kahn was asked to design a new art museum for Yale, he was obliged to deal with a much more complex mix of activities. As Yale had expanded dramatically during the 1960s, there developed growing local opposition to the increasing loss of taxable property. Moreover, there were many in the Yale community who resented the loss of inexpensive apartments and street-level shops along Chapel Street where the new museum was to go up; many students found inexpensive apartments there. Students and others feared the

9.43. Louis I. Kahn,
Yale Center for British Art,
Yale University, New Haven,
Connecticut, 1969–74.
The open recess at the corner
leads to the museum entry
lobby, whereas shops and
stores are fitted into the other
bays along the street. (Photo:
Tom Brown, courtesy of the
Yale Center for British Art.)

creation of a cordon sanitaire separating Yale from the "profane" city. Hence, when permits were sought for building the projected museum, a condition was imposed by the city that rental space for shops be included at ground level. If the housing was to be lost, at least the lively street life would be partly retained.

Kahn and university officials devised a solution in which the ground area of the building would be used for commercial purposes and taxed accordingly, but the university gallery above would not be subject to taxes. Such a mixture of uses, each with its own conflicting needs and circulation patterns, was not as Kahn would have preferred, for it seemed to preclude the clear, simple, compelling geometries he shaped so well. Kahn's final design, devised after a long period of study, consisted of a broadly scaled, boldly articulated reinforced-concrete frame, with the shops placed around the periphery of the block within this grid, the corner reserved for the public entry into the gallery, connecting with all the exhibition spaces, library, museum offices, and auxiliary spaces in the floors above. [9.43] Of the total floor area, commercial use accounts for 16 percent. In the upper floors the bays of the frame are filled with panels of gray glass and specially finished stainless steel with a matte finish, pewterlike in color. The uniform bays differ widely in the proportions of glass and pewter steel they contain, depending on the size of the individual rooms inside and their respective need for light. The overall expres-

sion is greatly restrained, and indeed from the exterior the building looks rather plain (perhaps even slightly "ordinary" in Venturi's sense), but inside the gallery is splendidly spacious with open courts rising through the four floors and intimate exhibition rooms opening onto the courts. Here natural white oak paneling, linen wall panels, and a natural wool carpet soften and complement in color the gray-beige of the exposed concrete frame. The building is at the same time bold and gentle, structurally hard and sensuously soft, heroic and soaring where the huge George Stubbs animal paintings hang in the spacious courts and yet quietly intimate where the small English watercolors hang in the surrounding galleries. And it is suffused everywhere with a soft enveloping light that filters down into the galleries from skylights that form the entire ceiling-roof; light is bounced off external stainless steel louvers, refracted and re-refracted through Plexiglas domes, harmful ultraviolet light thus absorbed before the light reaches the galleries. In the Yale Center for British Art, Kahn made an important, and, as it turned out, a parting statement about preserving and enhancing the quality of life in this area where the university and the city meet. He died before the building was completed, and the work was taken up by his former associates, Pellecchia & Meyers. Both university and city are necessary for the well-being of each other, and symbolically in this building they exist in fruitful symbiosis.

9.44. Paul Rudolph, Art and Architecture Building, Yale University, New Haven, Connecticut, 1958–64. Rudolph's Art and Architecture Building is a dynamic pinwheel of stacked spaces around central architecture studio spaces. At the far right is visible a small portion of the west wall of Louis Kahn's Yale Art Gallery, 1951–53. (Photo: L. M. Roth.)

HEROIC EXPRESSIONISM

Kahn's buildings have a timeless purity that combines attention to function, expression of building process, and care for the psychological ambience of the building, fitting it to utilitarian function. Another variant of Modernism, however, focused on extremely dramatic expression of form or structure, often to the detriment or exclusion of other considerations, including functional use. Paul Rudolph represented the more aggressively flamboyant aspect of this kind of Modernism. Paul Rudolph (1918–1997) studied at the Alabama Polytechnic Institute and then finished his architectural education under Walter Gropius at Harvard over a period interrupted by the war. His early work with Ralph Twitchell in Florida was marked by a precision of form and structure that spoke well of his training under Gropius. Indeed, in the Healy Guest House, in Siesta Key, Sarasota, built in 1949, there is a severity and simplicity worthy of Mies. The entire house is treated as a small pavilion and consists of one space subdivided into functional subspaces. During the next decade, however, Rudolph turned increasingly to expressive forms and idealized programs. In 1958 he was appointed chairman of the Yale School of Architecture and within the year he began studies for a new art and architecture building. [9.44] Completed in 1964, it seemed to bear little formal relationship to

the clear geometries of his early work, for in it Rudolph seemed driven to experiment with plastic sensation. Drawing inspiration from Wright's Larkin Building (with its internalized spaces) and Le Corbusier's recently completed monastery at La Tourette (with its heroically elevated masses), Rudolph wrapped balconies around central two-story rooms, intricately piling layer upon layer, creating more than thirty floor levels. The painting studios are raised high on the massive corner piers. Some of the piers house stairs in the manner of Wright, while others contain seminar rooms and offices. While in general there seems to be a loose relationship between specific function and form, the paramount interest clearly was in formal and visual qualities intensified by the rough texture obtained by hammering the ridged concrete surface. On its corner site, forming the culminating element in a row of Yale buildings along Chapel Street, it is certainly splendid. Yet there is a self-consciousness about its boldness and a presumptive willingness to manipulate the program for the sake of form that is disturbing. It suggested that architecture should be a heroic act and that art should be an uplifting, enhancing experience even at the expense of rational function. This building was seemingly designed more to reflect these ideals than to express how architecture, painting, or sculpture was actually taught, as Vincent Scully has noted.[22] The same was

true of Rudolph's Crawford Manor, in New Haven, built in 1962–66, a fifteen-story apartment tower for the elderly, which also has ruggedly manipulated forms, corrugated surfaces (in this case of more economical molded concrete block), and a prominently placed library where older citizens were expected to expand their minds.

The arrogant presumption of architects, planners, and city officials concerning urban realities, and a clear example of the conflicting aims and realities of modern abstraction, is seen in Rudolph's Earl Brydges Memorial Library, in Niagara Falls, New York, built in 1970–75. [9.45] In an effort to improve the quality of the Niagara Falls environment, to entice tourist and convention business away from the more attractive Canadian side, the city engaged prominent architects in the 1970s for new public buildings, including Philip Johnson for the convention center and Paul Rudolph for the library. Using the device of stacked corbeled rooms over a central nave that he had already employed in the Burroughs Wellcome Building of Durham, North Carolina, built in 1969–71, Rudolph developed for the library an even more complex plan with the superimposed corbeled elements—each bay a canted trapezoid—angled to shape entrance "funnels" on each side of the extended block. At the ground level, the walls defining the bays of the building extend as spurs beyond the outer wall, and since the library had been placed in a deteriorated section of town as an urban renewal project, these dark recesses proved to be ideal lairs for night-time muggers. The library became a no-man's-land after dark.

The library interior suffered from its own problems. The central nave, which contains the main reading room, is defined by the converging balconies above devoted to special and regional collections. It is an awe-inspiring space—library-reading as religious experience—yet to use the library collections one had to ferret for books under plastic sheets, for the complicated roof, window, and wall intersections proved impossible, at first, to seal against meltwater from the build-up of snow; throughout the building the shelves were covered with plastic tarpaulins draining into an army of strategically placed buckets and pails. It was undeniably a beautiful and visually engaging building, but one put in the wrong place and subjected to the wrong climate.

Of the several architects in the "exclusivist" camp in the 1960s, one firm that became progressively more reductivist was Skidmore, Owings, & Merrill. One of the clearest instances in which they forced the program into a preconceived sculptural form is their Beinecke Rare Book Library, at Yale University, built in 1960–63. [9.46] Since climatic control was crucial to preservation of the ancient books, Gordon Bunshaft, partner in charge, designed a boxlike exterior shell of thin marble slabs filtering sunlight into a large room, about one-quarter of which was occupied

9.45. Paul Rudolph, Earl Brydges Memorial Library, Niagara Falls, New York, 1970–75. The dynamic extensions of Rudolph's Niagara Falls library proved to be highly problematic in this setting. (Photo: Leland Roth.)

by a second smaller glass box enclosing the stacks of leather-bound volumes—a jewel box inside a jewel box. The catalog, delivery desk, offices, study rooms, and all other functional facilities were hidden away below ground, beneath the surrounding marble paved terrace. In fact, only one-fourth of the book collection was housed in the visible glass box, the remainder kept in storage in basements. Bunshaft designed the self-supporting walls of the outer box of welded steel, a cage formed of Vierendeel trusses on all four sides. The spaces in the truss were then filled with the translucent marble panels, and the steel frame in turn covered by carved marble sections (externally) and precast marble-concrete sections (internally) so that the apparent masonry wall is counterfeit. The four recessed corner piers contribute to this paradox, for they do not lie on the planes of the forces of the walls but have the loads shifted to them by means of heavy diagonal girders, all of which are hidden from view. The bottom of the outer box, lifted off the level of the plaza, forms an internal mezzanine floor, with special display cases and clusters of inviting leather couches, all with a splendid view of the sealed interior glass

9.46. *Skidmore, Owings & Merrill, Beinecke Rare Book Library, Yale University, New Haven, Connecticut, 1960–63. Although it protected the rare books inside, the Beinecke Library made no effort to relate to or connect with surrounding campus buildings. (Courtesy of Skidmore, Owings, & Merrill.)*

book box.[23]

The Beinecke Library is far more furtive about its purpose and its structure than any of the older historicist buildings that surround it, and in comparison with its neighbors it suffers doubly because of its scalelessness. This lack of human scale was mockingly and humorously exaggerated in 1969 when a giant lipstick by sculptor Claes Oldenburg was clandestinely placed in the courtyard facing the library. Neither the immaculate construction, the semiprecious materials, nor the marble sculpture by Isamu Noguchi in the sunken courtyard can quite counter the feeling that the building was conceived primarily as the optimum showcase for selected incunabula and that its human use was subordinate. In few other instances have the implications of the site or the needs for meaningful perceptual relationships been so blatantly disregarded in the quest of heroic expression.

By 1960 Philip Johnson too was beginning to move away from Miesian purism toward sculptural form and symbolism. Once Miesian minimalism seemed certain to become the mainstream norm, Johnson decided to strike off in a new direction, to become again the arbiter of taste. This shift was dramatically evident in the small shrine he designed for the Blaffer Trust in New Harmony, Indiana. [9.47] The Blaffer commission called for a "Roofless Church," in which the body of the church enclosure was defined by a high surrounding wall, the space open to the sky. The "narthex" was covered by a canopy of trees, as was the side entrance, but the "altar," marked by a sculpture by Jacques Lipchitz, was covered by a shrine consisting of a convoluted shingle-covered roof carried by six laminated wooden arches resting on marble pier blocks. The shrine roof seems to pay homage to the continuities of surface of the Shingle Style and its rich historical lineage, while at the same time asserting the evocative power of pure sculptural form.

As this interest in the language of architectural form developed in Johnson's architecture, it was fused with a concern for symbolic expression of function and place. These qualities are well illustrated by the Kline Biology Tower, at Yale University, built in 1962–66, in collaboration with Richard Foster. [9.48] The functional requirements were comparable to those of Kahn's Richards Medical Research Building at the University of Pennsylvania, and the restrictions of the site were also similar. Yet aside from their common verticality—the Kline Tower is fourteen stories tall—Johnson's solution is very different in expressive intent. The Kline Biology Tower is decidedly simple

9.47. *Philip Johnson, "Roofless Church" for the Blaffer Trust, New Harmony, Indiana, 1960. Johnson's open church focused on the highly sculptural umbrella over the altar area. (Photo: L. M. Roth.)*

and monumental, with its exterior walls formed of many closely set cylindrical, largely symbolic columns. One of the tower's prime purposes, according to Johnson, was to be a dramatic visible symbol of biological research at Yale; that is, a monument in the purest sense, marking a special place, calling attention to a unique activity.[24] Kahn had chosen to express the heroic qualities of the Richards tower as scientific apparatus, hence his sharp delineation of the service elements. Johnson, however, chose to use formal aesthetics alone and his dense sculptural columns (which are actually only semicircular in section) have only an indirect relationship to the service elements. Although Johnson's site was far more open than Kahn's, Johnson nonetheless piled up floor upon floor to create his soaring research tower, visible from almost anywhere in New Haven. Especially important, too, was Johnson's use of color; departing from the blacks and grays of Mies's palette, Johnson carefully selected dark brown salt-glazed brick and brownstone for the Kline tower, corresponding to the materials used in the buildings of the surrounding Pierson-Sage science complex, dating from 1913 to 1924. Through its sheer verticality the tower became the focus of the group, although it reads as a part of the group because of its materials. The Kline Biology Tower served as a fitting memorial to Yale president A. Whitney Griswold, whose perspicacity had been responsible for engaging so many important architects for Yale University

9.48. *Philip Johnson, with Richard Foster, Kline Biology Tower, Yale University, New Haven, Connecticut, 1962–66. One of the highly important considerations in Johnson's Kline tower design was the processional approach up the hill. (Courtesy of Philip Johnson.)*

buildings during the 1950s and 1960s, making the campus a veritable museum of midcentury modern architecture.

Saarinen's work also came close to heroic expressionism, as in his Yale Hockey Rink or the twin residential Stiles and Morse Colleges at Yale, but he never lost sight of function, and always accommodated it first. Following Saarinen's death in 1961, his office, under the direction of Kevin Roche and John Dinkeloo, continued in the monumental spirit already begun. Perhaps the most successful of this genre in their early years is Roche & Dinkeloo's Ford Foundation building, in New York, built in 1967. [9.49] The tall building has soaring glass walls facing the northerly vest-pocket park of the Tudor City complex. The working part of the building, with its tiers of offices, is in the form of an L along the west side

9.49. *Roche & Dinkeloo, Ford Foundation Building, New York, New York, 1967. The Ford Foundation Building wraps around an enclosed garden that looks out to the small parks of Tudor City. (Photo: L. M. Roth.)*

and rear; the remainder of the building is a vast glazed enclosed space, with a terraced garden descending from the higher level of Forty-first Street to the lower level of Forty-second Street. This internal park is therefore a perpetually green extension of the adjacent Tudor City park. In this way nearly 30 percent of the volume of the building is given over to being a greenhouse, where nature blooms year round. Though the building, at least the garden terrace, is open to the public, the Ford Foundation is nonetheless a private world, a secular cloister protected from the dirt and disorder of the external world.

The Ford Foundation building is a very special kind of corporate headquarters, and the form was meant to serve as a unique identifier, a signature building. Surprisingly, corporate clients at the end of the 1960s began to disfavor derivative and anonymous Miesian boxes in favor of such unique, identifiable signature buildings. An early example was the tall Bank of America World Headquarters building, in San Francisco, by Wurster, Bernardi & Emmons with Skidmore, Owings, & Merrill and Pietro Belluschi as design consultants, built in 1969–70. The external envelope consists of narrow angled bays, like those used in Eero Saarinen's CBS Building, in New York, in 1960–64, but instead of ending them all at the same point, the narrow window bays terminate at different floors, creating a series of gradual setbacks that recall the Art Deco complexities of the 1920s.

Roche & Dinkeloo, like Saarinen, proved adept at developing these site- and client-specific designs, and worked on a number of commercial office blocks and high-rises. One expressive signature design was their cluster of six pyramidlike blocks of concrete and glass for the College Life Insurance Company of America, in Indianapolis, of which the first three were built in 1972. In the final design of their glass tower complex called One United Nations Plaza, in New York, built in 1969–76, Roche & Dinkeloo modified the pure geometry of Mies by chamfering the edges, creating overhangs and setbacks, so that the towers have something like the ordered irregularity of quartz crystals with slight imperfections in their molecular lattices. [9.50]

Philip Johnson began a period of great activity and bounding commercial success in 1967 with a new partner, John Burgee. This coincided with their association with the Houston developer Gerald Hines, who commissioned a cluster of three speculative office blocks called Post Oak Central, in Houston, Texas,

9.50. *Roche & Dinkeloo, One United Nations Plaza, New York, New York, 1969–76. This view of the One United Nations apartment towers (just right of center) is also a capsule history of skyscraper design in New York City: in the foreground is the United Nations Headquarters, by Wallace K. Harrison and others, 1947–53, with its all-glass west wall and the curved mass of the General Assembly auditorium;* *immediately to the left of One United Nations Plaza, in the distance, is the Chrysler Building, by William Van Alen, 1926–30; and to the right is the Pan Am Building placed atop Grand Central Station, by Emery Roth and Sons with Gropius and Belluschi, 1961–63. (Courtesy of Roche & Dinkeloo.)*

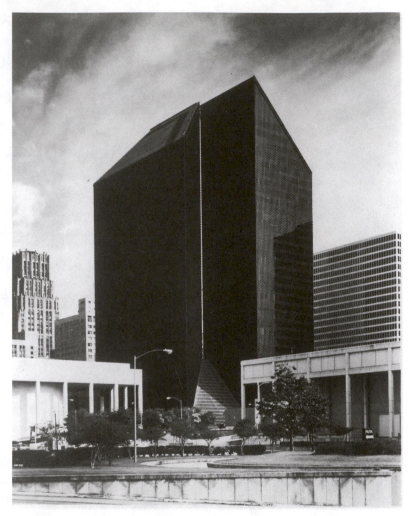

9.51. *Phillip Johnson and John Burgee, Pennzoil Place, Houston, Texas, 1972–76. In this decisive break with the minimalist glass box office skyscraper he had helped define with Mies van der Rohe in the Seagram Building, Johnson divided the Pennzoil building into twin, slanted-roof towers. (Courtesy of Philip Johnson.)*

9.52. *Pennzoil Place, plan. Two shaped towers seem to slide past each other in plan. (L. M. Roth.)*

built in 1970–81. The speculative office buildings were distinctive for their staggered setbacks and, even more, by the Art Deco–like contrasting horizontal bands of glass and spandrel panels that curve around the corners. Although Johnson had detested *moderne* architecture during the 1930s, he now drew inspiration from it because, as Burgee recalled, "we thought of the cheapest things we could do and they were ribbon windows, setbacks, and curved corners."[25] Their IDS Building (Investors Diversified Services) in Minneapolis, built in 1969–73, combined one immense tower with three low buildings filling a downtown block. Several elements set this complex apart, one being the public atrium space created at ground level. The irregular void between the four building units is covered by a glazed space-frame, so that the enclosed space can be (and is) used all year

round; even better, this open space is connected by glass-enclosed bridges to adjoining blocks. Moreover, the corners of the buildings, especially evident in the fifty-one-story tower, were cut away, with set-back notches allowing for an unprecedented number of thirty-two offices per floor, all with corner views. This shaped footprint was then accentuated by the use of a new chrome-coated mirror glass, producing interesting plays of reflection, light, and shadow.

Even more striking among the firm's early signature office towers is their Pennzoil Place, in Houston, built in 1972–76. This project, from the very beginning, was to establish an identity for Pennzoil; the client, J. Hugh Liedtke, gave pointed instructions to Johnson and Burgee that his building was not to be "another upturned cigar box."[26] Pennzoil Place consists of two trapezoidal towers, seemingly one rectangle cut on the bias with the sections then pulled slightly apart; each tower terminates with a sharp shed roof at conflicting angles. [9.51, 9.52] The remaining open ground-level spaces of the square are covered by two angled glass roofs covering atriums.

These office towers are distinctive in how their angled tops meet the sky, but in Hugh Stubbins's Citicorp Center, in New York, built in 1973–78, also having an angled top, an additional distinction was created in the way the building meets the street. [9.53] The forty-six floors of the tower are lifted on four massive stilts 127 feet into the air. At the top of the building is an unfenestrated crown, cut at a sharp angle and facing south. Originally solar collectors were to have been placed there to augment the building's energy needs, and although these were not installed, the total demand for heating and cooling was reduced by using strip windows with wide spandrel panels of brushed aluminum to reflect light and heat without causing intense glare. The space at the base was kept open for public use, a tall court covered by the building itself, and, at one of the corners, a strikingly angular new St. Peter's Church, also by Stubbins. Perhaps more than any of the other soaring new skyscrapers, Citycorp Center illustrated one way in which sophisticated structure, technical excellence, and perfection of detail could serve business interests and yet preserve and enhance the life of the city street.

One can observe an urge for apparent weightlessness in the Citycorp building and also in a distinctive creation of architect Gunnar Birkerts. Adherence to the Miesian structural grid lessened, too, in government buildings, and perhaps most dramatically in the Federal Reserve Bank of Minneapolis by Gunnar

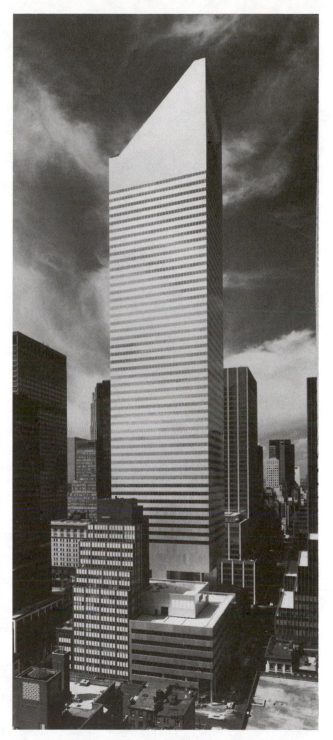

9.53. *Hugh Stubbins and Associates, Citicorp Center, New York, New York, 1973–74. The bright metal skin and the distinctive slanted top of the Citicorp Building quickly established it as one of the most recognizable skyscrapers of New York; originally the south-facing sloped roof was to have been clad with solar collectors. (Photo: Nick Wheeler, courtesy of Hugh Stubbins and Associates.)*

Birkerts and Associates, built in 1971–73. Because of a requirement for as much column-free space as possible below ground to allow armored trucks direct access to the subterranean vaults, the decision was made to suspend the office floors from cables, thus requiring only two support towers at the far ends. [9.54] The towers carrying the cables were placed 275 feet apart, with a bridge girder at the top to prevent the support piers from being pulled together. On either side of the 60-foot-wide slab were then hung rigid facade frames attached to the cables, so that the ground floor beneath is completely free of supports. To express the structural action, the catenary curve of the cable is marked by an emphatic change in the mirror-glass sidewalls; furthermore, the supporting end towers and bridge girder at the top are solidly clad. Certainly this is a tour-de-force and shows clearly that there are alternatives to the ubiquitous modernist steel frame. The Federal Reserve, together with the first wave of highly shaped and individualistic speculative skyscrapers, made it clear that there was no longer a single way to build office towers or even banks, no prototypical or universal solutions.

ALVAR AALTO IN AMERICA

That it was possible to find a balance between modernist purism and dramatic and expressive form, and yet fully accommodate function and human needs, to be symbolic without being boastful or bombastic, was demonstrated clearly in the few American buildings done by Finnish architect Alvar Aalto. The lesson of his achievement is still being absorbed by American architects. Aalto (1898–1976) had developed close associations with a number of Americans, such as William Wurster in San Francisco, and had designed the Finnish pavilion for the New York World's Fair in 1939. Aalto also had given lectures at Yale's School of Architecture and at the Cranbrook Academy, and

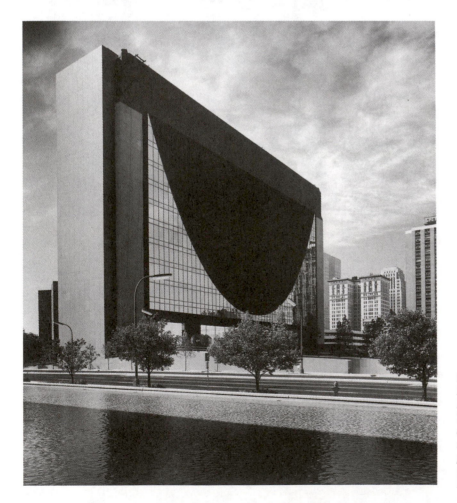

9.54. *Gunnar Birkerts and Associates, Federal Reserve Bank of Minneapolis, Minneapolis, Minnesota, 1971–73. The strongly expressed curve in the exterior glazing indicates the line of the suspension cables that carry the floor loads up to the two end towers. (Photo: B. Korab, courtesy of Gunnar Birkerts and Associates.)*

9.55. Alvar Aalto, Baker House, Massachusetts Institute of Technology, Cambridge, Massachusetts, 1946–49, aerial view. Aalto's S-shaped dormitory for MIT was an early expression of a strong interest in building form. (Rosenthal Archive, Northwestern University.)

momentarily even considered moving his practice to the United States. In 1940 he began intermittent teaching duties at MIT, where Wurster then headed the architecture program, becoming acquainted with a young faculty member, Vernon DeMars. Shortly after the war ended in 1946, Aalto was asked by MIT to design a new student dormitory, Baker House, on a restricted site along the Charles River. [9.55, 9.56] Finished in 1949, Aalto's Baker House combined the rational purism of the International Style, which he had helped to introduce in Finland, with intuited elements, achieving variation despite standardization, or what Aalto called "flexible standardization," in a humanization of technology.[27] In Baker House one of Aalto's major tasks was to provide the maximum number of rooms with an engaging oblique view of the river. This he achieved by bending the building in the form of a giant S so that very few rooms actually face the river frontally, while the great majority look obliquely up or down the expanse of water. The back of the building is even more irregular, for it contains larger suites of rooms and lounges. In addition, climbing the wall on the north side are stairs that branch out from the base of the building; cantilevered from the internal reinforced frame, they form a striking irregular zigzag. The enclosing walls are of rough, deep-red brick, laid with randomly spaced misshapen clinkers whose protrusions give the surfaces a rich tweedy tex-

9.56. Baker House. A close view of Baker House at street level reveals the rough clinker brick, carefully but randomly laid to create a rich, ever varying visual texture. (Rosenthal Archive, Northwestern University.)

ture. What Aalto showed in Baker House was that form should follow the irregularities of actual human use and that this expression of complexity could be enhanced by the use of warm colors and tactile surfaces. Such ideas were to lie fallow for nearly a decade before American architects took them up, but Aalto pursued them beautifully in buildings he designed on returning to Finland, particularly in his red brick and wood civic center for Säynatsälo, Finland.

Better still is the last building Aalto designed in the United States, the Mount Angel Abbey Library, in Mount Angel, Oregon. That it was built at all was a miracle, given the distance from Aalto's office and the limitations of the Abbey's finances. The Abbey had long delayed in building a permanent library, but as the need grew ever more urgent, it was the hope of both Abbot Damian Jentges and Friar Barnabas Reasoner (the Abbey's first professional librarian) to obtain the finest library design possible. Barnabas investigated the work of several acclaimed architects recommended to him, and came to value highly Aalto's handling of natural light and responsiveness to site. Barnabas wrote Aalto in 1964, saying, "We need you. We have this magnificent site and we don't want to spoil it. We want you to improve our site and give us a building that will fulfill our needs in a beautiful and intelligent way"[28] In declining health yet handling many commissions and thus unable to spend time away from his Helsinki office, Aalto politely declined. Barnabas persisted, searching out Aalto in Zurich, Switzerland, to persuade him to take on the job. Intrigued by the steeply sloping hillside site, dotted with large Douglas firs, Aalto finally accepted the commission, but with certain conditions. Aalto had come to know a young American of Finnish descent, Eric Vartiainen, who had worked in his office following his education under Vernon DeMars at the University of California, Berkeley. The conditions specified by Aalto were twofold: that DeMars (who was licensed to practice architecture in Oregon) agree to serve as the official legal architect and to prepare construction documents according to American standards; and that Vartiainen serve as liaison between Aalto's office in Helsinki and de Mars's office in Berkeley. Meanwhile the Abbey received a generous gift from Howard and Jean Vollum to pay for most of the cost of construction.

Aalto made his only visit to Oregon and to the building site in 1967, quickly justifying Barnabas's faith in Aalto's architectural sensitivity. For a long time Aalto stood in silence atop the butte around the edge of which the various abbey buildings stood. On the north side was an open space reserved as the library site. Aalto looked out over the valley below, dotted by farms and stretching away to the wooded slopes of snow-capped Mount Hood. After a long time he said, "This is magnificent, far better than I ever imagined. It is an acropolis." Then he spotted some stakes driven into the hillside, noting that just inside the perimeter were several mature fir trees. He inquired about the stakes and was told they marked the proposed corners of the library. Seeing that the trees would need to be cut down, he said, "We will move the library," and directed that the building be shifted ten feet to save the trees. Final construction drawings were revised and building commenced. With his health continuing to decline, Aalto was unable to attend the dedication in 1970 and died never seeing the finished building.

In working out the library design in Finland, Aalto had taken great advantage of the sloping site. [9.57, 9.58] The abbey sits atop a flat-topped mesa or butte, with the buildings placed at the edge of the butte loosely enclosing an open campus quadrangle. In fitting the library in the reserved space, Aalto's plan was shaped around functional requirements, with a fan-shaped book-stack area that lends itself to easy supervision from one central vantage point. Facing the quadrangle is a single-story block housing the entry passage, flanked by tightly clustered library offices to the left and a small auditorium on the right. Because the library is on the crest of the butte, the building needed to be only one story high where it faced the quadrangle, but could descend three levels as it dropped down the hill, providing for sufficient stack area without overpowering the adjoining buildings of the monastic quadrangle. Following the curve of the book-stack fan is a long skylight that deflects light down into a reading area and the adjoining stacks below. [9.59] Every detail was studied by Aalto—the exterior steel columns sheathed in wood and warm to the touch, the door handles angled to match the grip of the outstretched hand, and the internal lighting fixtures louvered to soften the illumination. The furnishings, the desks, chairs, and stools were all designed by Aalto in molded birch plywood with black leather upholstery. It is a quiet, unpretentious building, but one that never fails to lift the spirit. People are drawn to it, some for reasons they cannot quite articulate, simply because it is a good place to be. Indeed, one seminarian studying at the abbey while the building was being finished reported that he was so inspired by the library that he resolved to become a monk. Sitting in the

9.57. Alvar Aalto, Mount Angel Abbey Library, Mount Angel, Oregon, 1964–70 plan. This plan of Aalto's only other major work in the United States shows his careful attention to accommodating each function optimally while creating an expansive sense of space in the principal public area. (L. M. Roth.)

9.58. Mount Angel Abbey Library, exterior view. The splayed book-stack wing projects out dramatically on the lower hillside. (Photo: L. M. Roth.)

9.59. Mount Angel Abbey Library, interior view. A long curved skylight bounces diffused sunlight down into the book stacks; the edges of the curved balcony edges are designed as continuous reading desks with individual reading lamps. (Photo: L. M. Roth.)

study carrels spaced around the outer rim of the book stacks, one can see through the vertical window slits the panorama of fields, orchards, hills, and streams reaching to Mount Hood. Scholarship is made to seem a functional part of the work and life of the surrounding world.

A NEW URBANISM

After 1945 cities became the dominant force in American life. At the outbreak of the war, in 1940, over thirty percent of the US population lived in central cities, while another twenty percent lived in suburbs; almost forty-nine percent of the population lived in small towns and rural areas. Small town cultural values still tended to dominate. After the war things began to change. By 1950, the percentage of the population in central cities had about peaked at about thirty-two percent, while the suburbs held nearly twenty-four percent; the rural population dropped to just under forty-four percent. One reason the center cities grew in size in the 1940s was the northward migrations of African-American poor from the rural South to work in war industries in northern cities. A similar population shift happened in western and Pacific northwest cities with their aeronautical and electronic war industries. By 1970 the trend in the population distribution was clear, with just over thirty-one percent of the population in the center cities. The suburbs, in 1970, had the largest single portion of the population at almost thirty-eight percent. Small towns and rural areas now held the smallest percentage at thirty-one percent.[29] Hip urban cultural values now dominated. At the close of the twentieth century the percentage of the total population in the center cities remained at just over thirty percent, while the rural population had dropped dramatically to less than twenty percent; at century's end the great bulk of the US population, almost exactly fifty percent, lived in the suburbs.[30]

Comparative Population Distribution (in percentages of total U.S. population)			
	Central cities	Suburbs	Small town/rural
1940	31.6	19.5	48.9
1950	32.3	23.8	43.9
1970	31.4	37.6	31.0
2000	30.3	50	19.7

The urban refugees settled into their suburban crab-grass havens and tried to ignore the fact that some new suburbs were often minimally planned and built. In some jerry-built suburbs there were no parks or schools and the sewers became fountains during heavy rains. The only link to the urban core, the economic base, was the freeway, but it seemed that no matter how many expressways were opened into and through the growing megalopolises, there were always more cars to clog them. In the suburban "green ghettos" were deposited the women and the young who seldom saw the heart of the city.

Levittown

The postwar demand for housing inspired one developer and builder to apply the methods used in producing automobiles in the building of large tracts of inexpensive housing. Before the Second World War, William J. Levitt (1907–1994) and his sons had built some small suburban subdivisions on Long Island, designed to accommodate the limited numbers of upper-middle-class families then able to move out from New York. During the war, however, they were engaged to build navy housing, perfecting a system of mass production of identical house units that drove costs down. When the war ended Levitt recognized the enormous pent-up demand for housing and set about to build large housing tracts based on the standardized house types he had perfected. In 1946–51 Levitt and his sons built Levittown, in Long Island, planned around several neighborhood village greens. His son, Alfred Levitt, an architect, aimed at creating a sense of community, and his ideas for street layout, town center, parks, and other communal facilities were incorporated in part in the next development of 17,000 houses, the second Levittown, in Bucks County, Pennsylvania, built in 1951–55. Here the Levitts also built an adjoining shopping center. In 1955–58 the Levitt company began an even more ambitious development, the third Levittown, in New Jersey, after having purchased nearly the whole of Willingboro Township. At this third site 12,000 houses were initially built, in three basic house types—Cape Cod, Ranch, and Colonial—costing $11,500 to $14,500. The houses were grouped in neighborhood clusters of 1,200 houses around a school, playground, and swimming pool. Also included were shopping centers, schools, a library, and parks.[31] The company's success in cost control came from the deployment of teams of building specialists—carpenters, plumbers, electricians—who went from house site to house site, their operations carefully planned in advance and achieved

9.60. *John Graham and Company, Northgate Shopping Center, Seattle, Washington, 1946–50. The first regional shopping center to open was Northgate, just outside Seattle; others were being planned and would soon open in* *California, around Chicago, and around the large cities in the Northeast. Typically they were placed at critical nodes of the growing interstate superhighway system. (Courtesy of Meredith Clausen and DLR Group.)*

with a minimum of labor—a kind of inverted moving assembly line. Up to thirty houses were finished each day. Like automobiles, the houses were absolutely identical in form and detail, although in later years the owners made various additions and modifications so that today the original uniformity is largely gone. By 1990 Levittown, Long Island, had over 53,300 residents, the Pennsylvania Levittown had 55,400, and Levittown, New Jersey, had 36,300.[32]

On the West Coast comparable operations were conducted by such companies as Eichler Homes, which built communities like Terra Linda, Marin County, California, and by developer David D. Bohannon in the new suburb of San Lorenzo Village, in the San Francisco Bay Area, which had 4,600 houses by 1955.[33] Park Forest, built on 2,400 acres thirty miles south of Chicago, with its 8,000 homes and aiming for a total population of 30,000, was another early example. Market forces and a conservative suburban culture worked together to make these suburbs almost the same from coast to coast. Some of the lessons of Radburn were incorporated, with curving streets and cul-de-sacs alleviating to some degree the uniformity of the houses. William Whyte's middle-

management "Organization Man" could be transferred across the country, moving from one suburb into another that was virtually indistinguishable from the first. Whyte's social study of Park Forest residents revealed a frightening desire for excessive conformity and a mindless conservatism.[34]

Shopping Centers

Two simultaneous developments enabled the expanding suburbs to function. One was the system of publicly funded highways that tied the bedroom communities to the city centers. The other was the exodus of major retailing operations to the exploding suburbs. Levitt and company had incorporated a shopping center in their second development in 1951, but several years earlier the first sprawling shopping centers had opened outside Seattle, Detroit, and Minneapolis, and quickly thereafter around every major city. Perhaps the very first was Northgate Shopping Center, in Seattle, built in 1946–50, designed by John Graham and Company in consultation with Rex Allison, owner of the Bon Marché department store. [9.60] Graham (1908–1991) and his firm soon became a specialist in the design of such complexes, grouping stores around

an open pedestrian mall, with acres of free parking surrounding the stores. Even better known nationally was Victor Gruen (1903–1980), originally trained in Vienna, who had fled Hitler and resettled first in New York and then Los Angeles. Gruen developed such early shopping centers as Northland, outside Detroit (1954), and Southdale Center, Minneapolis (1956), and like Graham went on to design scores of subsequent shopping malls such as the Mall, in Fresno, California. From this Gruen gradually expanded his practice into the field of urban planning.

THE AUTOMOBILE CULTURE

During the Second World War, production of civilian automobiles ceased and gasoline, a critical defense resource, was carefully rationed. When the war ended and the factories returned to civilian production, automobile sales shot up. The Depression was over and the old cars were replaced with new. Only 610 civilian passenger vehicles were produced in 1944, but during 1945, with the war ending in September, auto production jumped to nearly 70,000. During 1946, 2.15 million private automobiles were built, and by 1955 the number had climbed to 7.9 million annually. A decade later, for the year 1965, American automakers produced a record number of 9.3 million automobiles.[35] In fact it became official design policy among the major automakers to introduce dramatically styled models every year or two and persuade owners, through powerful advertising, to buy the newest model. These finned and bechromed autos, each year featuring new technical innovations, coupled with the new highways being built, gave rise to a mobile culture that demanded services on the road. Most of the basic types had existed before the war as single mom-and-pop operations: roadside restaurants, motor inns, and gas stations. After the war, however, corporate ownership and franchising took hold. Gasoline stations became models of International Style purism, identified by distinctive signs bearing company logos, with standardized filling-station or garage designs identifying the brand. Some gas stations were built of prefabricated steel panels attached to metal frames. Public accommodations changed even more, especially the franchise motel or fast-food place, with buildings and signage strikingly designed to be seen and recognized from the road as the tourist approached at sixty miles per hour. The Holiday Inn at any one town, easily recognized by its large and flashy sign,

would be virtually the same as another one a hundred or two hundred miles back; you could be sure of the same clean rooms and efficient service. And when hunger struck, one had simply to look for the two golden arches signaling a new kind of restaurant, where the food was cooked quickly or often was already cooked and wrapped, simply awaiting your arrival. The McDonald brothers had begun with orange juice and barbecue stands in southern California in 1937, but began franchising hamburger stands in 1952. They approached architect Stanley C. Meston that year to design a simple, inexpensive, but eye-catching building to use for these franchised outlets. Richard McDonald first sketched the two arches that were then refined by Meston into the soaring yellow parabolic arches that helped support the canopy of the hamburger stand. The first of the new stands was finished in May 1953 in Phoenix, Arizona; although that was later demolished, the second "golden arches" McDonald's, finished in August 1953, still stands in the Downey area of Los Angeles, California.[36] The traveling and dining habits of Americans would never be the same, and for some people the absolute design uniformity of motels and of the fixed menu of fast-food restaurants became positive and reassuring features.

Freeways

What was happening by the 1950s was the realization, in the hands of land developers and business entrepreneurs, of what Frank Lloyd Wright had proposed in his decentralized Broadacre City. And as Wright had foreseen, the essential circulation system that enabled all of this to work was a vast network of freeways and expressways. The new urban and transcontinental highways were paid for with federal tax dollars, with the cities and states contributing as well. The federal government had previously enacted limited legislation for road building in 1916 and 1944, but challenged by the German Autobahn system built in the 1930s, and newly aware of the need for swift movement of troops across the country, Congress enacted the far more sweeping Highway Act of 1958 calling for the construction of 41,000 miles of multilane public freeways by 1969. This system would connect all cities of 50,000 people or more, at a projected cost of $24.8 billion, with 90 percent of the funding coming from the federal government and 10 percent being paid by the states.[37] Over the years the interstate highway system was enlarged, and the costs grew disproportionately due to inflation.

9.61. *Robert R. Taylor Homes, Chicago, Illinois, 1959–63. The multilane Dan Ryan Expressway (on the far left), Illinois Central railroad tracks (center), and the Robert Taylor Homes, a high-rise public housing urban renewal project. Except for the railroad tracks, this conjunction of multilane superhighways and high-rise buildings demonstrates the enormous impact of the urban visions of Le Corbusier in the 1920s, although he never proposed that skyscrapers by used for housing. (Courtesy of the Chicago Historical Society.)*

9.62. *Le Corbusier, view of superhighways and towers, "City for Three Million," 1922. (From Le Corbusier, Oeuvre Complète de 1910–29, Zurich, 1946, 476.)*

Urban Renewal

In almost every city the building of these freeways was merged with urban planning policy (if it could be called that), as defined by white middle-class professionals, in which areas deemed to be substandard slums—and these were almost invariably ethnic, African-American, or Hispanic neighborhoods—were cleared for the new highways. The result was dislocated and disaffected populations in cities, divided into isolated pockets by the freeways, which functioned as very effective walls. These new roads were destroying the city, as critic Lewis Mumford warned. Unthinkingly, Americans were eviscerating their cities, sometimes for no better reason than to lure suburban dwellers to ailing downtown department stores feeling the effects of competition of the suburban malls. As

Mumford exhorted: "The first lesson we have to learn is that a city exists, not for the constant passage of motor cars, but for the care and culture of men."[38] But not until the 1970s did the general public begin to rein in their planning officials and highway builders.

It could be argued that the more positive side of this urban renewal program, well intentioned if imperfectly executed, was the simultaneous construction of large expanses of public housing. Much of this was supported by the Federal Housing Act of 1949 (an expansion of the Housing Law of 1937), in which the government took the position that the general welfare and security of the nation "require housing production and related community development sufficient to remedy the serious housing shortage, the elimination of substandard and other inadequate housing through the clearance of slums and blighted areas, and the realization as soon as feasible of the goal of a decent home and suitable living environment for every American family."[39] This goal continued to drive government policy through the 1960s, as is evident in comments made by Richard J. Daley, mayor of Chicago, in 1970 before a congressional committee. "The goal of the city," he asserted, "is to provide a decent home for each and every citizen," concluding his remarks by saying that "the existence of any slum in a society of affluence is intolerable."[40] These were laudable goals, but the built results never lived up to the dream.

Dilapidated ethnic neighborhoods, viewed as crime-breeding slums by planners, were replaced in the 1950s with clusters of shining new public housing towers, the misapplied realization of the vision of the French architect Le Corbusier. Just as shown in Le Corbusier's drawings of the 1920s, these housing developments were built next to the new urban freeways; the Robert R. Taylor Homes towers, in Chicago, built in 1959–63 (designed by Shaw, Metz, and Associates), standing beside the twelve-lane Dan Ryan expressway, are a dramatic example. [9.61, 9.62] This campaign to rebuild cities and urban housing continued to expand, reaching its high point in the Housing and Urban Development Act of 1968, which set an ambitious goal: construction of 26,000,000 housing units in the next ten years. The legislation of 1968 was the high-water mark of the Great Society Program initially conceived in outline by President John F. Kennedy and realized, after his assassination, by President Lyndon Johnson. Johnson's achievements included passage of the Urban Mass Transit Act of 1964, creation of the Department of Housing and Urban Development in 1965, passage of legislation creating the National Endowment for the Arts and for the Humanities in 1965, passage of the National Historic Preservation Act in 1966, the creation of the Department of Transportation in 1966, and passage of the Model Cities Program in 1966. For the most part, however, the idealistic public housing projects of the 1950s and 1960s were designed with little understanding of the social patterns of the displaced urban minorities, and these public housing projects themselves soon deteriorated. Le Corbusier's *ville radieuse*, as realized in the United States, soon turned out to be something far short of "radiant."

While architects after the war theorized about the ideal prototypical building, the cities died. New York, said critic Ada Louise Huxtable, definitely seemed to have a death wish.[41] When politicians and business interests realized how the cities' life blood was ebbing away, their response was even more urban renewal, which, despite its cataclysmic sweep, was usually more cosmetic than substantive. The planning of isolated apartment towers set down in vast grassy lawns, and the new freeways that connected these oases, was based on theoretical assumptions that had little to do with the realities of American urban sociology. Typical of such autocratic presumptive planning was Lincoln Center in New York, built in 1959–68. [9.63] Here, in the company of the New York State Theater and Philharmonic Hall, the Metropolitan Opera found its long-desired new home (see the discussion of Rockefeller Center in chapter 8). Instead of being integrated into an established cultural environment, where it could have benefited from and enhanced existing activity, Lincoln Center was placed by Robert Moses in the midst of the blighted Upper West Side, where it was isolated from what was then the cultural center of the city. During 1954–55, a seventeen-block area of ethnic neighborhoods was seized through eminent domain and bulldozed, displacing 7,000 families. While it is true that 4,400 new apartment units were included in the new Lincoln Square development, 4,000 were designated as luxury apartments.

The notion of including an opera house, and then a symphony hall, theater, and other arts facilities came later, in 1956. Prestigious architects were engaged to design the major buildings of the performing arts center: Harrison & Abramovitz for Philharmonic Hall, built in 1959–62; Wallace Harrison for the Metropolitan Opera, built in 1962–66; Philip Johnson for the New York State Theater, built in 1961–64; Eero Saarinen for the Vivian Beaumont Theater, built

9.63. *Lincoln Center for the Performing Arts, New York, New York, 1959–68. Another well-intentioned urban renewal project that displaced hundreds of low-income families. The buildings, clockwise from left foreground are: The New York State Theater, Johnson & Foster, 1961–64; Guggenheim Band Shell; Metropolitan Opera House,* W. K. Harrison, 1962–66; Vivian Beaumont Theatre, E. Saarinen & Associates, 1961–65; Julliard School of Music, P. Belluschi with Catalano and Westermann; Philharmonic Hall, Harrison and Abramovitz, 1959–62. (Photo: Neal Boenzi, New York Times.)

in 1961–65; and Pietro Belluschi with Catalano and Westermann for the Juilliard School of Music, built in 1965–69. The buildings huddled close to one another, each of them hidebound in symbolic Neoclassicism, enclosing a rather sterile plaza. Over the next thirty years, however, the gradual accretion of other cultural facilities around Lincoln Center did make this area of the city a new cultural hub, while the pain caused by its creation slowly ebbed.

In actuality the plaza was little used when Lincoln Center first opened, for those attending performances entered the buildings from the sides. Indeed plazas by their very nature were anomalies in American cities in the 1950s and early 1960s. As places of leisure, they were an embarrassment to a culture consumed by the Protestant work ethic. Plazas were carved out, nonetheless, because they were regarded as being prestigious and thus, more important, they were good for public relations. Increasingly in the late 1960s and early 1970s new office towers—even when not set back on open pavement—were aggrandized by having "Plaza" as part of their name. Alternatively, a cluster of several new speculative office buildings might be designated a "plaza," as was the case with Constitution Plaza, in Hartford, Connecticut, begun in 1960. [9.64] Here, too, in a blighted urban riverside area, whole blocks of useful though dilapidated buildings were cleared and replaced by this new two-level elevated terrace on which the eye-catching office blocks were placed in studied irregularity. The most

9.64. Charles DuBose, coordinating architect, Sasaki, Dawson, DeMay Associates, designers, Constitution Plaza, Hartford, Connecticut, begun in 1960. Although the various buildings in this complex are not without distinction, Constitution Plaza suffered from two problems: its being lifted one level above the surrounding streets and sidewalks, and its being cut off from the Connecticut River (visible in the background) by parking lots and an interstate highway. (Courtesy of the Travelers Insurance Group.)

striking was the green glass, almond-shaped Phoenix Life Insurance Company Building by Harrison and Abramovitz (notable as one of the very first shaped office buildings). Nevertheless, despite the way in which coordinating architect Charles DuBose and designers Sasaki, Dawson, DeMay Associates manipulated the levels, stairs, planting boxes, and fountains, the complex was only minimally integrated with the business center of Hartford; it generated little traffic of its own and was cut off from existing sources of activity. It is a good example of what most such plazas were planned to be—sparkling lures to draw the suburban shopper into the city. As a consequence these plaza complexes were found next to freeway arteries,

just as this one lies next to Interstate 91. The pity is that the highway runs along the Connecticut River and cuts Constitution Plaza off from the water that could have been its natural focal point. In the 1960s and early 1970s the recreational potential of waterfronts was almost always ignored.

"Atrium" also became a buzzword during the later 1960s, signifying a large quasi-public open space, enclosed and usable year round. Some "atria" were made excessively opulent, such as Water Tower Place on North Michigan Avenue, Chicago, built in 1969–76. This enterprise was a mixture of uses, with a numerous chichi shops grouped around several large department store branches in the lower floors; the

posh Ritz Carlton Hotel rose above the shopping center; and a slender tower of condominium apartments above that. Externally the boxy building by Loebl, Schlossman, Bennett, & Dart with C. F. Murphy was monotonously severe, its polished gray marble veneer (with flush panels so as to "reveal" the reinforced-concrete skeletal frame) tending to merge with the featureless Chicago winter skies. Inside is an opulent and dazzling space that rises in expanding stages from the Michigan Avenue entrance, its landings forested with potted trees and its escalators running parallel to cascading fountains. At the center is a vast well of space, eight stories high, with the balconies linked by a single central column of glass-walled elevators. The luxurious interiors by Warren Platner & Associates make shopping simply an adjunct to being there. The materials are sumptuous—travertine, chrome-plated steel, and glass, for the most part—and, although the hotel above precludes a skylight, the vast interior space sparkles with artificial light glinting off the glass and chromium steel. It is the kind of space that one comes to not necessarily for any specific purpose but just to enjoy its public excess. That in itself marked a major change in American attitudes: going to the shopping mall simply to "hang out." The secret to the success of these malls—whether vertical as here, or horizontal, whether covered or open—was the availability of fast food and the presence of comfortable places to sit. Eventually these amenities were introduced in the open windswept plazas as well.

One architect who more than any other came to be associated with huge atrium public spaces was John Portman (born 1924), and though many critics claim his work has a certain kitsch quality, it is nonetheless true that he has shaped more actively used and commercially productive public spaces than perhaps any other single architect. From the mid-1960s he served as the "court architect" for the Hyatt hotel chain, starting with the Regency Hyatt Hotel in Atlanta, built in 1964–67. As this was being completed he started work on the larger, more complex, and grander Hyatt Regency in the Embarcadero Center, in San Francisco, finished in 1974. An irregular polygon in plan because of its site, it has 840 rooms arranged on more than fourteen stories, which are corbeled out over a soaring interior court 300 feet long and 170 feet high. As a consequence, a major part of the volume of the building is given over to this immense fourteen-story atrium on whose ground floor are arranged the lounges and restaurants.

Designing signature hotels for well-heeled transient visitors is one thing; enticing the middle class back into the city center to live was quite another, but that was the aim of Marina City, Chicago, begun in 1959 and completed in 1967. [9.65] The site was very restricted—a small area of air rights over railroad tracks running on the north side of the Chicago River—forcing architect Bertram Goldberg to be very efficient in his planning. His solution, drawn up in 1960, proposed a multilevel platform along the river, surmounted by a number of small auxiliary blocks

9.65. Bertram Goldberg Associates, Marina City, Chicago, Illinois, 1959–64, 1965–67. Goldberg's twin towers for the Marina City complex were unusual in their form and their use of concrete as the principle material; also nearly unique for the time was the inclusion of many services and shops so as to make this a self-enclosed living environment. The most distinctive feature, however, was the way this complex actively engaged its water frontage. (Photo: Richard Nickel, Condit Archive, Northwestern University.)

and two sixty-story cylindrical apartment towers of reinforced concrete. Each tower would contain 448 units. Goldberg made the automobile an integral part of the design, but instead of giving up large horizontal spaces he coiled a parking ramp around the bottom eighteen stories of each apartment tower. Above this helix are two stories of mechanical equipment and then forty stories of apartments. Goldberg used the cylinder to concentrate the services in a small central circular core, and he then expressed the wedge-shaped cellular apartment units by the cantilevered petal-like balconies.

Marina City was also significant because it is not solely a residential development but accommodations for a mix of many activities. Most noteworthy, it was intended to entice the middle class back to the city center (but, of course, rents shot up so that it became upper-income housing). The lower level of the platform houses a boat marina, while the upper levels house shops, a restaurant, beauty and barber shops, florist, bookstore, newsstand, skating rink, and an observation terrace. In the freestanding buildings on the upper terrace are a bank, health club, swimming pool, and bowling alley, while the distinctive hyperbolic-parabaloid form houses a theater. Unlike Constitution Plaza, which ignored its water frontage, Marina City fully exploited its setting on the river with a boat marina at its base. Marina City marked a new assertive belief in the positive qualities of urban life and a slight easing of the exodus of the middle class to the suburbs.

Another indicator of this growing desire to encourage downtown living among the middle class was Habitat by Moshe Safdie. This housing complex, built as part of Expo 67 in Montreal, was essentially a realization of Safdie's thesis project as an architectural student at McGill University. Though architects before him had projected large urban residential clusters, including Kevin Lynch and Kenzo Tange, young Safdie was the one to see his prototype built and inhabited. Safdie was born in Israel and spent summers on a kibbutz, and this experience in communal living was important to the creation of Habitat. Safdie studied with Louis Kahn and then at McGill University, Montreal, where he eventually settled. When plans for Expo 67 were announced in 1964, Safdie persuaded city authorities of the advantages of building a permanent housing exhibit based on his designs. The project was trimmed from the original 900 units for 5,000 people, first to 354 and then to 158 units for 700 people; it was built in this reduced version. It consisted of three hollow clusters of stacked prefabricated concrete boxes attached to a concrete frame providing elevated streets at every fourth floor. [9.66] Each of the prefabricated units was 17 feet 6 inches by 38 feet by 10 feet high, weighing 90 tons. They were lifted into place by special cranes, a technique reflecting the interests of his teacher, Louis Kahn. Safdie's arrangement of the units, stepping back and zigzagging along the structural spine, formed individual terraces for each apartment unit and semienclosed courts underneath. Each of the clusters and each apartment have separate identities through the varied massing of the blocks; the anonymous character of the filing-cabinet tower was avoided. There were problems, it is true, in routing the plumbing through the maze of stacked boxes, and in the enormous expense of construction, caused in part by the building of special cranes whose

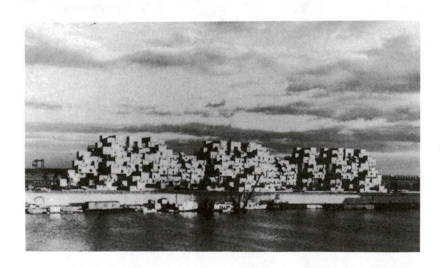

9.66. Moshe Safdie, David Barott, and Boulva, Habitat, Montreal Expo, Montreal, Quebec, Canada, 1964–67. Safdie envisioned inexpensive apartment complexes, made up of identical precast concrete units, lifted into place by gigantic cranes and placed so as to form individualized clusters attached to a continuous underlying armature. Courtesy of Moshie Safdie.)

cost could not be offset by mass production since the size of the project had been so curtailed. Nevertheless, the basic scheme was promising.

An even more ambitious project, though unrealized, was that by Paul Rudolph in 1967 for the Graphic Arts Center complex in Midtown Manhattan in New York comprising nearly fifty stories of four thousand modular housing units attached to twenty-six vertical utility cores. Rudolph's scheme was more suited to conventional technology and used light prefabricated units, moved to the site by truck, and raised into place by more conventional cranes. These units, to be made by a mobile home manufacturer, combined ease of transport, in contrast to the ponderous weight of the Habitat units, with the economics of mass production and quality control at the factory. Yet outdated municipal building codes, coupled with the resistance of recalcitrant building trade unions, prevented realization of such visionary schemes. The dream that persisted was of the "stick built" single-family freestanding suburban house on its own patch of grass in a Levittown, a Park Forest, or any other comparable suburb.

New Towns

The creations of Goldberg, Safdie, and Rudolph were only partial solutions; the ideal solution was construction of entire new satellite towns outside the major metropolitan areas. While this was done with initial success in England and Sweden after the Second World War, limited attempts were made in the United States. Only four towns were started during the 1960s on what was a true urban scale—Columbia, Maryland; Reston, Virginia; Jonathan, Minnesota, outside Minneapolis; and Irvine, California, the largest of them all but the most slowly developed. Central in the planning concepts behind all of these communities was the dependence on private automobiles as the primary means of transportation. By the close of the 1960s Columbia and Reston had been carried furthest. Columbia, the larger of the two, is situated roughly midway between Baltimore and Washington, D.C. It was begun in 1963 for a projected population of 110,000 people on a site of almost 14,000 acres, of which 7,400 acres were residential, 4,900 acres were reserved for commercial or industrial use, and 4,700 acres were set aside for parks and permanent open space. In addition about 500 acres of lake surface was created. The houses, of mixed types and styles, were arranged in ten villages of about 1,000 to 1,500 acres each, connected by multilane

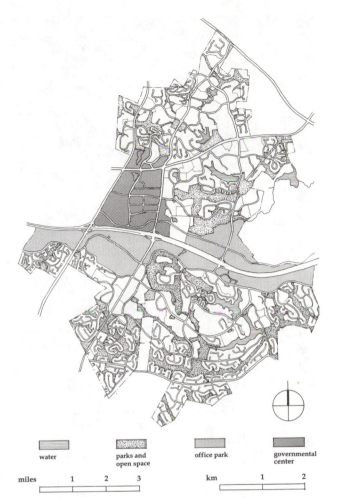

| water | parks and open space | office park | governmental center |

miles 1 2 3 km 1 2

9.67. *Reston, general plan, Fairfax County, Virginia, begun 1961. The several villages that make up Reston are bisected by the interstate highway that links Washington, D.C., with Dulles International Airport. Corporate office complexes and businesses flank the interstate. The component villages are grouped around golf links and lakes. (L. M. Roth.)*

boulevards and parkways. Reston, in Fairfax County, Virginia, west of Washington, D.C., was begun in 1961 by Robert E. Simon, whose initials suggested the town's name. On a site of nearly 7,400 acres, it was planned for a population of 75,000 people, with designs by William J. Conklin and Julian H. Whittlesey (former associates of Stein and Wright), working with James S. Rossant. [9.67] Like Columbia, Reston was based on clustered villages, each ringed by forested open space and connected by broad multilane boulevards. One of the first village centers, on Lake Anne, was designed by Conklin and Rossant, with Charles Goodman and Chloethiel

9.68. *Lake Anne Village center , Reston, Fairfax County, Virginia, 1963–67. With its shops and town houses exploiting a lakefront setting, this is a good example of the focus given to each of the component villages. Master plan by William J. Conklin, Julian H. Whittlesey, and James S. Rossant. Lake Anne Complex, 1963–67, by Conklin & Rossant, Cloethiel W. Smith, and Charles M. Goodman. (Photo: Stan Wayman,* Life Magazine © *1965 Time, Inc.)*

Woodard Smith, and developed during 1963–67. [9.68] In this new town, developer Simon had several objectives: well-developed recreational facilities including several golf courses, a broad range of housing types (including town houses, tower apartments, and semidetached and detached houses), varied landscape and architecture, and the integration of residences and work in the same area. Yet for all its variation, color, and artifice, Reston started out as a picturesque romantic escape to an almost preindustrial village. It was not yet a real city.[42]

Both the urban housing complexes and the rural new towns suffered from being too simplified and too neat. True cities were alive with dense populations and were messy places, explained Jane Jacobs in her *Death and Life of Great American Cities* of 1961.[43] Seemingly chaotic diversity was in fact the great advantage of urban life, she argued, and the street as an enclosed spatial social environment was important to a sense of identity in the city. Tall isolated apartment towers, set in open, sterile expanses of grass, actually inhibited human social interaction, she explained. But even as her book was read and discussed, housing projects went up in every major city.

PRESERVATION: THE USES OF THE PAST

Although Americans spent lavishly to travel to Europe, enjoying languid afternoons strolling through piazzas and gardens, their first reaction at home was to bulldoze and build bright urban towers set in sterile plazas. The puritan knee-jerk reaction was to clean things up. Dilapidated old buildings and plazas in Europe were charming and inviting, whereas old buildings at home were simply in the way of progress. Whatever pleasantries of style, scale, or character they might possess were overlooked.

Americans were happy to pay handsomely, however, for a sanitized recreation of the past, as the opening of Disneyland in Anaheim, California, in 1955 clearly demonstrated. In a mythical Victorian Main Street—reportedly patterned after Walt Disney's hometown of Marceline, Missouri—gingerbread mansarded buildings were reproduced at five-eighths to seven-eighths full scale. [9.69] In this quaint and comfortable memory of hometown, where litter was swept up almost before it could alight upon the pavement, middle-class tourists enjoyed themselves as never before. As Charles Moore wryly observed, however, in writing about Disneyland, "you have to pay for the public life."[44] Americans were not ready to do that in real life—pay taxes to improve the cities in which they actually lived—but they would cheerfully line up for hours to pay high prices at Anaheim. The success was so overwhelming, the crowds so great, and the development pressure around Disneyland so inexorable, that Walt Disney built a second theme park, in 1965–71, on a far grander scale, in central Florida. This time he acquired enough land, 27,443 acres, to control development and to ensure room for expansion.

As easy as it was (and still is) to fault Disney and his "imagineers" for simplifying, prettifying, and sanitizing the American past, it is, perhaps, not altogether

outrageous to suggest that Disneyland encouraged millions of ordinary Americans to begin to see the old architecture all around them in a different way. Florid building colors and mansard roofs were at their lowest public esteem in 1955 when Disneyland opened, but such quaint old architecture soon became identified with places to have fun. It may be no little coincidence that the National Historic Preservation Act was passed in 1966, just as Disney World was being started in Florida. The act provided federal funds for restoration of properties listed on the National Register of Historic Places.[45] Suddenly interest in the preservation of the nation's built history blossomed; it was good business.

As a result, by the close of the 1960s it began to become more common to deal more gently with the existing historic urban fabric and to insert new construction in such a way as to complement the existing historic environment; valued buildings were renovated and returned to economic productivity. A particularly good example is the Ghirardelli Square, in San Francisco, begun in 1964. [9.70] This hillside melange of nineteenth-century commercial buildings, clustered around a chocolate plant and its ornate Second Empire tower, was exactly the sort of "un-useful," old, dilapidated building previously seen as ripe for replacement. It was purchased in 1962 by William Roth to forestall wholesale development of the waterfront as a district of high-rent apartment towers, several of which had already been started and which blocked the view of the water of those living up the hill. Under the direction of planners Lawrence Halprin and Associates, the architects Wurster, Bernardi, and Emmons retained nearly all of the nineteenth-century buildings, refurbished them, and added a low arcade on the waterside enclosing a courtyard. There are several levels, dotted with kiosks and fountains, that offer varied prospects of San Francisco Bay. Perhaps most revealing of the changing attitudes was the preservation of the huge Ghirardelli sign as an important landmark; it is such improbable, irrational, and cherished idiosyncrasies that give cities identity and character.

Moreover, toward the end of the 1960s foliage and water were being increasingly used to enliven urban spaces, particularly in paved plazas and new vest-pocket parks. The recessed plaza and fountain of the First National Bank in Chicago was one example, but perhaps the best of these urban spaces was the fountain in the forecourt of the Portland Civic Auditorium, designed by Lawrence Halprin with Angela Tzvetin and Satoru Nishita, and built in 1966–70. [9.71] It is a complex series of pools and cascades, equaling in its exuberance the great fountains of Baroque Rome; like them it has become a focus of human activity. It is not a literal copy but an evocation of the tumbling streams in the nearby Cascade Mountains. The largest of the

9.69. *City Hall, Disneyland, Anaheim, California 1953–55. The modified and humanized scale of this re-creation of middle-American small towns appealed greatly to visitors to Disneyland; perhaps its old-fashioned-looking architecture was made a bit more appealing as a result. (©Disney Enterprises, Inc.)*

9.70. *Lawrence Halprin, planner, W. Wurster, and Bernardi & Emmons, architects, Ghirardelli Square, San Francisco, California, 1964. Here, what could have been a dense wall of private high-rise upscale apartments was made a public benefit, allowing residents on Telegraph Hill and Russian Hill to continue to see the Golden Gate Bridge. The old Ghirardelli chocolate factory building (by William Mooser, c. 1893–1914), complete with its enormous lighted sign, was converted into a shopping complex. (Courtesy of Saskia, Ltd.)*

9.71. *Lawrence Halprin & Associates, planners and designers (Angela Tzvetin and Satoru Nishita, designers), Civic Auditorium Forecourt Fountain ("Ira's Fountain"), Portland, Oregon, 1966–70. To create a public gathering place, Tzvetin and Nichita fashioned a cluster of waterfalls evoking the character of Cascade Mountain streams; the resemblance to mountain streams is even more pronounced today, now that the surrounding trees are becoming more mature and create a dense surrounding green wall. (Courtesy of the City of Portland.)*

falls is 20 feet high and 100 feet across; the rush of 13,000 gallons per minute plunging down this precipice blots out the noise of the city. More important than the statistics, however, is the way in which the fountain was designed. Halprin depressed the lowest pool 10 feet below the sidewalk so that the overflowing basins can be viewed easily from the street by the passersby. Halprin said he wished this to be a people's park, a place designed for adult play, where spatial and sensory experiences and human movement would be encouraged. In a period that might be characterized by a desperate search for personal peace in a frenetic world, Halprin's Portland fountain reasserted the basic human pleasure of playing in the water and the absolute functional and psychological necessity of such frivolous pleasure in our cities. He reminded those who think of the city only as an economic machine that it is, in fact, a human community. The city is the people. At the fountain's dedication, to make that message clear, having said a few words, Halprin kicked off his shoes, rolled up his trousers, and went wading—the shallow pools of the fountain have been full of waders of all ages ever since.

The years from 1940 to 1973 witnessed a dramatic shift in attitude among American architects, first toward maximum utility and pure function, and then, after about 1964, toward utility celebrated in bold, dramatic forms. The postwar years were characterized by Mies's embodiment of Sullivan's dictum "form follows function," which in actual practice, however, came to mean "form is dictated by structure." Moreover, the prevailing view among most planners and developers during the 1950s and 1960s was that newer and bigger was always better (and the corollary that unit costs had to be minimal to allow for more extensive construction). The results all too often were speculative commercial office buildings—cigar boxes set on end—in which the obsessive wrenching of the maximum profit per square foot produced some of the most banal and insipid urban architecture ever conceived. Pundits and theorists were convinced that people's needs were pretty much the same everywhere. Hence, the important contributions of architects like Wurster and Belluschi were dismissed because, after all, they were only "regionalists" in a period that increasingly sought the absolute and universal norm. In the 1950s and 1960s there was, nonetheless, some acceptance of Nowicki's idea that "form follows form." And then, quite literally, cracks began to appear in the dogma of Modernism.

BIBLIOGRAPHY

Banham, Reyner. *The Architecture of the Well-Tempered Environment.* London, 1969.

———. *Los Angeles: The Architecture of Four Ecologies.* Harmondsworth, 1971.

———. *The New Brutalism: Ethic or Aesthetic?* New York, 1966.

Blake, Peter. *No Place like Utopia: Modern Architecture and the Company We Kept.* New York, 1993.

Condit, Carl W. *American Building Art: The Twentieth Century.* New York, 1961.

———. *Chicago, 1910–29, Building, Planning, and Urban Technology.* Chicago, 1973.

———. *Chicago, 1930–70, Building, Planning, and Urban Technology.* Chicago, 1974.

Cook, John W., and Heinrich Klotz, eds. *Conversations with Architects.* New York, 1973.

Drexler, Arthur. *Ludwig Mies van der Rohe.* New York, 1960.

Goldberger, Paul. "The New Age of Philip Johnson," *The New York Times Magazine,* Sunday, May 14, 1978, 26–27, 65–73.

Heyer, Paul. *Architects on Architecture: New Directions in America,* rev. ed. New York, 1993.

Hitchcock, Henry-Russell, and Arthur Drexler, eds. *Built in USA: Post-War Architecture.* New York, 1952.

Huxtable, Ada Louise. *Architecture, Anyone?* New York, 1986.

———. *Kicked a Building Lately?* New York, 1976.

———. *Will They Ever Finish Bruckner Boulevard?* New York, 1970.

Jackson, Kenneth T. *Crabgrass Frontier: The Suburbanization of the United States.* New York, 1985.

Jacobs, Jane. *The Death and Life of Great American Cities.* New York, 1961.

———. *Modern Movements in Architecture.* Garden City, N.Y., 1973.

Jacobus, John M. *Philip Johnson.* New York, 1962.

———. *Twentieth-Century Architecture: The Middle Years, 1940–1965.* New York, 1965.

Johnson, Philip. *Mies van der Rohe.* New York, 1947.

Lyndon, Donlyn. "Philology of American Architecture," *Casabella* 281 (November 1963): viii–x, 8–42.

McCoy, Esther. *Five California Architects.* New York, 1960.

Moore, Charles W. "Plug It in, Rameses, and See if It Lights up, because We Aren't Going to Keep It Unless It Works," *Perspecta* 11 (1967): 32–43.

———. "You Have to Pay for the Public Life," *Perspecta* 9–10 (1965): 57–106.

Saarinen, Aline B., ed. *Eero Saarinen on His Work.* New Haven, Conn., 1962.

Schildt, Göran. *Alvar Aalto: The Mature Years.* New York, 1991.

Schulze, Franz. *Mies van der Rohe: A Critical Biography.* Chicago, 1985.

———. *Philip Johnson: Life and Work.* New York, 1994

Schwab, Gerhard. *The Architecture of Paul Rudolph.* New York, 1970.

Scully, Vincent. *Louis I. Kahn*. New York, 1962.

———. *The Shingle Style Today, or The Historian's Revenge*. New York, 1974.

Stern, Robert A. M. *New Directions in American Architecture*, rev. ed. New York, 1977.

Temko, Allan. Eero Saarinen. New York, 1962.

Wright, Frank Lloyd. *An American Architecture*. New York, 1955.

———. *The Living City*. New York, 1958.

———. *The Natural House*. New York, 1954.

———. *A Testament*. New York, 1957.

NOTES

1. Quoted by Carter Wiseman in *Shaping a Nation: Twentieth-Century American Architecture and Its Makers* (New York, 1998), 149. The original social agenda of Modernism is also described in Peter Blake, *No Place like Utopia: Modern Architecture and the Company We Kept* (New York, 1993).

2. Statistics from Bureau of the Census, *Historical Statistics of the United States, Colonial Times to 1957* (Washington, D.C., 1960), 393. See also Miles L. Colean et al., *Housing for Defense: A Review of the Role of Housing in Relation to America's Defense and a Program for Action* (New York, 1940); U.S. Housing Agency, *War Housing in the United States* (Washington, D.C., 1945); and "1940–1955: The Story of World War II Housing from Construction to Disposition," *Journal of Housing* 12 (May 1955): 152–59.

3. John Kenneth Galbraith, *The Affluent Society* (Cambridge, Mass., 1958).

4. Pietro Belluschi's memo to Anna Crocker, February 1931, quoted in Meredith Clausen, *Pietro Belluschi: Modern American Architect* (Cambridge, Mass., 1994), 57.

5. "New Buildings for 194X," *Architectural Forum* (May 1943): 108–11. The other invited architects included: Stonorov and Kahn, Hugh Stubbins, Carl Koch, Holabird & Root, William Lescaze, Serge Chermayeff, and Mies van der Rohe.

6. See Meredith Clausen, *Pietro Belluschi: Modern American Architect*, 164–72, and also her essay "Belluschi and the Equitable Building in History," *Journal of the Society of Architectural Historians* (June 1991): 109–27.

7. Mies van der Rohe, quoted in *Architectural Forum* 97 (November 1952): 94.

8. Henry-Russell Hitchcock and Arthur Drexler, *Built in USA: Post-War Architecture* (New York, 1952), 22.

9. As part of the recent sale of the building by the Seagram Company, covenants were written into the sale contract requiring all future owners to continue the oiling and waxing. This information was given to the author by Phyllis Bronfman Lambert, daughter of the building's client and the person instrumental in having the commission given to Mies van der Rohe.

10. Lewis Mumford's essay of commendation, "Crystal Lantern," originally appearing in his column "The Sky Line," *The New Yorker* 30 (November 13, 1954): 197–204, was collected in the anthology *From the Ground Up* (New York, 1956). It is reprinted in *America Builds*, 509–16.

11. These and other buildings from 1935–45, are illustrated and briefly discussed in Elizabeth Mock, ed., *Built in USA since 1932* (New York, 1945).

12. See Elizabeth A. T. Smith, *Blueprints for Modern Living: History and Legacy of the Case Study Houses* (Cambridge, Mass., 1989). Two of the Case Study Houses were illustrated and discussed in Hitchcock and Drexler, *Built in USA: Post-War Architecture*, 58–59, 108–9.

13. Philip Johnson, from Berlin, in a letter to Louise Johnson, September 1, 1920, quoted in Franz Schulze, *Philip Johnson: Life and Work* (New York, 1994), 69.

14. Portions of the essays by Henry-Russell Hitchcock and Philip Johnson that were published in *The International Style: Architecture since 1922* (New York, 1932) are reprinted in *America Builds*, 488–501.

15. Early study sketches and an analysis are found in Kenneth Frampton, "The Glass House Revisited," *Catalogue 9,* The Institute for Architecture and Urban Studies, September–October 1978, 39–59. Also included are photographs of the house on Ash Street, Cambridge. See also Schulze, *Philip Johnson*, 188–98.

16. Noted by Schulze, *Philip Johnson*, 245.

17. Philip Johnson, "The Seven Crutches of Modern Architecture," *Perspecta* 3 (1955): 40–44; reprinted in *America Builds*, 581–85.

18. Matthew Nowicki, "Origins and Trends in Modern Architecture," *Magazine of Art* 44 (November 1951): 273–79; reprinted in America Builds, 564–69. Nowicki (1910–1950) died in an airplane crash before this final essay was published. He was appointed to design the new capitol of the Punjab in India, a task that after his death went to Le Corbusier. Among his few executed buildings in the United States is the State Fair and Exposition Building, in Raleigh, North Carolina, completed in 1950–53, notable for its cable-suspended roof; it is illustrated in *America Builds*, 559.

19. See Mumford's essays "Monumentalism, Symbolism, and Style," *Architectural Review* 105 (April 1949): 173–80; and "The Disappearance of Penn Station," *The New Yorker* 34 (June 7, 1958): 40–43. Both are reprinted in *America Builds*, 528–35, 545–58.

20. Louis Kahn, "Talk at the Conclusion of the Otterloo Congress," in *New Frontiers in Architecture: C. I. A. M. '59 in Otterloo*, ed. Oscar Newman (New York, 1961), 210.

21. Louis Kahn, "The Continual Renewal of Architecture Comes from Changing Concepts of Space," *Perspecta* 4 (1957): 3.

22. Vincent Scully, *American Architecture and Urbanism* (New York, 1969), 200–3.

23. A legend developed at Yale that a lowly undergrad, tempted by the quiet spaciousness and luxuriant comfort of the Beinecke, ensconced himself in one of the welcoming divans during finals week, surrounded by his books and

notes. A guard confronted him, asking the student what he thought he was doing. "I'm studying," the student answered. "You can't study *here*," puffed the guard, "this is a *library*."

24. Philip Johnson, in an informal talk with Yale students, Spring 1970.

25. Burgee quoted in Schulze, *Philip Johnson*, 326.

26. Liedtke quoted in Schulze, *Philip Johnson*, 326.

27. See Göran Schildt, *Alvar Aalto: The Mature Years* (New York, 1991), 117–29.

28. Donald Canty, *Lasting Aalto Masterwork: The Library at Mount Angel Abbey* (St. Benedict, Ore., 1992), 22.

29 Statistics from *Historical Statistics of the United States, Colonial Times to 1957*, 14; *Statistical Abstract of the United States, 1994*, 114th ed. (Washington, D.C., 1995), 37;and www.census.gov.

30. From Joseph R. Conlin, *The American Past*, 2nd ed. (New York, 1987), 891.

31. See Herbert J. Gans, *The Levittowners: Ways of Life and Politics in a New Suburban Community* (New York, 1967). See also the discussion in Kenneth T. Jackson, *Crabgrass Frontier: The Suburbanization of the United States* (New York, 1985), 234–38.

32. U.S. Bureau of the Census, as reported in *The World Almanac* (New York, 1992).

33. See Annmarie Adams, "The Eichler Home: Intention and Experience in Postwar America," in *Gender, Class, and Shelter: Perspectives in Vernacular Architecture V*, ed. E. C. Cromley and C. L. Hudgins (Knoxville, Tenn., 1995). See also Jerry Ditto and Lanning Stern, *Design for Living: Eichler Homes* (San Francisco, 1995). For San Lorenzo Village, see Mell Scott, *American City Planning since 1890* (Berkeley, Calif., 1969), 456.

34. William Whyte, *The Organization Man* (New York, 1956).

35. Figures from U.S. Census, *Historical Statistics of the United States, Colonial Times to 1957*; Motor Vehicle Manufacturers Association of the United States, Inc., *MVMA Motor Vehicle Facts and Figures*, 1991.

36. Alan Hess, "The Origins of McDonald's Golden Arches," *Journal of the Society of Architectural Historians* 45 (March 1986): 60–67.

37. Important sections of this epochal legislation are reprinted in *America Builds*, 517–19.

38. Lewis Mumford, "The Highway and the City," *Architectural Record* 123 (April 1958): 179–86. Mumford soon collected his essays against blind submission to the needs of the automobile in an anthology also entitled *The Highway and the City* (New York, 1963); the title essay is reprinted in *American Builds*, 519–28.

39. The opening sections of the Housing Act of 1949 are reprinted in *American Builds*, 515–16.

40. Richard J. Daley, as reported in the *Congressional Record*, 91st Congress, 2nd Session, February 5, 1970, and reprinted in *The Annals of America* (Chicago, 1974), 19:104–9.

41. Ada Louise Huxtable, "Death by Development," *New York Times*, February 12, 1968. The architectural criti-cism of Huxtable has been collected in three anthologies: *Will They Ever Finish Bruckner Boulevard?* (New York, 1970), *Kicked a Building Lately?* (New York, 1976), and *Architecture, Anyone?* (New York, 1986). Excerpts of several of her essays are reprinted in *America Builds*, 636–45.

42. See Susan T. Hobby and David Hobby, *Columbia: A Celebration* (Columbia, Md., 1995); Tom Grubisich and P. McCandless, *Reston: The First Twenty Years* (Reston, Va., 1985); and Nan Netherton, *Reston: A New Town in the Old Dominion* (Norfolk, Va., 1989). Additional information supplied by the Columbia Association, The Rouse Company, Reston Board of Commerce, and Reston Land Corporation.

43. Introductory sections of Jane Jacobs, *The Death and Life of Great American Cities* (New York, 1961) are reprinted in *America Builds*, 535–44.

44. Charles Moore, "You Have to Pay for the Public Life," *Perspecta* 9–10 (1965): 57–82.

45 See William J. Murtagh, *Keeping Time: The History and Theory of Preservation in America* (Pittstown, N.J., 1988); Robert E. Stipe and Antoinette J. Lee, eds., *The American Mosaic: Preserving a Nation's Heritage* (Washington, D.C., 1987); and Antoinette J. Lee, ed., *Past Meets Future: Saving America's Historic Environments* (Washington, D.C., 1992). See also the magisterial three-volume history of the American preservation movement by Charles B. Hosmer Jr., *Presence of the Past* (New York, 1965), and *Preservation Comes of Age*, 2 vols. (Charlottesville, Va., 1981). As might be expected, there were numerous legal challenges to the ability of city and state government to list historic properties. One of the Supreme Court judges most sympathetic to the public value for preservation was Justice William J. Brennan. The court cases on which he rendered important decisions are analyzed in Charles M. Haar and Jerold S. Kayden, *Landmark Justice: The Influence of William J. Brennan on America's Communities* (Washington, D.C., 1987).

10.1. *Hyman Myers and others, Pennsylvania Academy of Fine Arts, renovation, Philadelphia, Pennsylvania. In anticipation of the bicentennial year in 1876, Furness's* *Pennsylvania Academy of Fine Arts was carefully restored inside and out. (Photo: Harris/Davis, courtesy of Hyman Myers and the Vitetta Group.)*

RESPONSES TO MODERNISM, 1973—2000

MODERNISM AND ITS DISCONTENTS

AGENTS OF CHANGE

By the early 1970s it was clear to many observers that American culture was experiencing significant change. One dramatic indication was the growing division in the populace between those who supported the Vietnam War and those who demonstrated for its immediate cessation. Long-haired, brightly bedecked youths, dressed in tie-died shirts and bell-bottom pants, sticking flowers into the rifle barrels of grim gas-masked National Guardsmen, were a vivid indication of this split. In American architecture, too, dramatic changes were beginning to be visible. Between 1965 and 1980 architectural polemics flashed, while the national economy went through wild gyrations and the national political policy shifted from civic-minded liberalism to self-obsessed conservatism.

An Economic Crisis

One of the worsening problems that had a clear impact on architecture was an economy that was slipping deeper and deeper into recession in the 1970s, fueled by President Johnson's determination that the nation have both "guns and butter." He expanded the conflict in Vietnam while pushing the liberal social amelioration programs initially proposed by President Kennedy but cut short by his assassination. The resulting inflation became so burdensome that in 1971 federal wage and price controls were imposed. The unhappy result in 1974 (when the controls were lifted) was a sharp 20 percent increase in prices. Within the next year the annual rate of inflation had risen to 12 percent. In another five years, in 1979, the prime lending interest rate stood at a staggering 20 percent. With

the cost of money so high, nobody could afford to build. The result was a serious business recession during the 1970s that decimated if not closed many architectural offices, significantly affecting even the larger firms. Some architects, like young Peter Eisenman, turned to shaping a new theoretical architecture in print when they couldn't build one in actuality.

The Energy Crisis

The depths of that recession also coincided, unfortunately, with an embargo on oil exports by Arab petroleum producers (OPEC) in retaliation for support by the United States of Israel in the Arab-Israeli War of 1973. The price of fuel had been climbing even before the embargo, from $2.80 a barrel in 1971 to $4.40 a barrel in 1973, but when the embargo ended and deliveries of imported oil resumed, the price was fixed at nearly $12, an increase of almost 400 percent. Gasoline, which had cost motorists 40 cents a gallon in 1973, cost $1.20 a gallon by 1980. This high price per barrel remained steady and gradually increased. Between 1973 and 1992, costs for oil (in constant 1987 dollars) increased another 46 percent.[1] Very quickly the implications of importing more than a third of the nation's oil became painfully apparent. The era of cheap energy was rapidly drawing to an end, and the search began for alternative and renewable sources, such as solar and wind power. Even so, now dependent on their automobiles, Americans continued to commute greater and greater distances to their daily jobs. Alternatives in transportation would not come until the end of the century, when pollution from automobile exhaust became a significant health problem.

One immediate architectural response to the "energy crisis" of the 1970s was the use of reflective glass in the Miesian glass box office tower so as to reduce the solar heat gain, and while this was partially successful during the summer months (discounting the fact that the light and heat were redirected onto some unfortunate adjacent buildings), it required even more heat in the winter when the heat gain from the sun was substantially diminished. Glass that changed its opacity according to the amount of ultraviolet light present was also developed, but it was expensive. The necessary radical rethinking of the implications of the glass box did not come very quickly.

Among some architects a new design vocabulary emerged, with some advocates arguing in favor of "passive" solar heat systems (which have no moving or motorized elements) while others favored more sophisticated and complex "active" systems (which use heat pumps, motorized louvers, heat transfer fluids, heat storage masses, and motorized controls) to store and recover heat energy. The pioneering solar heating work of the Keck brothers was rediscovered. And serious research was directed at the ways in which aboriginal native American buildings had deflected or conserved heat.

HISTORIC PRESERVATION

Preservation and rehabilitation of historic building continued to attract interest. The high and ever rising costs of materials, not to mention the cost of building construction (which of course was facilitated in all phases by gasoline-driven engines and generators), forced a new appraisal of rehabilitation of existing buildings, as contrasted to the wholesale destruction of buildings and neighborhoods that had been prevalent in the preceding two decades. Entire issues of major architectural periodicals in the mid-1970s were devoted to preservation and adaptive reuse, to the "recycling" of old buildings. This new interest was even more sharply focused by the approaching bicentennial celebration of 1976. Because of pervasive pragmatism among the public and Congress, strengthened by the recession, there was no single great national bicentennial celebration or exhibition as had been mounted in 1876. Instead, the federal funding that might have been so expended was disbursed to local governments and agencies to be used for projects of local historical significance in each community. The effects of this program are difficult to assess, but hun-dreds of buildings were preserved, restored, or adapted to new uses as a result of this policy.

One example of this new "preservation ethic" is the detailed renovation of Furness's Pennsylvania Academy of Fine Arts carried out in 1973–76 by Hyman Myers and Marc-Antoine Lombardini, in which Furness's inimitable interiors were returned to their once boisterous and colorful splendor. [10.1] Just as the original building was the symbol of the bold energies of 1876, the restored building a century later was indicative of a growing artistic maturity among Americans who could finally admit to loving its deliberate ugliness.

By this time both the National Trust for Historic Preservation and hundreds of local preservation organizations were active in listing significant properties and landscapes and agitating for their rehabilitation. In 1976 the Federal Tax Reform Act implemented tax advantages to owners who undertook restoration of listed properties. Two years later the Supreme Court issued an important decision against the owners of Grand Central Station in New York who wanted to put up another skyscraper over the building. Historic preservationists argued that this would destroy the building, the only one of its kind left in New York after the destruction of Penn Station in 1963. The court ruled against the proposed addition, stating that while owners are entitled to a reasonable financial return on their property, the law does not necessarily guarantee them the absolute *maximum* return. There continued to be challenges to designations of historic properties, but the program was enormously successful. Cumulative statistics indicate that between 1976 and 1988, when the law was modified, over $12 billion was spent in various restoration and rehabilitation projects around the country.[2]

Of the thousands of rehabilitation projects, a particularly celebrated one was the renovation of the Quincy Market area in Boston by the Rouse Company with architect Benjamin Thompson and Associates in 1976–78. [10.2] Over the years the initial functional purpose of the granite buildings—originally the meat, produce, and commodities exchange for the city—had changed as these activities moved away and other activities moved in. Although still structurally sound, the buildings had undergone many modifications, were heavily soiled, and fostered a seamy ambience considered inappropriate for the adjoining city hall. The Rouse corporation restored all the buildings, the once truck- and car-filled roadways were turned into cobblestone-paved, tree-shaded pedestrian malls that

10.2. *Quincy Market, Boston, Massachusetts. A former warehouse complex at the water's edge, the buildings of the Quincy Market were rehabilitated by Benjamin Thompson & Associates as a cluster of restaurants and shops, 1976–79. (Photo: Steve Rosenthal.)*

extended under the freeway to the water's edge (once the very reason for the existence of the market). Hundreds of fashionable shops soon moved into the refurbished buildings, and not long after, adjoining old warehouses along the waterfront were being converted into equally fashionable condominiums. Some critics bemoaned the change from a legitimate working area to a tastefully appointed district of upscale chic boutiques, but the Quincy Market area now draws hundreds of thousands of Bostonians and tourists to the waterside on summer weekends and it is a vibrant urban neighborhood. Other cities similarly began to reclaim their abandoned waterfronts, combining rehabilitation of old structures with infill of new construction; examples include the South Street Seaport in New York (1983–84, by the Rouse Company); Harborplace in Baltimore, Maryland (also by the Rouse company); Waterside in Norfolk, Virginia; and Portside in Toledo. Significantly, a great many of these redevelopments involved reclaiming waterfronts for public use.

Civic leaders and preservation professionals recognized, too, that the retention of merely a few buildings here and there, scattered about a neighborhood, as new development inserted bland tall buildings among

them, would eventually result in the loss of the distinctive character of urban places. This prompted the designation of entire historic districts. Although no one building in a historic district might warrant preservation by itself, the preservation of a combination of scores of buildings as a group, with their original landscaping and streetscape, resulted in the retention of valuable cultural artifacts.

CONTEXTUALISM

Related to this new desire to retain and rehabilitate older buildings was a growing awareness and positive estimation of the existing built context. During the 1970s, more and more architects and clients endeavored to put their newly inserted designs into a more harmonious dialogue with their settings; they responded sympathetically to the built context. An early building to show such sensitivity was I. M. Pei's East Building of the National Gallery in Washington, D.C., an addition to John Russell Pope's magisterial neoclassical National Gallery of Art, originally built in 1938–41. Without doubt, an important part of the impact Pei's building, begun in 1968 and opened in

1978, is its accommodation to the neighboring National Gallery, combined with its adjustment to a most difficult triangular site. [10.3] Like Pope's vast National Gallery, the East Building was a gift of the Mellon family to the nation; Paul Mellon, who endowed Pei's addition, specified that Pei use the same light pink Tennessee marble that had been used to build Pope's building. Pei had a narrow trapezoidal site on Pennsylvania Avenue, close to the Capitol. Flanked by the National Gallery and the Capitol—two classical exemplars—the new building needed to be equally sedate and perfected in proportion and detail. Taking his cue from L'Enfant's street plan, Pei crossed the trapezoid with an opposing diagonal reflecting that of Pennsylvania Avenue, dividing the plan into a long isosceles triangle and a right-angle triangle. Once this was done a logical system of related triangles was developed that gave the plan individual character and a clear sense of order, so that the building would be classically simple and universal while at the same time being particular and site-specific. The

ends of the sharp isosceles triangle rise in tall lozenge-shaped piers cradling a triangular skylight over an interior court that fills the center of the building. The expansive and dominant central space is countered by intimate surrounding galleries.

One could also respond to prevalent local building customs and materials, as Robert Venturi did in his pair of shingled summer cottages, the Trubeck and Wislocki houses on Nantucket Island, built in 1970. [10.4] Like the Montauk cottages by McKim, Mead & White, the two gable-roof shingled Nantucket houses sit in studied irregularity amid scrub-covered dunes overlooking the ocean, continuing a local building tradition stretching back perhaps two centuries.

More abstract but sympathetic nonetheless was Philip Johnson's addition to the rear of McKim, Mead & White's Boston Public Library, designed in 1964–67 and built in 1969–73. Johnson carefully maintained the overall scale of the original library block, enlarging the arcade module, using the same Milford granite of the original, and extending the roof line so that

10.3. I. M. Pei & Partners, East Building, addition to National Gallery, Washington, D.C., 1968–78. While using an architectural language of Modernism, in materials, scale, and nobility of form, I. M. Pei's East Building relates to the classical buildings that surround it. (Photo: 1978 Ezra Stoller © Esto.)

10.4. *Venturi & Rauch, Wislocki (left) and Trubeck houses, Nantucket, Massachusetts, 1970. Like the older nineteenth-century cottages on Nantucket Island, these two cottages* *also use a skin of wood shingles. (Photo: Steven Izenour, courtesy of Venturi, Scott Brown, and Associates.)*

both sections read as related components of a unified whole. In some instances respect for the context resulted in a building or an addition that carefully continues the character of the existing buildings, and a particularly good example is the addition to the University Museum at the University of Pennsylvania, Philadelphia, by Mitchell-Giurgola, built in 1971. The original Lombard Renaissance portion of the museum, started by Wilson Eyre, was extended in a brick wing of nearly equal dimensions. Both Johnson in his library addition and Mitchell-Giurgola in their museum extension pay homage to the older buildings, and indeed Johnson carefully separated his addition from McKim's building by a discrete "hyphen" link.

CHANGES IN PERCEPTION

Another harbinger of the change under way during the 1970s was a celebrated exhibition in fall 1975 at the Museum of Modern Art, in New York, of the huge nineteenth-century project drawings from the École des Beaux-Arts. Here, within the bastion of Modernism, the positive qualities of École design (which, only a generation earlier, had been viewed as the arch enemy) were discussed amid much fanfare and the publication of a massive illustrated book. Beaux-Arts architects, it was now declared, were not

intrinsically ignorant of modern materials or functions, but rather they consistently manipulated whatever materials seemed most satisfactory in the shaping of sequences of public spaces; they were more behavioral architects than functional architects (at least as "function" had been understood by modernists). Modern International Style purism, which, only a few years before, proponents had claimed embodied the solution to all building problems, was now seen as supplying only a limited range of solutions for very specific functions. Modernism was now merely one among many styles.

The Failures of Modernism

The attack on Modernism was made even more pointed in two books published in the mid-1970s: Brent Brolin's The Failure of Modern Architecture and Peter Blake's Form Follows Fiasco: Why Modern Architecture Hasn't Worked. Brolin took issue with Le Corbusier's ideal of "one single building for all nations and climates," illustrating how European-style modern buildings erected in equatorial Third World countries, for which the modernist style had never been intended, quickly began to self-destruct. Traditional methods of planning and building, he insisted, were almost always better adjusted to local climate and social systems than were the imported abstractions of International Style dogma. Peter

Blake's book has something of the character of Johnson's essay on the "Seven Crutches," but without the sardonic humor. As if to emphasize the greater complexity of the contemporary problem, he cites eleven fantasies that shaped modern purism (four more than the conventional Ruskinian seven), the blind pursuit of which had led so many architects into trouble: function, the open plan, purity of form, reliance on technology, the skyscraper-ideal, the ideal city, mobility, zoning, housing, ideal form, and the mystic religion of architecture itself.

The most popular form of this attack appeared in films that presented the horrors of fire in skyscrapers too tall to evacuate (*The Towering Inferno*, 1975), or

10.5. I. M. Pei office (Cobb), John Hancock Center, Boston. Newspaper photographs such as this show the temporary panels of plywood inserted when the glass was sucked from the windows. (Photo: Boston Globe.)

of towers shattered by earthquake and transformed into showers of glass daggers raining on hapless pedestrians below (*Earthquake*, 1975). In Boston this rain of glass shards was in fact materializing, though due to different causes.

There were other events that revealed the flaws, not only in Modernism as an architectural dogma, but in the basic structure of modern American culture with its absolute faith in the capacity of technology to isolate and solve all social problems. An early warning was the collapse of the electrical distribution system in the entire northeast quadrant of the country on November 9–10, 1965, starting in Niagara Falls and spreading through Ontario and Quebec, Canada, darkening all of New England and New York, south through New Jersey and Pennsylvania. In December another sweeping electrical failure blackened the Southwest and parts of Mexico. More power system failures struck the Northeast in June 1967. When another sweeping blackout hit the entire New York City metropolitan area in July 1977, one difference this time was extensive public looting and arson. Not only was the power system breaking down, so it seemed was the social system.

At least in the late 1960s, countering these power failures and the resulting personal inconveniences people suffered, the American public could look with pride at the technical success of the space program leading to Neil Armstrong's footsteps on the moon in July 1969. Soon space shuttle launches became almost commonplace, as the shuttle lifted one satellite after another into orbit. Thus it was with particular horror that the public watched the routine televised liftoff of the shuttle *Challenger* on January 28, 1986, carrying the first private civilian astronaut, only to see it explode like a great sunburst over Florida. Supertechnology was clearly and horrifically fallible.

Bridges began to collapse due to deferred maintenance, and in April 1988, the Williamsburg Bridge, in New York City, eighty-five years old, was closed to traffic (including four subway tracks) because of serious structural weakening. When it was built in 1903 it cost $24 million; to fix it would now cost $250 million, and twice that to replace. Moreover, some recent buildings were flawed from the moment of conception and design, the result of trying to maximize effect or minimize structure. The John Hancock Center, a slender glass-walled tower in Boston's Back Bay, begun in 1966–67 from designs by the office of I. M. Pei, began to loose its windows during construction in 1972–73 and the entire area below had to be blocked off due to

10.6. *Philip Johnson and Cyril M. Harris, Philharmonic Hall, Lincoln Center, New York, New York, renovation 1971–76. The new interior of Philharmonic Hall shows the use of large-scale angled flat wall panels to disperse sound through the room. (Photo: Norman McGrath, © 1976 Lincoln Center for the Performing Arts, courtesy of the Lincoln Center for the Performing Arts.)*

10.7. *Philharmonic Hall, plans before (above) and after (below) renovation. The original "milk bottle" plan of Philharmonic Hall proved to be an acoustical disaster; the renovated Philharmonic Hall reveals its debt to traditional rectangular orchestral halls such as those in Boston and the Gewandhaus in Leipzig, Germany. (L. M. Roth, after* Progressive Architecture, *March 1977.)*

the raining shards of glass. What had been intended as a great crystalline tower was patched with sheets of plywood as, year after year, teams of engineers attempted to solve the riddle. [10.5] The building stood empty until 1975, when windows of a revised design were installed; litigation as to the reason for the window failures continued until 1981.[3]

The problems with the John Hancock Center certainly frustrated client, architect, and owners of surrounding buildings. Other buildings manifested problems as well, although not always so dramatically. One was Philharmonic Hall in Lincoln Center, in New York. From the moment the hall had been opened in 1962, the acoustics had been widely decried as miserable and antithetical to producing good music. The architect, Max Abramovitz, and his acoustical consultants, the eminent Bolt, Beranek, & Newman, had incorporated the latest technical innovations in the auditorium shape and they had used the consultant's signature suspended "acoustic cloud" reflecting panels. [10.6, 10.7] The sound of the

orchestra was being partially absorbed by the reflecting panels and a light wood ceiling, reflected off the concrete floor, and unevenly distributed in the hall. Moreover, reverberations did not decay at an even rate. In 1971 Cyril M. Harris, who had become well known for his highly successful acoustical designs for the Kennedy Center concert halls, in Washington, D.C., and for other auditoriums he designed in Champaign, Illinois, and Minneapolis, was asked by Lincoln Center trustees if he could provide a remedy. After studying the original plans he reported he could, and made three recommendations: (l) he would remove everything inside the hall, down to the steel frame, (2) he would design an entirely new interior to be inserted into the existing shell, but (3) he would undertake this work only if allowed to collaborate with architect Philip Johnson. Harris also noted that because no cloakroom was provided, listeners brought their coats into the auditorium, stuffing them under the seats, thereby adding too much sound-absorbing material to the equation. Johnson and Harris were hired to prepare plans and they quickly settled on a purely rectangular hall with a megaphone-shaped concert stage. [10.7] They employed a great deal of wood in a heavier, more acoustically reflective flat ceiling, and in the walls and floor. On the ceiling and walls they devised large relief panels in patterns designed to disperse the sound. The final result,

unveiled in October 1976 (after the expenditure of nearly $4.5 million provided by Avery Fisher, for whom the new hall was named), proved to be a contemporary variation of acclaimed models, Boston Symphony Hall, by McKim, Mead & White, built in 1892–1901, and the Neues Gewandhaus, in Leipzig, built in 1884. The deeply figured walls and ceilings of all these halls broke and dispersed the sound. As was now abundantly clear, the ornamentation did indeed serve a very real acoustical function. For acoustical purposes, it might be said, "more was more," but it had proven to be a very expensive lesson.[4]

Other design problems, however, were not just inconvenient or cosmetically irritating but appallingly catastrophic. The worst single-building disaster occurred on July 17, 1981, when "sky bridges" spanning the atrium lobby of the Hyatt Regency Hotel, in Kansas City, Missouri, collapsed, instantly crushing 113 people to death and permanently maiming 180 more. [10.8] On Sunday afternoons it had become highly popular to have bands play in the spacious hotel atrium, and people flocked to this weekly event to dance and enjoy themselves. The elevated walkways had been hung from the most minimal of suspension rods to give the appearance that they were floating. The connections of the "sky bridge" decks to the rods, too delicate to resist the unanticipated dynamic load of scores of dancing people, had given

10.8. Hyatt Regency, Kansas City, Missouri, 1981. The collapse of the "sky bridges" during a dance in the atrium of this hotel at 7:01 p.m., Friday, July 17, 1981, caused the largest single toll of deaths and injuries in any American architectural failure. (Courtesy of Kansas City Star.)

10.9. Pruitt-Igoe Housing, St. Louis, Missouri. After prospective residents refused to move into this public housing project because it had proved such a dangerous area, the city demolished the buildings in 1972. (Courtesy of St. Louis Post Dispatch.)

way. Tragically, less was not more. Owners, architects, builders, and engineers all placed the blame with each other, but in 1985 the engineers who detailed the connections were cited for gross professional negligence, and a year later their professional licenses were permanently revoked by the State of Missouri.[5]

Of all these events, the one moment that seems to mark most publicly and visibly the death of Modernism as an architectural "faith" occurred at 3:32 p.m. on the afternoon of July 15, 1972, when the first explosive charges were detonated to bring down the Pruitt-Igoe housing complex in Saint Louis, Missouri. [10.9] The high-rise housing blocks had been built as a government-subsidized project in 1955, designed by the Saint Louis architect Minoru Yamasaki, in accordance with the latest thinking in public housing. Its eleven-story apartment blocks were not so different from acres of housing high-rises in New York City, Newark, Philadelphia, Chicago, or scores of other major cities. In the Saint Louis project, however, the escalating crime rate, the vicious vandalizing of the buildings, and the rapid descent of Pruitt-Igoe into a behavioral pit, was markedly worse. By the end of the 1960s poor families flatly refused to live there.[6] There was no alternative but to obliterate Pruitt-Igoe and somehow start over. That came to be symptomatic, in fact, of the architectural profession at large: rethinking fundamental premises and starting over.

THE BEGINNINGS OF POSTMODERNISM

As early as 1959 the often mind-numbing uniformity of Modernism prompted a few architects to imagine a more complex, inclusive architecture in which buildings were placed in sympathetic "dialogue" with their neighbors, an architecture that made clear links with history and that accepted the messy and seemingly chaotic quality of human activity. Taking its cues as much from human memory and the need for meaningful symbolism as from mechanistic and utilitarian responses, the newly defined architecture became known by 1975 as postmodern, although many architects had begun reacting to conventional Modernism as early as 1961.[7] Postmodernism was later defined by its principle theorist, Charles Jencks, as a double-coded architecture, one that combined modern techniques with traditional forms, so as to communicate not only with a small number of other architects but with the public as well. As Jencks observed in his 1989 book *What Is Post-Modernism?*, Modernism had failed to remain credible because it had not communicated effectively with its users and didn't make effective links with the city or with history. The new postmodern architecture, inclusive and pluralistic in its multiple coding, encountered stiff resistance from those still in the modernist and exclusivist camp. The early leaders of this new movement, found on both

10.10. Robert Venturi, Vanna Venturi house, Chestnut Hill, Philadelphia, Pennsylvania, 1959–64. Designed by Robert Venturi for his mother, this house was filled with abstracted references to traditional Colonial Philadelphia houses. (Photo: Rollin La France, courtesy of Venturi, Scott Brown, and Associates.)

10.11. Venturi house, plan. In plan, Venturi's mother's house revealed the pressure of several activities trying to crowd together in a small space. (L. M. Roth, after Venturi.)

coasts (and slightly later in Chicago), were Robert Venturi, initially, and then Robert A. M. Stern in the East, Charles W. Moore in California, and then Stanley Tigerman in Chicago.

Robert Venturi (born 1925) is perhaps the best-known advocate of this new inclusive pluralism. Born in Philadelphia, he studied architecture under Jean Labatut at Princeton University, where he learned something of the symbolic importance of image and form. It should be noted that since the architecture program had been started at Princeton in 1921, it had remained thoroughly integrated with a program in art history and archaeology. Labatut, French-born and École-trained, stressed École principles and encouraged his students to seek out and study closely the best architectural designs, whatever the historical period, recent or ancient. Later, as Carter Wiseman has put it, "as the renown of his students would demonstrate, Labatut's guerilla resistance to the hegemony of Modernism was to prove him something of a hero in retrospect."[8]

Venturi then worked for a number of architects, including Saarinen and eventually Louis Kahn, from whom he learned "what it is like actually to look at things," as Donlyn Lyndon noted.[9] An important turning point was Venturi's residency at the American Academy in Rome, for here he learned the primary importance of environmental and contextual relationships. Even as many architects were rushing to advance Miesian reductive purism, in 1953 Venturi wrote that "the architect has a responsibility toward the landscape, which he can subtly enhance or impair, for we see in perceptual wholes and the introduction of any new building will change the character of all

the other elements in a scheme."[10] This awareness emerged from his careful study of Michelangelo's Campidoglio and is illustrative of Venturi's analysis of the past. In addition, like Kahn, Venturi was forced to test his theory in the classroom at Princeton and at Yale. In his first book, *Complexity and Contradiction in Architecture* (1967) he attacked the pretentiousness of the exclusivists, arguing for accommodation and multiplicity: "Less is a bore," he retorted. Venturi accepted mundane grubbiness, the limitations of budgets, and imperfect human nature, admitting that "main street is almost all right," in *Learning from Las Vegas* (1972), his second book. The contemporary urban landscape may not have been perfect, but neither was it ripe for preemptory bulldozing.[11]

Venturi's own designs show this complexity and contradiction, and indicate just how early the dualism began to appear in his work. The house he designed for his mother on a restricted lot in Chestnut Hill, Philadelphia, was begun in mid-1959 and constructed in 1963–64. [10.10, 10.11] The plan is made up of an irregular cluster of rooms all trying to be in the same place at the same time. The way in which the rooms focus on a central fireplace recalls Wright and New

England, but the way in which the rooms seem to collide, the unexpected angles of walls, the jostling of spaces into mutual accommodation, is quite unlike the neat, compulsive geometries of Wright. On the exterior the windows change shape and size according to the function within—a high horizontal window band over the kitchen counters to the right, a small porthole in the bathroom to the left, and a large window in the bedroom far to the left—but all are tied together with thin belt course "strips." These, along with the abstracted broken gable and the intimated pediment arc, seem to refer to a formal classical Philadelphia heritage. Certainly Venturi's whimsy and irony are joyfully exhibited, revealing the architect as *homo ludens*, man at play, and it is this whimsy that so infuriated critics who believed that all architecture, public and private, is a serious confrontation of purist beauty seeking to vanquish ugliness. In Philadelphia, in the shadow of Furness, Venturi found in the contradictions of studied ugliness a powerful imaginative resource.

Whimsy, irony, and realism define Venturi's larger public buildings, of which his apartment building for the elderly, Guild House, in Philadelphia, built in 1960–65, is one of the earliest and best. [10.12] It is a

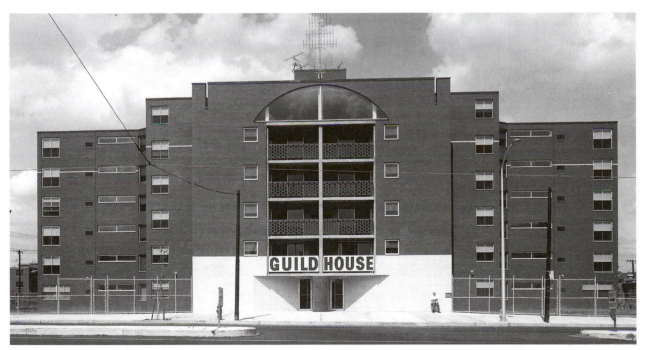

10.12. *Venturi & Rauch, Cope & Lippincott, associated architects, Guild House, Philadelphia, Pennsylvania, 1960–65. Guild House, an apartment block for elderly Quakers, placed among rather ordinary apartment blocks* *and loft buildings, attempts to blend with its neighbors. (Photo: William Watkins, courtesy of Venturi, Scott Brown, and Associates.)*

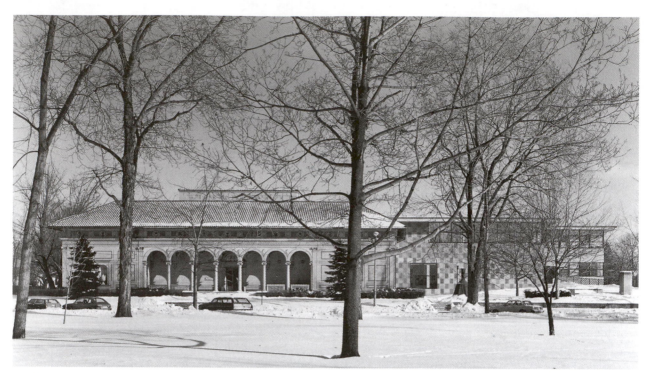

10.13. Venturi & Rauch, addition to the Allen Memorial Art Museum, Oberlin College, Oberlin, Ohio, 1973–76. In cladding materials and general scale, the Venturi & Rauch addition attempted to reflect the original Oberlin Art Museum building by Cass Gilbert, 1915–17. (Photo: Thomas Bernard, courtesy of Venturi, Scott Brown, and Associates.)

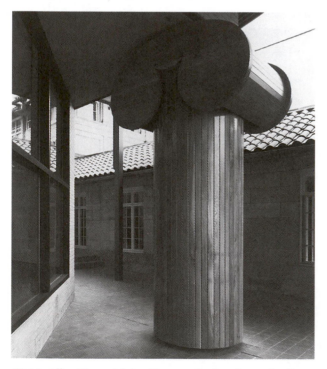

10.14. Allen Memorial Art Museum, Ionic column detail, at connection between original building and new gallery. (Photo: Thomas Bernard, courtesy of Venturi, Scott Brown, and Associates.)

very plain building, making no pretense to being any better or grander than the surrounding vernacular brick commercial buildings. Standard industrial elements are used throughout for windows, balconies, brickwork, and finishes. Nevertheless, Venturi avoided foursquare boxiness by stepping the center of the building forward in stages and by employing complexly interlocked floor plans that, as Charles Moore observed, recall apartments of the 1920s.[12] The wall planes are punctuated by openings of varied sizes, proportioned to changing internal functions. The street facade is made a frontispiece by using glazed subway tile at the entrance to form a base element. Above the door are supergraphics, and at the top is a large broad arched window, suggesting something of a pedimented crown. This window lights a large communal lounge for television viewing, for, unlike Rudolph in his library at Crawford Manor, Venturi did not moralize about what the elderly *should* do. He acknowledged what they actually do by placing a giant gold-plated antenna at the top of the building. Even more infuriating to the purists, this front antenna was a purely symbolic sculpture; the real functioning antenna was

mounted elsewhere.[13] Functional activities, structure, and external environment are all reconciled to one another, with touches of humor in the "misalignment" of the entrance recess and its bisecting column, the arch of the frontispiece, the slits in the parapet wall, and the razor-sharp line of the white tile, marking an "attic story" that slices through every window at the top and aligns with none. If purists had asked why he did things like this, Venturi, observing the complexity of High Victorian Gothic examples, particularly those of Furness nearby, might well have replied, with every justification, "Why not?" This early phase of Venturi's work, in conjunction with his wife and partner, Denise Scott Brown, and John Rauch, was rounded out by such projects as Fire Station No. 4, in Columbus, Indiana, built in 1966, an example of what he called "ugly and ordinary" architecture.

Venturi and Scott Brown's entry for the Yale Mathematics Building in 1969 marked the end of this early period. In a field of 468 entries, theirs was awarded first prize but was not built. The program called for an addition to Leet Oliver Hall, a small Gothic structure on Hillhouse Avenue, on a restricted trapezoidal site bisected diagonally by a railroad cut below grade. Across the street was the splendid Italian villa house built for Professor James Dwight Dana by Henry Austin in 1849; the house is both a New Haven Preservation Trust Landmark and a National Historic Landmark. Given the proximity of two such singular neighbors, not to mention such other nearby notable buildings as Saarinen's Hockey Rink and Johnson's Kline Tower, Venturi made his design as plain as possible (thereby giving it its own distinction), and on the boards of the final competition drawings he wrote: "The Image is Ordinary: a working, institutional building enhancing rather than upstaging the buildings around it."[14] The sense of change with which Venturi and other architects were then struggling is evident in his declaration concerning the Yale design, that "architecture for a time of questioning cannot be monumental. It cannot be a barracks either. But it must be more than a loft."[15]

Venturi's sense of context was well developed, as demonstrated when he added a new gallery and school wing to the Allen Memorial Art Museum at Oberlin College in 1973–76. He adjusted his adjoining block to the scale of the original museum, a sedate Renaissance palazzo designed by Cass Gilbert in 1915–17. [10.13] He also reiterated the gray and red limestone used by Gilbert, although in Venturi's hands it became a checkerboard pattern. Rather than pay the

original building too much deference, however, Venturi pushed the addition hard against palazzo; aside from a narrow strip of black marble at the joining, there is no gentle transition. At the rear inside corner, however, where the old and new buildings come together, Venturi opened up the corner and inserted an overscaled Ionic column, of wood, calling to mind Gilbert's Neoclassicism. [10.14]

Charles Moore (1925–1994) was born in Michigan and studied architecture first at the University of Michigan and later at Princeton, where he, too, was influenced by the stylistic freedom and keen study of history championed by Jean Labatut. To this, however, Moore added a strong feeling for the environmental role of architecture. After serving in the army during the Korean war, he settled in San Francisco and formed a practice with Donlyn Lyndon, William Turnball and

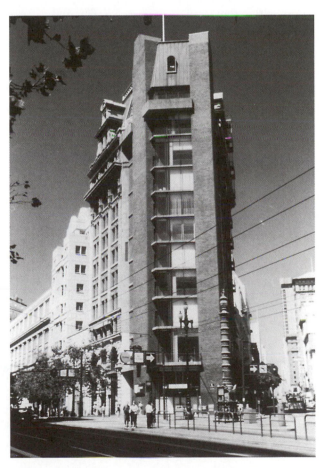

10.15. *Charles Moore with Clark and Beuttler, Citizen's Federal Savings and Loan, San Francisco, California, 1962. The addition to the bank (in the foreground) attempts to continue the general forms of the older portion, heavily molded Second Empire in style. (Photo: L. M. Roth.)*

Richard Whitaker; later he followed Rudolph as head of the architectural program at Yale. Moore came to view the architect as one who acts to particularize and reinforce a sense of place, thereby letting people know, he wrote, "where they are—in space, in time and in the order of things."[16] To reinforce the nature of a particular place, one must respect what is already there, but Moore also delighted in creating contrast and idiosyncrasy. A good early example of his work can be seen in the addition to the Citizen's Federal Savings and Loan Association, in San Francisco, which he did in collaboration with Clark and Beuttler in 1962. [10.15] The flamboyant Beaux-Arts motifs of the original building are restated in contemporary terms, in the large base element and especially in the modified mansard roof, so that the new building deals successfully with the awkward sharp corner site, augments the original building, and still asserts its own contemporaneity. The result is a combination that strengthens the character of the place.

In a rustic, remote landscape the character is very different, requiring a much different response; so in Moore's Sea Ranch housing, 1963–69, north of San Francisco, one finds a cluster of angular rough units. [10.16] Moore (and his partners Lyndon, Turnbull,

and Whitaker) collaborated with developer Alfred Boeke of Oceanic Properties, designing this condominium group so that it would have both communal unity and privacy. This same idea was carried out in later extensions to Sea Ranch by Joseph Esherick and landscape architect Lawrence Halprin. Groups of shed-roof pavilions, sheathed in rough siding left to weather naturally, enclose small spaces, and in their overall craggy silhouette echo the rugged coastal cliff. Prior to building, Moore had detailed studies made of the winds common here, so that the decks and balconies of individual condominiums could be designed to divert prevailing winds, creating microclimatic zones that made the balconies more comfortable. Sea Ranch enhances the nature of the place, but its nestled boxes reveal something even more important—a unity of many individualities, or what architect and critic Robert A. M. Stern calls "the willingness of many to give up something for the community."[17]

A growing division in design philosophy, however, was revealed in 1973 by an exhibition held at the Museum of Modern Art entitled "Five Architects" and featuring recent work of Peter Eisenman, Michael Graves, Charles Gwathmey, John Hejduk, and

10.16. Moore, Lyndon, Turnbull, & Whitaker, architects, Lawrence Halprin & Associates, planners, Sea Ranch, north of San Francisco, California, 1963–69. The individual residences, sheathed in wood left to weather, are clustered around a court that provides a pleasant warm microclimate in a larger macroclimate that can be quite windy and cool. (Photo: © Wayne Andrews/Esto.)

Richard Meier. Although differing in character, these five architects were all using a kind of late Modernism heavily influenced by Le Corbusier. And because of the general absence of color, as well as a kind of reductivist idealistic purity, they came to be called the "Whites." The highly abstract and minimalist drawing style used by all of them supported Eisenman's assertion that architecture was a complex formal language unrelated to any exterior reference.

Responding to this exhibition, and arraying themselves against the Whites were another group of young architects, whose spokesman, Robert Stern, called the "Grays." They believed that architecture, although a formal expression, works best when it acknowledges its context and incorporates allusions to the past, even references that are humorous and ironic.[18] Both of these groups stemmed from Louis Kahn, but whereas the Whites moved sharply in the direction of Le Corbusier in the 1920s, toward abstraction, the Grays followed the trail blazed by Venturi. Both factions, however, recognized the expressive power of architecture as a nonverbal language (no matter whether the end was conceptual or literal), and both used structure as a means to their respective ends rather than an end in itself. Both, too, proposed that architecture is simply architecture and not the instrument through which to reform society. Except for Stern himself, perhaps, these young architects abandoned the social commitment of their forebears of the 1930s, and developed increasingly hermetic philosophies. The Whites, especially, deliberately distanced themselves from the general public, using a theoretical language that became more and more abstruse.

The major White architects were Peter Eisenman, Richard Meier, and Michael Graves. Eisenman (born 1932 in Newark, New Jersey), educated at Cornel and Columbia Universities, was perhaps the most intellectually penetrating of this group. In his early practice he focused on private houses in which he developed multiple autonomous structural and visual systems that he termed "bi-valent," heightening and complicating the tensions between two conceptual relationships. Like abstract painters he avoided names for his houses and identified them as House I, House II, or House III. The first two (the Barenholtz pavilion at Princeton, New Jersey, built in 1967–68; and the Falk house, in Hardwick, Vermont, built in 1969–70 [10.17]), are based on parallel rectilinear grid systems that are played off against each other, while the third (the Robert Miller house, in Lakeville, Connecticut, built in 1971) has two grids turned at 45 degrees to each other.

10.17. Peter Eisenman, House II (the Falk house), Hardwick, Vermont, 1969–70. The precise and abstract geometries of Eisenman's early houses were presented in equally abstract axonometric line drawings. (From Eisenman et al., Five Architects, *New York, 1975.)*

The increasing abstraction of Eisenman's version of late Modernism prompted him to adopt an arcane drafting technique originally exploited in the 1920s by Dutch De Stijl artists and then the early modernist architects influenced by them—the axonometric view. An axonometric view replaces a traditional perspective view in which the horizontal lines of a building converge on distant vanishing points, and in which dimensions become smaller as they appear to recede in the distance. In an axonometric view everything is shown with parallel lines at 45- and 90-degree angles, and all dimensions remain true in the vertical as well as in the horizontal plane (as in 10.17). Furthermore, everything is delineated as lines or flat planes, without shading or shadows; if the image, furthermore, shows objects abstracted or nontraditional in character, the view can become very difficult to read, even by trained designers and students of architecture.

10.18. Richard Meier, Douglass house, Harbor Springs, Michigan, 1971–73. Inspired by the work of Le Corbusier in the 1920s, the Douglass house rises crisp and white against a background of deep green conifers, emphasizing its geometric clarity. (Photo: Ezra Stoller © Esto, courtesy of Richard Meier & Partners.)

The gulf between normal everyday practical architecture and the kind of detached, nonreferential architecture Eisenman envisioned in his axonometric views was dramatically—and most ironically—illustrated in 1994 in Suzanne Frank's *Peter Eisenman's House VI: The Client's Response*. On opening the cover, the reader is confronted with an errata insert that points out that the axonometric diagram used as the cover design was accidentally printed upside down, and that another axonometric diagram in the text is printed backwards. If even professional graphic designers cannot easily decipher Eisenman's drawings, how is the layperson or client to understand them?[19] How is the general public to become supportive of such an architecture?

Richard Meier (born in 1934, in Newark, New Jersey), while somewhat less theoretical, was more sculptural in his manipulation of solids and voids; he was also the most austere, with his monochrome white compositions standing in sharp contrast to their environment. After earning his architectural degree at Cornell University, Meier worked for New York City architects Brody, Davis, & Wisnieski, Skidmore,

Owings, & Merrill, and then Marcel Breuer. His early independent work consisted largely of private residences, such as the Smith house, in Darien, Connecticut, built in 1965–67, and the Saltzman house, in East Hampton, New York, built in 1967–69. His early masterpiece was arguably the Douglass house on the bluff above Lake Michigan at Harbor Springs, Michigan, built in 1971–73, in which the debts to Le Corbusier are clearly evident. [10.18] The blazingly white house sits on a tall base, perched on a steep bluff, set amid a thick stand of dark green conifers, looking out over the water. It exalts human artifice in contrast to nature, combining sculptural abstraction and mechanistic clarity, with those same maritime details like tubular steel railings on the steamships that Le Corbusier had admired so much in the 1920s.

Of the so-called Whites, Michael Graves (born in 1943, in Indianapolis), was even more adventurous in his work. Educated at the University of Cincinnati, he earned his architecture degrees at Harvard and then the American Academy in Rome, where, like countless others, he fell under the dulcet spell of Tuscany, its landscape, light, and pervasive antiquity. Inspired by stuccoed and painted Renaissance villas, he began to introduce muted colors in his work, initially as a way to isolate selected structural elements, as in his Benacerraf house, in Princeton, New Jersey, built in

1969, and his Snyderman house, in Fort Wayne, Indiana, built in 1972. In both of these the conceptual grid, in white, was in contrast to planes of pale violet, pink, and rose. His work began to expand beyond residential commissions with his entry in the Fargo-Moorhead Cultural Center Bridge competition in 1977, submitting drawings whose Tuscan earth colors of buff, terra cotta, and turquoise soon came to characterize his work. [10.19] In this striking design, too, he incorporated bold overscaled allusions to classical forms, such as wedge-shaped keystones, that soon became a standard element in the lexicon of what was by now beginning to be called Postmodernism.

Among the Grays, the most articulate advocate in the United States was Robert A. M. Stern (born in 1939, in New York City), who was educated at Columbia University and then at Yale, where he came under the influence of historian Vincent Scully. It was Stern who suggested that the Grays had moved beyond the strictures of Modernism into a new postmodernist phase. What concerns postmodernists, he declared, is not an abstract formal architectural language that exists independent of any reference to the outside world and normal experience, but an architecture that is primarily dependent on its historical and physical context. Postmodern architecture is rooted in its context, makes allusions to the past, and employs applied ornament. He singled out Moore's addition to

10.19. Michael Graves, Fargo-Moorhead Cultural Center Bridge, 1977. Graves presented his bridge design as a series of forms inspired by the components of classical architecture, focusing on the keystone shape in the middle, all colored in muted hues of terra cotta, turquoise blue, and buff. (From R. A. M. Stern, ed., The Architect's Eye, New York, 1979.)

10.20. R. A. M. Stern, Wiseman House, Montauk, Long Island, New York, 1965–67. Among the very first of Stern's independent commissions, this house is a playful but somewhat abstract interpretation of the gable form so favored by Shingle Style architects of the 1880s; like them, Stern used shingles across the entire exterior surface. (Photo: Hans Namuth.)

10.21. R. A. M. Stern, Lawsen summer house, Quoque, Long Island, New York, 1979–81. In this compact square summer house on the dunes overlooking the ocean, capped with its heavy lidded roof, Stern took a moderate stance between slight references to the traditional shingle style and to modern abstractions. (Photo: © Peter Aaron/Esto.)

the Citizen's Federal Savings and Loan of 1962 to illustrate this approach.[20] Stern included among the Gray architects colleagues such as Venturi, Moore, Romaldo Giurgola, and Allan Greenberg.

Stern's own early work immediately demonstrated what he had learned from Scully regarding American historical traditions, as well as from Venturi and Moore. The influence of the Shingle Style was clear in Stern's Wiseman house, in Montauk, Long Island, New York, built in 1965–67 (done with John S. Hagmann). [10.20] The shallow depth of the house, its broad extended gable, and the comprehensive shin-

gle covering recall McKim, Mead & White's Low house, but Stern may also have already discovered the simpler shingled summer cottages built by McKim, Mead & White in 1881–82 for a group of New York businessmen at Montauk Point, at the far eastern end of Long Island.[21] In the larger and more visually complex Saft house, in East Hampton, New York, built in 1973, Stern and Hagmann seem to acknowledge Arthur Little's Shingleside, at Swampscott, Massachusetts, built in 1881. Numerous other shingled cottages followed by Stern, leading eventually to an addition, in 1978, to one of the classics of the

Shingle Style: Peabody & Stearn's Redtop, in Dublin, New Hampshire, originally built in 1887. The end of this early phase of Stern's adaptive use of Shingle Style motifs and textures can be illustrated with his diminutive summer shore cottage for Lawsen, at Quogue, Long Island, New York, built in 1979–81. [10.21] Almost square in plan, the gray singled house is capped by a broadly flaring roof supported by white Tuscan Doric columns. The strong bold formal geometries are modulated by the appearance of precise classical details. This element of historicism would gradually increase in emphasis in Stern's subsequent work.

As with Venturi's veiled reference to classical moldings in his mother's house, Stern also began to refer to classical details, as can be seen in his urbane and formal Lang residence, in Washington, Connecticut, built in 1973–74. The assertive symmetrical entrance facade, trimmed with discreet classical moldings, contrasts with the main body of the house where the exigencies of internal functions assert themselves in playful geometries. The rather Mediterranean form and color of the Lang house were further expanded in a large country house in Westchester County, New York, built in 1974–76, and several others that followed.

POSTMODERNISM EMERGES

The rather fixed design philosophies of Modernism, whether of the canonical functionalist-structuralist kind, or of the grandiloquent expressionist kind, were being challenged by a more inclusive design approach by the mid-1970s. Before the close of that decade the term *postmodern* was being widely used to describe this new architecture. By the mid-1970s a pluralism of design options was opening up American architecture, and within a few years the exclusivists and inclusivists, the Whites and Grays, had branched into even more subdivisions. This growing pluralism of design strategies was made very clear in the mock competition of 1980 sponsored by a group of young self-styled radical architects in Chicago. They sent out a call for "late" entries in the Chicago Tribune Tower competition, and though the submissions were never intended for construction they nonetheless presented widely divergent visions of what an office skyscraper might be. The proposals ranged from decidedly classical entries by Stern and Thomas Gordon Smith to glass-sheathed heroic late Modernism by Helmut Jahn.[22] At

almost the same time, these American architects and their European counterparts publicly declared their embrace of a new postmodern classicism at the Venice Biennale of 1980, in an exhibition entitled "The Presence of the Past: Strada Novissima." For the show, styled as the First International Exhibition of Architecture at the Venice Biennale, and organized by Paolo Portoghesi, twenty architects were invited to design building facades that addressed the street. This became not only a kind of manifesto of postmodernist design objectives, but also an indication of just how many interpretations of Postmodernism there might be. American architects represented in the exhibition included Venturi, Moore, Allan Greenberg, and Thomas Gordon Smith.

The growing confusion of this expanding pluralism, at least among the classicists, was given some structure in a book by Stern himself, entitled *Modern Classicism* (1988), in which he developed a taxonomy that brought a measure of order to what seemed to be growing architectural tumult.[23] Stern proposed five divisions among the postmodern classicists: Ironic, Latent, Fundamentalist/Essentialist, Canonic, and Modern Traditionalist.

Ironic Classicism

The Ironic Classicists, most of whom had been the Grays of a decade earlier, included Robert Venturi, Elizabeth Scott Brown, Charles Moore, Stern (up to about 1985), Frank Gehry in some of his early work, and even Philip Johnson. They advocated a "semiological motivated approach," wrote Stern, "which more completely reflects the heterogeneous culture that contemporary architecture is destined to serve. Classical elements could be included in this architecture, yet always with 'quotation marks.' Historically-based elements ('signs') function as pretense, although useful pretense." But, as Stern was clearly aware, "in the hands of many ironists, architecture becomes a matter of built jokes, and nothing goes flat faster than a joke."[24] Venturi and Scott Brown were prominent in this group in the 1970s, with projects like their house in Delaware, built in 1978–93, with its squat flattened cartoons of archaic Doric columns, or their compacted version of Mount Vernon, built in 1976. Charles Moore was also notable in this group, especially in his flamboyant Piazza d'Italia, in New Orleans, built in 1975–78, with its bits and pieces of classical detail rendered in stainless steel and its fountains patterned after Moore's own face. [10.22] Other work by Moore in this vein, though less flamboyant, is his

10.22. Charles Moore, Piazza d'Italia, New Orleans, Louisiana, 1975–78. Moore's playful mix of highly interpreted classical forms is an excellent example of ironic Postmodernism; it even includes faces of Charles Moore spouting water as fountains. (Photo: Norman McGrath.)

Rudolph house, in Williamstown, Massachusetts, built in 1979–81 (with its allusions to Jefferson), his Williams College Art Museum addition, built in 1977–86, and his Hood Art Museum at Dartmouth College, built in 1981–85.

Also emerging as a leading ironist was Michael Graves. In 1978, with the strong support of Philip Johnson, Graves won the celebrated competition for the Portland Public Services Building, in Portland, Oregon, built in 1979–82 (for which Johnson served as one of the three jurors). [10.23] Although Portland was hampered by an extremely limited budget, Graves realized that the city nonetheless wished to make this a very special building. Moreover, the site, on a 200-foot square block, lay between the Renaissance-palazzo City Hall, built in 1895, by Whidden & Lewis, and the larger classical block of the Multnomah county courthouse, built in 1911–14, also by Whidden & Lewis. Graves decided to play off

those flanking classical public buildings, to which his new building would be closely related functionally. Moreover, to the east lay one of Portland's downtown parks, allowing the new building to be viewed virtually in its entirety.

Graves's winning design was the subject of intense public and professional criticism when the award was first made—so vigorous, in fact, that a second phase was introduced in the design competition to allow the judges to "rethink" their decision in favor of Graves.[25] The bold coloring and the large abstracted classical forms of Graves's design seemed to some people a joke. The criticism continued even as construction of this "fast track" project began. There was concern among many observers that Graves, unlike the other finalists, Arthur Erickson and Mitchell-Giurgola, did not have the necessary experience in designing and building such a large public building or with the fast-track design-build process. In such a design-build

10.23. Michael Graves, Portland Public Services Building, Portland, Oregon, 1978–82. The first major public building to be in the postmodern style, this greatly promoted Graves's career while also making Portland, Oregon, an important point on the architectural map. (Photo: Dallas Swogger, courtesy of the City of Portland, Oregon.)

process all parties involved agree to a fixed cost at the outset, meaning that cost overruns are dealt with by stripping the design. Juror Philip Johnson offered firm assurances that Graves was indeed up to the task. While he was busy insinuating himself as the maven of Postmodernism (just as he had thirty-five years before made himself the arbiter of European Modernism), Johnson was determined that the Portland Building commission be awarded to his protégé Michael Graves.

Finished in 1982, the Portland Building (as it is commonly called) was the first major public facility in the postmodern idiom and it firmly established Postmodernism as a mainstream architectural expression instead of merely the extravagant gesture of the avant-garde. Just after the building was opened, critic Paul Goldberger hailed it as the most significant American building of the decade because it dramatically marked the influence of Postmodernism on the modern cityscape.[26] But the many critics of the building, both local and national, had reason to suspect Graves's capabilities at that early point in his career, for a decade and a half later cracks would appear in upper floors, requiring the insertion of new bracing columns, and the ensuing investigation further revealed that the building had not been designed to meet the seismic codes in effect at the time of the competition.[27] The city of Portland was tempted briefly to walk away from the building that had put it on the architectural map, but has instead decided to remain in the building, somehow dealing with a horrendous retrofit repair bill.

Although it was evident from the moment the building opened that it suffered from small office windows, cramped public spaces, and awkward expression of public entrances, the Portland Building nonetheless made Postmodernism legitimate in a way no other work had yet done. Especially significant was the

10.24. *Frank Gehry, Loyola marymount University Law School, Los Angeles, California, 1978–86. Viewed from the end of the campus, Gehry's pedimented building masses and cylindrical column forms suggest the link to the Roman legal system that underlies American law. (Photo: © Tim Street-Porter/Esto.).*

inclusion of extensive ornamental sculpture in the design. Although the most extravagant of these embellishments, including the village of little penthouse "buildings" atop the main block, was eliminated due to cost, the most important piece, the large hammered copper figure of *Portlandia*, survived the cuts; the allegorical figure representing of the spirit of the city was sculpted by Raymond J. Kaskey. The largest such figure after the Statue of Liberty, *Portlandia* was among the first sculptures of the period to recall the work of sculptors like Daniel Chester French at the turn of the century. *Portlandia* enlivened and humanized what was for many a confusing and very abstract building.

Although he would soon be classed among the deconstructivists, in the early 1980s Frank Gehry produced a few works that could be viewed as Ironic Classicist. One clear example was the campus he was commissioned in 1978 to design for the Loyola Marymount University Law School, Los Angeles, built in 1984–86. [10.24] The ensemble of Gehry's buildings, some new and some renovated existing buildings, enclose a quadrangle court. Several of the buildings are small, gable-roof blocks, fronted by cylindrical columnar forms, suggesting a Roman forum.

Surprising additions to this group were Philip Johnson and his partner John Burgee. A shift to sober

10.25. *Johnson & Burgee, 1001 Fifth Avenue, New York, New York, 1977–79. Johnson's applied cosmetic facade (a definite improvement on the underlying building) borrows many features from the Italian Renaissance classicism of the adjoining apartment building at 998 Fifth Avenue by McKim, Mead & White, 1910–15. (Courtesy of Philip Johnson.)*

formal clarity and abstracted detail had been evident in Johnson's Boston Public Library Addition, 1964–67. But in Johnson and Burgee's facade remodeling of an apartment block at 1001 Fifth Avenue, done in 1977–79, far more literal historical references appeared. [10.25] The building fits snugly between a sedate Italian palazzo luxury apartment block by McKim, Mead & White of 1910–14 to the south, and a small mansarded French Baroque town house to the north. Johnson opted to continue the lines of the classical moldings as a way of relating his new building to its older neighbors. He also added a tall false-front mansard at the top. Sham construction aside, what this building clearly demonstrated was the growing popular dislike of Modernism's blandness, for Johnson and Burgee had been hired at the insistence of organized neighborhood groups specifically to create a more respectful (that is, traditional) facade for a vacuous modernist apartment block designed by Philip Birnbaum.

The building that announced Johnson's whole-hearted embrace of ironic postmodern classicism, and his rise to the status of superstar in the architectural world, was his design for the AT&T building in New York, of 1975–84. [10.26, 10.27] In 1979, in fact, Johnson was featured on the cover of *Time* holding a model of the proposed design, striking a pose that conjured images of Moses descending from Mount

10.26. Johnson & Burgee, AT&T Building, New York City, 1975–84. The AT&T Building was deliberately designed by Johnson (at the client's instruction) to create a dramatically new image for a corporate headquarters building. (Photo: Richard Payne.)

10.27. AT&T Building. While the top of the AT&T Building referred in an abstracted overscaled way to eighteenth-century furniture, the base with its tall arches seemed to refer to the base of the New York Central building a few blocks away. (Photo: Richard Payne.)

Sinai holding the tablets of the Law.[28] [see 10.72] In 1975, in the earliest conversations with the client, John deButts, then chairman of AT&T, it was made clear that the budget was to be big, that the building was to be unique (immediately suggesting to Johnson a distinctive top), and that stone would be an appropriate sheathing material. Butts instructed Johnson: "we would like the building to say, loud and clear, 'We love New York.'"[29] As the design developed, the main shaft of the office tower acquired three parts: a tall street-level base, a center zone of stacked-up offices, and a distinctive crown. The base devolved into a blank, almost unfenestrated block, punctured by a four-story arched opening on the Madison Avenue front. With the flanking square-headed openings it seemed to be a Palladian reference, but it also could be read as a quote of the base of the New York Central office tower at the foot of Park Avenue with its vehicular tunnels. Johnson pursued many studies of the building's crown, eventually arriving at the distinctive broken pediment with a circular opening cut in the center, suggesting Roman and Baroque broken pediments. The tall proportions of the building, however, made many observers think of grandfather clocks or furniture, and so it soon became known as "the Chippendale skyscraper." In the tall, barrel-vaulted lobby, Johnson installed the gold-painted figure *Genius of Electricity*, of 1916, by Evelyn Beatrice Longman, salvaged from the old AT&T Building.

Despite the introduction of this piece of historic sculpture, the historical allusions were as thin as the red granite veneer slabs, and critical opinion of the AT&T was sharply divided: Vincent Scully, in favor; Ada Louise Huxtable, vehemently against. She called it "do-it-yourself history," hitting on a delicate point.[30] Johnson had at least studied some architectural history, whereas hundreds of younger architects eager to follow Johnson's example, and who had studied in the 1950s and 1960s, had had the history of architecture, or of any art, banished from their architectural school curricula. As these architects clamored to climb aboard the postmodernist wagon, just as Huxtable feared, these mostly historically illiterate architects had to make it up as they went.

With the sources for AT&T so generically historical, critics and historians quibbled over what the precise references were. Johnson's historical quotes became more and more obvious, however, as in his design for the College of Architecture, University of Houston, built in 1982–85, which was lifted directly from Claude-Nicholas Ledoux's proposal for a House of Education, built in 1773–79. Were a writer to do the same sort of thing, it would be considered plagiarism.

Another celebrated design that was ironic in its historical references was the winning proposal by Arata Isozaki and James Polshek for expansion of the Brooklyn Museum, done in 1985–86. The architects' tall central obelisk, the focal vertical element around which all the other parts of the plan were disposed, was a clear reference to the huge Egyptian art collection for which the Brooklyn museum is famous.

Latent Classicism

The second of Stern's postmodernist categories is Latent Classicism, in which the technology and details of Modernism are used with the compositional principles of classicism, not unlike some of the earliest work of Le Corbusier around 1910. Among these architects there is no deliberate irony, no concern for semiotic messages, serious or whimsical. Among its practitioners have been Jaquelin Robertson (born in 1933), as illustrated in his Amvest Headquarters, in Charlottesville, Virginia, built in 1985–87, as well as the firm of Taft Architects (in their River Crest Country Club, in Fort Worth Texas, built in 1981–84), as well as Fred Koetter and Susie Kim (in their Codex Corporation Headquarters, in Canton, Massachusetts, built in 1986). A particularly good example of this approach is the design by Kevin Roche John Dinkeloo Associates for the General Foods Corporation Headquarters, in Rye, New York, built in 1977–83. [10.28] As this brief list indicates, something about the order and clarity of this approach appealed to corporations seeking to escape to the verdant suburbs in the late 1970s and 1980s.

Fundamentalist Classicism

Fundamental Classicists seek to reduce architecture to its absolute and timeless geometries. Most of the practitioners of this approach identified by Stern are European or Australian architects such as Demetri Porphyrios, Aldo Rossi, Rafael Moneo, or Robin Espie Dods. Among the Americans he identified were Andrew Batey (born in 1944) and Mark Mack (born in 1949), who built a number of houses in Napa Valley, California, as well as the large Holt residence, in Corpus Christi, Texas, in 1984. The early architectural work of the husband-and-wife team Andres Duany (born in 1949) and Elizabeth Plater-Zyberk (born in 1950) belongs to this category. Good examples include the houses and public buildings Duany and Plater-Zyberk designed for Charleston Place, in

10.28. *Kevin Roche John Dinkeloo Associates, General Foods Corporation Headquarters, Rye, New York, 1977–83. In such buildings as the General Foods corporate* *headquarters building, the pervasive symmetry and domed central rotunda suggest an implied or latent classicism. (Courtesy of Kevin Roche John Dinkeloo and Associates.)*

Boca Raton, Florida, built in 1984, and an apartment complex called the Williams, in Hialeah, Florida, built in 1986–87. These possess an unadorned and highly controlled simplicity that explains why Stern saw them as counterparts to the work of Italian architect Aldo Rossi.

Canonic or Archaeological Classicism

As the label suggests, Canonic Classicists argue that Renaissance and eighteenth-century classicism is the true language of Western architecture and that buildings erected since that time in other expressions are best ignored. Canonic Classicists aim to continue the classical tradition with the minimum of deviation from the paradigms supplied by Vignola, Palladio, Robert Adam, or Peter Harrison. The longtime American champion of this conservative approach was Henry Hope Reed, whose architect of choice, John Barrington Bailey (1914–1981), designed the seamless eighteenth-century addition to the Frick mansion museum in New York, in 1977. Younger

architects who took up this cause include John Blatteau (born in 1943), who designed the Bulfinch-like Roberson Pavilion for the Bayonne Hospital, in New Jersey, in 1979. Blatteau also designed traditional McKim, Mead & White–like interiors for the Lincoln branch of Riggs Bank, in Washington, D.C., built in 1983–85.

One of the first major examples of postmodern canonically correct classicism was the Roman villa "reconstructed" atop the bluffs of Malibu, California, to house the Getty Museum. Built in 1970–75, it was designed by Langdon and Wilson with archaeological advice from Norman Neuerberg. [10.29] Intended to house a portion of the oil baron's eclectic art collection, the Getty Museum was a re-creation of the destroyed ancient Roman Villa de Papiri outside Pompeii, Italy—although lifted up on a high podium that accommodates (and discreetly hides) the automobiles of visitors. When one drives into the classic podium-garage, the internal structure is revealed to be generic twentieth-century concrete and cinder block.

10.29. *Langdon & Wilson, with Norman Neuerberg, Getty Museum, Malibu, California, 1970–75. The Getty Museum* was based closely on the remains of an ancient Roman villa outside Pompeii. (Photo: L. M. Roth.)

10.30. *Allan Greenberg, Treaty Room Suite, Diplomatic Reception Rooms, U.S. Department of State, Washington, D.C., 1984. For these official state rooms, Greenberg opted for a formal, literal classicism, but he reinterpreted the Corinthian capitals by adding a Federal eagle between the upper volutes.* (Photo: Richard Cheek, courtesy of Allan Greenberg, Architect.)

Once one passes through the paneled bronze doors of the elevator to the museum above, however, one passes through a time warp. When the elevator doors open next to the museum, one steps out into a Pompeiian villa, two thousand years back in time.

The most difficult task for canonical classicists is to adhere to the strict rules of classical design, to know inside and out the many details that together make up this idiom, and be able to shape original designs that are not dry pastiches of the past, designs that have an internal logic and vigor. One of the best examples of such a postmodern classical architect is Allan Greenberg, whose work includes the ten Diplomatic Reception Rooms for the State Department, in Washington, D.C., built in 1984, inserted into an otherwise featureless 1950s late modern building. [10.30] In these rooms Greenberg's sources were essentially Roman, and he based his Corinthian columns directly on those of the ancient Pantheon, but he modified the capital, substituting for the rosette normally found between the projecting corners of the abacus block a small version of the Great Seal of the United States. For his News Building in Athens, Georgia, however, Greenberg did what few other canonical classicists have done: he returned to the austere and massive heaviness of Greek Doric to make a direct link to that city's examples of nineteenth-century Greek Revival such as the John Thomas Grant (University President's) house of 1858. Even further deviating

from other canonical classicists, but venturing closer to the ancient prototypes themselves, Greenberg painted his orders with the deep primary colors the Greeks themselves used.

Modern Traditionalism

The last of the classical idioms defined by Stern is Modern Traditionalism, an architecture that employs classical elements and composition freely, neither jokingly nor literally. Having rigorously examined a project's context, the modern traditionalist architect might use aspects of any of the other four variants in developing a final design that responds to the physical as well as psychological context. Included in this group would be Thomas Beebe of Chicago (born in 1941), who designed the North Shore Congregation Israel, in Glencoe, Illinois, built in 1982, as a reinterpretation of Palladian Renaissance formality. Other examples by Beebe are his Conrad Sulzer Library, in Chicago, built in 1985, with its heavy arcaded base and slightly ped-

imented entry, as well as his headquarters building for the American Academy of Pediatrics in Elk Grove, outside Chicago, built in 1984. Beebe and his firm, Hammond, Beebe, and Babka, are best known for the Harold Washington Library, built in 1987–91, the main building of the Chicago Public Library, in the south Loop area of Chicago, and the subject of another celebrated competition. [10.31] In this major civic building Beebe attempted to bring together references to the great commercial architecture of Chicago's past, for the library was built across the street from William Le Baron Jenney's severe Second Leiter Building of 1889–91, a good example of mature Chicago School architecture. In the library Beebe provided a summation of Chicago's architectural history. He referred to Richardson's Field Wholesale store (in the massive rough masonry base) to Burnham & Root's and Sullivan's office blocks (in the tall deep-set arcades of the upper floors) and to the classicism of the Columbian Exposition and the work of Burnham's

10.31. Hammond, Beebe, and Babka, Harold Washington Library Center, Chicago, Illinois, 1987–91. This sweeping view from the southeast makes up a summary of Chicago's downtown architecture. Directly east of the library is W. L. B. Jenney's Second Leiter Building (later Sears Roebuck); directly west is Jenney's Manhattan Building. In the immediate distance (just north of the Manhattan Building) are visible the tops of the Old Colony Building (Holabird & Roche) and the Fisher Building (D. H. Burnham & Co.). (Photo: Judith Bromley, courtesy of Hammand Beeby Rupert Ainge.)

10.32. *Kohn Pederson Fox, 333 Wacker Drive, Chicago, Illinois, 1979–83. Like few buildings before it (except for Goldberg's Marina City a few blocks downriver), the building at 333 Wacker Drive celebrated its unique position at the bend where the north and south branches of the Chicago River merge. (Photo: Barbara Karant, courtesy of Kohn Pederson Fox.)*

successors, Graham, Anderson, Probst, & White, in the classically gabled and pedimented roof, rich in sculptural embellishment.

Another approach to modern traditionalism is seen in the work of the New York architectural firm Kohn Pederson Fox, whose principal designer, William Pederson (born in 1938) introduced classical balance, and even abstracted traditional details, in office blocks. Perhaps the best example of his approach is seen in the firm's early office building known simply by its address, 333 Wacker Drive, Chicago, built in 1979–83. [10.32] What made this office block so special, and why it received so much attention when it was built, was that it was fitted carefully to a unique site where the Chicago River splits into its north and south branches. Pederson's building is turned on the diagonal, representing the turn of the river, arcing across its site in a great curve of green reflective glass. Moreover, the building is placed on a distinctive base,

articulated with broad geometric ornamental details, and it culminates at the top in an equally distinctive crown, suggesting the tripartite composition of Art Deco skyscrapers. The result is that 333 Wacker Drive was no prototypical building but one exploiting one particular site.

Other modern traditionalist architects include Stanley Tigerman (born in 1930), as evident in his modified classical Hard Rock Café in Chicago, built in 1985–86, which also houses a classically wrapped power substation at its east end. Still another is Thomas Gordon Smith (born in 1948), at least in his early work in southern California that featured a highly colored and idiosyncratic classicism (often using studiously and archaeologically correct elements). In the years since, Smith has become head of the architecture school at Notre Dame University in Indiana, transforming it into a bastion of very correct, one might even say canonically and reactionary classical design.[31]

Not so identified by Stern but clearly falling into this category of modern traditionalism is Charles Moore in some of his later designs such as the Beverly Hills City Hall extension, in Beverly Hills, California, built in 1982, which incorporated Spanish Colonial Baroque elements in a creative way. Also revealing is Moore's Science Building complex for the University of Oregon, in Eugene built in 1987–90, in which he made reference to selected features from the disparate surrounding buildings of the 1930s and 1940s to link the old and new buildings into a coherent group; as Moore said, "we are deeply rooted in culture, places and people. Architecture is part of a continuum."[32]

Another architect who belongs in this group is Graham Gund of Boston, whose work has ranged from residences to office blocks. One of his designs that has brought to the Boston skyline something of

the solid and urbane elegance of the 1920s is his 75 State Street, Boston, built in 1986–88, with Skidmore, Owings, & Merrill. Fitting an awkward downtown Boston site, it has restrained coloration (although with gold accents) and a broad setback form that gives it a density and solid presence lacking in other vertically stretched Boston towers—particularly the odd jumble of round and square towers by Johnson & Burgee called International Place, built in 1985 on the water's edge, with its senseless piling up of twenty-four stories of Palladian windows.

One architectural firm seemingly least likely to fall into the postmodernist camp would be the once arch-Miesian Skidmore, Owings, & Merrill; yet, with the rise of younger partners in the late 1970s even this firm began to change. The entry by SOM design chief David M. Childs in the Brooklyn Museum competi-

10.33. SOM (David M. Childs, designing partner), Rowes Wharf complex, Boston, Massachusetts, 1985–88. The Rowes Wharf complex, part of the city's effort to revitalize the bay front, is broken into several component parts to keep the level low, with the two halves joined by the large arch in the center. (Photo: Steve Rosenthal, courtesy of Skidmore, Owings, & Merrill.)

10.34. SOM (Childs), Worldwide Plaza, New York, New York, 1985–89. This redevelopment of a city block included building a large signature office tower at the east end (a grandchild of the setback Art Deco towers of the 1920s) with low-rise apartments and a small apartment tower at the west end. (Photo: Addison Thomson, courtesy of Skidmore, Owings, & Merrill.)

tion of 1985 was a restrained, bilaterally symmetrical, and decidedly classical building complex. Significantly, the firm's full-color presentation perspective showed the proposed rear facade as seen through a window framed by two beautifully rendered Roman Ionic pilasters carrying full (and accurate) entablatures. Another example of the firm's new direction is seen in the large mixed-activity redevelopment of Rowes Wharf on the Boston waterfront, built in 1985–88. A large **U**-shaped mix of hotel, offices, health club, condominiums, parking, shops, marina, and ferry services, built partly on land and partly on

wharves extending into the bay, it opens up through a huge arch at the base of the **U** providing a view through to the bay. [10.33] The arch, in fact, seems distinctly reminiscent of the huge arch of the Russian Winter Palace by Rossi in Moscow, built in 1819–29.

Childs was also partner-in-charge for the multiuse complex called Worldwide Plaza, in New York City, built in 1985–89. This cluster of housing and offices, with low-rise apartments, a small tower, and a huge main office skyscraper, was a project of developer William Zeckendorf. This "fast track" project involved the Zeckendorf company, HRH (Hyman,

Ravitch, and Horowitz) as construction managers, architects SOM (David Childs in charge), and sixty subcontractors. In such a project time is expensive, for the financing of construction funds makes up a significant part of the total cost. Hence, a primary objective is to shorten the total time involved in the design and construction process, meaning that some parts of the design are still being decided even as construction begins.[33] The principal element in the Worldwide Plaza complex, the 770–foot office skyscraper, was to house the headquarters and staff space for the huge advertising agency Ogilvy and Mather. [10.34] Like the office towers of the 1920s, Worldwide Plaza rises from a stepped base, through forty-seven floors, stepping back with chamfered corners to a large pyramidal crown. Like the towers of the 1920s, too, it is covered in a very traditional material, brick.

Building on his success in winning the competition for the Portland Building, Michael Graves won yet another competition in 1982, for the headquarters of the Humana Corporation in Louisville, Kentucky.[34] Liberated by a far more generous budget, Graves cre-

ated a shaped tower of twenty-six stories, the lower part filling the block and opening internally to a generous entry loggia and lobby. The setback upper section is a grand heroic gesture, with a cantilevered balcony terrace and a pylonlike penthouse. Perhaps because of this tripartite organization, the building was described by critics as being humanistic and adjusted to human scale. But the Humana Tower was also a highly self-conscious signature headquarters building, proclaiming the importance of a health-care corporation that, at the time, was making heavy investments in controversial heart transplant operations.

While Michael Graves's later and more mature work retained the bold geometric forms, generic Mediterranean themes, and signature buff, turquoise, and terra-cotta color palette now identified with him, his work after the Portland Building and Humana Tower became less and less ironic quips. A particularly good example of his more adaptive historicism is the public library for the southern California coast town of San Juan Capistrano, built in 1980–82. [10.35] Local building ordinances required that the

10.35. *Michael Graves, San Juan Capistrano Library, San Juan Capistrano, California, 1980–82. In deference to the strong historic character of this old Spanish coastal settlement, Graves made the scale of the library very small,* *incorporating an interior fountain court, and devised abstracted stucco-covered forms that suggested but did not copy local Spanish Colonial buildings. (Photo: Peter Aaron, © Esto, courtesy of Michael Graves.)*

new buildings adhere to an indigenous Spanish mission style (the library is only one block away from the ruins of the Mission San Juan Capistrano). Graves did this by keeping the scale small, using smooth blank stuccoed wall surfaces in broad masses, and red roof surfaces. He arranged entry spaces, the main stacks, and reading rooms around an internal court reminiscent of those found in Mexico and Spain; at the center is a fountain. A third side of the court is defined by the public auditorium and its service spaces. The fourth side of the central court is defined by five square reading pavilions, latticework outdoor rooms open to the breeze, covered by trailing vines where patrons, in the dappled light, can slip away to lose themselves in their books, enveloped in the music of the burbling courtyard fountain.

From this point, Graves's work settled into a clearly recognizable style, with bold, overscaled geometric masses, pierced by square windows, overlaid with wedge or keystone forms (sometimes split) and low curved blocks, opened up with loggias fronted by squat columns, with broad low gable roofs, all rendered in his distinctive palette. One sees this in his Clos Pegase Winery Buildings in Napa Valley, California, built in 1984; the Crown American Building, in Johnston, Pennsylvania, built in 1986; and the Historical Center of Industry, built in

Youngstown, Ohio, in 1986 even as the steel industry there and elsewhere around the Great Lakes was disappearing. A high point (or low, depending on one's point of view) was reached in the pair of hotels Graves designed for the Disney organization, sitting on either side of a man-made lagoon connecting with the Epcot Center, at Disney World, in Lake Buena Vista, Florida. The Dolphin and Swan Hotels—the Dolphin a twenty-six-story triangle and the Swan a long, low block with an arced roof—were built in 1986–87. Both hotels were embellished with enormous namesake figural sculptures, the decorative swans and dolphins rising the equivalent of four or five hotel stories. Meanwhile, at the other end of the continent, Graves designed the Team Disney Building, in Burbank, California, of 1985–91. [10.36] The axis of the pool in the entry court focuses on the main six-story office block, capped by a broad pediment. Supporting the bottom cornice of the pediment, and corresponding to the six principal piers below, are 19-foot "caryatid" figures of six of the dwarfs from Disney's *Snow White*; above them, the seventh and smallest of the dwarfs, Dopey, pushes up the ridge of the pediment.

Almost as surprising as the dramatic about-face by SOM was the shift made by Peter Eisenman, who had written earlier that architecture was a totally nonreferential intellectual discourse. For example, of his

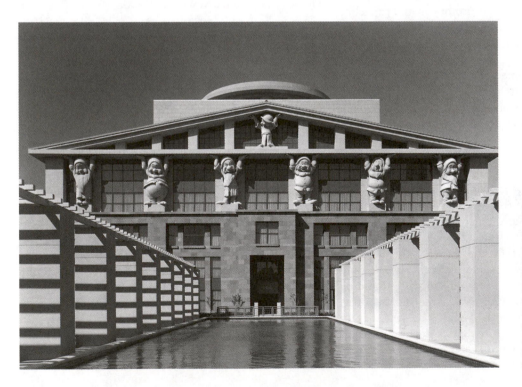

10.36. Michael Graves, Team Disney Building, Burbank, California. In this broadly massed building, Graves used the six older dwarfs from Snow White as caryatid figures to support the pediment; the figure of little Dopey lifts the ridge of the pediment. (Photo: © Jeff Goldberg/Esto.)

House VI, in Cornwall, Connecticut, built in 1976, Eisenman had said in 1985 that in it he had rejected the notions of memory and place, attempting instead "to destabilize the notion of home."[35] His House X was as formally and nonreferentially abstract as his previous nine designs but at larger scale. [10.37] This changed when he won the competition for the Wexner Center at Ohio State University in 1982. In developing the design Eisenman was persuaded by his associate architect, Richard Trott, to include brick towers that referred to the stout Richardson-like brick Armory Building, built in 1897, by Yost and Packard, that had once stood on the site.[36]

The Wexner Center for the Arts, finished in 1989, was a gift to the university from Leslie H. Wexner, owner of the Limited clothing chain. Its mission, as described by the original director, Robert Stearns, was "to present all the arts of our time, to reveal the underlying parallels among the many art forms, and to offer to the public insights into the future of the arts. Our mission is to encourage the creation of new works, new forms, and new technologies of art. The Center is about investigation and exploration."[37] Because Eisenman's design called for most of the exhibition space to be below ground, the extensive excavations soon unearthed the armory foundations remaining from the demolition of the armory following a fire in 1958. The decision to include unequivocal references to the original armory in the castlelike brick towers of the final design was intended to make the building a statement of the temporal connection between past and future. The other dominant design motif represents the emerging deconstructivist design philosophy, played off against the historicist brick towers: this is the collision of two three-dimensional grids built of white-painted square steel tubing. [10.38] One grid refers to the orthogonal grid of the Jeffersonian national land grid (and also the Columbus street system grid), while the other grid, tilted 12 degrees, is the grid of the campus plan. Eisenman's merging of the two grids was meant to be a statement referring to the geographical intersection of town and gown. Designed to accommodate the often controversial art of the present, the building itself became part of that controversy, confounding conventional notions of what a museum building should be; indeed, when it opened the building was left vacant for several months and was presented as an art object in its own right. In one spot, the museum recalls some of the willfully eccentric detailing of Eisenman's earlier houses, for over the main entry

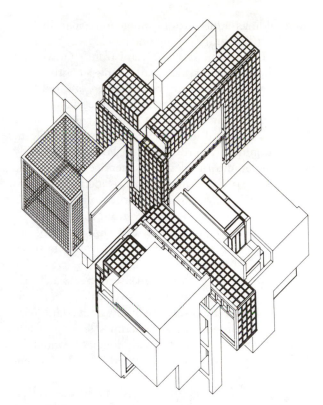

10.37. Peter Eisenman, House X, Scheme G, 1976–78. Continuing to use abstract Roman numerals to decontextualize his residential designs, Eisenman here went through seven detailed design revisions. (From Eisenman, House X, New York, New York, 1982.)

stair, where one of the grids ends, a steel corner post is simply cut off over the stair and hangs there, unsupported and somewhat threatening. [10.39] As with so much highly inventive architecture, however, the details have not stood up to the test of time and weather, particularly the sometimes harsh winters of central Ohio. This seems, like Rudolph's Bridges library, another case of a boastful building designed and built quite out of sympathy with its climatological context.

The Wexner Center was the beginning of a redirection in Eisenman's architecture, away from the extreme and pure abstraction of the grid manipulations toward a new biomorphic imagery said to be inspired by plant rhizomes, the thick tubers that grow horizontally underground and characteristically have shifting, twisted forms. The shifts and breaks, so abstractly and geometrically determined in the earlier houses, now became more "organic." Pleased with the national and even international attention that the

10.38. Peter Eisenman, Wexner Center for the Arts, Columbus, Ohio, 1982–89. Seen from the west, the Wexner Center presents the symbolic grid as well as the fractured but still recognizable references to the castellated armory that once stood on this site. (Photo: Kevin Fitzsimmons, courtesy of the Wexner Center for the Arts, The Ohio State University.)

10.39. Wexner Center. The disjunctive collision of the two grids (campus and county), and the irrelevance of human interaction with the theoretical construct governing the building's design, is symbolized by the grid post that ends in midair over the main entry stairway. (Photo: L. M. Roth.)

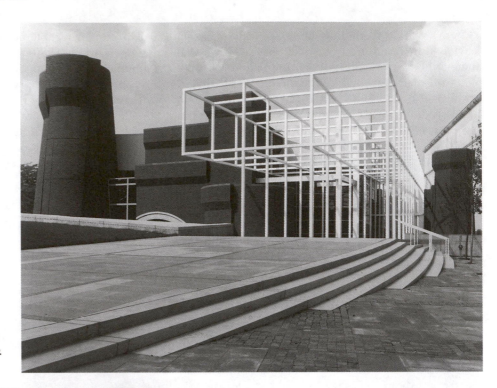

Wexner Center brought to Columbus, city officials soon gave Eisenman a second commission there, allowing him to explore this new approach. This was the Greater Columbus Convention Center, built in 1989–93, whose shifting, multicolored facade marches down High Street, tilting this way and that like fugitive stage sets from a 1920s German expressionist film.

The central figure in modern traditionalism is arguably Robert Stern himself, not simply because of the great volume of his firm's built work, but also because of his continued activity as a writer. Moreover, his design output has been extensively published, allowing a good overview of his architectural development. The campy, ironic quality of his early work culminated in extensive renovations and additions he was called on to make to a staid brick Georgian house, designed by Edgar Williams in 1929, in Llewellyn Park, West Orange, New Jersey, done in 1979–81. On the back side of the house, where the ground slopes away, Stern added a glass-covered swimming pool, fronted by massive columns. [10.40] Inside the pool room, the glass roof is supported on delicate metal columns that erupt in metallic palm fronds at the top, in a reference perhaps to John Nash's similar palm columns of iron with their copper fronds in his Brighton Pavilion of 1818.

Stern's work, like that of Graves, quickly matured, leaving such heavy irony behind. The weekend and summer houses he built on Long Island and Martha's Vineyard demonstrated an assuredness of spatial arrangement, massing, and detail that placed him beside McKim, Mead & White. This was evident in several residences, such as the broad triangular house (recalling the Low house) at Chilmark, Martha's Vineyard, built in 1979–83 [10.41]; and another broad triangular gable house built at Farm Neck on the Vineyard in 1980–83. His larger house at East Hampton, Long Island, built in 1980–83, with its long hip roof and expansive round bay capped by a squat half-conical roof, resembles Arthur Little's Shingleside, in Swampscott, Massachusetts, of 1880–81. The connection between Stern and McKim, Mead & White comes readily to mind because all of these houses are covered in wood shingles; Stern was

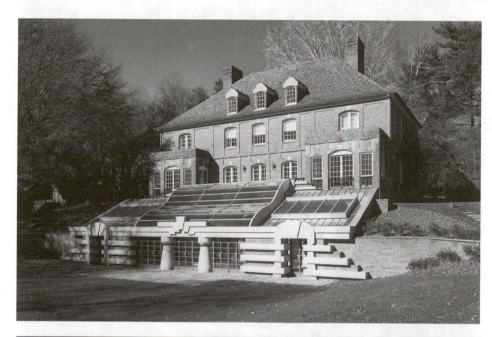

10.40. Robert A. M. Stern, Residence, in Llewellyn Park, West Orange, New Jersey, 1979–81. In adding an enclosed swimming pool, Stern made playful, ironic reference to the generic classicism of the Georgian-style original house built in the 1920s. (Courtesy of Robert A. M. Stern Architects.)

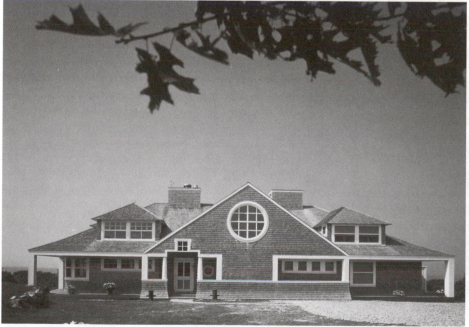

10.41. R. A. M. Stern, House at Chilmark, Martha's Vineyard, Martha's Vineyard, Massachusetts, 1979–83. As the 1970s progressed, Stern's references to the traditional Shingle Style, and its emphatic gables, became more literal, beginning in a still-abstracted way in the broad gable of the house at Chilmark. (Courtesy of Robert A. M. Stern Associates Architects.)

clearly proposing that the Shingle Style was not dead but part of a living American tradition.

Stern's use of shingles was also part of a response to place, for shingles had long been a favorite sheathing material along the Atlantic coast. As Stern's practice grew in scope and geographical extent he called upon other regional traditions—in form or material, or both—to integrate his buildings with their regional contexts. In his Prospect Point Office Building, in La Jolla, California, built in 1983–85, Stern used broad expanses of stucco and rooftop pergolas in reference to the local work of Irving Gill, with window balconies and a subtly curved pediment gently alluding to the distant Spanish past. In San Francisco, however, a shingled house on Russian Hill of 1985–89 suggests the turn-of-the-century shingled houses by Ernest Coxhead. One of Stern's most successful contextual designs was the Observatory Hill Dining Hall at the University of Virginia, Charlottesville, built in 1982–84. [10.42] In the shadow of Jefferson's magisterial buildings, Stern created a series of brick and Tuscan-colonnaded pavilions that match Jefferson's precision of detail, but with a low scale that never attempts to overreach the work of the master. There is even a small Jeffersonian quote: the chinoiserie grills at the French doors, placed there to prevent accidents just as the originals do at Monticello.

In the late 1980s and 1990s the buildings and projects coming out of Stern's office straddled the globe, the projects expanding in scope, but the response to site, plan requirement, and materials remained high. Two examples, from hundreds of commissions, illustrate Stern and his associates' response to place and local building tradition. One is the Ohrstrom Library at St. Paul's School, in Concord, New Hampshire, built in 1987–91, which stands across from the early masterwork of Henry Vaughan, the very correct English Perpendicular Gothic chapel. Stern's solution makes a general nod in the direction of Richardson's New England libraries without copying any, even using a few eyebrow dormers in the long roof, while the window bays and towers reflect the verticality of Vaughan's chapel. The other example is Stern's Normal Rockwell Museum, in Stockbridge, Massachusetts, built in 1987–92, a low white Colonial building that not only looks like something from one of Rockwell's *Saturday Evening Post* illustrations but also conveys the traditional spirit of Stockbridge.

Nonetheless, the same criticism could be leveled at Stern that was once made of the work of McKim, Mead & White or D. H. Burnham: that the sheer size of the office and the large number of commissions make direct involvement by Stern almost impossible.[38]

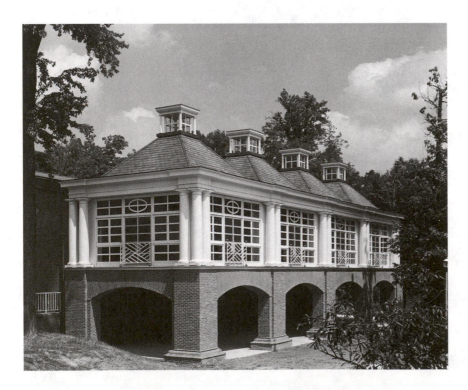

10.42. R. A. M. Stern, Observatory Hill Dining Hall, University of Virginia, Charlottesville, Virginia, 1982–84. At the University of Virginia, Stern made clear reference to the red brick and white trim Roman classicism of the campus's first architect, Thomas Jefferson, to connect, as Stern has noted, "to the vernacular of the place." (Photo: Whitney Cox.)

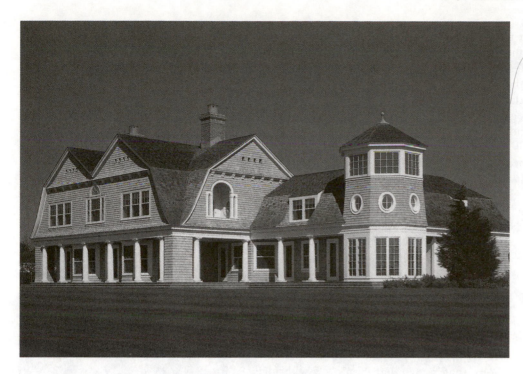

10.43. R. A. M. Stern, House at Calf Creek, Water Mill, New York, 1984–87. This residential design incorporates a number of elements derived from northeast coast Shingle Style houses of a century earlier that Stern used in many of the houses he designed in the 1980's; instead of the whimsical irony of Stern's work of a few years earlier, here he makes a serious and respectful effort to expand on this regional architectural idiom. (From Elizabeth Kraft, ed., Robert A. M. Stern: Buildings and Projects, 1987–92, New York, 1992.)

There was perhaps in Stern's work of the 1990s a little of the feeling that some of his buildings (country houses especially) were assembled from a kit of stock parts and details—the gambrel roof and a tower with its curved bell-cast roof, for example—and yet there is constant variety and adjustment to the peculiarities of site. One example is the expansive house at Wilderness Point, Fisher's Island, off the east end of Long Island, 1986–89, but simpler in composition is the house on Calf Creek, Water Mill, New York, 1984–87. [10.43] Such carping about the continuity of style for buildings of the same type betrays the century-old insistence of Modernism that every building be wholly original; residences, at least, do not change that much in function from one example to another. Another criticism is that there is no single recognizable "Stern style" as is immediately apparent in the Mediterranean earth-colored bold geometries of Graves, or the sleek white enameled surfaces of Meier. Again this suggests a restrictive vision, for Stern's buildings always respond to use, landscape, and setting urban or rural, north or south, east or west, before a "Stern style" is stamped upon them.

The whimsy in the heavy rustication and massively archaic columns of the Llewellyn Park house, almost Disneyesque in character, may have been one reason why Disney officials came to Stern to design a number of buildings for them. One of the first was the Casting Center at Walt Disney World, in Lake Buena Vista, Florida, built in 1987–89, with its bold diagonal checkerboard wall patterning. Small turrets along the parapet remind us of Disney World's Castle, and the cutouts making the battlements are three circles forming the profile of Mickey. Also for Disney World, Stern and his associates designed the Yacht and Beach Club Resorts, a collection of gabled, turreted, and pavilioned buildings no higher than six stories around a lagoon/swimming pool, with 1,215 hotel rooms. In this ensemble, however, the buildings look more reassuringly conventional, and the scale is not nearly as inhuman as it is in Graves's nearby Swan and Dolphin hotels.

In many ways the father figure behind modern traditionalism has been Robert Venturi, with his partners John Rauch and Denise Scott Brown. In the 1980s and 1990s Venturi's work moved away from the wry jokes of the 1960s and 1970s, like the wood Ionic column at Oberlin, toward a more subtle and substantial historicism. One example is Gordon Wu Hall, at Princeton University, built in 1980–83, a gathering place for students of Butler College. Built of red brick, like the existing adjoining buildings, it has its main staircase in a broad end bay, alluding to the bays of the adjacent Elizabethan-style buildings. [10.44] In 1985, while already working on the design of a new downtown art museum for Seattle, Washington, Venturi and Scott Brown were selected as one of six firms to prepare pre-

10.44. Venturi and Scott-Brown, Gordon Wu Hall, Princeton University, Princeton, New Jersey, 1980–83. Designed as the centerpiece of a new residential college at Princeton, Gordon Wu Hall was given strong, somewhat anthropomorphic elements to establish a clear identity for the new college. (Photo: Tom Bernard, courtesy of Venturi, Scott Brown, and Associates.)

10.45. Venturi and Scott-Brown, Sainsbury Wing, National Gallery of Art, London, England, 1985–91. Given the strong presence of the National Gallery across one side of Trafalgar Square, Venturi and Scott Brown opted to use various repeated classical elements to link the old and new portions of the museum. (Photo: Timothy Soar, courtesy of Venturi, Scott Brown, and Associates.)

liminary designs for the Sainsbury Wing of the National Gallery of Art, in London, England. Within six months Venturi and Scott Brown were selected as the architects for the addition to this prestigious British museum, and the statement Venturi made to the press when the commission was announced explains why the building committee had chosen his firm: "Our goal has been to create a building positive in its architecture quality—and yet sensitive to the rest to Trafalgar Square and appropriate as a context itself for the masterpieces within it."[39] Venturi's interest in responding to context was the key. The Sainsbury Wing was opened in July 1991, and the Seattle museum in December of the same year. [10.45. 10.46] The size and external features of the two buildings are different, but the basic footprint and plan arrangement are quite similar, and both are placed in the center of urban activity. Both are corner buildings on sloping sites.So,

10.46. *Venturi and Scott-Brown, Seattle Art Museum, Seattle, Washington, 1985–91. The Seattle museum also has an important street-corner location (as the Sainsbury in London), but Venturi and Scott Brown were more at liberty to model the surface of the building and include colorful details that hinted at the strengths of the collection within. (Photo: L. M. Roth.)*

10.47. *Seattle Art Museum. Matching the slope of the street along the south side of the building, this interior promenade rises from the museum store and a restaurant to the principal point of entry to the galleries. (Photo: Matt Wargo, courtesy of Venturi, Scott Brown, and Associates.)*

in both instances Venturi placed a grand public stair along the long outer wall, creating a place of promenading that was visible through ranges of windows to the street outside. For the Sainsbury Wing, facing as it does the broad neoclassical colonnaded facade of William Wilkins's National Gallery (1832–37), Venturi devised an angled, faceted facade that follows the irregular site line, the shifts in plane punctuated by Corinthian pilasters that are gathered together in a kind of frenetic climax at the point where the new facade merges with the old. The Seattle Art Museum exterior is also angled and chamfered at the corner, with striated limestone panels giving visual relief to the windowless walls above. At the ground level, following the rising slope of University Street and visible through a stretch of windows, is a long stepped processional walkway that rises to the elevators connecting to the rest of the museum. [10.47]

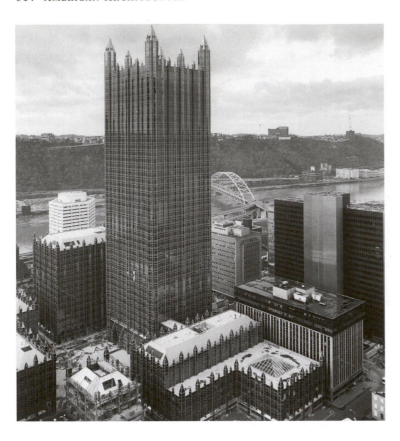

10.48. *Johnson & Burgee, PPG corporate headquarters, Pittsburgh, Pennsylvania, 1979–84. With its green glass corner spires recalling English Gothic towers, the PPG complex was significant in opening up an enclosed protected pedestrian plaza for the city's citizens; rather than being cold and aloof, it tended to accept city life as it is. (Photo: Richard Payne.)*

LATE EXPRESSIONIST/HEROIC MODERNISM

Johnson and Burgee

Beyond Stern's taxonomy describing varieties of classical Postmodernism, there are other paradigms that shaped postmodern expressions: the vernacular paradigm based on ordinary non-architect-designed structures, and the process or technological paradigm that focuses on the technology of building. Continuing into the 1970s and 1980s there remained many architects who followed the process/technology paradigm formerly championed by the modernist credo. In the mid-1970s, however, this late Modernism was sculpted and larger in scale, making grand heroic gestures. One of the early examples of this type was the long, dark blue glass Pacific Design Center, in Los Angeles, by Cesar Pelli, built in 1972–75 (expanded by Pelli in 1984). Other important indicators of this approach had already been designed by Philip Johnson and John Burgee, notably their IDS tower and their Texas office buildings such as Pennzoil Place and the projects for Gerald Hines. A particularly grand and heroic example by Johnson is his "Crystal Cathedral," the Garden Grove Community Church, built in 1975–80, designed for the television evangelist Dr. Robert

Schuller. A vast four-sided star measuring 207 by 415 feet, its somewhat scaleless mirrored glass surfaces leave the visitor unprepared for the enormity of the space inside that rises 128 feet tall and has a clear span of 200 feet, accommodating four thousand seats. The walls, completely of glass, are supported by a tubular steel space frame, so delicate it seems to disappear. Remarkably, by using 86 percent reflective glass in this naturally benign climate, and by providing adjustable louvers along the walls to provide ample cross-ventilation, no air-conditioning was required.

If some sort of historical reference were desired, Johnson & Burgee showed how this could be done in their green glazed PPG (Pittsburgh Plate Glass) Corporate Headquarters Building, in Pittsburgh, built in 1979–84. [10.48] As Johnson and Burgee received more and more office tower commissions in the late 1970s and early 1980s, Burgee developed a formula to avoid total banality in such high-rises: give it shape, give it texture, and pack in activity at the bottom.[40] They accomplished all three objectives in the PPG complex. The basic shape came from English perpendicular Gothic tower, with its corner spiked towers; and the texture came from both the dark green mirror glass (with the reflections it created) and the undulat-

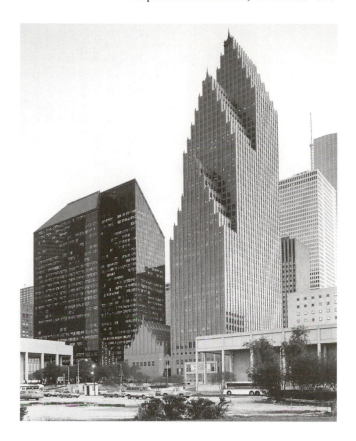

10.49. *Johnson & Burgee, RepublicBank Building, Houston, Texas, 1984–85. Perhaps in a typically urban Texan way, the RepublicBank is far more visually interesting when glimpsed from afar from a moving automobile than it is when seen from street level at close range. (Photo: Richard Payne.)*

ing surface formed by projecting window bays, also recalling perpendicular Gothic in profile (and further expanding the multiplicity of reflections). Similar to the IDS complex, the PPG consists of a series of five low glazed turreted blocks enclosing a plaza at the base of the principal 630-foot tower, and in these surrounding buildings were located shops and other public facilities opening onto the plaza.

Even more commanding was Johnson & Burgee's freestanding Transco Tower, in Houston, built in 1979–85, removed from the downtown core and rising 900 feet from an open landscaped campus. Resembling the Art Deco skyscrapers of the late 1920s, like Raymond Hood's Daily News Building, it rises from a setback base and begins to diminish with further setbacks at the top, but unlike its models the Transco Tower is sheathed completely in mirror glass. And because it stands alone, it can be seen in its full height.

The PPG complex and the Transco buildings were somewhat better than the hundreds of office towers that were quickly thrown up in what has come to be called "The Roaring Eighties" of the late twentieth century. But the architects who provided the models for this rush of construction were Johnson & Burgee, partly because their designs were often the most artis-

tically or outrageously identifiable, and partly because so many of their designs were built in Texas, a state that became linked with this boom period. Most of the hastily built office towers of the Roaring Eighties, attempts to cash in on the building boom, were garish breast-beaters. Even Johnson's official biographer, Franz Schulze, does not flinch from using such words as *vulgar* to describe the classically derived office tower 190 S. La Salle Street, Chicago, built in 1983–86, its steep intersecting gable roofs allegedly patterned after Burnham & Root's long-gone Masonic Temple tower of 1890.[41] Repeatedly during the 1980s, Johnson's favorite developer, Gerald Hines, called upon the architect to devise one office tower after another. As Hines had learned from experience, rental rates and response were directly affected by a building's recognition factor on the skyline. Novelty gave the developer a recognizable product and a competitive edge.[42] By now, too, Johnson's name as designer also added considerable cachet. Johnson was always ready to serve up the distinguishability that Hines or other clients required, and perhaps nowhere more so in the RepublicBank Building (later the NCNB Center), in Houston, built in 1984–85, another of Hines's commissions. [10.49] Situated next to his earlier dark shed-

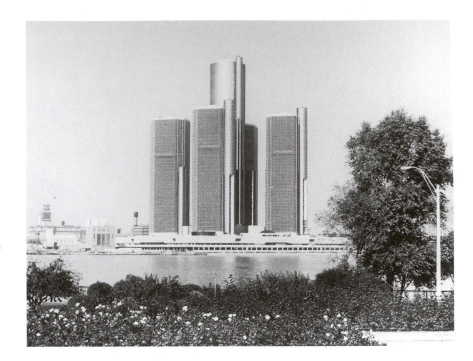

10.50. John Portman, Renaissance Center, Detroit, Michigan, 1973–78. In the mid-1970s, John Portman's signature reflective glass towers, whether rectangular or cylindrical, were symbols of urban prosperity and hence highly desirable for this urban redevelopment project. (Courtesy of the Renaissance Center Partnership.)

roof Pennzoil Place, Johnson's new building would need to have an even more assertive identity. Accordingly, Johnson divided the 772-foot tower into three huge setbacks, but he shaped each setback as a steep ten-story gable, suggesting something like late medieval guildhalls and town halls in Germany or Flanders. The steep upper gables, turreted at the corners, augmented by the narrow windows recessed in continuous vertical bands, make the building look even taller than it is. Of course, steep medieval gables had nothing in particular to do with twentieth-century office skyscrapers, but Franz Schulze suggests that this very strangeness may have made such prototypes even more enticing to Johnson, whose "history source books were growing dog-eared."[43]

John Portman

Another architect whose later work might be placed in the heroic modernist category is John Portman (born in 1924). This would be correct insofar as he tended to rely on brute concrete and mirror glass in his buildings, but Portman was interested in much more than simply exploiting technology. Beginning in the late 1960s, Portman was interested in making public spaces that attracted and pleased users. His articles describing his design objectives frequently touched on this concern, employing titles like "Architecture Is Not a Building" and "An Architecture for People and Not for

Things."[44] What disturbed many of his colleagues was that Portman invested large amounts of his own money in the buildings he designed, and thus had a vested interest in how they performed; this was considered unprofessional conduct. What really distinguished Portman's buildings—especially the hotels in which he specialized—was the creation of large indoor public spaces. To this was now added a glitzy sheathing of mirror glass, as in the Bonaventure Hotel, in Los Angeles, built in 1975, whose composition became something of a Portman type: a central glazed cylinder surrounded by four smaller cylinders. By the early 1970s Portman's flashy buildings, featuring cylindrical towers sheathed in mirror glass, had become symbols of commercial success. So when a new building was proposed as a way of regenerating downtown Detroit, ravaged by race riots in 1976, the selection of Portman as architect was both an act of faith and a statement of the presumed efficacy of his work as a generator of business and civic prosperity. The Renaissance Center complex in Detroit, built in 1973–78, consists of a central high tower enclosed by four lower towers. [10.50] In the Renaissance Center the center shaft is the round Detroit Plaza Hotel (seventy-three stories), and the surrounding shafts are square office towers (thirty-nine stories) in which large amounts of space were occupied by the Ford Motor Company, General Motors, and Manufacturers National Bank.

Helmut Jahn

Without doubt the most audacious of the heroic modernists has been Helmut Jahn of Chicago (born in Nuremberg, Germany, in 1940). Educated in Munich, Jahn fell under the spell of Mies van der Rohe and eventually came to the United States on a scholarship to study at ITT. He worked in the office of C. F. Murphy, gradually surviving or buying out the partners until he reconstituted the office in 1983 as Murphy/Jahn Associates. Jahn's inclination to make hugely heroic technological and structural gestures was evident in the first building by the C. F. Murphy office to bear his name, the Kemper Crosby Arena in Kansas City, Missouri, built in 1974, in which the roof of the enormous building is carried entirely by three external space-frame trusses, spaced 153 feet apart and measuring 27 feet in depth. Subsequent buildings by Jahn continued to exploit structural systems and sleek metal and glass curtain walls. Yet increasingly, shaped masses, angles, and other non-Miesian elements began to creep into his work. A building in which form appears to have begun to determine design was the large circular Argonne Program Support Facility, on the grounds of the Argonne National Laboratories outside Chicago, built in 1978–82. The most visible declaration of his swing to expressive form, however, was the forty-four-story Xerox Centre in downtown Chicago. From the rear its unmodulated wall of glass and aluminum panels looks like Mies redone, but the main corner is curved, with a circular penthouse at the top. Moreover, the glazed wall at the sidewalk undulates sinuously in front of and then behind the structural columns.

Immediately following this came Jahn's addition to the Chicago Board of Trade, built in 1978–82, a crystalline box of blue glass complete with low-hipped roof mimicking that of the main Art Deco building by

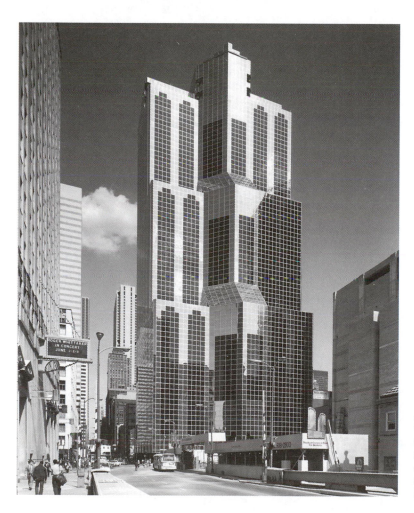

10.51. Helmut Jahn, 1 South Wacker, Chicago, Illinois, 1979–82. Jahn was an early advocate of shaped and molded office towers, sheathed entirely in reflective glass of various tints and colors. (Courtesy of Murphy/Jahn.)

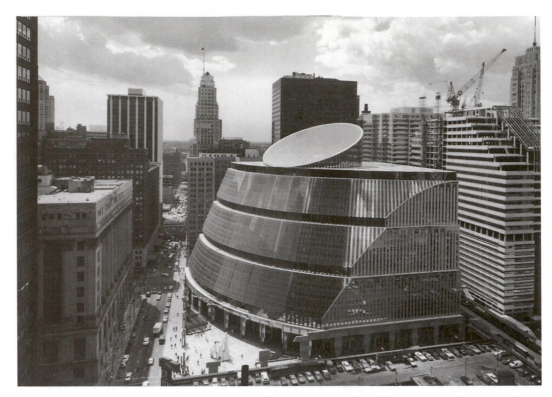

10.52. Helmut Jahn, James R. Thompson Center (State of Illinois Center), Chicago, Illinois, 1979–85. Filling the entire block, the Thompson Center building wraps around an internal open space (represented by the sloping roof of the cylinder), and opens to the city and county buildings immediately to the south. (Courtesy of Murphy/Jahn.)

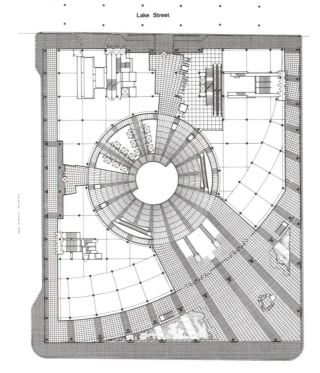

10.53. Thompson Center. The plan shows the office spaces enclosing a circular atrium that rises the full height of the building. (Courtesy of Murphy/Jahn.)

Holabird & Root. The Board of Trade addition was kept low and relatively restrained in deference to the esteemed main building of the 1920s, but when Jahn designed the shaped glass-enclosed office block at 1 South Wacker Drive, Chicago, built in 1979–82, it took control of its environment. [10.51] The same was true of the enormous blue glass jukebox built over and replacing the Northwestern Railroad Terminal, in Chicago, in 1979–87 (a jukebox is suggested by the rounded horizontal setbacks at the base and at the top).

Perhaps Jahn's grandest dramatic gesture was made in a signature building commissioned by then governor William Thompson to house state offices in Chicago, built on a site diagonally across from the city hall and county building in 1979–85. [10.52, 10.53, 10.54] Jahn shaped a tapered and rounded blue glass block around a circular central rotunda 160 feet across that rises through the full seventeen stories of the building and past the roof as a cylinder sliced off at an angle—the heroic modernist version of a classical dome. In the interest of expressing the openness and interconnectedness of state operations, Jahn kept each office floor open to the soaring rotunda, but this caused problems with air circulation, especially with the accumulation of hotter air in the upper stories.

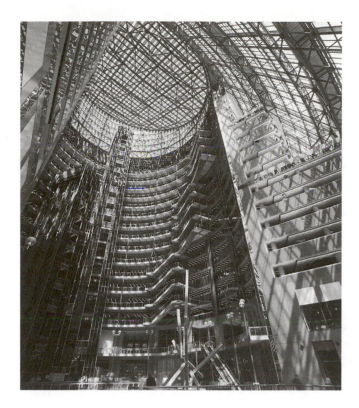

10.54. *Thompson Center. Projecting into the soaring interior space, banks of glass-enclosed elevators rise to the upper floors. (Courtesy of Murphy/Jahn.)*

10.55. *Helmut Jahn, Terminal of Tomorrow (United Airlines section), O'Hare Airport, Chicago, 1983–88. Using dramatically exposed metal framing, Jahn devised a unique, identifiable airport design. (Photo: Timothy Hursley, courtesy of Murphy/Jahn.)*

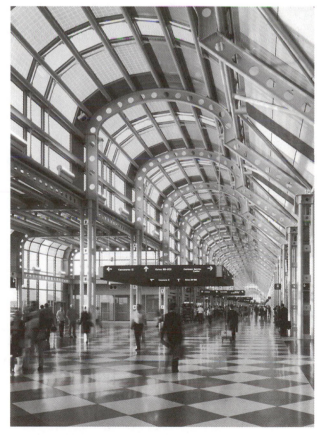

With its balconies, cantilevered and open stairs, and glass-enclosed elevator cars, the rotunda proclaims technology at its most triumphant (but ascent to the very top in the transparent elevator cage is perhaps not for the faint of heart). By the mid-1980s, as the Illinois Building unquestionably demonstrated, for Jahn the standardized universality of Mies had given way to highly individualized and unique creations.

Jahn was also able to invest something of the adventure of technological achievement in his futuristic United Airlines Terminal at O'Hare International Airport, in Chicago, built in 1983–88 [10.55], making it the structurally heroic counterpart to Saarinen's poetically sculptural statement for TWA in 1957. The curved steel bents, the clustered tubular steel columns, the sometimes overscaled cross-bracing, and the walls and vaulted ceiling of glass all made this an exciting place; the traveler never wonders, "What airport am I in *now*?" When clients and investors have wanted crystalline signature buildings, Jahn has been one of two architects of choice, and his work now stretches around the globe, examples standing in Minneapolis, New York City, Philadelphia, Frankfort, Germany, Johannesburg, South Africa, and Durban, West Africa.

Cesar Pelli

The other architect of choice for crystalline towers in the late twentieth century has been Cesar Pelli, born in 1926 in Argentina, and educated there and at the University of Illinois at Champaign. After working in Saarinen's office, he relocated to Victor Gruen's office in Los Angeles, but later moved to New Haven, Connecticut, when he served as Dean of the Yale School of Architecture from 1977 to 1984. One of his first buildings to receive considerable attention was done while in Gruen's office, the enormously elongated deep blue glass Pacific Design Center, in Los Angeles, built in 1972–75. In 1977–84 Pelli built the controversial condominium tower addition to the Museum of Modern Art, in New York City, contro-

versial because of its great height juxtaposed to the museum itself and other surrounding low-rise buildings, but otherwise possessing a sophisticated skin of articulated glass in brown-tinted hues. His most extensive ensemble in this crystalline idiom is the World Financial Center, in New York City, built in 1982–88, a staggered grouping of four office towers, ranging in height from thirty-four to fifty-one stories, built on landfill in the Hudson River. [10.56] The building profiles are varied with setbacks at the base and top, with additionally varied crowns (pyramidal, round, setback), but all sheathed in metal and glass skins. Terracing and landscaping provide numerous engaging spaces for visitors and the public, but the most enticing space is the glass barrel-vaulted winter

10.56. Cesar Pelli, World Financial Center, New York, New York, 1982–88. In separating the office space into three individual towers, and arranging the ground space in a series of riverside terraces, Pelli created a far more human cityscape than that represented by the scaleless World Trade Center towers that rose just behind. Both World Trade Center towers were destroyed on September 11, 2001, by terrorists who flew hijacked commercial airliners into them, causing both to collapse and killing thousands. (Photo: Jeff Perkell, courtesy of Cesar Pelli and Associates.)

10.57. *Richard Meier, High Museum of Art, Atlanta, Georgia, 1980–83. The High Museum of Art, brilliant in its cladding of white enameled metal panels, established Meier as a leading interpreter of late Modernism. (Photo: Ezra Stoller © Esto.)*

garden that connects the central towers. Overall, it is considered by some critics to be the best urban space created in New York since Rockefeller Center; it certainly goes far in softening the abrupt skyline of the World Trade Center towers.

Richard Meier

Richard Meier, one of the White architects of the early 1970s, continued in the 1980s and 1990s to refine and perfect the idiom he had developed decades earlier. His work can be described as late Modernism in the sense that it retains, even in the late 1990s, a great debt to the work of modernists like Le Corbusier. And, as in the later work of Le Corbusier, there has been in Meier's work a strong modeling of space, the complexities of this plasticity sharpened by the retention of a monochrome palette of materials, especially his prized white enameled metal panels. There were occasional variations, as in the brushed aluminum panel system used throughout the Bronx Developmental Center, a facility for physically disabled and mentally retarded children in New York City, built in 1970–77. The major commission that accelerated Meier's career was the Atheneum at New Harmony, Indiana, built in 1975–79, a facility designed as the interpretive center for visitors to this remarkable utopian community. A basically square

10.58. *High Museum. The sky-lit atrium is defined along its curved side by ramps that double back on themselves and rise from floor to floor. (Photo: Ezra Stoller © Esto)*

10.59. Richard Meier, Getty Center, Brentwood, California, 1984–98, aerial view. Made up of five separate agencies, the Getty Center was designed with relatively low buildings that hug the hillside overlooking Los Angeles. (Courtesy of the Getty Center.)

block, opening out with curved walls and angular corners, the building was completely covered by the square white enameled panels, although, as the convolutions of the building show, this panel system did not dictate totally rectilinear plans. More cubic and rectilinear, though, was the Hartford Seminary, in Hartford, Connecticut, built in 1978–81, an interdenominational study center.

Meier's most celebrated commission of the early 1980s was the High Museum of Art in Atlanta, Georgia, built in 1980–83. [10.57, 10.58] Although he was designing a new wing to an existing museum (a very nondescript brick and concrete box of 1955), Meier paid little attention to the parent building, and in fact made only an incidental physical connection to it, and virtually no reference to the surrounding context. The museum consists of five square modules, containing the exhibition spaces, arranged in an **L**. Sweeping in a quarter-circle arc within the arms of the

L is a four-story sky-lit atrium; along the curved perimeter of the atrium a ramp switches back and forth, rising up to each of the levels. The atrium, of course, with its skylight and ramps, is taken directly from Wright's Guggenheim but without his amplitude of space (Meier, incidentally, had designed a reading room in the Guggenheim in 1978). Separate from the curved atrium is a small block containing an auditorium and a freeform extension that houses the entry. The approach to the building is via a long ramp rising diagonally from the street, leading to an elevated terrace between the atrium and the auditorium. The doors into the museum, however, are behind those coming up the ramp and here too Meier may have been thinking of Wright's circuitous entry paths. Other museum commissions soon followed, for the Des Moines, Iowa, Art Center (1984), the highly regarded Museum für Kunsthandwerk in Frankfurt, Germany, as well as a Museum of Ethnology there

10.60. *Getty Center. The entry to the museum section is through a large, airy circular rotunda. (Photo: © Scott Frances/Esto.)*

public in early 1998, Meier's hill town for art is clad in pale buff or ivory enameled panels (a response to the bright light of southern California) that complement the portions of the museum clad in panels of honey-colored Italian travertine. [10.59, 10.60] Also in an apparent response to the abundant light in California, the ratio of wall to window is higher, and many banks of windows are sheltered under projecting louvered balconies and porticoes. As in his earlier buildings there is an underlying grid that governs the arrangement of spaces and building masses, but the many curves and freeform elements disguise the grid. Softening and humanizing the multiple terraces even more are the arbors and trellises, to be filled out as vine-covered shading devices, and the many water sculptures and fountains.

LATE EXPRESSIONISM

There was yet another approach that several architects took in the late 1970s through the 1990s that clearly lies outside Stern's variants of modern classicism, or the celebration of pure building technology. It some respects it is the extension of the emphasis on building form begun by Eero Saarinen in the late 1950s and can be called a kind of late expressionism. One architect whose later output, in large part, can be placed in this category is Frank Gehry (born in 1929). Born Ephraim Goldberg in Toronto, Canada, Gehry was educated in southern California, earning his architecture degree at the University of Southern California. During 1955–56, Gehry served in the U.S. Army, where he was obliged to exploit ordinary building materials like corrugated sheet metal. After his army service, Gehry worked in the Los Angeles offices of architects Pereira and Luckman and then Victor Gruen. Gehry's early independent work, following Gruen's minimal Modernism, was rectilinear in plan with flat roofs. By 1972, however, Gehry had begun to move away from the strictures of Modernism, using trapezoidal plans and sloping roofs, and exploiting ordinary materials like corrugated sheet metal. By 1978 Gehry's interest in visual and spatial complexity increased in the rhomboidal forms and angular intersections of the Wagner house project of 1978; and now his lexicon of ordinary materials included chain-link fencing.

A dramatic manifesto of Gehry's new direction was made in his own remodeled house in Santa Monica, California, in 1978, in which an ordinary Dutch Colonial gambrel-roof tract house was enlarged and

(1984 and 1989). There followed an exhibition building in Ulm, Germany (1986), and the Museum of Contemporary Art in Barcelona, Spain (1988). Small wonder that the Getty Museum directors selected Meier in 1984 to design the sprawling six-building Getty Center complex providing for museum, office, and education facilities that was to be built around landscaped terraces across a hilltop in the Santa Monica mountains outside Los Angeles. The J. Paul Getty Trust had been the recipient of an endowment worth $3.6 billion, yielding an annual income of roughly $150 million that by law must be expended. Even so, the initial cost estimates of the Getty Center required cut-backs of 12 percent to meet the $360 million projected cost. The one million square feet cost roughly $1,000 per square foot, for a total cost of approximately $1 billion—certainly the most expensive arts complex, perhaps the most expensive building, ever built in the United States. Opening to the

10.61. Frank Gehry, Gehry house, Santa Monica, 1978. Gehry transformed an ordinary small Dutch Colonial house into a dynamic sculptural object by creating exterior layers of space defined with the most ordinary building materials. (Photo: © Tim Street-Porter/Esto.)

enclosed with angled and intersecting planes, using wire glass, corrugated metal, and chain-link fencing. [10.61] Gehry's new architectural language was then exploited in the Spiller house, in Venice, California, built in 1977–80, as well as in other commissions. The increasing sculptural complexity of Gehry's compositions was clearly connected to his original undergraduate studies as a fine arts major, and this interest in pure form would emerge as a major driving force in Gehry's architecture in the 1990s. For the moment, however, the emphasized disjointedness of Gehry's work seemed to put him in the deconstructivist camp.

A major public building that brought Gehry significant national attention was his California Aerospace Museum, in Los Angeles, built in 1982–84, with its carefully contrasted angular masses. What impressed the public was the jet aircraft attached to a huge bracket extending in front of the building, a feature that advertised the purpose of the building in a whimsical way. At almost the same time, Gehry was engaged to expand the Law School of Loyola Marymount University, in Los Angeles, built in 1978–84. For an urban school, with undistinguished buildings that Gehry described as large, gray, and bland, he was to create a campus that would attract students and faculty, that would provide them places to gather for impromptu discussions. Loyola faculty also told him they wanted a design that would convey something of the sense of permanence, the history and

traditions of the law.[45] The result is a cluster of individualized buildings, contrasting in shapes and color, around a forum in the center of which stands a freestanding templelike lecture hall. [10.24] Isolated rows of tall cylinders evoke ruined columns, and columnar porticoes on some of the buildings suggest the probity of traditional neoclassical American court houses (as well as referring back to ancient Rome itself).

In the later 1980s Gehry's work took a new twist—quite literally. For several years his building designs had featured sharp, decidedly angular juxtapositions to otherwise straightforward rectilinear volumes. Now these nonrectilinear elements became curved, twisting shapes, housing distinct functional activities. This was demonstrated in his assembly plant and exhibition gallery/museum for the Vitra International Furniture company; this was also one of his first completed building complexes outside the United States, built in Weil-am-Rhein, Germany, in 1987–89. It was the freestanding gallery/museum portion that was based on twisting, spiraling shapes, in what Gehry described as "frozen motion."[46] Soon after came Gehry's twisting, undulating central pavilion in his Team Disney Administration Building in Anaheim, California, built in 1987–95.

In Paris, France, Gehry and his team designed and built the American Center in 1988–94, a venue for expatriate American artists, musicians, and performers. The commission had been given to Gehry at the

recommendation of Martin and Mildred Weisman of Minneapolis. Beginning as an angular cluster of tubes, the design was transformed to focus on a center section of curving, undulating, intersecting volumes, sheathed in carefully fitted curved panels of ivory-colored limestone attached to an internal metal structural armature. While the American Center was, as Gehry said, "an American interpretation of Paris" and not an attempt to imitate French buildings, at about this time Gehry took up enthusiastically a French computer design program that made the design of his freeform buildings easier and more cost-effective.[47] Gehry's team's adoption of CATIA now made possible the production of construction documents for such complex designs, as well as the analysis of structural details and the simultaneous calculation of building costs during the course of design. CATIA is a computer modeling program that was developed by the French aerospace company Dassault in designing the Mirage. CATIA models and calculates three-dimensional forms not as isolated points in space but in terms of continuous polynomial equations. Now Gehry had at his disposal a way of shaping practicable buildings as easily as his pencil could slide over paper.

The buildings of the Gehry team that followed, making use of this new technology, were devoted to the visual or performing arts. One was the Center for the Visual Arts, at University of Toledo, Ohio, built in 1990–92. Employing both flat angular surfaces and curving walls, the Toledo center employed essentially two materials, glass in the flat angular walls, and a curving skin of lead-coated copper sheets. The subsequent Frederick R. Weisman Art and Teaching Museum, in Minneapolis, Minnesota, built in 1990–93, has at its center a series of compactly organized orthogonal volumes, but the whole is wrapped in sweeping, flowing, sometimes hovering, undulating surfaces sheathed in shimmering stainless steel. Increasingly, Gehry and his team of architects attempted to utterly dissolve the restricting straight lines of the Cartesian grid in favor of more totally sculptural forms. The increasing freedom of form made possible by CATIA was well demonstrated by the numerous studies for the Walt Disney Concert Hall, in Los Angeles, that were begun in 1989, but that soon became mired in political and Disney family squabbles that have postponed its construction. The full realization of what was possible through computer-aided design would next be demonstrated in another new art museum, a stunning showpiece for both the Guggenheim Museum and the Spanish city of

Bilbao, the project's joint clients.

At the height of the Middle Ages, Europe was blanketed with a "white mantle of churches," wrote a medieval chronicler. At the end of the twentieth it is no longer the cathedral that stands as the measure of civic aspiration and self-esteem but rather the art museum. In the last third of the twentieth century, scores of such museums were built, with Eisenman, Meier, Gehry, and many others making significant contributions in this building campaign. Gehry's concurrent growing interest in architecture as pure form, as demonstrated in the curved and folded planes of the Disney Concert Hall project, would lead to his single most important commission. In 1987 Gehry was sapproached by the Basque government and the Guggenheim Museum to participate in a limited competition for a new art museum to be built as part of a sweeping urban revitalization program. Bilbao, on the Nervion River in northern Spain, had once been a major blue-collar industrial city, a center for shipping and shipbuilding. Now a rust-belt city, like so many in the United States, Bilbao embarked on a broad program of replacing industry with cultural amenities in an effort to attract tourism and to erase the stigma generated by the repeated terrorist bombings by Basque separatists. At the same time, the Guggenheim Museum of New York, under its director Thomas Krens, was casting about for regional locations for branch museums; the interests of Bilbao and the museum nicely complemented each other. Besides the art museum, the city and regional government undertook to build a new conference and concert hall by Federico Soriano and Delores Palacios, as well as a new multiuse complex by Cesar Pelli.

On visiting Bilbao to look at a museum site proposed by the city, Gehry suggested a site on the riverfont, adjacent to the downtown, for it seemed to Gehry more beneficial to use the new museum to unite the city with its abandoned industrial waterfront. Gehry's striking riverfront design, with its billowing shapes and restless energy, won him the commission. His free-flowing competition sketches were translated into drawings by office assistant Jim Glymph and models were constructed using the CATIA program, defining the circulation, major galleries, and support spaces.

A decision was made not to use sculpted limestone panels to sheath the curved planes, as had been done in Paris and was proposed in Los Angeles. Nor, however, could lead-coated copper plates be used now because of environmental concerns. At this point another fortunate coincidence occurred with the concurrent col-

lapse of the Soviet Union. Desperate for cash, the new Russian government threw on the world market its large reserves of the rare metal titanium, glimmering bright and far more resistant to urban air pollution than stone. Now available at a fairly reasonable cost, titanium was purchased, experiments were carried out on its fabrication, and eventually a form of rolled titanium was used in small sheets to cover the undulating surfaces of the Bilbao museum, with glass and panels of Spanish limestone making up the rest of the building shell. The titanium turned out to be a wondrous choice, glistening in the sunlight, reflecting different color hues depending on the angle of the light. Moreover, the final rolled skin is only a third of a millimeter thick, and, as Gehry commented, "is pillowy, it doesn't lie flat and a strong wind makes its surface flutter" creating a fluctuating, shimmering light.[48]

Construction began in 1993, with the building being opened to the public at the end of 1997. [10.62, 10.63] The sweeping forms of the museum, the shimmering skin echoing the river, seem from some vantage points to resemble the billowing sails of a great metallic ship. Gehry wanted to evoke the spirit of the "mother ship," Wright's inimitable Guggenheim on Fifth Avenue, and he did so on his own terms. The largest gallery is a huge room, 450 long and 85 feet across, sinuously curved with its walls slanting inward as they rise, covered with a gently arched vaulted roof. The visitor walks down into an atrium that soars upward 165 feet, threaded over with catwalks and elevated walkways branching off into the galleries. Giant treelike trunks of plaster and titanium, here swelling and there deflating rhythmically, rise to the top of the five-story atrium; they house utilities, stairs, and an elevator. The Bilbao Guggenheim, wrote Robert Hughes, is "a building that spells the end of the smarty-boots, smirkingly facile historicism on which so much Postmodernist building was based—a quoted capital here, an ironic reference there." Although Gehry is unafraid of metaphor, his Bilbao Guggenheim demonstrates that the essence of building is structure and placemaking. Hughes notes that the museum "is a work of art in its own right . . . [and] is far more interesting than many of its contents—the dull, inflated conceptual art and late minimalism" preferred then by the Guggenheim's director. Hughes wonders if in time the museum will become filled with what he calls heavy-metal, late-imperial American cultural landfill; "what broad public is really interested in such art? For the present, however, people will come *for the building*."[49]

Gehry and New Museums

Gehry quickly followed his celebrated success at Bilbao with other museums in a similar vein. During 1998–2000, he developed a variation on the Bilbao theme for a Guggenheim branch museum proposed for lower Manhattan, near the foot of Wall Street on the East River. Like the ground-breaking original Guggenheim building by Wright on Fifth Avenue that turned its back on the surrounding apartment towers and made them background, the new Guggenheim, with its broad swirling, undulating bands of glistening titanium, would turn the Wall Street office skyscrapers into background buildings. Meanwhile, Gehry was finishing a commission for Paul Allen of Seattle, one of the several billionaire cofounders of Microsoft. Gehry's task was to design what came to be called the Experience Music Project, an interactive museum of rock music, at the base of the famed Space Needle in Seattle. Allen—also a rock musician—had been collecting memorabilia related to rock music for years. The idea for a museum began to form in 1992 when Allen acquired Jimi Hendrix artifacts. At first Allen intended to build something celebrating Hendrix (a Seattle native); out of this emerged the concept of a complex of interactive displays explaining the evolution of the guitar, its electric transformation, and the larger world of rock music. Gehry's striking undulating building, built at a cost of $240 million, opened in June 2000. If, as Gehry has noted, democracy creates chaos in its collisions of thoughts and ideas, then this Seattle museum is the physical expression of popular music in a democracy: twisting, wiggling, writhing, a veritable celebration in metal (heavy?) of "shake, rattle, and roll."[50] Gehry began work on the Experience Music Project by experimenting with rearrangements of broken pieces of guitars (recalling how Hendrix and other provocative and demonstrative rock performers smashed instruments) to suggest forms that were then turned into study models. Certainly Gehry's EMP, with its more intuitive conflicting forms, seems more in the spirit of rock music than the crisp and serene geometries of I. M. Pei's Rock and Rock Hall of Fame in Cleveland.

Gehry's Bilbao Museum has produced what has come to be called "the Bilbao Effect," the purported power of pure architecture, even of a single building, to open people's eyes, to change perceptions and entice people to visit a place they never wanted to go to before. Soon Gehry became a victim of his own success, as his office was flooded with calls from around the world from people or committees who wanted a Gehry museum, something that would put them on

10.62. Frank Gehry,
*Guggenheim Museum, Bilbao,
Spain, 1987–97. Over two
decades, Gehry's dynamic
angular building forms were
transformed, through the use
of computer-aided design, into
sinuous curving biomorphic
forms; none has been quite
as evocative as the Bilbao
Guggenheim Museum, with
its shimmering silvery titanium
skin. (Photo: © Jeff Goldberg/
Esto.)*

10.63. *Guggenheim Museum,
Bilbao, plan of main floor.
The plan of the museum is
distinctive for its near absence
of any truly straight lines.
(L. M. Roth, after Gehry.)*

the map and lift their city from its doldrums and make it a place of pilgrimage.[51] In fact, the comparison with the medieval pilgrimage and the relic-protecting churches spaced along the pilgrimage route is apt, for the relics and the spectacular white churches built around them brought their cities income siphoned from the religious. For medieval pilgrims, the draw was the belief in the power of the relics, but whether any of the hopeful clients contacting Gehry had anything to display in their desired museums was almost irrelevant; a building by Gehry, in itself, would produce the desired effect.

Museums, particularly art museums, have become the coveted signature commission of the late 1990s and early years of the new century—the more unusual, the more in contrast with their surroundings, the better. And the more exotic the architect, the better as well. Daniel Libeskind, one of the early deconstructivist architects, has designed a new Denver Art Museum as well as the Jewish Museum of San Francisco. His early comrade in the deconstructivist trenches, Zaha Hadid, is completing a striking Contemporary Arts Center at the busiest corner in downtown Cincinnati, a profusion of jostling near-transparent cubes certain to be a traffic stopper. While American architects have been given important museum commissions around the turn of the century—such as Gehry, who in 1999 began design of an expansion of the Corcoran Gallery of Art in Washington, D.C., and Steven Holl, who designed the completed Bellevue Art Museum in Washington State, and an addition to the Nelson-Atkins Museum of Art in Kansas City—many American museums are being enlarged by celebrated international architects. For the Museum of Fine Arts in Houston, the Spanish architect Raphael Moneo was engaged. Tadao Ando of Japan has completed the Pulitzer Art Collection building in St. Louis; his countryman Arata Isozaki is involved in the construction of the Bass Museum of Art in Miami Beach. Renzo Piano of Italy has been selected to design changes to the Art Institute of Chicago; and the Netherlander Rem Koolhaas designed the Guggenheim/Hermitage Museum, scheduled to open in Las Vegas, Nevada, late in 2001. When a strong earthquake badly damaged the M. H. de Young Museum in San Francisco in 1989, it was clear that the facility would need to be rebuilt from the ground up. Museum director Harry Parker and capital campaign chairman Dee Dee Wilsey examined new museums across Europe, selecting Swiss architects Herzog & de Meuron to design a curving, shimmering new museum for Golden Gate Park, projected to be finished in 2005.

The bolder and more atypical the building design, the easier it is to raise money. The soaring curved wings hovering over the new Milwaukee Art Museum designed by Spanish engineer/architect Santiago Calatrava prompted a major donation by John and Murph Burke, so large in fact that the aerial sunscreen will likely be known as the Burke brise soleil. When the design was first developed and presented to the public, museum director Russell Bowman had expected some resistance from Milwaukee citizens, but within months people were proudly saying it was going to be their Sydney Opera house, a white sail rising above Lake Michigan that would make their city known to the world.[52]

Not much is mentioned concerning how these new buildings will enhance the experience of an individual standing before a work of art. Not to be forgotten are the many small specialized art museums designed and built in the 1980s and 1990s, as noted in Victoria Newhouse's book *Towards a New Museum* (1998).[53] These tend to focus on the personal experience of the individual visitor. Most of the aggressively assertive museums just cited, however, are being designed to house the big blockbuster exhibitions that bring in so much money. They will also, of course, house larger and better restaurants, and bigger shops for the exhibition tie-in merchandise. Museums and marketing are morphing together, raising the question of whether we might be putting the art cart before the horse.

Bart Prince

Another architect whose imaginative work is highly personal and expressive is Bart Prince (born in 1947), based in Albuquerque, New Mexico. Prince was deeply influenced by his study of Frank Lloyd Wright's architecture as a youth, by frequent visits to Paolo Soleri's architectural commune and city-in-progress, Arcosanti, and also by meeting Bruce Goff. Prince's buildings are fantastic in the literal sense, giving physical form to fantasy. His own house in Albuquerque resembles a cigar-shaped spaceship, seemingly hovering over a desert landscape. His seaside house for Joe and Azoic Price, at Corona del Mar, California, built in 1983–90, is wrapped in an undulating freeform roof, covered with shingles, that looks like a gigantic oyster shell.

Arquitectonica

The architectural partnership Arquitectonica, comprised by Bernardo Fort-Brescia (born in 1951) and his wife, Laurinda Hope Spear (born in 1950),

although in practice for only a short time, has created an intriguing body of work using irregular forms, bright colors, and inventive details. Walls sheathed in variegated deep blue glass, cantilevered out at sharp angles, and trapezoidal plans describe their Center for Innovative Technology, in Herndon, Virginia, built in 1985–88. Perhaps Arquitectonica's best-known building is their Banco de Crédito, at the edge of Lima, Peru, built in 1983–88. Basically the bank is a large five-story square doughnut, but in the open internal court the projecting staircases become sculptural accents, each one different in shape. The boardroom is a projecting separate block, with a steep shed roof. Often illustrated is the dramatic main vertical circulation area, a smooth-surfaced open oval well, through which a bank of escalators rises, with the curved walls made of glass block.

DECONSTRUCTIVISM

American architects, in general, were not given to theorizing regarding design during the eighteenth or nineteenth centuries—planning theory or structural theory, yes, but artistic theory, no. Even as polemics raged in Europe before and after the First World War, American-born architects seldom bothered with such esoterica. They wrote and lectured, focusing on how to make a profitable commercial office block or what the implications of the metal frame would be, but only as a solution to a specific practical problem and not as a polemic or universal theory. Wright wrote about the nature of materials, and Cram wrote about a moral architecture, but their ideas did not call for the abolition of architecture as it was generally understood. Even the few articles and speeches of the transplanted European modernist Mies van der Rohe proclaiming a new technological architecture are remarkably short. Hence in summer 1988 there was considerable interest when the Museum of Modern Art (with Johnson very much an eminence grise, pulling important strings behind the scenes) hastily mounted an exhibition entitled "Deconstructivist Architecture." Johnson even wrote part of the catalogue, natural enough since he had been behind the selection of the seven designers represented. Three of the seven were American architects: Frank Gehry, Bernard Tschumi, and Peter Eisenman. The motives of the organizers and the impenetrable rhetoric of their theoretical essays made the exhibition something of a cause célèbre; the principal catalogue essay, by Mark Wigley, was generally held by reviewers to be

as a "litany of theoretical maunderings that generated more critical heat than the work it was meant to be about."[54] Cathleen McGuigan wrote of the exhibition: "They've tossed out every orderly precept of architecture since the Greeks and have prompted the most basic questions, starting with which end is up?"[55] Many critics were strongly negative: Hilton Kramer, for instance, who dismissed Deconstructivism as architecture "designed to cause pain to everybody except the happy few who might make some money or win some fame from it," and Vincent Scully called it the "terminal twitch of modernism," comparing it to the horror movie cliché: "we thought modernism was dead, and here it comes again."

Ostensibly derived from the literary theory of Jacques Derrida, Deconstructivism—DECON—was intended as "a strategy, a way of reading philosophical or literary texts," wrote apologist Alois Müller, "in order to get to the bottom of them. . . . Deconstruction means burrowing deep, to find out what unconscious premises a text is based on and what the blind in the author's eye cannot see."[56] Deconstructivist architects claimed to be "working to disencumber architecture of too limited a scientific, technical rationality—and of the symbols of such a rationality—with the aid of reason." Traditionally, architects operating in the public realm, observed Robert Stern, had seen their task as the making of buildings fulfilling "grand public purposes"; their job was to create an environment that was safe, secure, orderly, friendly, functional, and provided some measure of comfort in an otherwise fractious world. In the manifestoes and essays that laid out Deconstructivism, a distinctly negative and violent language emerged, laced with such verbs as "violate," "tear," "dislocate," "infect," "scar," "reject," "confuse," and "destabilize." Stability is exactly what the deconstructivists set out to destroy. To these criticisms, Peter Eisenman retorted, "Are the Parthenon and St. Peter's in Rome 'friendly'? They're awe-inspiring, mysterious, sublime. I don't think friendliness has anything to do with it."[57]

Whether the larger public supported or even understood Deconstructivism was beside the point. Architects and writers seemed bent on creating a language that deliberately distanced them from their public. Consider this response by Eisenman to an interviewer's question concerning the role of the national media in architecture: "Architecture posits the question of aura in regard to both iconic and indexical signs. . . . I believe we are always going to have an auratic condition, meaning some kind of pres-

ence in architecture, because there is always some *being-in* as opposed to the condition of language of *being-as*. It is the being-in of architecture that is questioned in the media today." As Carter Wiseman notes in quoting such an impenetrable passage, this is the kind of commentary that can be understood only through access to the private and esoteric language of its participants. Eisenman and his fellow theorists had rediscovered the ancient mystique of appearing to be profound by using material with which their listeners or readers were unfamiliar and which they were not likely to challenge while they willingly gave the speaker or writer the status of guru.[58]

The drawings and models that were so important in published writings and exhibitions apparently were extreme examples, abstractly and obsessively self-referential and essentially nihilist. The few buildings that have actually been built by these Deconstructivist architects, however, are somewhat simpler, though they are still confusing jumbles for most users. They are theoretical constructs that happen to house certain activities; they may or may not function very well, but that is rather beside the point. Even their architects get lost in them, as Eisenman has said jokingly of his Wexner Center. Among the American deconstructivists is Eric Owen Moss (born in 1943) of Los Angeles, whom Philip Johnson described as "a jeweler of junk" because of the way Moss integrates bits of old machinery or broken trusses in his buildings.[59] Perhaps Deconstructivism will prove too arcane for most architects and clients, for as critic Kenneth Frampton observed, "These guys get into their fashionable intellectual delusions, but architecture isn't art or literature; it is mixed up with the world—and with life."[60]

REGIONALISM

For orthodox modernists in the 1950s and 1960s, the term of most profound derisive dismissal was "regionalist." The unchallenged objective of modern architecture then was to create a system of such universal validity that it could be used anywhere, for any building. Gropius and Le Corbusier had made this their credo, saying, respectively, that "the necessities of life are the same for the majority of people," which made possible a method of building "for all nations and climates."[61] Yet even as this universality was being promoted in the 1950s, a method of design distinctly responsive to the Pacific Northwest was developed by architects such as Pietro Belluschi, John Yeon, and

Paul Thiry. This concern for appropriateness to site and climate resurfaced in the Northwest in the 1970s. In part this resurgence was certainly due to the return of Belluschi to Portland, Oregon, where he resumed the design of elegantly restrained churches. These late designs are among his very best, including the soaring Immanuel Lutheran Church, in Silverton, Oregon, built in 1975–79; although this was destroyed by an arson fire in 1995, something of its exultant quality can be found in St. Matthew's Lutheran Church, in Beaverton, Oregon, built in 1982–84.[62]

Among the new generation of regionalists could be counted Antoine Predock (born in 1936), who has worked primarily in the Southwest, and who describes his approach as "site-specific—expressing spirit of place."[63] Although his work has ranged beyond New Mexico and Arizona, his buildings in the desert employ masses of blunt concrete, with small windows where exposed to the sun, as in his Nelson Fine Arts Center, at Arizona State University, in Tempe, Arizona, built in 1985–89, where slits and delicate lattices in the roofs create a play of light across the walls and floor. In his Las Vegas Library and Museum, in Las Vegas, Nevada, built in 1986–90, light is filtered and manipulated, and water is incorporated as a precious embellishment. In looking at his sharp sculpted masses—like the great conical roof of the American Heritage Center and Art Museum at the University of Wyoming, Laramie, built in 1986–93, as seen silhouetted against its mountainous landscape—one sees a veritable realization of the architecture described by Le Corbusier: the magnificent play of masses brought together in light.[64] [10.64]

Of the architects often described as having a unique sensitivity to place, one who certainly deserves mention is Arthur Erickson (born in 1924), whose practice was based in Vancouver, British Columbia, Canada. A native of Vancouver, with an architectural education from McGill University in Montreal, he eventually returned to Vancouver to build his practice. In the book he later prepared on his own work, Erickson begins by analyzing the conditions that shaped his work: site, light, cadence, and space. Structure is simply a means to other ends.[65] His early residences near Vancouver, although minimalist in form and material, show this adjustment to site and to the need for light in this northern, often clouded environment. His Simon Fraser University, outside Vancouver, built in 1964–65, is also highly rational in form, but incorporates many roof overhangs and roofed-over areas to provide covered public spaces in an environment

10.64. *Antoine Predock, Nelson Fine Arts Center, Arizona State University, Tempe, Arizona, 1985–89. In the harsh realities of the desert Southwest environment, drenched in piercing sunlight, Predock has made good use of screens and grills to break up sunlight, creating intriguing, ever changing patterns over the course of days and seasons. (Photo: Timothy Hursley, courtesy of Antoine Predock.)*

where rain is sometimes too plentiful. In the Provincial Government Offices and Law Courts, in Vancouver, built in 1974–79, he devised a wholly new image for a courthouse, with a long pedestrian spine covered in glass, again a solution that creates a tree-filled light-flooded public space available year round. In Ottawa, the Canadian capital, standing across Wellington Street from the Canadian Houses of Parliament—one of the most visible and magisterial settings in Canada—is Erickson's Bank of Canada, built in 1970–80, a masterful solution to a most difficult problem: how to expand the bank with new construction, retain the existing austere blocky Art Deco building of 1929, and yet still make a fitting addition to the setting of the national government.[66] His solution was to place two twelve-story office towers at slight distances to the north and south, with a connecting section to the rear that joins the two towers to the original building. Rather than gut the old building and use its empty facade as a false front (a practice that became popular in the late 1970s and 1980s), Erickson embedded the old building in the new, which becomes a frame around it. The profile of the taller glass enclosing structures is softened by chamfered corners and a slopped mansardlike top floor. The middle section, enclosing the rear of the old building, is an open garden atrium running the full height of twelve stories, with dense clusters of plants around a pool at

sidewalk level. In contrast with the dense stone walls of the old bank, the new enclosing structure was sheathed entirely in green mirrored glass, complemented by copper detailing of the wall panels and mullions, and green slate was used in walls and paving. The copper has turned green, complementing the windows, but, more important, reiterating the green copper roof of the old bank and of all of the other surrounding copper-roofed high Victorian Gothic and Chateauesque government buildings. Unlike the Seagram Building, which must be laboriously maintained in chemical stasis, its bronze kept forever brown at enormous expense, the Bank of Canada ages gracefully, the colors of its materials merging ever closer together.

Another architect who might be described as a regionalist is E. Fay Jones (born in 1921). Raised in a small town in Arkansas, Jones had been captivated by a movie newsreel segment describing Wright's newly finished Johnson Wax Building and he instantly decided on a career in architecture. Before serving in the naval air corps during the Second World War, he studied engineering at the University of Arkansas; he returned there after 1945 to a newly organized architecture program (meeting Wright during a visit to Houston in 1949) and graduated in 1950. For several years he taught and studied at Rice University (taking courses in philosophy) and at the University of

10.65. Fay Jones, Thorncroft Chapel, Eureka Springs, Arkansas, 1980. The delicacy of the structure was the direct result of deciding to handcraft all parts of the building using materials hand-carried onto the building site. (Photo: Timothy Hursley.)

Oklahoma, where he came under the influence of Bruce Goff. Through Goff, Jones renewed his contact with Wright and spent part of 1953 at Taliesin (Wisconsin) before returning to Fayetteville, Arkansas, to take up a teaching job at the University of Arkansas. This has remained his base ever since.

At Fayetteville, Jones became known as "the guy who does faculty houses," building for the head of the philosophy department, the dean of the law school, and a music professor.[67] These and other houses—low, horizontal, of rough rock piers, and shaded by the long extended eaves of low-pitched roofs—revealed the unmistakable influence of Wright. Gradually they became more insistent in their geometry (like Wright's work before 1910), often stressing their vertical lines in delicate lacy structures, but always carefully attuned to the particularities of their wooded sites. As

Jones put it, "the building and site achieve a kind of oneness, a harmonious ideal relationship."[68] Materials and details here and there in Jones's work—the warm brown of natural wood against buff walls, or a detail generated from the structural necessity of articulated wood supports—bear witness to the architects he readily admits to admiring: the Greene brothers, Bernard Maybeck, Richard Neutra (in his later desert houses), Harwell Hamilton Harris, and Bruce Goff.

Good though his residences were, his true masterworks began in 1980 with the design of the Thorncroft Chapel, in Eureka Springs, Arkansas, built in 1980. [10.65] Commissioned by Jim Reed as a little chapel to provide wayfarers a place for contemplative rest, it is a nondenominational facility nestled in eight acres of dense woodland. Having examined the heavily wooded site, Jones decided that the entire

building had to be constructed only with materials that could be hand-carried through the woods by the workmen so as not to disturb the ecosystem. Hence the entire building was put together of two-by-fours, two-by-sixes, and two-by-twelves, with trusswork built on the floor slab and lifted into place. With walls of glass, and a linear skylight running the length of the simple gable roof, the latticelike building has a transparency that enables one to see it as being one with the trees. Especially in the autumn, when the falling leaves take on their marzipan hues of russet and orange, the slender supports of the chapel and the interlacing lines of the roof trusses seem to merge with the denuded branches of the trees and they seem to weave together. The building becomes one with its place.

Reed and Jones succeeded far beyond their wildest expectations. In a secular, commerce-driven world, where hype and image count for nearly everything among a people who desperately seek the shadow of things and not the substance of the spirit, this little building suddenly became a sacred place, not because of a creed taught or an individual's charisma but through the sheer power of its pure and naked architecture. Crowds of pilgrims began to flood the parking lot, sometimes two or three thousand a day, just to see the chapel and perhaps, as Jones said in an interview, to collect themselves in the quiet and "to think their best thoughts."[69] So great were the demands for weddings and other services in the chapel that Jones was brought in to build another building nearby, the Thorncroft Worship Center, in 1989. Other chapels followed: the Mildred B. Cooper Memorial Chapel outside Bella Vista, Arkansas, built in 1988, with its delicate curved steel arches, and the Marty Leonard Community Chapel at the Lena Pope treatment center for emotionally disturbed adolescents, in Forth Worth, Texas, built in 1990. The sacred quality of Jones's buildings has nothing to do with their being religious, but rather with a feeling of connectedness to the cosmos, a oneness of being. Hence it was appropriate that Jones was engaged to design the Pinecote Pavilion in the Crosby Arboretum, in Picayune, Mississippi, built in 1987. This larger and even more latticelike shelter—built on the edge of a bayou in a pine forest, with slender, closely spaced supports that echo the bare trunks of the pine trees—was meant to encourage visitors to contemplate the interconnections among all living species. Viewing the expanse of bayou from such an architectural setting, seeing the tendrils of rising morning mist, listening to the philharmonia of insect, amphibian, beast, and bird, and to the sigh of

the wind through the surrounding trees, perhaps the visitor might begin to grasp what is meant by the phrase that ends Lakota prayers: *mi taku oyasin,* "we are all related."

GREEN ARCHITECTURE

American architecture in the next century, the beginning of a new millennium, will of necessity need to focus on issues never given much thought before, one of which will be building for a sustainable future, the theme of the annual meeting of the American Institute of Architects in 1993. One example of how this might be done—if we can ever shed the hubris of self-aggrandizement in corporate headquarters—was given in the new headquarters building of the National Audubon Society. Rather than commissioning a new "signature" or "object" building by a high-profile architect, the society selected a department store of 1891 in Manhattan and had the Croxton Collaborative renovate the structure. Not only were no fossil fuels consumed demolishing an old structure, or in hoisting materials to build a new one, but the energy-saving strategies and equipment employed in the renewed building resulted in energy consumption 69 percent below the city's strict new energy code.[70]

The Audubon Society Building illustrates how, in an urban environment where demolishing an existing building is a profligate waste of both human and fossil fuel energies, it is possible to accommodate new activities and uses in older buildings of artistic and cultural merit. This kind of conservation fosters a far more sustainable overall environment, the antithesis of the cut-down, dig-up, exploit-and-exhaust economy that has prevailed since the dawn of the industrial age.

Yet another alternative approach to design is illustrated in the work of Seattle architect James L. Cutler. In reaction to his upbringing in Pennsylvania coal country, where he saw the earth being turned upside down and abandoned as sterile heaps in the search for fossil fuel, Cutler later became extremely sensitive to the despoliation of the natural landscape, to the way that conventional construction processes ruined the surrounding building site, and of course to how the need for building materials stripped the landscape of trees. In one case, after many discussions with a client concerning a proposed residence, Cutler returned to the client's building site on the forested shore of one of the

10.66. *James Cutler, Bridge House, Bainbridge Island, Seattle, Washington 1987. Showing an uncomplicated house built across a stream on a delicate site, this view was taken* *weeks before completion of the house, revealing the careful preservation of this lush setting. (Photo: © Peter Aaron/ Esto, courtesy of James Cutler.)*

lakes surrounding Seattle, only to find the site now a bare and open expanse dotted with stumps where the large mature fir trees had been clear-cut, earning the client a few hundred dollars but destroying the very qualities that had made the site so attractive in the first place. Cutler and the client quickly parted company, for, as the architect said brutally to the former client, he would not work for murderers. At the same time, Cutler was working on the residential compound of Bill Gates, founder of Microsoft Corporation, in which an enclave of buildings was to be built using the exposed large-scale timber framing that has come to distinguish Cutler's work.[71] Gates commented one day that Cutler should let him know when he wanted them to go out into the forest to select the old-growth trees to be felled to provide the timbers for the buildings, prompting Cutler to consider other ways of finding the necessary wood. Cutler then contacted a Seattle timber broker who alerted Cutler to the imminent demolition of a sprawling lumber mill built nearly a

hundred years before, a mill built of massive timbers sawn from huge old-growth trees already five or six hundred years old when they were felled. By buying up the timbers from the disassembled mill, and recutting and replaning them to the desired dimensions, Cutler and Gates were able to obtain some of the most beautiful straight-grain, knot-free Douglas fir that will ever be seen, for it is a certainty that trees like those that provided these timbers do not exist any longer except in a few protected reserves. It is Cutler's view not that the architect should shun the use of wood but rather that when it is used the architect should honor the wood.

Cutler has observed that in general terms our culture is set up to eventually destroy us as a species, and the customary building process is a microcosm of this dynamic. In the process of putting up a building, the site around the building is gradually destroyed; earth from the excavation is piled to one side, trucks pull up to the building to deliver materials alternately tearing up and compacting the soil;

excess concrete is dumped on the ground, other wastes are similarly dumped, building scraps are littered about. When construction is done, a few new trees are planted and sod rolled out to simulate in an impoverished way what was once there. In one of his houses, Cutler (like Fay Jones) has recently shown how this dismissive, cavalier, and destructive building process can be turned around. In 1987 Cutler was working with a builder who had acquired a heavily wooded site crossed by a seasonal stream. The builder's intention was to remove the trees, and he had already obtained permits to allow putting in a culvert to divert the stream, cover it over, and build on top. Cutler suggested an alternative, constructing the house atop long beams over the stream, with the beams resting on small concrete foundation abutments that could be placed in hand-dug excavations. This would eliminate the need to bring heavy digging equipment onto the site and would leave the large fir trees and delicate wild indigenous groundcover plants intact. The builder agreed, and Cutler met with the workmen to explain their common objective of disturbing the building site as little as possible, and of carrying in as much of the building material as possible. The workers agreed. [10.66]

The wood-framed residence, soon dubbed the Bridge House, was simple in its elements and recalled local vernacular buildings such as fishing shacks. Naturally finished wood structural members and trimwork dominate the interiors. What makes the image shown in 10.65 all the more remarkable is that the photograph was taken about a month *before* completion of the building, and yet the setting is as lush and verdant as if it has been lavishly finished by a landscape architect. This is Cutler's objective: to build with minimal impact on the supplies of natural construction materials, to use materials that rely in the least way on chemical and industrial processing, and to build with the lightest impact on the landscape. This is the kind of architecture that facilitates human life rather than leaving in its wake a trail of depleted resources, of pollution and toxic wastes that later generations must deal with. The challenge of this way of building is that it contradicts thousands of years of human building conventions, especially American building conventions rooted in the supposition that trees and water and clean air are all inexhaustible. American architecture in the next millennium must of necessity be conceived in a very different way, one that considers the impact of present activities on the seventh generation.

THE NEW URBANISM

This concept of connectedness, of the building of community, was a subject of both aspiration and scorn—when it was thought of at all during the 1970s and 1980s. In some quarters there was little if any concern for the larger community or with civic building. After the social programs of the 1960s, the following decades were often described as the "me" years, marked by the rise of the obsession with self. If the watchwords of the Roaring Eighties were not "Where's mine?" then they were surely "He who dies with the most toys wins." Ivan Boesky, Wall Street arbitrageur extraordinaire, later convicted of stock fraud and fined $100 million, spoke to the graduating class of the University of California School of Business in 1985, and reassured them that "greed is all right, greed is healthy"; shortly thereafter, in 1987, the fictional corporate raider Gordon Gekko in Oliver Stone's film *Wall Street* echoed this, saying, "Greed is good." Stone sought to indict the generation of his peers too busy enlarging their personal fortunes to bother with the social problems around them.[72] The vacuous soaring glass towers and the bespangled postmodern extravaganzas put up in the 1980s were the corporate emblems of this overarching self-aggrandizement. One illustrative example, put up by perhaps the best self-promoter of the decade, is the green glass Trump Tower, in New York City, built in 1980–83, at sixty-eight stories. Rising at the same time were Johnson & Burgee's RepublicBank Center and their Transco Tower, in Houston. These, and the other glazed leviathans that thrust themselves up in Houston and in scores of other cities, made no effort to engage the street, to encourage pedestrian activity. A building like the RepublicBank Center was, Vincent Scully wrote, "an architectural one-liner, intended to knock our eyes out for a fleeting instant as we glimpse it from behind the wheel." The closer you got, the emptier and more inarticulate they were.[73]

There were a few notable exceptions, however, to this deadening tread. The generous public space created at the base of, and uniting the parts of Pelli's World Financial Center on New York's Hudson River waterfront was one. Another interesting example of urban design and the creation of public spaces integrated with modeled building masses can be seen the Proctor & Gamble General Offices Complex, in Cincinnati, Ohio, designed by Kohn Pederson Fox and built in 1982–85. [10.67] Designed to be integrated with existing company offices, the new complex con-

10.67. Kohn Pederson Fox, Proctor & Gamble Headquarters, Cincinnati, Ohio, 1982–85. By setting the new office space back, and dividing the required space into two short towers, an open campus is created. (Photo: Timothy Hursley, courtesy of Kohn Pederson Fox.)

sists of two horizontal office blocks forming an **L** that defines a new public park extending to the older buildings. At the corner of the **L** is an auditorium, and where the two office wings meet this auditorium, twin octagonal seventeen-story towers rise through setbacks to octagonal pyramid crowns. Shaped to make reference to the Art Deco office towers of Cincinnati, the Proctor & Gamble towers were divided rather than making one overpowering single tower. Such an expression of good urban manners was rare.

The other pressing urban issue was housing. While the construction numbers of private single-family housing in the suburbs went up (or down) according to interest rates, the construction of publicly assisted or subsidized housing in the cities almost disappeared due to a shifting political agenda. At the height of President Johnson's Great Society program, when the Housing and Urban Development Act of 1968 was passed, the goal was to build 26 million new homes in the next decade. In two years the low-income portion of this program was well under way, with almost 127,000 housing units started in 1970. Yet despite a Democratic Congress, once Ronald Reagan entered the White House in 1981 this commitment to assisted housing disappeared. In 1980 only 21,000 low-income units were under construction. In 1985 there were only 9,600 units started, and by 1990 this had dropped even more to 7,600.[74] In 1992, at the end of

the Bush presidency, this dropped to 7,200 low-income housing units under construction *across the entire nation* for the year. In 1987 the nonprofit Urban Institute calculated that there were half a million homeless people in the United States, and two years later the National Alliance to End Homelessness calculated the base number at 735,000, with as many as 2 million people rendered homeless for at least several days during the course of a year. An "official" count taken by the Census Bureau on March 20 and 21, 1990, revealed 178,828 people in shelters or on the streets. Other studies revealed that single men made up about half of this number, while single women constituted about 12 percent. But most alarming was that 35 percent were families with children, and this number has been the fastest growing component of the homeless, even though 18 percent of the adults have full-time employment.[75] The working poor have found themselves cast into the street.

There occurred in 1993, however, one brief but brilliant glimmer in this increasingly dark picture. The *Chicago Tribune*, no stranger to architectural competition, announced a contest for the redesign of Chicago's notorious Cabrini-Green public housing complex. On seventy-one acres, in bare warehouselike row houses and apartment slabs, built from 1941 to 1958, lived 6,935 people, mostly single-parent families. Household incomes averaged $6,000, but only one in every ten households had an employed member. At the time, remembers Larry Amstadter, an architect who had worked on the original apartments in the 1950s, "we were moving people out of some of the worst housing imaginable and we were putting them into something truly decent. We thought we were doing a great thing, doing a lot of innovative design things, like putting open galleries on each floor so kids could play right in front of their apartments. We didn't foresee the kids throwing each other *off* them."[76] As at Pruitt-Igoe, residents were fleeing, and the vacancy rate was 32 percent, the empty units being used as staging areas by warring gangs. Though little visible result came of the *Tribune*'s noble effort, it was evidence of an increasing awareness of the problem. But with the election of an almost reactionary Republican majority to Congress in 1994, and the appearance of conservative legislatures in almost all the states, the prospects of any increase in low-income housing construction seems to have been quashed well into the next century. We can only hope that the frustration and discontent do not continue to boil over, as happened in Los Angeles in April 1992, when fifty-

two people were killed in riots and six hundred buildings were torched. How much housing could have been built, and how many educational and social programs could have been initiated with the $1 billion spent to repair the damage—or with the $1.5 billion required to build just one B-2 Stealth Bomber?

Neither during the grim economic slump of the 1970s nor in the boom years of the Roaring Eighties did American architects in any number address the problem of housing, particularly housing of the "underclass." One notable exception has been Robert A. M. Stern. Even as he was starting his career with designs for posh shingled getaways in the Hamptons and chic penthouse apartments, Stern began exploring the design of housing groups, beginning with an entry in the Roosevelt Island competition of 1975 that combined low-income, middle-income, and upper-income apartment clusters. The next year he developed a proposal for the Venice Biennale of what he called "Subway Suburbs," compact detached single-family houses, grouped around common oval parks, suitable for placement on abandoned land within urban boundaries. Although residents would use public transportation, automobile garages were included in each residence. In 1980 Stern developed a series of prototype medium-cost houses that did employ a range of traditional styles like classical or Tudor, giving them names like Somerset, Wellington, Fairfax, Heathcote. As he was pursuing these designs, Stern was closely examining earlier housing successes such as Forest Hills Gardens and Radburn.

As Stern's theoretical studies became known, he began to receive commissions for house groups, such as the two adjacent houses designed for Corbel Properties, in New York, built in 1981. Stern's brief description of his objectives says much about his approach to design:

These two houses . . . represent a departure from our usual practice in that, though they are purpose designed, they are not tailored to the requirements of a particular client but are conceived for sale in an affluent resort community. . . . Our intention was to make two houses that used the elements of the local summer house vernacular—which is a somewhat anglicized version of the Shingle Style—to establish a sympathetic dialogue between the present and the past.[77]

Some of the housing complexes Stern designed in the 1980s were, admittedly, for upper-income resi-

dents, including the group of eight Shingle Style houses on fourteen acres at Mecox Fields, in Bridgehampton, New York, built in 1981, and especially the large complex developed for his client Arnold Palmer, the St. Andrews condominiums at Hastings-on-Hudson, New York, built in 1982. Here Stern arranged 209 two- to four-unit gable-roofand shingled town houses around a golf course. The former Andrew Carnegie summer cottage on the grounds was retained and renovated to house a recreation center. Additional housing clusters followed in the 1980s, including a two-hundred-duplex complex proposed for Fox Hollow Run, in Chappaqua, New York, in 1983, and a group of twenty-three stone and stucco houses built on the former estate of architect Ernest Flagg, in Staten Island, New York, also of 1983.[78] In 1985 Stern accepted a request from *Builder* and *Home* magazines, and the National Council of the Housing Industry, to design a 2,200-square-foot house, based on the vernacular Texas farmhouse, to be built outside Dallas, Texas. The house, constructed in time for the annual convention of the National Association of Home Builders held in Dallas in 1986, was published

in *Home* in February of that year.[79] Stern's subsequent town house and apartment complexes designed for Miami Beach and Vero Beach, Florida, of 1986–88, employed subdued Mediterranean details. The scale of his planning continued to expand, as in the master plan for the development called Rocky Fork, outside Columbus, Ohio, begun in 1989, where five hundred individual houses were arranged in eight villages around a centrally located neo-Georgian clubhouse. In 1994 Stern again provided a moderate-cost design for a mass-market magazine, designing a 2,100-square-foot, story-and-a-half shingled house for *Life* magazine; estimates by Ryan Homes made from the plans put the cost at between $140,000 and $160,000, although elimination of some decorative trim could bring the cost down by $30,000.[80] [10.68] Highly adaptable, the house provided a room capable of being a family room, a nursery, or a home office, plus two to four bedrooms on the upper floor. This litany of selected projects and housing complexes by Stern, one of the most visible "high-style" architects, is a truly extraordinary record, demonstrating a continuing commitment to creating communities.

10.68. R. A. M. Stern Architects, Life Dream House, 1994. One of several median-cost model house designs commissioned by Life magazine in the mid-1990s, plans for this house were made available to readers for a fee.

Many variations have been built in eastern states, but one supervised directly by the Stern office is located in the Legacy Park development in Kennesaw, Georgia. (Photo: © Peter Aaron/Esto for Life magazine.)

10.69. *Duany and Plater-Zyberk, Seaside, Florida, 1978–83. Seaside, although small, was among the first of the New Urbanism planned communities to be built, and hence attracted a great deal of attention. Unlike earlier communities, it was pedestrian-oriented, and had a strongly graduated hierarchical system of streets that led to a recognizable town center. (Courtesy of Duany and Plater-Zyberk.)*

One of the turning points away from the traditional "development" mentality in favor of "community making" was the beginning of Seaside, Florida, planned in 1978–83 by Andres Duany and Elizabeth Plater-Zyberk, with Leon Krier as consultant. Robert Davis, owner of a large parcel of beach land about seventy miles east of Pensacola on the Florida panhandle, wanted to build a vacation complex and approached Arquitectonica in Miami, where Duany and Plater-Zyberk were then partners. What began as a strip of about fifty houses was soon expanded by Davis to include the entire parcel of eighty acres. The goal of developer and architects was to create a real town, not merely a cluster of buildings. Recognizing that conventional planning methods based on the automobile and traffic engineering would not achieve this end, Duany and Plater-Zyberk turned to urban theorist Leon Krier, whose work they had been reading. Former students at Princeton and then Yale, Duany and Plater-Zyberk were also well aware of Stern's suburban village studies.[81] They took the radical approach of taking the eighteenth-century pedestrian town as a model and began to lay out a town predicated on residents *walking* to village centers where convenience stores would be located. They also took into account important existing features, such as the county highway and existing stands of trees that suggested diagonals in a grid plan, and they differentiated between major and minor roads. The end result was a plan that closely resembled Mariemont and the planned war-industry housing villages done in 1917–18. [10.69] They drew two detailed codes, one for planning and the other for architecture that regulated scale and architectural detail. Their intent was to increase the density, and thereby human interaction, while creating the ambience of a small Southern town, and ensuring that the ensemble of buildings did not disintegrate into anarchy or become locked in monotonous uniformity. They specified the incorporation of porches and picket fences (of real wood, not vinyl extrusions), houses clad in wood clapboards, shingles, brick, or stone, with hip or gable roofs pitched at traditional angles. Although licensed architects, neither Duany nor Plater-Zyberk elected to design any of the buildings at Seaside.

LEGEND
■ Retail
■ Employment
▨ Multi-Family Residential
▢ Single-Family Residential
▢ Parks and Open Space

SITE PLAN
1" = 300'

10.70. Peter Calthorpe, Laguna West, outside Sacramento, California, 1989. In the western United States, Calthorpe argued in favor of dense development, with houses set close to the street, and a strongly hierarchical plan that focused on a town center. (Courtesy of Peter Calthorpe.)

In some respects, Seaside soon became the victim of its own success, as lot purchasers hired high-profile architects to design quaint up-scale cottages. Costs and taxes rose so high that owners began renting out their places, and Seaside soon became an exclusive resort community. Nonetheless, the planning pattern established by Duany and Plater-Zyberk worked extremely well, and the husband-and-wife team were soon hired by other developers to repeat their success in more than thirty new developments around the country. Remarkably, many of these new communities were being built by developers who, like Joseph Alfandre, had formerly been doing things in the conventional way but had decided to use this new planning approach. Alfandre scrapped his original plans for the 352-acre site called Kentlands, near Gaithersburg, Maryland, northwest of Washington, D.C., and in 1988 hired Duany and Plater-Zyberk to create a new plan. The houses, available in a variety of traditional styles ranging from Federalist to Queen Anne, are grouped closely together, encouraging pedestrian movement, with the garages tucked away

behind houses or on special alleyways. Alfandre went on to have Duany and Plater-Zyberk design Belmont, Virginia. Other communities planned by Duany and Plater-Zyberk include: Tannin, Alabama; Nance Canyon, near Chico, California; Blount Springs, north of Birmingham, Alabama; Wellington, near Palm Beach, Florida; and Friday Mountain, southwest of Austin, Texas, among others. Even more intriguing is the application by Duany and Plater-Zyberk of the same planning and design concepts in the Gate District, four 1,100-acre neighborhoods being rebuilt in an abandoned tract in downtown St. Louis. Many of these projects are presented, along with the basic planning code, in their book *Towns and Town-Making Principles.*

On the West Coast, very much the same message has been propounded by planner and architect Peter Calthorpe, first in a book entitled *Sustainable Cities* and more recently in a review of his own planning work, *The Next American Metropolis: Ecology, Community, and the American Dream.* Like Duany and Plater-Zyberk, Calthorpe employs increased den-

sity and mixed uses and housing types with plentiful landscaping, emphasizing pedestrian movement. One of his largest designs is for Laguna West, a planned development outside Sacramento, California, begun in 1989. [10.70] Streets in the residential areas are narrow, and the houses are set back 12 feet instead of 20 feet. Double rows of trees line the major streets (single rows on all others). None of the houses are located more than a half mile from the town center.

The planning of Calthorpe, and of Duany and Plater-Zyberk, can be grouped into fourteen principles:

1. Make streets narrow, 26 feet instead of the conventional 36 to 40, since this tends to slow down traffic.
2. Get rid of the cul-de-sac since this focuses all traffic on a few streets.
3. Hide the garage to the side or rear so that a blank wall of garage doors is not presented to the street.
4. Get rid of the large lawn and increase density.
5. Plant trees along the street curb where they will grow to form a canopy over the street.
6. Mix housing types including single family, duplexes, and apartments.
7. Bring back the corner grocery, drugstore, dry cleaner, and other convenience stores so that they are no more than a quarter-mile walk from any house.
8. Plan for mass transit with stops no more than a quarter mile from any house.
9. Link work to home and decrease or eliminate commuting (Apple Computer, for example, is a major employer within Laguna West).
10. Create a town center with community services and retail space; this might also include public open space.
11. Shrink parking lots.
12. Think green by retaining open space around communities rather than viewing open land as "unimproved" or "underdeveloped"; retain a balance between densely developed areas and open space, whether agricultural, recreational, or left in its primeval state.
13. Establish boundaries for growth.
14. Put new life into malls, whether closed urban streets or islands of stores in oceans of asphalt.

Attention to Calthorpe's book, as well as Duany and Plater-Zyberk's, is desperately needed as traditional suburban development continues to explode. The census of 1990 revealed that 75.2 percent of the national population now lives in urban/suburban areas; only 24.8 percent live in rural villages and on farms. In 1995, the unplanned housing tracts around Phoenix, Arizona, were expanding at the rate of *an acre per hour*. In places like Cleveland the urban land area expanded by a third between 1970 and 1990, even as the total population declined.[82] This kind of expansion cannot be sustained, and the realities are perhaps finally being addressed by the institutions that have so long encouraged this kind of sprawling development. In March 1995, the Bank of America, the financial giant of California, issued a report entitled "Beyond Sprawl," adding up the full economic, social, and environmental costs of continued unplanned suburban expansion and concluding these were "costs that California can no longer afford." The report urged compact and efficient development and growth. Oregon has been at the forefront of limiting thoughtless urban sprawl, beginning in 1973 when, under the leadership of Republican governor Tom McCall, the legislature established the Land Conservation and Development Commission. The best agent in shaping growth has been the establishment of urban growth boundaries in Oregon that severely limit expansion outside the boundaries although they do not always improve the quality of development inside the boundaries.[83]

One critical ingredient in the gradual revitalization of existing small towns has been historic preservation, especially the Main Street Center Program launched by the National Trust for Historic Preservation in 1980, which assists communities and main street property owners in restoring buildings and returning them to economic productivity. Some 750 business centers were revitalized in this way by 1991, in such places as Athens and Rome, Georgia; Lawrence, Kansas; Sonora, California; Beaufort, South Carolina; Holland, Michigan; Galesburg, Illinois; Hot Springs, South Dakota; and Madison, Indiana.[84]

While such improvements were being made in smaller cities, in major urban centers a new and unfortunate twist in "preservation" gained popularity in the 1970s and 1980s: "facadism," in which the outer twelve inches of a building or a row of buildings is saved while everything behind it is cut away to make room for a new glass box—what has been called "having your building and eating it too." This was done at Exchange Place, in Boston, in 1981–84, where at least a few feet of the old Stock Exchange of 1889–90 by Peabody & Stearns was saved, while a mirror glass tower of forty stories was built behind it. The contrast is equally jarring in 2000 Pennsylvania Avenue, better known as Red Lion Row, Washington, D.C., where in 1983–5 a row of turn-of-the-century town houses was gutted and a blank commercial

10.71. Red Lion Row, Washington, D.C., 1983–85. After the interiors of this row of nineteenth-century houses were completely gutted, boutique shops were installed and a hulking, bland (but "efficient") office box was built behind the facades. (L. M. Roth.)

block put up behind them. [10.71] Even worse, as with the virtual destruction of the Zion Commercial Mercantile Institution (ZCM) in Salt Lake City, is when the old facade is a paper-thin applique attached to a featureless box.

THE CULT OF THE HIGH-PROFILE ARCHITECT

Frank Lloyd Wright was seldom out of the spotlight in the 1950s. He had a positive talent for self-promotion, and was the subject of television interviews on NBC (with Hugh Downs) and CBS (with Mike Wallace) shortly before his death. In 1960, few Americans knew any other architect by name. In the late 1970s, 1980s, and 1990s, however, creating and sustaining architectural celebrity has become a growth industry. On January 8, 1979, Philip Johnson was featured on the cover of *Time* magazine, holding a model of the AT&T Building, in a pose clearly meant to remind us of Moses holding the tablets of the law. [10.72] In the 1980s architects like Meier, Graves, Stern, and Gehry were hired to design furniture, lamps, teapots, and a whole range of home furnishings, which sold for scandalous sums simply because of who designed them. The architects become purveyors in the consumer culture; they were no longer social crusaders or esthetes, but trendsetters and media stars. In the early 1980s Graves established himself as a designer of upscale household objects with such items as a sterling silver

tea service for Alessi and even a shopping bag for the New York department store Bloomingdale's. Table clocks for Yamagiwa of Tokyo and various chairs for the Diane von Furstenberg boutique in New York followed. A conical teakettle, an architectural-looking table clock, and additional tableware for Alessi were added in 1985–87. It became hard to tell sometimes whether Graves's clocks and lamps were miniature buildings, or whether his buildings of the period were overscaled lamps and clocks. This exclusive and limited designer market was greatly expanded in the early 1990s when Graves was approached by Ron Johnson, an executive of the Target division of Dayton Hudson, to redesign numerous inexpensive household products offered by the store. Over the next several years, using his signature muted Mediterranean colors and dramatically bold geometries, Graves developed more than six hundred products that Target introduced on their shelves in 1998.[85] Now, for only a few dollars, anyone can take home a genuine designer clock, toaster, teapot, telephone, or toilet bowl brush—guaranteed good taste for the aesthetically (and financially) challenged. One might attempt a psychological study of the disingenuous and self-important poses struck by the eight architects whose portraits were taken for an article on skyscrapers in *National Geographic* in February 1989.[86] The most exalted high-profile architects became the subjects of magazine articles, as for example Suzanne Stephens' piece on Stern and "The Fountainhead Syndrome" or Charles Candee's essay

on Graves, "The Prince of Princeton." For the cognoscenti, such architects were sufficiently chichi to endorse products, as in Graves's praise of Dexter Shoes in the *New York Times* in 1987.[87]

Part of the mystique of the superstar architects was their globetrotting, for they worked everywhere. Major public commissions in the United States were awarded to non-American architects: the Museum of Contemporary Art and the Brooklyn Museum by Arata Isozaki; the Museum of Modern Art in San Francisco by Mario Botta; the Architectural School at the University of Florida, Miami, by Aldo Rossi; and a highly colored Team Disney office building in Lake Buena Vista for Disney by Isozaki. And at the same time, American architects received prestigious commissions in Europe and Asia. The Disney organization, in fact, emerged as the world's most important patron of high-profile architecture. When Disney built its European theme park outside Paris, they had the major shops and theme hotels designed by architects like Robert Venturi, Bernard Tschumi, Peter Eisenman, Michael Graves, Antoine Predock, and Frank Gehry.[88]

In the late 1980 and 1990s, during a slump in office building in the United States, American architects shifted their activity to building around the Pacific rim, designing huge office towers of the kind they had overbuilt in Houston, Dallas, and Chicago. These included Caltex House in Singapore by Jahn, and also by Jahn the 21st Century Tower in Shanghai. For the Jin Mao hotel, also in Shanghai, China, Childs and SOM devised a tricked-up pagodalike flourish at the top. What has emerged as the symbol of all these off-shore enormities is the pair of soaring eighty-eight-story twin Petronas Towers in Kuala Lampur, Malaysia, designed by Cesar Pelli, built in 1991–98. Their height is 1,483 feet (451.9 meters). As engineers associated with the Petronas project readily admitted, there was no compelling need for this extraordinary height except to draw world attention to the national oil company. These towers were built, as in Houston and elsewhere in the United States, to make a dramatic statement of power and wealth; so far none of the off-shore clients or users seem to care that these towers destroy the unique regional character of the Asian cities in which they are built. For the local governments, the great towers mean modernization. In many instances, however, the American architects are careful to respond to the local tropical climate with reflective glass, overhangs, louvers, or shaded windows, as in the extensive covered terraces of the new

10.72. *Philip Johnson, holding the "Tablets of the Law." 1979. In the 1980s and 1990s, the architect emerged as the arbiter of public taste and good design, and no one relished this role more than Philip Johnson, shown here on the cover of* Time, *January 8, 1979, like a latter-day Moses descending from some holy mount, carrying the tablets of the newly revealed artistic law. (Courtesy of Time Inc.)*

polytechnic school in Singapore being built by Gwathmey-Siegal. Yet in other instances ignorance of cultural subtleties has caused problems. In Taiwan, Kohn Pederson Fox designed a building shaped like a flat iron but it was viewed by the Taiwanese as having bad feng shui because it seemed to be pointing at something.

MAKING COMMUNITIES

As a case study in community building, one town, Columbus, Indiana, deserves special attention, because there, for half a century, important architects (and some not yet famous when first engaged) were called on to create a broad spectrum of public buildings. Nowhere on the continent is there such a concentration of high-quality architecture than in this manufac-

turing town of about 35,000 people. The architects were hired not to give a designer stamp to the community as a means of commercial promotion or town self-aggrandizement, but because town leaders wanted the best churches, schools, and public and business buildings that could be obtained. The enterprise began in 1942 when the congregants of the First Christian Church debated on whether to select Wright or Eliel Saarinen to design their new church; they finally opted in favor of Eliel Saarinen, and he created for them an austere and exquisitely handcrafted modernist building, assisted by his son, Eero, and Charles Eames. By the end of the Second World War one of the principal industries in Columbus was the Cummins Diesel Engine Company, with J. Irwin Miller on its board of directors; Miller was also chairman of the board of the Irwin Union Bank. In 1954 he asked Eero Saarinen to design a building for the bank, and Saarinen produced a refined gem of pure Miesian Modernism. Additions to the bank, as well as construction of branch offices, would come later by Kevin Roche and John Dinkeloo, Saarinen's successors, as well as by Harry Weese and other significant architects.

J. Irwin Miller, a graduate of Yale and Oxford Universities, had a strong interest in architecture, especially its potential for making a positive impact on users and the public. In 1957 he made an intriguing proposal to school officials in Columbus. Because of population growth during the war, the city was badly in need of schools, but Miller felt that it would be a mistake to build too quickly and on the cheap, in a short-sighted effort to save money. The Cummins Engine Company, he pledged, would pay the architectural design fees if the city would engage the very best architect for their new schools. Later this offer was extended to include any public building in the city. Over the years the city's schools were designed by Harry Weese, John Carl Warnecke, Norman Fletcher, Edward Larrabee Barnes, Gunnar Birkerts, John Johansen, Eliot Noyes, Caudill Rowlett Scott, Mitchell-Giurgola, and Richard Meier. Among the public buildings were a home for the elderly by Harry Weese (1957), the North Christian Church by Eero Saarinen (1964), the First Baptist Church by Harry Weese (1965), Fire Station No. 4 by Venturi and Rauch (1967), the public library by I. M. Pei (1969), a post office by Roche & Dinkeloo (1970), a consulting center by James Stewart Polshek (1972), a medical clinic by Hardy Holzman Pfeiffer (1973), a downtown shopping center by Cesar Pelli (1973), the city hall by Edward Bassett of Skidmore, Owings, & Merrill

(1981), apartments by Gwathmey-Siegel (1984), another fire station by Susana Torre (1987), and St. Peter's Lutheran Church by Gunnar Birkerts (1988). It is a list that leaves one breathless, not just because of sheer length but because of unwavering high quality in design and workmanship. One after another the buildings have earned design excellence awards. As photographer Balthazar Korab notes in his affectionate essay on Columbus, the town is never finished and is preparing, with the help of a new generation of Millers, to enter the twenty-first century.[89]

The premise when this most ambitious program was begun was that architecture mattered and that it affected people's lives. J. Irwin Miller was convinced "it is expensive to be mediocre in this world. Quality is always cost-effective. The tragic mistake in history that's always been made by the well-to-do is that they have feathered their own nests. Today we know that society does not survive unless it works for everybody."[90]

There has been, naturally, a very practical commercial upside to this building program; nearly 40,000 people visit Columbus each year just to see the architecture (nearly 10,000 more than the number who actually live there). But has all this excellence in architecture truly had a beneficial effect on the inhabitants? Does Miller's philosophy of providing "the best for the most" really work? That story has not yet been fully told. Could we tell anything by looking at crime rates or other social indicators of well-being? Perhaps the best way to judge is to visit Columbus. One woman who has lived there for twenty years is sure that townspeople "have become more culturally aware by osmosis. The architecture even influences our children, I think, by making them aware of how important it is to take care of their community and of their physical and spiritual environment. There's a feeling on the streets of Columbus that every person is proud to be here."[91] Perhaps a photograph can give part of the answer: Consider the view of children playing outside Sycamore Place and Pence Place in Columbus, designed by Gwathmey Siegel Associates, 1982–84 [10.73]; one would likely never guess that these carefree moments are being enjoyed in the play yards of subsidized public housing.

Another maturing planned city that warrants continued scrutiny is Columbia, Maryland; this new city, begun in 1963, was intended, as developer James Rouse put it, to be "a garden for the growing of people." Has it worked? The final three of its planned eleven component villages are now nearly finished,

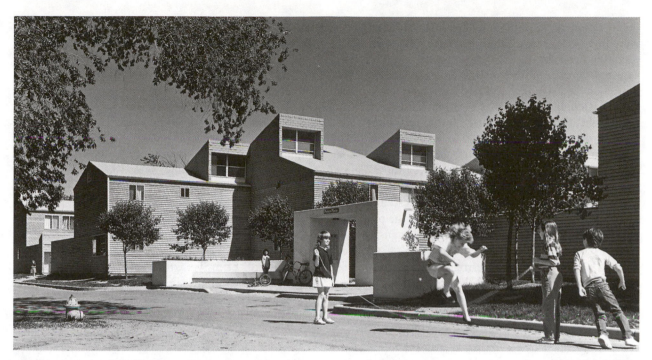

10.73. *Gwathmey Siegel Associates, Sycamore Place and Pence Place housing complexes, Columbus, Indiana, 1982–84. These two groups of town house apartments* are good evidence that public housing does not need to be in sterile towers—or a threat to human well-being. (Photo: Balthazar Korab.)

and almost 88,000 people lived there as of 1999; if all goes well it will eventually fill out at 110,000 residents. There are more than 2,900 business in the community, employing 75 percent of the town's workforce. There is a hospital, a community college, as well as branches of two universities, sixty-three restaurants, and a major shopping center with two hundred stores, plus smaller neighborhood shopping clusters. There are numerous recreational facilities, pools, basketball courts, and a total of 5,300 acres set aside as parks, playgrounds, and wilderness preserves. The utility lines are all underground. Some observers would say that the greatest success, however, is in the planned diversity of the population; the 1980 census showed that 76 percent of the population were white, 19 percent were black, and 4 percent belonged to other ethnic groups. The hope had been that 10 percent of the population would be welfare recipients, but the cutbacks in federal housing subsidies have capped that figure at 7 percent and it is shrinking. Nonetheless, it is most significant that subsidized low-income housing was planned in the very beginning as part of the total housing stock. Maybe the critical element to Columbia's success is that the creator of Columbia, James Rouse, continued to live there. It is

said that residents who knew who he was would walk up to him, clasp his hand, and say, "I just want to thank you for Columbia."[92]

More recently another new community has been started in Osceola county about twenty miles southwest of Orlando, Florida, on land that had been acquired by the Disney company when the idea of building Disney World arose. Although Walt Disney had dreamed of building an ideal town, when Epcot Center opened at Disney World it was a theme park and not a model "community of tomorrow." In 1985 the first preliminary discussions were held by Disney officials for building a town on swampy land just south of Disney World, even though this would require extensive dredging and bringing in three feet of soil to raise the town's basic ground level. Various names were suggested for the proposed town, but Celebration Gardens was selected by Disney CEO Michael Eisner because, it was reported, he felt the conceptual design of the town represented the "celebration of the human spirit."[93] The name was later shortened to Celebration.

In 1985 three architectural firms were selected to propose preliminary plans: Duany and Plater-Zyberk, Charles Gwathmey of Gwathmey Siegel Associates,

and Robert A. M. Stern; soon after, the number of competitors was expanded to include Charles Moore, Jacquelin Robertson, and the office of Skidmore, Owings, & Merrill. Eventually, Stern was selected to work with Robertson to develop the basic town plan. A governing principle in designing this model town was promoting the sense of connectedness and community among its inhabitants, and so very early the decision was made to emphasize walking instead of automobile use, and hence to pull everything closer together. In this regard Celebration is much like Seaside, except Seaside is a vacation enclave of only about 240 houses, whose owners, traveling from urban centers such as Atlanta or Birmingham, are there intermittently. Only about two dozen families live in Seaside year round. In contrast, Celebration was to be a true town of as many as 15,000 residents. It was decided at the outset that the houses were to be placed near the town center, and that they would be close together, with prominent porches facing the streets.

An artificial lake was created adjacent to an existing wetland, with streets radiating from the lake in a wedge-shaped fan toward the north. [10.74] At the lower rounded point of the wedge, overlooking the lake, is the town center and commercial district, flanked by a site set aside for a Presbyterian church to the east and a large site for the town's school to the west. Around this are the individual neighborhoods, with parks at the center of each neighborhood superblock. Additional residential districts were planned to the east and west sides of this central wedge. Beyond these neighborhoods, to the north, stretching in an arc around the core of the town, is a golf course designed by Robert Trent Jones. With its target population of 15,000 residents, the town will spread over 4,900 acres, with an additional 4,700 acres set aside as a surrounding greenbelt.

In a move guaranteed to attract attention, Eisner's planners selected prominent and celebrated architects to design the major public buildings, thus providing the new town with an instant pedigree and certain media attention. The architects included Philip Johnson, who was persuaded to design the town hall, which is marked by an enclosure of myriad slender square piers suggesting a forest of columns. Other architects were Robert Venturi and Denise Scott-Brown, who designed the bank; Charles Moore, who designed the Preview Center (sales office); Michael Graves, who did the bold abstract cylinder of the post office; Helmut Jahn, who designed the shopping mall; William Rawn, who did Celebration School; Graham

Gund, who designed the hotel downtown at the edge of the lake; Robertson, who designed the golf club house; and Stern, who did the large regional hospital north of the encircling golf course. Also on this northern permimeter was a 109-acre office park, with three initial buildings by Aldo Rossi.[94]

Celebration is a neotraditional town, with the cutoff date of architectural styles for both the public buildings and the residences set at 1940. Although Cesar Pelli, designer of the movie house, wanted to use a modern style (a glass and metal crystal perhaps), he was obliged to adhere to the streamlined moderne of the 1930s and 1940s. For the residences, a pattern book of sanctioned historical styles and details was developed by Raymond L. Gindroz of UDA Architects, Pittsburgh, with a broad spectrum of historically based images for the apartments, town houses, and single-family houses. Some visitors would ask residents how it felt to move back to the past, and others considered the architecture of Celebration's quaint houses false. The perception of Celebration's designers, from Michael Eisner on down, was no doubt mirrored by the comment of Christoff, the creator-like character in Peter Weir's film *The Truman Show*, when he's asked about the deliberate illusion of the picture-perfect town in that story: "It's not fake," he replied, "it's just controlled."[95]

The pattern-book house designs are based on a broad range of traditional houses built in the Southeast prior to 1940, including antebellum Greek Revival Classical, Victorian, French Colonial rural vernacular, Coastal Vernacular (meaning houses built in the tidal low country of the Carolinas in the eighteenth and early nineteenth centuries), and Colonial Revival as it appeared in the 1920s in Orlando, Tampa, and other southern cities. Also authorized was Mediterranean Revival, which Stern used for his health center, with a broad, low-slung entry arch flanked by an octagonal tower that strongly evokes a Californian prototype—the Santa Barbara County Courthouse. In size, residences range from Cottage Homes of about 2,500 square feet (beginning at $220,000) and Village Homes priced from $300,000, to custom-designed Estate Homes, priced at $600,000 and up. Celebration was spared the awkwardness of having lower-income subsidized housing, because the Disney organization made a very large contribution to the Osceola County subsidized housing program. Clearly the steep house prices ensure that only a selected population of the well-to-do upper middle class can become Celebrationites. In *The Unreal*

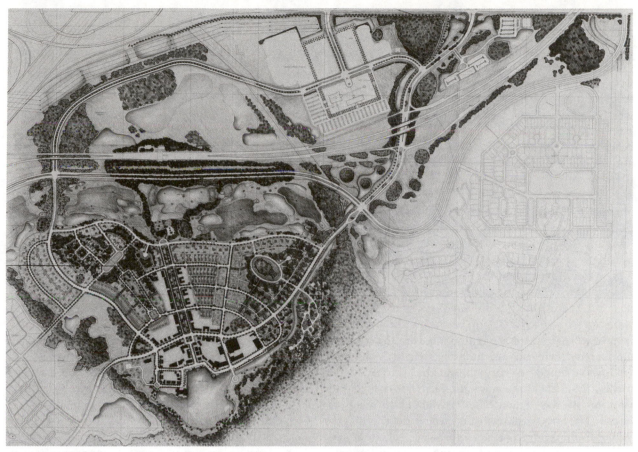

10.74. Plan of Celebration. Robert A. M. Stern with Jacquelin Robertson, conceptual planners, Celebration, Osceola County, Florida, begun 1985. General conceptual plan. Conceived as an ideal traditional American town, *Celebration is meant to feel like a small community of the 1930s or 1940s, with an emphasis on pedestrian movement and the exploitation of traditional historic styles in the public and residential architecture. (Courtesy of Robert A. M. Stern.)*

America, Ada Louise Huxtable attacks the "selectively annotated and historically correct" sanctioned house styles. "Clever 'authentic' adaptation," she warns, "makes the ridiculous acceptable; this is a managed eclecticism of a seductive unreality that both blows and corrupts the mind."[96]

Despite extensive conceptual planning, Celebration is not a perfect town. Substandard construction in some of the early houses was one initial architectural problem; others were more social or economic difficulties, such as retaining businesses in the downtown marketplace, and dealing with a highly unconventional curricular structure in the school. Residents also discovered that they could not live there totally independent of the automobile. Some early residents have left, but others love the neotraditional character of Celebration, even if the town is not a problem-free, live-in theme park as some may have initially hoped. But, given a population of only about 3,500 in early 2001, Celebration is still far from complete.

These upscale communities, most notably Celebration, have been created for the fortunate minority who can afford the rising housing prices. Up to the late 1980s there had been a decreasing concern for building housing for the less affluent and the working poor. The great irony was that while the Reagan and Bush administrations proudly proclaimed their concern for the middle-income American, the economy shifted in favor of the highest income brackets and corporations. As the wealthiest 1 percent of Americans saw their income skyrocket by 74 percent in the 1980s, the poorest 10 percent of the population saw their effective income drop by 10 percent. The disproportionate distribution of wealth and income returned to where it had been in 1929, before the Great Depression, when the wealthiest 1 percent of the population controlled

10.75. Michael Pyatok, Tower Apartments, Rohnert Park, California, 1993. By arranging the low-rise apartments around interior courts, Pyatok and his associates create a strong sense of identity and community. (Courtesy of Michael Pyatok.)

almost 43 percent of the national wealth. In contrast, during the turbulent but more egalitarian 1960s and 1970s, the sum of the national wealth controlled by the richest 1 percent of the population had been roughly 15 percent. By the early 1980s the well-off members of society "began to feel annoyance with, rather than pity for, the nonproductive members whom their dollars supported. By the end of the seventies, the well of popular generosity was running dry."[97] This view became even more prevalent in the 1990s.

What was left out of the economic equation drawn up by the all administrations since Jimmy Carter was any serious commitment to building housing for the lowest-paid Americans. Funds allocated for building subsidized housing were repeatedly cut, so that while 126,800 units were under construction in 1970, only 9,600 units were built in 1985, and this dropped further to 7,200 units by 1992.

What have filled this gap have been private philanthropic groups working with city governments, and architectural offices that specialize in designing clusters of high-density apartment units. Learning from the lessons that emerged from the architectural and social failures of housing complexes such as Pruitt-Igoe, especially the lack of visual surveillance over the open areas outside their homes, architects such as Michael Pyatok, William Pettus, Konig & Eisenberg, and others have devoted their energies to designing affordable housing. Struggling against building codes and prejudice that disapproved the construction of well-designed housing for "those people," Pyatok has succeeded in creating apartment complexes of ingenious variety in their projecting bays, molded spaces, and internal landscaped courts, bright with earth colors. Of scores of examples, Pyatok's Tower Apartments in Rohnert Park, California, of 1993, built for residents earning between $13,500 and $28,000, can serve to illustrate the design concepts.[98] [10.74] In one case, when a cluster of Pyatok's rental apartments was nearing completion in the Seattle area, people driving past began to stop and inquire when these attractive condos were going on sale. One might imagine their shocked surprise when they were told they could have household incomes no more than 80 percent of the median in that area to qualify for the subsidized housing. The low-income apartments were far better designed than the faceless, characterless, expensive condominiums these middle-class people were accustomed to and eager to buy. Even more important, Pyatok and his associates have successfully created densities of population and a strong focus on internal streets and courts around the common facilities that foster a sense of community among the residents and an identification with their place of residence. Pyatok likes to tell the story of when, several years after completion, he returned to take some photographs of one of the housing clusters his office designed. He was stopped by a group of children at the entry to one of the internal courts and asked who he was and why he was photographing *their* homes. This is the kind of identification with, and concern for, one's home that never existed in the bare-bones "efficient" high-rise apartments at Pruitt-Igoe.

EPILOGUE

Among cultural and architectural historians—those who have looked critically at the building history of the United States—there has long been the judgment that the work of architects Richardson, Sullivan, and Wright has been superior in nature because it endeavored to define a unique national American architecture, particularly in the case of Sullivan and Wright. In large part this assessment was one fostered by Wright himself regarding his own work and that of his admired *lieber meister*. In truth, the culture of the United States has in nearly all ways—with the sole exceptions of the pursuit of business and the quest of a political ideal—been one in search of elsewhere. Wherever European colonists set foot on the North American continent, and wherever Euro-Americans ventured across it, they transplanted memories of the "elsewheres" they had left behind, whether is was the Mexican-trained priests in Arizona or California with their late Baroque mission churches, the Dutch with their stepped brick gables at the mouth of the Hudson, or the British with their vernacular English traditions or, later, their aping of classical forms from home. American settlers carried with them, across the Oregon Trail, the images of Greek Revival houses left behind in the Midwest. And other arrivals brought their "elsewheres" too, the Africans with evocations of their narrow Ivory Coast houses that became American shotgun houses, or the Chinese who topped their family benevolent association buildings with bits of temples from home. Today, after four centuries of living on this continent, the search for elsewhere is still a major driving force in American built culture.

Architecture critic Ada Louise Huxtable has been particularly adamant in her denunciation of this well-intended if intellectually empty architecture, what she has called the faux architecture of the late twentieth century. In 1992 she published an extended essay on this topic, followed up by a book in 1997 entitled *The Unreal America: Architecture and Illusion*. The point of origin for this fondness for the fake, she suggested, was Williamsburg, that fanciful but earnestly "authentic" re-creation of the eighteenth century.[99] Williamsburg was "themed," she wrote, to give it the right consistency and the dubious honor of being an "authentic reproduction." But, she cautioned, it was "a short distance down the yellow brick road from Williamsburg to Disneyland." Both are doctored realities, and it is this distancing from reality that she sees as a real danger not only to architecture but to our

culture as a whole as the twentieth century has come to a close. Americans, it would seem, would rather experience the comfortably scaled-down fiberglass version of a re-created history than the real thing; they like virtual history better. One woman, who moved to Orlando with her husband so they could more readily withdraw into the all-encompassing fictional reality of Disney World whenever they wanted, commented that "when we went to Jamaica, I loved the island, I loved the people. But I had a really hard time enjoying my vacation [in Jamaica] when I could look across the street and people were living in absolute poverty."[100] It should be noted, however, that the Disney organization's obsession with building artificial, carefully themed historical places was thwarted in 1994 by an enormous public outcry against their proposal to build a commercial historical theme park virtually on top of real Civil War battlefields just miles from Washington, D.C. This "theming" of America can now be seen everywhere, in themed restaurants, themed shopping centers, themed motels, and themed communities like Kentlands and Celebration. Since 1600, virtually all of American architecture has been an invented reality, admits Huxtable, as for example with Thomas Jefferson's importation of Roman classicism to express American democratic ideals, but themed architecture, in contrast, exists only for the moment; theme and decor will be instantly changed when marketing studies show that profits can be increased by exploiting a different fantasy.

Today, Huxtable laments, Americans eagerly embrace faux architecture, yet even that term has lost its negative punch, since faux is no longer a pejorative but rather a merchandising term used to transform the fake into something chic. "We accept the insouciant rip-off of punk-Palladian skyscrapers with drop-dead lobbies above which everything is cost-conscious banality," Huxtable writes. "We do not question sloppy, free-fall history and surface novelties where paraphrase is considered an act of clever design, and, supposedly, of irony and art. Such buildings appeal to a public increasingly nurtured by and hooked on pretense, and to developers and patrons who find them the easiest route to status and style."[101]

What we are getting, and, even worse, what we are placidly settling for is "an architecture of facile illusion, of image over substance, of artifice over reality," in which form follows feeling and fantasy. As Huxtable reminds us, architecture is not a studio art satisfying merely the whims of an limited audience; "it is a balance of structural science and aesthetic expression for the satisfaction of needs that go far beyond the utilitarian." Once we substitute sentiment, esoterica, or derivative abstractions for this "creative engagement," we deny the very essence of real building.

Making an architecture of genuine spiritual probity, a real architecture, is far more difficult because of its inherent truth and simplicity than making an architecture loaded with allusionistic and *illusionistic* detail. Much strip commercial building today is a great lie; it consists of the most rudimentary of structural support sheathed with plywood, then covered with layers of plastic foam that are cut, carved, sanded, and themed into whatever bollection-modilion-cavetto sausage moldings or cartoon cartouches the prevailing public fantasy craves. This sham of sculpted plastic bubbles is then smeared with a scrim coat of concrete and painted. What truth can such "architecture" speak of? Against the emptiness of such disposable shells stands the elegant nakedness and structural truth of Louis Kahn's Salk Labs or Fay Jones's chapels, with their sense of eternal silence. Such architecture draws visitors to it and revitalizes them.

There are any number of definitions of what architecture is—a blossoming in stone and a flowering of geometry (Emerson), frozen music (Goethe), man's triumph over gravitation and his will to power (Nietzsche), the will of an epoch translated into space (Mies van der Rohe), the magnificent play of forms in light (Le Corbusier), a cultural instrument (Kahn), inhabited sculpture (Brancusi)—yet all of these definitions widely miss the mark. At least the sculptor Constantin Brancusi said "inhabited," indicating he understood that human beings are meant to be in and around buildings. Ada Louise Huxtable's rather clinical definition of a "balance of structural science and aesthetic expression serving needs far beyond the utilitarian" is better, but there is a particular grace and poetry in developer James Rouse's description of architecture or a city being "a garden for the growing of people." The metaphor of a garden suggests, rightly, that architecture incorporates not just bricks, stone, wood, and glass, but trees, grass, water, sound, light, textures—*everything* is involved in its creation. It is the landscape we make to work, play, and live in, a landscape where the very act of living might become something sacred. Foremost, architecture is about people, not just accommodating physical needs for functional spaces or providing protection from the weather, but, more important, facilitating and enhancing our human adventure and sustaining our spirit. But to fulfill such a task architecture must first be real.

From the time of Horatio Greenough, and Sullivan, and Wright, down to the present day, there have been architects who have endeavored to create a distinct and characteristic American architecture. Like the mythical "Great American novel," this American architecture endeavors to sum up the democratic and inventive spirit of the American people. The American nation, however, remains in constant flux, with new groups ever seeking opportunity and safe haven. In 1786 a European correspondent asked Dr. Benjamin Rush what would happen now that the American revolution was over. Rush replied that this was far from being the case, for, he said, "we have only finished the first act of the great drama. We have changed our form of government, but it remains yet to effect a revolution in our principles, opinions, and manners."[102] That revolution is continuing still. In a nation of so many peoples—native, emigrated, long-established, as well as recent arrivals—and dispersed as we are across a continent of such great geographic and climatic extremes, perhaps there can never be a single, fixed, and all-inclusive American architecture. Like American democracy itself, American architecture is continually being rethought and reshaped to the requirements of particular places and all its many peoples.

As this book was on press, the most heinous coordinated acts of terrorism in American history caused a series of building disasters in New York City and Washington, D.C. that brought about the deaths of thousands. The death toll of all other catastrophic American building failures combined pales in significance.

On the morning of September 11, 2001, three transcontinental commercial airliners were hijacked, redirected from their normal flight paths, and deliberately flown into economically and politically symbolic buildings. Among those buildings hit were the twin towers of the World Trade Center in New York City. Fully loaded with fuel for transcontinental flights, the planes were used as huge flying bombs. Like the Empire State Building, which years before had been struck by a World War II bomber, both World Trade Center towers survived the initial impacts, swaying perhaps two feet. However, the intense fires caused by the tons of jet fuel were the real threat.

When designed and built during 1966–76, the two 110-storey towers (1362 and 1368 feet high) relied on exterior bearing walls of closely spaced steel columns, just over three feet apart, with internal cores ringed with steel columns; the cores contained elevators, staircases, and utilities. Like the John Hancock and Sears towers in Chicago, the twin World Trade Center towers acted structurally like vertically cantilevered hollow tubes. As the heat of the fires reached around two thousand degrees Fahrenheit, the steel framing of the utility cores, likely stripped of fire-resistant insulation by the explosions, softened and buckled, placing an unbearable load on the remaining external columns. As the upper floors collapsed they instantly placed enormous overloads on the columns below, which then in turn collapsed, floor upon floor; within seconds the towers dropped vertically, gravity finishing the deadly work. Because of the time lag between the explosive start of the fires and the ensuing building collapse, the lower levels of both towers and the streets around them were filled with hundreds of police, fire fighters, and other rescue personnel; they, like the thousands of employees in the two towers, were crushed by the collapsing buildings. The World Trade Center towers were properly engineered, with adequate redundancy to resist hurricanes, possible earthquakes, and even the impact of the kind of aircraft being flown in the mid-1960s. But against a huge jumbo jet, its tanks brimming with fuel, and against a handful of zealots prepared to make any sacrifice to express their political convictions, such proud towers and their counterparts around the world, exposed beacons of the hubris of progress, remain vulnerable.

BIBLIOGRAPHY

Calthorpe, Peter. *The Next American Metropolis: Ecology, Community, and the American Dream.* Princeton, N.J., 1994.

Cannell, Michael. *I. M. Pei: Mandarin of Modernism.* New York, 1995.

Claussen, Meredith L. *Pietro Belluschi: Modern American Architect.* Cambridge, Mass., 1994.

———. *Spiritual Space: The Religious Architecture of Pietro Belluschi.* Seattle, Wash., 1992.

Cohen, Stuart E. *Chicago Architects.* Chicago, 1976.

Collins, Brad, and Juliette Robbins. *Antoine Predock: Architect.* New York, 1994.

Crosbie, Michael J. *Green Architecture: A Guide to Sustainable Design.* Washington, D.C., 1994.

Davis, Sam. *The Architecture of Affordable Housing.* Berkeley, Calif., 1995.

Derber, Charles. *The Wilding of America: How Greed and Violence Are Eroding Our Nation's Character.* New York, 1995.

Ditto, Jerry, and Lanning Stern. *Eichler Homes: Design for Living.* San Francisco, 1995.

Duany, Andres, and Elizabeth Plater-Zyberk. *Towns and Town-Making Principles.* New York, 1992.

Dunlop, Beth. *Arquitectonica.* Washington, D.C., 1991.

Eisenman, Peter, et al. *Five Architects.* New York, 1972.

Eisenman, Peter, and Robert A. M. Stern, eds. "White and Gray," *Architecture and Urbanism* 52 (April 1975): 3–180.

Frank, Suzanne. *Peter Eisenman's House VI: The Client's Response.* New York, 1994.

Goldberger, Paul, et al. *Cesar Pelli: Buildings and Projects, 1965–1990.* New York, 1990.

Greenberg, Allan. *Selected Works. Architectural Monographs No. 39.* London, 1995.

Graham Gund Architects. Washington, D.C., 1993.

Irace, Fulvio. *Emerging Skylines: The New American Skyscrapers.* New York, 1990.

Ivy, Robert Adams, Jr. *Fay Jones.* Washington, D.C., 1992.

Jencks, Charles. *The Language of Post-Modern Architecture.* New York, 1977.

———. *Modern Movements in Architecture.* Garden City, N.Y., 1973.

Jodidio, Philip. *Richard Meier.* Cologne, Germany, 1995.

Kaiser, Kay. *The Architecture of Gunnar Birkerts.* Washington, D.C., 1989.

Knight, Carleton, III. *Philip Johnson/John Burgee: Architecture 1979–1985.* New York, 1985.

Lewis, H., and J. O'Connor, eds. *Philip Johnson: The Architect in His Own Words.* New York, 1994.

Meier, Richard. *Richard Meier, Architect.* New York, 1976 .

Moss, Eric Owen. *Architectural Monographs No. 29.* London, 1993.

Nichols, Karen, ed. *Michael Graves: Buildings and Projects, 1990–1994.* New York, 1995.

Ojeda, Oscar R., and Lucas H. Guerra. *Moore Ruble Yudell: Houses and Housing.* Washington, D.C., 1994.

Scully, Vincent. *The Shingle Style Today, or The Historian's Revenge.* New York, 1974.

Stern, Robert A. M. *The American Houses of Robert A. M. Stern.* New York, 1991.

———. *New Directions in American Architecture*, rev. ed. New York, 1977.

Tzonis, Alexander, Liane Lefaivre, and Richard Diamond. *Architecture in North America since 1960.* Boston, 1995

Venturi, Robert. *Complexity and Contradiction in Architecture.* New York, 1967.

Venturi, R., Denise Scott Brown, and Steven Izenour. *Learning from Las Vegas.* New York, 1972.

Wigley, Mark. *The Architecture of Deconstruction.* Cambridge, Mass., 1993.

Wiseman, Carter. *I. M. Pei: A Profile in American Architecture.* New York, 1995.

NOTES

1. Not that this embargo had much long-term effect on oil imports, from Arab or other nations. Imports from Arab exporters did drop 17.7 percent in 1974 but shot up almost 100 percent the next year and have climbed ever since. In 1993 oil imports from Arab producers had increased almost 165 percent since the low year of 1974. *World Almanac, 1995,* 164–65; statistics from U.S. Department of Energy, *Monthly Energy Review*, June 1994. See also Gary B. Nash and Julie R. Jeffrey, eds., *The American People: Creating a Nation and a Society,* 3rd ed. (New York, 1994), 980–81.

2. William J. Murtagh, *Keeping Time: The History and Theory of Preservation in America* (Pittstown, N.J., 1988). See also Antoinette J. Lee, ed., *Past Meets Future: Saving America's Historic Environments* (Washington, D.C., 1992); and Charles M. Haar and Jerold S. Kayden, *Landmark Justice: The Influence of William J. Brennan on America's Communities* (Washington, D.C., 1989).

3. Most regrettably the court records of this settlement were sealed. See Steven S. Ross, *Construction Disasters: Design Failures, Causes, and Prevention* (New York, 1984), 274–87.

4. See chapter 5, "'Delight': Architectural Acoustics, Shape, and Sound," in my *Understanding Architecture* (New York, 1993); Michael Forsyth, *Buildings for Music: The Architect, the Musician, and Listener from the Seventeenth Century to the Present Day* (Cambridge, Mass., 1985); Bruce Bliven Jr., "Annals of Architecture: A Better Sound," *The New Yorker*, November 8, 1976, 51 ff; and Sharon Lee Ryder, "Music to My Ears?" *Progressive Architecture* 58 (March 1977): 64–68.

5. See analysis of the walkway hanger design by Rick Alm and Thomas G. Watts, *Kansas City Star*, as carried in the *San Francisco Chronicle*, July 22, 1981, 9–10. See also Ross, *Construction Disasters*, 388–406.

6. For an analysis of what went wrong at Pruitt-Igoe and other similar housing complexes, see Oscar Newman, *Defensible Space: Crime Prevention through Urban Design* (New York, 1972).

7. *Postmodernism* as a term describing a reaction to Modernism was first used by Spanish Writer Federico De Onis in 1934 and then picked up by Arnold Toynbee in his *A Study of History* written in 1938 but not published until 1947. With respect to architecture specifically, the term was used first by Joseph Hudnut in an article entitled "The post-modern house," *Architectural Record* 97 (May 1945): 70–75, and then included in Hudnut's collection of essays *Architecture and the Spirit of Man* (Cambridge, Mass., 1949), 109–19. Almost simultaneously in 1975, the term was used, capitalized and hyphenated, by Robert A. M. Stern and Peter Eisenman in New York, and Charles Jencks in London. Jencks discussed the rise of ironic Postmodernism in two essays in published in 1975 and then in the first edition of his book *The Language of Post-Modern Architecture* (London, 1977), which was quickly reissued in a series of updated editions. For an analysis of Postmodernism and its meaning in late-twentieth-century architecture, see Charles Jencks, *The Language of Post- Modern Architecture*, 4th ed. (New York, 1977; 6th ed. 1991), 8; Charles Jencks, *What Is Post-Modernism?* 3rd ed. (New York, 1989); and Robert A. M. Stern, "The Doubles of Post-Modernism," *Harvard Architecture Review* 1 (1980): 75–97, reprinted in *America Builds*.

8. Carter Wiseman, *Shaping a Nation: Twentieth-Century American Architecture and Its Makers* (New York, 1998), 247.

9. Donlyn Lyndon, "Philology of American Architecture," *Casabella* 221 (November 1963): viii.

10. Robert Venturi, "The Campidoglio: A Case Study," *Architectural Review* 113 (May 1953): 333. This and other of Venturi's published essays are collected in *A View from the Campidoglio, Selected Essays, 1953–84* (New York, 1985).

11. Both books were reissued in new editions in 1977.

12. Charles Moore's analysis of Venturi's Guild House is included in the essay "Plug It In, Ramses, and See If It Lights Up, Because We Aren't Going to Keep It Unless It Works," *Perspecta* 11 (1967): 40–41.

13. This emphasis on the antenna will seem arcane, perhaps, since now cable systems carry analog or digital signals in almost all urban areas.

14. See Charles W. Moore and Nicholas Pyle, eds., *The Yale Mathematics Building Competition* (New Haven, 1974), 86.

15. Quoted in Stanislaus von Moos, *Venturi, Rauch, & Scott Brown: Building and Projects* (New York, 1987), 172.

16. Donlyn Lyndon, "Sea Ranch: The Process of Design," in *World Architecture II*, ed. John Donat (New York, 1965), 33.

17. Robert A. M. Stern, *New Directions in American Architecture*, rev. ed. (New York, 1977), 73.

18. A book accompanying the exhibition appeared was published in 1972 and reissued in 1975: Peter Eisenman et al., *Five Architects* (New York, 1975). For the Whites and Grays see Peter Eisenman and Robert A. M. Stern, eds., "White and Gray," *Architecture and Urbanism* 52 (April 1975): 3–4, 25–180; and Robert A. M. Stern, "Gray Architecture: Quelques variations post-modernistes autour de l'orthodoxie," *L'Architecture d'aujourd'hui* 186 (August–September 1976): 83.

19. Suzanne Frank, *Peter Eisenman's Hiouse VI: The Client's Response* (New York, 1994). In designing the layout of the dummy of my *Concise History of American Architecture* in 1977–78 a similar inversion of an Eisenman axonometric drawing occurred but was spotted and corrected before printing.

20. One of the earliest histories of recent American architecture was Stern's *New Directions*, first published in 1969 and expanded in a new edition in 1977.

21. The surviving Montauk houses have been beautifully restored by their respective owners, and are well illustrated in Samuel White, *The Houses of Stanford White* (New York, 1998).

22. The submissions were published in Stanley Tigerman, *Chicago Tribune Competition and Late Entries* (New York, 1980) with essays by Stuart Cohen, George Baird, Juan Paul Bonta, Charles Jencks, Vincent Scully, and Norris Kelly Smith. The book also contains in reduced form all the entries originally published in the book produced by the Tribune in 1922.

23. Robert A. M. Stern, *Modern Classicism* (New York, 1988). This includes a brief discussion of the Venice Biennale of 1980, 246–49.

24. Stern, *Modern Classicism*, 62.

25. The controversy relating to the competition and Graves's winning is well covered in Gavin MacRae-Gibson, *The Secret Life of Building: An American Mythology for Modern Architecture* (Cambridge, Mass., 1985), 74–97; and in Tod A. Marder, ed., *The Critical Edge: Controversy in Recent American Architecture* (Cambridge, Mass., 1985), 163–74.

26. Paul Goldberger, "Architecture of a Different Color," *New York Times Magazine*, October 10, 1982, 43; and also Paul Goldberger, "The Modern Cityscape Now Finds Room for the Picturesque," *New York Times*, December 26, 1982, 27. For a discussion of the Portland Building see Gavin Macrae-Gibson, *The Secret Life of Buildings: An American Mythology for Modern Architecture* (Cambridge, Mass., 1985); and especially Marder, *The Critical Edge*.

27. Portland, *The Oregonian*, February 8, 1997, A1, A13. Blame for the structural deficiencies was directed at the consulting structural engineer.

28. Franz Schulze, *Philip Johnson* (New York, 1994), 344.

29. Quoted in Kenneth Frampton, "AT&T Headquarters, New York, Johnson/Burgee Architects," *Catalogue 9*, Institute for Architecture and Urban Studies, September–October 1978, 61. This article includes study drawings for the building, including twelve studies for the facade.

30. Ada Louise Huxtable, "The Troubled State of Modern Architecture," *The New York Review of Books*, May 1, 1980, 22–29; reprinted in *Architectural Record* (January 1981): 72–79. The irony of the AT&T Building became

greater when, in the wave of deregulation during the Reagan administration, AT&T was broken up in 1983. Shrunken in size, AT&T moved to smaller headquarters in lower Manhattan, selling the "signature building" to the Sony Corporation and removing the lobby sculpture.

31. See Patricia Leigh Brown, "Architecture's New Classicists: A Young Bunch of Old Fogies," *New York Times*, February 9, 1995, B1–B4.

32. Moore, quoted in Philip Jodidio, *Contemporary American Architects* (Cologne, Germany, 1993), 109.

33. The entire development and construction process was carefully analyzed in a five-hour PBS television documentary and also in Karl Sabbagh, *Skyscraper* (New York, 1989).

34. See Peter Arnell and Ted Bickford, eds., *A Tower for Louisville: The Humana Competition* (New York, 1982); this includes a revealing joint statement by the chairman and president of Humana on the "sense of poetry" of Graves's winning design.

35. Eisenman interview with Robert A. M. Stern, May 9, 1985; quoted in R. A. M. Stern, *Pride of Place: Building the American Dream* (Boston, 1986), 87. The extreme abstraction of Eisenman's houses continued right up to his winning of the Wexner commission; see a review of his houses in Peter Eisenman, *House X* (New York, 1982).

36. Peter Arnell and Ted Bickford, eds., *A Center for the Visual Arts: The Ohio State University Competition* (New York, 1984); and Rafael Moneo and Anthony Vidler, *Wexner Center for the Visual Arts, Ohio State University* (New York, 1989).

37. Libby Dawson Farr, *Art Museums as Bridges Across Time: Four American Collegiate Art Museums of the 1980s*, Ph.D. diss., University of Oregon, June 1994, 267–68; this is based on an interview she had with Richard Stearns.

38. In the third of the volumes devoted to Stern's output—*Robert A. M. Stern: Buildings and Projects, 1987–1992* (New York, 1992)—an appendix, "Project Information," gives full particulars on the principle architect and assistants for all of the major buildings.

39. Colin Amery, *A Celebration of Art and Architecture: The National Gallery Sainsbury Wing* (London, 1991), 65.

40. Nory Miller, *Johnson/Burgee Architecture: The Buildings and Projects of Philip Johnson and John Burgee* (New York, 1979), 113.

41. Schulze, *Philip Johnson*, 368–69.

42. Ada Louise Huxtable, *The Tall Building Artistically Reconsidered: The Search for a Skyscraper Style* (New York, 1984), 68.

43. Schulze, *Philip Johnson*, 364.

44. Bernhard Leitner, "John Portman: Architecture Is Not a Building," *Art in America* 61 (1973): 80–82; John Portman and Jonathan Barnett, "An Architecture for People and Not for Things," *Architectural Record* 161 (1977): 133–40.

45. Peter Arnell and Ted Bickford, eds., *Frank Gehry: Buildings and Projects* (New York, 1985), 220.

46. Jodidio, *Contemporary American Architects*, 71.

47. Franceso Dal Co and Kurt W. Forster, *Frank O. Gehry: The Complete Works* (New York, 1998), 396.

48. Coosje van Bruggen, *Frank O. Gehry: Guggenheim Museum Bilbao* (New York, 1997), 141.

49. Robert Hughes, "Brava, Bravo," *Time*, November 3, 1997, 98–105; italics added.

50. Gehry quoted in Richard Lacayo, "The Frank Gehry Experience," *Time*, June 26, 2000, 64–68; Cathleen McGuigan, "The Man Who Designed Bilbao," *Newsweek*, November 22, 1999, 92. For the New York Guggenheim proposal see Herbert Muschamp, "The Guggenheim's East Side Vision," *New York Times*, Monday, April 17, 2000, A23; and Cathleen McGuigan, "Mega Museum Riv. Vu [river view]," *Newsweek*, December 11, 2000, 79–82. for Gehry's complex CATIA-designed buildings of the 1990's, see J. Fiona Ragheb, ed., *Frank Gehry, Architect* (New York, 2001).

51. See Cathleen McGuigan, "Everyone Will Want a Bilbao," *Newsweek*, January 1, 2000, 105.

52. For a brief presentation of the many new museums under way at the turn of the century, see Cathleen McGuigan and Peter Plagens, "State of the Art," *Newsweek*, March 26, 2001, 52–61.

53. Victoria Newhouse, *Towards a New Museum* (New York, 1998).

54. Schulze, *Philip Johnson*, 396. See also Philip Johnson and Mark Wigley, *Deconstructivist Architecture* (Boston, 1988).

55. Cathleen McGuigan, "From Bauhaus to Fun House," *Newsweek*, July 11, 1988, 64. McGuigan is making a play on the title of a slim book by Tom Wolfe, *From Bauhaus to Our House* (New York, 1981), a send-up critique of the modern movement.

56. Alois Martin Müller, "The Dialectic of Modernism," in *Architecture in Transition: Between Deconstruction and New Modernism*, ed. Peter Noever (Munich, Germany, 1991), 10.

57. Kramer, Scully, and Eisenman quoted in Miriam Horn, "A New Twist on Architecture," *U.S. News and World Report*, July 18, 1988, 40–42.

58. Wiseman, *Shaping a Nation*, 345–48.

59. Jodidio, *Contemporary American Architects*, 122.

60. Horn, "New Twist," 42.

61. Walter Gropius, "Bauhaus Dessau—Principles of Bauhaus Production," from a sheet printed by the Bauhaus, March 1926, reprinted in Tim and Charlotte Benton, eds., *Architecture and Design, 1890–1939: An International Anthology of Original Articles* (New York, 1975); and Le Corbusier, *Précisions sur un état présent de l'architecture et de l'urbanisme* (Paris, 1930), 64. See also my *Understanding Architecture*, 467–81.

62. Pietro Belluschi's churches are well described and illustrated in Meredith L. Clausen, *Spiritual Space: The Religious Architecture of Pietro Belluschi* (Seattle, Wash., 1992).

63. Jodidio, *Contemporary American Architects*, 143.

64. Le Corbusier, *Towards a New Architecture* (London, 1927), 31.

65. Arthur Erickson, *The Architecture of Arthur Erickson* (New York, 1989).

66. "Bank of Canada Head Office, Ottawa," *Canadian Architect* 23 (June 1978): 22–37.

67. Robert Adams Ivy Jr., *Fay Jones* (Washington, D.C. 1992), 20.

68. Ivy, *Fay Jones*, 24.

69. Michael Ryan, "Here They Can Think Their Highest Thoughts," *Parade Magazine,* January 17, 1993, 5.

70. See National Audubon Society and the Croxton Collaborative, *Audubon House: Building the Environmentally Responsible, Energy-Efficient Office* (New York, 1994).

71. For a brief introduction to Cutler's work see Theresa Morrow et al., *James Cutler* (Rockport, Mass., 1997). A number of the buildings shown there bearing only general identification are portions of the compound built for Bill Gates, and illustrate the beautiful refabricated old-growth timbers. Other information given here is based on lectures given by Cutler at the University of Oregon and on conversations with the architect, May 1999.

72. Adam Smith, *The Roaring 80s: A Roller-Coaster Ride through the Greed Decade* (New York, 1988), 209, 279–81.

73. Vincent Scully, *American Architecture and Urbanism,* rev. ed. (New York, 1988), 281–82.

74. *Statistical Abstracts of the United States,* 1994, 744.

75. Homeless figures from *The World Almanac,* 1993, 295–97; and *The Universal Almanac,* 1993, 396.

76. *Chicago Tribune,* February 21, 1993, 13–15; *Newsweek,* March 15, 1993, 71.

77. Peter Arnell and Ted Bickford, eds., *Robert A. M. Stern, 1965–1980: Toward a Modern Architecture after Modernism* (New York, 1981), 230.

78. It should be remembered that Flagg himself was intensely interested in the problem of housing, designing and building several model apartment complexes and publishing in 1922 a book, *Small Houses: Their Economical Design and Construction* (New York).

79. "The New American Home," *Home* 32 (February 1986): 42–53. The house contained three bedrooms and two and a half baths, and was projected to cost $150,000.

80. "A House for All America," *Life,* June 1994, 82–92. Stern also included drawings showing similar houses in simplified Dutch Colonial, Craftsman, Grecian Classical, Tudor, and Spanish Colonial styles. Compare the estimated cost by Ryan Homes, $110,000 to $160,000, to the average prices of new single-family homes in 1993: $115,000 in the South to $162,600 in the Northeast, with a national average of $126,500. *Statistical Abstract of the United States,* 1994, 732.

81. Interviews with Andres Duany and Elizabeth Plater-Zyberk in David Mahoncy and Keller Easterling, *Seaside* (New York, 1991), 62–85. This book also contains a photo essay on Seaside as well as detailed presentations on many of the buildings and individual houses built there, including the neoclassical cottage designed by Krier for his own family. Also included is an analytical essay by Neil Levine.

82. *Newsweek*, May 15, 1995, 43.

83. "Striking Back at Sprawl," *Historic Preservation* 47 (September–October, 1995): 54– 63, 108–10, 116.

84. Richard Longstreth, "When the Present Becomes the Past," in *Past Meets Future,* ed. A. J. Lee, 221.

85. I must thank J. Erin Williamson, who researched Graves's design work for Target. See also Frank Gibney Jr. et al., "The Redesigning of America," *Time,* March 20, 2000, 66–76; Carolyn Sollis, "Giants of Design," *House Beautiful* 142 (June 2000): 39; Cara Beardi, "On Target," *Interiors* 158 (April 1999): 66–69.

86. William S. Ellis, "Skyscraper: Above The Crowd," *National Geographic* 175 (February, 1989): 143–74. This is followed by an article on the Hancock Building, in Chicago, 175–85.

87. Stephens' piece on Stern appeared in *Vanity Fair*, April 1984, and Candee's essay on Graves in *House and Garden,* July 1988. I owe these observations to Mary McLoed, "Architecture and Politics in the Reagan Era: From PostModernism to Deconstructivism," *Assemblage* 8 (February 1989): 23–60. There were rumors at the time that Ayn Rand's architectural novel, *The Fountainhead,* would be refilmed, but this never materialized; there must not have been a discernable market in 1980s or 1990s for a movie about an architect of principle.

88. Kurt Anderson, "Look Mickey, No Kitsch," *Time,* July 100. 29, 1991, 66–69; Cathleen McGuigan, "Après Micker, le Deluge," *Newsweek,* April 13, 1993, 64–66.

89. Balthazar Korab, *Columbus, Indiana: An American Landmark* (South Bend, Ind., 1989). This personal photo 101. essay by one of the most accomplished architectural photographers of the late twentieth century also contains a 102. complete list of all buildings commissioned by J. Irwin Miller or in which the Cummins Engine Company was involved, as well as an extensive bibliography of the articles written about Miller and the buildings in Columbus.

90. Jules Schwerin, "The Town That Triumphed," *Parade Magazine,* February 22, 1987, 20–21.

91. Schwerin, "Town That Triumphed," 21. See also Robert Campbell, "Modernism on Main Street," *Preservation* 50 (September–October, 1998): 38–45.

92. Data supplied by the Columbia Association and the Rouse Company, Columbia, Maryland. See also Nikki Finke Greenberg, "A Town Built on Dreams," *Newsweek,* May 27, 1985, 11.

93. Eisner is quoted by Don Killoren (head of the project for Disney) in *USA Today,* October 18, 1995, A1. The original announcement of Disney's town is noted in Edward Gunts, "Disney Unveils New Town," *Architecture* 80 (August 1991): 27. See also Carol Lawson, "When You Wish upon a House," *New York Times,* November 16, 1995, C1, C6; June Fletcher, "Dream-Builder Disney Offers Dream Homes," *Wall Street Journal,* October 20, 1995, B8; and Tom Vanderbilt, "Mickey Goes to Town(s)," *Designer/Builder* 11 (October 1995). Extensive information is available at the official Celebration web site: www.celebrationfl.com/press-room/. Two books appeared in 1999, drawn from personal experiences of

living in Celebration: Douglas Frantz and Catherine Collins, *Celebration U.S.A: Living in Disney's Brave New Town* (New York, 1999); and Andrew Ross, *The Celebration Chronicles: Life, Liberty, and the Pursuit of Property Value in Disney's New Town* (New York, 1999).

94. For buildings at Disney World in Florida, in the Disney Headquarters in Burbank, California, and at the Euro Disney Park outside Paris, the names of prominent architects engaged for Disney buildings read like a who's who of award-winning contemporary designers: Arquitectonica, Thomas Beeby, Andres Duany and Elizabeth Plater-Zyberk, Peter Eisenman, Frank Gehry, Michael Graves, Graham Gund, Charles Gwathmey, Hans Holein, Arata Isozaki, Rem Koolhaas, Alan Lapidua, Antoine Predock, Michael Rotondi, Robert Siegal, Robert A. M. Stern, Stanley Tigerman, Bernard Tschumi, Robert Venturi, and Denise Scott-Brown, and Jean-Paul Vigier. See Beth Dunlop, *Building the Dream: The Art of Disney Architecture* (New York, 1996).

95. The filming of *The Truman Show* (1998, dir. Peter Weir) in Seaside was likely made easier since so many of its home owners do not live there year round. As in Celebration, the small scale of the Seaside buildings, the pedestrian-based close proximity, and the highly traditional styles of the buildings led many people to believe that Seaside was a purpose-built stage set, not a real town. *Control* is overwhelmingly the operative word in real-life Celebration as well. Home purchasers are obliged to sign a one-hundred-page covenant that controls all aspects of the appearance of the exterior of their houses. Some live in dread of so-called porch police who file complaints if a resident has too many or the wrong kind of porch plants or other accoutrements. Two books written on the basis of living in Celebration—*Celebration, U.S.A.* and *The Celebration Chronicles*—are filled with commentary and quotes documenting such pervasive artistic and social control.

96. Ada Louise Huxtable, *The Unreal America: Architecture and Illusion* (New York, 1997): 65; quoted in Ross, *The Celebration Chronicles*, p. 65, 329, n. 1. Huxtable's book is an expansion of her essay "Inventing American Reality," *The New York Review of Books* 39 (December 3, 1992): 24–29, reprinted in *America Builds*.

97. John Taylor, *Circus of Ambition: The Culture of Wealth and Power in the Eighties* (New York, 1989), 10, 15.

98. The Tower Apartments and many other examples are discussed and illustrated in Tom Jones, William Pettus, and Michael Pyatok, *Good Neighbors: Affordable Family Housing* (New York, 1995). Ironically, most city building and zooming codes positively prohibit individuals from providing even the most simple shelter for those in the most need. Architect Donald MacDonald of San Francisco noticed cardboard box shelters beginning to appear in the parking lot of his office building and over many months got to know the homeless squatters and spoke with them of their needs and concerns. One particular concern was that their cardboard shelters were not secure and their residents could not leave during the day to earn even the smallest amount of money lest their few belongings be stolen. MacDonald then devised a compact shelter box built of several panels of plywood that could be secured with a simple padlock. Having built several in his own parking lot and turning them over to his homeless acquaintances, he was served with a summons by the city to destroy and remove the shelters at once because they violated various codes. The homeless are powerless to house themselves, the general public (except for a handful of organizations and architects) is most reluctant or refuses to build any sort affordable housing, and government officials prevent concerned individuals from carrying out their own innovative solutions. The days when one could move west onto open land and cut trees to build one's own log cabin, the days of self-reliance that political conservatives so fondly recall, are no more.

99. Ada Louise Huxtable, "Inventing American Reality," *The New York Review*, December 3, 1992, 24–29. Her figures come from Marcus Whiffen, *Public Buildings of Colonial Williamsburg* (Colonial Williamsburg, 1958), v. She also cites Carl Lounsbury, "Beaux-Arts Ideals and Colonial Reality: The Reconstruction of Williamsburg's Capitol, 1928–1934," *Journal of the Society of Architectural Historians* (December 1990). Huxtable's article would become the basis of her longer book *The Unreal America: Architecture and Illusion* (New York, 1997).

Valarie Bungart, quoted by Ted Anthony in "The Ultimate Elsewhere: Visit Central Florida and See the World—or at Least a Facsimile of It," for the Associated Press, *Eugene Register Guard*, February 7, 1999, 3B–4B.

Huxtable, "Inventing American Reality," 28.

Letter, Dr. Benjamin Rush to Richard Price, May 25, 1786; reprinted in *The Annals of America* (Chicago, 1968), 3:55–56.

CHRONOLOGY

An architectural style represents a family of spatial forms together with a body of details that form a coherent and recognizable whole. Although capable of being modified and reshaped, a given style remains recognizable in variations. Moreover, since architecture is a form of non-verbal communication, various styles represent clusters of ideas and concepts that the building owners and designers or architects hope to communicate with observers. An attempt to codify the development and interrelationship of styles is certain to incorporate generalizations and simplifications that do not express fully the complexities of historical fact nor the varieties of local manifestation. Nonetheless this chronology of styles used in the United States is presented in the hope that it may clarify the many options that have existed for American architects since the early seventeenth century.

The style entries for the seventeenth and eighteenth centuries list ethnic and regional developments that were unique to particular geographic areas. In contrast, the stylistic groups for the nineteenth and twentieth centuries run across the continent in large measure due to the rapid dissemination of design ideas through architectural publication and the movement of people. Although the stylistic categories of the nineteenth and twentieth centuries are modes employed by architects, local vernacular builders also incorporated many details of currently fashionable styles in their work.

The dates at which a style emerges or later passes from use are difficult to pinpoint, particularly for a geographic area as large as the United States. Although it is sometimes known when the first of a type appeared, vernacular variations of various styles often continued to appear in outlying areas well after the use of a particular style had subsided in the area of origin. The dates shown here, therefore, should be considered approximate but by no means absolute.

Although there are often slightly different terms used to identify a particular style, there has emerged general agreement regarding the stylistic families and specific styles for the period before 1975. The stylistic categories listed here are drawn from Marcus Whiffen, *American Architecture Since 1780: A Guide to the Styles*, rev. ed. (Cambridge, Mass., 1992), and also from J. J. G. Blumenson, *Identifying American Architecture: A Pictorial Guide to Styles and Terms, 1600-1945*, 2nd ed. (Nashville, Tenn., 1981), and J. Poppeliers et al., *What Style is It?* (Washington, DC, 1977). For the many vernacular and ethnic styles and ways of building, see Dell Upton, *America's Architectural Roots: Ethnic Groups that Built America* (Washington, DC, 1986).

With the rise of Post-Modernism after 1965 a number of new stylistic characters were developed in the last third of the twentieth century, and various authors and critics have coined sometimes conflicting names to identify these expressions. The terminology used here reflects the definitions developed by Robert A. M. Stern, *Modern Classicism* (New York, 1988); James Steele, *Architecture Today* (London, 1997); and Charles Jencks, *The Language of Post-Modern Architecture* (New York, 1991).

SEVENTEETH-CENTURY VERNACULAR REGIONALISM

Provincial Spanish Colonial Baroque
 Southwest and Florida, 1565–1700
 California, 1769 – 1820 (Mission Style)
French Colonial, 1700 – 1805
 Mississippi Valley
Provincial Dutch Renaissance Colonial, 1624 – 1750
 New Netherlands
Swedish Colonial Vernacular, 1638 – 1665
 Delaware, Pennsylvania
English Colonial
 English Late Medieval Vernacular, 1607 – 1695
 New England
 Provincial Jacobean, 1600 – 1740
 Virginia, Carolinas
 English Vernacular, 1664 – 1700
 Pennsylvania, Delaware, New Jersey, New York

EIGHTEENTH CENTURY GEORGIAN CLASSICISM

Early Georgian, middle 1680s
 Isolated early Georgian buildings in Boston and
 Philadelphia
Early Southern Georgian, 1695–1775
 Virginia, Maryland, Carolinas
Early New England Georgian 1706–1775
Late New England Georgian, 1754–1790
Late Georgian in the Middle Colonies, 1756–1799
Late Georgian in the Southern Colonies, 1760–1795
Colonial Neo-Palladianism

FEDERAL ARCHITECTURE

(Synthetic Eclecticism)
New England Adamesque, 1781–1820
Jeffersonian Roman Neo–Classicism, 1785 –1820
"Gothick," 1799–1830

ECLECTIC REVIVALISM, 1818–1860

Greek Revival, 1818–1850
Early Medieval (generic in nature), 1821–1850
Romanesque Revival, 1845–1860
Gothic Revival, 1839–1870
 Downing-Davis Cottage, 1842–1890
Egyptian Revival, 1834–1850
Renaissance Revival, 1835–1860
Italianate and Italian Villa, 1837–1860
The Octagon Mode, 1848–1860

CREATIVE ECLECTICISM I, 1860–1885*

Second Empire Baroque, 1855–1880
High Victorian Gothic, 1860–1880
High Victorian Italianate, 1865–90
Stick Style, 1862–1880
Eastlake, 1872–1885
Queen Anne 1875–1890
Shingle Style, 1879–1900
Early Colonial Revival, 1882–1920
Richardson Romanesque, 1880–1895
François Premier or Chateauesque, 1880–1900

CREATIVE ECLECTICISM II, 1885–1940

(Academic Eclecticism)
Renaissance Revival II, 1882–1940
Beaux-Arts Classicism, 1890–1930
Academic Neo-Gothic (Late Gothic Revival), 1885–1940
Suburban & Regional Eclecticism, 1910–1940
 Georgian Colonial Revival
 Jacobethan Revival (combining Tudor/Elizabethan
 and Jacobean elements)
 Spanish Colonial Revival
 Mission Revival

Residential Styles
 Craftsman Style (generic in character), 1900–1940
 Bungalow Style, 1900–1935
 Bay Area Style, 1890–1920
 Prairie School, 1900–1920

Chicago Commercial
 Chicago School, 1880–1915
 Sullivanesque, 1890–1920

AMERICAN MODERNISM I, 1925–1940

Art Deco, 1925–1940 (including Pueblo Deco in the Southwest)
Streamline Moderne, 1930–1950
Stripped Classicism, 1920–1940
European Modernism (International Style), 1929–1940
Western Regional Modernism, 1935–1950
 Pacific Northwest
 Bay Area Modernism

AMERICAN MODERNISM II, 1937–1973

Miesian Modernism, 1937–73
Formalism (New Formalism), 1957–73 (e.g., E. D. Stone)
Expressionism (Neo-Expressionism), I957– (e.g., Eero Saarinen)
Brutalism, 1950–75 (e.g., L. I. Kahn)

POST–MODERNISM, 1964–

(Creative Eclecticism III)
Classical Modes
 Ironic Classicism, 1964– (e.g., early C. Moore)
 Latent Classicism, 1977– (e.g., later K. Roche)
 Fundamentalist Classicism (seen mostly in Europe),
 1975– (e.g., A. Batey and M. Mack)
 Canonical or Archaeological Classicism, 1977–
 (e.g., A. Greenberg)
 Creative Post-Modernism (Modern Traditionalism),
 1978– (e.g., R. A. M. Stern)
Populism, 1985– (e.g., J. Jerde and some M. Graves)
Modernist Modes
 Late Modernism (New Modernism), 1970– (e.g., R. Meier)
Deconstructionism
 Theoretical discourse, 1970s
 Buildings, 1980– (e.g., later P. Eisenman, Z. Hadid)
Late Expressionist Modernism (Organic Expressionism)
 New Expressionism, 1980– (e.g., later Gunnar Birkerts,
 early F. Gehry)
 Heroic Modernism (Functional Expressionism), 1980–
 (e.g., H. Jahn)
 Organic Expressionism, 1980– (e.g., later F. Gehry)
Regionalism, 1980– (e.g., Arquitectonica, A. Predock)
"Green Architecture," 1975– (e.g., J. Cutler)

* Note: there is no stylistic name "Victorian" since this is too
 vague and denotes merely a period of time and not a histori-
 cal stylistic association.

GLOSSARY

For terms that cannot be included in this brief selection, please consult such compact dictionaries as: John Fleming, Hugh Honour, and Nikolaus Pevsner, *The Penguin Dictionary of Architecture*, 2nd ed. (Baltimore, 1972), and Henry H. Saylor, *Dictionary of Architecture*, (New York, 1952). More extensive definitions may be found in three large works by Cyril M. Harris: *American Architecture: An Illustrated Encyclopedia* (New York, 1998); *Dictionary of Architecture and Construction*, New York, 1975; and *Historic Architecture Sourcebook*, (New York, 1977). For brief biographies of important architects see such resources as: J. M. Richards, ed., *Who's Who in Architecture, from 1400 to the Present* (London and New York, 1977); *Macmillan Encyclopedia of Architects*, 4 vols. (New York, 1982).

acanthus A common leafy plant of the Mediterranean whose thick leaves inspired the leafy forms of the Corinthian capital. Vitruvius recounts the legend of the origin of the Corinthian capital that resulted from the placement of a funereal offering, in a basket, over the grave of a recently deceased young woman. Held down by a tile placed on top, the basket was placed over the root of an acanthus plant which grew up around the basket, its leaves curling like volutes under the tile.

acroterion A sculptural ornament placed at the roof peak of a Greek building.

adobe From Spanish *adobe*, which comes from Arabic *al-toba*, "the brick." A brick of sun-dried mud (using soil rich in clay and silt) mixed with grass or straw, and by extension, buildings made of such brick.

American basement Essentially the same as the English basement.

arcade Literally, a series of arches supported on columns or square or rectangular piers; or a covered passageway whose sides are open arcades; and by extension a covered way lined with shops even if no arches are used.

architrave From Old French and Old Italian *arch* + *trabs*, "chief beam." Specifically, the lowest element in the entablatures of the Ionic and Corinthian columnar orders (see *order*), with two or three stepped-back faces; but by extension the frame around windows, doors, and arches in Renaissance architecture.

ashlar masonry From Middle English *assheler*, from Old French *aisselier*, "board," from *aissele*, from Medieval Latin *axicellus*. A stone block dressed and squared; the masonry made up of such stone blocks. Ashlar masonry may be coursed, with continuous horizontal joints or random, with discontinuous joints.

astylar From Greek *a* + *stulos*, "without + column." Term used to denote a building which, though embodying classical features, has none of the traditional orders or pilasters.

axis An imaginary line about which parts of a building, or individual buildings in a group, are disposed, usually with careful attention to bilateral symmetry.

balloon frame A method of light wooden framing with closely-spaced studs, typically of pieces of identical mill-sawn dimensional lumber. Developed in the American Midwest about 1830 and called this because (a) the frame seemed to go up as fast as a hot air or hydrogen balloon, (b) because the frame seemed to have as much substance as a balloon compared to the earlier heavy hewn or sawn frame, or (c) on the basis of a corruption of a French term, *boullin*, referring to very-small-dimension boards or lumber. In the most accurate and specific sense, a true balloon is framed with the vertical studs extending continuously through two or more stories; since such extremely long boards must be cut from old growth trees, framing in the late twentieth century is more typically *platform frame*, in which individual floors are framed on top of framed platform floors, one atop another. In both types of light framing, the principal fastening device are abundant inexpensive wire nails. In early balloon frames, the initial rough wall surface was of boards nailed diagonally to the studs, providing lateral bracing; today the same effect is achieved by nailing full sheets of plywood or particle board horizontally across the studs. The outer walls are then finished with a weather surface of clapboards or vertical board-and-batten siding.

baluster From French and Italian derivatives of Greek, *bal-*

austion, the flower of the pomegranate, because of the shape of the post. An upright vase-shaped post used to support a rail.

balustrade A series of balusters supporting a rail.

bargeboard A trim element running along the lower edge of a gable roof; originally a carved board with foliate Gothic ornamental devices, but later translated into flat scroll-sawn patterns. Also called *vergeboards*.

barrel vault A masonry vault resting on two parallel walls and having the form of a half cylinder; sometimes called tunnel vault; also, by extension, a nonstructural wooden and plaster ceiling of the same form.

batten From French *baton*; and from Latin *bastum*, "stick." A narrow strip of wood used to cover and seal a joint or crack (see *board and batten*).

batter The downward and outward slope of the lower section of a masonry wall.

bay A basic unit or module of a building defined by repeated columns or pilasters or similar framing members.

bay window A window in an enclosure projecting from a main wall; found on the ground floor of a building.

belt course (or *stringcourse*) A projecting horizontal course of masonry in a wall, of the same material as the wall, used to throw rain water off a wall; usually coincides with the level of an interior floor.

blind arch An arch within a wall that contains a recessed flat wall panel rather than framing an opening; used to enliven an otherwise unrelieved expanse of masonry or to decrease the dead weight.

board and batten A form of sheathing for frame buildings consisting of wide boards (usually placed vertically) with the joints covered by battens.

bousillage (also *columbage* or *pierrotage*) In French vernacular construction of Louisiana and the Mississippi valley, the rough infill of lime mortar or clay mixed with straw and small stones forced between the spaced wall timbers of *poteaux-sur-sole* or *poteaux-en-terre* construction. See *nogging*.

box construction (also *plank construction*) A form of light wood construction that is not frame in nature, used fairly extensively in the 1840s to 1870s in the southern, mid-western, and western timbered territories and states. It was the most economical form of wooden construction, but suffered from a serious structural deficiency. In this structural system broad boards are placed edge-to-edge vertically against a sill plate and nailed to it; a top plate is nailed at the upper edge of the boards, and wood rafters rest on this upper plate. The structural wall is only one board thick, about 1 to 1½ inches. In its simplest form, the joints between the wall boards could be covered with battens (box-and-strip construction), or in more finished construction horizontal clapboards could be nailed on for an exterior weather surface. The problem was the lack of any diagonal bracing so that lateral resistance to wind pressure was minimal. With the gradual disappearance of old growth timber capable of producing straight-grain boards sixteen inches wide or more, this form of box or plank construction was replaced by balloon or platform frame construction.

bracket A projecting support used under cornices, eaves, balconies, or windows to provide structural or purely visual support.

brickwork Three types of brickwork or bonding are common in eighteenth-century architecture. The simplest is common bond in which the bricks are all laid lengthwise to the plane of the wall. More complex is English bond in which the brick are laid in alternating courses, one course lengthwise (stretchers) and the other endwise (headers). Flemish bond is even more intricate with each course consisting of alternate stretchers and headers, offset so that a header is directly over a stretcher (see illustration).

common bond	English bond	Flemish bond

broken scroll pediment The most sculpturally elaborate of the door pediment treatments, this incorporates two flanking S-curved cornices that terminate near the top in rosettes, with reverse curves that drop to a center block. It was most frequently used between c. 1740 and c. 1780. Often the center block was pedestal for a pineapple finial, a symbol of prosperity and hospitality.

Broken scroll pediment, W. Williams house, Northford, Conn. (From F. Kelly, Early Domestic Architecture of Connecticut, *New Haven, 1924.)*

cantilever A beam, or a part of a building supported by such beams, which is supported at one end only, the other end hovering in the air.

capital The top-most part of a column (see *order*), above the shaft, which carries the entablature.

casement A window pivoted at the side, like the page of a book, and usually taller than it is wide. (See the contrasting *double hung window*).

cast iron See *iron*.

castellated Having battlements (parapet walls with notched openings) and turrets like those of a medieval castle.

chair rail See *wainscot*.

chamfer From French *chanfrein*, "a bevel." To remove the edge or corner; also, the flat surface left after the corner is cut away.

chinking The material used to fill the horizontal gaps between logs in the exterior walls of log houses; typically a mixture of straw, grass, clay mud, and other similar material. See *nogging*.

clapboard From Dutch *clappen*, "to split," + board. A thin board, originally riven or split, thinner at one edge than the other (later sawn with this profile), laid horizontally and with edges overlapping on a wood framed building. See *weatherboard*.

clerestory From Middle English, *clere*, "lighted," + story. Originally the upper section of the nave of a Gothic cathedral with its banks of large windows, hence any elevated series of windows for light and ventilation.

coffer From Middle English, *coffre*, "box," and Latin *cophinus*, "basket." A recessed box-like panel in a ceiling or vault; usually square but sometimes octagonal or lozenge-shaped.

colonnette A diminutive column or a greatly elongated column, most often used for visual effect rather than for structural support.

common bond See *brickwork*. From Latin *consolator*, "one who consoles," hence a support. See *bracket*.

corbel From Middle English *corp*, and Latin *corvus*, "raven." A block of masonry projecting from the plane of the wall used to support an upper element (cornice, battlements, upper wall).

Corinthian order See *order*.

cornice From Greek *koronos*, "curved," referring to the curved profile. Specifically, the uppermost and projecting section of the entablature; hence, the uppermost projecting molding or combination of brackets and moldings used to crown a building or to define the meeting of wall and ceiling (see *order*).

crocket From Old French *crochet*, "hook." In Gothic architecture, a carved, ornamental foliate hook-like projection used along the edges of roofs, spires, towers, and other upper elements.

cross gable A gable that rises from the eave of a roof.

crowstep gable A masonry gable extended above the roof line with a series of setbacks; often found in northern European medieval architecture, especially Dutch architecture. See the related *Flemish gable* and *mousetooth gable*.

cupola From Late Latin *cupula*, diminutive form of "tub." A rounded tower-like device rising from the roof of northern Renaissance and Baroque buildings, usually terminating in a miniature dome.

dentil From Latin *dens*, "tooth." A small rectangular block used in a series below the cornice in the Corinthian order; any such block used to form a molding below a cornice.

dependency An outbuilding or other subordinate structure that serves as an adjunct to a central dominant building.

Doric order See *order* .

dormer From Old French *dormeor*, "bedroom window." A vertical window and its projected housing that rises from a sloping roof.

double-hung window A window of two (or more) sash, or glazed frames, set in vertically grooved frames and capable of being raised or lowered independently of each other; widely used in the American English colonies after about 1700.

earth-fast construction English term referring to structural posts or closely spaced wall timbers placed in holes or trenches in the earth. See *poteaux-en-terre construction*. Sometimes also called in English *puncheon construction*.

eave The lower edge, often overhanging, of a roof.

engaged column A column that is attached to and appears to emerge from the wall; in plan it consists of one half to three-quarters of a fully round column. It may be purely decorative or it may serve as a buttress-like thickening of the wall.

English basement A lower level or ground level floor that is half below grade level, often with open wells to provide better light to windows.

English bond See *brickwork*.

entablature Obsolete French, from Italian *intavolatura*, from *intavolare*, "to put on a table"; from "in, on" + *tavola*, "table" (from Latin *tabula*, "board"). The composite horizontal beam-like ensemble supported by a classical column (see *order*). Although the details and proportions of the entablatures of the Doric, Ionic, and Corinthian orders vary, each has three component parts: the lower architrave, the middle frieze, and the crowning moldings with cornice.

eyebrow dormer A dormer formed by bowing upward a section of the roof and inserting a narrow segmental window beneath.

fanlight A semi-circular or elliptical window over a door, often with elaborately contrived and interwoven thin mullions; used extensively c. 1700 to 1850.

fenestration From Latin *fenestra*, "window." A general term used to denote the pattern or arrangement of windows.

finial From Latin *finis*, "end." In Gothic architecture, an ornament usually foliate, used at the end or peak of a gable, tower, or spire.

Flemish bond See *brickwork*.

Flemish gable A masonry gable extended above the roof with set-back stages that may have stepped or curved profiles in any of a variety of combinations. Related to the crowstep gable.

foliate From Latin, *foliatus*, "bearing leaves." Having a two-dimensional or carved three-dimensional pattern based on leaves or plants; often stylized.

frame A structural support composed of separate members joined together to form a cage, as contrasted to solid masonry construction. Traditionally a wooden frame was composed of large, hewn hardwood members fastened by complex interlocking joints (see *mortice and tenon*). See the frame of the Gleason house (chapter 2).

In about 1830 a radically new method was introduced that employed mass-produced softwood lumber in a frame that could be much more speedily raised (see *balloon frame*).

frieze From Latin use of the name Phrygia, a city known for its elaborate embroidery. Specifically the flat, horizontal panel in the entablature of the Ionic order, between the lower architrave and the crowning cornice, ornamented with low-relief sculpture (because of its resemblance to elaborate embroidery). Hence, by extension, the center panel or section of all entablatures, even in the much different Doric order, which has grooved stylized beam ends (triglyphs) with the spaces between filled with panels of low relief sculpture (metopes); see *order*. By further extension any elevated horizontal decorative band or panel.

gable From Middle English *gable*, *gavel*, from Norman French *gable* (perhaps of Celtic origin). The triangularly shaped area enclosed by the two sloped surfaces of a gable roof and the wall below; a generic term distinct from *pediment*, which refers to the closed triangular portion at the end of the gable roof of a classical Greek or Roman temple.

gable roof A simple roof composed of two flat surfaces meeting to form a straight ridge.

galerie From French meaning a long porch or room. In French vernacular architecture of Louisiana and the Mississippi valley, a broad veranda or porch, typically surrounding a building or house, with slender posts supporting an extended hip or saddle-back roof.

gambrel roof From Old North French *gamberel*; from Late Latin *gamba*, "leg," referring to the bent or crooked stick used by butchers to suspend carcasses. A roof, similar to a gable roof, but with two slopes on each side, a steeper pitch to the lower outer portion of the roof, and a gentler pitch to the upper center portion of the roof. In the colonies the gambrel roof was used by Dutch, Swedish, and English settlers, though in each area the profile differed.

girt From Middle English *girth*, *gerth*, "belt." In a seventeenth-century heavy timber frame house, the girts were the major beams that ran around the exterior, from post to post.

golden section A proportional ratio devised by the Greeks that expresses the ideal relationship of unequal parts. Capable of being demonstrated by Euclidian geometry, it can also be stated thus: a is to b as b is to $a+b$, or $a/b = b/-a+b$. If this is rewritten as a quadratic equation, the value 1 assigned to a, and solved for b, the value of b is 1.618034. Thus, the golden section is 1:1.618.

half timbering Frame construction in wood in which the framing members are left exposed on both exterior and interior, with the spaces between the framing members filled with brick *nogging* (random brickwork) or wattle and daub. Practiced in medieval France and England and briefly in the English colonies, it was revived as a purely decorative motif early in the twentieth century by using applied "half timbering," which is not structural.

heavy timber frame The type of wooden frame developed during the Middle Ages, using widely spaced, large-dimension structural timbers of hard wood, usually oak. On groundsills, posts are placed, fastened with girts at the top of the first floor, with second-floor posts rising to the walls plates that receive the roof rafters. Within the frame, summerbeams run from outer girts to interior cross-beams.

hexastyle From Greek *hex* + *stulos*, "six" + "columns"; a portico of six columns.

hip roof A roof of four sloped surfaces that meet in a point (with a square plan) or a sharp ridge line (rectangular plan).

hood molding A large projected molding over a window used to throw rain water away from the window; sometimes supported by brackets.

impost From French *imposte*, from Italian *imposta*, from Latin feminine past participle of *imponere*, "to place upon." The line above which an arch starts to spring or curve; *impost block*: the masonry piece, capitol, molding, and so on, on which an arch rests.

in antis Used to described columns set between projecting walls (*antae*).

Ionic order See *order*.

iron, cast iron A ferrous metal, sometimes with other metallic elements alloyed, with a carbon content of up to 5 percent that results from the smelting process that uses coal. Cast iron is made by pouring molten iron into sand or other molds, cooling to form architectural members or utensils. Crystalline in structure (like stone), cast iron has good compressive strength but can be quite brittle, and has little tensile strength. Although non-combustible by itself, cast iron can easily deform and even melt in building fires.

jetty From Middle French *jetee* from the verb "to throw out" or "thrust." The projection of an upper story over a lower story. Also called overhang or overshoot (and in the case of Pennsylvania "Dutch" barns it is called the *forebay*).

lancet Used to describe extremely narrow sharply pointed Gothic windows.

lantern In architecture, a small square or round glazed structure built atop a larger structure to admit light.

latia, latias Thin branches or saplings cut and laid to span from *viga* to viga in Spanish Colonial roof construction. Often laid diagonally to create a herringbone pattern when seen from below; rush mats are laid on top, and topped with adobe clay to create upper floors or roofs.

leaded glass Small glass panes, most of them clear but often colored, forming a geometric or foliate pattern, held in place by channels of lead soldered together.

lintel From Middle English and Old French; from Latin, *limen*, "threshold." A beam or support used to carry a load over an opening or to span between two columns.

loggia Italian, from French *loge*, "small house, hut." A covered but open gallery, often in the upper part of a building; also, a covered passageway, often with an open trellis roof, connecting two buildings.

mansard roof From François Mansart, French architect (1598–1666) who employed this roof form extensively. A roof with two slopes on each of its four sides—a steep and nearly vertical slope on the outside and a gentle nearly flat slope on the top. The outer roof slope may often be convex or concave in profile.

modillion From French and Italian *modiglione*, from Latin *mutulus*, from an Etruscan root meaning "to stand out." A small curved and ornamented bracket used to support the upper part of the cornice in the Corinthian order; any such small curved ornamented bracket used in series.

molding Any carved or modeled band integral to the fabric of a wall or applied to it.

monitor A form of lantern atop a roof, used to admit light to the space below, but wider and usually square in plan.

mortice and tenon One of the basic wood joining methods. One member is cut with a rectangular or square hole (mortice) to receive the other member, cut with a rectangular or square tongue (tenon). *Mortice* from Middle English *mortaise*, from Old French, perhaps from Arabic *murtazz*, "fastened," from *irtazza*, "to be fixed (in place)."

mousetooth gable (or *muisetanden gable*) Dutch term referring to the infilling in the steps of a crowstep or stepped gable. Brick is laid at an angle perpendicular to the slope of the gable within the steps, and the gable is finished off with a smooth brick or stone coping or sill, an adaptation widely used in New Netherlands and Virginia.

mullion From Middle English *moniel*, from Latin *medianus*, "median." Originally the large vertical stone divider in medieval windows; later the vertical supports in glazed windows; often now any support strip, vertical or horizontal, in a glazed window.

muntin From French *montant*, derived from the verb "to rise." In windows, the thin bar used to hold glass panes in place; in paneled doors, the vertical central member used to hold the panels in place.

néo-grec From French meaning literally "new Greek." A French structural development, of around 1840 to 1890, in which architects strove to express the structural function of masonry by using flat arches and massive lintels, together with simplified geometric ornament; used briefly by only a few French-trained American architects.

nogging Origin unknown. Rough brick or miscellaneous masonry material used to fill the spaces between the wood supports in a half-timber frame or between the logs in a log house.

non-load-bearing wall A wall that carries no structural load from above, but supports only itself or, if an external wall, transmits the force of the wind to structural members.

obelisk From Old French *obelisque*, from Greek *obeliskos*, "spit or pointed pillar." A tall, narrow square shaft, tapering and ending in a pyramidal point.

octastyle From Greek *okta*, "eight" + *stulos*, "column." A portico having eight columns.

order From Old French *ordre*, from Latin *ordo*, "line or row," possibly from Greek *arariskein*, "to fit together." Any of the several types of classical columns, together with their pedestal bases and entablatures. The Greeks developed three orders, the Doric, Ionic, and Corinthian; the Romans adopted the latter two and added the thinner Tuscan Doric and the Composite (a combination of the features of Ionic and Corinthian).

1. The **Greek Doric**, developed in the western Dorian region of Greece, is the heaviest and most massive of the orders. It rises from the **stylobate** without any base; it is from 4 to 6½ times as tall as its diameter; it has twenty broad flutes. The capital consists simply of a banded necking swelling out into a smooth echinus that carries a flat square abacus. The Doric entablature is also the heaviest, being about one-fourth the height of the column. The Greek Doric order was not used after about 100 B.C. until its "rediscovery" in the mid-eighteenth-century.

2. The **Ionic** order was developed along the west coast of what is now Turkey, once Ionian Greece. It is generally about nine times as high as its diameter. It has a base, twenty-four flutes, and a much more elaborate capital consisting of thick flaring volutes that emerge from a thick central cushion; above this is a decorative band and a circular egg and dart molding on which rests the distinctive volutes and cushion; on top of the volutes rests a thin flat abacus. The Ionic entablature is about one-fifth the height of the column. In the Roman variant the volutes are less prominent and curl out from a flat central area (that is, with no expanded cushion).

3. The **Corinthian** order, the most attenuated and richly embellished, was the least used by the Greeks. It is about ten times as high as its diameter, rising from an elaborate base, with twenty-four flutes, and a tall capital consisting of a band from which spread upward three or four layers of curling acanthus leaves ending in small tight volutes in the four corners and supporting a concave abacus. The Corinthian entablature, similar to that of the Ionic order, is also about one-fifth the height of the column.

4. Other orders: The **Roman Doric** order is much slimmer than the Greek prototype, being nearly as slender as the Ionic order; it has a short base. More original is the **Tuscan Doric** order which has a base and an unfluted shaft and is about seven times as high as its diameter; its capital is similar to that of the Greek original but more strongly articulated. The Romans also combined the Ionic and Corinthian orders, placing the volutes atop the acanthus leaves, creating the **Composite** order, the most sculpturally elaborate of them all.

oriel From Middle French *oriol*, "porch" or "gallery." A cantilevered window enclosure projecting from a wall, supported by corbels or brackets; a bay window by comparison is found on the ground floor and has a foundation wall that projects from the principal wall.

outbuilding See *dependency*.

outkitchen See *summer kitchen*.

overhang (or *overshoot*) See *jetty*.

Palladian window A type of opening or window much used by Sebastiano Serlio and Andrea Palladio (hence the name), combining a tall round-headed center opening flanked by shorter rectangular openings. Four columns or pilasters frame the flanking openings and the entablatures they carry form a base for the arch framing the center opening.

Palladian window, from Ely house, Ely's Landing, Connecticut. (From F. Kelly, Early Domestic Architecture of Connecticut, *New Haven, 1924.)*

parapet From French, from Italian *parapetto*, *parare*, "to shield." A low protective wall at the edge of a roof, balcony, or other elevated platform.

pargeting (or *parge coat*) From Middle English, probably from *pargetten*, "to parget," from Old French *pargeter*, *parjeter*, "to throw about," and from Old French *porgeter*, "to roughcast a wall." A coat of plaster applied to a wall; sometimes done rough in surface, other times done smoothly with decorative or ornamental detail.

pattern book A publication filled with plates or illustrations of typical building plans and building details, aimed at the non-architect or at the builder. The many books published by Asher Benjamin and Minard Lefever are good examples.

pavilion From Old English *pavilon*, from Latin *papilio*, "butterfly," perhaps because of the resemblance of ornamental tents to butterfly wings. Originally a tent, especially an elaborately ornamented shelter; later, any portion of a building projected forward and otherwise set apart, or even a separate structure. Much favored in French Renaissance and especially Baroque architecture, and hence in Second Empire Baroque architecture, 1850 to 1890.

pebble-dash stucco (or **rough cast stucco**) A type of stucco finish in which pebbles or shells are either mixed into the stucco or forced into the soft surface before the stucco hardens; yields a rough surface that catches the light and offers visual detail.

pediment From a variation of obsolete English *perement*, perhaps from *pyramid*. Originally the closed triangular gable above the entablature of Greek and Roman temples enclosed by the horizontal cornice of the entablature, and raking cornices following the edges of the roof; later, any such cornice-framed crown over a door or window, whether triangular, segmental, broken, or consisting of curved broken cornices ending in volutes.

pen From Old English *penn*, small restrictive, fenced enclosure, usually referring to such an enclosure for holding animals or livestock. By extension any relatively small enclosure, and used in this way to describe the small rooms of a log structure or any restricted module.

pendill (also **pendant**) From French *pendant*, "hanging." The projecting and exposed lower end of a post of the overhanging upper story, or jetty, of seventeenth-century New England houses, often carved.

Pennsylvania "Dutch" A misnomer arising from the similarity in English between the words *Dutch* and *Deutsch*, meaning "German." Hence the German settlers invited to settle in Pennsylvania by Penn and his agents became known as the Pennsylvania "Deutsch" or the Pennsylvania Dutch.

pent roof From Middle English *pentis*, from Latin *appendicula*, "small appendage." A short sloping roof attached to the wall over the door and windows; widely used along the Delaware River during the seventeenth and eighteenth centuries.

pentastyle From Greek *pente*, "five," and *stulos*, "column." A portico consisting of five columns across; seldom used by the Greeks who typically used end porticoes of even numbers.

period architecture (or **period houses**) Referring to the time around 1919 to 1930 during which houses and other buildings were designed by architects, well educated in the historical styles, using plans devised to accommodate contemporary needs but with original or invented details and forms based on a thorough knowledge of past styles. Often individual rooms within such a house might be done in disparate historical periods, each one correct for its respective referred time period.

peripteral From Greek *peri*, "around," + *pteron*, "wing," or "flying around." Adjective used to describe a building with a free-standing colonnade on all four sides.

peristyle From Greek *peri*, "around," + *styos*, "column." Noun, referring to a free-standing colonnade running completely around a building.

piazza From Italian and from Latin *plata*, "street," derived from Greek *plateia* (hodos), "broad" (way), feminine of *platus*, "broad." In Italian, a broad open urban space or square (and pronounced with a hard "tz"). In eighteenth-century England and in her colonies the term acquired a specialized meaning (pronounced with a soft "sz") referring to broad residential porches or verandas. This usage continues in American southern states up to the present, particularly in Charleston, South Carolina.

pièce-sur-pièce construction From French, meaning literally "piece on piece." A form of French vernacular construction used in Quebec and carried to western areas settled by French trappers and to Louisiana by displaced Acadians. Carefully squared-off logs are cut with tongues at the ends; these logs are placed horizontally with the tongues fitted into groves in vertical stabilizing wall timbers.

pierrotage See *bousillage.*

pilaster From Old French *pilastre*, from medieval Latin *pilastrum*, "pillar." A buttress-like projection from a wall in the form of one of the classical orders, and like them, having a base, a fluted or unfluted shaft, and a capital, carrying an entablature or cornice.

pile From Middle English. A term referring to the number of rooms in a building from front to back, single pile having one layer of rooms, and double pile having a range of front rooms and a range of rooms to the rear. In one typical double-pile Georgian house plan, the front rooms are separated from the rear rooms by the central fireplaces and chimneys.

planch-debout-en-terre construction French, meaning literally "planks standing upright in the earth." See *poteaux-en-terre construction.*

plank-frame construction See *box construction.*

platform frame Also called *Western frame construction.* A variation of the balloon frame in which each floor level is framed individually, one atop the other, with the floor first being built of closely horizontal spaced joists and then covered with (originally) broad diagonally running boards for bracing or (today) sheets of plywood or particle board, often with tongue-and-groove edges. The wall panels can then be nailed together flat on the finished floor platform and tilted into final vertical position. On top of the finished lower stories, another platform floor is constructed and then the upper wall sections or panels.

plinth From French *plinthe*, from Greek *plinthos*, "square stone block." Specifically, a square flat block used as the base under a column, but by extension any block-like podium beneath a building.

polychromy From Greek *polukhromos*, from *polus*, "many," + *khroma*, "color." The use of many colors; also, particularly in nineteenth-century architecture, the employment of many building materials with contrasting natural colors.

porte cochère From French, "coach door." A covered area, attached to a house, providing shelter for those alighting from carriages.

portico From Latin *porticus*, "porch." A porch, with a roof usually carried by columns, protecting the main entrance to a building.

post and lintel A structural term used to describe a generic type in which upright columns support horizontal beams. The structure may be stone, wood, or iron and steel.

poteaux-en-terre construction French, meaning literally "posts in the earth." In French vernacular architecture of the upper Mississippi valley, a form of wall construction (and used for free-standing posts) in which the posts are closely spaced in a trench dug in the earth, with the space between the wall timbers filled with **bousillage** or **pierrotage** (**noggin**). Since ground moisture and insect infiltration (such a termites) caused such earth-fast timbers to rot, it was used for temporary buildings. Cedar and cypress timbers tended to last much longer.

poteaux-sur-sole construction French, meaning literally "posts on a sill." In French vernacular architecture of the upper Mississippi valley, a form of wall construction in which a sill plate was placed on foundation stones. Wall timbers (sometimes with tenons cut in the ends) were placed into mortice holes cut into the sill; an upper plate timber held the wall timbers at the top. The space between the wall timbers was filled with **bousillage** or **pierrotage**.

prostyle From Greek pro, "in front," + stulos, "column." Referring to a type of temple with a portico of columns running across the front (or the rear, as well) but not along the sides.

quarry-faced masonry A form of ashlar masonry in which the outer surfaces or sides of the stone blocks are left roughly finished, essentially as the stones come from the quarry. One of the distinctive characteristics of H. H. Richardson's mature architecture.

quatrefoil From Latin, meaning "four leaves." An ornamental pattern of four circular or pointed lobes.

quoin From Old French *coing*, "wedge." Originally the structural use of large masonry blocks to reinforce the corner of a brick or other masonry wall; but often used as a decorative embellishment in non-load-bearing materials.

ramada Spanish, "branches" or "arbor." An open-air structure of posts carrying a flat or sloped trellis covered with branches and leaves; provide a ventilated shaded work area.

random ashlar masonry Masonry of cut and finished stones in which there are no continuous horizontal joints; instead, the stones vary in size vertically.

rangework masonry Ashlar masonry in which all stones of a given course are of equal height, but in which individual courses may vary irregularly in height; often used by H. H. Richardson.

relieving arch (also *discharging arch*) In a masonry, but particularly in a brick wall, an arch built into the wall over an opening such as a window or door to direct the weight of the wall away from the opening; the tympanum area directly over the window may be filled with brick or other material to maintain the rectilinear form of the window.

rinceau From Middle French *rainsel*, "branch." Ornamental work, often low-relief sculpture, consisting of curvilinear intertwining leaves and branches.

riven or *rived* Middle English riven, from Old Norse rifa, "to tear" or "to rend." To split, as in making rough boards by splitting wood along its grain. Before sawmills were readily available, rough clapboards were made by splitting logs that were free of knots.

rosette Stylized circular floral ornament in the form of a fully opened rose.

rustication From Latin *rusticus*, "of the country, rude, coarse." The treatment of stone masonry with the joints between the blocks deeply cut back. The surfaces of the blocks may be smoothly dressed, textured, or left extremely rough, or quarryfaced.

saddleback roof Traditionally a roof with two gables and one ridge, but also a roof (gable or hipped) with two slopes on each side, the outer portion gentler in slope, the inner portion steeper.

saltbox Term used to describe the typical seventeenth-century New England house with a short gable roof to the front and a long gable roof to the rear; some such houses were the result of a lean-to addition being added to the rear of the house, continuing the slope of the upper with or without a change in the slope. Other such saltbox houses were designed with the extra rear rooms and the long roof from the outset. Less seen in the southern colonies, there it was called a "cat slide" roof.

sash From French *chassis*, "frame." A frame in which glass window panes are set; often subdivided by muntins.

scantling A square-edged piece of lumber of relatively small cross-section. The earliest balloon frames around Chicago were described as being made of scantling.

scuttle From Latin *scutum*, "shield." A hatchway or opening in a roof deck or ceiling.

segmental Referring to a segment of a circle, used to describe an arch that is not a full semicircle, and also to a pediment that has a partial circular curved upper part instead of a triangular peak.

setback The minimum distance required between the property line and the building line. Also a recessed upper section of a building; used in New York and Chicago skyscrapers of the 1920s as a way of admitting more light and air to the streets below.

shake A thick, rough wood shingle made by splitting straight grain wooden blocks.

shed roof The simplest roof consisting of a single inclined plane; used widely in domestic architecture from 1965 to 1975.

shingle A thin piece of wood (or even tile or slate) used as a exterior sheathing material, both for walls and roofs. In modern use it almost always refers to sawn, slightly tapered wood pieces in contrast to rough split shakes.

shotgun house Found largely in the southern rural and urban United States, this was a long narrow wood frame house, one room wide, with a hall or passage along one side, covered with a long gable roof. According to folklore, one could fire a shotgun through the front door, down the passage, and leave the rest of the interior undamaged. Largely associated with Negro residents and owners, the form may have been derived from vernacular houses of west central Africa, carried to the West Indies and the Caribbean, and then to New Orleans.

side light A narrow vertical window to the side of a entry door, almost always in pairs on both side of the door, used together with a *fanlight* to admit light into an entry hall. Used extensively during the eighteenth-century Georgian period, the Federalist, and through the Greek Revival up to about 1850.

sill, sill plate A principal horizontal timber on which other members rest.

sill course A horizontal course of brick or stone in a masonry wall, usually placed at the window-sill level, differentiated from the rest of the masonry, often projecting.

skeleton frame See *skyscraper construction.*

skyscraper construction In a strictly structural sense, this construction relies on an internal frame of metal (typically ferrous metals); the weight of all the exterior walls, whether masonry or curtain panels of metal or glass, is carried entirely by the frame. First used widely in Chicago.

sleeping porch An open porch, or room with extensive operable windows, used for sleeping. Popular in more benign climate in the years before air conditioning, sleeping porches were believed to be especially therapeutic for respiratory ailments.

soffit The exposed flat surface of any overhead building component, whether of an arch, eave, balcony, beam, cornice, or lintel.

spandrel From Old French *espandre*, "to spread out." In a wall system of arches, the area between the architraves of the arches and the entablature above; in a skeletal frame building, the panels between the columns and the windows of each story.

spindlework From Old English *spinel*, "spindle," from Germanic *spinnan*, "to spin." A spindle is a thin round rod used for the winding of fibers; spindlework consists of a grill of lathe-turned round wooden rods, often of elaborate profile. Often found in Eastlake, Queen Anne, and Shingle Style interior room screens and exterior porch screens.

spire From Middle English, from Old English *spir*, from Lation *spina*, "thorn." A thin, elongated, pointed vertical building form.

steel A strong alloyed ferrous metal made by remelting cast-iron ingots and heating the molten iron to high temperature to drive off the carbon (reducing carbon content to 1.7 percent) and to remove small amounts of phosphorus, silicon, aluminum, and other deleterious elements. For special types of steel small amounts of other elements such as nickel, chromium, manganese, and molybdenum are added to the molten mass. Stainless steel, for example, may have from 4 to 25 percent chromium and nickel. Although steel had been made for centuries, the process was difficult and yielded very small quantities. In the 1850s large-scale smelting processes were developed by Henry Bessemer in England and William Kelly in the United States, followed by the Siemens-Martin open-hearth process in the 1860s. By the 1890s, steel was the major ferrous metal being produced. Usually malleable, possessing good tensile strength, especially when rolled into shaped forms (I beams, H columns, angles, and so on) for structural use.

steeple From Middle English *stepel*, from Old English *stepel*, related to Old English *steap*, "high, steep." A tall, comparatively thin tower-like building form made up of stacked diminishing components, often culminating in a spire.

stereobate From Greek *sterebates*, "solid base." The total substructure or base of a classical building; in a columnar building, the top- or upper-most level is called the *stylobate*.

stoop From Dutch *stoep*, "step of a building." An entry platform or porch; in the Northeast United States (especially New York City) often having many steps.

stringcourse See *belt course.*

stucco From Italian. An exterior durable plaster-like finish, often textured, mixed of Portland cement, lime, sand, and water, applied over other structural materials (brick, stone, wood frame).

stylobate From Greek *stylobates*, "column foundation or base." The upper layer of the *stereobate* upon which the columns rest.

summer-beam From Old English *somer*, "park horse," from Middle French *somier*, assumed to be from Vulgar Latin and Late Latin *sagmarius*, "pack saddle." A large major beam, in a seventeenth-century timber framed house, running from girt to girt across a room, supporting small floor joists. After 1750 the use of larger, heavier floor joists obviated the need for a summer-beam.

summer kitchen In midwestern and southern regions, a second kitchen building separate and removed from the main house, much used in summer months to keep heat build-up from the main house.

surround In eighteenth-century Georgian architecture, a decorative frame around a door, window, or fireplace, most commonly made up of flanking pilasters or engaged columns, supporting an entablature (and, over doors, a pediment).

swan's neck pediment So called because the facing reverse-curved cornices could be said to look like two swans facing each other. (See *broken scroll pediment.*)

tabby From Gullah 'tabi, of African origin, from Hausa *ta'bo*, "mud." A concrete-like material of shell lime, sand, aggregate of sea shells, and sea water in equal proportions. Used along the coast in Florida, Georgia, and South Carolina. Packed into forms until firm and then usually plastered over.

tenon From Middle English from Old French *tenir*, from Latin *tenere*, "to hold." A tongue-like projection carved or cut at the end of a beam or post, meant to fit into a matching mortise recess in a girt, sill, or upper plate in a heavy timber frame.

terra cotta From Latin, "cooked earth." A ceramic material made from clay forced into negative plaster molds and fired; often glazed in single or many colors; capable of assuming many forms; widely used from 1875 to 1930 as a sheathing material.

tetrastyle From Greek *tetra*, "four," + *stulos*, "column." A portico of four columns.

trabeated structure From Latin *trabs*, "beam." A structural system using repeated posts and beams; used in place of "post and lintel."

transom From Middle English *traunsom*, probably alteration of Latin *transtrum*, "cross-beam," from *trans*, "across." A

horizontal member that separates a door from a window directly above; also a horizontal cross-bar that divides a window horizontally.

transom light A rectangular window directly above the transom bar over a window.

treenail (also *trenail, trunnel*) From Middle English *trenayle*. A wooden pin or dowel used to lock together the joints of a heavy timber frame. Pronounced "trunnel."

tripartite organization A method of organizing the large mass of tall skyscrapers, associated with McKim, Mead, & White, Daniel Burnham, Holabird & Roche, and Louis Sullivan.

truss From Middle English *trusse*, from Old French *trousser*, "to secure tightly." In architecture, a frame assembled of small members (of wood or metal) in triangular sections in such a way that the whole is rigid and cannot be deformed except by the physical bending or breaking of one of the component members; used to span large distances.

turret, tourelle From Old French *tourete*, diminutive for "tower." A small tower, sometimes corbeled out from the corner of a building.

vault From Middle English *vaute*, from Latin *volvere*, "to turn." An arched ceiling of masonry; if circular or oval in plan, a dome.

veranda, verandah From Hindi *varanda*, which is partly from Portuguese *varanda*, akin to Spanish *baranda*, "railing." An extensive open gallery or porch.

vergeboard See *bargeboard*.

vermiculation From Latin *vermiculus*, "small worm." A decorative treatment of the surface of stone in masonry, making it look as if it has been tunneled or eaten by worms. Favored for the base elements of Second Empire Baroque buildings, in rusticated masonry.

Vierendeel truss From M. A. Vierendeel, Belgian engineer, who developed it in 1896. A lattice frame with members at right angles that derives its strength from the rigidity built into its joints; it has no diagonal members as in a typical truss.

viga Spanish, "beam" or "rafter." In Southwest native American and Spanish Colonial architecture, the round log beams laid at close intervals on adobe or stone walls, with the ends protruding through the finished wall. Occasionally hewn square. Covered with a platform of *latias*, then rush mats, and finally adobe clay to create upper floors or roofs.

volute From Latin *voluta*, "scroll," from *volvere*, "to turn." A spiral curve; the curled top of the Ionic capital.

voussoir From Old French *vossoir*, derived perhaps from Latin *volvere*, "to turn." Any of the wedge-shaped blocks used to form an arch, the center one of which is the keystone.

wainscot From Middle English, from Middle Dutch *waghenscot*, perhaps from *waghen* or *wagen*, "wagon" (from the quality of wood used for wagon carriagework) + *scot*, "partition." In the seventeenth and eighteenth centuries the term referred to sheathing or paneling applied to an entire interior wall, floor to ceiling, but from the nineteenth century onward the term referred to ornamental

raised paneling used on the lower portion of a wall. The terminating upper molding of later wainscoting is the *chair rail*, a molding designed to keep the backs of chairs from marring the finish of the wall.

water table A molded course of masonry forming a transition between the foundation wall and the upper wall, designed to throw rain water away from the wall. See illustration.

Watertable (molded brick course). (From F. Kelly, Early Domestic Architecture of Connecticut, *New Haven, 1924.)*

wattle and daub A rough form of construction in which a woven basketwork of twigs is coated with mud plaster; employed to fill the spaces between framing members in half-timber construction.

weatherboard Sawn boards, laid overlapping and horizontally, used as external sheathing on timber frames. Sometimes flat but also tapered in cross-section like clapboards but usually thicker.

window seat A built-in bench below a window sill for use as a sitting area, especially in thick walls.

wrought iron From Middle English *wroght*, from Old English *geworht*, past participle of *wyrcan*, "to work." A relatively pure form of iron produced by "working," hammering or forging heated pieces of pig or cast iron. The forging or hammering process mechanically destroys the crystalline structure of cast iron, creating a more fibrous structure that possesses good tensile strength, and also better resistance to oxidation. Wrought-iron rods were used for the bottom chords of trusses that are in tension, and also for beams, the bottom edges of which are in tension. In large measure after 1870 it was supplanted by steel for large-scale structural members.

wrought-iron nail A nail cut from sheets of wrought iron. For special uses, such nails were forged and hammered with shaped heads to form decorative patterns when hammered in place. Largely replaced, generally speaking, by wire nails after 1800, and hence often a dating feature.

zapata Spanish, "half boot." In Spanish Colonial architecture of the Southwest, the zapata is a carved block placed atop a post to provide more bearing area for beams placed on top. Also called a bolster in other situations.

ziggurat From Assyrian *zigguratu*, "summit, mountain top." A temple or tower of multiple stepped-back stages built by the Babylonians and Assyrians.

LIST OF ILLUSTRATIONS

HABS refers to the materials in the Historic American Buildings Survey collection, housed in the Prints and Photographs division of the Library of Congress, Washington, D.C. The HABS collection is made up of documents and written reports, specially commissioned photographs, and detailed measured drawings of thousands of historic American buildings. Begun as a works project for unemployed architects during the Great Depression, this program of careful documentation is ongoing, now employing architecture students and educators during the summer months. For this book, many plans were simplified and redrawn from HABS documents. For the HABS program and documentary materials see C. Ford Peatross, ed., *Historic America: Buildings, Structures, and Sites* (Washington D.C., 1983), and Marilyn Ibach and Georgette R. Wilson, *America Preserved: A Checklist of Historic Buildings, Structures, and Sites* (Washington D.C., 1995).

2.40 Thomas Holme, surveyor, Philadelphia, Pennsylvania, 1682. (From *A Portraiture of the City of Philadelphia*, London, 1683.)

3.1a James Oglethorpe, Savannah, Georgia, 1733, *A View of Savannah As It Stood the 29th of March 1734*, London, 1734. (Library of Congress, Prints and Photographs.)

3.1b Diagram of Oglethorpe's basic planning module for Savannah. (L. M. Roth.)

3.2 Bernard Ratzer, New York City, New York, 1767. (Bernard Ratzer, *Plan of the City of New York, in North America*, London, 1776; Library of Congress, Map Division.)

3.3 "Frenchman's Map," Williamsburg, Virginia, 1699. (Courtesy of the Swem Library, College of William and Mary, Williamsburg.)

3.4 Thomas Lee house, Stratford, Westmoreland County, Virginia, 1730–38. (Photo: Jack Boucher, 1969, Library of Congress, HABS VA 97 4-4.)

3.5 Stratford; plan. (L. M. Roth, after HABS.)

3.6 William Byrd house, Westover, Charles City County, Virginia, c. 1750. (Photo: Thomas T. Waterman, Library of Congress, HABS VA 14-WEST 1-1.)

3.7 William Byrd house; plan. (L. M. Roth, after HABS.)

3.8 Richard Bayliss, wood carver, central hall of Carter's Grove, James City County, Virginia, 1750–53. (Courtesy of Virginia State Library.)

3.9 Carter's Grove; plan. (L. M. Roth, after HABS.)

3.10 Richard Taliaferro, George Wythe house, Williamsburg, Virginia, 1755. (Photo:. (Courtesy of Colonial Williamsburg, 1956–GB-905.)

3.11 Wythe house; plan. (L. M. Roth, after HABS.)

3.12 John Drayton house, "Drayton Hall," near Charleston, South Carolina, c. 1738–42. (Photo: © Wayne Andrews/ Esto.)

3.13 James Porteus, Samuel Carpenter house, "Slate Roof House," Philadelphia, Pennsylvania, c. 1690. (From J. Harter, *Images of World Architecture*, New York, 1990.)

3.14 James Smart, house carpenter (attributed), Letitia Street house, Philadelphia, Pennsylvania, c. 1703–15. (Photo: Courtesy of the Philadelphia Museum of Art.)

3.15 Brinton house, Dilworthtown, Pennsylvania, 1704. (Photo: Library of Congress, HABS PA 23-DIL.V 1-3.)

3.16 Sir William Keith house, Graeme Park, near Horsham, Pennsylvania, 1721–22 .(Photo: Courtesy of the Essex Institute, Salem, Massachusetts, neg. 1942.)

3.17 Parson John Sergeant house, Stockbridge, Massachusetts, 1739. (Photo: © Wayne Andrews/Esto.)

3.18 Foster-Hutchinson house, Boston, Massachusetts, c. 1688. (From J. Stark, *Stark's Antique Views of Boston*, Boston, 1907.)

3.19 John Drew, designer and builder, MacPheadris-Warner house, Portsmouth, New Hampshire, 1716–18. (Carnegie Photo, Visual Resources Collection, University of Oregon.)

3.20 Isaac Royall house, Medford, Massachusetts, 1733–50. (Photo: Library of Congress, HABS MASS 9-MED 1-17.)

3.21 Wentworth-Gardner house, Portsmouth, New Hampshire, c. 1760. (Photo: Samuel Chamberlain.)

3.22 Joshua Twelves, designer; Joshua Blanchard, builder; Old South Meeting House, Boston, Massachusetts, 1713. (Photo: Library of Congress, HABS MASS 13-BOST 54-2.)

3.23 Richard Munday, Trinity Church, Newport, Rhode Island, 1725–26. (Photo: Sandak, courtesy of the University of Georgia.)

3.24 College of William and Mary, Wren Building, Williamsburg, Virginia, 1695–1702. (Courtesy of Colonial Williamsburg, neg. 76-FO-690.)

3.25 Col. Thomas Dawes, Massachusetts Hall, Harvard University, Cambridge, Massachusetts, 1718–20. (Photo: Sandak, Courtesy of the University of Georgia.)

3.26 Richard Munday, Old Colony House, Newport, Rhode Island, 1739–41. (Photo: Library of Congress, HABS RI 3-NEWP 9-28.)

3.27 John Vassal house, Cambridge, Massachusetts, 1759. (Photo: Library of Congress, HABS MASS 9-CAMB 1-5.)

3.28 Vassal house; plan. (L. M. Roth, after HABS.)

3.29 Lady Pepperrell house, Kittery Point, Maine, c. 1760. (Photo: Courtesy of the Society for the Preservation of New England Antiquities.)

3.30 John MacPherson house, Mount Pleasant, Philadelphia, Pennsylvania, 1761–62. (Photo: Library of Congress, HABS PA 51- PHILA 15-13.)

3.31 Mt. Pleasant, Philadelphia; plan with dependencies. (L. M. Roth, after HABS.)

3.32 Blackwell house, Philadelphia, Pennsylvania, c. 1760. (Photo: Courtesy of the Henry Francis du Pont Winterthur Museum.)

3.33 John Ariss (?), Col. John Tayloe house, Mount Airy, Richmond County, Virginia, 1758–62. (Photo: Library of Congress, HABS VA 80-WAR.V 4-21.)

3.34 Mount Airy; plan with dependencies. (L. M. Roth, after HABS.)

3.35 James Gibbs, *A Book of Architecture*, plate 58. (From *A Book of Architecture*, London, 1728, courtesy of the Avery Library, Columbia University.)

3.36 Richard Moncrieff, builder, Miles Brewton house, Charleston, South Carolina, c. 1769–73. (Photo: Library of Congress, HABS SC 10-CHAR 5-4.)

3.37 Miles Brewton house; plan, with outbuildings. (L. M. Roth, after HABS.)

3.38 Judge Robert Pringle house, Charleston, South Carolina, c. 1774. (Photo: Library of Congress, HABS SC 10-CHAR 148-1.)

3.39 Pringle house, Charleston, South Carolina; plan, with outbuildings. (L. M. Roth, after A. R. Huger Smith and *D. E. Huger Smith, The Dwelling Houses of Charleston, South Carolina*, Philadelphia, 1917; and a property plat of 1789, McCrady Plat Collection, in J. H. Poston et al., eds., *The Vernacular Architecture of Charleston and the Low Country*, 1670–1990, Charleston, 1994.)

3.40 Dr. John Kearsley, designer, Christ Church, Philadelphia, Pennsylvania, 1727–54. (Photo: Courtesy of the Essex Institute, Salem, Massachusetts, neg. 2385.)

4.19 Lavius Fillmore, Congregational Church, Bennington, Vermont, 1806. (Photo: Library of Congress, HABS VT 2-BEN 1-1.)

4.20 Lemuel Porter, builder, Congregational Church, Tallmadge, Ohio, 1822–25. (Photo: Library of Congress, HABS OHIO 77-TALM 1-1.)

4.21 Benjamin Henry Latrobe, Virginia State Penitentiary, Richmond, Virginia, 1797–98. (Courtesy of the Virginia State Library.)

4.22 Virginia State Penitentiary. (L. M. Roth, after Latrobe.)

4.23 Benjamin Henry Latrobe, Bank of Pennsylvania, Philadelphia, Pennsylvania, 1798–1800; plan. (L. M. Roth, after Latrobe.)

4.24 Benjamin Henry Latrobe, Bank of Pennsylvania, Philadelphia, Pennsylvania, 1798–1800; perspective view. (*The Papers of Benjamin Henry Latrobe*, Maryland Historical Society.)

4.25 Benjamin Henry Latrobe, Baltimore Cathedral, Cathedral of the Assumption of the Blessed Virgin Mary, Baltimore, Maryland, 1804–21; perspective view. (*The Papers of Benjamin Henry Latrobe*, Maryland Historical Society.)

4.26 Baltimore Cathedral; plan. (L. M. Roth, after Latrobe and Hamlin.)

4.27 Baltimore Cathedral, chancel and altar; interior view. (Photo: Larry Miyamoto, 1958, Library of Congress, HABS MD 4-BALT 41-2.)

4.28 Baltimore Cathedral, longitudinal section by Latrobe, 1805. (Photo: Courtesy of the Diocese of Baltimore and the Maryland Historical Society.)

4.29 Benjamin Henry Latrobe, Center Square Pumphouse, Philadelphia Waterworks, Philadelphia, Pennsylvania, 1799–1801. (Courtesy of Prints Division, the New York Public Library; Astor, Lenox, and Tilden Foundations.)

4.30 William Hamilton house, Woodlands, Philadelphia, Pennsylvania, 1786–89. (Photo: Sandak, courtesy of the University of Georgia.)

4.31 Hamilton house, Woodlands; plan. (L. M. Roth, after HABS.)

4.32 Joseph F Mangin, with John McComb, Jr., New York City Hall, New York, New York, 1802–11. (Carnegie Photo, Northwestern University.)

4.33 Maximilian Godefroy, Unitarian Church, Baltimore, Maryland, 1817–18. (Photo: Sandak, courtesy of the University of Georgia.)

4.34 William Thornton, Col. John Tayloe III house, the Octagon, Washington, D.C., 1797–1800. (Photo: Library of Congress, HABS DC WASH 8-35.)

4.35 Tayloe house, the Octagon; ground floor plan. (L. M. Roth, after W. L. Bottomley, ed., *Great Georgian Houses of America*, v. 2, New York, 1937.)

4.36 Christopher Gore house, Gore Mansion, Waltham, Massachusetts, 1801–04. (Photo: Sandak, courtesy of the University of Georgia.)

4.37 George Hadfield, Custis-Lee house, Alexandria, Virginia, 1817–20. (Photo: Library of Congress, USZ62-9788.)

4.38 Thomas Jefferson, Monticello, near Charlottesville, Virginia, 1769–82, 1796–1809; aerial view. (Courtesy of Thomas Jefferson Memorial Foundation, Inc.)

4.39 Monticello. Garden façade. (Photo: Sandak, courtesy of the University of Georgia.)

4.40 Thomas Jefferson, with C.-L. Clérisseau, Virginia State Capitol, Richmond, Virginia, 1785; plaster model. (Photo: Condit Archive, Northwestern University.)

4.41 Virginia State Capitol, Richmond, Virginia, 1785–89. (Photo: L. M. Roth.)

4.42 Joseph Jacques Ramée, Union College, Schenectady, New York, 1813, aerial perspective. (From P. Turner, Campus, New York, 1984.)

4.43 Union College; general campus plan. "College de l'Union a Schenectady, Etat de New York, 1813." (Courtesy of the Schaffer Library, Union College.)

4.44 Thomas Jefferson, University of Virginia, Charlottesville, Virginia, 1817; campus plan. (*Thomas Jefferson Papers*, University of Virginia Library.)

4.45 University of Virginia; aerial view of campus as built, 1817–26 and later. (Courtesy of the Department of Graphic Communications, University of Virginia.)

4.46 University of Virginia, Rotunda, 1823–27; rotunda exterior as restored by McKim, Mead & White, 1896–98, following a fire. (Courtesy of the Department of Graphic Communications, University of Virginia.)

4.47 Slater Textile Mill, Pawtucket, Rhode Island. (Photo: Sandak, courtesy of the University of Georgia.)

4.48 Kirk Boott, Merrimack Manufacturing Company, Lowell, Massachusetts, 1821 and later. (From J. Coolidge, *Mill and Mansion*, Cambridge, Mass, 1942.)

4.49 Aliceanna Street Rowhouses, Baltimore, Maryland, early nineteenth century. (Photo: Library of Congress, HABS MD 4-BALT 86-1.)

4.50 Manasah Cutler, "Map of the Federal Territor,. from the Western Boundary of Pennsylvania to the Scioto River . . . ," c. 1787. (Library of Congress, Map Division.)

4.51 Commissioner's Plan of New York, New York, 1807–11. (Courtesy of the New-York Historical Society.)

4.52 Single-pen cabin; plan. (L. M. Roth.)

4.53 Dog-trot cabin; plan. (L. M. Roth.)

4.54 Types of log notching. (L. M. Roth, after F. B. Kniffen and H. Glassie, "Building in Wood in the Eastern United States: A Time-Place Perspective," *Geographical Review* 56, January 1966.)

4.55 Round Barn, Hancock, Massachusetts, 1826. (Photo: Library of Congress, HABS MASS 2-HANC 9-1.)

4.56 Dr. Ephraim McDowell house, Danville, Kentucky, 1803–04. (Photo: Library of Congress, HABS KY 11-DANV 1-1.)

4.57 "Shotgun" house. (L. M. Roth, after Preservation Alliance of Louisville and Jefferson Co., *The Shotgun House*, Louisville, 1980.)

5.1 Robert Mills, County Records Office Building, "Fireproof Building," Charleston, South Carolina, 1821–27. (Photo: Library of Congress, HABS SC 10-CHAR 64-7.)

5.41 Alexander Jackson Davis, Edward W. Nichols house, Llewellyn Park, Orange, New Jersey, 1858–59. (Photo: © Wayne Andrews/Esto.)

5.42 Louis Scholl, Army Surgeon's Headquarters, Fort Dalles, The Dalles, Oregon, 1857. (Photo: L. M. Roth.)

5.43 Alexander Jackson Davis, William Paulding house, Lyndhurst. (as expanded for George Merritt), near Tarrytown, New York, 1838–42. (Courtesy of The Metropolitan Museum of Art, Harris Brisbane Dick Fund, 1924.)

5.44 Alexander Jackson Davis, Lyndhurst, Tarrytown, New York, 1864–67. (Photo: Louis H. Frohman, courtesy of the National Trust for Historic Preservation.)

5.45 Richard Upjohn, Noble Jones house, Kingscote, Newport, Rhode Island, 1841. (Photo: Library of Congress, HABS RI 3-NEWP 61.8.)

5.46 James Renwick, the Smithsonian Institution, Washington, D.C., 1846–55. (From R. D. Owen, *Hints on Public Architecture*, New York, 1849.)

5.47 Henry Austin, Railroad Station design project, New Haven, Connecticut, 1848–49. (Courtesy of the Yale University Library; from the Henry Austin Papers, Manuscripts and Archives Collection.)

5.48 Thomas Tefft, Union Passenger Depot, Providence, Rhode Island, 1848. (Photo: Courtesy of the Rhode Island Historical Society.)

5.49 John Haviland, Eastern State Penitentiary of Pennsylvania, Philadelphia, Pennsylvania, 1823–25; engraving by Fenner, Sears & Co. (Courtesy of the New-York Historical Society.)

5.50 Eastern State Penitentiary; ground floor plan. (L. M. Roth, after Haviland.)

5.51 John Haviland, Halls of Justice ("The Tombs"), New York, New York, 1836–38; photo by J. S. Johnston, 1894. (Courtesy of the New-York Historical Society.)

5.52 Henry Austin, Gate, Grove Street Cemetery, New Haven, Connecticut, 1845–48. (Photo: Library of Congress, HABS CONN 5-NEWHA 3-2.)

5.53 John Notman, Philadelphia Athenaeum, Philadelphia, Pennsylvania, 1845–47. (Photo: Library of Congress, HABS PA 51-PHILA 116-1.)

5.54 "Design VI, Villa in the Italian Style, bracketed." (From Andrew Jackson Downing, *Cottage Residences*, New York, 1842.)

5.55 Henry Austin, Morse-Libby house, Portland, Maine, 1859. (Photo: Sandak, courtesy of the University of Georgia.)

5.56 Morse-Libby house; interior of the music room. (Photo: Library of Congress, HABS ME 3-PORT 15-7.)

5.57 Town (and Davis?), Tappan Store, New York City, New York, 1829. (Visual Resources Collection, University of Oregon.)

5.58 Isaiah Rogers, Tremont House Hotel, Boston, Massachusetts, 1828–29. (From William Eliot, *A Description of the Tremont House*, Boston, 1830, courtesy of the Houghton Library, Harvard University.)

5.59 James Dakin, Bank of Louisville, Louisville, Kentucky, 1834–36. (Photo: Library of Congress, HABS KY 56-LOUVI 1-3.)

5.60 Old Shawneetown Bank, Old Shawneetown, Illinois, 1836. (Photo: L. M. Roth.)

5.61 William Johnston and Thomas Ustick Walter, Jayne Building, Philadelphia, Pennsylvania, 1849–51. (Courtesy of the Library Company of Philadelphia.)

5.62 Alexander Jackson Davis, project for a Commercial Exchange, c. 1860. (Courtesy of the New-York Historical Society.)

5.63 John B. Corlies, designer, James Bogardus, manufacturer, Harper Brothers Building, New York, New York, 1854. (Photo: Courtesy of the Museum of the City of New York.)

5.64 John P. Gaynor, architect, Daniel Badger, manufacturer, Haughwout Building, New York, New York, 1857, Daniel Badger, manufacturer. (Photo: © Wayne Andrews/Esto.)

5.65 William E. Bell, *Carpentry Made Easy*, Philadelphia, 1858; plate 6. (Courtesy of the Art Institute of Chicago.)

5.66 Orson Squire Fowler house, Fishkill, New York, 1848–53, frontispiece. (From O. S. Fowler, A Home For All, revised edition, New York, 1854.)

5.67 Samuel Sloan, Haller Nutt house, Longwood, Natchez, Mississippi, 1861. (Photo: Sandak, courtesy of the University of Georgia.)

5.68 Plan of Chicago, 1833. (National Archives.)

5.69 Gen. Henry A. S. Dearborn, designer, Mount Auburn Cemetery, Cambridge, Massachusetts, 1829–30. (L. M. Roth, after A. Wadsworth, *Plan of Mount Auburn*, 1831.)

5.70 Robert C. Phillips; plan of Glendale, Ohio, 1851. (Courtesy of Cincinnati Historical Museum.)

5.71a Llewellyn Haskell with A. J. Davis with A. J. Downing, with later additions by E. A. Baumann and Howard Daniels; plan of Llewellyn Park, Orange, New Jersey, 1852–69. (Courtesy of Avery Library, Columbia University, New York.)

5.71b Lewellyn Park; plan. (L. M. Roth.)

5.72 Alexander Jackson Davis, gatehouse, Llewellyn Park, Orange, New Jersey, 1853. (Photo: Sandak, courtesy of the University of Georgia.)

5.73 John B. Papworth, planner; plan of Hygeia, Kentucky, 1827. (From William Bullock, *Sketch of a Journey Through the Western States of North America*, London, 1827.)

5.74 Stedman Whitwell, with Robert Owen, aerial view of New Harmony, Indiana, c. 1825; lithograph. (Courtesy of the New-York Historical Society.)

5.75 Sawyer-Black farm house complex, Sweden, Maine, early to mid-1800s. (From Thomas Hubka, *Big House, Little House, Back House, Barn: The Connected Farm Buildings of New England*, Amherst, Massachusetts, 1990.)

5.76 Ainsworth farm complex, Mason County, Illinois, c. 1860, detail of plate. (From *Mason County Atlas*, 1874; courtesy of the Illinois State Historical Library, Springfield, Illinois.)

6.1 James Renwick, Corcoran Gallery (now Renwick

Middletown, Rhode Island, 1872. (Courtesy of The Preservation Society of Newport County.)

6.37 Jacob Cram house; plan. (L. M. Roth, after V. Scully and H.-R. Hitchcock.)

6.38 Robert Beatty, Jr., James W. Bryan house, Kansas City, Missouri, c. 1886–87. (From E. Mitchell, *American Victoriana: A Gallery of Color Plates*; reprinted from *Scientific American Architects and Builders Editions*, 1880–1905, San Francisco, 1979.)

6.39 J. W. Bryan house; plan. (L. M. Roth, after Beatty.)

6.40 McKim, Mead & White, Newport Casino, Newport, Rhode Island, 1879–80. (Photo: L. M. Roth.)

6.41 Henry Hobson Richardson, William Watts Sherman house, Newport, Rhode Island, 1874–75. (From *The New York Sketch Book of Architecture*, v. 2, May, 1874.)

6.42 Sherman house; plan. (L. M. Roth, after J. K. Ochsner and T. Hubka, "H. H. Richardson: The Design of the William Watts Sherman House," *Journal of the Society of Architectural Historians* 51, June 1992.)

6.43 Henry Hobson Richardson, M. F. Stoughton house, Cambridge, Massachusetts, 1882–83. (Photo: © Wayne Andrews/Esto.)

6.44 McKim, Mead & White, Isaac Bell house, Newport, Rhode Island, 1881–83. (Photo: Library of Congress, HABS 3-NEWP 44-1.)

6.45 Isaac Bell house; plan. (L. M. Roth, after George Sheldon, *Artistic Country Seats*, New York, 1886–87 and HABS plans.)

6.46 McKim, Mead & White, William G. Low house, Bristol, Rhode Island, 1886–87. (Photo: Cerwin Robinson, Library of Congress, HABS RI 1-BRIST 18-3.)

6.47 McKim, Mead & White, H. A. C. Taylor house, Newport, Rhode Island, 1882–86. (From *American Architect and Building News*, July 23, 1887.)

6.48 Joseph Lyman Silsbee, speculative house for John L. Cochran, in Edgewater (now part of Chicago), Illinois, 1886–87. (Photo: Charles Allgeier, Chicago, c. 1887–88; author's collection.)

6.49 John Augustus and Washington Augustus Roebling, Brooklyn Bridge, Brooklyn, New York, 1869–83. (Courtesy of the Long Island Historical Society.)

6.50 Brooklyn Bridge, tower caisson. (From *Harper's Weekly*, December 17, 1870.)

6.51 Richard Morris Hunt, Tribune Building, New York, New York, 1873–75. (Courtesy of the Museum of the City of New York.)

6.52 George Browne Post, Produce Exchange, New York, New York, 1881–85. (Courtesy of the Museum of the City of New York.)

6.53 Henry Hobson Richardson, Trinity Church, Boston, Massachusetts, 1872–77. (From M. G. Van Rensselaer, *Henry Hobson Richardson*, Boston, 1888.)

6.54 Henry Hobson Richardson, Robert Treat Paine house, Waltham, Massachusetts, 1884–86. (Photo: Sandak, courtesy of the University of Georgia.)

6.55 Henry Hobson Richardson, Crane Memorial Library, Quincy, Massachusetts, 1880–83. (From Van Rensselaer, *Henry Hobson Richardson*, Boston, 1888.)

6.56 Crane Memorial Library; plan. (L. M. Roth, after Van Rensselaer, *Henry Hobson Richardson*.)

6.57 Henry Hobson Richardson, Cheney Block, Hartford, Connecticut, 1875–76. (Photo: © Wayne Andrews/Esto.)

6.58 Henry Hobson Richardson, Marshall Field Wholesale Store, Chicago, Illinois, 1885–87. (From Van Rensselaer, *Henry Hobson Richardson*.)

6.59 Marshall Field Wholesale Store; street level view. (Photo: Charles Allgeier, Chicago, c. 1887–88; author's collection.)

6.60 Henry Hobson Richardson, John J. Glessner house, Chicago, Illinois, 1885–87. (Photo: Charles Allgeier, Chicago, c. 1887–88; author's collection.)

6.61 Glessner house; plan. (L. M. Roth, after E. Harrington and HABS.)

6.62 Henry Hobson Richardson, Allegheny County Courthouse and Jail, Pittsburgh, Pennsylvania, 1884–88. (Carnegie Photo, Northwestern University.)

6.63 Allegheny Courthouse and Jail; overall plan. (L. M. Roth, reconstructed after Van Rensselaer, *Henry Hobson Richardson*.)

7.1 William Le Baron Jenney, Home Insurance Building, Chicago, Illinois, 1883–85. (From A. T. Andreas, *History of Chicago*, Chicago, 1884–86.)

7.2 Burnham & Root, Rookery Building, Chicago, Illinois, 1884–86. (Photo: Library of Congress, HABS ILL 16-CHIG 31-1.)

7.3 Burnham & Root, Rookery Building, Chicago, Illinois, 1884–86. (Photo: Charles Allgeier, Chicago, c. 1887–88; author's collection.)

7.4 Burnham & Root, Monadnock Building, Chicago, Illinois, 1884–85, 1889–92. (Condit Archive, Northwestern University.)

7.5 Monadnock Building; plan. (L. M. Roth, after HABS.)

7.6 Comparison of masonry pyramidal foundation pier, on wooden pilings, with a Chicago floating raft concrete foundation pad. (L. M. Roth, after a construction drawing in J. O'Gorman, ed., *H. H. Richardson and His Office: Selected Drawings*, Cambridge, Mass., 1974.)

7.7 William Le Baron Jenny, diagram showing reinforced pad foundations. (L. M. Roth, after W. L. Jenny in *Engineering & Building Record* 24, November 14, 1891: 388.)

7.8 Burnham & Root, Reliance Building, Chicago, Illinois, 1889–91, 1892–95. (Photo: J. W. Taylor, c. 1892, Library of Congress, HABS ILL 16-CHIG 30-2.)

7.9 Reliance Building; plan. (L. M. Roth, after HABS.)

7.10 Adler & Sullivan, Auditorium Building, Chicago, Illinois, 1886–90. (Library of Congress, HABS ILL 16-CHIG 39-1.)

7.11 Auditorium Building; longitudinal section. (From *Inland Architect and News Record*, v. 11, July 1888, courtesy of the Burnham Library, Art Institute of Chicago.)

7.12 Auditorium Building; interior view of the Auditorium theater. (Photo: Hedrich-Blessing, Chicago Historical Society.)

7.57 Frank Lloyd Wright, Frederick C. Robie house, Chicago, Illinois, 1906–9. (From Wright, *Ausgeführte Bauten.*)

7.58 Robie house; second floor plan. (From Wright, *Ausgeführte Bauten.*)

7.59 Robie house; interior, dining room. (Rosenthal Archive, Northwestern University.)

7.60 Robie house; cross section of living room. (L. M. Roth, after HABS.)

7.61 Walter Burley Griffin, Frederick B. Carter house, Evanston, Illinois, 1909–10. (Photo: L. M .Roth.)

7.62 Purcell & Elmslie, Harold C. Bradley house, Woods Hole, Massachusetts, 1911–12. (Photo: © Wayne Andrews/Esto.)

7.63 Bernard Maybeck, S. H. Erlanger house, Forest Hill area, San Francisco, California, 1916. (Photo: Richard Barnes, from S. Woodbridge, Bernard Maybeck, *Visionary Architect*, New York, 1992.)

7.64 Julia Morgan, St. John's Presbyterian Church, Berkeley, California, 1908–10. (Photo: Morley Baer, from S. Woodbridge, ed., *Bay Area Houses*, 2nd ed., Layton, Utah, 1988.)

7.65 Greene & Greene, David B. Gamble house, Pasadena, California, 1907–8. (Photo: Sandak, courtesy of the University of Georgia.)

7.66 Irving Gill, Lewis Courts, Sierra Madre, California, 1910. (Courtesy of Esther McCoy.)

7.67 World's Columbian Exposition, Chicago, 1891–93. (L. M. Roth, after John J. Flinn, *Official Guide to the World's Columbian Exposition*, Chicago, 1892.)

7.68 Columbian Exposition, 1891–93; view looking west in the Court of Honor. (Courtesy of the Chicago Historical Society.)

7.69 Bernard Maybeck, Palace of Fine Arts, Panama-Pacific Exposition, San Francisco, California, 1911–15. (Courtesy of the Bancroft Library, University of California, Berkeley.)

7.70 Daniel Burnham, with Arnold Brunner and John M. Carrère, Civic Center plan for Cleveland, Ohio, 1902–3. (From *Architecture*, v. 8, September 15, 1903.)

7.71 Senate Park Commission, plan of proposed changes to the Mall, Washington, D.C., 1901–2. (McKim, Mead & White Archive, the New-York Historical Society.)

7.72 Daniel H. Burnham, plan of Chicago, metropolitan plan. (From D. H. Burnham, *Plan of Chicago*, Chicago, 1909.)

7.73 Chicago Plan, rendered plan of the central business and governmental district, 1904–9. (From D. H. Burnham, *Plan of Chicago*, Chicago, 1909.)

7.74 Proposed double-level drive along the Chicago River. (From Burnham, *Plan of Chicago.*)

7.75 Frederick Law Olmsted, plan for the Apollo Steel Company, Vandergrift, Pennsylvania, 1895. (C. Dykstra, ed., *Supplementary Report of the Urbanism Committee, Natural Resources Committee*, v. 2, Washington, D.C., 1939.)

7.76 Robert A. Cook, architect, Arthur A. Shurtleff, planner, Lakeside Group, 1910. (From *Architectural Review*, Boston, v. 28, April, 1918.)

7.77 Bertram Grosvenor Goodhue, view of the village piazza, as planned, Tyrone, New Mexico, 1914–15. (From *Architectural Review*, Boston, v. 28, April 1918.)

7.78 Tyrone, New Mexico; plan. (From *Architectural Review*, Boston v. 28, April 1918.)

7.79 Grosvenor Atterbury, Indian Hill, Worcester, Massachusetts, 1915. (From *Architectural Record*, v. 41, April, 1918.)

7.80 Grosvenor Atterbury, architect, Frederick Law Olmsted, Jr. planner, Forest Hills Gardens, New York, New York, 1909–12. (From *American Architect*, v. 102, October, 1912.)

7.81 Station Square, Forest Hills Gardens. (From *American Architect*, v. 102, October, 1912.)

7.82 Sears Roebuck & Co., gambrel-roof barn, Montpelier, Virginia, 1920s. (Photo: Courtesy of Montpelier Estate.)

7.83 Sears Roebuck & Co., four-square house, "The Chelsea." (From Sears Roebuck & Co., *Honor Bilt Modern Homes*, house catalogue, Chicago, 1926.)

8.1 George B. Post & Sons, architects, William Pitkin, Jr., planner, Eclipse Park, Beloit, Wisconsin, 1916–17. (From *American Architect*, v. 112, May 22, 1918.)

8.2 George B. Post & Sons, typical generic Dutch Colonial house for Eclipse Park, 1918. (From *American Architect*, v. 112 , May 22, 1918.)

8.3 Electus D. Litchfield and others, Yorkship Garden Village, Fairview, Camden, New Jersey, 1918. (*Report of the United States Shipping Board Emergency Fleet Corporation*, Washington, D.C., 1919.)

8.4 Richard H. Marr, Douglas Apartments, Detroit, Michigan, 1928. (From R. W. Sexton, *American Apartment Houses, Hotels, and Apartment Hotels of Today*, New York, 1929.)

8.5 Howard Van Doren Shaw, Market Square, Lake Forest, Illinois, 1913. (Photo: L. M. Roth.)

8.6 George Kessler, overall plan for the Country Club District, Kansas City, Missouri, 1908–24. (From C. Dykstra, ed., *Supplementary Report of the Urbanism Committee*, Natural Resources Committee, v. 2, Washington, D.C., 1939.)

8.7 J. W. Hersey, with William Mooser and Company, Santa Barbara County Courthouse, Santa Barbara, California, 1927–29. (Courtesy of the Santa Barbara Historical Society.)

8.8 Addison Mizner, Daniel H. Carstairs house, Palm Beach, Florida, 1923. (Photo: © Craig Kuhner.)

8.9 Fink and Paist, Venetian Pool, Coral Gables, Florida, 1924–25. (From G. H. Edgell, *The American Architecture of To-Day*, New York, 1928.)

8.10 I. H. Rapp and W. M. Rapp, Museum of Fine Arts, Santa Fe, 1917. (Courtesy of the Museum of New Mexico.)

8.11 John Gaw Meem, Zimmerman Library, University of New Mexico, Albuquerque, New Mexico, 1933–36. (Courtesy of the University of New Mexico.)

8.12 Mellor, Meigs & Howe, C. Heatley Dulles house, Villanova, Pennsylvania, 1916–17. (Photo: © Wayne Andrews/Esto.)

Michigan, 1939. (Rosenthal Archive, Northwestern University.)

8.54 Frank Lloyd Wright, Goetsch-Winkler house, Okemos, Michigan, 1939. (Photo: Leavenworth; Author's collection.)

8.55 Goetsch-Winkler house; plan. (From Wright, Natural House.)

8.56 Frank Lloyd Wright, S. C. Johnson Wax Company Administration Building, Racine, Wisconsin, 1936–39. (Rosenthal Archive, Northwestern University.)

8.57 S. C. Johnson Wax Company Administration Building; interior. (Rosenthal Archive, Northwestern University.)

8.58 Irving Gill, Walter L. Dodge house, West Hollywood, Los Angeles, California, 1914–16. (Photo: Library of Congress, HABS CAL 19-LOSAN 27-4.)

8.59 R. M .Schindler, Schindler-Chase house, West Hollywood, Los Angeles, 1921–22; isometric plan and elevated view. (L. M. Roth, after HABS.)

8.60 R. M Schindler, beach house for Dr. Phillip Lovell, Newport Beach, California, 1922–26. (Photo: Library of Congress, HABS CAL 30-NEWBE 1-1.)

8.61 Richard Neutra, Dr. Phillip Lovell house, Hollywood Hills, Los Angeles, California, 1927–29. (Photo: Luckhouse Studio, Rosenthal Archive, Northwestern University.)

8.62 Richard Neutra, Strathmore Apartments, Los Angeles, California, 1937. (Rosenthal Archive, Northwestern University.)

8.63 Park Avenue, New York, New York, 1929. (Wurts Brothers photo, courtesy of the Museum of the City of New York.)

8.64 Fred French Company, Tudor City, New York, New York, 1925–28. (From R. W. Sexton, *American Apartment Houses, Hotels, and Apartment Hotels of Today*, New York, 1929.)

8.65 Stein & Wright, Radburn, New Jersey, 1928–29; aerial view. (*Clarence Stein Papers*, Cornell University Library.)

8.66 Radburn; plan. (From C. Stein, *Toward New Towns for America*, Cambridge, Mass., 1957.)

8.67 Stein and Wright, Chatham Village, Pittsburgh, Pennsylvania, 1929–33; plan. (L. M. Roth, after Stein in *Gray Housing and Citizenship*, New York, 1946.)

8.68 Stein & Wright, planners, with Ingham & Boyd, architects, Chatham Village; interior park strip. (Courtesy of The MIT Press.)

8.69 John Nolen with Philip W. Foster and Justin R. Hartzog, Mariemont, near Cincinnati, Ohio, 1923 and after. (From C. Dykstra, ed., *Supplementary Report of the Urbanism Committee, Natural Resources Committee*, v. 2, Washington, D.C., 1939.)

8.70 Hale Walker, planner, Greenbelt, Maryland, 1935; plan. (From Stein, *Toward New Towns for America*.)

8.71 Ellington & Wadsworth, architects, apartment blocks, Greenbelt, Maryland; aerial view. (Photo: Library of Congress.)

8.72 Roland Wank, architect, and Arthur Morgan, engineer. Norris Dam, Norris, Tennessee, 1934–36; close view of

Elevator Tower and entrance to the Power House. (Photo: Library of Congress.)

9.1 Walter Gropius & Marcel Breuer, New Kensington, near Pittsburgh, Pennsylvania, 1941. (Rosenthal Archive, Northwestern University.)

9.2 Pietro Belluschi, Equitable Savings and Loan Association Building, Portland, Oregon, 1944–48. (Rosenthal Archive, Northwestern University.)

9.3 Skidmore, Owings & Merrill, Lever House, New York, New York, 1951–52. (Photo: L. M. Roth.)

9.4 Ludwig Mies van der Rohe, Illinois Institute of Technology, Chicago, Illinois, 1939–42; campus plan. (L. M. Roth, after A. Drexler, *Mies van der Rohe*, New York, 1960.)

9.5 Mies van der Rohe, Metallurgy and Chemical Engineering Building, Illinois Institute of Technology, 1942–44. (Photo: Bill Engdahl, Hedrich-Blessing.)

9.6 Mies van der Rohe, Crown Hall, Illinois Institute of Technology, 1950-56. (Rosenthal Archive, Northwestern University.)

9.7 Crown Hall; interior. (Rosenthal Archive, Northwestern University.)

9.8 Mies van der Rohe, Lakeshore Drive Apartments, 860–880 Lakeshore Drive, Chicago, Illinois, 1948–51. (Photo: © Wayne Andrews/Esto.)

9.9 860–880 Lake Shore Drive Apartments; site plan. (D. Rabbitt after Mies van der Rohe.)

9.10 Mies van der Rohe and Philip Johnson, Seagram Building, New York, New York, 1954–58. (Photo: Ezra Stoller © Esto, courtesy of Philip Johnson.)

9.11 Skidmore, Owings & Merrill, Union Carbide Building, New York, New York, 1957–60. (Courtesy Union Carbide Company.)

9.12 Skidmore, Owings & Merrill, Manufacturers Hanover Trust, New York, New York, 1953–54. (Photo: Ezra Stoller © Esto.)

9.13 Skidmore, Owings & Merrill, John Hancock Center, Chicago, Illinois, 1965–70. (Photo: c. 1972, Hedrich-Blessing, courtesy of Skidmore, Owings & Merrill.)

9.14 Skidmore, Owings & Merrill, Sears Tower, Chicago, Illinois, 1970–74. (Photo: c. 1976, Hedrich-Blessing, courtesy of Skidmore, Owings & Merrill.)

9.15 C. F. Murphy Associates, with Skidmore, Owings & Merrill and Loebl, Schlossman & Bennett, Civic Center (now the Daley Center), Chicago, Illinois, 1959–65. (Photo: Hedrich-Blessing.)

9.16 R. Buckminster Fuller, U.S. Pavilion, Montreal Expo, Montreal, Quebec, Canada, 1967. (Photo: Ilse Friesmen, courtesy of R. Buckminster Fuller.)

9.17 Harwell Hamilton Harris, Ralph Johnson house, Los Angeles, California, 1949–51. (Rosenthal Archive, Northwestern University.)

9.18 Pietro Belluschi, Peter Kerr house, Gearhart, Oregon, 1941. (Rosenthal Archive, Northwestern University.)

9.19 Pietro Belluschi, Central Lutheran Church, Portland, Oregon, 1948–50. (Rosenthal Archive, Northwestern University.)

9.20 Ludwig Mies van der Rohe, Dr. Edith Farnsworth

9.66 Moshe Safdie, David Barott, and Boulva, Habitat, Montreal Expo, Montreal, Quebec, Canada, 1964–67. (Courtesy of Moshie Safdie.)

9.67 Reston, Fairfax County, Virginia, begun 1961; general plan. (L. M. Roth.)

9.68 Lake Anne Village center, Reston, Fairfax County, Virginia, 1963–67. (Photo: Stan Wayman, *Life Magazine* © 1965 TIME, Inc.)

9.69 City Hall, Disneyland, Anaheim, California, Disney. (Courtesy of Disney Enterprises Inc., © Disney Enterprises, Inc.)

9.70 Lawrence Halprin, planner, W. Wurster, and Bernardi & Emmons, architects, Ghirardelli Square, San Francisco, California, 1964. (Courtesy of Saskia, Ltd.)

9.71 Lawrence Halprin & Associates, planners and designers (Angela Tzvetin and Satoru Nishita, designers), Civic Auditorium Forecourt Fountain ("Ira's Fountain"), Portland, Oregon, 1966–70. (Courtesy of the City of Portland.)

10.1 Frank Furness, Pennsylvania Academy of Fine Arts, Philadelphia, Pennsylvania, 1871–76; restoration and renovation, 1975–76 by Hyman Myers and the Vitetta Group. (Photo: Harris/Davis, courtesy of Hyman Myers and the Vitetta Group.)

10.2 Alexander Parris, Quincy Market, Boston, Massachusetts, 1825–26; renovated as the Faneuil Hall Marketplace complex, 1975–78, by Benjamin Thompson and Associates, BTA Architects for the Rouse Company; elevated view. (Photo: Steve Rosenthal.)

10.3 I. M. Pei & Partners, East Building, addition to National Gallery, Washington, D.C., 1968–78. (Photo: 1978 © Ezra Stoller, Esto.)

10.4 Venturi & Rauch, Wislocki and Trubeck houses, Nantucket, Massachusetts, 1970. (Photo: Steven Izenour, courtesy of Venturi, Scott Brown, and Associates.)

10.5 I. M. Pei office, Cobb, John Hancock Center, Boston; view of building with temporary plywood panels. (Photo: Boston Globe.)

10.6 Philip Johnson and Cyril M. Harris, Philharmonic Hall, Lincoln Center, New York, New York, renovation 1971-76. (Photo: Norman McGrath, © 1976 Lincoln Center for the Performing Arts, courtesy of the Lincoln Center for the Performing Arts.)

10.7 Philharmonic Hall; plans before and after renovation. (L. M. Roth, after *Progressive Architecture,* v. 58, March, 1977: 64-66.)

10.8 Hyatt Regency, Kansas City, Missouri, 1981; news photo, July 18, 1981, of collapsed skybridges. (Courtesy of *Kansas City Star.*)

10.9 Pruitt-Igoe Housing, St. Louis, Missouri; beginning of demolition, July 15, 1972. (Photo: Courtesy of *St. Louis Post Dispatch.*)

10.10 Robert Venturi, Vanna Venturi house, Chestnut Hill, Philadelphia, Pennsylvania, 1959–64. (Photo: Rollin La France, courtesy of Venturi, Scott Brown and Associates.)

10.11 Venturi house; plan. (L. M. Roth, after Venturi.)

10.12 Venturi & Rauch, Cope & Lippincott, associated architects, Guild House, Philadelphia, Pennsylvania, 1960–65. (Photo: William Watkins, courtesy of Venturi, Scott Brown and Associates.)

10.13 Venturi & Rauch, addition to the Allen Memorial Art Museum, Oberlin College, Oberlin, Ohio, 1973–76. (Photo: Thomas Bernard, courtesy of Venturi, Scott Brown and Associates.)

10.14 Allen Memorial Art Museum, Ionic column detail, at connection between original building and new gallery. (Photo: Thomas Bernard, courtesy of Venturi, Scott Brown and Associates.)

10.15 Charles Moore with Clark and Beuttler, Citizen's Federal Savings and Loan, San Francisco, California, 1962. (Photo: L. M. Roth.)

10.16 Moore, Lyndon, Turnbull & Whitaker, architects, Lawrence Halprin & Associates, planners, Sea Ranch, north of San Francisco, California, 1963–69. (Photo: © Wayne Andrews/Esto.)

10.17 Peter Eisenman, House II (the Falk house), Hardwick, Vermont, 1969–70. (From *Five Architects,* New York, 1975.)

10.18 Richard Meier, Douglass house, Harbor Springs, Michigan, 1971–73. (Photo: © Ezra Stoller/Esto, courtetsy of Richard Meier & Partners.)

10.19 Michael Graves, Fargo-Moorhead Cultural Center Bridge, 1977. (From R. Stern, ed., *The Architect's Eye,* New York, 1979.)

10.20 R. A. M. Stern, Wiseman House, Montauk, Long Island, New York, 1965–67. (Photograph by Hans Namuth, © Hans Namuth Estate, courtesy Center for Creative Photography, the University of Arizona.)

10.21 R. A. M. Stern, Lawsen summer house, Quoque, Long Island, New York, 1979–81. (Photo: © Peter Aaron/ Esto.)

10.22 Charles Moore, Piazza d'Italia, New Orleans, Louisiana, 1975–78. (Photo: Norman McGrath.)

10.23 Michael Graves, Portland Public Services Building, Portland, Oregon, 1978–82. (Photo: Dallas Swogger, courtesy of the City of Portland, Oregon.)

10.24 Frank Gehry, Loyola Marymount University Law School, Los Angeles, California, 1978–86. (Photo: © Tim Street-Porter/Esto.)

10.25 Johnson & Burgee, 1001 Fifth Avenue, New York, New York, 1977–79. (Courtesy of Philip Johnson.)

10.26 Johnson & Burgee, AT&T Building, New York City, 1975–84. (Photo: Richard Payne.)

10.27 AT&T Building; ground level view. (Photo: Richard Payne.)

10.28 Kevin Roche John Dinkeloo Associates, General Foods Corporation Headquarters, Rye, New York, 1977–83. (Courtesy of Kevin Roche John Dinkeloo and Associates.)

10.29 Langdon & Wilson, with Norman Neuerberg, Getty Museum, Malibu, California, 1970–75. (Photo: L. M. Roth.)

10.30 Allan Greenberg, Treaty Room Suite, Diplomatic Reception Rooms, U. S. Department of State, Washington, D.C., 1984. (Photo: Richard Cheek, courtesy of Allan Greenberg, Architect.)

INDEX

Page numbers in *italics* refer to illustrations.